Prebles'

Artforms

An Introduction to the Visual Arts

ELEVENTH EDITION

Patrick Frank

PEARSON

Boston Columbus Indianapolis New York San Francisco
Upper Saddle River Amsterdam Cape Town Dubai London
Madrid Milan Munich Paris Montréal Toronto Delhi Mexico City
São Paulo Sydney Hong Kong Seoul Singapore Taipei Tokyo

TO ALL WHO COME TO KNOW THE ARTIST WITHIN

Editor in Chief: Sarah Touborg
Senior Sponsoring Editor: Helen Ronan
Editorial Assistant: Victoria Engros
Vice President, Director of Marketing: Brandy Dawson
Executive Marketing Manager: Kelly May
Marketing Assistant: Paige Patunas
Managing Editor: Melissa Feimer
Production Project Manager: Marlene Gassler
Senior Operations Supervisor: Mary Fischer
Senior Operations Specialist: Diane Peirano
Media Director: Brian Hyland
Senior Media Editor: David Alick
Media Project Manager: Richard Barnes

Pearson Imaging Center: Corin Skidds
Printer/Binder: Manufactured in the United States by RR Donnell
Cover Printer: Phoenix Color/Hagerstown

Team at Laurence King Publishing:
Commissioning editor: Kara Hattersley-Smith
Senior editors: Susie May, Melissa Danny
Production controller: Simon Walsh
Picture researcher: Evi Peroulaki
Interior and Cover Design: Robin Farrow
Copy editor: Kirsty Seymour-Ure
Indexer: Vicki Robinson

Cover image: Arman. *Accumulation of Teapots*. 1964. Sliced teapots in plastic case. 16″ × 18″ × 16″.
Collection Walker Art Center, Minneapolis. Gift of the T.B. Walker Foundation, 1964.
© 2013 Artists Rights Society (ARS), New York/ADAGP, Paris.

For details about the image shown on page iv, please refer to fig 2.4.

Library of Congress Cataloging-in-Publication Data

Frank, Patrick
 Prebles' Artforms : an introduction to the visual arts / Patrick Frank. -- 11th edition.
 pages cm
 ISBN-13: 978-0-205-96811-4 (student edition)
 ISBN-10: 0-205-96811-2
 ISBN-10: 0-205-96811-2
1. Composition (Art) 2. Visual perception. 3. Art--History. I. Preble, Duane.
 Artforms. II. Title.
 N7430.P69 2014
 701'.8--dc23
 2013023462

V011
10 9

Student Edition
ISBN 10: 0-205-96811-2
ISBN 13: 978-0-205-96811-4

Instructor's Review Copy
ISBN 10: 0-205-96816-3
ISBN 13: 978-0-205-96816-9

Books à la Carte
ISBN 10: 0-205-96817-1
ISBN 13: 978-0-205-96817-6

BRIEF CONTENTS

CONTENTS

Part Two
THE MEDIA OF ART

ACKNOWLEDGMENTS

I greatly appreciate the help and encouragement of the many people who have been directly involved in the writing of this eleventh edition. Several deserve special mention for their contributions: Developmental editor Melanie Walker had a great many ideas about how to move this book forward while keeping its basic identity intact. Picture researcher Evi Peroulaki tirelessly tracked down images and fulfilled the increasingly complex legal requirements of today's copyright-sensitive age. Helen Ronan, Melissa Danny, and Susie May served as project managers, keeping us all on track while preserving a wonderfully civilized attitude.

This book also benefitted from assistance in specialized content areas from Elizabeth East, Charles James, Philip James, and Anthony Lee. Many artists opened their homes and studios to me as I was researching this book; I greatly appreciate their generosity, just as I hope that I have communicated the vigor and inspiration of their creativity.

I also express my sincere appreciation to the instructors who use this textbook as well as the following reviewers. All offered exceedingly valuable suggestions that were vital to the revising and updating of this edition:

Helen Barnes, *Butler Community College*
Rodrigo Benavides, *St. Philip*
Paul Benero, *Tarrant County College*
Paul Berger, *Modesto Junior College*
Joan Bontempo,
 Hagerstown Community College
Ingrid Cartwright, *Western Kentucky University*
Judith Dierkes, *Southwest TN community
 College, University of Memphis, Dyersburg
 State Community College*
Bobette Guillory, *Carl Albert State College*
Sandra Hardee, *Coastal Carolina University*
Pamela Harris,
 University of North Texas at Dallas
Beth Hinte, *San Jacinto Junior College*
Leah Johnson, *Hinds Community College*
Timothy Jones,
 *Oklahoma City Community College/
 University of Oklahoma*
Paul Levitt, *Hawaii Pacific University*
Nanci Schrieber-Smith, *Fullerton College*

Patrick Frank

PREFACE

We form art. Art forms us. The title of this book has a dual meaning. As humans form works of art, we in turn are formed by what we have created. Several editions ago, the title was changed to Prebles' Artforms, acknowledging the pioneering contribution of the original authors, Duane and Sarah Preble. They first posited the emphasis on our two-way interaction with works of art, and that emphasis continues to inform every page of this book.

Why study art?

Because at some point in human history, artists have dealt with nearly every aspect of the human experience, from the common to the forbidden, the mundane to the sacred, the repugnant to the sublime. Artistic creativity is a response to being alive, and by experiencing such creativity, we enrich our experience of life. This is especially true of today's creations, which are more wide-ranging than ever before, and sufficiently accessible to almost any curious person. Artistic creativity is a human treasure, and in today's art world we can see it in a very pure form.

Beyond fostering appreciation of major works of art, this book's primary concern is to open students' eyes and minds to the richness of the visual arts as unique forms of human communication and to convey the idea that the arts enrich life best when we experience, understand, and enjoy them as integral parts of the process of living.

Why use this book?

Because the art world is changing, and Prebles' Artforms is changing with it. The eleventh edition of this book is one of the deepest revisions it has ever seen. Critical to the revising process have been reviews, e-mails, and conversations with instructors from across the country who helped mold new ideas and redirect the book's course while keeping it true to its roots. Three recent trends drive this new edition:

- advice from instructors about changing pedagogical needs
- new scholarly research
- recent creativity by artists around the world.

Changing Pedagogical Needs: **The most important changes in this new edition are expanded pedagogical features** found throughout the book. In response to instructor and reviewer feedback, each chapter now begins with "**Think Ahead**" statements, which highlight a set of learning objectives specific to that chapter. Then, at each chapter's close, readers will find "**Think Back**" points in the form of review questions that reinforce those learning objectives. Key terms introduced in each chapter are now defined in a box, and a "**Try This**" exercise branches out from the chapter material asking students to think critically and actively apply what they have learned. Throughout the book, vocabulary items are bolded and defined in the text. Finally, the text links even more closely to the Pearson on-line

3 THE VISUAL ELEMENTS

THINK AHEAD

3.1 Describe the visual elements used in the production and analysis of art.

3.2 Indicate how artists use visual elements to create optical and illusionistic effects.

3.3 Explain technical devices used to render space and volume in painting.

3.4 Discuss the physical properties and relationships of color.

3.5 Show how visual elements convey expressive and symbolic meaning in a work of art.

3.6 Use basic tools of visual analysis to explain a work of art.

KEY TERMS

analogous colors – colors that are adjacent to each other on the color wheel, such as blue, blue-green, and green

atmospheric perspective – a type of perspective in which the illusion of depth is created by changing color, value, and detail

complementary colors – two hues directly opposite one another on a color wheel, such as red and green, that, when mixed together in proper proportions, produce a neutral gray

figure–ground reversal – a visual effect in which what was seen as a positive shape becomes a negative shape, and vice versa

geometric shape – any shape enclosed by square or straight or perfectly circular lines

hue – that property of a color identifying a specific, named wavelength of light such as green, red, violet, and so on

intensity – the relative purity or saturation of a hue (color), on a scale from bright (pure) to dull

linear perspective – a system of perspective in which parallel lines appear to converge as they recede into the distance, meeting at a vanishing point on the horizon

mass – the physical bulk of a solid body of material

organic shape – an irregular, non-geometric shape

picture plane – the two-dimensional picture surface

value – the relative lightness and darkness of surfaces

In the first half of the book, thirteen biographical essays have been rewritten **to show how those artists shape artworks**: How they process information, personal feeling, their media, other art, or public input to create their work. These boxes let the artists speak for themselves, as actual quotes by the creators enliven the discussions wherever possible.

In the second half of the book, eleven text boxes approach the theme "Art Forms Us" by examining in more detail **how art fulfills the six social purposes** introduced in Chapter 2. For example, in connection with the discussion of Realist art of the nineteenth century, an Art Forms Us box presents several works from widely disparate times to show how other artists throughout history have "Formed Us" by making their work a commentary on their times. In Chapter 23, the discussion of politically driven art of the 1930s leads to an Art Forms Us box that discusses other examples of persuasive art, including a piece of sculpture from the London Olympic grounds, a medieval weaving, and

resource **MyArtsLab** by highlighting direct connections between the book and that expanded body of material, which includes interviews, podcasts, videos, and interactive exercises.

Thematic teaching is another key pedagogical trend that drives several changes in this new edition. The title of this book itself suggested how to accomplish this, because *Artforms* arose from the simple statement: We form art; art forms us. In response to the growing number of instructors who use a thematic approach to art appreciation, the content of *Artforms* has been revamped in several important ways to enable such teaching. First, a new Chapter 2 discusses **artistic creation according to six purposes or functions** that it fulfills in society. These are Commentary, Delight, Persuasion, Commemoration, Worship and Ritual, and Self-Expression. Several examples of each are given from diverse cultures and times.

Second, **our text boxes have been streamlined and refocused** around the theme "Forming Art."

FORMING ART

Henri de Toulouse-Lautrec (1864–1901): Printing from Life

8.16 Henri de Toulouse-Lautrec in his studio.
Photograph courtesy of Patrick Frank

The cabaret singer Aristide Bruant provides an important key to the work of Henri de Toulouse-Lautrec, because the two were friends who inhabited the nocturnal world of the bar and the nightclub. The artist's relationship with Bruant helped to shape some of his lithographic creations.

Bruant as a teenager had lived in the poor neighborhoods of Paris, where he befriended people on both sides of the law. He even obtained passes to enter the prison of La Roquette, where executions were carried out. Bruant used these experiences in his songs, which were laden with sad social commentary about the poor and the desperate. He was among the most popular singers of the day.

When Bruant opened his own cabaret in 1885, Toulouse-Lautrec became one of its most

devoted patrons; the following year, the singer put the artist's work on permanent display at the club. Toulouse-Lautrec in turn created a lithographic portrait of Bruant (**fig. 8.17**). In this work, we see the singer's unconventional attire, with broad-brimmed hat and bright neck wrap.

We also see the artist's fluid and creative use of the lithographic medium. He used crayons of various widths for the lines, and tusche for the solid dark areas. He created the white patches at the right by dropping melted wax on the stone, keeping ink away from that part. The speckles were created by spattering, as he flicked the bristles of an ink-laden brush.

For ten years, Bruant's cabaret flourished; his act, which included taunting the audience, drew crowds of people who made the trek out to the somewhat shady neighborhood of Montmartre. There they saw the aloof and somber singer perform his tragic songs.

When the upper-crust nightclub les Ambassadeurs lured Bruant for an engagement in its fashionable area of Champs Elysées, the singer commissioned Toulouse-Lautrec to design a poster (see fig. 8.15). He responded with a rich creation in five colors, composed of a few, mostly flat, shapes in a large format unusual for that time. Each color required a separate lithographic stone. The deep blue area at the upper right

is a doorway where a sailor stands. Bruant's body fills most of the frame, bringing him close to the picture surface, overlapping the name of the club at the top. The two zones of the flaming red scarf converge near Bruant's head, leading us to the singer's distant and somewhat haughty demeanor in his face. Toulouse-Lautrec specialized in capturing such reserved emotional states. The poster also reflects Toulouse-Lautrec's careful study of Japanese printmakers, who often used

flat shapes in bright colors to depict nightlife scenes.

This poster was not an immediate success; the Ambassadeurs manager disliked the bold design, which was novel for its day. But Bruant loved it: "Am I that grand?" he reportedly remarked.[1] He insisted that hundreds be printed and plastered across Paris. They survive to this day, the originals mostly in museums, and many knock-off copies everywhere else.

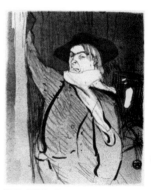

8.17 Henri de Toulouse-Lautrec.
Aristide Bruant, 1893. Lithograph. 10½" × 8¼".
National Gallery of Art, Washington D.C. Rosenwald Collection 1947.7.169

PRINTMAKING CHAPTER 8

FORMS US: PERSUASION

Power

an African staff. These boxes **enable students to see common threads among widely diverse periods of creation**, and they allow teachers who approach the subject thematically to base their courses around the six functions.

New Research: Several **content areas have received expanded treatment**, in response to new research, audience feedback, or increased public interest. An expanded section on **Creativity** in Chapter 1 highlights important new findings in that field. **New discoveries in Paleolithic Art** have yielded new coverage there. The new design fields of **Interactive and Motion Graphics** have caused a further update of Chapter 11. Recent censorship controversies are included. Altogether, these

pedagogical and content changes have lengthened the book by a little over 30 pages, adding depth, breadth, and flexibility to the coverage.

This edition also introduces a large number of new images. In fact, 26 percent of the works pictured in this edition are new, a total of 165. These new images support the new pedagogical approaches, as they refresh the text from various angles. Some are ancient, such as a rock art panel from Utah and a bronze tray from Central Asia. Some are "classics," such as the *Augustus of Prima Porta* and the *Tempietto* of Bramante. They come from diverse media as well, including works created on the Apple iPad, for example, and a building in Japan whose façade is a giant QR code. Many new illustrations come from widespread cultures, including several important African pieces, continuing the global emphasis that *Artforms* pioneered in 1998.

Recent Works by Artists Across the Globe: Nearly half of the 165 new images in this edition are contemporary, meaning that the works are either by living artists, or were created in the new millennium. This reflects my ongoing commitment to contemporary art as the best gateway to art appreciation. It also reflects the fact that I live in the midst of one of the world's most dynamic art centers, where I personally know many collectors, dealers, critics, scholars, and, yes, artists. In the Postmodern period, many artists work in more accessible languages and styles than in the Modern past. I believe that their contemporary creativity is engaging, wide-ranging, surprising, and thought-provoking. Because of all that, it's inspiring.

In conclusion, this new edition reflects my desire to connect with the instructors, readers, and students who use this book, and my ongoing involvement in the art world. I want *Artforms* to be the best it can be. To communicate with me more directly with thoughts, suggestions, or feedback, I invite e-mails to pfrank@artformstext.com.

Patrick Frank
Venice, California

MyArtsLab LETS YOUR STUDENTS EXPERIENCE AND INTERACT WITH ART

This program will provide a better teaching and learning experience for you and your students. Here's how:

The new **MyArtsLab** delivers proven results in helping individual students succeed. Its automatically graded assessments, personalized study plan, and interactive eText provide engaging experiences that personalize, stimulate, and measure learning for each student.

- The **Pearson eText** lets students access their textbook anytime, anywhere, and any way they want—including downloading to an iPad or listening to chapter audio read by Patrick Frank. Includes a unique scale feature showing students the size of a work in relation to the human figure.

- **Personalized** study plan for each student promotes critical-thinking skills. Assessment tied to videos, applications, and chapters enables both instructors and students to track progress and get immediate feedback.

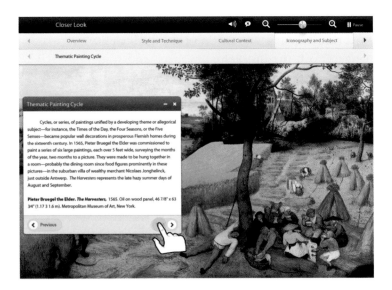

- **New:** Henry Sayre's *Writing About Art* 6th edition is now available online in its entirety as an eText within MyArtsLab.

- **New and expanded:** Closer Look tours—interactive walkthroughs featuring expert audio—offer in-depth looks at key works of art. *Now optimized for mobile.*

- **New and expanded:** 360-degree architectural panoramas and simulations of major monuments help students understand buildings—inside and out. *Now optimized for mobile.*

art21

- **New:** Art21 videos present prominent artists at work and in conversation about their work with more than 20 Art21 Exclusives, including recently digitized archival clips of artists such as Richard Serra, Cindy Sherman, Fred Wilson, and Shahzia Sikander.

Art:21 Cindy Sherman: Masks & Mannequins

Click the ✕ icon to view fullscreen.

Description: Cindy Sherman (b. 1954) takes photographs of herself in various guises. She mimics the style and appearance of familiar films, paintings, magazine centerfolds and other visual sources. Although still photographs, the realistic details and engaging subject matter encourage the viewer to imagine a narrative context for each scene. In this way, Sherman calls attention to how photographs may be constructed to convey different impressions, forcing us to consider the function of popular images in everyday life.

Credits: Episode #087: December 18, 2009 (RT 02:41) VIDEO | Producer: Wesley Miller & Nick Ravich. Interview: Susan Sollins. Camera: Joel Shapiro. Sound: Roger Phenix. Editor: Lizzie Donahue & Paulo Padilha. Artwork Courtesy: Cindy Sherman.

BREAK THROUGH TO A NEW WORLD OF LEARNING

MyArtsLab consistently and positively impacts the quality of learning in the classroom. When educators require and integrate MyArtsLab in their course, students and instructors experience success. Join our ever-growing community of 50,000 users across the country giving their students access to the high quality rich media and assessment on MyArtsLab.

"MyArtsLab also makes students more active learners. They are more engaged with the material."
—Maya Jiménez, Kingsborough Community College

"MyArtsLab keeps students connected in another way to the course material. A student could be immersed for hours!"
—Cindy B. Damschroder, University of Cincinnati

"I really enjoy using MyArtsLab. At the end of the quarter, I ask students to write a paragraph about their experience with MyArtsLab and 97% of them are positive."
—Rebecca Trittel, Savannah College of Art and Design

Give your students choices

Pearson arts titles are available in the following formats to give you and your students more choices—and more ways to save.

The **CourseSmart eTextbook** offers the same content as the printed text in a convenient online format—with highlighting, online search, and printing capabilities. **www.coursesmart.com**

The **Books à la Carte edition** offers a convenient, three-hole-punched, loose-leaf version of the traditional text at a discounted price—allowing students to take only what they need to class. Books à la Carte editions are available both with and without access to MyArtsLab.

Build your own Pearson Custom course material. Work with a dedicated Pearson Custom editor to create your ideal textbook and web material—publishing your own original content or mixing and matching Pearson content. *Contact your Pearson representative to get started.*

Instructor resources

PowerPoints featuring nearly every image in the book, with captions and without captions.

NEW! The Class Preparation Tool collects the very best class presentation resources in one convenient online destination, so instructors can keep students engaged throughout every class. With art and figures from the text, videos, classroom activities, and much more, it makes lecture preparation simpler and less time-consuming.

NEW! Teaching with MyArtsLab PowerPoints help instructors make their lectures come alive. These slides allow instructors to display the very best interactive features from MyArtsLab in the classroom—quickly and easily.

Instructor's Manual and Test Item File

This is an invaluable professional resource and reference for new and experienced faculty. Each chapter contains the following sections: Chapter Overview, Chapter Objectives, Key Terms, Lecture and Discussion Topics, Resources, and Writing Assignments and Projects. The test bank includes multiple-choice, true/false, short-answer, and essay questions. Available for download from the instructor support section at **www.myartslab.com.**

MyTest

This flexible online test-generating software includes all questions found in the printed Test Item File. Instructors can quickly and easily create customized tests with MyTest. **www.pearsonmytest.com**

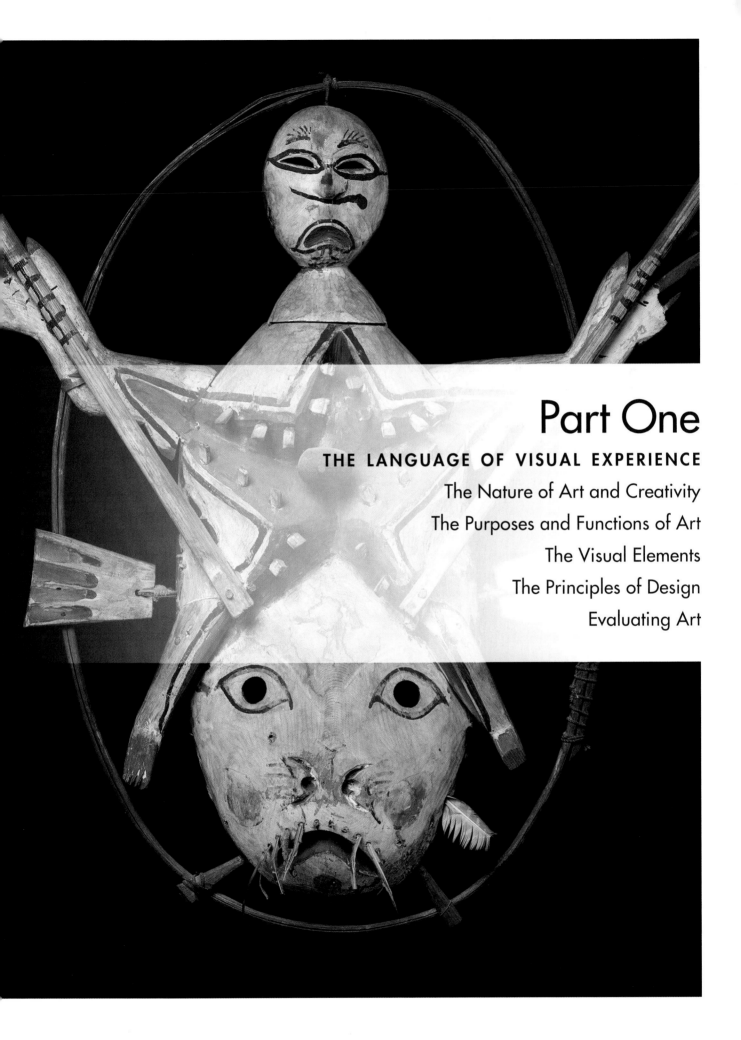

Part One

THE LANGUAGE OF VISUAL EXPERIENCE

The Nature of Art and Creativity
The Purposes and Functions of Art
The Visual Elements
The Principles of Design
Evaluating Art

1 THE NATURE OF ART AND CREATIVITY

THINK AHEAD

1.1 Describe art as means of visual expression using different media and forms.

1.2 Show human creativity as an inherent trait that inspires the production of art.

1.3 Demonstrate the diverse intellectual, cultural, and skills backgrounds of artists.

1.4 Distinguish form and meaning in visual analysis.

1.5 Define the terms representational, abstract, nonrepresentational, and iconography used to discuss art.

Is it necessary for us to give physical form to things we feel, think, and imagine? Must we gesture, dance, draw, speak, sing, write, and build? To be fully human, it seems we must. In fact, the ability to create is one of the special characteristics of being human. The urge to make and enjoy what we call art has been a driving force throughout human history. Art is not something apart from us. It grows from common—as well as uncommon—human insights, feelings, and experiences.

Art does not need to be "understood" to be enjoyed. Like life itself, it can simply be experienced. Yet the more we understand what art can offer, the richer our experience of it will be.

For example, when Janet Echelman's huge artwork *Her Secret Is Patience* (**fig. 1.1**) was hoisted into the air above Phoenix in mid-2009, even most of the doubters became admirers once they experienced this stunning work. Suspended from three leaning poles between 40 and 100 feet above the ground, its colored circles of netting appear both permanent and ever changing, solid yet spacious, defying gravity as they dance and wave slowly in the breeze.

The artist chose the cactus flower shape to symbolize the Arizona desert city of Phoenix. She was inspired by the patience of the saguaro cactus, she said, "a spiny cactus putting down roots in search of water in the desert, saving up every ounce of energy until, one night, in the middle of the cool darkness, it unfurls one succulent bloom."[1] The work also refers to the character of nature itself. Echelman drew her title from the words of American poet and philosopher Ralph Waldo Emerson, who wrote, "Adopt the pace of nature; her secret is patience."

The citizens who advocated the piece over the extended waiting time between conception and completion were patient as well. Doubters objected to the price tag ($2.4 million), the shape (one said it resembled a giant jellyfish), and the artist's origins (she is not from Arizona). Those misgivings and a few technical issues kept *Her Secret Is Patience* on the drawing board for a year and a half. But today most Arizonians look on the work with pride: This unique visual delight has become a landmark for the city of Phoenix just as the Eiffel Tower became one for Paris. The *Arizona Republic* editorialized: "This is just what Phoenix needs: a distinctive feature that helps create a real sense of place."[2]

The creation and the reception of *Her Secret Is Patience* embody an important idea: artistic creation is a two-way street. That is, we form art, and then the art forms us by enriching our lives, teaching us, touching our spirits, commemorating our human past, and inspiring or persuading us (see Chapter 2).

((•─ **Listen** to the chapter audio on myartslab.com

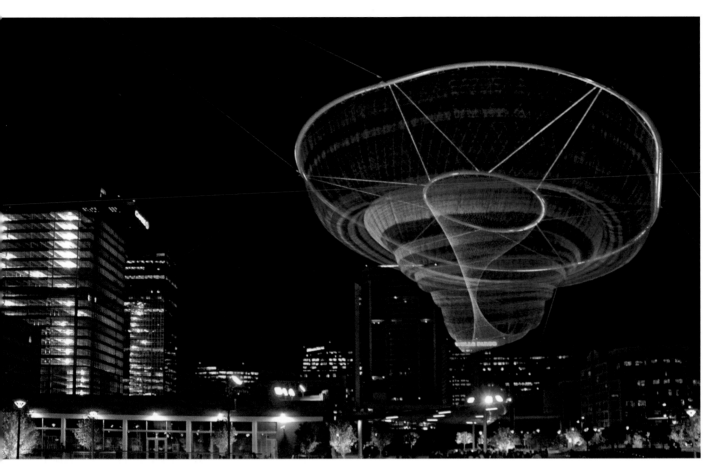

1.1 Janet Echelman. *Her Secret Is Patience.* 2009. Fiber, steel, and lighting. Height 100′ with a top diameter of 100′.
Civic Space Park, Phoenix, AZ. Courtesy Janet Echelman, Inc. Photograph: Will Novak.

It can also challenge us to think and see in new ways, and help each of us to develop a personal sense of beauty and truth.

While *Her Secret Is Patience* may not resemble the type of artwork that you are familiar with—it is not a painting, and it is not in a museum—it is art. In this chapter we will explore some definitions of what is meant by "art" and "creativity," and look at how creativity is expressed through different types of art and through its form and content.

What is Art?

When people speak of the arts, they are usually referring to music, dance, theater, literature, and the visual arts. Each artform is perceived in different ways by our senses, yet each grows from a common need to give expressive substance to feelings, insights, and experiences. The arts communicate meanings that go far beyond ordinary verbal exchange, and artists use the entire range of thought, feeling, and observation as the subjects of their art.

The visual arts include drawing, painting, sculpture, film, architecture, and design. Some ideas and feelings can best be communicated only through visual forms. American painter Georgia O'Keeffe said: "I found that I could say things with colors and shapes that I couldn't say in any other way—things I had no words for."[3]

A **work of art** is the visual expression of an idea or experience, formed with skill, through the use of a **medium**. A medium is a particular material, along with its accompanying technique. (The plural is *media.*) Artists select media to suit the function of the work, as well as the ideas they wish to present. When a medium is used in such a way that the object or performance contributes to our understanding or enjoyment of life, we experience the final product as art.

For *Her Secret Is Patience*, Echelman sought to create a work that would say something about the Phoenix area, in a way that harmonized with the forces of nature. Thus, she chose flexible netting for the medium because it responds gracefully to the wind. She similarly

chose the size, scale, shape, and color of the work that would best support and express her message.

Media in use for many centuries include clay, fiber, stone, wood, and paint. By the mid-twentieth century, modern technology had added new media, including video and computers, to the nineteenth-century contributions of photography and motion pictures. Art made with a combination of different materials, as many artists do today, is referred to as **mixed media**.

What is Creativity?

The source of all art, science, and technology—in fact, all of civilization—is human imagination, or creative thinking. But what do we mean by this talent we call "creativity"?

Creativity is the ability to bring forth something new that has value. Mere novelty is not enough; the new thing must have some relevance, or unlock some new way of thinking.

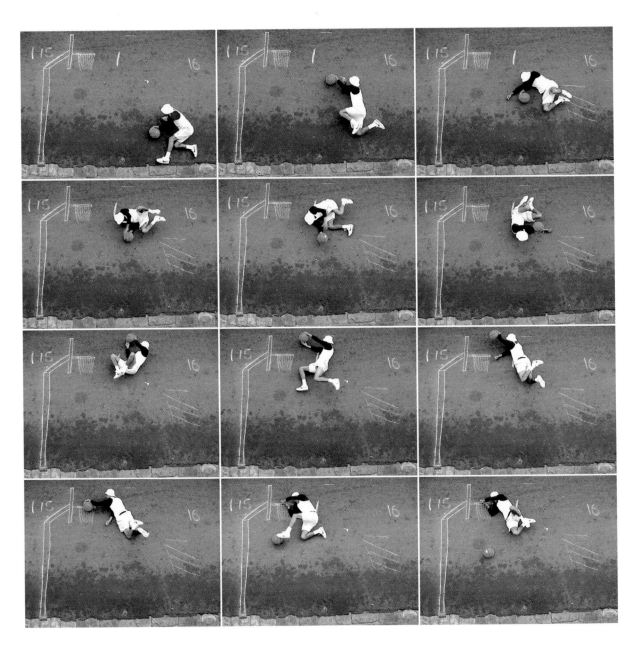

1.2 Robin Rhode.
He Got Game. 2000. Twelve color photographs.
Lehmann Maupin, New York and Hong Kong © Robin Rhode.

Creativity also has the potential to influence future thought or action and is vital to most walks of life. In 2010, the IBM corporation interviewed 1,500 chief executive officers (CEOs) from 60 countries, asking them what was the most important leadership skill for the successful businesses of the future. Their answer was not economic knowledge, management skills, integrity, or personal discipline, but creativity.

While studying creative people in several disciplines, the authors of the 2011 book *Innovator's DNA*[4] found five traits that seem to define creativity:

1. Associating. The ability to make connections across seemingly unrelated fields.
2. Questioning. Persistently challenging the status quo, asking why things function as they do now, and how or why they might be changed.
3. Observing. Intently watching the world around, without judgment, in search of new insights or ways of operating.
4. Networking. Being willing to interact with others, and learn from them, even if their views are radically different or their competencies seem unrelated.
5. Experimenting. Exploring new possibilities by trying them out, building models, and taking them apart for further improvement.

Creativity can be found in most human endeavors, but here we focus on artistic creativity, which can take many forms. A film director places actors and cameras on a stage in order to emphasize a certain aspect of the script. A Hopi potter decorates a water jar by combining traditional designs in new ways. A graphic designer seated at a computer screen arranges a composition of type, images, and colors in order to help get his or her message across. A carver in Japan fashions wood into a Buddha that will aid in meditation at a monastery. Most of us have at some time arranged images on our walls or composed a picture for a camera. All of these actions involve visual creativity, the use of imagery to communicate beyond what mere words can say.

He Got Game (**fig. 1.2**) is a good example of visual creativity using simple means. Contemporary South African artist Robin Rhode drew a basketball hoop on the asphalt surface of a street, and then photographed himself lying down in 12 positions as if he were flipping through the air performing an impossible slam dunk. The artist here imitates the slow-motion and stop-motion photography often seen in sports television to create a piece with transcendent dramatic flair. The work cleverly uses low-tech chalk drawing and a slangy title to celebrate the cheeky boastfulness of street culture. As it clearly shows, creativity is an attitude; one that is as fundamental to experiencing and appreciating a work of art as it is to making one. Insightful seeing is itself a creative act; it requires open receptivity—putting aside habitual modes of thought—and a willingness to stretch the mind.

Twentieth-century American artist Romare Bearden showed a different type of creativity in his depictions of the daily life he witnessed in the rural South and in Harlem, New York City. In *Prevalence of Ritual: Tidings* (**fig. 1.3**) he created a **photomontage** using borrowed picture fragments with a few muted colors to portray a mood of melancholy and longing. In the work, a winged figure seems to comfort an introspective woman who holds a flower, suggesting the story of the Christian Annunciation; a train implies departure perhaps from this world or simply to a better life in the North. In this photomontage, as in many of his others, Bearden was concerned with the effectiveness of his communication

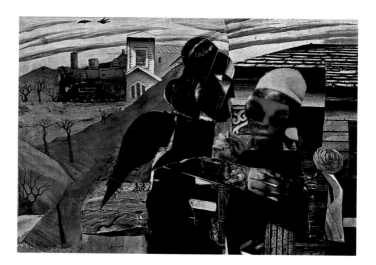

1.3 Romare Bearden.
Prevalence of Ritual: Tidings. 1967.
Photomontage. 36″ × 48″.
© Romare Bearden Foundation/Licensed by VAGA, New York, NY.

Watch a video of Romare Bearden discussing his work on myartslab.com

FORMING ART

Romare Bearden (1911–88): Jazz and Memory

1.4 Romare Bearden
Bernard Brown & Associates.

How can the influence of jazz and memory spark creativity and help form visual art? Romare Bearden shows us how. Growing up in Harlem in the 1920s and 1930s, he witnessed firsthand the outpouring of African-American culture called the Harlem Renaissance. His mother was a political activist and journalist, his father a city inspector. The musicians, artists, and authors of the Harlem Renaissance were frequent guests in his home.

In his youth, he drew political cartoons for an African-American newspaper. He studied art in New York, and in Paris after his army service in World War II. During his European study he met several leading African intellectuals who urged artists to reconnect with their ethnic roots. But Bearden went beyond his heritage and reached for a wider impact. Of his Paris years, he recalled, "The biggest thing I learned was reaching into your consciousness of black experience and relating it to universals."[5]

Being intellectually curious about all sorts of traditions helped enable his quest. He admired the novels of Irish writer James Joyce and the art of the early Italian Renaissance. Novelist Ralph Ellison recounted Bearden's wide knowledge of the history of art: "I can recall visits to Romie's 125th Street studio during which he stood at his easel sketching, and explaining the perspectives of the Dutch and Italian masters."[6] He made paintings inspired by the seventeenth-century poet Andrew Marvell, by the Bible, and by the *Iliad* of Homer.

Music weighed even more potently in Bearden's creativity. He knew Duke Ellington, Fats Waller, and singer-actor Paul Robeson. Bearden said, "I'd take a sheet of paper and just make lines while I listened to records, a kind of shorthand to pick up the rhythm and the intervals."[7] He was especially drawn to the piano style of Earl "Fatha" Hines. Bearden listened both to the notes and to the spaces between them, discerning musical structures that influenced his art. He said of Hines: "His delicate and precise spacing helped me a great deal with pictorial composition."[8]

We see this tendency at work in his collage *Rocket to the Moon* (**fig. 1.5**), where collage fragments build a scene of quiet despair and stoic perseverance. The buildings are large blocks that function like verses of a song, with a space between. The figures are more detailed, like embellishing

musical notes. "You put down one color," the artist said, "and it calls for another. You have to look at it like a melody."[9] Just as the construction of a song can sound inevitable, so the parts of an artwork should hang together easily.

Of course, the African-American roots of his work are inescapable. "You should always respect what you are in your culture, because if your art's going to mean anything, that's where it has to come from," he said.[10] *Rocket to the Moon* tells of a certain indifference in urban black neighborhoods to the fact of the lunar exploration.

Bearden kept a list of key events from his life on the

wall of his studio. He often drew upon memories of his childhood in North Carolina. The idea of homecoming fascinated him. He said, "You can come back to where you started from with added experience and you hope more understanding. You leave and then return to the homeland of your imagination."[11]

Interviewed for a retrospective exhibition at the San Francisco Museum of Modern Art, he explained his goal as an artist: "I have tried to bring the Afro-American experience into art and give it a universal dimension."[12] Through his creativity, and with the aid of jazz and memory, he succeeded.

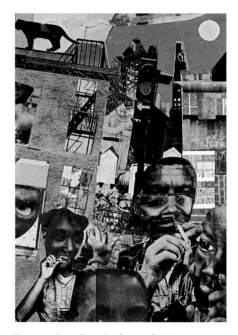

1.5 Romare Bearden. *Rocket to the Moon*. 1971. Collage on board. 13″ × 9¼″.
© Romare Bearden Foundation/Licensed by VAGA, New York, NY.

to others, but equally important was his own inner need for creative expression—an aspect of how art forms us (see Chapter 2).

Trained and Untrained Artists

Most of us tend to think of "art" as something produced only by "artists"—uniquely gifted people—and because art is often separated from community life in contemporary society, many people believe they have no artistic talent. Yet we all have the potential to be creative.

In the past, the world's trained artists generally learned by working as apprentices to accomplished masters. (With a few notable exceptions, women were excluded from such apprenticeships.) Through practical experience, they gained necessary skills and developed knowledge of their society's art traditions. Today most art training takes place in art schools, or in college or university art departments. Learning in such settings develops sophisticated knowledge of alternative points of view, both contemporary and historical, and often trained artists show a self-conscious awareness of their relationship to art history.

While training, skills, and intelligence are helpful in creativity, they are not always necessary. The urge to create is universal and has little to do with art training. Those with a small amount of or no formal art education—usually described as untrained artists or **folk artists**—and children can be highly creative. Art by untrained artists, also called naïve or **outsider artists**, is made by people who are largely unaware of art history or the art trends of their time. Unlike folk art, which is made by people working within a tradition, art by outsider artists is personal expression created apart from any conventional practice or style.

One of the best-known (and largest) pieces of outsider art in the United States is *Nuestro Pueblo (Our Town)*, more commonly known as the Watts Towers (**fig. 1.6**). Creator Sabatino "Simon" Rodia exemplifies the artist who visualizes new possibilities for ordinary materials. He worked on his cathedral-like towers for 33 years, making the fantastic structures from cast-off materials such as metal pipes and bed frames held together with steel reinforcing rods, mesh, and mortar. Incredibly, he built the towers without power tools, rivets, welds, or bolts.

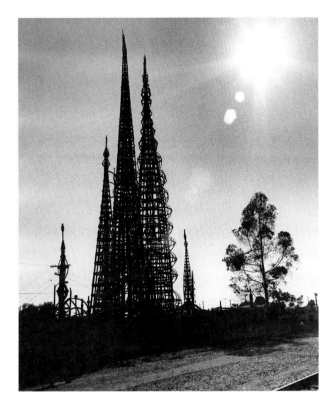

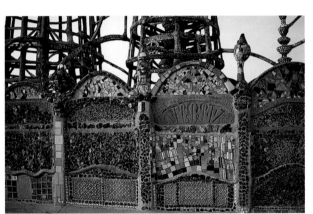

1.6 Sabatino "Simon" Rodia. *Nuestro Pueblo.*
Top: distant view. Bottom: detail of enclosing wall with construction tool impressions. 1921–1954. Mixed media. Height 100′. Watts, California.
Photographs: Duane Preble.

As the towers rose in his triangular backyard, he methodically covered their surfaces with bits and pieces of broken dishes, tile, melted bottle glass, shells, and other colorful junk from the vacant lots of his neighborhood. Rodia's towers are testimony to the artist's creativity and perseverance. He said, "I had it in mind to do something big, and I did it."[13]

Some creative people are so far outside the art world that their names are unknown to us. In 1982, an art student in Philadelphia found several boxes of

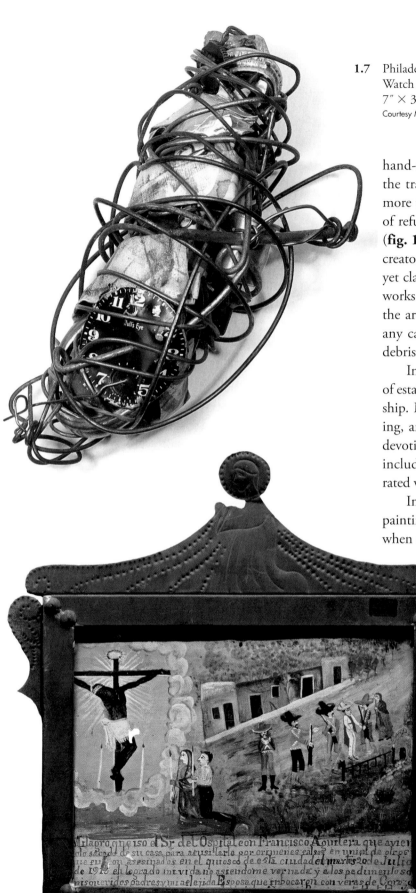

1.7 Philadelphia Wireman. *Untitled (Watch Face)*. c.1970.
Watch face, bottle cap, nail, drawing on paper, and wire.
7″ × 3½″ × 2¼″.
Courtesy Matthew Marks Gallery.

hand-sized sculptures that had been set out among the trash in a run-down neighborhood. Numbering more than a thousand, the sculptures were collections of refuse and other small objects, all wrapped in wire (**fig. 1.7**). Dubbed the Philadelphia Wireman, the creator of these works is still unknown, as no one has yet claimed authorship after several exhibitions of the works. Because of the force required to bend the wire, the artist is generally thought to have been male. In any case, he created compelling conglomerations of debris that stir memory and imagination.

In contrast to outsider artists, folk artists are part of established traditions of style, theme, and craftsmanship. Most folk artists have little systematic art training, and their work often shows great enthusiasm or devotion to tradition. Folk art can take many forms, including quilts, embroidered handkerchiefs, decorated weather vanes, sculptures, or customized cars.

In Mexico and the American Southwest, *retablo* painting is a customary way of giving thanks to God when someone escapes from some danger or recovers from an illness. Such paintings generally depict the scene of salvation along with a narrative of the events. In this example (**fig. 1.8**), a man falsely accused of a crime escaped execution and created the painting. The inscription credits the "fervent prayers of my dear parents and my aggrieved wife" for saving him from the ultimate punishment. The spelling errors in the inscription combine with the sincere and charming painting style to yield a highly attractive work.

Children use a universal visual language. All over the world, drawings by children aged two to six show similar

1.8 *Retablo*. 1915.
Paint on tin. 9″ × 11″.
Fowler Museum at UCLA. Photograph by Don Cole.

1.9 Alana, age 3. *Grandma.*

stages of mental growth, from exploring with mark-making, to inventing shapes, to symbolizing things seen and imagined. Until they are about six years old, children usually depict the world in symbolic rather than realistic ways. Their images are more mental constructions than records of visual observations. The drawing *Grandma* (**fig. 1.9**) by three-year-old Alana shows enthusiasm and self-assurance in the repeated circles of green and brown. She found a rhythm in the eyes and the head, and she followed it exuberantly out to the sleeves.

Young children often demonstrate an intuitive sense of composition. Unfortunately, much of this intuitive sense of balanced design is lost when they begin to look at the world from a conceptual and self-conscious point of view. Most children who have been given coloring books, workbooks, and predrawn printed single sheets become overly dependent on such impersonal stereotyped props. In this way, children often lose the urge to invent unique images based on their own experiences. Recent research shows that many children begin to doubt their creativity at about the age of nine or ten years. But creative people, be they artists or CEOs, retain their creativity into adulthood.

Whether trained, outsider, or folk, artists must be independent thinkers and must have the courage to go beyond group mentality. In this way artists can offer fresh insights that extend the experiences of those who see their art.

Art and Reality

Artists may depict what they see in the physical world, they may alter appearances, or they may utilize forms that no one has seen in either the natural or the human-made world. Regardless of their approaches, most artists invite viewers to see beyond mere appearances. The terms **representational**, **abstract**, and **nonrepresentational** are used to describe an artwork's relationship to the physical world.

Representational Art

Representational art depicts the appearance of things. (When human form is the primary subject, it is called **figurative art**.) It represents—or "presents again"—objects we recognize from the natural, everyday world. Objects that representational art depicts are called **subjects**.

There are many ways to create representational art. The most "real"-looking paintings are in a style called *trompe l'oeil* (pronounced "tromp loy")—French for "fool the eye." Paintings in this illusionistic style impress us because they look so "real." In Harnett's painting *A Smoke Backstage* (**fig. 1.10**), the assembled objects are close to life-size, which contributes to the illusion. We almost believe that we could touch the pipe and match.

Belgian painter René Magritte shows a different relationship between art and reality (**fig. 1.11**). The subject of the painting appears to be a pipe, but written in French on the painting are the words, "This is not a pipe." The viewer may wonder, "If this is not a pipe, what is it?" The answer, of course, is that it is a painting! Magritte's title, *The Treachery of Images (La Trahison des Images)*, suggests the visual game that the artist had in mind.

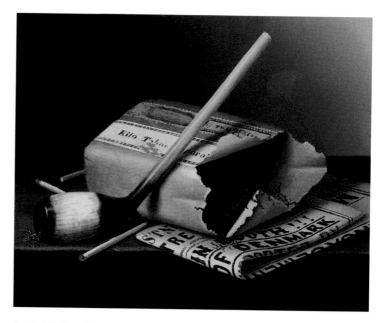

1.10 William Harnett. *A Smoke Backstage.* 1877.
Oil on canvas. 7″ × 8½″.
Honolulu Museum of Art, Gift of John Wyatt Gregg Allerton, 1964. (32111).

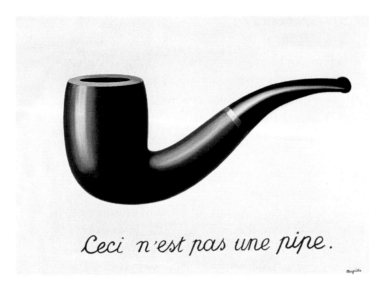

1.11 René Magritte. *La Trahison des Images (Ceci N'est Pas une Pipe)*. 1929.
Oil on canvas. 25⅜" × 37".
Los Angeles County Museum of Art (LACMA). Purchased with funds provided by the Mr. and Mrs. William Preston Harrison Collection (78.7). Digital Image Museum Associates/LACMA/Art Resource NY/ Scala, Florence © 2013 C. Herscovici, London/Artists Rights Society (ARS), New York.

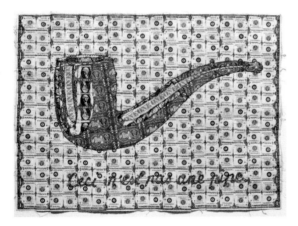

1.12 Ray Beldner. *This Is Definitely Not a Pipe*. 2000.
After René Magritte's *The Treachery of Images* (1929).
Sewn US currency. 24" × 33".
Courtesy of the artist.

👁 **Watch** a podcast interview with Ray Beldner about his "money pieces" on myartslab.com

California artist Ray Beldner further complicated the relationship between art and reality. He created a reproduction of Magritte's painting out of sewn dollar bills, and called it *This is Definitely Not a Pipe* (**fig. 1.12**). Modern artists are so famous these days,

and their work sells for such high prices, that they may as well be "made of money," just as this work is. Beldner's point is that even representational art has a complex relationship to reality; artists almost never merely depict what they see. Rather, they select, arrange, and compose reality to fit their personal vision. The process can take them several steps away from the fact of a pipe on a tabletop.

Abstract Art

The verb "to abstract" means "to take from"; it means to extract the essence of an object or idea. In art, the word "abstract" can mean either (1) works of art that have no reference at all to natural objects, or (2) works that depict

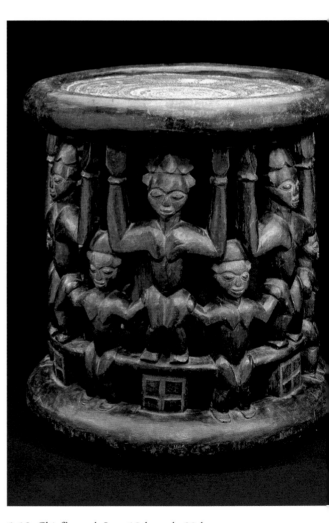

1.13 Chief's stool. Late 19th–early 20th century.
Wood plant fibre. Height 16½".
Western Grasslands, Cameroon.
Fowler Museum at UCLA. Photograph by Don Cole.

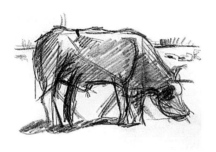

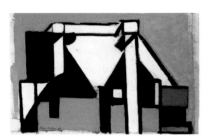

1.14 Theo van Doesburg (born C. E. M. Küpper). *Abstraction of a Cow* series.

Museum of Modern Art (MoMA) Purchase 227.1948.1 (top left), 227.1948.6 (top right), 226.1948 (bottom left), and 225.1948 (bottom right). © 2013 Digital image, The Museum of Modern Art, New York/Scala, Florence.

top two images:
Composition (The Cow). c.1917. Pencil on paper. Each 4⅝″ × 6¼″.

Composition (The Cow). c.1917. Tempera, oil, and charcoal on paper. 15⅝″ × 22¾″.

Composition VIII (The Cow). c.1918. Oil on canvas. 14¼″ × 25″.

natural objects in simplified, distorted, or exaggerated ways. Here we use abstract in the second sense.

In abstract art the artist changes the object's natural appearance in order to emphasize or reveal certain qualities. Just as there are many approaches to representational art, there are many approaches to abstraction. We may be able to recognize the subject matter of an abstract work quite easily, or we may need the help of a clue (such as a title). The interaction between how the subject actually looks and how an artist presents it is part of the pleasure and challenge of abstract art.

Abstraction in one form or another is common in the art of many cultures. The chief's stool (**fig. 1.13**) from Cameroon shows repeated abstractions of the human form. We still recognize, of course, that the principal subject of the sculpture is people. They symbolize the community of the Cameroon grasslands that supports the chief who sits on this stool. This piece was regarded as the chief's "seat of power." No one else was allowed to use it, and when he died, according to custom, the stool was buried or thrown away.

Early modern artists in Europe also embraced abstraction. We see stages of abstraction in Theo van Doesburg's series of drawings and paintings,

Abstraction of a Cow (**fig. 1.14**). The artist apparently wanted to see how far he could abstract the cow through simplification and still have his image symbolize the essence of the animal. Van Doesburg used the subject as a point of departure for a composition made up of colored rectangles. If we viewed only the final painting and none of the earlier ones, we would probably see it as a nonrepresentational painting.

Nonrepresentational Art

A great deal of the world's art was not meant to be representational at all. Amish quilts, many Navajo textiles, and most Islamic wood carvings consist primarily of flat patterns that give pleasure through mere variety of line, shape, and color. Nonrepresentational art (sometimes called **nonobjective** or nonfigurative art) presents visual forms with no specific references to anything outside themselves. Just as we can respond to the pure sound forms of music, so can we respond to the pure visual forms of nonrepresentational art.

The following two contrasting works show that in nonrepresentational art, an extremely wide variety of forms, compositions, moods, and messages is possible. In Alma Woodsey Thomas's *Gray Night Phenomenon*

1.15 Alma Woodsey Thomas. *Gray Night Phenomenon.* 1972. Acrylic on canvas. 68⅞″ × 53⅛″.

Smithsonian American Art Museum, Washington, D.C. Gift of Vincent Melzac. © 2013 Photograph Smithsonian American Art Museum/Art Resource/Scala, Florence.

(**fig. 1.15**) only two colors and brushstrokes that are more or less regular are used. She created a pattern across the picture plane that is neither gray nor night-like. The subject of this work is not from the visible world; rather, it depicts a mood that might strike the artist in the middle of a gray night.

In New Zealand, Maori women working in pairs weave strips of dyed flax into geometric patterns called tukutuku panels (**fig. 1.16**). These patterns are traditional in Maori societies and they have such names as "sand flounder," "human ribs," and "albatross tears." The panels are woven in specific sizes to fit between the wooden uprights of meeting houses where religious ceremonies are held. A given meeting house may contain *tukutuku* panels of many different designs, giving the room a rich and varied visual texture.

While nonrepresentational art may at first seem more difficult to grasp than representational or abstract art, it can offer fresh ways of seeing. Absence of subject matter actually clarifies the way all visual forms

1.16 Maori peoples, New Zealand. *Tukutuku* panels. 1930s. Dyed, plaited flax strips over wood laths. Dimensions variable. Te Whare Runanga, Maori Meeting House, New Zealand.

Photograph: David Wall/Alamy.

affect us. Once we learn how to "read" the language of vision, we can respond to art and the world with greater understanding and enjoyment.

Looking and Seeing

Whether a work of art is representational, abstract, or nonrepresentational, we access it primarily through our eyes; thus we need to consider how we use them.

The verbs "look" and "see" indicate varying degrees of visual awareness. Looking is habitual and implies taking in what is before us in a generally mechanical or goal-oriented way. If we care only about function, we simply need to look quickly at a doorknob in order to grasp and turn it. But when we get excited about the shape and finish of a doorknob, or the bright quality of a winter day, or we empathize with the creator of an artwork, we go beyond simple, functional looking to a higher level of perception called "seeing."

Seeing is a more open, receptive, and focused version of looking. In seeing, we look with our memories, imaginations, and feelings attached. We take in something with our eyes, and then we remember similar experiences, or we imagine other possible outcomes, or we allow ourselves to feel something. We are doing more than looking.

The twentieth-century French artist Henri Matisse wrote about how to see intently:

> To see is itself a creative operation, requiring an effort. Everything that we see in our daily life is more or less distorted by acquired habits, and this is perhaps more evident in an age like ours when cinema, posters, and magazines present us every day with a flood of readymade images which are to the eye what prejudices are to the mind. The effort needed to see things without distortion takes something very like courage.[14]

But, since words and visual images are two different "languages," talking about visual arts with words is always an act of translation one step removed from actually experiencing art. In fact, our eyes have their own connections to our minds and emotions. By cultivating these connections, we can take better advantage of what art has to offer.

1.17 Edward Weston. *Pepper #30.* 1930. Photograph.
Photograph by Edward Weston. Collection Center for Creative Photography.
© 1981 Arizona Board of Regents.

Ordinary things become extraordinary when we see them deeply. Is Edward Weston's photograph of a pepper (**fig. 1.17**) meaningful to us because we like peppers so much? Probably not. To help us truly see, Weston created a memorable image on a flat surface with the help of a common pepper. A time exposure of over two hours gave *Pepper #30* a quality of glowing light—a living presence that resembles an embrace. Through his sensitivity to form, Weston revealed how this pepper appeared to him. Notes from his *Daybook* communicate his enthusiasm about this photograph:

> August 8, 1930
> I could wait no longer to print them—my new peppers, so I put aside several orders, and yesterday afternoon had an exciting time with seven new negatives.

First I printed my favorite, the one made last Saturday, August 2, just as the light was failing—quickly made, but with a week's previous effort back of my immediate, unhesitating decision. A week?—Yes, on this certain pepper,—but twenty-eight years of effort, starting with a youth on a farm in Michigan, armed with a No. 2 Bull's Eye [Kodak] 3½ × 3½, have gone into the making of this pepper, which I consider a peak of achievement.

It is a classic, completely satisfying—a pepper—but more than a pepper: abstract, in that it is completely outside subject matter . . . this new pepper takes one beyond the world we know in the conscious mind.[15]

1.19 Constantin Brancusi. *The Kiss.* 1916. Limestone. 23″ × 13″ × 10″.
Photo The Philadelphia Museum of Art/Art Resource/Scala, Florence. © 2013 Artists Rights Society (ARS), New York/ADAGP, Paris.

👁—**Watch** a podcast interview about *The Kiss* on myartslab.com

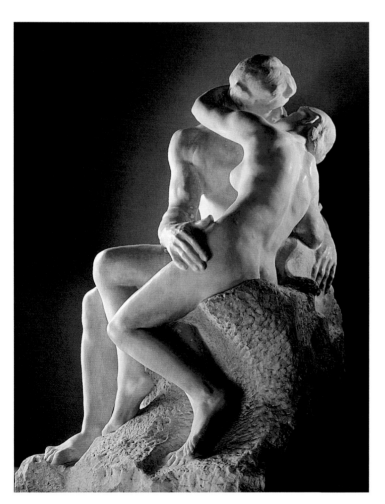

1.18 Auguste Rodin. *The Kiss.* 1886. Marble. 5′11¼″.
Musée Rodin, Paris. RMN-Grand Palais/Agence Bulloz.

Weston's photograph of a seemingly common object is a good example of the creative process at work. The artist was uniquely aware of something in his surroundings. He worked for a long time (perhaps 28 years!) to achieve the image he wanted. The photograph that resulted not only represents the object but also communicates a sense of wonder about the natural world.

Finally, seeing is a personal process. No two people will see the same thing in the same way, because each of us brings our own mental equipment to bear. Confronted with the same visual information, different people will come to different conclusions about its meaning, worth, or importance (see Chapter 5).

Form and Content

In Weston's *Pepper #30* the texture, light and shadow, and shape of the pepper is the form that we see, and the content is the meaning (or meanings) the work communicates—for example, a sense of wonder about the natural world. **Form** thus refers to the total effect of

the combined visual qualities within a work, including such components as materials, color, shape, line, and design. **Content** refers to the message or meaning of the work of art—what the artist expresses or communicates to the viewer. Content determines form, and form expresses content; thus the two are inseparable.

One way to better understand the relationship is to compare works that have the same subject but differ greatly in form and content. *The Kiss* (**fig. 1.18**) by Auguste Rodin and *The Kiss* (**fig. 1.19**) by Constantin Brancusi show how two sculptors interpret an embrace. In Rodin's work, the life-size human figures represent Western ideals of the masculine and the feminine. Rodin captures the sensual delight of that highly charged moment when lovers embrace. Our emotions are engaged as we overlook the hardness of the marble from which he carved it. The natural softness of flesh is heightened by the rough texture of the unfinished marble supporting the figures.

In contrast to Rodin's sensuous approach, Brancusi used the solid quality of a block of stone to express lasting love. Through minimal cutting of the block, Brancusi symbolized—rather than illustrated—the concept of two becoming one. He chose geometric abstraction rather than representational naturalism to express love. We might say that Rodin's work expresses the feelings of love while Brancusi's expresses the idea of love.

Seeing and Responding to Form

Obviously, artists expend effort to produce a work of art; less obvious is the fact that responding to a work of art also requires effort. The artist is the source or sender of any work put on view; the work itself is the medium carrying the message. We viewers must receive and experience the work to make the communication complete. In this way, we participate in the creative process.

Learning to respond to form is part of learning to live in the world. We guide our actions by "reading" forms of people, things, and events that make up our environment. Even as infants, we have an amazing ability to remember visual forms such as faces, and all through life we interpret events based on our previous experiences with these forms. Every form can evoke some kind of response from each of us.

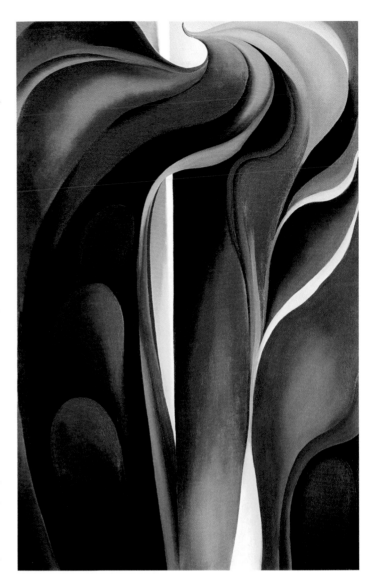

1.20 Georgia O'Keeffe. *Jack-in-the-Pulpit No. V.* 1930. Oil on canvas. 48″ × 30″.
Alfred Stieglitz Collection, Bequest of Georgia O'Keeffe, National Gallery of Art, Washington, D.C. 1987.58.4. Photograph: Malcolm Varon © 2013 Georgia O'Keeffe Museum/Artists Rights Society (ARS), New York.

Subject matter can interfere with our perception of form. One way to learn to see form without subject is to look at pictures upside down. Inverting recognizable images frees the mind from the process of identifying and naming things. Familiar objects become unfamiliar.

When confronted with something unfamiliar, we often see it freshly only because we have no idea what we are looking at. For example, when we see the twisting, curving green and rust-red shapes in Georgia O'Keeffe's painting (**fig. 1.20**), we may not at first realize that the work depicts a jack-in-the-pulpit

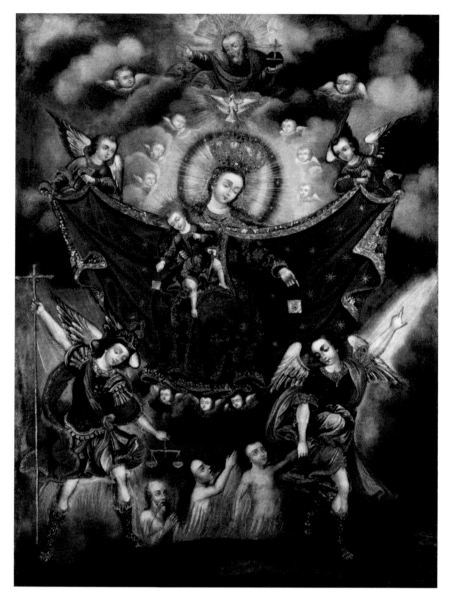

1.21 Circle of Diego Quispe Tito.
The Virgin of Carmel Saving Souls in Purgatory.
Late 17th century. Oil on canvas. 41″ × 29″.
Brooklyn Museum of Art, New York/The Bridgeman Art Library.

way—nobody sees a flower—really—it is so small—we haven't the time—and to see takes time, like to have a friend takes time. If I could paint the flower exactly as I see it, no one would see what I see because I would paint it small like the flower is small. So I said to myself—I'll paint what I see—what the flower is to me but I'll paint it big and they will be surprised into taking time to look at it.[16]

Iconography

As we have noted, form conveys content even when no nameable subject matter is represented. But when subject matter is present, meaning is often based on traditional interpretations.

Iconography refers to the subjects, symbols, and motifs used in an image to convey its meaning (from the Greek *eikon*, meaning image or picture). Not all works of art contain iconography. In those that do, it is often the symbolism (rather than the obvious subject matter) that carries the deepest levels of meaning. If we are seeing a painting of a mother and child, for example, its iconography will tell us whether it is Mary and the baby Jesus.

An artist's use of iconography can reveal a wealth of cultural information. For example, the Peruvian painting *The Virgin of Carmel Saving Souls in Purgatory* (**fig. 1.21**) contains many iconographic details that enrich its meaning. Some of these are obvious to those familiar with Christian iconography: The two winged figures standing in the foreground are angels; at the top is God the Father holding the orb of the world; below him is a dove that represents the Holy Spirit; Mary wears a crown

flower. The artist greatly enlarged it to 4 feet in height, and she focused closely on the flower, omitting nearly all else. We may wonder for a moment if we are looking at abstract or representational art.

O'Keeffe hoped that her way of seeing would cause us to sense the natural rhythms present in a flower. She said of this painting:

Everyone has many associations with a flower—the idea of flowers. Still—in a

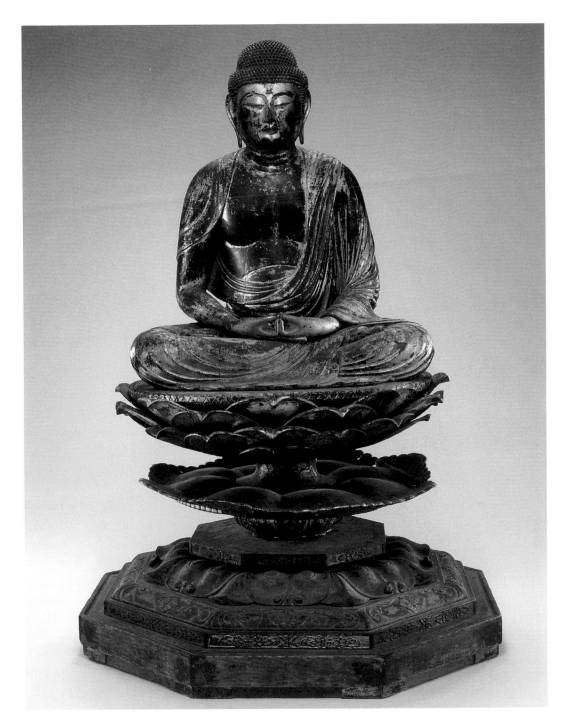

1.22 Amida Buddha. Japan. 12th century.
Wood with traces of lacquer, pigment, and gilding. Height 52½″.
The Avery Brundage Collection, B60S10+ © Asian Art Museum, San Francisco. Used by permission.

to show that she is the Queen of Heaven. People emerge from a flaming pit that is purgatory, led by an angel. In the left corner, another angel holds a cross that symbolizes the sacrifice of Christ; he also holds a balance, symbolizing the weighing of souls that takes place in purgatory. The meaning of these details is established by convention and long use.

Other details might be less familiar but equally meaningful: The Virgin of Carmel refers to an appearance of Mary that took place in the thirteenth century; at that time she promised that anyone who wore a special garment called a scapular would not suffer the fires of hell. Both Mary and the child Jesus carry purselike objects that represent the scapulars that people wore

or carried for protection. In this painting, Mary makes a special effort to save the souls from purgatory who may not have owned the protecting scapular. Thus the work was a sign of hope.

Asian traditions also use a rich iconographic language, which makes the Amida Buddha (**fig. 1.22**) easily distinguishable from a portrait of any other seated person. He has a topknot that symbolizes his enlightenment. The long earlobes show that he was a wealthy prince who wore heavy earrings before he sought religious truth. His garment is simple, as after enlightenment he lived by begging. His hands are folded in the traditional position of meditation. His lotus-flower throne symbolizes the fact that enlightenment can come in the midst of life, just as a lotus flower may bloom on the surface of a stagnant pond. The degrees of abstraction in the hands, chest, and face point to a twelfth-century date for this work, but

1.23 Alexis Smith. *Black 'n' Blue (for Howie Long)*. 1997.
Mixed media collage. 30″ × 22″ × 4″.
Photo by Douglas Parker. Courtesy of the artist and Margo Leavin Gallery, Los Angeles.

the iconographic details that mark him as the Buddha had already been in use for over a thousand years.

In our time, artists often quote and use the iconography of popular culture, sometimes in humorous ways. Alexis Smith combined references to the art world with the violence of professional sport in her work *Black 'n' Blue (for Howie Long)* (**fig. 1.23**). The sarcastic, inscribed sentence on this work is a quote from Howie Long, who for most of the 1980s was among the most famous (and fiercest) players in the National Football League. A defensive lineman, he set several records for tackles on the opposing quarterback, for which he was elected to the Pro Football Hall of Fame. After his athletic career he appeared in movies and worked as a sports analyst on television, cementing his celebrity status.

Smith borrowed his most famous statement and inscribed it on an artist's palette, along with a photo of wrestlers and some tools that could become weapons. She created an "artist's palette" for an athlete who made his name through jarring physical contact.

As we have seen from the works illustrated in this chapter alone, art is produced in a range of media and for different reasons. Artists, whether trained or untrained, may use their creativity to bring forth something new of value that can enrich and inform our lives.

✔—Study and review on myartslab.com

THINK BACK

1. What is art?

2. What are the key traits that define creativity?

3. What are some ways that art relates to reality?

4. What is the difference between looking and seeing?

TRY THIS

Think about the boundaries of art. In response to Magritte's painting *The Treachery of Images* (fig. 1.11), an artist in a 2011 exhibition hung an actual drainpipe in a frame above his handwritten inscription, "This is a pipe." Consider whether this creation amounts to a work of art according to the definition given in this chapter.

KEY TERMS

abstract art – art that depicts natural objects in simplified, distorted, or exaggerated ways

content – the meaning or message communicated by a work of art, including its emotional, intellectual, symbolic, thematic, and narrative connotations

form – the total effect of the combined visual qualities within a work, including such components as materials, color, shape, line, and design

iconography – the symbolic meanings of subjects and signs used to convey ideas important to particular cultures or religions

medium (plural **media**) – a particular material along with its accompanying technique

nonrepresentational art – art without reference to anything outside itself

representational art – art that recognizably represents or depicts a particular subject

2

THE PURPOSES AND FUNCTIONS OF ART

THINK AHEAD

2.1 Contrast the ritual, social, and public functions of art.

2.2 Discuss the aesthetic and emotional appeal of art that gives pleasure.

2.3 Consider the historical shift toward greater self-expression through art

2.4 Identify and explain examples that reveal art's different functions in society.

Art forms us by meeting our needs. Not our most basic needs for food or shelter, but deeper and more subtle ones that define us as people and as members of a society. These needs vary with time and cultural setting. In a culture in which religion is very important, for example, a great deal of art answers that need. In our own society, which emphasizes individual achievement, much of our art is devoted to self-expression. Note that here we are considering *public* purposes and functions of art, not the *personal* goals or needs of artists themselves. Thus, in this chapter we consider art in its social and cultural context, as it relates to six functions, with several diverse examples of each: delight, commentary, worship, commemoration, persuasion, and self-expression. (Each of these functions is discussed in *Art Forms Us* features in chapters 14–25.)

As we begin this discussion, we will quickly see that a given work may well address more than one function or need. And if one purpose for art seems to dominate in one culture, this does not mean that other possible functions go unfilled or are ignored. Viewing art from the perspective of its purpose or function shows us commonalities across different time periods and civilizations, from ancient times to the present. This is because most human needs have remained relatively constant throughout history. On

((•─Listen to the chapter audio on myartslab.com

the other hand, artists' answers to those needs vary greatly. Thus art embraces many of the shared traits, and all of the diversity, of humanity itself.

Art for Delight

Many of us probably think of delight as the principal goal of art. Why create art, after all, if not for someone's pleasure or enjoyment? We need delight, enjoyment, pleasure, decoration, amusement, and embellishment in our lives to "lift us above the stream of life,"[1] as a noted art critic wrote. Absorbed in contemplating a work, we forget where we are for a moment.

Visual delight in a work of art can take many forms, including an appreciation of beauty or decoration, or delight in an element of surprise. **Aesthetics** refers to an awareness of beauty or to that quality in a work of art or other manmade or natural form which evokes a sense of elevated awareness in the viewer. Most cultures that have a definition of "beautiful" define it as something pleasing to the eye, and often approximating to an ideal of some sort. In the Western tradition works from **classical** Greece or the Renaissance are most frequently described as beautiful. However, what is pleasing to the eye (and hence to the sense of beauty) varies considerably across cultures.

Most definitions of beauty in painting include a pleasant or inspiring subject, thoughtful execution, and a harmonious balance of colors in a pleasing

The decoration of useful objects is another source of delight, and a decorative urge has motivated a great deal of creativity throughout history. For example, the bowl (**fig. 2.2**) from the Mimbres culture of the American Southwest shows a highly dynamic design. Bowls from this culture were used daily, and most were embellished with paintings of animals, people, or invented forms, as here. The potter divided the bowl into four sectors and filled them with curving shapes that dance around a central circle, separated by triangular zones of finely painted parallel lines. The design was painted using **slip**, or clay that is thinned with water to the consistency of cream. The Mimbres people buried their dead with these bowls atop their heads, and they put a hole in the bowl to allow the spirit of the deceased to depart upward. Most Mimbres bowls show this hole, which also symbolized the end of its useful life.

A contemporary type of delight is surprise, when we see something recognizable but unexpected. Mexican artist Gabriel Orozco has been surprising viewers for a little over two decades. He created such a moment with his 2001 work *Juego de Limones*

2.1 James Abbott McNeill Whistler.
Nocturne: Blue and Gold—Old Battersea Bridge.
1872–1875. Oil on canvas. 26⅞″ × 12¼″.
Tate, London. Photograph: akg-images/Erich Lessing.

arrangement. The nineteenth-century artist James Abbott McNeill Whistler attempted to create a beautiful work when he painted *Nocturne: Blue and Gold— Old Battersea Bridge* (**fig. 2.1**). He captured the subtle variations of blue in the sky and water against flickering city lights below a fireworks display. The fading light renders this scene almost **monochromatic**, or based mostly on one color. He made the bridge taller and thinner than it really was. He also suppressed details in the urban scene before him to yield a balanced set of related shapes. The moment is tranquil, as the day's activities have ended and the Thames River is smooth, while a lone boatman paddles home. Whistler once stated in a lecture that art's only goal ought to be beauty. Art is, he said, "selfishly preoccupied with her own perfection only, having no desire to teach, seeking and finding the beautiful in all conditions and in all times."[2] Here he transformed a humdrum zone of London into a quietly poetic moment.

2.2 Bowl. Classic Mimbres geometric. c.1000 CE.
Earthenware. Height 4¼″, diameter 11¼″.
Private collection. Photograph by Tony Berlant.

FORMING ART

Gabriel Orozco (b. 1962): The Art of Surprise

2.3 Gabriel Orozco.
Portrait by Enrique Badulescu.
Courtesy of the artist and Marian
Goodman Gallery, New York.

Gabriel Orozco has been called "one of the most challenging artists living today," an artist who generates "torrential novelty." Yet he often forms art from the most simple means, and that simplicity creates surprise and delight.

Orozco's early work from the 1980s involved changing his urban environment in subtle ways, hoping passers-by would notice. He arranged wooden boxes on a stairway; he bought flashlights and deposited them on sidewalks, switched on. He abandoned these works to the street for alert viewers, and never sold or collected them.

He resists working in a studio because, he says, "A studio is like an artificial place, like a bubble. It gets out of reality." He learned the traditional skills of an artist, drawing

and painting in his teen years alongside his father, a mural painter. Having mastered those techniques, however, he left them behind, saying, "I don't want to be a specialist . . . I prefer to be a beginner." He began photographing his subtle displacements, and creating them indoors. He once placed cans of cat food atop the watermelons in a supermarket.

Orozco hopes that such visual surprises will be beneficially jarring: "I think the smallest gestures that we make in our lives can have much greater repercussions than some things we might consider to be more forceful. You can say the same thing about your house: maybe there's a hotel that you only stayed at once, but the memory of that hotel could be much more important to you than the house where you've lived for years. In art it's the same: there are pieces that require years to complete, but aren't as stunning as the quick one that came about all at once, in one day."

Though the ideas for his pieces may come in an instant, not all of his works are so quickly executed. During a stay in France he had the idea to cut the middle third out of a Citroën DS sedan, and reattach the outer portions. Realizing that vision took him and an assistant an entire month, as they flawlessly

reunited the sundered car parts into *La DS* (**fig. 2.4**). The resulting work resembles an optical illusion, but some viewers and critics saw deeper meanings. Orozco created an "edited version" of the car, removing the center and leaving the right and the left, similar to how the media exaggerate the extremes of political debate.

The artist resists such readings, preferring to focus on the visual jolt. Invited to exhibit in 2009 at the Museum of Modern Art in New York, he carried out one of his most audacious maneuvers. He recruited the apartment dwellers across the street to install oranges in their windows, in patterns on coffee cups and saucers.

The work was viewable from inside the museum, but was also available to anyone passing on the street. He preferred to leave the scene unphotographed, so that people hearing about it later could reconstruct it in their imagination.

Orozco describes the intended effect of his work as a contemporary sort of beauty: "I don't use the word *beauty* anymore . . . The word *beautiful* is not an absolute, it's a moment. I would say, it's more like a moment in which you look at something and you feel alive, you feel that you are enjoying something. And that is a moment of poetry, pleasure, revelation, thinking."[3]

2.4 Gabriel Orozco.
La DS. 1993. Modified Citroen DS auto.
4'7³⁄₁₆" × 15'9¹⁵⁄₁₆" × 3'9⁵⁄₁₆".
Courtesy of the artist and Marian Goodman Gallery, New York.

2.5 Gabriel Orozco.
Juego de Limones (Game of Limes). 2001.
Silver dye bleach print. 16″ × 20″.
Courtesy of the artist and Marian Goodman Gallery, New York.

(**fig. 2.5**). Seeing potential in an outdoor chess table, he bought and quartered two limes, arranged them like tokens on the board, and photographed the scene. Viewers can easily imagine two players seated at the table, deeply involved in a wholly invented game, sending the fruit jumping about like checkers. The contrast between the deep red of the table surface and the green of the limes adds richness to the work's surface. The artist here shows us a way of being open to an everyday event, as he turns it into a surprising picture. Note also that the red, green, and white that play such a strong role in this work are the colors of the Mexican national flag.

Art as Commentary

Art has often been used to answer to our need for information. Before the advent of photography in the nineteenth century, artists and illustrators were our only source of information about the visual appearance of anything. By providing a visual account of an event or a person, or by expressing an opinion, artists have shaped not only the way people understand their own world but also how their culture is viewed by others.

Artists who fulfill our need for commentary often speak in a language easy to understand; they view art's primary goal as communication between artist and viewer by means of subject matter. Nineteenth-century painter Gustave Courbet spoke for this function of art when he wrote, "To record the manners, ideas, and aspect of the age as I myself saw them—to be a man as well as a painter, in short to create a living art—that has been my aim."[4]

One of the classic instances of commentary in Western art is Francisco Goya's print series *The Disasters of War*. Goya made 82 prints dealing with various episodes in Spain's 1808–14 war of resistance against domination by Napoleon. *I Saw This* (**fig. 2.6**), for example, shows a stream of refugees fleeing their homes in advance of invading troops. The mother and child in the foreground draw an unbelieving stare from another refugee at the left. Goya both witnessed and recorded many scenes in that conflict, some of them

2.6 Francisco Goya.
I Saw This. From the series
The Disasters of War, 1810.
Etching, drypoint, and burin.
6¼″ × 9″.
Private collection.

2.7　Berthe Morisot.
In a Villa at the Seaside. 1874.
Oil on canvas. 19¾" × 24".
Norton Simon Art Foundation M. 1979.21.P
© 2012 Norton Simon Art Foundation.

rather gruesome; the title of this work indicates his presence at the scene. His commentaries in *The Disasters of War* form a strong protest against the brutality and violence of conflict. In order to improve their distribution, he created them as **prints**, or works that exist in multiple copies.

Capturing what they had seen was also one of the more important goals of the **Impressionist** artists of the nineteenth century. When Berthe Morisot went on vacation to the seashore in 1874, she took her canvas and easel and set them up to paint a picture of a relaxed afternoon. The **painterly** (loose or spontaneous) brushwork in *In a Villa at the Seaside* (**fig. 2.7**) shows that she created it swiftly, perhaps in a single sitting, before the light changed or anyone moved very far. Historians might study this work to learn about feminine dress details and vacation sites of the upper classes; the rest of us can appreciate a spontaneous, calm moment with the family, captured in delicate, dancing strokes of paint. This work testifies clearly to what the artist experienced and takes us to a specific place and time.

Artists' commentaries often include personal judgments on conditions, facts, or politics. In the fall of 2011, as the Occupy movement crowded into its encampment on the grounds of the Los Angeles City Hall, an artist created a huge mural that made such a statement about our contemporary economy. At the center of the *Occupy LA Mural* (**fig. 2.8**) is an octopus that personifies the Federal Reserve Bank. It grasps the city, bundles of cash, and a foreclosed home in its tentacles. In the lower right, the top-hatted man from the Monopoly board game announces, "You're bankrupt!"

Along the left edge, another tentacle lifts a balance in which the 1 percent outweighs the other 99 percent. Just below the scale, the inscribed name "Scott Olsen" refers not to the artist but to an Iraq war veteran who was seriously injured while protesting alongside the Occupy group in Oakland a few weeks before. The Occupy LA Mural is not subtle, and it likely oversimplifies the causes of the 2008 economic downturn, but it embodied the artist's commentary on an urgently important subject.

2.8　Unknown artist.
Occupy LA Mural. 2011.
Poster paint on wood panels. Height 14′.
Formerly City Hall Park, Los Angeles. Photograph: Patrick Frank.

Art in Worship and Ritual

Another function of art has been to enhance religious contemplation, and most of the world's religions have found ways to incorporate artists' creativity into their sacred rituals, places, and ceremonies. One of the most important Roman Catholic theologians, Thomas Aquinas, wrote in the thirteenth century of the function of art as an aid to religious teaching: "It is befitting Holy Scripture to put forward divine and spiritual truths by means of comparisons with material things. For God provides for everything according to the capacity of its nature." He wrote, "It is natural for man to be pleased with representations," meaning that we humans enjoy looking at pictures of things. Thus an artwork, if attractively presented, "raises [viewers] to the knowledge of intelligible truths."[5]

This belief about art dominated visual creativity during the period in which Aquinas lived, the Middle Ages. In the twelfth and thirteenth centuries in Europe, towering cathedrals were drenched in light, a symbol of God's presence, through windows that illustrated Bible stories and divine truths. *The Tree of Jesse* (**fig. 2.9**), in Chartres Cathedral in France, illustrates the genealogy of Christ, starting with the Jewish patriarch Jesse in red at the base of the tree. The spreading branches above show four kings in successive layers, then Mary, the mother of Jesus; Christ himself sits at the top. The composition leads the eye upward toward Christ, a metaphor for elevating the mind beyond the physical world toward the spiritual. For worshippers the window thus reveals Christ's humanity—as evidenced through this ancestry—but also provides a vehicle for religious transcendence.

Avenues to the spiritual realm are as varied as cultures themselves. In the Zen school of Buddhism, followers are taught that they may reach enlightenment, a state of spiritual insight, by solitary meditation that cleanses the mind and empties it of distractions. The nearly barren Rock Garden (**fig. 2.10**), at Ryoan-ji temple near Kyoto in Japan, is a well-known aid to

2.9 *The Tree of Jesse.* c.1150–1170. Stained glass. West façade of Chartres Cathedral.
Sonia Halliday Photographs.

View the Closer Look for the stained glass at Chartres on myartslab.com

2.10 Rock Garden. Built beginning 1480.
Ryoan-ji, Kyoto, Japan. 30′ × 73′.
Michael S. Yamashita/CORBIS.

2.11 Complex mask. c.1880.
Yupik Eskimo, Southwest Alaska.
Wood, pigments, and feathers. Height 35″.
Donald Ellis Gallery Ltd., New York, NY. Photo John Bigelow Taylor.

such contemplation. The garden sits before a terrace where Zen monks (and tourists on select days) gather for meditation. A few seemingly random rocks protrude from the smooth surface of gravel, which Zen monks rake regularly. These protrusions seem to imitate the most minimal version of nature, like mountain tops that rise through clouds, or stony islands out of the sea. Other interpretations of the arrangement have been offered, but the emptiness of this garden is its chief distinguishing feature.

In traditional Eskimo societies of Southwest Alaska, shamans fulfill a priestly function by interpreting the spirit world to the people, and interceding for them to the spirits. Eskimo shamans enter the spirit realm by taking on the identity of sacred animals in ceremonies that enact ancient myths through chanting and dancing with the aid of masks and costumes. Shamanic masks reveal vivid pictures of these transformations, as in the complex mask (**fig. 2.11**) pictured here. This mask shows a shaman at the top, arms and legs splayed outward. He holds two staffs that culminate in feathers. His body seems to be flayed open, as his chest cavity is red and shows a round heart at the center. Below him, as if emerging from his torso, is a seal, a product of his self-opening. Because the stories that accompanied this mask are lost to us, we do not know exactly what myth this mask may illustrate, but it was created to aid in ceremonies of spiritual transformation.

2.12 Beatrice Wood. *Chalice*. 1985.
Pottery. Height 12⅞″, diameter 7⅝″.
Collection of The Newark Museum. Purchase 1986 Louis Bamberger Bequest
Fund (86.4) © 2013 Photo The Newark Museum/Art Resource/Scala, Florence.
Courtesy Beatrice Wood Center for the Arts/Happy Valley Foundation.

Many objects created for ritual use look precious, befitting their use in divine ceremonies. The chalice (**fig. 2.12**) by American sculptor Beatrice Wood seems to radiate warm light. Muslim potters centuries ago developed the technique that produces this glowing, metallic surface. The profile of the piece shows its origins in the natural forms of the earth, as it lacks straight lines and square edges. The symmetrical loops at the sides invite us to grasp this work and lift it high, which is what priests do in the Roman Catholic mass. The loops also suggest a resemblance to the human form, intimating that this work unites the divine with the human.

Art for Commemoration

As the word itself suggests, commemoration is something done as an aid to memory. We all have a profound need to remember and show respect for those who have gone before us. Some commemoration is personal, as we each hold memories of people important in our lives. But commemoration is more often a more public act, perhaps celebrating a significant person or event, or honoring patriotic actions. Commemoration of any kind connects us with the chain of humanity that stretches back for millennia, making human life seem more significant and

valuable. Visual imagery has played a decisive role in most types of commemoration.

One of the world's best-known monuments, the Taj Mahal in India (**fig. 2.13**), is an example of personal commemoration. Erected in the seventeenth century on the banks of a river between a guest house and a small mosque, the Taj Mahal (which means "Crown of the Palace") was a tomb for the Mughal ruler Shah Jahan's favorite wife, who died in childbirth. It sits at one end of a four-part paradise garden that recalls the description of Paradise in the Qur'an. The surface of the white marble exterior seems to change color by catching sunlight at various angles. The proportions of the bulb-shaped dome make the building look light, as if it barely touches the ground. The Taj Mahal's testament to romantic love and devotion, and

2.13 Taj Mahal. Agra, India. 1632–1648.
Photograph: Peter Adams/Corbis.

👁 ▬**Watch** a video about the Taj Mahal
on myartslab.com

2.14 Benjamin West. *The Death of General Wolfe*. 1770. Oil on canvas. 60″ × 84½″.
National Gallery of Canada, Ottawa. Transfer from the Canadian War Memorials, 1921. Gift of the 2nd Duke of Westminster, Eaton Hall, Cheshire, 1918.
Gift of the Duke of Westminster.

its combination of otherworldliness and beauty, draws visitors from across the world.

A different type of commemoration, and one that was controversial at the time of its creation, is *The Death of General Wolfe* (**fig. 2.14**). This work, painted by Benjamin West in 1770, depicts the military battle of 1759 in which the British army defeated the French in a struggle for control of the Canadian portion of North America. The British commander, General James Wolfe, died on the battlefield just as his troops secured the victory in a campaign that determined the eventual French defeat. General Wolfe thus exemplified the idea of patriotic self-sacrifice.

At the time the painting was made, it was customary for painters to depict heroes wearing the garb of classical Greece or Rome, to lend their achievements a timeless aura. But Pennsylvania-born West, who before the United States gained its independence from Britain was chief history-painter for King George III, innovated by portraying everyone in the clothing that they might have actually worn on that day.

Controversy arose when the king made plain his opposition, calling it "very ridiculous to exhibit heroes in coats, breeches, and cock'd hats." He sent the president of the Royal Academy to West's London studio in an attempt to talk him out of it.

West responded by stating his commemorative intent: "The subject that I have to represent is the conquest of a great province of America by the British troops. It is a topic that history will proudly record, and the same truth that guides the pen of the historian should govern the pencil of the artist. I consider myself as undertaking to tell this great event to the eye of the world." To depict the participants clothed as Greeks and Romans, he said, would be to "represent classical fictions," and to sacrifice "all the truth and propriety of the subject."[6] The Royal Academy president, after studying the work silently for about a half hour, sided with West. The work was put on public display and attracted large crowds. It also influenced the course of European art, showing painters and viewers new and more vivid ways of depicting historical subjects.

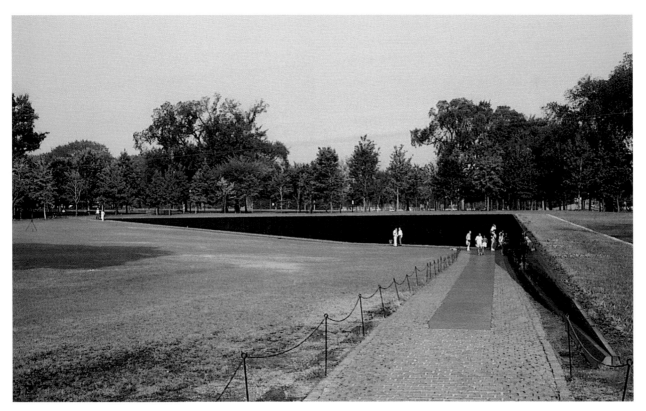

2.15 Maya Lin.
Vietnam Veterans Memorial. The Mall, Washington, D.C. 1980–1982.
Black granite. Each wall 10′1″ × 246′9″.
Photograph: Duane Preble.

Closer to our own time, the Vietnam Veterans Memorial (**fig. 2.15**) in Washington, D.C., by Maya Lin, also aroused controversy when completed in 1982. The almost 250-foot-long, V-shaped wall bears the names of the nearly 60,000 American servicemen and women who died or are missing from the time of that controversial war. The style of the monument, with its simple chronological list, was unprecedented among the monuments on the National Mall. The initial resistance to the work was so great that a further monument was commissioned, a statue of a group of three soldiers, for a nearby location. But the Vietnam Veterans Memorial soon attracted thousands of visitors, who appreciated the solemnity of the black granite walls, and the personal attention involved in the recording of every lost soldier's name. The monument has also influenced many other public memorials since, as inscribing the names of all commemorated people has become a more common practice.

Art for Persuasion

Many artforms have a persuasive function. Splendid government buildings, public monuments, television commercials, and music videos all harness the power of art to influence action and opinion. They invite and urge us to do or think things that we may not have otherwise thought of.

We do not know which ancient Roman artist or artists created the *Augustus of Prima Porta* (**fig. 2.16**), but we do know that they created one of the most beautiful pieces of persuasive art. The emperor Augustus wears a military uniform as he stands, one arm extended, gesturing as if to address his troops. He wears the body armor of the day, a breastplate with relief sculptures that tell of a military victory, amid depictions of various Roman gods. We know from contemporary coins and other statues that the head is indeed a portrait. The face is calm, and the body seems to stride serenely, with assurance. This is a leader in deliberate action.

But the statue implies that the emperor may be more than a man. The shoeless feet follow the Roman manner of representing gods, and along his right calf, the Cupid riding the dolphin is a subtle reminder that Augustus's family claimed descent from the goddess Venus (the mother of Cupid). Augustus seems to have tolerated such rumors of divine parentage, which likely brought him political benefits. This statue was found in a private home, but it resembles others that the Romans routinely set up in public places, requiring citizens to bow toward them or salute as they passed. The Romans knew that societies run more efficiently

2.17 Pierre Patel. *Versailles*. c.1665.
Oil on canvas. 45¼″ × 63½″. Chateau de Versailles et de Trianon, Versailles, France.
Giraudon/The Bridgeman Art Library.

if the people believe their rulers to be strong and wise, and this statue boldly encourages that belief.

Another ruler who realized that visual imagery could be used to help shape public opinion about his rule was Louis XIV of France. In 1664, he invited all the artist members of the French Royal Academy to a meeting and charged them in the following memorable way: "I entrust to you the most precious thing on earth: my fame."[7]

At Versailles, 12 miles south of Paris, he built an enormous palace and formal garden designed to surpass all others in its splendor (**fig. 2.17**). The interior was decorated with many artworks that depicted his exploits. The purpose of the palace was to symbolize the strength of his monarchy, and to impress the nobility with his power (see Chapter 17).

Some artworks attempt to persuade by inspiration, reminding us of ideals that we already share, and urging us to emulate and learn from them. Classical Greek sculpture often fulfilled this function; it generally idealized humans by presenting them in the prime of life and engaged in serious pursuits. The charioteer (**fig. 2.18**), for example, is intended to inspire: He has won the race, but he remains alertly calm rather than jubilant. The sculpture personifies balance and quiet

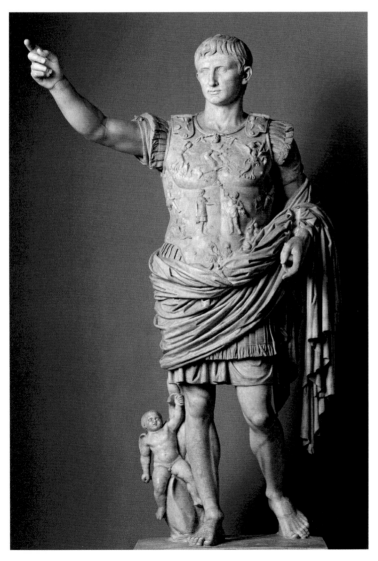

2.16 *Augustus of Prima Porta*. Early 1st century CE.
Marble. Height 6′8″.
Araldo de Luca/CORBIS.

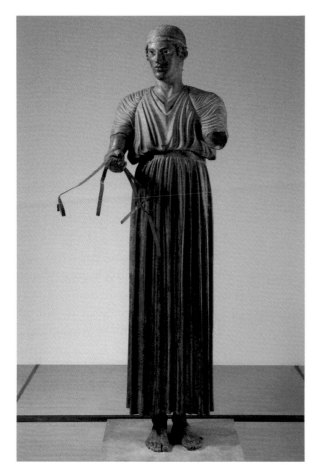

2.18 Charioteer. c.470 BCE. Height 5′11″.
Archeological Museum, Delphi. © Craig & Marie Mauzy, Athens.

dignity; it shows "noble simplicity and calm grandeur," as a critic once wrote. This work is not a portrait—portraiture was rare in ancient Greece—because real people are too often imperfect in their looks and fallible in their deeds. Rather, classical Greek sculpture usually encouraged an ideal of sober self-restraint.

Such **idealism** was also a trend in Europe during the Renaissance. An early leader in this tendency was Ambrogio Lorenzetti, who created a series of works for the city hall of Siena, Italy. *Effects of Good Government* (**fig. 2.19**) aptly describes the subject of this large work, which depicts a city under wise administration. At the right we see all manner of trades, as herders, shopkeepers, and preachers tranquilly carry out their duties. At the left center, nine carefree women dance in a circle. At the very top, carpenters work on a new building. This painting decorates the hall where the governing council met; it attempts to influence their deliberations by providing an example. Nearby, as a warning, Lorenzetti created another work that depicts the effects of bad government: crime, despotism, disrepair, and struggle.

Not all attempts at persuasion in art are quite as literal as the *Good Government* mural. In the traditional

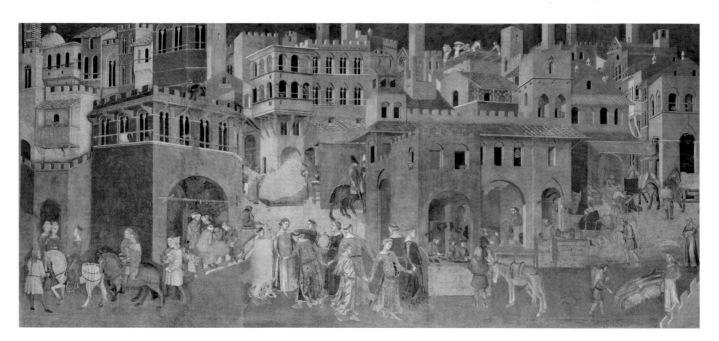

2.19 Ambrogio Lorenzetti. *Effects of Good Government in the City.* 1338–39. Fresco. Palazzo Pubblico, Siena.
Studio Fotografico Quattrone, Florence.

View the Closer Look for *The Effects of Good Government* on myartslab.com

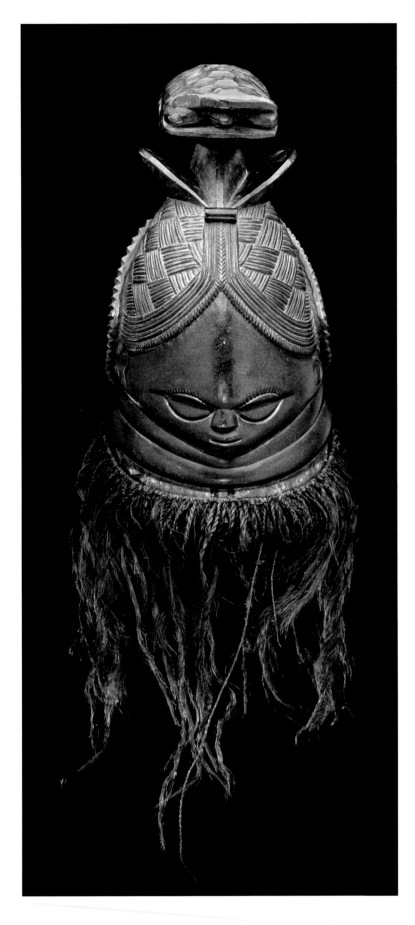

2.20 Mask. 19th century.
Mende peoples, Sierra Leone.
Wood, pigment, plant fiber. Height 26¾″.
Fowler Museum at UCLA. Photograph by Don Cole.

Mende societies of Sierra Leone in West Africa, masks use symbolic language to help instill proper behavior. The Mende mask (**fig. 2.20**) was used in initiation ceremonies for girls on the verge of adulthood. We see a face with a narrow mouth and downcast eyes, symbolizing prudent behavior and the ability to keep secrets. The rings around the neck refer to the fleshy curves of attractive women, and also to the ripples in water when female ancestral spirits emerge from the depths where they reside. The hair is carefully stylized, symbolizing both beauty and the presence of friends to help in grooming. The turtle at the top refers to the secrecy of the initiation ceremonies, which take place out of public view. These teaching sessions culminate when the teachers wear the masks as helmets in dances and pantomimes, hoping to inspire the young women to virtuous conduct and impeccable appearance.

In more recent times, many of the design disciplines have been devoted to persuasion of one kind or another. Today, companies and organizations use posters, billboards, and advertising layouts to attempt to convince us to buy or believe something. Artists have also used such media to criticize or influence values and public opinion. An example of this can be seen in the work of the socially committed graphic designer Chaz Maviyane-Davies. For a United Nations conference on climate change, he created the poster *Global Warning* (**fig. 2.21**). Here we see the Earth literally roasting under the impact of the hot breath of the man at the lower left. The poster leaves no doubt as to the global nature of the problem, and also as to who is causing it: us.

2.21 Chaz Maviyane-Davies. *Global Warning.* 1997. Poster for 3rd United Nations Convention on Climate Change, Kyoto.
Courtesy of the artist.

Art as Self-Expression

For most of human history, self-expression has not been a primary reason for creating art. Other social and cultural needs, such as the five we have already considered, more fully engaged the talents of artists. In more recent times, however, particularly when a great deal of art is sold as a private possession, self-expression has increasingly become one of art's most common functions.

Art fulfills an expressive function when an artist conveys information about his or her personality or feelings or worldview, aside from a social cause, market demand, commissioning ruler, or aesthetic urge. Such art becomes a meeting site between artist and viewer, the viewer feeling empathy and gaining an understanding of the creator's personality. We all derive comfort from the fact that others in the world are similar to ourselves, and artists' various modes of self-expression reach out to us in hopes of establishing a bond.

Self-portraiture has traditionally been an important vehicle by which artists reach out to us. Felix Nussbaum's *Self-Portrait with Jewish Identity Card* (**fig. 2.22**) is one of the more compelling works of this type. The artist furtively turns back his collar to reveal the yellow star that the Nazi regime required all Jews to wear. In his other hand he holds the card with his ethnicity prominently displayed in red block letters.

2.22 Felix Nussbaum. *Self-Portrait with Jewish Identity Card.* 1943. Oil on canvas. 22″ × 19¼″.
Kulturgeschichtliches Museum, Osnabrueck, Germany/ Artothek/The Bridgeman Art Library.

The high wall behind, and his sidelong glance, tell of an existence haunted by fear and oppression. The artist invites us to share his personal and political anxiety. Nussbaum's life played out tragically: In the year after he painted this work, he was arrested and sent to a concentration camp, where he joined the millions of other victims of the Holocaust.

Korean-American artist Yong Soon Min created a more recent self-portrait with *Dwelling* (**fig. 2.23**) in 1994, which tells of her sense of a divided self. Born near the end of the Korean War, she came to the United States at age seven. Thus, while she was raised mostly in California, it is not her native land. Yet on trips back to Korea she feels distant from her country of origin as well. *Dwelling* thus expresses absence

2.23 Yong Soon Min.
Dwelling. 1993.
Mixed media. 72″ × 42″ × 28″.
Photo by Erik Landsberg. Courtesy of the artist.

Watch a podcast interview with Yong Soon Min about *Dwelling* on myartslab.com

and distance. She inserted personal mementoes into a traditional Korean dress and hung it over a pile of books, maps, and photos. Inside the dress is a script by a Korean poet that gives voice to a loss of identity. We might describe this work as an **assemblage**, or collection of objects gathered into an artwork. The hauntingly empty dress seems to await a Korean girl who will never wear it. This sense of divided nationality is increasingly common among Americans, many of whom were born elsewhere.

Wassily Kandinsky, a leader in the Expressionist movement of early modern Germany (see Chapter 22), reached out to viewers by beginning with his inner feelings. He wrote that he hoped to create art only in response to what he called "inner necessity," or the emotional stirrings of the soul, rather than in response to what he saw in the world. He created abstract works in which he attempted to translate the swirl and surge of inner spiritual energies into color and form. *Composition VI* (**fig. 2.24**) renders a restless and aroused inner state, an experience probably not unknown to most viewers. Kandinsky often named his works after musical forms, because he wanted them to communicate as music does: "Color directly influences the soul," he wrote; "Color is the keyboard, the eyes are the hammers, the soul is the piano with many strings. The artist is the hand that plays, touching one key or another purposefully, to cause vibrations in the soul."[8] He hoped that the souls of viewers would resonate with the rhythms and colors of his paintings, and infect viewers with the same emotions that he felt while creating them.

As we have seen, many works of art may fulfill more than one function; art that is persuasive may also delight with its beauty; a religious work may also express the creator's personal quest for transcendence; a commemorative piece may also inform us. Yet all art meets one human need or another, and has the power to shape our lives in many ways.

Study and review on myartslab.com

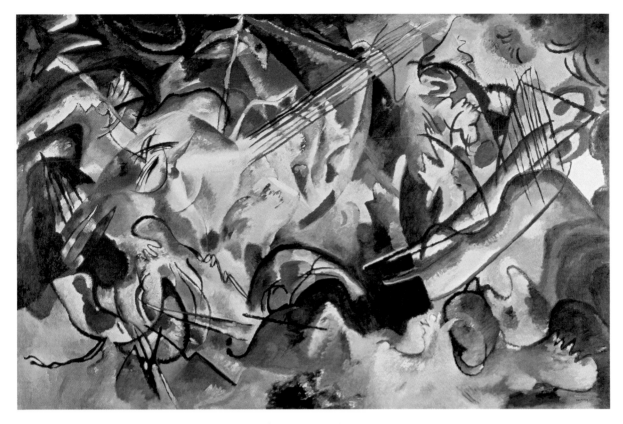

2.24 Wassily Kandinsky. *Composition VI*. 1913. Oil on canvas. 76¾″ × 118″.
The State Hermitage Museum, St. Petersburg, Russia/The Bridgeman Art Library © 2013 Artists Rights Society (ARS), New York/ADAGP, Paris.

THINK BACK

1. What are six functions that art fulfills?

2. What separates commentary from self-expression in art?

3. What needs does commemorative art meet?

4. What type of art might a ruler use to encourage allegiance?

TRY THIS

Visit a museum or a museum Web site and select three pieces of art, each from a different period and culture. Outline the possible functions that each piece fulfills or might fulfill.

KEY TERMS

aesthetics – in the art context, the philosophy of art focusing on questions regarding what art is and how it is evaluated, the concept of beauty, and the relationship between the idea of beauty and the concept of art

idealism – the representation of subjects in an ideal or perfect state or form

THE VISUAL ELEMENTS

THINK AHEAD

3.1 Describe the visual elements used in the production and analysis of art.

3.2 Indicate how artists use visual elements to create optical and illusionistic effects.

3.3 Explain technical devices used to render space and volume in painting.

3.4 Discuss the physical properties and relationships of color.

3.5 Show how visual elements convey expressive and symbolic meaning in a work of art.

3.6 Use basic tools of visual analysis to explain a work of art.

> Remember that a picture—before being a war horse, a nude woman, or some anecdote—is essentially a plane surface covered with colors assembled in a certain order.[1]
>
> Maurice Denis

Painter Maurice Denis might have gone on to say that the plane, the **two-dimensional** picture surface, can also be covered with lines, shapes, textures, and other aspects of visual form (visual elements). Sculpture consists of these same elements organized and presented in **three-dimensional** space. Because of their overlapping qualities, it is impossible to draw rigid boundaries between the elements of visual form.

A glance at Daniel Richter's painting *Ooa2* (**fig. 3.1**) shows his fluent use of several visual elements. Flowing *lines* of paint define several *shapes*. Some of these suggest a mountain landscape, but others are less recognizable. The black running soldier suggests a dominating *mass* at the center of the work. This figure overlays a background *space* of unclear depth. The paint drips suggest the passage of *time*, as does the implied *motion* of the soldier from left to right. In the

3.1 Daniel Richter. *Ooa2*. 2011.
Oil on linen. 78¾″ × 106⅓″.
Courtesy Regen Projects, Los Angeles © Daniel Richter.

upper left of the work, patches of bright white suggest *light* trying to break through. The artist's use of *color* is bold and distinctive, contributing to the work's vivid atmosphere. The various methods of paint application that he used create several zones of varying *texture*.

This chapter introduces the visual elements identified in *Ooa2*: line, shape, mass, space, time, motion,

((•─ **Listen** to the chapter audio on myartslab.com

light, color, and texture. Not all these elements are important, or even present, in every work of art; many works emphasize only a few of them. To understand their expressive possibilities, we will examine, one at a time, some of the expressive qualities of each of these aspects of visual form.

Line

We write, draw, plan, and play with lines. Our individuality and feelings are expressed as we write our one-of-a-kind signatures or make other unmechanical lines. **Line** is our basic means for recording and symbolizing ideas, observations, and feelings; it is a primary means of visual communication.

A line is an extension of a point. Our habit of making all kinds of lines obscures the fact that pure geometric line—line with only one dimension, length—is a mental concept. Such geometric lines, with no height or depth, do not exist in the three-dimensional physical world. Lines are actually linear forms in which length dominates over width. Wherever we see an edge, we can perceive the edge as a line—the place where one object or plane appears to end and another object or space begins. In a sense, we often "draw" with our eyes, converting edges to lines.

In art and in nature, we can consider lines as paths of action—records of the energy left by moving

points. Many intersecting and contrasting linear paths form the composition in Lee Friedlander's photograph *Bismarck, North Dakota* (**fig. 3.2**). Wires, poles, railings, building edges, and the shadows they cast all present themselves as lines in this work.

Characteristics of Line

Lines can be active or static, aggressive or passive, sensual or mechanical. Lines can indicate directions, define boundaries of shapes and spaces, imply volumes or solid masses, and suggest motion or emotion. Lines can also be grouped to depict light and shadow and to form patterns and textures. Note the line qualities shown in the Line Variations diagram (**fig. 3.3**).

3.3 Line Variations.

a. Actual line.

b. Implied line.

c. Actual straight lines
and implied curved line.

d. Line created by an edge.

e. Vertical line (attitude of alert attention); horizontal line (attitude of rest).

f. Diagonal lines (slow action, fast action).

g. Sharp, jagged line.

h. Dance of curving lines.

i. Hard line, soft line.

j. Ragged, irregular line.

✴ **Explore** the Discovering Art tutorial
Introduction to Line on myartslab.com

3.4 Sophie Taeuber-Arp. *Mouvement de lignes en couleurs (Movement of Colored Lines)*. 1994.
Colored pencil on cardboard. 14⅛″ × 12½″.
Donation Hans Arp and Sophie Taeuber-Arp e.V, Rolandswerth.
© 2013 Artists Rights Society (ARS), New York/VG Bild-Kunst, Bonn.

3.5 Aleksandr Rodchenko. *Untitled*. c.1920.
Pencil on colored paper. 12⅛″ × 8¼″.
Museum of Modern Art (MoMA). Gift of an anonymous donor.
Acc. n.: 2452.2001 © 2013. Digital image, The Museum of
Modern Art, New York/Scala, Florence © Estate of Alexander
Rodchenko/RAO, Moscow/VAGA, New York.

Consider the range of uses artists found for lines in the works pictured on these two pages. Sophie Taeuber-Arp made many swerving and dancing marks in her work *Movement of Colored Lines* (**fig. 3.4**). Our eye naturally tends to follow these lines, taking us on a gracefully curving visual ride. In contrast, Aleksandr Rodchenko used only straight lines in one color for his untitled work (**fig. 3.5**). This work invites our eyes into an entirely different set of movements that are more

3.6 Anselm Reyle.
Untitled, 2006.
119 neon tubes, chains, cable, and
13 transformers. 16′4″ × 32′8″ × 26′4″.
Courtesy of the Saatchi Gallery London © Anselm Reyle.

3.7 Fred Sandback. *Untitled (Sculptural Study, Six-Part Construction)*. 1977/2008. Black acrylic yarn. Dimensions variable.
Photo by Cathy Carver © 2013 Fred Sandback Archive; courtesy of David Zwirner, New York/London.

halting and erratic. Anselm Reyle took lines into the third dimension, as he used both straight and bent neon tubes in real space (**fig. 3.6**). Fred Sandback also put lines into our space (**fig. 3.7**), but he used black yarn in a much more organized array to suggest elegant open rectangles.

Many types of prints are made up almost entirely of lines, with little shading or color. Kiki Smith etched lines in a metal plate to create *Ginzer* (**fig. 3.8**), a depiction of her cat. She painstakingly drew one line for each of Ginzer's hairs, it seems. The eyes and foot pads are slightly shaded, but all else was done with line. She successfully captured the cat's flexible limbs and back as Ginzer reclined, but she also showed a hint of the cat's wild side in the mouth and alert eyes.

3.8 Kiki Smith. *Ginzer*. 2000. Etching, aquatint, and drypoint on mold-made paper. 22½″ × 31″.
Published by Harlan & Weaver, New York.

Watch the Art21 video of Kiki Smith discussing her work on myartslab.com

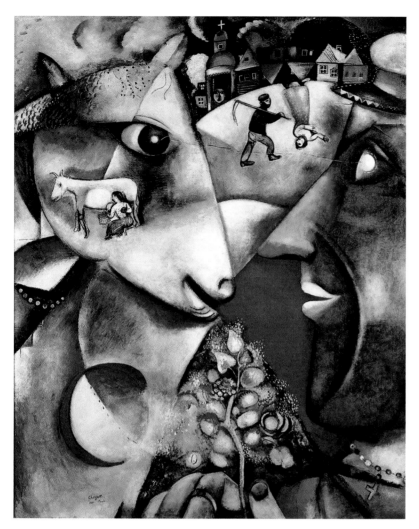

3.9 Marc Chagall. *I and the Village*. 1911.
Oil on canvas. 75⅝″ × 59⅝″.

Museum of Modern Art (MoMA) Mrs. Simon Guggenheim Fund. 146.1945.
© 2013 Digital image, The Museum of Modern Art, New York/Scala,
Florence. © 2013 Artists Rights Society (ARS), New York/ADAGP, Paris.

Implied Line

Implied lines suggest visual connections. Implied lines that form geometric shapes can serve as an underlying organizational structure. In *I and the Village* (**fig. 3.9**), Marc Chagall used implied lines to create a large circle at the lower center that brings together scenes of Russian Jewish village life. Notice that he also drew in the implied sightline between man and animal with a fine line.

Shape

The words *shape*, *mass*, and *form* are sometimes used interchangeably, but they mean different things in the visual arts. Here *shape* refers to the expanse within the outline of a two-dimensional area or within the outer

boundaries of a three-dimensional object. When we see a three-dimensional object in natural light, we see that it has mass, or volume. If the same object is silhouetted against a sunset, we may see it only as a flat shape. Enclosing lines or changing color sets a shape apart from its surroundings so that we recognize it.

We can group the infinite variety of shapes into two general categories: geometric and organic. **Geometric shapes**—such as circles, triangles, and squares—tend to be precise and regular. **Organic shapes** are irregular, often curving or rounded, and seem more relaxed and informal than geometric shapes. The most common shapes in the human-made world are geometric. Although some geometric shapes exist in nature—in such forms as crystals, honeycombs, and snowflakes—most shapes in nature are organic. A related term with a similar meaning is **biomorphic**, which also suggests shapes based on natural forms. Fred Sandback created geometric shapes in fig. 3.7, as did Lee Friedlander in his photo (see fig. 3.2). Sophie Taeuber-Arp suggested organic shapes in her drawing (see fig. 3.4).

In *I and the Village*, Chagall used a geometric structure of circles and triangles to organize the organic shapes of people, animals, and plants. He softened the severity of geometric shapes to achieve a natural flow between the various parts of the painting. Conversely, he abstracted natural subjects toward geometric simplicity in order to strengthen visual impact and symbolic content.

When a shape appears on a **picture plane** (the flat picture surface), it simultaneously creates a second shape out of the background area. The dominant shapes are referred to as **figures** or **positive shapes**; background areas are **ground** or **negative shapes**. The figure–ground relationship is a fundamental aspect of perception; it allows us to sort out and interpret what we see. Because we are conditioned to see only objects, and not the spaces between and around them, it takes a shift in awareness to see the white negative shapes

3.10 A Shape of Space. Implied space.

in A Shape of Space (**fig. 3.10**). Most artists consider both positive and negative shapes simultaneously and treat them as equally important to the total effectiveness of a composition.

Interactions between figure and ground are heightened in some images. In the upper half of M. C. Escher's print *Sky and Water I* (**fig. 3.11**), we see dark geese on a white ground. As our eyes move down the page, the light upper background becomes fish against a black background. In the middle, however, fish and geese interlock so perfectly that we are not sure what is figure and what

is ground. As our awareness shifts, fish shapes and bird shapes trade places, a phenomenon called **figure–ground reversal**.

We see a more subtle use of positive and negative spaces in Katharina Grosse's untitled work (**fig. 3.12**). She created this work by laying stencils and templates over a white background, and then spraying through them. Then she complicated the painting by spraying white from the background over the curving positive shapes. On the left, colored paint drips flow over white, while on the right, the reverse happens.

3.11 M. C. Escher. *Sky and Water I*. 1938. Woodcut. 17⅛″ × 17¼″.

3.12 Katharina Grosse. *Untitled*. 2010. Acrylic on canvas. 79″ × 53″.

Mass

A two-dimensional area is called a shape, but a three-dimensional area is called a **mass**: the physical bulk of a solid body of material. When mass encloses space, the space is called **volume**. The word *form* is sometimes used instead of mass to refer to physical bulk.

Mass in Three Dimensions

Mass is often a major element in sculpture and architecture. The contemporary sculptor Fernando Botero, for example, created a bronze horse of immense mass for a public monument in Mexico (**fig. 3.13**). The bulging legs and neck are intensified by the horse's short backbone, bringing the four legs together like strong pillars. The mass of this horse goes far beyond what mere muscle could produce, giving the body an inflated look. The legs are in a position of rest, and the head points toward the ground, yielding a form that does not openly interact with the surrounding space. *The Horse* is thus a good example of **closed form**.

3.14 Alberto Giacometti *Man Pointing*. 1947. Bronze. 70½″ × 40¾″ × 16⅜″, at base, 12″ × 13¼″.
Gift of Mrs. John D. Rockefeller 3rd. (678.1954) The Museum of Modern Art, New York. © 2013 Digital image, The Museum of Modern Art, New York/Scala, Florence.
© 2013 Alberto Giacometti Estate/Licensed by VAGA and ARS, New York, NY.

3.13 Fernando Botero. *The Horse*. 2008. Bronze. Height 134″. Plaza Centenario, Monterrey, Mexico.
Photograph: Patrick Frank.

In contrast to the hulking mass of Botero's horse, Alberto Giacometti's *Man Pointing* (**fig. 3.14**) conveys a sense of fleeting presence rather than permanence. The tall, thin figure appears eroded by time and barely existing. Because Giacometti used little solid material to construct the figure, we are more aware of a linear form in space than of mass. The figure reaches out; its **open form** interacts with the surrounding space, which seems to overwhelm it, suggesting the fragile, impermanent nature of human existence.

Mass in Two Dimensions

With two-dimensional media such as painting and drawing, mass must be implied. In the print *Bread* (**fig. 3.15**), Elizabeth Catlett drew lines that seem to wrap around and define a girl in space, implying a solid mass. The work gives the appearance of mass because the lines both follow the curvature of the head and build up dark areas to suggest mass revealed by light. Her use of lines convinces us that we are seeing a fully rounded person.

Space

Space is the indefinable, general receptacle of all things—the seemingly empty space around us. How artists organize space in the works they make is one of their most important creative considerations.

Space in Three Dimensions

Of all the visual elements, space is the most difficult to convey in words and pictures. To experience three-dimensional space, we must be in it. We experience space beginning with our own positions in relation to other people, objects, surfaces, and voids at various distances from ourselves. Each of us has a sense of personal space—the area surrounding our body—that we like to protect, and the extent of this invisible boundary varies from person to person and from culture to culture.

Architects are especially concerned with the qualities of space. Imagine how you would feel in a small room with a very low ceiling. What if you raised the ceiling to 15 feet? What if you added skylights? What if you replaced the walls with glass? In each case you would have changed the character of the space and, by doing so, would have radically changed your experience.

Whereas we experience the outside of a building as mass in space, we experience the inside as volume and as a sequence of enclosed spaces. Cesar Pelli's design for the North Terminal at Ronald Reagan Washington National Airport (**fig. 3.16**) takes the passenger's experience of space into account. Large windows offer

3.15 Elizabeth Catlett. *Bread*. 1962.
Linocut on paper. 15⅝″ × 11⅝″.
Courtesy of the Library of Congress LC-DIG-ppmsca-02388.
© Catlett Mora Family Trust/Licensed by VAGA, New York, NY.

3.16 Cesar Pelli and Associates. North Terminal, Ronald Reagan Washington National Airport. 1997.
Visions of America/Joe Sohm/Getty Images.

3.17 Doug Wheeler. *DW 68 VEN MCASD 11.* 1968/2011. Coved plaster walls, acrylic paint, nylon scrim, white UV and Grolux neon tubing. 216″ × 408″ × 405″.

Collection Museum of Contemporary Art San Diego. Museum purchase, Elizabeth W. Russell Foundation and Louise R. and Robert S. Harper Funds. Photo: Philipp Scholz Rittermann. © Doug Wheeler.

Space in Two Dimensions

With three-dimensional objects and spaces, such as sculpture and architecture, we must move around to get the full experience. With two-dimensional works, such as drawing and painting, we see the space of the surface all at once. In drawings, prints, photographs, and paintings, the actual space of each picture's surface (picture plane) is defined by its edges—usually the two dimensions of height and width. Yet within these boundaries, a great variety of possible pictorial spaces can be implied or suggested, creating depth in the picture plane.

Paintings from ancient Egypt, for example, show little or no depth. Early Egyptian painters made their images clear by portraying objects from their most easily identifiable angles and by avoiding the visual confusion caused by overlap and the appearance of diminishing size. *Pool in the Garden* (**fig. 3.18**) demonstrates this technique. The pool is shown from above while the trees, fish, and birds are all pictured from the side.

views of the runways and also of the Potomac River and the nearby Washington Monument. The architect divided the huge interior space into smaller modules to give the concourse a more domestic feel: "The module has an important psychological value in that each one is like a very large living room in size," the architect said. "It's a space that we experience in our daily life. . . . The domes make spaces designed on the scale of people, not on the scale of big machines."[2]

Doug Wheeler creates a feeling of infinite space in his installations in art galleries. He created the rim of white light in **fig. 3.17** by combining two kinds of light to yield a soft glow. This makes the end wall seem to detach from the rest of the room, tempting viewers to proceed toward it. The space where they stand also seems to take on mass, so that a viewer "senses the mass of space," as the artist put it.

3.18 *Pool in the Garden.* Wall painting from the tomb of Nebamun. Egypt. c.1400 BCE. Paint on dry plaster.

The British Museum © The Trustees of the British Museum.

3.19 Clues to Spatial Depth.

a. Overlap.

b. Overlap and diminishing size.

c. Vertical placement.

d. Overlap, vertical placement, and diminishing size.

Implied Depth

Almost any mark on a picture plane begins to give the illusion of a third dimension: depth. Clues to seeing spatial depth are learned in early childhood. A few of the major ways of indicating space on a picture plane are shown in the diagrams Clues to Spatial Depth (**fig. 3.19**).

When shapes overlap, we immediately assume from experience that one is in front of the other (diagram a). Overlapping is the most basic way to achieve the effect of depth on a flat surface. (Note that *Pool in the Garden* uses very little overlapping.) The effect of overlap is strengthened by diminishing size, which gives a sense of increasing distance between each of the shapes (diagram b). Our perception of distance depends on the observation that distant objects appear smaller than near objects. A third method of achieving the illusion of depth is **vertical placement**: Objects placed low on the picture plane (diagram c) appear to be closer to the viewer than objects placed high on the plane. This is the way we see most things in actual space. Creating illusions of depth on a flat surface usually involves one or more such devices (diagram d).

When we look at a picture, we may be conscious of both its actual flat surface and the illusion of depth that the picture contains. Artists can emphasize either the reality or the illusion, or strike a balance between these extremes. Paul Cézanne suggested depth in various ways in his small work *Still Life with Apples* (**fig. 3.20**). The basic subject is a dark tabletop against a pale background. We see the "horizon line" of the tabletop at either end of the picture, but the artist left an intriguing gap

in the middle. On the tabletop, he created pictorial depth both by overlapping and by vertical placement of the fruit. The lemon is both closer to us and lower in the picture. Note also that the three fruits on the tabletop seem to inhabit a different space from the apples on the dish. The space before the dish seems flat, parallel to the picture surface. Cézanne also flattened the overall space by placing patches of parallel brushstrokes in both background and tabletop; this encourages us to read both spaces as "surface." Finally, the space behind the tabletop is unclear; it could be a fraction of an inch deep, or several feet. These suggestions and denials of space create an absorbing and unstable visual experience, a set of subtle optical illusions.

3.20 Paul Cézanne. *Still Life with Apples.* c.1890. Oil on canvas. 13¾" × 18⅛".
The Hermitage, St. Petersburg/
The Bridgeman Art Library.

Linear Perspective

In general usage, the word **perspective** refers to point of view. In the visual arts, perspective refers to any means of representing three-dimensional objects in space on a two-dimensional surface. In this sense it is correct to speak of the perspective of Persian miniatures, Japanese prints, Chinese Song dynasty paintings, or Egyptian murals—although none of these styles is similar to the **linear perspective** system, which was developed during the Italian **Renaissance**. Different traditions and intentions, rather than mere skill, give us various ways of depicting depth.

3.21 Linear Perspective.

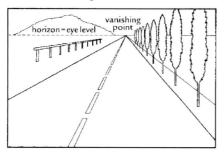

a. One-point linear perspective.

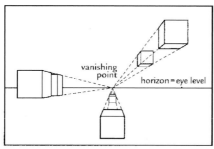

b. One-point linear perspective. Cubes above eye level, at eye level, and below eye level.

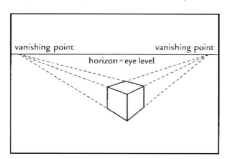

c. Two-point linear perspective.

View the Closer Look for the technique of Renaissance perspective on myartslab.com

In the West, we have become accustomed to linear perspective (also called simply *perspective*) to depict the way objects in space appear to the eye. This system was developed by Italian architects and painters in the fifteenth century, at the beginning of the Renaissance.

Linear perspective is based on the way we see. We have already noted that objects appear smaller when seen at a distance than when viewed close up. Because the spaces between objects also appear smaller when seen at a distance, parallel lines appear to converge as they recede into the distance, as shown in the first of the Linear Perspective diagrams (**fig. 3.21a**). Intellectually, we know that the edge lines of the road must be parallel, yet they seem to converge, meeting at last at what is called a **vanishing point** on the horizon—the place where land and sky appear to meet. On a picture surface, the horizon (or **horizon line**) also represents your eye level as you look at a scene.

Eye level is an imaginary plane, the height of the artist's eyes, parallel with the ground plane and extending to the horizon, where the eye level and ground plane appear to converge. In a finished picture, the artist's eye level becomes the eye level of anyone looking at the picture. Although the horizon is frequently blocked from view, it is necessary for an artist to establish a combined eye-level/horizon line to construct images using linear perspective.

With the linear perspective system, an entire picture can be constructed from a single, fixed position called a **vantage point**, or viewpoint. Diagram a shows **one-point perspective**, in which the parallel sides of the road appear to converge and trees in a row appear smaller as their distances from the vantage point increase.

Diagram b shows cubes drawn in one-point linear perspective. The cubes at the left are at eye level; we can see neither their top nor their bottom surfaces. We might imagine them as buildings.

The cubes in the center are below eye level: we can look down on their tops. These cubes are drawn from a high vantage point: a viewing position above the subject. The horizon line is above these cubes, and their perspective lines go up to it. We may imagine these as boxes on the floor.

The cubes at the right are above our eye level; We can look up at their bottom sides. These cubes are

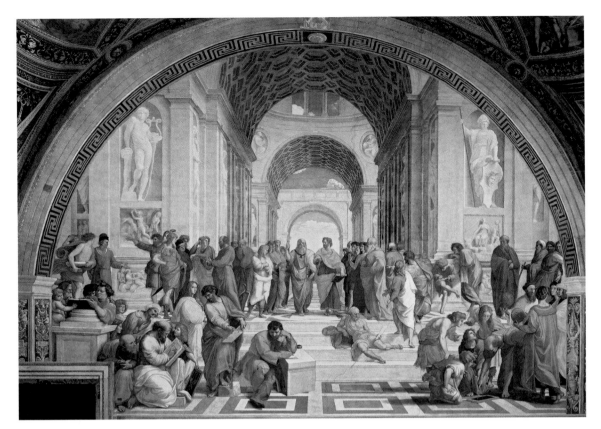

3.22 Raphael. *The School of Athens*. 1508.
Fresco. Approximately 18′ × 26′.
Stanza della Segnatura, Vatican, Rome.
Photograph: akg-image/Erich Lessing.

View the Closer Look for *The School of Athens*
on myartslab.com

drawn from a low vantage point. The horizon line is
below these cubes and their perspective lines go down
to it. Imagine that these boxes are sitting on a glass
shelf high above our heads.

In one-point perspective, all the major receding
"lines" of the subject are actually parallel, yet visually
they appear to converge at a single vanishing point on
the horizon line. In two-point perspective, two sets of
parallel lines appear to converge at two points on the
horizon line, as in diagram c.

When a cube or any other rectilinear object is posi-
tioned so that a corner, instead of a side, is closest to us,
we need two vanishing points to draw it. The parallel
lines of the right side converge to the right; the parallel
lines of the left side converge to the left. There can be as
many vanishing points as there are sets and directions
of parallel lines. Horizontal parallel lines moving away
from the viewer above eye level appear to go down to
the horizon line; those below eye level appear to go up
to the horizon line.

In *The School of Athens* (**fig. 3.22**), Raphael
invented a grand architectural setting in the Renaissance
style to provide an appropriate space for his depiction
of the Greek philosophers Plato and Aristotle and other

3.23 Study of *The School of Athens*.

important thinkers. The size of each figure is drawn to scale according to its distance from the viewer; thus the entire group seems natural. Lines superimposed over the painting reveal the basic one-point perspective system Raphael used. However, the cube in the foreground is not parallel to the picture plane or to the painted architecture and is in two-point perspective.

Raphael used perspective for emphasis. We infer that Plato and Aristotle are the most important figures in this painting because of their placement at the center of receding archways in the zone of greatest implied depth.

If the figures are removed, as shown in the study of *The School of Athens* (**fig. 3.23**), our attention is pulled right through the painted setting into implied infinite space. Conversely, without their architectural background defined by perspective, Plato and Aristotle lose importance; picking them out from the crowd becomes difficult.

3.24 Asher Brown Durand. *Kindred Spirits*. 1849.
Oil on canvas. 44″ × 36″.
Courtesy Crystal Bridges Museum of American Art, Bentonville, Arkansas. Photography by The Metropolitan Museum of Art.

Atmospheric Perspective

Atmospheric or **aerial perspective** is a nonlinear means for giving an illusion of depth. In atmospheric perspective, the illusion of depth is created by changing color, value, and detail. In visual experience of the real world, as the distance increases between the viewer and faraway objects such as mountains, the increased quantity of air, moisture, and dust causes the distant objects to appear increasingly bluer and less distinct. Color intensity is diminished, and contrast between light and dark is reduced.

Asher Brown Durand used atmospheric perspective in his painting *Kindred Spirits* (**fig. 3.24**) to provide a sense of the vast distances in the North American wilderness. The illusion of infinite space is balanced by dramatically illuminated foreground details, by the figures of the men, and by Durand's lively portrayal of trees, rocks, and waterfalls. We identify with the figures of painter Thomas Cole and poet William Cullen Bryant as they enjoy the spectacular landscape. As in *The School of Athens*, the implied deep space appears as an extension of the space we occupy.

Traditional Chinese landscape painters have another way of creating atmospheric perspective. In Shen Zhou's painting *Poet on a Mountaintop* (**fig. 3.25**), near and distant mountains are suggested by washes of ink and color on white paper. The light gray of the farthest mountain at the upper right implies space and atmosphere. Traditional Chinese landscape paintings present poetic symbols of landforms rather than realistic representations. Whereas *Kindred Spirits* draws the viewer's eye into and through the suggested deep space, *Poet on a Mountaintop* leads the eye across (rather than into) space.

Time and Motion

Time is the fourth dimension, in which events occur in succession. Because we live in an environment combining space and time, our experience of time often depends on our movement in space, and vice versa. Although time itself is invisible, it can be made perceptible in art. Time and motion become major elements in visual media such as film, video, and kinetic (moving) sculpture.

澗
苔
吹
簫
沈
周

杖
藜
舒
眺
望
欲
鳴

磴
飛
空
細
路
遙
獨
倚

白
雲
如
帶
東
山
腰
石

3.25 Shen Zhou. *Poet on a Mountaintop*. c.1500.
From the series *Landscape Album: Five Leaves*. Album
leaf mounted as a handscroll; ink and watercolor on
paper on silk mount. 15¼″ × 23¾″ overall.
The Nelson-Atkins Museum of Art, Kansas City, Missouri.
Purchase: William Rockhill Nelson Trust, 46-51/2. Photo: John Lamberton.

The Passage of Time

Many traditional non-Western cultures teach that time
is cyclic. The Aztecs of ancient Mexico, for example,
held that the Earth was subject to periodic cycles of
destruction and recreation, and their calendar stone
embodies this idea. At the center of the Aztec Calendar
Stone (**fig. 3.26**) is a face of the sun god represent-
ing the present world, surrounded by four rectangular
compartments that each represent one previous incar-
nation of the world. The whole stone is round, symbol-
izing the circular nature of time.

The Judeo-Christian tradition of Western culture
teaches that time is linear—continually moving for-
ward. The early Renaissance painter Sassetta implied

3.26 Aztec Calendar Stone. 1479. Diameter 141″.
National Anthropological Museum Mexico. The Art Archive/Alamy.

View the Closer Look for the Aztec Calendar Stone
on myartslab.com

3.27 Sassetta. *The Meeting of Saint Anthony and Saint Paul.* c.1440. Tempera on panel. 18⁵⁄₁₆″ × 13⅛″.
The National Gallery of Art, Washington. 1939.1.293.(404)
Samuel H. Kress Collection.

3.28 Gary Panter. *Back to Nature.* 2001.
Self-published comic. 5″ × 3¼″.
Courtesy of the the artist.

the passage of time in his painted narration *The Meeting of Saint Anthony and Saint Paul* (**fig. 3.27**). The painting depicts key moments during Saint Anthony's progression through time and space, including the start of his journey in the city, which is barely visible behind the trees at the top center. He first comes into view as he approaches the wilderness in the upper left; we next see him encountering the centaur at upper right; finally, he emerges into the clearing in the foreground, where he meets Saint Paul. The road on which he travels implies continuous forward movement in time.

Comics also generally express a linear conception of time, as we read the frames from left to right and top to bottom. Gary Panter's six-panel comic *Back to Nature* (**fig. 3.28**) shows the progression of his thoughts as he comes to grips with the attacks of September 11, 2001. Although he thinks of the past

and hopes for the future, the sequence of frames implies succession in time.

In both film and television, the impression of time need not be linear but can be manipulated so that past, present, and future are intermixed, and events that occur too quickly or too slowly to be perceived can be made visible by slowing them down or speeding them up. The impression of time can thus be compressed, expanded, run backward, and rerun. Contemporary music videos often present widely disparate moments of time in quick succession, as if time moves in a series of sudden jumps of unpredictable length. This creates a feeling of disjunction from the passage of clock time.

3.29 Christian Marclay. *The Clock*. 2010.
Single channel video with stereo sound. 24 hours, looped.
Courtesy Paula Cooper Gallery, New York © Christian Marclay.

While most movies compress time to varying degrees, Christian Marclay in 2010 created a riveting meditation on time that actually passes in real time. His video *The Clock* (**fig. 3.29**) lasts 24 hours, and is assembled from thousands of film clips in which characters look at their watches or discuss what time it is. The snippets are perfectly coordinated to the time of day, so that every viewer will see dozens of film clips of clocks and watches, all registering the correct time. In *The Clock*, we see time pass, but through a dizzying variety of moments captured from jarringly unpredictable scraps pulled from the entire history of film.

Implied Motion

To give lifelike feeling, artists often search for ways to create a sense of movement. Sometimes movement itself is the subject or a central quality of the subject. An appealing depiction of movement, the dancing Krishna (**fig. 3.30**) portrays the Hindu god

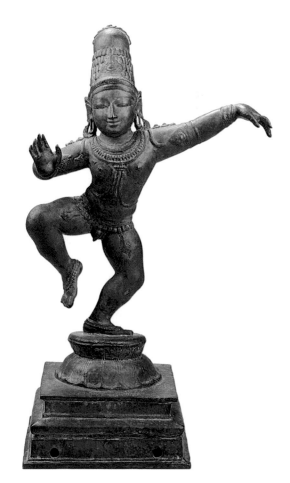

3.30 Dancing Krishna. Tamil Nadu, South India. Chola dynasty. c.1300. Bronze. Height 23⅝".
Honolulu Museum of Art. Partial gift of Mr. and Mrs. Christian H. Aall; partial purchase, The Jhamandas Watumull Family Fund, 1997. (8640.1) Photo by Shuzo Uemoto.

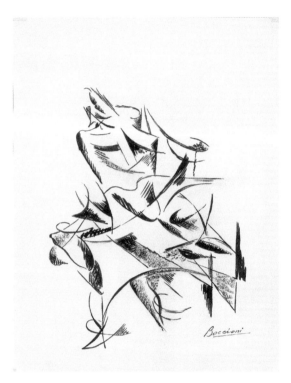

3.31 Umberto Boccioni.
Dynamism of a Human Body: Footballer. 1913–1914.
Ink and graphite on paper. 12⅜" × 9⁹⁄₁₆".
Collection Walker Art Center, Minneapolis. Donated by
Mr. and Mrs. Edmond R. Ruben, 1995.

3.32 Jenny Holzer. *Untitled (Selections from Truisms,
Inflammatory Essays, The Living Series, The Survival
Series, Under a Rock, Laments, and Child Text).*
1989. Extended helical tricolor L.E.D. electronic
display signboard. Site-specific dimensions:
height 16½", length 162'.
Solomon R. Guggenheim Museum, New York. Partial gift of the artist, 1989;
Gift, Jay Chiat, 1995; and purchased with funds contributed by the International
Director's Council and Executive Members: Eli Broad, Elaine Terner Cooper,
Ronnie Heyman, Dakis Joannou, Peter Norton, Inge Rodenstock, and Thomas
Walther, 1996 89.3626 © 2013 Jenny Holzer, member Artists Rights Society
(ARS), New York.

as a playful child who just stole his mother's butter
supply and now dances with glee. The cast-bronze
medium provides the necessary strength to hold the
dynamic pose as the energy-radiating figure stands on
one foot, counterbalancing arms, legs, and torso.

Artists of the Futurist movement in the early twen-
tieth century found innovative ways to depict motion
and speed, which they regarded as the most impor-
tant new subjects for art. Umberto Boccioni captured
a soccer player in motion in his drawing *Dynamism
of a Human Body: Footballer* (**fig. 3.31**). The outer
boundaries of the human form disappear, as the art-
ist captured limbs extended in various directions and
combined them into a single moment.

Contemporary artist Jenny Holzer made clever
use of implied motion in an untitled work (**fig. 3.32**),
in which she installed light boards on the inner edge
of the spiral ramp in the Guggenheim Museum
in New York. These boards are commonly used for
advertising, but she populated this extended helix

with sayings of her own invention. The sayings seem
to progress down the ramp in a continuous flow, but
in reality the lights go on and off only at carefully pro-
grammed intervals. In this welter of constantly shift-
ing slogans, she hoped to show how the mass media
bombard us with input.

Actual Motion

Before the advent of electric motors, artists created
moving sculpture by harnessing the forces of wind and
water. Fountains, kites, banners, and flags have been
popular since ancient times.

Alexander Calder's mobiles, such as his large work
in the National Gallery (**fig. 3.33**) in Washington,
D.C., rely on air movement to perform their subtle
dances. As viewers enter and leave the galleries of the

3.33 Alexander Calder. *Untitled.* 1972. Aluminum and steel. Overall: 358⅜″ × 911⅝″.
National Gallery of Art, Washington. 1977.76.1. Gift of the Collectors Committee. © 2013 Calder Foundation, New York/
Artists Rights Society (ARS), New York.

East Building, the sculpture slowly moves in space. Calder, a leading inventor of **kinetic art**, was one of the first twentieth-century artists who made actual motion a major feature of their art.

Light

Our eyes are light-sensing instruments. Everything we see is made visible by the radiant energy we call light. Sunlight, or natural light, although perceived as white, actually contains all the colors of light that make up the visible part of the electromagnetic spectrum. Light can be directed, reflected, refracted, diffracted, or diffused. The source, color, intensity, and direction of light greatly affect the way things appear; as light changes, surfaces illuminated by it also appear to change.

Seeing Light

The way light falls on a subject powerfully influences how we see it. A simple shift in the direction of light dramatically changes the way we perceive the sculpture of Abraham Lincoln (**fig. 3.34**) by Daniel Chester French. When the monumental figure was first installed in the Lincoln Memorial in Washington, D.C., the sculptor was disturbed by the lighting. Sunlight reflected off the floor seemed to radically change Lincoln's character from wise leader to frightened novice. The problem was corrected by placing spotlights in the ceiling above the statue. Because the spotlights are stronger than the natural light reflected from the white marble floor, they illuminate the figure with the kind of overhead light that creates an entirely different expression.

3.34 Daniel Chester French.
Lincoln Memorial (detail). 1911–1922.
Left: As originally lit by daylight.
Right: With the addition of artificial
light. Historical professional composite
photograph (1922) of full-sized plaster
model of head (1917–18). 50½" tall.

Chapin Library, Williams College; gift of the National
Trust for Historic Preservation Chesterwood Archive.
Photographer: De Witt Ward.

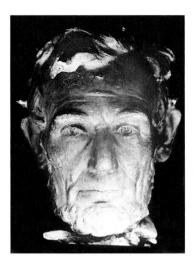
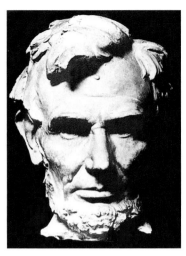

Most of us have some experience in managing light if we take pictures outdoors: Light coming from a source directly in front of or behind objects seems to flatten three-dimensional form and emphasize shape. Light from above or from the side, and slightly in front, most clearly reveals the form of objects in space.

In the terminology of art, **value** (sometimes called *tone*) refers to the relative lightness and darkness of surfaces. Value ranges from white through various grays to black. Value can be considered a property of color or an element independent of color. Subtle relationships between light and dark areas determine how things look. To suggest the way light reveals form, artists use changes in value. A gradual shift from lighter to darker tones can give the illusion of a curving surface, while an abrupt value change usually indicates an abrupt change in surface direction.

Implied Light

The diagram Dark/Light Relationships (**fig. 3.35**) shows that we perceive value as a relationship rather than an isolated form: The gray bar has the same gray value over its entire length, yet it appears to change from one end to the other as the value of the background changes.

Rosa Bonheur's painting *Harvest Season* (**fig. 3.36**) uses all of the values from light to dark. We see bright white accents in the workers' shirts, and rich, dark shadows on the ground. In between, she used light in several places both to illuminate the subjects and to show their volume as masses. We see this in the shading that she applied to the front of the haystack on the wagon; because the hay is a uniform color, she used light to show its rough and indented surface. Likewise, the arm of the worker leading the draft animals has a bold shape because of the light that falls on it. On the bodies of the draft animals, Bonheur suggested their roundness by shading from light to dark, a common technique known as **chiaroscuro** (from Italian, *chiaro*, light; *oscuro*, dark). This technique makes it possible to create the illusion that figures and objects depicted on a flat surface have roundness and bulk.

The preoccupation with mass or solid form as revealed by light is a Western tradition that began with

3.35 Dark/Light Relationships. Value scale compared to uniform middle gray.

3.36 Rosa Bonheur. *Harvest Season*. c.1859. Oil on canvas. 17½″ × 33½″.
The Haggin Museum, Stockton, California. cat.no 1931.391.26.

Italian artists in the Renaissance. When the Japanese first saw Western portraits in the nineteenth century, they wanted to know why one side of the face was dirty!

Light as a Medium

Some contemporary artists use artificial light as their medium. They enjoy using light because it gives pure, intense colors that radiate into the viewer's space. Others who use light are drawn to the idea of making electric power into art. Keith Sonnier did both when he placed an array of neon tubes in the outdoor lobby of a new government building in Los Angeles. He called the work *Motordom* (**fig. 3.37**), to express the reality of car culture that Southern Californians live with. The neon tubes slowly flicker in a pattern that repeats every five minutes, as if taillights are passing along the sides of the walls and around the lobby. The agency that

3.37 Keith Sonnier. *Motordom*. 2004.
Light installation at Caltrans District 7.
Photograph: Roland Halbe © 2013 Keith Sonnier/
Artists Rights Society (ARS), New York.

👁 ▷ **Watch** a podcast interview with Keith Sonnier about *Motordom* on myartslab.com

FORMING ART

Keith Sonnier (b. 1941): Turning Light into Art

3.38 Keith Sonnier. 2012.
Photograph by Jason Schmidt, courtesy the artist and Pace Gallery.

It may have been the electric fences in the region of rural Louisana where Keith Sonnier grew up that led to his fascination with electricity. He told an interviewer, "When I was a kid in the country, we had electric fences and we were always getting shocked. We loved getting shocked— you know, there are very few thrills out in the country."[3] That interest in electricity later evolved into pioneering artworks that use light as a medium.

After studies at Rutgers University, Sonnier settled in New York in the late 1960s, a time when many artists were abandoning oil painting, some moving to video, others toward large-scale sculpture. He recalled, "Our type of work was somehow counterculture. We chose materials that were not 'high art'; we weren't working in bronze, or paint, even. We were using materials that weren't previously considered art materials. They were deliberately chosen to

psychologically evoke certain kinds of feelings."

Sonnier wanted to create works that involved the viewer more directly than mere looking at a work on the wall. "When I began to work in light, I began to think about an artwork being interactive with an audience, meaning how it affects the audience physically when they look at an artwork. . . When you stand in front of the work, you are in the work, and I wanted artworks that forced the audience to be a part of the work. . . . One is physically and psychologically cut by the materials that you move through."

Colored light tends to move outward from its source, projecting into the viewer's space; thus it can seem to take on volume. As Sonnier has explained: "When color becomes that intense and physical, you begin to think of color as a material. There is a density to color, and color becomes a volume in fact." We see this effect with *Motordom* (see fig. 3.37), in which light invades the space of the outdoor lobby, and it changes as the lights flicker. At different moments, the quality and color of light influences the volume that viewers perceive. Because the light seems to shape the surrounding space, viewers do more than merely look at the work; they enter it.

In his light works for galleries, Sonnier generally includes the transformers and wiring in

the work, so that the electric sources remain obvious. We see this in his recent work *Hartebeest* (**fig. 3.39**). This work has a human scale, confronting viewers with an electrical, stick-figured person with huge blue horns. The upward sweep of blue lights is based on drawings that Sonnier made during a trip to Africa, where he saw wildebeest and other long-horned animals.

Sonnier's use of neon is related only to its color properties, not to its possible uses in lettered signs. He said, "I love light in my work but I was never influenced by neon signage in itself, rather its effect on nature and architecture." His pieces give us a sense of what light can do in art, as it both illuminates the surroundings and creates colored volumes in space.

3.39 Keith Sonnier. *Hartebeest*. 2008.
Steel, neon paint, neoprene, rubber, and transformer. 10′2″ × 3′6″ × 1′10″.
Photography by Genevieve Hanson, courtesy Pace Gallery.
© 2013 Keith Sonnier/Artists Rights Society (ARS), New York.

3.40 Paul Chan. *1st ~~Light~~*. 2005. Digital video projection. 14 minutes.
Courtesy the artist and Greene Naftali, New York. Photograph: Jean Vong.

commissioned the building operates the state's roads and bridges, making *Motordom* particularly appropriate for that space.

Paul Chan uses light from a digital projector to display his haunting creations (**fig. 3.40**). For his series of seven works called *The 7 ~~Lights~~*, he installed the projector at various angles so that it sent an irregular window of light onto the floor or wall of the gallery space. Over each work's 14-minute duration, a bewildering variety of objects seems to tumble or glide or fall through the projected field of light. We see shadows of all kinds of things, from pets to people, from luggage to locomotives. These shadows are "light that has been struck out," said the artist, and thus the word ~~Lights~~ of the title has been struck through. It looks as if we are witnessing some silent catastrophe, as the laws of gravity are suspended and everything has come loose from its moorings.

Color

Color, a component of light, affects us directly by modifying our thoughts, moods, actions, and even our health. Psychologists, as well as designers of schools, offices, hospitals, and prisons, understand that colors can affect work habits and mental conditions. People surrounded by expanses of solid orange or red for long periods often experience nervousness and raised blood pressure. In contrast, some blues have a calming effect, causing blood pressure, pulse, and activity rates to drop to below normal levels.

Dressing according to our color preferences is one way we express ourselves. Designers of everything from clothing and cars to housewares and interiors recognize the importance of individual color preferences, and they spend considerable time and expense determining the colors of their products.

Most cultures use color according to established customs. In the Italian Renaissance, Leonardo da Vinci was influenced by earlier European traditions when he wrote, "We shall set down for white the representative of light, without which no color can be seen; yellow for earth; green for water; blue for air; red for fire; and black for total darkness."[4] In traditional painting in North India, flat areas of color are used to suggest certain moods, such as red for anger and blue for sexual passion. A modern artist may paint the sky or the ground with a bright shade that relates not to the appearance of the area, but

to the feeling appropriate to the work. In Austrian slang, yellow describes a state of envy or jealousy, while blue means intoxicated.

Between the fifteenth and nineteenth centuries, color was used in limited, traditional ways in Western art, as Leonardo da Vinci indicated. In the 1860s and 1870s, influenced by the new discoveries in optics, the French Impressionist painters revolutionized the way artists used color (see Chapter 21).

The Physics of Color

What we call "color" is the effect on our eyes of light waves of differing wavelengths or frequencies. When combined, these light waves make white light, the visible part of the spectrum. Individual colors are components of white light.

The phenomenon of color is a paradox: color exists only in light, but light itself seems colorless to the human eye. Objects that appear to have color are merely reflecting the colors that are present in the light that illuminates them. In 1666, British scientist Isaac Newton discovered that white light is composed of all the colors of the spectrum. He found that when the white light of the sun passes through a glass prism, it is separated into the bands of color that make up the visible spectrum, as shown in the diagram White Light Refracted by a Prism (**fig. 3.41**).

Because each color has a different wavelength, each travels through the glass of the prism at a different speed. Red, which has the longest wavelength, travels more rapidly through the glass than blue, which has a shorter wavelength. A rainbow results when sunlight is refracted and dispersed by the spherical forms of raindrops, producing a combined effect like that of the glass prism. In both cases, the sequence of spectral colors is: red, orange, yellow, green, blue, and violet.

Pigments and Light

Our common experience with color is provided by light reflected from pigmented surfaces. Therefore, the emphasis in the following discussion is on pigment color rather than on color coming from light alone.

When light illuminates an object, some of the light is absorbed by the surface of the object and some is reflected. The color that appears to our eyes as that of the object (called **local color**) is determined by the wavelengths of light being reflected. Thus, a red surface illuminated by white light (full-spectrum light) appears red because it reflects mostly red light and absorbs the rest of the spectrum. A green surface absorbs most of the spectrum except green, which it reflects, and so on with all the hues.

When all the wavelengths of light are absorbed by a surface, the object appears black; when all the wavelengths are reflected, the surface appears white. Black and white are not true colors: white, black, and their combination, gray, are **achromatic** (without the property of hue) and are often referred to as **neutrals**.

Each of the millions of colors human beings can distinguish is identifiable in terms of just three variables: hue, value, and intensity.

- **Hue** refers to a particular wavelength of spectral color to which we give a name. Colors of the spectrum—such as yellow and green—are called hues.
- **Value** refers to relative lightness or darkness from white through grays to black. Pure hues vary in value. On the color chart shown in The Three Dimensions of Color (**fig. 3.42**), hues in their purest state are at their usual values. Pure yellow is the lightest of hues; violet is the darkest. Red and green are middle-value hues. Black and white pigments can be important ingredients in changing color values. Adding black to a hue produces a **shade** of that hue. For example, when black is added to orange, the result is a brown; when black is mixed with red, the result is maroon. White added to a hue produces a **tint**. Lavender is a tint of violet; pink is a tint of red.

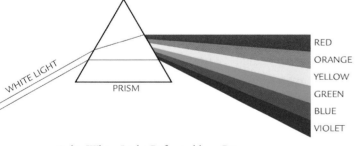

3.41 White Light Refracted by a Prism.

✳ Explore the Discovering Art tutorial on color and light on myartslab.com

3.42 The Three Dimensions of Color.

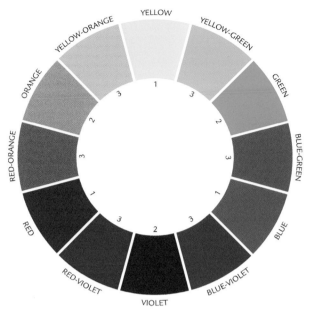

a. Hue—the color wheel.

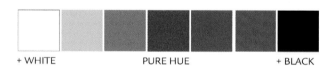

b. Value—from light to dark. Value scale from white to black.

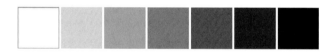

+ WHITE PURE HUE + BLACK

c. Value variation in red.

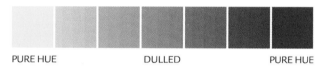

PURE HUE DULLED PURE HUE

d. Intensity—from bright to dull.

- **Intensity**, also called **saturation**, refers to the purity of a hue or color. A pure hue is the most intense form of a given color; it is the hue at its highest saturation, in its brightest form. With pigment, if white, black, gray, or another hue is added to a pure hue, its intensity diminishes and the color is thereby dulled.

Most people are familiar with the three pigment primaries: red, yellow, and blue (**fig. 3.43**). Mixtures of

3.43 Pigment Primaries: Subtractive Color Mixture.

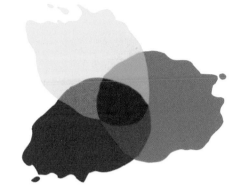

3.44 Light Primaries: Additive Color Mixture.

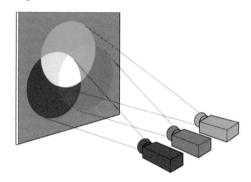

these are what we usually experience as local color when we look at a leaf, a wall, or a painting. When the pigments of different hues are mixed together, the mixture appears duller and darker because pigments absorb more and more light as their absorptive qualities combine. For this reason, pigment mixtures are called **subtractive color mixtures**. Mixing red, blue, and yellow will produce a dark gray, almost black, depending on the proportions and the type of pigment used.

A lesser-known triad is the three light primaries: red-orange, green, and blue-violet (**fig. 3.44**). These are actual electric light colors that produce white light when combined; they are the colors that our televisions and computer screens use, along with certain light artists such as Sonnier (see fig. 3.37). Such mixtures are called **additive color mixtures**. Combinations of the light primaries produce lighter colors: red and green light, when mixed, produce yellow light.

Color Wheel

The color wheel (see fig. 3.42) is a twentieth-century version of a concept first developed in the seventeenth

3.45 Warm/Cool Colors.

century by Isaac Newton. After Newton discovered the spectrum, he found that both ends could be combined into the hue red-violet, making the color wheel concept possible. Numerous color systems have followed since that time, each with its own basic hues. The color wheel shown here is based on twelve pure hues and can be divided into the following groups:

3.46 Color Printing.

a. Yellow.

b. Magenta.

c. Yellow and magenta.

d. Cyan.

e. Yellow, magenta, and cyan.

f. Black.

g. Yellow, magenta, cyan, and black.

h. Color printing detail of Sandro Botticelli's *Birth of Venus*.

3.47 Red, Blue, and Green color palettes from Gimp, an image-editing application.

- **Primary hues** (see 1 on the color wheel): red, yellow, and blue. These pigment hues cannot be produced by an intermixing of other hues. They are also referred to as primary colors.
- **Secondary hues** (see 2 on the color wheel): orange, green, and violet. The mixture of two primaries produces a secondary hue. Secondaries are placed on the color wheel between the two primaries of which they are composed.
- **Intermediate hues** (see 3 on the color wheel): red-orange, yellow-orange, yellow-green, blue-green, blue-violet, and red-violet. Each intermediate is located between the primary and the secondary of which it is composed.

The blue-green side of the wheel seems **cool** in psychological temperature, and the red-orange side **warm**. Yellow-green and red-violet are the poles dividing the color wheel into warm and cool hues. The difference between warm and cool colors may come chiefly from association. Relative warm and cool differences can be seen in any combination of hues. Color affects our feelings about size and distance as well as temperature. Cool colors appear to contract and recede; warm colors appear to expand and advance, as in the Warm/Cool Colors diagram (**fig. 3.45**).

The most vibrant color sensations come not from blending colors, but from placing tiny dots of purer hues next to each other so that they blend in the eye and the mind. This is what happens in modern four-color printing, in which tiny dots of ink in the printer's three primary colors—magenta (a bluish red), yellow, and cyan (a greenish blue)—are printed together in various amounts with black ink on white paper to achieve the effect of full color. For example, in the color printing separations and the enlarged detail of Botticelli's *Birth of Venus* (**fig. 3.46**), the eye perceives subtle blends as it optically mixes tiny dots of intense color.

Today, many computer users employ color pickers or on-line palettes (**fig. 3.47**) in the way that painters use the color wheel. In this example, we see the various shades and tints of the light primaries, which are arrived at by adding small increments of white or black to the pure hue. Digital designers and some computer artists choose colors by merely clicking on a region; they can combine and further shade their choices using sliders. Because computer screens use the light primaries rather than the pigment primaries, their color mixtures retain a high level of brightness; this effect is visible with every Web page or phone application that we open.

3.48 Mary Corse. *Untitled (White multiple inner band, beveled)*. 2009. Glass microspheres in acrylic on canvas. 90″ × 60″.
Courtesy of Ace Gallery.

Color Schemes

Color groupings that provide distinct color harmonies are called **color schemes**.

Monochromatic color schemes are based on variations in the value and intensity of a single hue. In a monochromatic scheme, a pure hue is used alone with black and/or white, or mixed with black and/or white. Artists may choose a monochromatic color scheme because they feel that a certain color represents a mood. Pablo Picasso, for example, made many blue paintings in the early years of the twentieth century, at a time in his life when he was poor. Other artists adopt the monochromatic color scheme as a kind of personal discipline, in order to experiment with the various gradations of a relatively narrow band of the spectrum. An extreme example of such an artist is Mary Corse, who for many years has been making only white paintings. She creates them by embedding tiny spheres of glass into their surfaces in patterned zones. These white areas reflect surrounding light, and even change as the viewer walks past them. In *Untitled (White multiple inner band, beveled)* (**fig. 3.48**) shown here, the spheres form four vertical stripes.

Analogous color schemes are based on colors adjacent to one another on the color wheel, each containing the same pure hue, such as a color scheme of yellow-green, green, and blue-green. Tints and shades of each analogous hue may be used to add variations to such color schemes.

3.49 Jennifer Bartlett. *Trio*. 2008.
Enamel over silkscreen grid on baked enamel, steel plates. Overall installed, 45 plates: 63″ × 27′.
Photograph courtesy the artist and Pace Gallery.

3.50 Keith Haring. *Monkey Puzzle*. 1988.
Acrylic on canvas. Diameter 120″.
© Keith Haring Foundation.

Jennifer Bartlett often examines the effect of analogous color in her work. In *Trio* (**fig. 3.49**), for example, she painted 45 steel plates with enamel in various analogous color schemes. Viewers can mentally select the primaries, secondaries, and intermediates in each of the squares. Each of the three rows has a different wave pattern, which creates the effect of pale light reflecting off a gently rippled surface of water. The work as a whole fills the eyes, as it measures 27 feet across; it resembles a beautiful scientific investigation of the properties of analogous color.

Complementary color schemes emphasize two hues directly opposite each other on the color wheel, such as red and green. Keith Haring's *Monkey Puzzle* (**fig. 3.50**) shows their jarring effect. When actually mixed together as pigments in almost equal amounts, complementary hues form neutral grays, but when placed side by side as pure hues, they contrast strongly and intensify each other, as they do in this work. Complementary hues red-orange and blue-green tend to "vibrate" more when placed next

to each other than do other complements because they are close in value and produce a strong warm/cool contrast. The complements yellow and violet provide the strongest value contrast possible with pure hues. The complement of a primary is the opposite secondary, which is obtained by mixing the other two primaries. For example, the complement of yellow is violet. *Monkey Puzzle* contains various examples of several complementary pairs, all in one exuberant disk. In some cases the complementary pair is in one of the bodies; in others the pair includes the surrounding stripe. The black background further heightens the strident impact of Haring's color choices.

These examples provide only a basic foundation in color theory. In fact, most artists work intuitively with color harmonies more complex than the schemes described above.

3.51 Meret Oppenheim. *Object (Breakfast in Fur)*. 1936.
Fur-covered cup, saucer, and spoon.
Saucer diameter 9⅜″.

✳ **Explore** the Discovering Art tutorial on
texture and pattern on myartslab.com

Texture

In the visual arts, **texture** refers to the tactile qualities of surfaces, or to the visual representation of those qualities. As children, we explored our surroundings by touching everything within reach, and we learned to equate the feel with the look of surfaces. As adults we know how most things feel, yet we still enjoy the pleasures that touching gives; we delight in running our hands over the fur of a pet or the smooth surface of polished wood.

All surfaces have textures that can be experienced by touching or through visual suggestion. Textures are categorized as either actual or simulated. Actual textures are those we can feel by touching, such as polished marble, wood, sand, or swirls of thick paint. Simulated (or implied) textures are those created to look like something other than paint on a flat surface. A painter can simulate textures that look like real fur or wood, but to the touch would feel like smooth paint. Artists can also invent actual or simulated textures. We can appreciate most textures even when we are not permitted to touch them, because we know, from experience, how they would feel.

Meret Oppenheim's fur-covered teacup, titled *Object* (**fig. 3.51**), is a rude tactile experience . She presented an intentionally contradictory object designed to evoke strong responses ranging from revulsion to amusement. The actual texture of fur is pleasant, as is the smooth texture of a teacup, but the idea of touching one's tongue to fur rather than porcelain is startling.

Sculptors and architects make use of the actual textures of their materials and the relationships between them. They can also create new textures in the finishing of surfaces. For example, Giacometti's *Man Pointing* (see fig. 3.14) uses eroded surfaces to heighten emotional impact.

Texture is also extremely important for an appreciation of pottery, which we may take in our hands. For example, handling the flask from Tang dynasty China (**fig. 3.52**) is likely to be even more interesting than looking at it. The potter achieved the complex texture of the surface by splashing a lighter glaze of a different chemical composition over the original dark glaze. Incomplete mixing of the two left a mottled surface. Elsewhere in the body of the piece, the clay has loops and ridges that disclose the origin of the shape to be the leather flasks carried by horsemen. These varied textures make our experience of this object multisensory.

A painter may develop a rich tactile surface as well as an implied or simulated texture. We can see actual texture on a two-dimensional surface in the detail of van Gogh's *The Starry Night* (**fig. 3.53**, and see

3.52 Flask. China. Tang dynasty. c.9th century.
Stoneware with suffused glaze. Height 11½".

The Metropolitan Museum of Art. Gift of Mr. and Mrs. John R. Menke.
1972 (1972.274). © 2013. Image copyright The Metropolitan
Museum of Art/Art Resource/Scala, Florence.

3.54 Jan van Eyck. *The Arnolfini Portrait* (detail). 1434.
Oil on oak. 32⅜" × 23⅝".

Acc. No.: NG186. Bought, 1842. © 2013. Copyright The National Gallery,
London/Scala, Florence.

3.53 Vincent van Gogh. *The Starry Night* (detail). 1889. Oil on canvas, 29" × 36¼".

Acquired through the Lillie P. Bliss Bequest. Acc. n.: 472.1941 Digital image, The Museum of Modern Art, New York/Scala, Florence.

fig. 21.30). With brush strokes of thick paint, called **impasto**, van Gogh invented textural rhythms that convey his intense feelings.

Four centuries earlier, painter Jan van Eyck used tiny brush strokes to show, in minute detail, the incredible richness of various materials. In *The Arnolfini Portrait* (see fig. 17.12), van Eyck simulated a wide range of textural qualities. In the section of the painting reproduced here close to actual size (**fig. 3.54**) we see the smooth textures of the mirror, amber beads, metal chandelier, a corner of a whisk broom, and the fur of the man's coat.

In this chapter we have explored how artists use some of the expressive qualities of line, shape, mass, space, time, motion, light, color, and texture in their works. As we have seen, not all of these visual elements are present in every artwork but each can be a valuable tool for conveying ideas, emotions, and atmosphere—creating art that can inform, inspire, and delight us.

✔•—[**Study** and review on myartslab.com

THINK BACK

1. What is a line?

2. What are two ways of showing perspective in a painting?

3. How can artists suggest volume with light?

4. Why are primary colors so called?

TRY THIS

Investigate the impact of color balance on an artwork. Download a mid-resolution picture of an artwork from the Web (try the Web Museum on http://www.ibiblio.org/wm/paint/, or some other site). Open the image using a simple photo program such as iPhoto or Photo Gallery, and transform it by adjusting the contrast, hue, or saturation. Assess the impact of such changes on the message of the work.

KEY TERMS

analogous colors – colors that are adjacent to each other on the color wheel, such as blue, blue-green, and green

atmospheric perspective – a type of perspective in which the illusion of depth is created by changing color, value, and detail

complementary colors – two hues directly opposite one another on a color wheel, such as red and green, that, when mixed together in proper proportions, produce a neutral gray

figure–ground reversal – a visual effect in which what was seen as a positive shape becomes a negative shape, and vice versa

geometric shape – any shape enclosed by square or straight or perfectly circular lines

hue – that property of a color identifying a specific, named wavelength of light such as green, red, violet, and so on

intensity – the relative purity or saturation of a hue (color), on a scale from bright (pure) to dull

linear perspective – a system of perspective in which parallel lines appear to converge as they recede into the distance, meeting at a vanishing point on the horizon

mass – the physical bulk of a solid body of material

organic shape – an irregular, non-geometric shape

picture plane – the two-dimensional picture surface

value – the relative lightness and darkness of surfaces

Part Two
THE MEDIA OF ART

Drawing

Painting

Printmaking

Photography

Moving Images: Film and Digital Arts

Design Disciplines

Sculpture

Craft Media: Flirting with Function

Architecture

4
THE PRINCIPLES OF DESIGN

THINK AHEAD

4.1 Describe the role of design in the production and analysis of works of art.

4.2 Analyze the use of design principles to organize a work of art.

4.3 Examine the ability of certain design principles to direct the viewer's attention to details in a work of art.

4.4 Identify methods used to create symmetrical, asymmetrical, and radial balance in a composition.

4.5 Distinguish scale and proportion in art.

4.6 Demonstrate how design principles work together to engage the viewer.

Organized perception is what art is all about.[1]

Roy Lichtenstein

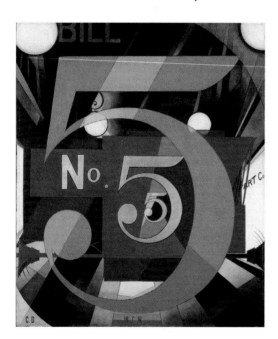

4.1 Charles Demuth. *I Saw the Figure 5 in Gold.* 1928. Oil on cardboard. 35½″ × 30″.

The Metropolitan Museum of Art, Alfred Stieglitz Collection, 1949 (49.59.1). © 2013 Image The Metropolitan Museum of Art/Art Resource/Scala, Florence.

((•─ **Listen** to the chapter audio on myartslab.com

Artists create works of art for many reasons; oftentimes it is to communicate a message or express a personal vision. The process of creation involves choosing not only which visual elements to use but also how they should be organized so that the final arrangement best conveys the artist's intention. In two-dimensional arts, such as painting and photography, this organization of the visual elements is usually called **composition**, but a broader term that applies to the entire range of visual arts is **design**. The word *design* indicates both the process of organizing visual elements and the product of that process.

In 1928, American artist Charles Demuth set out to make a portrait of his friend the poet William Carlos Williams. Demuth visualized a line from a poem that Williams wrote when he saw a fire engine racing through the streets on a rainy night: "I saw the figure 5 in gold." To Demuth, that vivid line of poetry seemed to symbolize the poet, and provided a compelling subject for an artwork.

In creating *I Saw the Figure 5 in Gold* (**fig. 4.1**), Demuth used the large numeral 5 to unify the composition. Though the work is not symmetrical, it seems balanced. The other inscriptions on the work, such as "Bill" at the top for William Carlos Williams, are

4.2 John McCracken. *Silver*. 2006. Polyester resin, fiberglass, and plywood. 93″ × 17″ × 3½″.
© The Estate of John McCracken. Courtesy David Zwirner, New York/London.

subordinated to the central figure 5. The diagonals in the work suggest slanting raindrops, establishing a strong directional force. The red color (presumably of the fire engine) contrasts with the gray background of the rainy city night. The numeral is repeated in a way that suggests the approach and passing of the truck. We see the numeral in various scales of size.

As he created *I Saw the Figure 5 in Gold,* Demuth thus used the seven key principles of design:

> unity and variety
> balance
> emphasis and subordination
> directional forces
> contrast
> repetition and rhythm
> scale and proportion

In this chapter we will explore these principles in more detail because they provide an understanding not only of how artists work, but also of how design affects us.

Unity and Variety

Unity and **variety** are complementary concerns. Unity is the appearance or condition of oneness. In design, unity describes the feeling that all the elements in a work belong together and make up a coherent and harmonious whole. When a work of art has unity, we feel that any change would diminish its quality.

Yet very few artworks are absolutely unified into one homogeneous thing; most such works were created as experiments. For example, the French artist Yves Klein made several paintings in the 1960s that were solid blue in color, with no variation. An example from sculpture is *Silver* (**fig. 4.2**) by John McCracken. The work is actually black, but under some lighting conditions it appears silver. Standing nearly 8 feet tall, it leans quietly and anonymously against the wall, as the artist specified. Few works have ever been as unified as this.

Variety, on the other hand, provides diversity. Variety acts to counter unity. The sameness of too much unity can be boring, and the diversity of uncontrolled variety may be chaotic; most artists strive for a balance between unity and variety that can yield interesting compositions.

In his painting *Going Home* (**fig. 4.3**), Jacob Lawrence balanced unity and variety. He established visual themes with the **lines**, **shapes**, and colors of the train seats, figures, and luggage, and then he repeated and varied those themes. Notice the varied repetition in the green chair seats and window shades. As a unifying element, the same red is used in a variety of shapes. The many figures and objects in the complex composition form a unified design through the artist's skillful use of abstraction, theme, and variation.

Lawrence was known for the lively harmony of his distinctive compositions. Although he worked in a manner that may seem unsophisticated, he was always resolving his designs through adjustments of unity and diversity. Lawrence studied other artists' work, and he was influenced by painters who were design problem-solvers. He said, "I like to study the design to see how the artist solves his problems and brings his subjects to the public."[2]

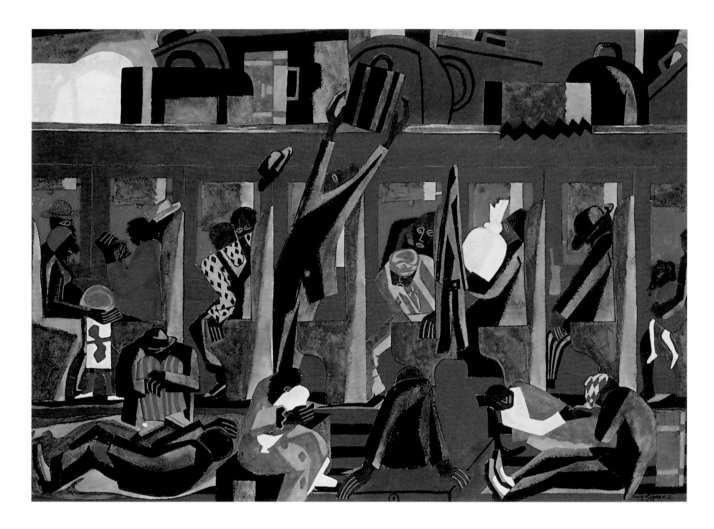

4.3 Jacob Lawrence. *Going Home.* 1946. Gouache. 21½" × 29½".

Private collection, courtesy of DC Moore Gallery, New York. © 2013 The Jacob and Gwendolyn Lawrence Foundation, Seattle / Artists Rights Society (ARS), New York.

The flat quality of *Going Home* contrasts with the illusion of depth in *Interior of a Dutch House* (**fig. 4.4**), painted by Pieter de Hooch three hundred years earlier. Each artist depicted daily life in a style relevant to his times. In both, the painter's depiction of space provides the unity in the composition. De Hooch used the unity of the room to unify pictorial space and provide a cohesive setting for the interaction of figures.

Pattern refers to a repetitive ordering of design elements. In de Hooch's painting, the patterns of floor tiles and windows play off against the larger rectangles of map, painting, fireplace, and ceiling. These rectangular shapes provide a unifying structure. The nearly square picture plane itself forms the largest rectangle. He then created a whole family of related rectangles, as indicated in the accompanying diagram. In addition, the shapes and colors in the figures around the table relate to the shapes and colors of the figures in the

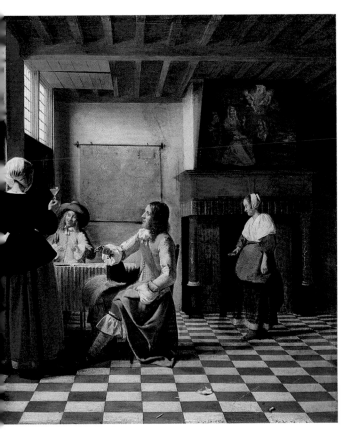

4.4 Pieter de Hooch.
Interior of a Dutch House. 1658.
Oil on canvas. 29″ × 35″.
The National Gallery, London/Scala, Florence.

painting above the fireplace—another use of theme and variation.

Just as few works strive for perfect unity, even fewer display complete disorder. Robert Rauschenberg sought to duplicate the randomness of modern life in his works, such as *Gift for Apollo* (**fig. 4.5**). In this piece, he began with a sawn-off door, turned it upside down, and casually applied paint strokes in various colors. He then attached a green necktie, some old postcards, a cloth pocket from a shirt, and part of a sign. He placed the whole assemblage on small, spoked wheels, and "finished" the work by chaining a bucket to it. Yet even this level of disorder still has some sense of harmony. As in *Interior of a Dutch House*, we see repeated rectangles; the chain extends at a right angle to the axles and seems to anchor the work. Glue and gravity still hold it all in place. The passage of time and the evolution of taste probably make this work seem less random now than when he first created it over 50 years ago.

4.5 Robert Rauschenberg. *Gift for Apollo.* 1959.
Combine: oil, pant fragments, necktie, wood, fabric, newspaper, printed reproductions on wood with metal bucket, metal chain, door knob, L brackets, metal washer, nail, and rubber wheels with metal spokes.
43¾″ × 29½″ × 41″.
The Museum of Contemporary Art, Los Angeles The Panza Collection 86.17
© Robert Rauschenberg Foundation/Licensed by VAGA, New York, NY.

Balance

Balance is the achievement of equilibrium, in which acting influences are held in check by opposing forces. We strive for balance in our lives, and may lack peace of mind in its absence. The dynamic process of seeking balance is equally basic in art, and here our instinct for physical balance finds its parallel in a desire for visual balance (although some artists seek lack of balance in their work for one expressive reason or another). Balance may be achieved through either **symmetry** or **asymmetry**.

Symmetrical Balance

Symmetrical balance is the near or exact matching of left and right sides of a three-dimensional form or a two-dimensional composition. Such works have symmetry.

Architects often employ symmetrical balance to give unity and formal grandeur to a building's façade or front side. For example, in 1792 James Hoban won a competition for his *Design for the President's House*, a drawing of a symmetrical, Georgian-style mansion. Today, two centuries and several additions later, we know it as the White House (**fig. 4.6**).

Symmetrical design is useful in architecture because it is easier to comprehend than asymmetry. Symmetry imposes a balanced unity, making large complex buildings comprehensible at a glance. Symmetry connotes permanence and poise. We generally want our symbolically important buildings to seem motionless and stable. All the qualities that make symmetry desirable

4.6 James Hoban. *Design for the President's House*. 1792.
Top: Elevation.
Courtesy of the Maryland Historical Society, Item ID # 1976.88.3.
Bottom: *The White House*, Washington, D.C.
Front view. 1997.
Antonio M. Rosario/Image Bank/Getty images.

4.7 Damien Hirst. *Posterity—The Holy Place*. 2006.
Butterflies and household gloss on canvas.
89⅝" × 48".
© Damien Hirst. Courtesy of Gagosian Gallery.
Photographed by Prudence Cuming Associates, Inc.
© 2013 Damien Hirst and Science Ltd.
All rights reserved/DACS, London/ARS, NY.

in architecture make it generally less desirable in sculpture and two-dimensional art. Too much symmetry can be boring. Although artists admire symmetry for its formal qualities, they rarely use it rigidly. Artists usually do not want their work to seem static.

Few works of art are perfectly symmetrical, but *Posterity—The Holy Place* (**fig. 4.7**) by Damien Hirst is one. The artist formed it entirely out of butterflies (purchased from a dealer who raises them), and it is symmetrical at every level: each butterfly, each unit of the composition, and the work as a whole. It resembles a stained-glass window, but is even more symmetrical than most of those. The stability of symmetry is a useful tool for religious art, which suggests the divine. But the sheer luminosity of *Posterity—The Holy Place* exceeds even that of a stained-glass window because butterfly wings do not depend on direct sunlight to show brilliance. Because the work is made up of so many small parts, the levels of symmetry help to structure the composition. We can prove this simply by imagining a work of similarly large size without a symmetrical arrangement.

Asymmetrical Balance

With **asymmetrical balance**, the left and right sides are not the same. Instead, various elements are balanced, according to their size and meaning, around a felt or implied center of gravity. For example, in *Noli Me Tangere* by Lavinia Fontana (**fig. 4.8**), the composition as a whole seems balanced, but only because dramatic imbalances are held in check. The painting illustrates a New Testament story in which Mary Magdalene went to the empty tomb of Jesus and saw the risen Christ, whom she at first took for the gardener. The story thus requires two people in the foreground, one of them prostrate.

This presents a difficult balancing problem, but Fontana solved it with a few ingenious steps. First, she gave the center of the composition strong weight, with Mary's large figure dressed in warm colors; above Mary is a glow in the sky. These anchor the composition. Christ occupies the right foreground, but he does not disrupt the equilibrium of the whole, because he is balanced by the higher and more massive tomb on the left. The small figure in red just outside the tomb also helps balance the strong figure of Christ.

4.8 Lavinia Fontana. *Noli Me Tangere*. 1581.
Oil on wood. 47⅜″ × 36⅝″.
Galleria degli Uffizi. Photograph: akg-images/Erich Lessing.

What exactly are the visual weights of colors and forms, and how does an artist go about balancing them? As with design itself, there are no rules, only principles. Here are a few about visual balance:

- A large form is heavier and more attention-getting than a small form. Thus, two or more small forms can balance one large form.
- A form gathers visual weight as it nears the edge of a picture. In this way, a small form near an edge can balance a larger form near the center.
- A complex form is heavier than a simple form. Thus, a small complex form can balance a large simple form.

The introduction of color complicates these principles. Here are four color principles that counteract the three principles of form just given:

- Warm colors are heavier than cool colors. A single small yellow form can therefore balance a large dark blue form.

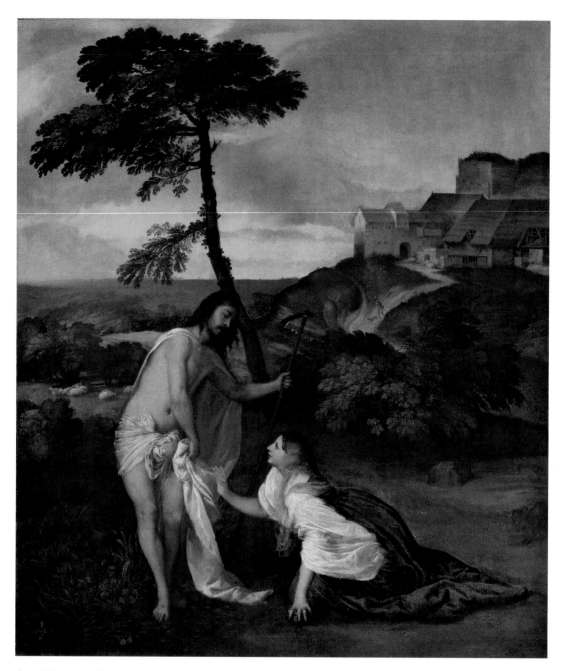

4.9 Titian. *Noli Me Tangere*. 1514. Oil on canvas. 43″ × 36″.
The National Gallery, London. Acc. No.: NG270. Bequeathed by Samuel Rogers, 1856. © 2013. Copyright The National Gallery, London/Scala, Florence.

- Related to the point above, warm colors tend to advance toward the viewer, while cool colors tend to recede. This means that when considering two similar forms of opposing temperature, the warmer will be visually heavier because it seems closer to the viewer.

- Intense colors are heavier than weak or pale colors (tints and shades). Hence, a single small bright-blue form near the center can balance a large pale-blue form near an edge.

- The intensity, and therefore the weight, of any color increases as the background color approaches its complementary hue. Thus, on a green background, a small simple red form can balance a large complex blue form.

Although guidelines such as these are interesting to study and can be valuable to an artist if she or he gets "stuck," they are really "laboratory" examples. The truth is that most artists rely on a highly developed

sensitivity to what "looks right" to arrive at a dynamic balance. Simply put, a work of art is balanced when it feels balanced.

If we look at a different version of *Noli me Tangere* (**fig. 4.9**), we can compare how two artists painting the same subject arrived at balance. In both cases, Mary Magdalene kneels before the newly risen Christ. Titian's version, which was painted about 67 years earlier, shows a more subtle approach, closer to symmetry than the Fontana work, with more delicate balances. Christ outweighs Mary because he is standing, and Titian put yet more weight on that half of the canvas by placing the tree above him. This tree also serves to mark Christ as the more important figure in the encounter. The central group forms an irregular triangle whose three points are Christ's head and foot, and the red tip of Mary's garment. These elements create a great deal of weight on the left half of the work, but Titian balanced it skillfully. Mary's head, left arm, and hand seem to continue the vertical line of the central tree, establishing

an axis in the lower portion of the work. On the right side, Titian created balance by giving Mary a red dress, a warm color that advances toward the viewer. The green bush also helps to balance Christ's fleshy body. Above, the artist placed a distant village whose high position and solid masses further counteract the weight of Christ and the tree. The jagged pathway to this village roughly balances the leaning tree with its protruding lower branch. As a final touch, Titian painted the remote landscape in blue, a cool color which recedes, reducing its influence. Titian here shows himself an adept composer of pictorial dynamics; viewers who take a long look at this work can enjoy the effortless quality of good asymmetrical balance.

An extreme case of dynamic balancing is *Jockeys Before the Race* by Edgar Degas (**fig. 4.10**). The artist boldly located the center of gravity on the right. To reinforce it, he drew it in as a pole. At first glance, all our attention is drawn to our extreme right, to the nearest and largest horse. But the solitary circle of the

4.10 Edgar Degas. *Jockeys Before the Race.* c.1878–1879. Oil essence, gouache, and pastel. 42½″ × 29″.
The Barber Institute of Fine Arts, University of Birmingham. Bridgeman Art Library.

4.11 Mark di Suvero. *Declaration*. 1999–2001. Steel, height 60´.
© Mark di Suvero. Courtesy L.A. Louver, Venice, CA.

sun in the upper left exerts a strong fascination. The red cap, the pale pink jacket of the distant jockey, the subtle warm/cool color intersection at the horizon, and the decreasing sizes of the horses all help to move our eyes over to the left portion of the picture, where a barely discernible but very important vertical line directs our attention upward.

In this work, a trail of visual cues moves our attention from right to left. If we are sensitive to them, we will perform the act of balancing the painting. If we are not, the painting will seem forever unbalanced. Degas, who was known for his adventurous compositions, relied on the fact that seeing is an active, creative process and not a passive one.

A good way to explore a picture's balance is to imagine it painted differently. Cover the jockey's red cap in the Degas, or mentally remove the small tree

below the sun, and you will see a spark of life go out of the painting.

Besides whatever visual balance the creator may seek, works of sculpture and architecture need structural balance or they will not stand up. Mark di Suvero's *Declaration* (**fig. 4.11**) was erected in 2001 on a spot near the beach in Venice, California. As a work of public art, *Declaration* required a building permit and official structural checks to ensure its safety in earthquakes and tsunamis. The artist used his engineering ability to balance the long V-shaped wings that seem to leap out from the three-legged base. The artist described the work as "a painting in three dimensions with the crane as my paintbrush." Originally intended for a four-month viewing period, the dynamic geometries of *Declaration* have remained on the site ever since.

Emphasis and Subordination

Artists use **emphasis** to draw our attention to an area. If that area is a specific spot or figure, it is called a **focal point**. Position, contrast, color intensity, and size can all be used to create emphasis.

Through **subordination**, an artist creates neutral areas of lesser interest that keep us from being distracted from the areas of emphasis. We have seen them at work in the two paintings we have just examined.

In *Noli me Tangere* (see fig. 4.9), Titian placed the figures near the center, the strongest location in any visual field. The bodies of both are lighter in color than their immediate surroundings. In *Jockeys Before the Race* (see fig. 4.10), Degas took a different approach, using size, shape, placement, and color to create areas of emphasis *away* from the center. The sun is a separate focal point created through contrast (it is lighter than the surrounding sky area and the only circle in the painting) and through placement (it is the only shape in that part of the painting). Sky and grass areas, however, are muted in color with almost no detail so that they are subordinate to, and thus support, the areas of emphasis.

Directional Forces

As with emphasis and subordination, artists use **directional forces** to influence the way we look at a work of art. Directional forces are "paths" for the eye to follow, provided by actual or implied lines. Implied directional lines may be suggested by a form's axis, by the imagined connection between similar or adjacent forms, or by the implied continuation of actual lines. Studying directional lines and forces often reveals a work of art's underlying energy and basic visual structure.

Looking at *Jockeys Before the Race*, we find that our attention is pulled to a series of focal points: the horse and jockey at the extreme right, the vertical pole, the red cap, the pink jacket, and the blue-green at the horizon. The dominant directional forces in this work are diagonal. The focal points mentioned above create an implied directional line. The face of the first jockey is included in this line.

The implied diagonal line created by the bodies of the three receding horses acts as a related directional force. As our eyes follow the recession, encouraged by the attraction of the focal points, we perform the act of balancing the composition by correcting our original attraction to the extreme right.

Just as our physical and visual feelings for balance correspond, so do our physical and visual feelings about directional lines and forces. The direction of lines produces sensations similar to standing still (|), being at rest (—), or being in motion (/). Therefore, a combination of vertical and horizontal lines provides stability. For example, the horizon line in Titian's *Noli me Tangere*, crossed by the tree, stabilizes that composition. The vertical pole and the horizon also provide stability in *Jockeys Before the Race*.

Francisco Goya's print *Bullfight* provides a fascinating example of effective design based on a dramatic use of directional forces (**fig. 4.12**). To emphasize the drama of man and bull, Goya isolated them in the foreground as large, dark shapes against a light background. He created suspense by crowding the spectators into the upper left corner.

Goya evoked a sense of motion by placing the bullfighter exactly on the diagonal axis that runs from lower left to upper right (**fig. 4.12a**). He reinforced

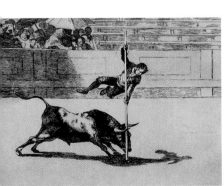

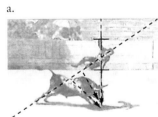
a.

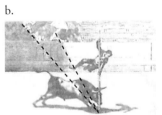
b.

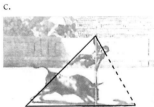
c.

4.12 Francisco Goya. *Bullfight: The Agility and Daring of Juanito Apinani.* Plate 20. c.1815. Etching with aquatint. 9½" × 14".
Ashmolean Museum, Oxford, England, UK.

the feeling by placing the bull's hind legs along the same line.

Goya further emphasized two main features of the drama by placing the man's hands at the intersection of the image's most important horizontal and vertical lines. He also directed powerful diagonals from the bull's head and front legs to the pole's balancing point on the ground (**fig. 4.12a**). The resulting sense of motion to the right is so powerful that everything in the rest of the etching is needed to balance it.

By placing the light source to the left, Goya extended the bull's shadow to the right, to create a relatively stable horizontal line. The man looks down at the shadow, creating a directional force that causes us also to look. When we do, we realize that the implied lines reveal the underlying structure to be a stable triangle (**fig. 4.12c**). Formally, the triangle serves as a

balancing force; psychologically, its missing side serves to heighten the tension of the situation.

The dynamism of the man's diagonal axis is so strong that the composition needed additional balancing elements; thus, Goya used light to create two more diagonals in the opposite direction (**fig. 4.12b**). The area of shadow in the background completes the balance by adding visual weight and stability to the left.

It has taken many words and several diagrams to describe the visual dynamics that make the design of Goya's etching so effective. However, our eyes take it in instantly. Good design is efficient; it communicates its power immediately.

Contrast

Contrast is the juxtaposition of strongly dissimilar elements. Dramatic effects can be produced when dark is set against light, large against small, bright colors against dull. Without contrast, visual experience would be monotonous.

We see contrast in the thick and thin areas of a single brush stroke. It can also be seen in the

4.13 Kim MacConnel. *Woman with Mirror, Canvas #13*. 2007. Latex acrylic on canvas. 48″ × 48″.
Image courtesy of Rosamund Felsen Gallery, Santa Monica.

juxtaposition of regular geometric and irregular organic shapes, or in hard (sharp) and soft (blurred) edges. Contrast can provide visual interest, emphasize a point, and express content.

The first thing we may notice about *Woman with Mirror, Canvas #13* (**fig. 4.13**) is striking contrasts: there are curving and straight lines, organic and geometric shapes, and colors that clash. Horizontal lines at each edge pull the eye inward and appear to confine the brightly painted shapes within. In the green shape, white reads as positive, while in the blue shapes it reads as negative. Yet despite these contrasts, the work has a degree of unity. The upright green and blue shapes loosely correspond to the woman and mirror of the title of the work. The composition overall is roughly symmetrical and the color scheme, while clashing, is still of uniformly high intensity across the picture plane.

Repetition and Rhythm

The repetition of visual elements gives a composition unity, continuity, flow, and emphasis. As we saw earlier, *Interior of a Dutch House* (see fig. 4.4) is organized around the repetition of rectangular shapes.

A more extreme version of repetition can be seen in the sculptures of Donald Judd. His untitled work (**fig. 4.14**) shown here consists of ten identical rectangles, attached in a stately vertical procession up the wall. Judd sought to create works lacking in all symbolic or expressive meaning; works that provide only a visual experience. As we look at this sculpture, we notice how our viewpoint causes the shapes to appear to shift as they climb upward. The plexiglass horizontal surfaces of each module seem solid at the lower levels, and transparent higher up. The repeated use of ten modules means there is no block at the midpoint for our eye to pick out, and the number is more difficult to keep track of than, say, four modules, thus enhancing our perception of the repeated forms.

Rhythm refers to any kind of movement or structure of dominant and subordinate elements in sequence. We generally associate rhythm with temporal arts such as music, dance, and poetry. In the visual arts, rhythm is created through the regular recurrence of elements with related variations, and artists use this principle as an organizational and expressive device.

4.14 Donald Judd. *Untitled.* 1990. Anodized aluminum, steel, and Plexiglass. Overall, 10 elements: 14′9″ × 40″ × 31″.
Photo © Tate, London 2013. Art © Judd Foundation. Licensed by VAGA, New York, NY.

4.15 Lyubov Popova. *The Pianist*. 1915.
Oil on canvas. 41¹⁵⁄₁₆″ × 34¹⁵⁄₁₆″.
National Gallery of Canada, Ottawa.

In Lyubov Popova's *The Pianist* (**fig. 4.15**), for example, the white shape at the center (the pianist's shirt front) is related visually to the pages of music, which form a strong rhythm leading the eye rightward and toward the keyboard. Likewise, the gray area of the pianist's face is repeated in organic shapes to the right and upward. (Both of these rhythmic sequences lead the eye in the same left-to-right direction that Westerners normally use in reading either music or books.) The angled shapes of the fingers suggest rhythmic motion across the keyboard just above. Indeed, the fragmentary shapes that dominate this painting suggest the rapidly ticking rhythm of the composition that the pianist seems to play.

Japanese artist Ogata Korin used both repetition and rhythm to charming effect in *Cranes* (**fig. 4.16**), one of a pair of folding screens. The landscape is a flat yet opulent background of gold leaf, interrupted only by a suggestion of a curving stream at the right. The birds are severely simplified, their bodies and legs forming a pattern that is repeated with variations. The heads and beaks of the cranes create a strong directional force toward our left, leading the eye to an ironically empty rectangle. The heads are held high, and their location near the top of the composition enhances this loftiness, making the birds seem just a

4.16 Ogata Korin. *Cranes.* c.1700. Ink, color, gold, and silver on paper. 65⅜″ × 146⅛″.
Freer Gallery of Art, Smithsonian Institution, Washington, DC: Purchase, F1956.20.

bit pretentious. Their rhythmic procession in marching steps in a seemingly straight line supports this note of humor.

Scale and Proportion

Scale is the size relation of one thing to another. **Proportion** is the size relationship of parts to a whole.

Scale is one of the first decisions an artist makes when planning a work of art. How big will it be? We experience scale in relation to our own size, and this experience constitutes an important part of our response to works of art.

We see many relationships in terms of scale. You have probably noticed that when a short person stands next to a tall person, the short one seems shorter and the tall one taller. Their relationship exaggerates the

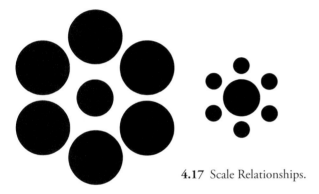

4.17 Scale Relationships.

relative difference in their heights. In the diagram Scale Relationships (**fig. 4.17**), the inner circles at the center in both groups are the same size, but the center circle at the right seems much larger.

Many artists since the twentieth century have distorted scale for visual effect. Claes Oldenburg and Coosje van Bruggen's *Shuttlecocks* (**fig. 4.18**) uses such distortion in a humorous way. The artists arrayed four huge metal shuttlecocks on the lawns outside the north and south façades of the Nelson-Atkins Museum of Art in Kansas City, Missouri. Each shuttlecock is an outlandish 18 feet high and weighs over 5,000 pounds. Because badminton is played on grass, it appears that the shuttlecocks fell during a game between giants who used the museum as a net. *Shuttlecocks* thus uses distortion of scale to poke gentle fun at the museum, mocking its rather prim look with a playfully irreverent attitude.

When the size of any work is modified for reproduction in a book, its character changes. Almost every work in this book is pictured at reduced size, with this exception: *Cruzeiro do Sul (Southern Cross)* by Cildo Meireles (**fig. 4.19**). This piece of two tiny, joined blocks of wood is less than a half-inch across. The artist made it to comment on the lack of importance that most people attribute to Southern

4.18 Claes Oldenburg and Coosje van Bruggen. *Shuttlecocks* (one of four). 1994. Aluminum, fiberglass-reinforced plastic, and paint. 215¾″ × 209″ × 191¾″.

The Nelson-Atkins Museum of Art, Kansas City, Missouri. Purchase: acquired through the generosity of the Sosland Family, F94-1/1. Photo: Jamison Miller © 1994 Claes Oldenburg and Coosje van Bruggen.

4.19 Cildo Meireles. *Cruzeiro do Sul (Southern Cross)*. 1969–70. Wooden cube, one section pine, one section oak. ⅜″ × ⅜″ × ⅜″.

© Cildo Meireles. Courtesy Galerie Lelong, New York.

4.20 Michelangelo Buonarroti. *Pietà*, 1498–1500. Marble. Height 5′8½″.
St. Peter's, Vatican, Rome. Canali Photobank.

View the Closer Look for Michelangelo's *Pietà* on myartslab.com

two-dimensional picture plane, such as a piece of paper, a canvas, a book page, or a video screen. For example, the format of this book is a vertical 8½ by 11–inch rectangle, the same format used for computer paper and most notebooks. Formats of movies have evolved over time; early films were created at a more or less 4:3 ratio of screen width to height, while today much wider formats such as 16:9, or even 2:1, are the norm. This matters because some television screens alter the format of older material played on them.

The format an artist chooses strongly influences the total composition of a particular work. Henri Matisse made this clear in his "Notes of a Painter":

Composition, the aim of which should be expression, is modified according to the surface to be covered. If I take a sheet of paper of a given size, my drawing will have a necessary relationship to its format. I would not repeat this drawing on another sheet of different proportions, for example, rectangular instead of square.[3]

Change in proportion can make a major difference in how we experience a given subject. This becomes apparent when we compare two *pietàs* (*pietà*, Italian for "pity," refers to a depiction of Mary holding and mourning over the body of Jesus).

Creating a composition with an infant on its mother's lap is much easier than showing a fully grown man in such a position. In his most famous *Pietà* (**fig. 4.20**), Michelangelo solved the problem by dramatically altering the human proportions of Mary's figure. Michelangelo made the heads of the two figures the same size but greatly enlarged Mary's body in relation to that of Christ, disguising her immensity with deep folds of drapery. Her seated figure spreads out to support the almost horizontal curve of Christ's limp body. Imagine how the figure of Mary would appear if she were standing. Michelangelo made Mary's body into that of a giant; if she were a living human being rather than a work of art, she would stand at least 8 feet tall!

Hemisphere countries, which produce many natural products such as lumber. This work is so small that exhibiting it is a challenge because most viewers miss it, just as many of them skip the news from South America. (Another work reproduced close to actual size is Tom Wudl's *Rembrandt's Indulgence*, fig. 7.12.) On the other hand, many large-sized works have been reduced in this book to a tiny fraction of their actual size, thereby altering their impact. Because works of art are distorted in a variety of ways when they are reproduced, it is important to experience original art whenever possible.

The term **format** refers to the size and shape—and thus to the scale and proportion—of a

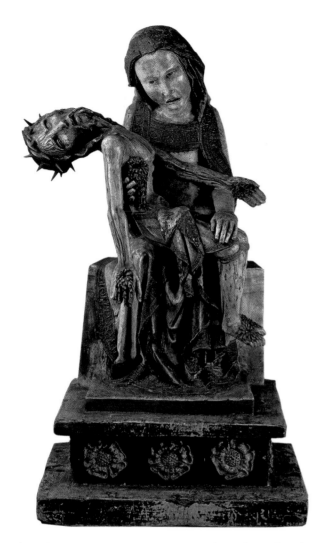

4.21 *Roettgen Pietà*. 1300–1325. Painted wood. Height 34½″. LVR-Landesmuseum Bonn.

Because the proportions of the figure of Christ are anatomically correct and there are abundant naturalistic details, we overlook the proportions of Mary's figure, yet the distortion is essential to the way we experience the content of the work.

Compare Michelangelo's work with the *Roettgen Pietà*, created about two centuries earlier (**fig. 4.21**). Unlike the Renaissance work, the German sculptor carved both figures of similar height. Making Christ bony and emaciated helped to alleviate the problem of how Mary can support a person of similar size; Christ's gaunt body also expresses the truth of his suffering in a way that Michelangelo avoided. The anonymous creator of the *Roettgen Pietà* also carved both heads larger, out of proportion to the sizes of their bodies. These distortions help to heighten the expressiveness of the work.

Design Summary

A finished work affects us because its design seems inevitable, but design is not inevitable at all. Faced with a blank piece of paper, an empty canvas, a lump of clay, or a block of marble, an artist begins a process involving many decisions, false starts, and changes, in order to arrive at an integrated whole. This chapter has presented some of the principles of design that guide the creation of artworks.

By photographing the progress of his painting *Large Reclining Nude*, Henri Matisse left us a rare record of the process of designing (**fig. 4.22**). He took 24 photographs over a period of four months; three of them are reproduced here.

The first version (State I) (**fig. 4.22a**) is by far the most naturalistic: The proportions of the model's body on the couch and the three-dimensional space of the room seem ordinary. This stage of the work shows the traditional rules of picture construction, but this is only the start of a fascinating journey.

By State IX (**fig. 4.22b**), Matisse had introduced a number of bold changes. Because the model's head and crooked right arm did not give the proper weight to that side of the composition, he greatly enlarged the arm. He added more curves to the torso, and he put the legs together to provide a balancing element on the left side. The space of the room now has a new look because he removed the diagonal; this change flattened the composition, highlighting its two-dimensional design. The model's left arm is now closer to a 90-degree angle, which makes it seem to support more weight; this is a stronger effect than that of the rubbery arm in the first photo. The boldest change regards the couch. Now it is far larger, with vertical white stripes in a rhythmic pattern. Because the stripes are parallel, they do not function as perspective lines; rather, the couch appears to be tipped toward us. Matisse kept the potted flowers and the chair, but he simplified the chair and placed the flowers on the couch.

By the time the artist took our third photograph (State XIII) (**fig. 4.22c**), he had introduced even more changes, to compensate for some of the bold effects he had introduced earlier. The model's head is larger and placed upright, so that it fits better into the shape of the raised arm. He simplified the curves of the torso and created a new position for the left arm, a compromise

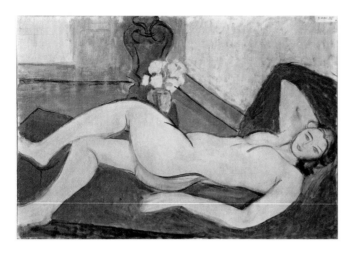

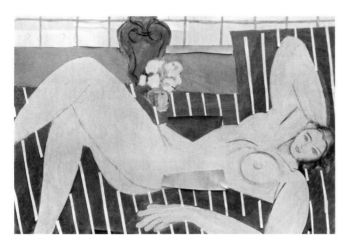

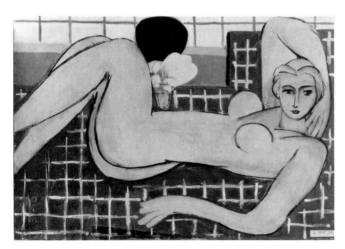

4.22 Henri Matisse. Photographs of three states of *Large Reclining Nude*. a. State I, May 3, 1935.
b. State IX, May 29, 1935.
c. State XIII, September 4, 1935.

◉ **Watch** a podcast about Henri Matisse's "Notes of a Painter" on myartslab.com

between its position in the first photo and the second one. The legs are now almost a unit, their bulky mass balancing the verticals and diagonals on the right. He added horizontal lines to the couch, making a pattern of squares that parallel the framing edges of the painting. This netlike motif is repeated in the larger squares on the back wall of the room. The composition is already interesting, but Matisse did not stop here.

The final version (**fig. 4.23**) shows further refinements and a few discoveries. Because the model's left arm probably still seemed weak, Matisse finally fixed it in the corner of the work at a strong angle aligned with the picture frame. The head is smaller, because the new position of the arms provides enough visual weight on that side of the work. He intensified the pattern on the back wall, so that it now serves as a variation of the motif on the couch. He gave new functions to the shapes and lines of the chair back and flowers by emphasizing their curves. They now echo the shapes of the body and balance the rigidity of the squares in the couch and wall. The position of the legs is the biggest change. By moving one of them down, he created a "pinwheel" effect that the arms carry through, adding a new circular element to the design of the whole. Finally, he repositioned the model's entire body at a slight angle from the horizontal.

Matisse's keen sense of design and restless experimentation produced a work in which powerful forces in the composition are balanced with seemingly simple means. He wrote that the expressiveness of a work does not rest merely on facial expressions or gestures of figures:

> The entire arrangement of my picture is expressive: the place occupied by the figures, the empty spaces around them, the proportions, everything has its share.[4]

As we have seen in the works illustrated in this chapter, artists organize visual elements in order to create meaningful and interesting form—a process known as design. While there are no absolute rules for good design, there are seven key principles. Studying these not only gives us a vocabulary for talking to one another about what we see, but increases our sensitivity to the expressive and relational possibilities of art.

4.23 Henri Matisse. *Large Reclining Nude.* 1935. Oil on canvas. 26⅛″ × 36¾″.
The Baltimore Museum of Art: The Cone Collection, formed by Dr. Claribel Cone and Miss Etta Cone of Baltimore, Maryland,
BMA 1950.258 Photography by: Mitro Hood © 2013 Succession H. Matisse/Artists Rights Society (ARS), New York.

✓——⸤**Study** and review on myartslab.com

THINK BACK

1. How can a small object in a painting balance a much larger one?

2. Why do artists establish directional forces in a work?

3. Why might an artist distort the scale of an object?

TRY THIS

Assess design in a work of abstract art. Examine *The City* by Fernand Léger at the Philadelphia Museum of Art Web site (http://www. philamuseum.org/collections/permanent/53928. html). Find examples of directional forces, repetition, and rhythm. Where are the focal points in the work?

KEY TERMS

asymmetrical balance – the various elements of a work are balanced but not symmetrical

directional forces – pathways that the artist embeds in a work for the viewer's eye to follow

focal point – the principal area of emphasis in a work of art; the place to which the artist directs the most attention through composition

format – the shape or proportions of a picture plane

pattern – repetitive ordering of design elements

scale – the size relation of one thing to another

symmetrical balance – the near or exact matching of left and right sides of a three-dimensional form or a two-dimensional composition

5

EVALUATING ART

THINK AHEAD

5.1 Discuss the subjective biases involved in evaluating a work of art.

5.2 Compare formal, contextual, and expressive approaches used in art criticism.

5.3 Examine the relationship of art's economic, cultural, and personal value to issues of quality and social context.

5.4 Combine factual, analytical, and evaluative information to write an essay about an artwork.

5.5 Explain censorship as a type of evaluation, based on political, moral, or religious values.

What makes a work of art worthwhile? Is it innovative? Does it move our feelings? Is it skillfully done? Which criteria are relevant to judging art? Who is qualified to make such judgments? As we consider answers to these questions, we will find that there are many ways of judging the quality of art. Further, we will see that our assessments of quality are usually connected to other values that we also hold about the function of art in society; hence our preferences about art generally embody other deeply held beliefs.

Evaluation

Have you ever heard someone say, "I don't know anything about art, but I know what I like"? We all express our own likes or dislikes many times a day. When we select one thing over another, or appreciate the specialness of something, we are evaluating.

The creative experience is also a process of selecting and evaluating. For the artist, the creative process involves selecting and evaluating each component before deciding if or how to include it in the final form. After the work is complete, the viewer's enjoyment comes from recognizing the quality that has

been achieved. How do viewers evaluate art to determine whether it has quality?

Quality is relative. How a work of art is evaluated varies from person to person, from culture to culture, and from age to age. In Mexico before the Spanish conquest, the Aztecs judged art to be good if it resembled the style of the Toltecs, an ancient neighboring people that the Aztecs admired (see Chapter 20). In traditional Chinese art criticism, mere skill in representation led to poor evaluations. A good artist could understand and communicate the inner spirit or "life breath" of a subject. To call an artwork "skillful" was to give it faint praise.

In the European tradition, few famous artists or styles have had unchanging reputations. For example, the Impressionist painters of the late nineteenth century were ridiculed by most critics, museum curators, and the public of the time. Their style differed too radically from that of their predecessors. Today, Impressionist paintings have an honored place in museums and are eagerly sought by the public. Conversely, many artists who were celebrated in their own time are forgotten today.

Value judgments about art necessarily involve subjectivity; it is not possible to measure artistic quality objectively. In this regard, let us compare *Shy Glance* by

((•─[**Listen** to the chapter audio on myartslab.com

5.1 Dawn Marie Jingagian. *Shy Glance.* 1976. Acrylic on canvas. 24″ × 18″.
The Museum of Bad Art, Dedham, MA.

5.2 Marie Louise Elisabeth Vigée-LeBrun. *Self-Portrait in a Straw Hat.* 1782. Oil on canvas. 38½″ × 27¾″.
The National Gallery, London NG1653. © 2013. Copyright The National Gallery, London/Scala, Florence.

Dawn Marie Jingagian (**fig. 5.1**), with *Self-Portrait in a Straw Hat* by Marie Louise Elisabeth Vigée-LeBrun (**fig. 5.2**). The former work was recovered from a trash bin; the latter was created by a leading painter of the late eighteenth century. The painter of *Shy Glance* lacks skill in many areas: color shading (the cheek is blotchy), anatomy (the eyebrow is too narrow and the forehead bulges), composition (it is difficult to tell positive from negative space), and brushwork (the hair and eyelashes!). The feeling it communicates is almost embarrassingly sweet. In contrast, *Self-Portrait* shows great assuredness in the use of paint to show anatomy. The light seems to fall naturally over the subject's face and shoulder. The eyes and face show a relaxed, confident gaze. The two artists are poles apart in level of traditional skill.

Yet today's viewers might find *Shy Glance* at least as interesting as the other work. *Self-Portrait,* for all

its skill, looks conventional, even ordinary. In contrast, *Shy Glance* has an obvious sincerity and enthusiasm that may be infectious. The painter of *Shy Glance* showed great boldness in even bringing forth this work, which shows no training. Hence the level of traditional skill that an artist shows may be relevant to a judgment of quality, but rarely gives the final answer.

When we look at a work of art and feel pleased or displeased, asking ourselves why we respond in that way is an excellent exercise. What we find in a work of art depends on what we are looking for. Do we like art to dazzle our senses? Show great skill? Move our feelings? Show a vision of a better world? Bare the artist's soul? These are personal value orientations that will lead us to make judgments about the works of art we encounter.

Each of us applies these assumptions about the function of art each time we look at a work. If we hope

5.3 Titian. *Pietà*. 1576. Oil on canvas. 149″ × 136″.
Accademia, Venice. © Cameraphoto Arte, Venice.

View the Closer Look for Titian's *Pietà* on myartslab.com

that art will divert us from our daily problems and routines, then we will favor certain kinds of creations. If we want art to build understanding between people, we will likely favor other sorts of works. Expressing our taste in art involves our personality and our values more than other kinds of judgments. The type of art that we prefer reveals far more about us than does our selection from a dinner menu, for example.

Whether you are approaching art for your own enjoyment or for a class assignment, it is most rewarding to begin with an open, receptive mind, and go beyond snap judgments. Give yourself time to get acquainted and to respond. Practice seeing rather than merely looking (see Chapter 1).

Art Criticism

The term **art criticism** refers to making discriminating judgments, both favorable and unfavorable. We all do art criticism, but professionals tend to follow one or more of three basic theories:

- **Formal theories**, which focus attention on the composition of the work and how it may have been influenced by earlier works
- **Contextual theories**, which consider art as a product of a culture and value system
- **Expressive theories**, which pay attention to the artist's expression of a personality or worldview

These theories emphasize the work, the culture, and the artist, respectively. Let us consider each in turn, as they might be used to analyze three paintings that are pictured in this chapter.

Formal Theories

Critics who use formal theories look carefully at how a work is made: how the parts of the composition come together to create a visual experience that may interest us, or not. They generally believe that the most important influence on a work is other works that the artist has seen or studied. Because the formal organization of the work is the most important factor in evaluating it, the theories are called *formal*. The subject or theme of the work is less important than how the artist presented it. Formalist critics value innovation in style above all; thus they always want to know when a work was done, so that they can compare it (at least mentally) with its predecessors and contemporaries. They value such stylistic novelty because they believe that art can be an important source of visual refreshment, unconnected to our complicated and strife-torn world.

From a formal perspective, Titian's *Pietà* (**fig. 5.3**) is very innovative in its brushwork. His immediate predecessors in Italian art were the Renaissance masters Raphael, Michelangelo Buonarroti, and Leonardo da Vinci, among others. Titian understood the painting methods that they used, but he went beyond them by making his brushwork more painterly, adding a new element of expressiveness to painting that would influence artists for generations to come. The work also uses an innovative composition: The center is an empty niche surrounded by a diagonal row of heads that is balanced by the two figures at the upper right. This emptiness at the center is a bold compositional device for that time.

Sonia Delaunay-Terk also innovated when she painted *Simultaneous Contrasts* (**fig. 5.4**) in 1913. The work was influenced by the early twentieth-century art movement **Cubism**, which represented

5.4 Sonia Delaunay-Terk. *Simultaneous Contrasts*. 1913. Oil on canvas. 18½" × 21½".
Museo Thyssen-Bornemisza, Madrid. 518 (1976.81). Photo Museo Thyssen-Bornemisza/Scala, Florence © Pracusa. 2013020.

5.5 Jean-Michel Basquiat. *Horn Players*. 1983. Acrylic and oil paintstick on three canvas panels. Overall 8′ × 6′5″.
The Broad Art Foundation, Santa Monica. Photograph: Douglas M. Parker Studio, Los Angeles. © The Estate of Jean-Michel Basquiat/ADAGP, Paris/ARS, New York 2013.

A more recent work, *Horn Players* (**fig. 5.5**) by Jean-Michel Basquiat, also presents interesting formal innnovations. First, he created it using techniques he learned from making graffiti, something few other artists were doing at the time. Second, the division into three vertical panels is interesting because the artist successfully avoided the pitfall of making the work seem like three separate paintings. He counteracted the division, and held the work together, by repeating certain motifs across the panels, such as heads, patches of white, and words in boxes. The work's roots in graffiti may make it look improvised at first glance; yet he brought discipline to the work, creating a knowing balance between order and disorder.

Contextual Theories

Critics who use these theories tend to look first at the environmental influences on a work of art: the economic system, the cultural values, and even the politics of the time; because the context matters a great deal, they are termed *contextual theories*. Just as formalist critics will want to know the date of a work, contextual critics are likely to ask, "What else was going on in the culture at that time?" Contextual critics tend to favor works that either cogently embody important cultural values, or memorably express resistance to them. Let us see how they might judge our three paintings.

Titian's *Pietà* is an altarpiece, destined for public viewing in a chapel at a church in Venice; altarpieces generally took up important Christian themes, and this one is no exception. However, Titian painted it during an epidemic of the plague, and its theme of mortality and grief takes on added meaning in that context. The vacant niche probably symbolizes death, and Titian's eloquent depiction of the dead Christ must have given comfort to the many Venetians who lost relatives in the epidemic. The work expresses grief over current events, but Titian has successfully taken it out of its time, so that even today we can still appreciate its mournful aspect.

subjects as flattened, geometric shapes (see Chapter 22). Delaunay-Terk did not, however, overlap the planes as earlier Cubists did; the elements of this work fit together like a jigsaw puzzle. Yet she used shading to shape each zone, as if the zones were curved surfaces. The work is innovative for how it suggests and denies a third dimension at the same time. This painting is also more innovative in its color than most early Cubist works, and explores how one bright color can have an impact on our perception of a neighboring one. The work is also a novel treatment of the landscape as a subject. In sum, the way that this work revises and expands on the Cubist style is its most interesting formal characteristic.

Simultaneous Contrasts by Sonia Delaunay-Terk is less interesting from a contextual perspective because its subject seems to be a simple sunlit landscape. The work tells us very little about its time (the early twentieth century). The work refers to an optical theory that many artists studied in those days, which dealt with the interaction of colors. The nineteenth-century scientist Michel-Eugène Chevreul researched the ways in which our perception of one color influences how we see a neighboring one. He called this visual effect the "Law of Simultaneous Contrasts," a phrase that the artist borrowed for the title of this work. Delaunay-Terk also did fabric designs, and she used her discoveries in painting to inspire ideas for her fashion work. This painting fueled her innovative clothing designs.

In contrast, *Horn Players* is filled with contextual information. Basquiat admired the leaders of the bebop movement in jazz which originated in the 1940s, and this work is a homage to them. Saxophonist Charlie Parker is at the upper left, red musical notes pouring out of his instrument. The ear that seems about to be cut off may refer to the late nineteenth-century painter Vincent van Gogh, an artist of similar innovative power who indeed cut off his ear. (Both Parker and van Gogh died young, "cut off" in their prime.) We can make out the name of trumpeter Dizzy Gillespie at the top center and see him pictured at the right. The word "ornithology" refers to one of Parker's musical compositions that the two of them recorded in a famous track. Together they must have created the "alchemy" (magically transformative mixture) that the artist scrawled at the lower right. In this work, Basquiat affirmed an important African-American musical movement.

Expressive Theories

All artworks are made by people. The skill level, personal intent, emotional state, mindset, and gender of the creator must play a role in the creative process. Artist-centered theories are thus termed *expressive theories*. If formalists want to know dates and contextualists want to know about the background culture, an expressive critic will want to know "Who made it? And who is she or he?" Critics who favor this approach tend to look for powerful personal meanings, deep psychological insight, or profound human concern.

These types of critical theories have been strongly influenced by psychoanalysis and by gender studies. Each of our three paintings is quite expressive, but in different ways.

Titian painted the *Pietà* in the last year of his life; hence its somber reflection on death expresses the artist's own mortality. Indeed, the figure at the lower right in the red shawl is Titian himself. Anyone who has ever mourned can probably identify with Mary's grieving attitude in this painting. The brushwork here is loose and expressive: Many critics believe that this represents an "old-age style" in which the artist cast off the restraint of his younger days, and painted with greater freedom.

Contemporaries attested to Sonia Delaunay-Terk's ebullient personality, and it comes across in *Simultaneous Contrasts*. No clouds darken its sunlit skies. Her bright and exuberant color palette comes from her memories of brightly colored folk costumes in her native Ukraine, especially wedding costumes that were festooned with ribbons. This work's vivid and expressive qualities are infectious.

Critics of an expressive bent tend to like Jean-Michel Basquiat because his works are full of personal meaning. Most interesting is his use of line: It is a personal style that seems both intent and intense, characteristics that the artist also displayed in life. That intensity contrasts nicely with the seemingly casual arrangement of the figures and script. The painting seems to have come together like a three-verse song. This work also explores the artist's personal history as an African American by upholding examples from the music world, and sharing with us some people who are important to him.

What Makes Art Great?

Artworks are bought and sold every day in our world, and every few months some work makes news because of its high price at auction. Though a handful of private sales have taken place at unverified higher amounts, at the time of writing, one of the versions of Edvard Munch's *The Scream* holds the record for a public auction price, $119.9 million (see fig. 21.35 for another, similar version). Generally speaking, however, the art market and art auctions can tell us only what a certain group of collectors

wants to pay for a given work at a given time. Such dollar values only loosely correlate with either the historical importance of an artwork, or its degree of innovation, and is not a likely indicator of whether a work of art is great.

So what is the answer to the question? The most obvious one is, "It's great if you think it is!" And everyone has their own personal list of great artworks. However, with our three theories in hand, we can now say how a work of art comes to be regarded as a "masterpiece," and command the place of honor in a museum (or appear in a book such as this). Some degree of innovation, important cultural meanings, and a recognizable personal statement are key ingredients. Not all three are necessary, but at least one must be strongly present.

Most works hanging in museums have been selected by the specialists on the staff because they embody at least one of the three theories. Your judgments may not agree with theirs, and that is fine.

But to go deeper is rewarding. The three theories of art criticism presented here give us three standards of quality, and three ways of judging artworks. Often we apply one or more of these without thinking, and we say something like, "I like art that I can relate to." Well, why do you relate to it? What are you looking for? A little self-examination should help you to uncover what values are motivating your choices, and can help open an interesting discussion about art with other viewers.

Evaluating Art with Words

Writing about art is an excellent way to understand it, because writing can channel our thoughts and clarify our beliefs. Writing about art also involves us more deeply in the process of creation. Here is a three-step method that can serve for almost any work.

1. Get the facts. These include the name of the creator, title, date, subject, medium, size, and location of the work. (Not all of these may be knowable for every work.) Describe the work using as many of the facts as you can find. If you are looking at a reproduction of a work, it is especially important to clarify its original medium and size.

2. Analyze. Look at the parts of the work and how they fit together. How does the choice of medium affect the work (see Chapters 6 to 14)? What formal elements did the creator use (see Chapter 3)? Assess the work in its context: Does it fit into a movement or time period? Does it lead the way to a new movement, or follow behind? Consider also its place in the artist's overall output. If the work was created years ago, how was it received at that time?

3. Evaluate. Use one of the three types of art criticism discussed above to assess the quality or historical importance of the work. Is it innovative? Does it move your feelings? Does it express a particular time period or artist's personality? Does it communicate a social vision or cause? Is it ravishingly beautiful, or challenging to the eyes? What function might the work fulfill, and how effectively does it accomplish this?

An essay on a work should include all three steps, seamlessly blended together. Steps 1 and 2 should be fairly objective; Step 3 should lead you to a debatable thesis or position on the work. The three steps are not equal in weight or difficulty. Step 1 should be the easiest. Step 2 requires study and background knowledge. Step 3, the most important, requires practice and careful seeing.

Censorship: The Ultimate Evaluation

Simply defined, censorship is the alteration or removal of works of art from public view. Censorship may be carried out for religious, moral, or political reasons, when civil authorities decide that the artist's freedom takes a back seat to other important values.

Censoring art is not a recent practice. In the Byzantine Empire, which dominated Eastern Europe from the fourth to the fifteenth century (see Chapter 16), a controversy took place from 726 to 843 over religious images. Called the Iconoclastic Controversy, it began when Emperor Leo III ordered the destruction of all images of Christ, Mary, the saints, and the angels. Leo and his party believed that such images encouraged idolatry, or worship of the image rather than the divine being. Many images were removed

from churches and destroyed during this time and any person found owning such an image was also punished.

In sixteenth-century Italy, the nude figures in Michelangelo's *The Last Judgment*, which he painted for Pope Julius II on the end wall of the Sistine Chapel (see Chapter 17), proved controversial. Later popes found the figures too revealing and ordered loincloths to be painted over their genitals; several of these survive to this day.

On political grounds, many dictatorial regimes, such as that in Nazi Germany, have censored art production. In 1937, the Nazis confiscated more than 16,000 pieces of modern art that did not conform to their party goals. Nazi theoreticians believed that most modern art, especially abstract art, was not sufficiently nationalistic. The artists who had made the confiscated pieces were banned from working, and many emigrated. Artists who glorified the German people in acceptable ways were widely exhibited.

Artists in the United States today usually enjoy wide latitude to create as they please. This right was best codified in a 1973 court case, Miller v. California, which held that a work may be censored only if it is demonstrably obscene; that is, if the "average person, applying contemporary community standards," finds it obscene, and if "the work taken as a whole lacks serious literary, artistic, political or scientific value." Thus our society, which places high value on individual achievement and personal self-expression, seems to tip the balance in favor of freedom for artists. However, when an exhibition benefits from public funds, or it gives rise to protests, or an official finds it inflammatory, attempts to censor often ensue.

Consider the following recent cases, which show that artistic creation is often contested territory in which wider struggles over values, culture, and politics resonate.

In the fall of 1999, New York City mayor Rudolph Giuliani tried to close the Brooklyn Museum because of the painting *Holy Virgin Mary* by Chris

5.6 Chris Ofili. *Holy Virgin Mary.* 1996.
Acrylic, oil, resin, paper collage, glitter, map pins, and elephant dung on linen. 8′ × 6′.
MONA, Museum of Old and New Art, Hobart, Tasmania, Australia.
Courtesy Victoria Miro Gallery, London © Chris Ofili.

Ofili (**fig. 5.6**). Giuliani found the work offensive to Roman Catholicism because of the way it portrayed Mary, and because the work had pieces of elephant dung attached to it. Because the museum operates in a city-owned building, the mayor went to court to try to evict it and cut off its maintenance funds if the directors did not remove the work from view. The artist and the museum claimed that elephant dung is an art medium in certain African cultures, and that Ofili has the right to interpret the Christian religion, in which he was also raised, as he chooses. The court sided with the artist and the museum. Far from suppressing Ofili's work, the mayor's lawsuit brought record-breaking crowds.

5.7 Judy Taylor. *History of Labor in Maine.* 2007. Oil on particle board, eleven joined panels. 8′ × 36′.
Courtesy of Judy Taylor Studio.

In 2010, YouTube was party to a controversy over the videos of artist Amy Greenfield. She posted three works to her YouTube channel, but the site's authorities removed them because they contained nudity. YouTube also threatened to revoke her uploading privileges. Various interested groups lodged protests, claiming that the works were far from pornographic, and citing her wide reputation as a video artist. The videos were reinstated a few days later.

Nudity was also an issue when the New York Academy of Art posted some drawings of nude models to its Facebook page in September 2011. The Facebook authorities removed them and advised the school of its policy prohibiting nudity. The Academy protested on its blog, "As an institution of higher learning with a long tradition of upholding the art world's traditional values and skills, we find it difficult to allow Facebook to be the final arbiter—and online curator—of the artwork we share with the world." Facebook apologized and adjusted its policy to prohibit only nude photos of actual people, but allowing artistic depictions of them.

An example of political censorship occurred in late 2011 when the governor of Maine removed a mural from the headquarters of the state's Labor Department, claiming that it showed bias toward organized labor, and implied a bias against business. The 36-foot mural was installed in 2007, and depicted the history of workers in the state (**fig. 5.7**). In defending the removal, the governor's press secretary said, "The Department of Labor is a state agency that works very closely with both employees and employers, and we need to have a décor that represents neutrality." The artist responded, "I don't agree that it's one-sided. It's based on historical fact. I'm not sure how you can say history is one-sided." After the artist and some union activists sued to have the work put back on view, a district judge ruled that because the government paid for the mural, it could dispose of it. State workers removed the work to an undisclosed location.

As we have seen in this chapter, although we can describe, analyze, interpret, and appraise art, there is no single correct way to evaluate it. All of the three approaches discussed have enjoyed favor at one time or another. But the process of evaluation is rewarding from any viewpoint because it draws the viewer into the creative process.

✔●─[**Study** and review on myartslab.com

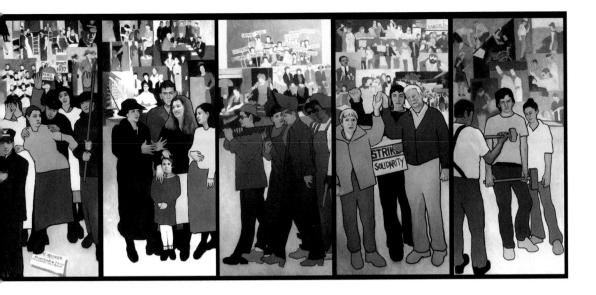

THINK BACK

1. What are the three principal theories of art criticism?

2. How do specialists decide what art is great?

3. What court case clearly established artists' freedom of expression?

TRY THIS

Visit an art museum and choose one or two works that you particularly like and think examples of good art. Assess your reasons for the choices according to the theories of art criticism.

Repeat the activity with a few friends, this time comparing your choices, discussing the reasons behind your choices, and the merits of the different works.

KEY TERMS

art criticism – the process of using formal analysis, description, and interpretation to evaluate or explain the quality and meanings of art

contextual theory – a method of art criticism that focuses on the cultural systems behind works of art; these may be economic, racial, political, or social

expressive theory – a method of art criticism that attempts to discern personal elements in works of art, as opposed to formal strategies or cultural influences

formal theory – a method of art criticism that values stylistic innovation over personal expression or cultural communication

6 DRAWING

THINK AHEAD

6.1 Characterize drawing as an immediate means of communicating with visual images.

6.2 Distinguish the use of drawings to record ideas, as preliminary studies, and as independent works of art.

6.3 Discuss drawing tools and techniques used with dry and liquid media.

6.4 Compare effects achieved through different drawing techniques.

6.5 Recognize the role of drawing in comics and graphic novels.

6.6 Examine contemporary drawing techniques and technologies.

6.1 Henry Moore. Study for *Tube Shelter Perspective.* 1940–1941. Pencil, wax crayon, colored crayon, watercolor, wash, pen and ink, Conté crayon on wove paper. 8″ × 6½″.

Reproduced by permission of The Henry Moore Foundation. © The Henry Moore Foundation. All Rights Reserved, DACS 2013/www.henry-moore.org.

((•— **Listen** to the chapter audio on myartslab.com

Drawing is an immediate and accessible way to communicate through imagery. When the British government appointed Henry Moore an Official War Artist in 1940, he made dozens of drawings of Londoners sheltering from the Nazi bombing raids (**fig. 6.1**). His official status gave him a pass to the basements and subway tunnels where thousands sought refuge. Moore made his drawings later from notes taken on the spot. This drawing shows a mostly illegible inscription that begins "Rows . . ." along with the words "tunnel shelterers," above a receding subway tunnel crowded with tensely reclining figures. He suppressed details of each person's appearance, which helped to transform a scene of immense fear into one of stoic endurance. Because most cameras do not function in such dimly lit spaces, Moore's *Shelter Drawings* are among the few records we have of these episodes.

Through his drawings Moore not only provided a valuable record of events but shared with us his feelings and experiences of war. Drawing can also be used to communicate ideas and to convey an artist's imaginings. In this chapter we will explore the various purposes of drawing and the tools and techniques artists use to create works from studies to finished drawings, comics and graphic novels to more contemporary pieces involving the use of diverse media.

6.2 Leonardo da Vinci.
Facial Proportions of a Man in Profile. 1490–1495.
Brown ink, charcoal, and red chalk. 11″ × 8¾″.
Academia Venice. © 2013. Photo Scala, Florence—courtesy of the
Ministero Beni e Att. Culturali.

✳ **Explore** the Discovering Art tutorial
on drawing on myartslab.com

The Drawing Process

The desire to draw is as natural as the desire to talk.
As children, we draw long before we learn to read and
write. In fact, making letter forms is a kind of draw-
ing—especially when we first learn to "write." Some
of us continue to enjoy drawing; others return to
drawing as adults. Those who no longer draw prob-
ably came to believe they did not draw well enough
to suit themselves or others. Yet drawing is a learned
process. It is a way of seeing and communicating, a
way of paying attention.

In the most basic sense, to draw means to pull,
push, or drag a marking tool across a surface to leave
a line or mark. Most people working in the visual
arts use drawing as an important tool
for visual thinking—for recording and
developing ideas.

Many people find it valuable to keep
a sketchbook handy to serve as a visual
diary, a place to develop and maintain
drawing skills and to note whatever
catches the eye or imagination. From
sketchbook drawings, some ideas may
develop and reach maturity as finished
drawings or complete works in other
media. Leonardo da Vinci, for exam-
ple, was a restless draftsman who used
sketches as a type of scientific research.
His drawing *Facial Proportions of a Man
in Profile* (**fig. 6.2**) shows him measuring
the various ratios in a human face, as he
also sketches figures on horseback.

Guillermo del Toro, director and
producer of *Don't Be Afraid of the Dark*, *Pacific Rim*,
and other films, keeps a sketchbook for jotting notes
and ideas. The pages here (**fig. 6.3**) show his musings
about the desire for fame, meeting other directors, and
sketches of some strange beings that found their way

6.3 Guillermo del Toro. Pages from
sketchbook. 2006. *Pan's Labyrinth.*
© MMVI. New Line Productions Inc. Photo appears courtesy
of New Line Cinema/ Time Warner.

◉ **View** the Closer Look for Guillermo del Toro's
sketchbook on myartslab.com

6.4 Martín Ramírez. *Untitled No. 111 (Train and Tunnel)*. c.1960–1963. Gouache, colored pencil, and graphite on pieced paper. 15″ × 31″.
© Estate of Martín Ramírez.

into his 2006 feature *Pan's Labyrinth*. (See Chapter 10 for a discussion of this film.)

A great deal of drawing is receptive; that is, we use it to attempt to capture the physical appearance of something before us. Many people use drawing in this way, as they take up a pencil or pen or chalk to render the fall of light on a jar, the leaves of a tree, the arrangement of a landscape, the roundness of a body, or their own reflection in a mirror. This was Moore's goal in *Tube Shelter Perspective* (see fig. 6.1). Such drawings can be a professional necessity for an artist, or recreation for the rest of us.

Other drawings, in contrast, are projective: We may draw something that exists only in our minds, either as a memory of something we have seen or a vision of something we imagine. Some of the most compelling projective drawings were created by the Mexican-American artist Martín Ramírez, who lived most of his life in a mental hospital. His imaginary scenes resound with fantasy and vision. In this drawing (**fig. 6.4**), a train passes through an impossible tunnel. Artists whose work is based on imagination often use this sort of drawing, as do architects when they plan new structures. Leonardo da Vinci's drawings are more often projective than receptive; Del Toro's sketchbook likewise combines projective

and receptive approaches. The general tendency among today's artists in Europe and the United States seems to be toward projective types of drawing. These artists are also expanding the definition of the medium, as we shall see at the end of this chapter.

Many artists regard drawing as deeply important to their creative process. Sculptor Richard Serra, for example, said, "It's a place where I can get lost, and a place where I can throw out work, and a place where I don't have to worry about what it is I'm up to."[1] Keith Haring, in contrast, valued the immediacy: "Drawing is still the same as it has been since prehistoric times. It brings together man and the world. It lives through magic."[2]

Some artists, such as Pablo Picasso, demonstrated exceptional drawing ability as young children. Others, such as Paul Cézanne and Vincent van Gogh, did not start out with obvious drawing ability; they developed skills through diligent effort. In spite of early difficulties, they succeeded in teaching themselves to draw. Their examples show that seeing and drawing are learned processes, not just inborn gifts.

Van Gogh learned a great deal about both seeing and painting through his practice of drawing. He was just beginning his short career as an artist when he made

the drawing *Carpenter* (**fig. 6.5**). Although stiff, and clumsy in proportion, the drawing reveals van Gogh's careful observation and attention to detail. His letters to his brother Theo show how he struggled to render the world with pencil and crayon. In one of these notes, he recalled the difficulty and a breakthrough:

> I remember quite well, now that you write about it, that at the time when you spoke of my becoming a painter, I thought it very impractical and would not hear of it. What made me stop doubting was reading a clear book on perspective . . . and a week later I drew the interior of a kitchen with stove, chair, table, and window—in their places and on their legs—whereas before it had seemed to me that getting depth and the right

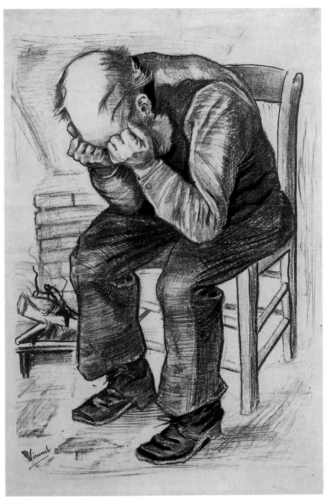

6.6 Vincent van Gogh. *Old Man with His Head in His Hands.* 1882. Pencil on paper. 19¹¹⁄₁₆″ × 12³⁄₁₆″. Van Gogh Museum, Amsterdam (Vincent van Gogh Foundation).

perspective into a drawing was witchcraft or pure chance. If only you drew one thing right, you would feel an irresistible longing to draw a thousand other things.[3]

Old Man with His Head in His Hands (**fig. 6.6**), made two years after *Carpenter,* shows that van Gogh made great progress in seeing and drawing during those two years. By this time, van Gogh was able to portray the old man's grief, as well as the solidity of the figure, and to give a suggestion of his surroundings. The groups of parallel lines appear to have been drawn quickly, with sensitivity and self-assurance.

Good drawing may appear deceptively simple, yet it can take years of patient work to learn to draw

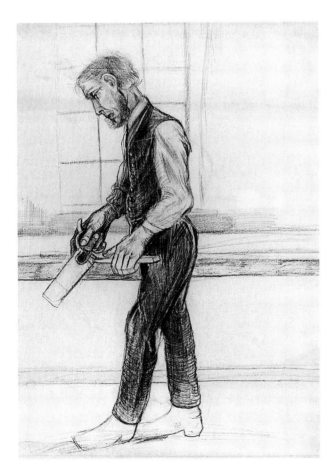

6.5 Vincent van Gogh. *Carpenter.* c.1880. Black crayon. 22″ × 15″. Kröller-Müller Museum, Otterlo, Netherlands.

FORMING ART

Vincent van Gogh (1853–90): Mastering Drawing

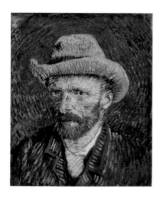

6.7 Vincent van Gogh. *Self-Portrait with Felt Hat.* 1888. Oil on canvas. 17¼" × 14¾". Van Gogh Museum, Amsterdam (Vincent van Gogh Foundation).

Vincent van Gogh took up art, not because he possessed any obvious talent, but because he saw art as a means of communication with others. Although determined to be a painter, he believed that he had to master drawing before he allowed himself to use color. His letters to his brother Theo show both the effort that he expended, and a certain rebellious attitude that he had toward the drawing methods of his day.

After attempting the careers of art dealer and lay preacher, van Gogh enrolled in a private drawing school where traditional techniques were taught. These included drawing from plaster casts of human body parts, which most art schools then used as teaching tools. Van Gogh disliked this routine:

> I utterly detest drawing from plaster casts—yet I had a couple of hands and feet hanging in the studio, though not for drawing. Once he [the teacher] spoke to me about drawing from plaster casts in a tone that even the worst teacher at the academy wouldn't have used, and I held my peace, but at home I got so angry about it that I threw the poor plaster moldings into the coal-scuttle, broken. And I thought: I'll draw from plaster casts when you lot become whole and white again and there are no longer any hands and feet of living people to draw.[4]

Once van Gogh started drawing from life, he found it so interesting that he kept it up for hours at a time:

> In these new drawings I'm starting the figures with the torso, and it seems to me that they're fuller and broader as a result. If 50 aren't enough, I'll draw 100 of them, and if that's still not enough, even more, until I've got what I want solidly, that's to say that everything is round, and there is, as it were, neither beginning nor end anywhere on the form, but it constitutes a single, harmonious, living whole.[5]

Yet his goal was not a slavish, photographic accuracy. He hoped to capture moods and energies in the moments that he sketched: "What I'm trying to get with it is to be able to draw not a hand but the gesture, not a mathematically correct head but the overall expression. . . Life, in short."[6]

In 1888, he moved to southern France, where in little more than two years he produced most of the paintings for which he is now known. Parallel with his paintings, he also drew continuously. His drawing *Trees with Ivy in the Asylum Garden* (**fig. 6.8**) is based on a painting that he completed in 1890. He described the subject of this drawing to his brother: "Thick tree trunks covered with ivy, the ground also covered with ivy and periwinkle; a stone bench and a bush with roses that have paled in the cool shadow. In the foreground a couple of plants with white calyces. It is green, violet and pink."[7] The drawing's distinctly busy welter of pen strokes and its crowded composition express some of the urgency that he felt when depicting the scene.

Van Gogh admired more simple styles of drawing, and the ability to capture a subject quickly (see fig. 6.21): "I envy the Japanese the extreme clarity that everything in their work has," he wrote in late 1888. "It's never dull, and never appears to be done too hastily. Their work is as simple as breathing, and they do a figure with a few confident strokes with the same ease as if it was as simple as buttoning your waistcoat. Ah, I must manage to do a figure with a few strokes."[8]

Although van Gogh struggled with drawing, he always believed in its importance for an artist. In 1888 he wrote to Theo: "What's always urgent is to draw, and whether it is done directly with a brush, or with something else such as a pen, you never do enough."[9] While most of his contemporaries could not see the value of his art, van Gogh's drawings and paintings are displayed today in major museums worldwide.

6.8 Vincent van Gogh. *Trees with Ivy in the Asylum Garden.* 1890. Reed pen and pen in ink on cream wove paper. 24½" × 18½". Van Gogh Museum, Amsterdam (Vincent van Gogh Foundation).

6.9 Michelangelo Buonarotti. *Study of a Reclining Male Nude.* c.1511. Red chalk over stylus underdrawing. 7⅝″ × 10¼″.
The British Museum © The Trustees of the British Museum.

easily and effectively. According to one account, a person viewing a drawing by Constantin Brancusi with only a few quick lines asked the artist with some disgust, "How long did it take you to do this?" Brancusi replied, "Forty years."[10]

Purposes of Drawing

A drawing can function in three ways:

- as a notation, sketch, or record of something seen, remembered, or imagined
- as a study or preparation for another, usually larger and more complex work
- as an end in itself, a complete work of art

We see examples of the first case in Henry Moore's *Shelter Scene* that began this chapter, and in the Vincent van Gogh drawings just examined. The second case, drawing as preparatory tool, is traditional in Western art. For example, Michelangelo made detailed studies of a *Reclining Male Nude* (**fig. 6.9**) for his finished painting of the figure on the ceiling of the Sistine Chapel (see fig. 17.10b).

Michelangelo's studies are a record of search and discovery as he carefully drew what he observed. His knowledge of anatomy helped him to define each muscle. The flow between the head, shoulders, and arms of the figure is based on Michelangelo's feeling for visual continuity as well as his attention to detail. The parts of the figure that he felt needed further study he drew repeatedly, as we see in the hands. To achieve the dark reds, Michelangelo evidently licked the point of the chalk.

A simple, tiny sketch, quickly done, is often the starting point for a far larger and more complex work. In such drawings an artist can work out problems of

6.10 Pablo Picasso. First Composition Study for *Guernica*. May 1, 1937. Pencil on blue paper. 8¼″ × 10⅝″.
Museo Nacional Centro de Arte Reina Sofia, Madrid, Spain. © 2013 Estate of Pablo Picasso/Artists Rights Society (ARS), New York.

View the Closer Look for Picasso's *Guernica* on myartslab.com

overall design or concentrate on small details. For example, Picasso did many studies in preparation for his major painting *Guernica* (**figs. 6.10–12**), a huge work measuring more than 11 by 25 feet (see fig. 23.16 for a larger picture). Forty-five of Picasso's studies are preserved and dated; they show the evolution of this important work.

The first drawing for *Guernica* shows a dark form at the top center; this later became a woman with a lamp, apparently an important symbol to Picasso. The woman leans out of a house in the upper right. On the left appears a bull with a bird on its back. Both the bull and the woman with the lamp are major elements in the final painting. The first drawing was probably completed in a few seconds, yet its quick gestural lines contain the essence of the large, complex painting.

Although artists do not generally consider their preliminary sketches as finished pieces, studies by leading artists are often treasured both for their intrinsic beauty and for what they reveal about the creative process. Picasso recognized the importance of documenting this process from initial idea to finished painting:

> It would be very interesting to preserve photographically, not the stages, but the metamorphoses of a picture. Possibly one might then discover the path followed by the brain in materializing a dream. But there is one very odd thing to notice, that basically a picture doesn't change, that the first "vision" remains almost intact, in spite of appearances.[11]

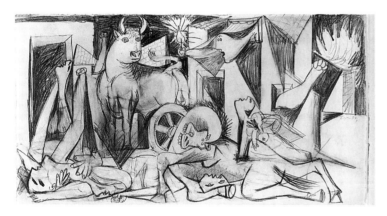

6.11 Pablo Picasso. Composition study for *Guernica*. May 9, 1937. Pencil on white paper. 9½″ × 17⅞″.
Museo Nacional Centro de Arte Reina Sofia, Madrid, Spain. © 2013 Estate of Pablo Picasso/Artists Rights Society (ARS), New York.

Another type of preparatory drawing is the **cartoon**. The original meaning of cartoon, still used by art professionals, is a full-sized drawing made as a guide for a large work in another medium, particularly a **fresco** painting, **mosaic**, or tapestry. In making the final work, artists often use such cartoons as overlays for tracing.

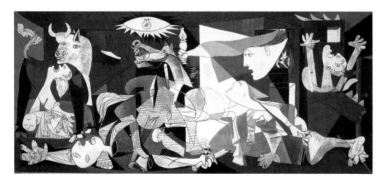

6.12 Pablo Picasso. *Guernica*. 1937. Oil on canvas. 11′6″ × 25′8″.
Museo Nacional Centro de Arte Reina Sofia, Madrid, Spain. Art Resource/Scala, Florence/John Bigelow Taylor. © 2013 Estate of Pablo Picasso/Artists Rights Society (ARS), New York.

6.13 Drawing Tools and their Characteristic Lines.

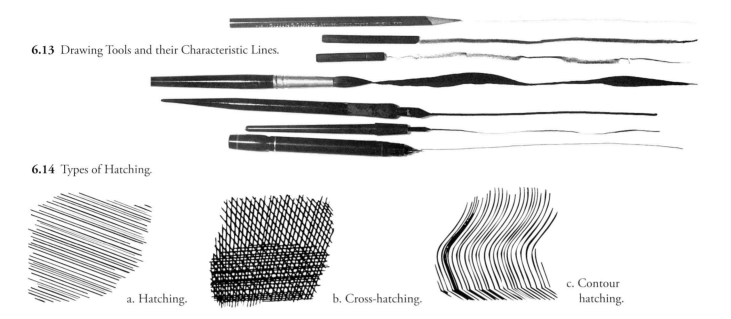

6.14 Types of Hatching.

a. Hatching.

b. Cross-hatching.

c. Contour hatching.

In today's common usage, the word *cartoon* refers to a narrative drawing emphasizing humorous or satirical content. Cartoons and comics are among the most widely enjoyed drawings, and will be discussed later in this chapter.

Many artists today view drawing as a medium in itself, and drawings as finished works of art. Among these are several in this chapter, such as the works by Charles White, Nancy Spero, and Julie Mehretu.

Tools and Techniques

Each drawing tool and each type of paper has its own characteristics. The interaction between these materials and the technique of the artist determines the nature of the resulting drawing. The illustration Drawing Tools (**fig. 6.13**) shows the different qualities of marks made by common drawing tools. Some of these tools give a dry, refined line; others are wet and more expressive. Note also how each tool responds to varying degrees of pressure; the ink brush in the middle is most responsive, the pen at the bottom, the least.

Artists often use rows of parallel lines to suggest shadows or volumes. These parallel lines are called **hatching**; each method is illustrated in the accompanying diagram, Types of Hatching (**fig. 6.14**). Charles White used **cross-hatched** ink lines in *Preacher* to build up the figure's mass and gesture in a forceful manner (**fig. 6.15**). Through the use of **contour hatching**, White gave the figure a feeling

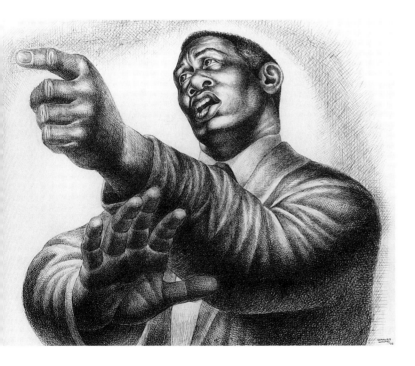

6.15 Charles White. *Preacher.* 1952.
Pen and black ink, and graphite pencil on board. 22¹³⁄₁₆″ × 29¹⁵⁄₁₆″ × ³⁄₁₆″.

of sculptural mass. The foreshortened right hand and forearm add to the drawing's dramatic impact. Printmakers often use hatching to suggest mass and shadow (see Chapter 8).

The quality and type of paper that an artist uses also have an important impact on the drawing. Most drawing surfaces are smooth, but some papers have **tooth**, a quality of roughness or surface grain that gives texture to a drawing. The drawing by Georges Seurat, *L'Écho* (see fig. 6.18), was done on toothy paper and it shows its texture as a result.

Dry Media

Dry drawing media include pencil, **charcoal**, **Conté crayon**, and **pastel**. Most drawing pencils are made of graphite (a crystalline form of carbon). They are available in varying degrees of hardness; softer pencils give darker lines, and harder pencils give lighter ones.

Darkness and line quality are determined both by the degree of hardness of the pencil and by the texture of the drawing surface. Pencil lines can vary in width or length, can be made by using the side of the pencil point in broad strokes, and can be repeated as hatching. Artists create a considerable range of values by varying the pressure on a medium-soft drawing pencil.

Umberto Boccioni used a variety of tools and techniques to create his drawing *States of Mind: The Farewells* (**fig. 6.16**). We see sharp lines, strokes made with the side of the charcoal, parallel hatched lines, and shaded areas.

The sticks of charcoal used today are similar to those used by prehistoric people to draw on cave walls: both are simply charred sticks of wood. With charcoal, dark passages can be drawn quickly. The various hard-to-soft grades of charcoal provide a versatile medium for both beginning and advanced artists. Because not all charcoal particles bind to the surface of the paper, charcoal is easy to smudge, blur, or erase. This quality is both an advantage and a drawback: it enables quick changes, but finished works can easily smear. A completed charcoal drawing may be set or "fixed" with a thin varnish called a **fixative**, which is sprayed over it to help seal the charcoal onto the paper and prevent smudging. Charcoal produces a wide range of light to

6.16 Umberto Boccioni. *States of Mind: The Farewells*. 1911. Charcoal and Conté crayon on paper. 23″ × 34″.

Museum of Modern Art (MoMA) Gift of Vico Baer. Acc. n.: 522.1941 © 2013. Digital image The Museum of Modern Art, New York/Scala, Florence.

6.17 Vija Celmins.
Web #5. 1999.
Charcoal on paper.
22″ × 25½″.
Private Collection, NY.
Courtesy McKee Gallery, NY.

dark values from soft grays to deep velvety blacks.

We see many shades of gray in the remarkable drawing *Web #5* by Vija Celmins (**fig. 6.17**). The web emerges from darkness at the upper left, as the artist carefully shaded each concentric circle. She made only black marks, letting the paper show through for the white portions. She even captured the web's flaws and incomplete parts.

Conté crayon is made from graphite that is mixed with clay and pressed into sticks. It can produce varied lines or broad strokes that resist smudging far more than charcoal. Wax-based crayons, such as those children use, are avoided by serious artists; they lack flexibility, and most fade over time. Because the strokes do not blend easily, it is difficult to obtain bright color mixtures with wax crayons.

Georges Seurat used Conté crayon to build up the illusion of three-dimensional form through value gradations (chiaroscuro) in his drawing *L'Echo* (**fig. 6.18**). Seurat actually drew a multitude of lines, yet in the final drawing the individual lines are obscured by the total effect of finely textured light and dark areas. He selected Conté crayon on rough paper as a means of concentrating on basic forms and on the interplay of light and shadow.

Natural chalks of red, white, and black have been used for drawing since ancient times. Pastels, produced since the seventeenth century, have characteristics similar to those of natural chalk. They have a freshness and purity of color because they are composed mostly of pigment, with very little binding material. Because no drying is needed, there is no change in color, as

6.18 Georges Seurat. *L'Echo.*
Study for *Une Baignade, Asnières.* 1883–1884.
Black Conté crayon on Michallet paper.
12⅝″ × 9⅞″.
Bequest of Edith Malvina K. Wetmore. Yale University
Art Gallery, New Haven, Connecticut, USA.

occurs in some paints as they dry. Soft pastels do not allow for much detail; they force the user to work boldly. Blending of strokes with fingers or a paper stump made for the purpose produces a soft blur that lightly mixes the colors. Pastels yield the most exciting results when not overworked.

Venetian portraitist Rosalba Carriera made dozens of works with pastels in the early eighteenth century. Her *Portrait of a Girl with a Bussola* (**fig. 6.19**) shows her sensitivity to the medium. The hard, fine-grained pastels in common use at that time give the finished work a smooth surface that makes possible fine color shadings. Because of the artist's light, deft touch with short strokes of the pastel, the work resembles an oil painting in its appearance, an effect promoted by the very smooth paper.

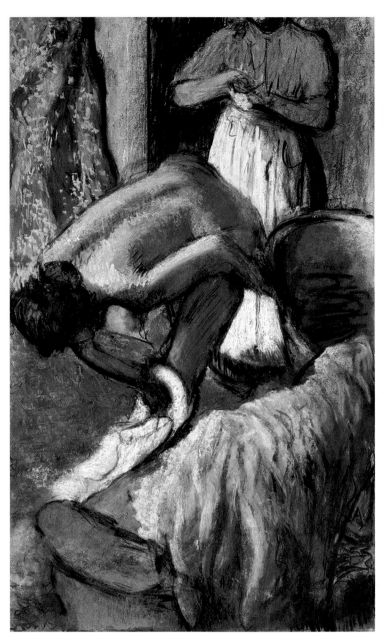

6.20 Edgar Degas.
Le Petit déjeuner après le bain (jeune femme s'essuyant).
c.1894. Pastel on paper. 39¼″ × 23½″.
Private Collection/Photo © Christie's Image/The Bridgeman Art Library.

6.19 Rosalba Carriera. *Portrait of a Girl with a Bussola.*
1725–1730. Gallerie dell'Accademia, Venice.
Pastel on paper. 13⅜″ × 10½″.
© Cameraphoto Arte, Venice.

French artist Edgar Degas shifted from oil painting to pastels in his later years, and occasionally he combined the two. He took advantage of the rich colors and subtle blends possible with pastel. Although carefully constructed, his compositions look like casual, fleeting glimpses of everyday life. In *Le Petit déjeuner après le bain* (*Breakfast after the Bath*) (**fig. 6.20**), bold contours give a sense of movement to the whole design.

Liquid Media

Black and brown inks are the most common drawing liquids. Some brush drawings are made with **washes** of ink thinned with water. Such ink drawings are similar to watercolor paintings. Felt- and fiber-tipped marker pens are widely used recent additions to the traditional pen-and-ink media.

Nineteenth-century Japanese artist Hokusai, a skilled and prolific draftsman, is said to have created about 13,000 prints and drawings during his lifetime.

In *Tuning the Samisen* (**fig. 6.21**), the expressive elegance of his lines was made possible by his control of the responsive brush. In Asia, the same brushes are used for traditional writing and drawing. These brushes are ideal for making calligraphic lines because they hold a substantial amount of ink and readily produce lines thick and thin. Hokusai played the uniformly thin lines of head, hands, and instrument against the bold spontaneous strokes indicating the folds of the kimono.

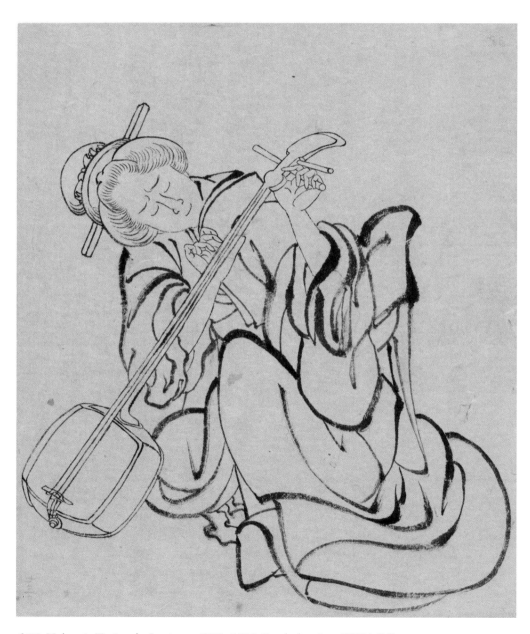

6.21 Hokusai. *Tuning the Samisen*. c.1820–1825. Brush drawing. 9¾″ × 8¼″.
Freer Gallery of Art, Smithsonian Institution, Washington. D.C.: Gift of Charles Lang Freer, F1904.241.

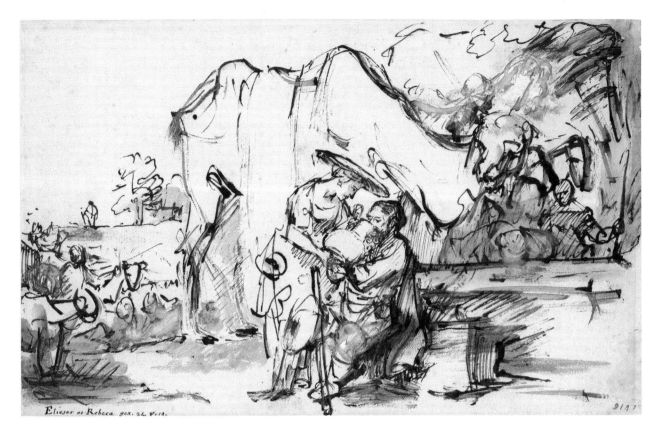

6.22 Rembrandt van Rijn. *Eliezer and Rebecca at the Well*. 1640s.
Reed pen and brown ink with brown wash and white gouache. 8¼″ × 13¹⁄₁₆″.
National Gallery of Art, Washington D.C. Widener Collection 1942.9.665

In *Eliezer and Rebecca at the Well* (**fig. 6.22**), the seventeenth-century artist Rembrandt van Rijn used liquid media to sketch quickly a compositional arrangement for a possible painting. Pens of varying widths yield ink strokes that show his speed of execution. He used parallel hatching lines for darker areas, and further darkened several of these regions with brown wash, especially in the right half of the page. In a few places—near the foot of the cliff, at Eliezer's knee, and near the top of the mountain at the right—he lightened his previous shadings by applying white **gouache**, a type of opaque watercolor. This drawing shows Rembrandt at his most spontaneous, having little idea that others would study it centuries later. The inscriptions along the lower edge come from a later owner.

More recently, Nancy Spero used mostly liquid media to make drawings that she considered finished works. One of these is *Peace* (**fig. 6.23**), a protest against the Vietnam War made at the height of that conflict in 1968. She used black ink and white gouache to sketch a jubilant figure standing on a flattened helicopter. She smudged the ink around the figure before it dried, creating an aura. The quick execution and casual composition of this work reveal its exuberant, impulsive force.

6.23 Nancy Spero. *Peace*. 1968.
Gouache and ink on paper. 19″ × 23¾″.
© Estate of Nancy Spero/Licensed by VAGA, New York, NY.

6.24 Windsor McCay. *Little Nemo in Slumberland* (detail). Published in *New York Herald,* April 4, 1906.

Comics and Graphic Novels

A comic is a sequential artform based on drawing. Printed comics represent the culmination of a development that includes some ancient Egyptian murals, medieval tapestries, and some print series created in the 1730s. They have been a popular feature in newspapers for more than a hundred years. One of the most imaginative of the early newspaper comics was *Little Nemo in Slumberland* (**fig. 6.24**), which narrated and illustrated a child's fantastic dreams. In the example shown here—the last line of a full-page comic—a tuba player loses control of his instrument as it lengthens with every note that he plays.

In recent years, comics have become a much more serious artform, as their creators take up unusual or important subjects. In the 1980s, Los Angeles-based Gilbert Hernandez teamed with his brothers Jaime and Mario to create *Love and Rockets*, one of the longest-running alternative comics. This series dealt with gang life, love and romance, and social issues that the Southern California Mexican-American community faced. When the series came to an end in 1996, Gilbert began drawing highly imaginative short stories that were collected into the volume *Fear of Comics* (**fig. 6.25**) in 2000. These stories show a wide range of characters and themes (not all of them publishable in a book such as this). In one story for example, Gilbert takes Herman Melville's classic novel *Moby Dick* and boils it down to six crisply drawn frames.

More ambitious are graphic novels, which have book-length story lines. The increasing acceptance of this type of novel has led major publishers to seek out

6.25 Gilbert Hernandez. Cover of *Fear of Comics.* 2000.
Courtesy Fantagraphics Books, Inc. © Gilbert Hernandez, 2007.

6.26 Marjane Satrapi.
Page from *Persepolis*. 2001.
L'association, Paris.

artists and produce their work for national distribution. Among the most successful of these is *Persepolis* (**fig. 6.26**) by Marjane Satrapi, a story of a girl growing up in a progressive family in Tehran, Iran, in the years surrounding the Iranian revolution of 1979. The bold and simple drawing style parallels the crystal-clear narration of an intelligent young person. In the present frame (published first in France), we see the artist reflecting with regret on how the revolutionary fundamentalist regime justified its existence with the Iran–Iraq war, which wasted a million lives. Through it all, we see not only the artist's uneasiness under the new regime, but also her love for her country. "Iran is my mother," she once told an interviewer. "My mother, whether she's crazy or not, I would die for her; no matter what, she is my mother."

She could have written *Persepolis* as a narrative without pictures, but for Satrapi as for other graphic novelists, combining word and drawn image adds to the power of each. She said, "Images are a way of writing. When you have the talent to be able to write and to draw it seems a shame to choose one. I think it's better to do both."[12]

At the furthest edge of comic arts are abstract comics, which allow viewers to invent their own narratives. Janusz Jaworski filled each frame of his comic (**fig. 6.27**) with nonrepresentational brushstrokes, and drew doodles instead of statements in the speech bubbles. The artist even refused to title this work, leaving viewers to their own imagination.

6.27 Janusz Jaworski. Untitled abstract comic. 2001. Ink and watercolor on paper.
Courtesy of the artist.

6.28 Julie Mehretu.
Back to Gondwanaland. 2000.
Ink and acrylic on canvas. 8′ × 10′.
Collection A & J Gordts-Vanthournout, Belgium.
Courtesy of the artist and Marian Goodman Gallery.

Watch the Art21 video of Julie Mehretu discussing her work on myartslab.com

Contemporary Approaches

Today's artists have considerably expanded the definitions and uses of drawing. Many use it in combination with other media in finished works. Some artists create works in new ways using new media, and label them drawings because no other name quite describes what they do. Julie Mehretu, for example, uses media from both drawing and painting in the same large works. Her *Back to Gondwanaland* (**fig. 6.28**) includes colored swatches of cut paper along with drawn ink lines. She makes abstract drawings, but the shapes she uses generally suggest the impersonal public spaces of today's mass-produced world: offices, classrooms, airports, and stadiums. If drawing has been traditionally an organic process, her works do not look entirely handmade. Rather, they exist in a gap between the natural and the manufactured.

Christine Hiebert makes lines directly on walls with the blue tape that painters use to mask negative spaces. In works that she creates specifically for each exhibition, her lines affect our perception of the space. In her work *Reconnaissance* (**fig. 6.29**), for example, she interrupted the clean horizontals and verticals of a gallery with diagonals of varying thickness. Her lines resemble drawn lines, but in fact she has "drawn" the tape across the walls. When the show is over, the tape comes off without leaving a trace.

6.29 Christine Hiebert.
Reconnaissance (view #2). 2009–2010.
Blue tape and glue on wall. Wall coverage
c.110′ running wall length × c.35′ high.
Installation view from the Davis Museum
and Cultural Center at Wellesley College.
Photo © Christine Hiebert.

Watch a podcast interview with
Christine Hiebert on myartslab.com

6.30 Ingrid Calame.
*#334 Drawing (Tracings from the L.A. River and
ArcelorMittal Steel)*. 2011. Colored pencil on
tracing Mylar. 115¼″ × 75″ × 3¼″.
Courtesy of Susanne Vielmetter Los Angeles Projects and James Cohan
Gallery, New York/Shanghai.

The drawings of Ingrid Calame begin as rubbings taken from highly textured surfaces. For *#334 Drawing* (**fig. 6.30**), she visited an abandoned steel plant in upstate New York, and the cement-lined pathway of the Los Angeles River. She selects and combines rubbings by overlaying them, and then she laboriously copies each layer with colored pencil. Each color in a final drawing comes from a different initial rubbing. These drawings render the most minute details of the floor beneath us, exactly and painstakingly, in images of eerie beauty.

Electronic drawing media have been available for years, but new digital devices have made them more accessible. British artist David Hockney creates some of the most sophisticated drawings on his iPad (**fig. 6.31**). He made one drawing every day for several months in 2011, illustrating the arrival of spring to the countryside near his studio. He made all of the marks with his finger on the glass screen, choosing colors to fit his composition. He said of these works, "You couldn't have had Impressionism without the invention of the collapsible tube so you could take paints outside. Technology affects things all the time and it certainly does pictures. I follow it, I follow that

6.31 David Hockney. *The Arrival of Spring in Woldgate, East Yorkshire in 2011 (twenty-eleven)—4 January.* 2011. 56¾" ×42½". Part of a 52-part work. iPad drawing.
© David Hockney.

aspect of technology. And I've no doubt it is a marvelous new tool."[13] As this is a 52-part work, one drawing shows only a moment of the land coming to life.

As we have seen in the examples in this chapter, drawing is an immediate way to communicate through imagery. It enables artists to share their ideas, feelings, experiences, and imaginings with us whether in a sketch, a preparatory study, or a finished work.

 Study and review on myartslab.com

THINK BACK

1. Why do artists make drawings?

2. What are the two principal categories of drawing media?

3. Are today's artists using drawing in a way similar to artists in the past?

TRY THIS

Closely examine the two drawings by Vincent van Gogh in this chapter (figs. 6.5 and 6.6). Which drawing is better at showing the roundness of the subject's limbs or body? Which better expresses the subject's physical weight? What techniques did the artist use to achieve these?

KEY TERMS

cartoon – a full-sized drawing made as a guide for a large work in another medium, particularly a fresco painting, mosaic, or tapestry; a humorous or satirical drawing

Conté crayon – a drawing medium developed in the late eighteenth century; similar to pencil in its graphic content, includes clay and small amounts of wax

gouache – an opaque water-soluble paint

hatching – a technique in which lines are placed in parallel series to darken the value of an area

wash – a thin, transparent layer of paint or ink

7 PAINTING

7.1 Gerhard Richter. *Abstract Painting*. 1984. Oil on canvas. 17″ × 23⅝″.
© Gerhard Richter 2013.

((•─ **Listen** to the chapter audio on myartslab.com

Drawing is often a natural prelude to painting, and painting is often drawing with paint. In Gerhard Richter's *Abstract Painting* (**fig. 7.1**), the medium (paint) and the process of its application are a major part of the message. Richter's invented landscape suggests rugged forms in the foreground and an open, distant sky. Large brushstrokes of thickly applied oil paint contrast with the smooth gradations of paint in the sky area.

For many people in the Western world, the word "art" means painting. The long, rich history of painting, the strong appeal of color, and the endless image-making possibilities have made painting a preferred medium for both artists and viewers for centuries.

The people who made the earliest cave paintings used natural pigments obtained from plants and nearby deposits of minerals and clays. Pigments used in cave paintings at Pont d'Arc, France—including blacks from charred woods and earth colors—have lasted more than 30,000 years.

By Rembrandt van Rijn's time, the seventeenth century, painters or their assistants mixed finely ground pigments with oil by hand until the paint reached a desirable fineness and consistency. Today

high-quality paints are conveniently packaged in tubes or jars, ready for immediate use.

In this chapter we will look in more detail at the process of making paintings, and then explore the unique characteristics, advantages, and disadvantages of the most common types of paint.

Ingredients and Surfaces

All paints consist of three ingredients: **pigment**, **binder**, and **vehicle**. The pigment provides color, usually in the form of a very fine powder. Some of the purest and most brilliant colors available to the human eye are in pigment powders. Lita Albuquerque's large *Wind Painting* (**fig. 7.2**) illustrates the dusty nature of this basic ingredient. She allowed the wind to scatter a rich red pigment powder over the blue surface she had painted earlier. The full title of this work tells the date and time of its creation.

Pigment colors must be stable while drying and resist fading over time. Ground minerals and dried plant juices were the most common pigment sources in ancient times. More exotic pigments have included powdered animal urine and even dried insect blood.

7.2 Lita Albuquerque. *Wind Painting 01.08.12, 1:10:44pm PST.* 2012. Pigment on canvas. 72″ × 114″.
Courtesy of Lita Albuquerque and Craig Krull Gallery, Santa Monica, California.

In the nineteenth and twentieth centuries, major advances in the chemical industry made it possible to produce synthetic pigments that extend the available range of stable colors. Since then, the durability of both natural and synthetic pigments has improved. Most of the same pigment powders are used in manufacturing the various painting and drawing media.

The binder is a sticky substance that holds the pigment particles together and attaches the pigment to the surface. Binders vary with the type of paint: Oil paint, for example, contains linseed oil as a binder, while traditional **tempera** uses egg yolk.

The vehicle makes the paint a liquid, and can be added to the paint for thinning. In traditional oil paint, turpentine is the vehicle; watercolors, of course, use water.

Paint surfaces require a **support**, or structure to hold them. Wood panel, stretched canvas, and paper are common supports. Many of these supports require sealing, to lessen their absorptive qualities and to smooth them by filling in the pores of the material. Such sealant is usually called **size** or sizing, and is generally made from liquid clay, wax, or glue. Wood and canvas usually require sizing, while paper used for watercolor generally does not. Atop the sizing (or instead of it), artists often apply a **primer** (usually white) in order to create a uniform surface. The sizing plus the primer creates the ground of a painting, and constitutes the surface preparation that artists generally do.

We will now consider the most common painting media in historical order of their appearance.

Watercolor

Artists have used water-based paint media for thousands of years. Paints very similar to modern watercolor appear in paintings from ancient Egypt, and also in ancient Chinese manuscripts.

In **watercolor**, pigments are mixed with water as a vehicle and gum arabic (sap from the acacia tree) as a binder. The most common support today is white rag paper (made from cotton rag), because of its superior absorbency and long-lasting qualities. Such paper requires neither sizing nor priming; the paper itself is both the ground and support. Watercolor was traditionally sold in solid blocks that the painter mixed with water to reach the desired thickness; today most professional watercolor is sold in tubes.

Watercolor is basically a staining technique. The paint is applied in thin, translucent washes that allow light to pass through the layers of color and to reflect back from the white paper. Highlights are obtained by leaving areas of white paper unpainted. **Opaque** (nontranslucent) watercolor is sometimes added for detail. Watercolors are well suited to spontaneous as well as carefully planned applications. Despite the simple materials involved, watercolor is a demanding medium because it does not permit easy changes or corrections. If you overwork a watercolor, you lose its characteristic freshness.

Watercolor's fluid spontaneity makes it a favorite medium for painters who want to catch quick impressions outdoors. The translucent quality of watercolor washes particularly suits depictions of water, atmosphere, light, and weather.

American artist John Singer Sargent ranks among the best watercolorists. He created *Rio de Santa Maria Formosa* (**fig. 7.3**) during a gondola ride in Venice, Italy. In this work, we discern Sargent's viewpoint from the passenger seat of the rocking vessel. He captured gentle ripples in the water, allowing the white of the paper to stand for the highlights. The water surface also picks up reflections from the colors of the surrounding buildings. In darker regions, such as the underside of the nearest bridge, his application of paint shows the stains that watercolor can produce. In other places he used a dry brush, such as in the gondolier's pole, which extends in a strong diagonal downward to a slot on the deck. The work's decidedly spontaneous appearance contributes to its attractiveness.

Opaque watercolor (also called gouache) has been widely used for centuries. It was common in book illustration during the European Middle Ages, and also in traditional Persian art (see fig. 19.8 for an example). Gouache resembles watercolor except that the vehicle includes small amounts of fine chalk powder that make it opaque. It is popular in our times with designers and illustrators because of its ease of use and low cost. Jacob Lawrence used gouache to good advantage in his work *Going Home* (see fig. 4.3). Here we see the typical opaque appearance of the colors.

7.3 John Singer Sargent. *Rio de Santa Maria Formosa, Venice.*
1905. Watercolor over graphite and pen and ink on
wove paper. 13¹³⁄₁₆″ × 19⅜″.
Gift of Mrs. Murray S. Danforth 42.223. Museum of Art, Rhode
Island School of Design, Providence. Photography by Erik Gould.

Watch a video about the technique of
watercolor painting on myartslab.com

In traditional Chinese watercolor technique, the artist
employs water-based black ink as well as color, and often uses
the ink without color. The Chinese regard painting as descended
from the art of **calligraphy**, which is also done with black ink. In
Asia, black ink painting is a fully developed artform, accorded at
least as much honor as painting with color.

A modern Chinese artist who updated the ancient tradi-
tions was Zhang Daqian, and we see his skillful use of water-
based media in *Hidden Valley, After Guo Xi* (**fig. 7.4**). Zhang
used black ink for outlining, for trees, and for the darkest
areas of this large landscape painting, which is over 6 feet tall.
Opaque watercolors gave the earthy tones for the rocks, and the
red accents near the base. This work borrows the dramatic style
of Guo Xi, an important artist from the twelfth century.

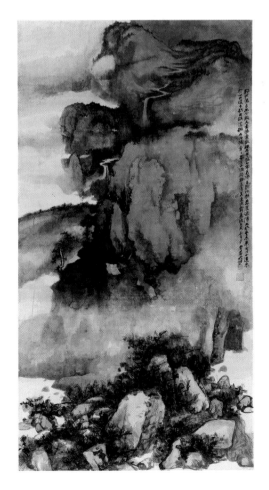

7.4 Zhang Daqian. *Hidden Valley, After Guo Xi.* 1962.
Ink and color on paper. 76¼″ × 40⅛″.
Arthur M. Sackler Gallery, Smithsonian Institution, Washington D.C.: Gift of the
Arthur M. Sackler Foundation, S1999.119.

Fresco

In **true fresco**, or ***buon fresco***, pigments suspended in water are applied to a damp lime-plaster surface. The vehicle is water, and the binder is the lime present in the damp plaster. The earliest true fresco paintings date from about 1800 BCE at a site in today's southwestern Turkey. The technique was also practiced in some cultures of pre-Columbian Mexico.

Most modern fresco painters first prepare a full-size drawing called a cartoon, then transfer the design to the freshly laid plaster wall before painting. Because the plaster dries quickly, only the portion of the wall that can be painted in one day is prepared; joints between each day's work are usually arranged along the edges of major shapes in the composition.

The painter works quickly in a rapid staining process similar to watercolor. Lime, in contact with air, forms transparent calcium crystals that chemically bind the pigment to the moist lime-plaster wall. The lime in the plaster thus becomes the binder, creating a smooth, extremely durable surface. Once the surface has dried, the painting is part of the wall, rather than resting on its surface. Because lime-plaster walls are subject to mold infestations, fresco is most suitable to drier climatic zones. Notice the texture of the plaster in the detail from Diego Rivera's fresco *Detroit Industry* (**fig. 7.5**). Completion of the chemical reaction occurs slowly, deepening and enriching the colors as the fresco ages. Colors reach their greatest intensity 50 to 100 years after a fresco is painted, yet the hues always have a muted quality.

The artist must have the design completely worked out before painting, because no changes can be made after the paint is applied to the fresh plaster. It may take 12 to 14 straight hours of work just to complete 2 square yards of a fresco painting. Fresco technique does not permit the delicate manipulation of transitional tones; but the luminosity, fine surface, and permanent color make it an ideal medium for large murals. (A mural is any wall-sized painting; fresco is one possible medium for such a work.)

Fresco secco (dry fresco), another ancient wall-painting method, is done on finished, dried lime-plaster walls. With this technique, tempera paint is applied to a clean, dry surface or over an already dried true fresco to achieve greater color intensity than is possible with true fresco alone. Fresco painters often retouch their work, or put on finishing details, in *fresco secco* over the true fresco.

In Renaissance Italy, fresco was the favored medium for painting on church walls. Probably the best-known fresco paintings are those by Michelangelo on the Sistine Chapel ceiling in the Vatican (see figs 17.10a and 17.10b). After the Renaissance and **Baroque** periods, fresco became

7.5 Diego Rivera. *Detroit Industry* (detail).
1932–1933. Fresco.
Detroit Institute of Arts, USA/The Bridgeman Art Library © 2013
Banco de México Diego Rivera Frida Kahlo Museums Trust,
Mexico, D.F./Artists Rights Society (ARS), New York.

👁 **Watch** a video about Diego Rivera's frescoes on myartslab.com

less popular, being eclipsed by the more flexible oil medium. However, a revival of the fresco technique began in Mexico in the 1920s, encouraged by the new revolutionary government's support for the arts. The Mexican government paid painters at union wages to decorate public buildings with murals, most of them in fresco.

By leading the revival in fresco mural painting, Diego Rivera broke away from the limited studio and gallery audience and made art a part of the life of the people. His style blends European and native art traditions with contemporary subject matter. He created *Detroit Industry* (**fig. 7.6**) in the lobby of the Detroit Institute of Arts.

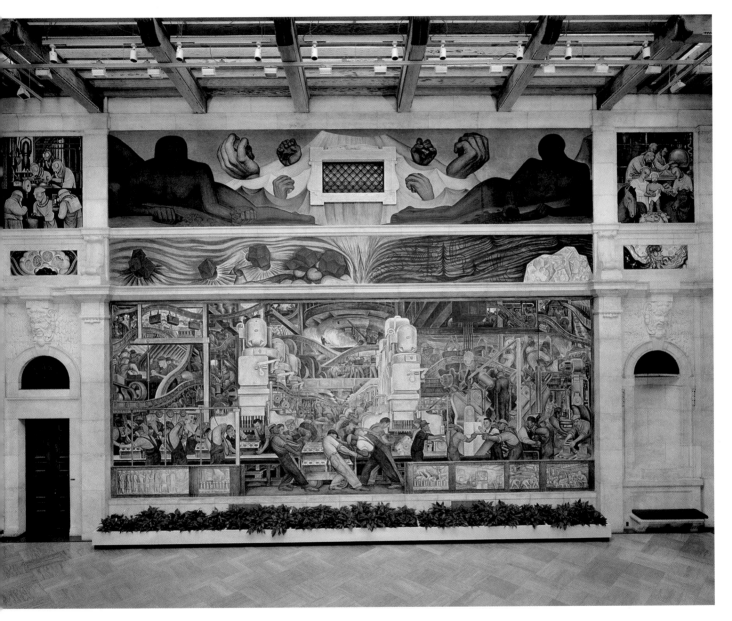

7.6 Diego Rivera. *Detroit Industry.* 1932–1933. Fresco.

Detroit Institute of Arts, USA/The Bridgeman Art Library © 2013 Banco de México Diego Rivera Frida Kahlo Museums Trust, Mexico, D.F./Artists Rights Society (ARS), New York.

View the Closer Look for Diego Rivera's *Detroit Industry* on myartslab.com

FORMING ART

Diego Rivera (1886–1957): Creating Controversy

7.7 Diego Rivera.
Archive Photos/Getty Images.

Because murals are often created for public spaces, their imagery can be the subject of controversy. Such disputes can influence the content and location of a mural as much as the artist's engagement with the medium. One of New York's most famous murals, for example, does not exist in its original location; it was the subject of the largest art controversy of the Depression era.

At the time he began work on *Man at the Crossroads* (**fig. 7.8**) in 1933, Diego Rivera was already an established master of fresco painting technique, having created numerous murals in his native Mexico and several more in the United States. Rockefeller Center was then under construction in New York City, and several artists were hired to execute mural decorations for the new buildings. Rivera was assigned the most prominent location, the wall above the elevators in the Center's main lobby.

Rivera's contract stipulated the subject: "Man at the crossroads, looking with uncertainty but with hope and high vision to the choosing of a course leading to a new and better future." In creating the work, Rivera followed the traditional fresco techniques. After measuring the space available, he made full-scale cartoons of the subject on huge sheets of paper.

His assistants prepared the wall for each day's work, troweling on damp lime plaster, and then transferring the design from the cartoons to the wall. They first pricked tiny holes in the lines of the drawings before attaching them to the wall and pouncing (dusting the perforations with fine powder to transfer the design to the surface beneath). Rivera then mounted a scaffold and painted over the drawing that he had created, adding color and shape to the flat design.

Rivera described the core of the mural design: "The center of my mural showed a worker at the controls of a large machine. In front of him, emerging from space, was a large hand holding a globe on which the dynamics of chemistry and biology, the recombination of atoms, and the division of a cell, were represented schematically.

Two elongated ellipses crossed and met in the figure of the worker, one showing the wonders of the telescope and its revelation of bodies in space; the other showing the microscope and its discoveries—cells, germs, bacteria, and delicate tissues."[1] Surrounding this central group are scenes of modern life.

The controversy over the mural arose when building supervisors noticed that Rivera had depicted Russian Communist revolutionary leader Vladimir Lenin between the ellipses on the right side of the work, clasping hands with a group of laborers. Nelson Rockefeller protested to Rivera that the portrait of Lenin "might very easily seriously offend a great many people." He requested that Rivera substitute an anonymous worker.

Rivera offered to compromise by painting on the opposite side a portrait of Abraham Lincoln or Cyrus McCormick, the inventor of the reaping machine. But Rockefeller insisted. Rivera was fired and the mural, which was about two-thirds complete, destroyed. Because fresco paint actually soaks into the wall rather than lying atop it, workers had to use jackhammers to remove it.

Returning to Mexico, Rivera executed the planned mural on a wall in the Palacio de Bellas Artes auditorium building in Mexico City. Viewers who wish to see Rivera's proposed contribution to the Rockefeller Center must visit it there.

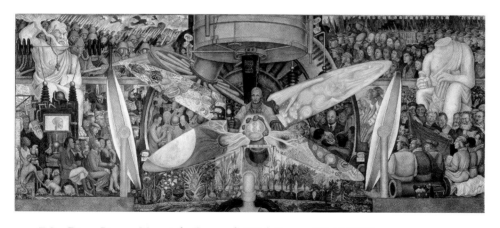

7.8 Diego Rivera. *Man at the Crossroads.* 1934. Fresco. 16' × 37'6".
Museo del Palacio Nacional de Bellas Artes, Mexico City. Banco de Mexico Trust. © 2013 Photo Art Resource/Bob Schalkwijk/Scala, Florence © 2013 Banco de México Diego Rivera Frida Kahlo Museums Trust, Mexico, D.F./Artists Rights Society (ARS), New York.

Encaustic

Encaustic was known to the ancient Greeks, and flourished in Egypt during the time when it was a Roman colony. Encaustic pigments are suspended in hot beeswax, resulting in lustrous surfaces that bring out the full richness of colors. The wax is both binder and vehicle. The Egyptian city of Fayum was a center of encaustic painting during the second century CE. Fayum portraits, such as *Portrait of a Boy* (**fig. 7.9**), were memorials to the deceased, painted directly on their wooden coffins. These are the earliest surviving encaustic works. In these portraits, the sense of lifelike individuality remains strong, and colors have retained their intensity after almost two thousand years.

Early practitioners found it difficult to keep the wax binder of encaustic at the right temperature for proper handling. Though modern electrical heating devices make such temperature maintenance easier, encaustic today is used by only a small minority of painters.

Tempera

Tempera was also known to the Greeks and Romans, but was highly developed during the late Middle Ages, when it was used for small paintings on wood panels. Since those times the principal tempera medium has been egg tempera, in which egg yolk is the binder, mixed in equal parts with pigment powder and then thinned with water. Tempera is little used today, and as a result the word has changed its meaning. Today, "tempera" is often used for water-based paints such as poster paints or paints with binders of glue or **casein** (milk protein).

Traditional egg tempera has a luminous, slightly **matte** (not shiny) surface when dry. Because it cannot be mixed after it is applied, artists generally apply tempera in thin layers to build up desired shades of color. The preferred ground for egg tempera is **gesso**, a chalky, water-based liquid that dries to a bright white.

Egg tempera is good for achieving sharp lines and precise details, and it does not darken with age. However, its colors change during drying, and blending and reworking are difficult because tempera dries rapidly. Tempera painting traditionally requires complete preliminary drawing and pale underpainting because of its translucency and the difficulty in

7.9 *Portrait of a Boy.* c.100–150 CE.
Encaustic on wood. 15″ × 7½″.
Metropolitan Museum of Art. Gift of Edward S. Harkness, 1918.
Acc.n.: 18.9.2. © 2013. Image copyright The Metropolitan Museum of Art/Art Resource/Scala, Florence.

making changes. Overpainting consists of applying layers of translucent paint in small, careful strokes. Because tempera lacks flexibility, movement of the support may cause the gesso and pigment to crack. Thus a rigid support, such as a wood panel, is required.

Tempera paintings have a rich glow that comes from the thin layers of paint that most artists use. We can see this trait in Botticelli's work *The Story of*

7.10 Sandro Botticelli, *The Story of Nastagio degli Onesti* (I). 1483. Tempera on panel. 32½″ × 54½″.
Museo Nacional del Prado/Oronoz.

👁‍🗨 **Watch** a video about the technique of egg tempera on myartslab.com

Nastagio degli Onesti (**fig. 7.10**). Nastagio is the figure at the left center, who has taken up a stick to protect a woman threatened by attacking dogs. The charming style of this painting, with its frozen gestures and merry-go-round horse, mark it as an early Renaissance work; the reddish glow of the colors reflects its creation in tempera.

Oil

In Western art, oil paint has been a favorite medium for five centuries. Pigments mixed with various vegetable oils, such as linseed, walnut, and poppyseed, were used in the Middle Ages for decorative purposes. But, beginning in the fifteenth century, oil painting flourished when Flemish painters perfected a recipe for paint made with linseed oil pressed from the seeds of the flax plant. In this early period,

artists applied oil paint to wood panels covered with smooth layers of gesso, as in the older tradition of tempera painting.

The brothers Hubert and Jan van Eyck were among the early leaders of European oil painting. They achieved glowing, jewel-like surfaces that remain amazingly fresh to the present day. Jan van Eyck's *Madonna and Child with the Chancellor Rolin* (**fig. 7.11**) is an example of his early mastery of the oil technique. Jan painted it on a small gesso-covered wood panel. After beginning with a brush drawing in tempera, he proceeded with thin layers of oil paint, moving from light to dark and from opaque to translucent colors. The luminous quality of the surface is the result of successive oil glazes. A **glaze** is a very thin, transparent film of color applied over a previously painted surface. To produce glazes, oil colors selected for their transparency

7.11 Jan van Eyck. *Madonna and Child with the Chancellor Rolin.* c.1433–1434.
Oil and tempera on panel. 26″ × 24⅜″.
Louvre museum, Paris. Photograph: akg-images/Erich Lessing.

are diluted with a mixture of oil and varnish. Glazes give depth to painted surfaces by allowing light to pass through and reflect from lower paint layers.

In this painting, the sparkling jewels, the textiles, and the furs each show their own refined textures. Within the context of the religious subject, the artist demonstrated his enthusiasm for the delights of the visible world. Veils of glazes in the sky area provide atmospheric perspective and thus contribute to the illusion of deep space in the enticing view beyond the open window. The evolution in the new oil painting technique made such realism possible.

Oil has many advantages over other traditional media. Compared to tempera, oil paint can provide both increased opacity—which yields better covering power—and, when thinned, greater transparency. Its slow drying time is a distinct advantage, allowing artists to blend strokes of color and make changes during the painting process. Pigment colors in oil change little when drying; however, the binder (usually linseed oil) has a tendency to darken and yellow slightly with age. Because layers of dried oil paint are flexible, sixteenth-century Venetian painters who wished to paint large pictures could replace heavy wood panels with canvas stretched on wood frames. A painted canvas not only is light in weight but also can be unstretched and rolled for transporting if the paint layer is not too thick. Most oil painters today still prefer canvas supports.

Oil can be applied thickly or thinly, wet onto wet or wet onto dry. When applied thickly, it is called impasto (oil paint works best for this technique). When a work is painted wet onto wet and completed at one sitting, the process is called the **direct painting** method.

This tiny work, alongside *Madonna and Child with the Chancellor Rolin,* shows us a wide range of the capabilities of oil paint.

Tom Wudl used the direct method to create his small work *Rembrandt's Indulgence was Van Gogh's Dilemma* (**fig. 7.12**), shown here slightly larger than actual size. In this painting we see the texture of the canvas at the edges, covered with a white ground. The artist built up layers of impasto near the top of the work, showing the piled-up strokes that oil-based paint makes possible. The paint must be relatively thick, like paste, to create this effect. Below, curving strokes in shades of yellow swim around. Here he thinned the paint by adding turpentine. At the center is a meticulous depiction of a metal pitcher similar to one that the artist saw in a painting by Rembrandt. In that portion of the work, Wudl smoothed over his brushstrokes to heighten the ***trompe l'oeil*** qualities.

A work that shows a more spontaneous approach to the use of oil paint is Joan Mitchell's untitled work from 1987 (**fig. 7.13**). Here she used oil paint to recreate emotional states in abstract visual form. The work consists of two joined canvases that spread out to 13 feet in width. Although it is nonrepresentational, many factors unify it: She used colors from just two or three segments of the color wheel, which create harmonies; and the two halves of the work seem to echo each other in composition. Most important, Mitchell used paint of uniform thickness in quick, hooking brushstrokes to create a visual rhythm. We can actually follow the creation of this work, layer by layer and color by color, as we look at this embodiment of a warm, even excited, mood.

7.13 Joan Mitchell. *Untitled*. 1987. Oil on canvas.
Diptych. 102⅜″ × 157½″.

Private collection. © Estate of Joan Mitchell. Image courtesy of the
Joan Mitchell Foundation and Cheim & Read Gallery, New York.

Acrylic

Many artists today use **acrylic** paint, an invention of
the mid-twentieth century. The binder that holds the
pigment is acrylic polymer, a synthetic resin that pro-
vides a fast-drying, flexible film. The vehicle is water.
These relatively permanent paints can be applied to
a wider variety of surfaces than traditional painting
media. Because the acrylic resin binder is transparent,
colors can maintain a high degree of intensity. Unlike
oils, acrylics rarely darken or yellow with age. Their
rapid drying time restricts blending and limits rework-
ing, but it greatly reduces the time involved in layering
processes such as glazing. Water thinning is also more
convenient in the studio than the volatile and toxic
turpentine of oil paint.

Sculptor Anne Truitt used acrylic on her sculp-
tural pieces, applying many layers of narrowly varying
shades, and sanding between each application to create
a rich surface. Acrylic works well when brushed on in
flat areas, as we see in her 2004 piece *Return* (**fig. 7.14**).
This work is taller than most people. She said that her
goal was "to lift the color up, and set it free in three
dimensions [so that] it becomes alive, and it vibrates."[2]

7.14 Anne Truitt. *Return*. 2004.
Acrylic on wood. 81″ × 8″ × 8″.

Private Collection/annetruitt.org/The Bridgeman Art Library.

Contemporary Approaches

While traditional brushes are the most common tool for applying paint, in recent years many painters have used **airbrushes** to apply acrylics, oil, and other types of paint. An airbrush is a small-scale paint sprayer capable of projecting a fine, controlled mist of paint. It provides an even paint application without the personal touch of individual brush strokes, and it is therefore well suited to creating subtle gradations of color. Graffiti artists, of course, also favor airbrushes or spray cans because the quickness of execution reduces their exposure to law enforcement.

Keltie Ferris uses spray guns to finish most of her works. The work illustrated here (**fig. 7.15**) shows clouds of sprayed dots that partially obscure what lies beneath. The layers that she builds up do not necessarily harmonize in color or texture, creating jarring vertical mixtures. She told an interviewer: "To me, painting is most exciting when it has some notion of touch and texture. It's the human element of abstract work . . . By contrast spray paint is about a complete lack of touch. I'm painting with a machine on top of my more hand-made marks."[3]

Other painters in recent years have attempted to come to grips with computer animation, to create "moving paintings." A leader in this trend was Jeremy Blake, who created DVD collages that combined film footage and still photos with hand-painted elements. His 2005 work *Sodium Fox* (**fig. 7.16**) uses a poem by rock musician David Berman as a narration for a "dreamlike, deeply psychological exploration of Pop portraiture,"[4] according to Blake. The seemingly endless variety of elements that flow past during the film's 14-minute duration are bound together by the poem, by the intense color scheme, and by the frequent recurrence of hand-painted imagery.

As we have seen, artists have found myriad ways to make a statement by applying colors to flat surfaces. These techniques can be grouped by medium, and each has its own unique strengths and characteristics.

✓—[**Study** and review on myartslab.com

7.15 Keltie Ferris. ++++****)))). 2012.
Oil, acrylic, and pastel on canvas. 80″ × 100″.
Mitchell-Innes & Nash.

7.16 Jeremy Blake. *Sodium Fox*. 2005. Still from digital animation. 14-minute continuous loop.
Courtesy Kinz + Tillou Fine Art.

THINK BACK

1. What are the three basic ingredients of paint?

2. What advantages does oil have over other traditional media?

3. How has twentieth-century technology affected painting?

TRY THIS

Watercolor can be used for both quick sketches and highly detailed studies. One of the best known of the latter is Albrecht Dürer's *Large Piece of Turf* from 1503. See this work up close at the Google Art Project (googleartproject.com) by searching for the artist or for the Albertina Museum in Vienna. Compare the style of this work with that of John Singer Sargent's watercolor *Rio de Santa Maria Formosa* (fig. 7.3).

KEY TERMS

encaustic – a type of painting in which pigment is suspended in a binder of hot wax

fresco – a technique in which pigments suspended in water are applied to a damp lime-plaster surface

gesso – a mixture of glue and chalk, thinned with water and applied as a ground before painting with oil or egg tempera

glaze – a thin transparent or translucent layer brushed over another layer of paint, allowing the first layer to show through but enriching its color slightly

ground – the surface onto which paint is applied, consisting of sizing plus primer

impasto – thick paint applied to a surface in a heavy manner, having the appearance and consistency of buttery paste or of cake frosting

sizing – any of several substances made from glue, wax, or clay, used as a filler for porous material such as paper, canvas, or other cloth, or wall surfaces

tempera – a water-based paint that uses egg yolk as a binder

8 PRINTMAKING

THINK AHEAD

8.1 Define printmaking terms such as print, matrix, edition, and artist's proof.

8.2 Summarize the origins of printmaking in China and Western Europe.

8.3 Identify the artistic, social, and political functions of prints.

8.4 Distinguish methods of relief, intaglio, and lithographic printmaking processes.

8.5 Recognize the use of stencils, screenprinting, and digital technologies as contemporary forms of printmaking.

8.6 Compare the sculptural practice of working in editions to printmaking.

The first thing we might notice about the print *Quiver* (**fig. 8.1**) is its layering of images. A framed dragonfly hovers in a yellow-green square; a negative picture of a radio telescope seems to overlay a closer view of a similar device. Underneath all is a pattern of gray-green branches, silhouetted as if on a forest floor. Note that each layer has its color: gray, blue, brown, black, green. Overall, the work seems a meditation on fragile structures, which might "quiver" in a strong wind.

This layering of images resembles in some ways the process of memory: Each of our memories inhabits a layer of our minds, and each probably has its "color" of feeling or association. Such are the goals of the creator of *Quiver*, who said that she tries to make "visual poems." It is no mistake that she chose a print to realize this vision because this type of layering is a technique uniquely suited to printmaking.

In the visual arts, printmaking describes a variety of techniques developed to create multiple copies of a single image. A print is thus one of a series of nearly identical pieces, usually printed on paper. Prints are made from a **matrix**, which an artist may create of metal, wood, or stone. The artist supervises the printing of a group of images from the same matrix, usually called an **edition**.

8.1 Tanja Softic. *Quiver.* 2008. Lithograph. 20″ × 52″.
University of Richmond.

Listen to the chapter audio on myartslab.com

Nearly all original prints are numbered to indicate the total number of prints pulled, or printed, in the edition, and to give the number of each print in the sequence. The figure 6/50 on a print, for example, would indicate that it was the sixth print pulled from an edition of 50.

As part of the printmaking process, artists make prints called progressive proofs at various stages to see how the image on the matrix is developing. When a satisfactory stage is reached, the artist makes a few prints for his or her record and personal use. These are marked AP, meaning **artist's proof**.

One of the best definitions of an original print comes from artist June Wayne: "It is a work of art, usually on paper, which has siblings . . . They all look alike, they were all made at the same time from the same matrix, the same creative impulse, and they are all originals. The fact that there are many of them is irrelevant."[1] Another artist described print editions this way: "Prints mimic what we are as humans: we are all the same and yet every one is different."[2]

In this chapter we will look at some reasons for creating prints, and discuss the various traditional methods of printmaking: relief, intaglio, lithography, stencil. In our time, artists are using the old methods in new ways, sometimes combining them with digital techniques; we will conclude this chapter with a discussion of some of these new approaches.

Purposes of Printmaking

Although new technology is bringing different ways of communicating information, much in our society is still printed—newspapers, books, posters, magazines, greetings cards, billboards—so it is hard to imagine a time in which all illustrations were produced by hand, one at a time.

The technologies for both printing and paper-making came to Europe from China. By the ninth century, the Chinese were printing pictures; by the eleventh century, they had invented (but seldom used) movable type. Printmaking was developed in Europe during the fifteenth century—first to meet the demand for inexpensive religious **icons** and playing cards, then to illustrate books printed with the new European movable type.

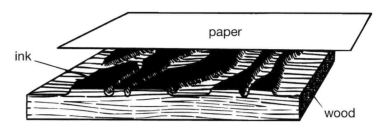

8.2 Relief.

As recently as the late nineteenth century, printmakers were still needed to copy drawings, paintings, and even early photographs by making plates to be used, along with movable type, for illustrating newspapers and books. However, as photomechanical methods of reproduction were developed in the later nineteenth century, handwork played a decreasing role in the printing process.

Generally, artists make prints for one or more of the following reasons:

- They may wish to make multiple works that are less expensive than paintings or sculpture, so that their work will be available for purchase by a wider group of viewers.
- They may wish to influence social causes. Because prints are multiple works, they are easy to distribute far more widely than a unique work of art.
- They may be fascinated by the process of printmaking, which is an absorbing craft in itself.

Relief

We already know what a **relief print** is, if we think of how fingerprints, rubber stamps, and wet tires leave their marks. In a relief process, the printmaker cuts away all parts of the printing surface not meant to carry ink, leaving the design "in relief" at the level of the original surface (see the Relief diagram, **fig. 8.2**). The surface is then inked, and the ink is transferred to paper with pressure.

Woodcut

The oldest relief prints are **woodcuts** (or **woodblocks**). The woodcut process lends itself to designs with bold black-and-white contrast. The image-bearing block of (usually soft) wood is a plank cut along the grain. Because the woodcut medium does not easily yield

8.3 Utagawa Hiroshige. *Shono hakuu* (*Light Rain at Shono*), number 46. 1832–1833.
Full-color woodcut. 8⅞″ × 13¾″.
Collection UCLA Grunwald Center for the Graphic Arts, Hammer Museum. Purchased from the Frank Lloyd Wright Collection.

View the Closer Look for Japanese
woodblock prints on myartslab.com

shades of color, artists who use it are generally drawn by the challenge of working in black and white only. Others use woodcut because they enjoy the feel of carving a fresh block of wood. Woodcut editions are limited to a couple of hundred because the relief edges begin to deteriorate with repeated pressure.

Woodblock printing flourished in Japan in the seventeenth through the nineteenth centuries. Japanese woodblock prints were made through a complex process that included multiple blocks to achieve subtle and highly integrated color effects. Because they were much cheaper than paintings, these prints were the preferred artform for middle-class people who lived in the capital city of Edo (now known as Tokyo). Their subject matter included famous theater actors, nightlife, landscapes, and even erotic pictures.

Japanese prints were among the first objects of Asian art to find favor among European artists, and many Impressionist and **Post-Impressionist** painters were strongly influenced by them (see Chapter 21).

Color woodcuts are usually printed with multiple woodblocks. As with most printmaking techniques, when more than one color is used, individually inked blocks—one for each color—are carefully **registered** (lined up) to ensure that colors will be exactly placed in the final print.

Hiroshige's print *Light Rain at Shono* (**fig. 8.3**) is a good example of Japanese printmaking at a high level. The print required four blocks, one for each color. The atmospheric effects of the rain and the distant forest are delicate, and difficult to achieve, as the fine lines in this work require both careful carving and precision printing. The work is one of 53 that Hiroshige created that depict various stops on the road from Edo to Kyoto; it was his most popular series.

8.4 Emil Nolde. *Prophet.* 1912. Woodcut. (Cat. Rais. Schiefler-Mosel 110.) 12½″ × 8¹³⁄₁₆″.

National Gallery of Art, Washington D.C. Rosenwald Collection. 1943.3.6698 © Nolde Stiftung Seebuell.

👁️⃞ **Watch** a video about the printmaking process of woodcut on myartslab.com

8.5 Rockwell Kent. *Workers of the World, Unite.* 1937. Wood engraving. 8″ × 5⅛″.

Fine Arts Museums of San Francisco, Achenbach Foundation for the Graphic Arts. Gift of the American College Society of Print Collectors. 54959. Courtesy of the Plattsburgh State Art Museum, State University of New York, Rockwell Kent Gallery and Collection, Bequest of Sally Kent Gorton.

The detail in Hiroshige's print is quite different from the roughness of the woodcut *Prophet* (**fig. 8.4**) by German artist Emil Nolde. Each cut in this block is expressive of an old man's face, and reveals the character of the wood and the woodcut process. The simplified light-and-dark pattern of the features gives emotional intensity to the image. Nolde's direct approach is part of a long tradition of German printmaking.

Wood Engraving

A related method that was traditionally used for book illustration is **wood engraving**. In this method, the artist uses very dense wood (often boxwood) set on end rather than sideways. The hardness of the wood requires the use of metal engraving tools, but it also makes large editions possible, facilitating the use of wood engraving in publishing.

One of the best wood engravers was the American artist Rockwell Kent, who made *Workers of the World, Unite* (**fig. 8.5**) in 1937. We see here the fine detail in the body and the background cloud that the dense wood, placed on end, allows. This work is also an example of socially conscious printmaking, as it shows a farmer defending his territory against encroaching military bayonets. Kent was an agitator throughout his life on behalf of workers of all sorts, and frequently made prints to forward his favorite causes.

Linocut

The **linoleum cut** (or **linocut**) is a modern development in relief printing. The artist starts with the rubbery, synthetic surface of linoleum, and just as in woodcut, gouges out the areas not intended to take ink. Linoleum is softer than wood, has no grain, and can be cut with equal ease in any direction. The softness of this matrix material makes fine detail impossible.

An example of a linoleum cut is *Sharecropper* (**fig. 8.6**) by Elizabeth Catlett, in which the even, white gouges betray the soft material. This work also typifies Catlett's lifelong devotion to creating dignified images of African Americans.

A contemporary artist who uses relief techniques in an original way is Betsabeé Romero of Mexico City (**fig. 8.7**). She buys used tires whose tread is almost gone, and she carves relief patterns in them that are based on traditional Mexican popular culture motifs such as skeletons and flowers. The tires are easily inked for printing on long sheets, which she either sells by the yard or exhibits together with the tires.

8.6 Elizabeth Catlett. *Sharecropper.* 1970.
Color linocut on cream Japanese paper. 21⁷⁄₁₆″ × 20³⁄₁₆″.
The Art Institute of Chicago Restricted gift of Mr. and Mrs Robert S. Hartman. 1992.182. Photography © The Art Institute of Chicago. © Catlett Mora Family Trust/Licensed by VAGA, New York , NY.

8.7 Betsabeé Romero, *Ciudades que se van (Cities on the Move).* 2004. Tires and relief prints. Installation view. Each tire 23⁵⁄₈″ diameter × 6¹⁹⁄₆₄″ wide. Four prints on domestic fabric. Each 59′ × 19¹¹⁄₁₆″.
Inset: *Del otro lado de la velocidad (On the Other Side of Speed).* Tire. 51³⁄₁₆″ × 15³⁄₄″.
Courtesy of the artist.

Intaglio

Intaglio printing is the opposite of relief printing: Areas below the surface hold the ink (see the Intaglio diagram, **fig. 8.8**). The word *intaglio* comes from the Italian *intagliare*, "to cut into." The image to be printed is cut or scratched or etched into a metal surface. To make an intaglio print, the printmaker first daubs the plate with printer's ink, then wipes the surface clean, leaving ink only in the etched or grooved portions. Damp paper is then placed on the inked plate, which then passes beneath the press roller. A print is made when the dampened paper picks up the ink in the grooves. The pressure of the roller creates a characteristic **plate mark** around the edges of the image. Intaglio printing was traditionally done from polished copper plates, but now zinc, steel, aluminum, and even plastic are often used. Engraving, drypoint, and etching are the principal intaglio processes.

8.8 Intaglio.

👁 **Watch** a video about the process of intaglio printmaking on myartslab.com

Engraving

To make an **engraving**, the artist cuts lines into the polished surface of a metal plate with a **burin**, or engraving tool. This exacting process takes strength and control. Lines are made by pushing the burin into the metal to carve a groove, removing a narrow strip of metal in the process. A clean line is preferable; thus any rough edges of the groove must be smoothed down with a scraper. Engraved lines cannot be freely drawn because of the pressure needed to cut the grooves. Darker areas are shaded with various types of crosshatching. A successful engraving therefore requires precise, smooth curves and parallel lines. To see a good example of engraving, look at the United States currency; all of our bills are engravings, made by experts.

We can also see the complex richness of engraved lines in Albrecht Dürer's engraving *The Knight, Death, and the Devil* (**fig. 8.10**), reproduced close to its actual size. Thousands of fine lines define the shapes, masses, spaces, values, and textures in this complex print. The precision of Dürer's lines seems appropriate to the subject—an image of the noble Christian knight moving with resolute commitment, unswayed by the forces of chaos, evil, and death that surround him.

Drypoint

Drypoint is similar to line engraving. Using a pointed tool with a steel or diamond tip, the artist scratches lines into a soft copper or zinc plate. The displaced metal leaves a **burr**, or rough edge, similar to the row of earth left by a plow. The burr catches the ink and, when printed, leaves a slightly blurred line (see Drypoint diagram, **fig. 8.9**). Because the burr is fragile and deteriorates rapidly from the pressure of the printing press rollers, drypoint editions are by necessity small and rarely done. Skillful draftsmanship is required, for drypoint lines are difficult to execute and almost impossible to correct. More often, artists use drypoint to fill in details in already-etched plates.

8.9 Drypoint Plate.

Etching

The process of making an **etching** begins with the preparation of a metal plate. The artist paints the surface of the copper or zinc plate with a coating of either wax or varnish that will resist acid. The artist then draws easily through this ground with a pointed tool, exposing the metal with each stroke. An etching tool may be as thick as a pen, but is more often closer to a needle. Finally, the plate is immersed in nitric acid. Acid bites into the plate where the drawing has exposed the metal, making a groove that varies in depth according to the strength of the acid and the length of time the plate is in the acid bath.

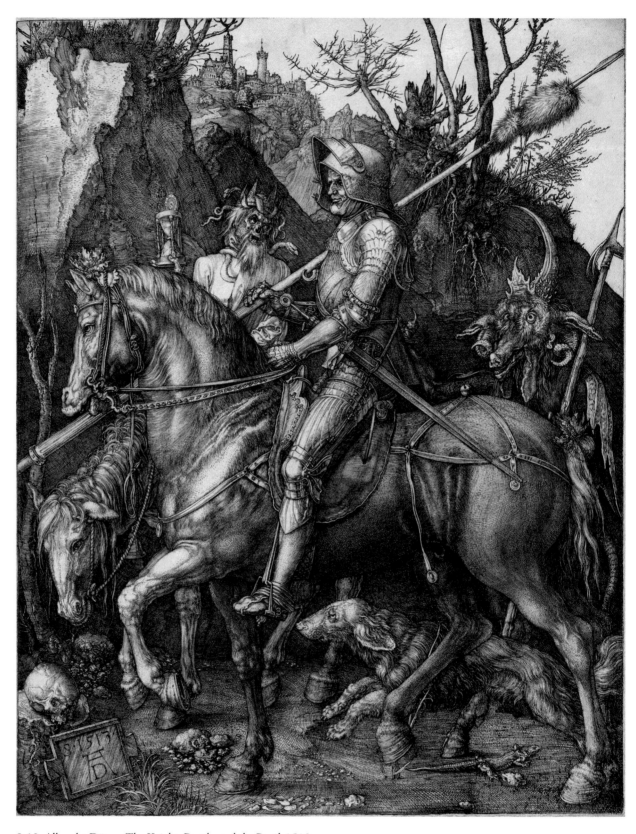

8.10 Albrecht Dürer. *The Knight, Death, and the Devil.* 1513.
Engraving. Plate 9⅝″ × 7½″.
National Gallery of Art, Washington D.C. Rosenwald Collection 1943.3.3519.

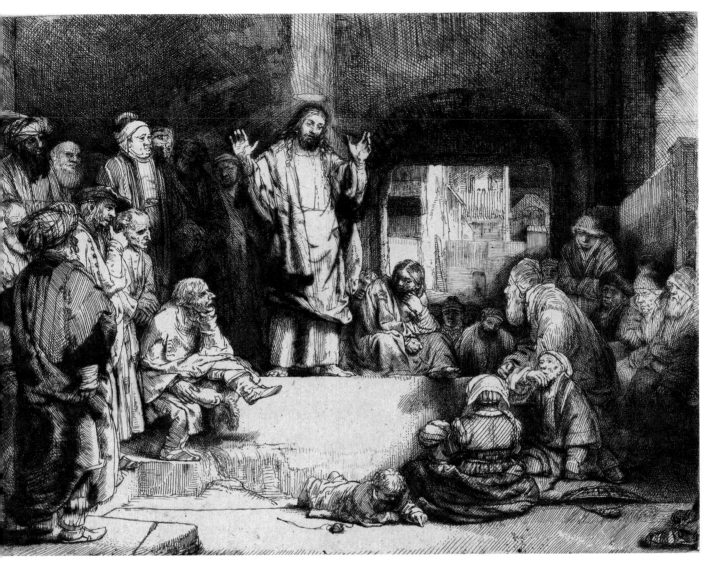

8.11 Rembrandt van Rijn. *Christ Preaching*. c.1652.
Etching, engraving, and drypoint. Plate 6¹⁄₁₆″ × 8⅛″.
National Gallery of Art, Washington D.C. Gift of W.G. Russell Allen 1955.6.5.

Because they are more easily produced, etched lines are generally more relaxed or irregular than engraved lines. We can see the difference in line quality between an etching and an engraving—the freedom versus the precision—by comparing the lines in Rembrandt's etching *Christ Preaching* (**fig. 8.11**) with the lines in Dürer's engraving (see fig. 8.10).

In *Christ Preaching*, Rembrandt's personal understanding of Christ's compassion harmonizes with the decisive yet relaxed quality of the artist's etched lines. This etching shows Rembrandt's typical use of a wide range of values, mostly created through hatching.

Skillful use of light and shadow draws attention to the figure of Christ and gives clarity and interest to the whole image. In a composition in which each figure is similar in size, Rembrandt identified Jesus as the key figure by setting him off with a light area below, a light vertical band above, and implied lines of attention leading to him from the faces of his listeners.

Etching yields only lines, but there is a way to create shaded areas in intaglio. **Aquatint** is an etching process used to obtain gray areas in black-and-white or color prints. The artist sprinkles acid-resistant powder on the plate over parts that need a gray tone. When

Because the acids used in intaglio printing are highly toxic and give off potent fumes, many contemporary intaglio artists are drawn to new nontoxic methods. Some of these involve using different chemicals, such as dry citric acid or ferric chloride powders, in place of the nitric acid bath. Another method is electroetching, in which a low-wattage electric current is passed through a solution of sulfate salts in water. This process yields a nonacidic bath that will etch a plate without endangering the health of the artist.

Lithography

Etching and engraving date from the fifteenth and sixteenth centuries, respectively; **lithography** was perfected in the early nineteenth century.

Lithography is a surface or planographic printing process based on the mutual antipathy of oil and water (**fig. 8.13**). Lithography lends itself well to a direct manner of working because the artist draws an image on the surface of the stone or plate, without any cutting. Its directness makes lithography faster and somewhat more flexible than other methods. A lithograph is often difficult to distinguish from a crayon drawing.

Using litho crayons, litho pencils, or a greasy liquid called **tusche**, the artist draws the image on flat, fine-grained Bavarian limestone (or on a metal surface that duplicates its character). After the image is complete, it is chemically treated with gum arabic and a small amount of acid to "fix" the drawing on the upper layer of the stone. The surface is then dampened with water and inked. Water repels the oil-based ink in the blank areas, but ink adheres to the greasy

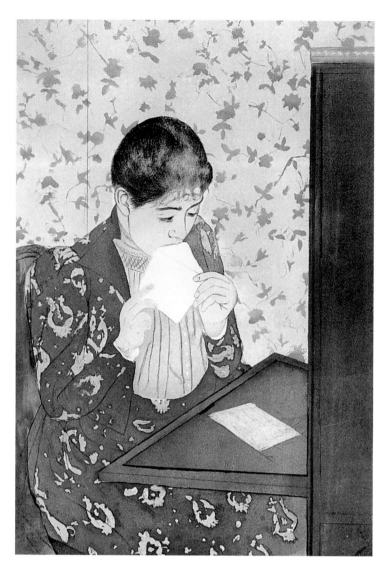

8.12 Mary Cassatt. *The Letter*. 1891.
Drypoint and aquatint, printed in color from three plates; fourth state of four. 13⅝″ × 8¹⁵⁄₁₆″.
The Metropolitan Museum of Art Gift of Paul J. Sachs, 1916. © 2013 Image copyright The Metropolitan Museum of Art/Art Resource/Scala, Florence.

the plate is bathed in acid, the exposed areas between the paint particles are eaten away to produce a rough surface capable of holding ink. Values thus produced can vary from light to dark, depending on how long the plate is in the acid and how thick the dusting of powder. Because aquatint is not suited to making thin lines, it is usually combined with a linear print process such as engraving or etching.

American artist Mary Cassatt combined a few intaglio techniques in her work *The Letter* (**fig. 8.12**). She made the colored areas with aquatint; she scratched the lines in the surface of the plates with drypoint. She used three plates, one for each color.

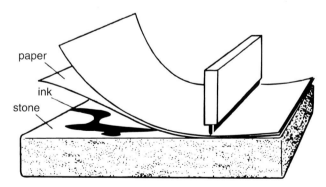

paper
ink
stone

8.13 Lithography.

👁 **Watch** a video about the technique of lithography on myartslab.com

area of the image. As in other print processes, when the surface is covered with paper and run through a press, the image is transferred to the paper. Because the surface remains intact, lithographic stones or plates can be reused after cleaning.

Although lithography was a new medium in the early 1800s, it had a major impact on society because prints could be produced quickly and easily. Before the development of modern printing presses, it provided the illustrations for newspapers, posters, and handbills. Honoré Daumier, one of the first great lithographic artists, made his living drawing satirical and documentary lithographs for French newspapers. His personal style was well suited to the direct quality of the lithographic process.

In *Rue Transnonain* (**fig. 8.14**), Daumier carefully reconstructed a horrible event that occurred during a period of civil unrest in Paris in 1834. The militia claimed that a shot was fired from a building on Transnonain Street. Soldiers responded by entering the apartment and killing all the occupants, including many innocent people. Daumier's lithograph of the event was published the following day. The lithograph reflects the artist's feelings, but it also conveys information in the way news photographs and Web sites do today. Rembrandt's influence is evident in the composition of strong light and dark areas that increase the dramatic impact of Daumier's image.

The leading European printmaker of the late nineteenth century, Henri de Toulouse-Lautrec, created many of his most innovative works using lithography. In the space of about ten years, he created hundreds of posters that advertised everything from nightclub acts to bicycles. His use of bright colors and flattened,

8.14 Honoré Daumier. *Rue Transnonain, April 15, 1834.* 1834. Lithograph. 11¼″ × 17⅜″.
© The Cleveland Museum of Art, 2001. Gift of Ralph King. 1924.809.

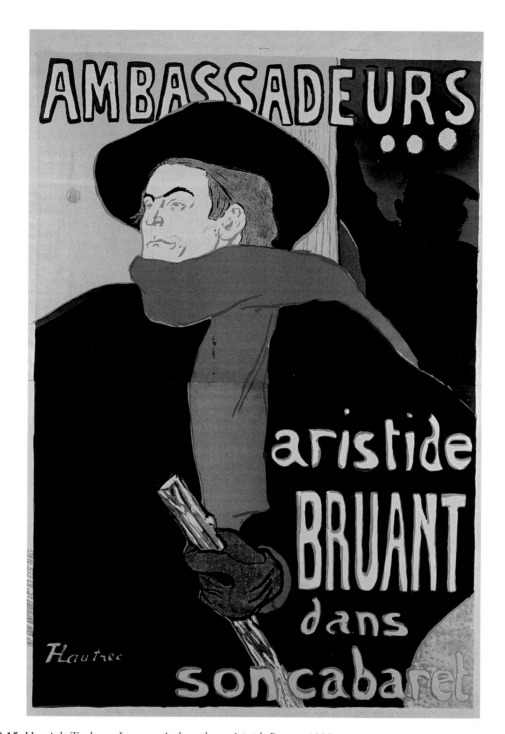

8.15 Henri de Toulouse-Lautrec. *Ambassadeurs: Aristide Bruant.* 1892.
Color tusche and spatter lithograph. 52$\frac{15}{16}$" × 36$\frac{1}{4}$".
The Baltimore Museum of Art: Nelson and Juanita Greif Gutman Collection, BMA 1951.69.4. Photography by Mitro Hood.

modern compositions influenced graphic designers for several decades. Among his most vivid works is *Ambassadeurs: Aristide Bruant* (**fig. 8.15**), the poster that he created for Aristide Bruant's engagement at an upscale nightclub (see facing page).

Most books that have pictures are printed today with a version of lithography called **offset**. Each page image is burned onto a metal lithographic plate and then inked, but the ink is first transferred, or offset, onto a rubber cylinder before printing on paper. This method, which is suited to rotary presses, gives uniform ink depth across an entire printing. It is used to print this book and many others.

FORMING ART

Henri de Toulouse-Lautrec (1864–1901): Printing from Life

8.16 Henri de Toulouse-Lautrec in his studio.
Photograph courtesy of Patrick Frank.

The cabaret singer Aristide Bruant provides an important key to the work of Henri de Toulouse-Lautrec, because the two were friends who inhabited the nocturnal world of the bar and the nightclub. The artist's relationship with Bruant helped to shape some of his lithographic creations.

Bruant as a teenager had lived in the poor neighborhoods of Paris, where he befriended people on both sides of the law. He even obtained passes to enter the prison of La Roquette, where executions were carried out. Bruant used these experiences in his songs, which were laden with sad social commentary about the poor and the desperate. He was among the most popular singers of the day.

When Bruant opened his own cabaret in 1885, Toulouse-Lautrec became one of its most

devoted patrons; the following year, the singer put the artist's work on permanent display at the club. Toulouse-Lautrec in turn created a lithographic portrait of Bruant (**fig. 8.17**). In this work, we see the singer's unconventional attire, with broad-brimmed hat and bright neck wrap.

We also see the artist's fluid and creative use of the lithographic medium. He used crayons of various widths for the lines, and tusche for the solid dark areas. He created the white patches at the right by dropping melted wax on the stone, keeping ink away from that part. The speckles were created by spattering, as he flicked the bristles of an ink-laden brush.

For ten years, Bruant's cabaret flourished; his act, which included taunting the audience, drew crowds of people who made the trek out to the somewhat shady neighborhood of Montmartre. There they saw the aloof and somber singer perform his tragic songs.

When the upper-crust nightclub Les Ambassadeurs lured Bruant for an engagement in its fashionable area of Champs Elysées, the singer commissioned Toulouse-Lautrec to design a poster (see fig. 8.15). He responded with a rich creation in five colors, composed of a few, mostly flat, shapes in a large format unusual for that time. Each color required a separate lithographic stone. The deep blue area at the upper right

is a doorway where a sailor stands. Bruant's body fills most of the frame, bringing him close to the picture surface, overlapping the name of the club at the top. The two zones of the flaming red scarf converge near Bruant's head, leading us to the singer's distant and somewhat haughty demeanor in his face. Toulouse-Lautrec specialized in capturing such reserved emotional states. The poster also reflects Toulouse-Lautrec's careful study of Japanese printmakers, who often used

flat shapes in bright colors to depict nightlife scenes.

This poster was not an immediate success; the Ambassadeurs manager disliked the bold design, which was novel for its day. But Bruant loved it: "Am I that grand?" he reportedly remarked.[3] He insisted that hundreds be printed and plastered across Paris. They survive to this day, the originals mostly in museums, and many knock-off copies everywhere else.

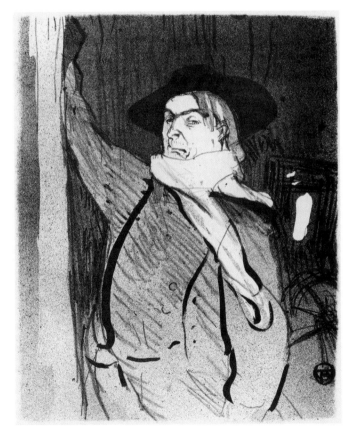

8.17 Henri de Toulouse-Lautrec.
Aristide Bruant. 1893. Lithograph. 10½" × 8¼".
National Gallery of Art, Washington D.C. Rosenwald Collection 1947.7.169.

Stencil and Screenprinting

In simplest terms, a **stencil** is a sheet with a design cut out of it; painting or spraying over the sheet transfers the design to the picture plane. Stencils are a quick way of making lettering or repeated designs on walls, but here we will consider them as a method for making multiple works of art.

Stencils are a favored method of street artists who communicate political messages, because they permit fast fabrication without the need for redrawing each time. (One such work, by the well-known street artist Banksy, is pictured in fig. 25.25.) A few stencil artists make objects of more subtle design, however. One of these is Kim McCarthy, a Seattle-based artist who

8.19 Screenprinting.

Watch a video about the process of silkscreen printing on myartslab.com

also uses the alias Urban Soule. Her *Urban Buddha* (**fig. 8.18**) shows many repeated patterns in the background that she achieved with stencils using blue and green paint. The black skulls and the dominant Buddha image were also sprayed through stencils. The drawback to using stencils is that only positive and negative spaces are produced; shading is not possible. McCarthy overcame this difficulty by adding many colors, brushstrokes, and paint drips. The trails of black and white paint suggest the quick execution of street art.

Screenprinting is a refinement of the technique of stencil printing. Early in the twentieth century, stencil technique was improved by adhering the stencil to a screen made of silk fabric stretched across a frame (synthetic fabric is used today). With a rubber-edged tool (called a squeegee), ink is then pushed through the fabric in the open areas of the stencil to make an image of the stencil on the material being printed (see Screenprinting diagram, **fig. 8.19**). Because silk was the traditional material used for the screen, the process is also known as **silkscreen** or **serigraphy** (from the Latin for silk, *sericum*).

Screenprinting is well suited to the production of images with areas of uniform color. Each separate color requires a different screen, but registering and printing are relatively simple. There is no reversal of the image in screenprinting—in contrast to relief, intaglio, and lithographic processes in which the image on the plate is "flopped" in the printing process. The medium also allows the production of large, nearly mass-produced editions without loss of quality.

Silkscreen printing thus lends itself to poster production, and many social movements have allied themselves with silkscreen artists to help spread the word about their causes. For example, Ester Hernández

8.18 Kim McCarthy. *Urban Buddha*. 2009.
Stencils and mixed media on canvas. 36″ × 48″.
Kim McCarthy.

8.20 Ester Hernández. *Sun Mad.* 1982
Silkscreen. 22″ × 17″.
Courtesy of the artist.

8.21 Elizabeth Murray. *Exile* from *Thirty-Eight.* 1993.
Twenty-three color lithograph/screenprint
construction with unique pastel application by the
artist. 30″ × 23″ × 2½″. Thirty-eight unique works.
© 2013 The Murray-Holman Family Trust/Artists Rights Society (ARS),
New York.

View the Closer Look for Elizabeth Murray's *Exile* on
myartslab.com

made hundreds of posters that asserted Chicano
identity and denounced the working conditions of
Mexican-American laborers. Her screenprint *Sun Mad*
(**fig. 8.20**) is both an excellent example of silkscreen art
and a memorable protest against the use of pesticides.

The latest development in screenprinting is the
photographic stencil, or **photo screen**, achieved by
attaching light-sensitive gelatin to the screen fabric.

Elizabeth Murray's *Exile* (**fig. 8.21**) takes screen-
printing and stenciling to the limit. The base of this
work is a piece of irregularly shaped yellow board
embossed with a pattern and screenprinted with a
design based on newspaper pages. Above this she laid
a jagged and perforated blue sheet, which was also
silkscreened and lithographed with colors. Finally,
she cut a large piece of red paper, screenprinted and
lithographed on it, and then set it above the other two
layers. All the layers show hand-drawn crayon and
pencil marks along with the printed colors. The artist
describes *Exile* as a "23-color lithograph and screen-
print construction with collage and pastel."[4]

Contemporary Approaches

Experimental printmaking in recent years has taken on
new types of printing materials, and digital technol-
ogy. More artists are also taking the idea of multiple
artworks into the third dimension. Each of these has
altered the boundaries of the medium.

African-American artist Ellen Gallagher leafed
through stacks of 50-year-old magazines directed at
a black audience, and borrowed advertisements that
encouraged people to erase their blackness in various
ways. She digitally scanned these ads and then altered
them by affixing mold-made plasticine shapes to their
surfaces (**fig. 8.22**). *"Mr. Terrific"* is one of 60 panels
that make up the larger work *Deluxe*. In this panel
we see a man holding a can of hair straightener called
Johnson's Ultra-Wave, which the ad says "will make
you *really* proud of your hair." Gallagher satirized this
1950s attempt at self-fashioning by attaching a huge
yellow blob that covers both hair and eyes. She said of
this work: "I'm creating fiction on top of an existing
readability."[5] All 60 panels of *Deluxe* were made in an
edition of 20.

Digital technology has altered printmaking at a
basic level by eliminating the tangible plate. A digital

8.22 Ellen Gallagher. *"Mr. Terrific"* from *Deluxe*. 2004–2005. Aquatint, photogravure, and plasticine. 13″ × 10″.
© Ellen Gallagher. Courtesy Gagosian Gallery.

matrix is made not by hand but with a keyboard and mouse. Some artists make digital prints using painting and photo-editing programs, and then erase the matrix files when the "edition" is complete. This technology allows for the creation of prints that are not original in the traditional sense because they are infinitely reproducible. In 2007, the English duo Gilbert and George (who do not use their last names) made a print available for free downloading on the Internet for 36 hours. The edition was limited not by the number of downloads, but by the clock.

Many printmakers today combine printmaking techniques with other kinds of media. One of these is Nicola López, who uses woodcut and lithography to create installations that are specific to each exhibition. In her 2006 work *Blighted* (**fig. 8.23**), she printed on Mylar, a transparent film. Her images of shattering buildings and tumbling structures are based on her memories of the attacks of September 11, 2001.

Related to the print is the editioned work, in which artists create molds that can generate a limited number of three-dimensional works. Artists make editioned works for many of the same reasons that they made prints in the past. Like a traditional print, an editioned work is made in multiple copies, but it may or may not use the traditional techniques. In a recent editioned work, Walter Martin and Paloma Muñoz borrowed the format of the snow globe to create haunting works with scenes of danger. Their series *Travelers* shows tourists and hikers in precarious positions. In *Traveler CLXXXVI* (**fig. 8.24**), a snowbound hiker has stumbled on a rabbit hole which is occupied by two very large specimens of menacing size. The mysterious atmosphere of this work collides in a darkly humorous

8.23 Nicola López. *Blighted*. 2006. Woodblock and lithography on mylar. 20′ × 22′.
Caren Golden Fine Art/Nicola Lopez.

8.24 Walter Martin and Paloma Muñoz.
Traveler CLXXXVI. 2006. Mixed media.
9″ × 6″ × 6″.
2006 © Walter Martin & Paloma Muñoz.

way with the cheap and sentimental prototype of the snow globe. The artists created this work in an edition of 250, filling the globe with plastic snowflakes like the souvenir-shop versions that they parody. Shaking the globe only adds to the scene's humorous aspect.

As we have seen in the examples in this chapter, prints have been used throughout the centuries to produce multiple copies of an image. Because printmaking is less expensive than other media, and can be more easily distributed, works can reach a wider audience.

✓●—**Study** and review on myartslab.com

THINK BACK

1. Why do artists make prints?

2. What are the principal techniques of printmaking?

3. How are today's artists varying the traditional techniques?

TRY THIS

In 2009, the Associated Press filed a copyright lawsuit against the artist Shepard Fairey for his use of a news photo of President Barack Obama in a lithographic poster titled "Hope." Fairey claimed that he had transformed the photo enough that the poster amounted to a new creation. The case was settled in 2011 under terms that neither party was allowed to disclose. Research the case with online materials, and form an opinion: How original was Fairey's print?

KEY TERMS

intaglio – any printmaking technique in which lines and areas to be inked are recessed below the surface of the printing plate

matrix – the block of metal, wood, stone, or other material that an artist works to create a print

offset lithography – lithographic printing by indirect image transfer from photomechanical plates

registration – in color printmaking or machine printing, the process of aligning the impressions of blocks or plates on the same sheet of paper

relief printmaking – a technique in which the parts of the printing surface that carry ink are left raised, while remaining areas are cut away

screenprinting – a technique in which stencils are applied to fabric stretched across a frame and paint or ink is forced through the unblocked portions of the screen onto paper or another surface beneath

PHOTOGRAPHY

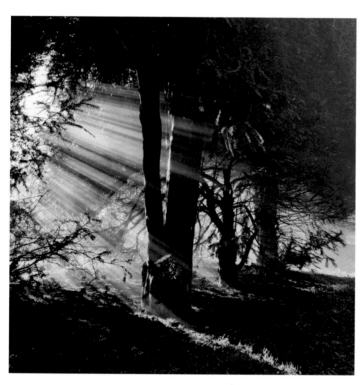

9.1 Jane and Louise Wilson. *The Silence Is Twice as Fast Backwards I.* 2008. Photograph (C-print). 72″ × 72″.
Courtesy 303 Gallery, New York.

((•— **Listen** to the chapter audio on myartslab.com

Jane and Louise Wilson's photograph *The Silence Is Twice as Fast Backwards I* (**fig. 9.1**) captures a magical moment in a lush, green forest. It appears as if the artists went for a morning walk and stumbled upon a wooded glade, flooded with streaking sunlight. The original picture is 6 feet square, filling our entire field of vision. The image is irresistible: Viewers want to dive right into the scene.

The word *photography* literally means "light-writing," although a more accurate description would be "light-drawing." Like drawing, photography can be either a practical tool or an artform. Beyond its many uses in journalism, science, advertising, and personal record keeping, photography offers artists, such as Jane and Louise Wilson, a powerful means of expression.

Beyond selecting camera, lens, and film, a skilled photographer makes many choices about composition, angle, focus, distance, and light. The Wilson sisters carefully composed *The Silence Is Twice as Fast Backwards I*. The three trees are perfectly positioned in the frame, and the branch that leads our eye in from the lower left points upward to connect with the foliage of the second tree. Note also how the branch at the lower right seems to parallel the one at lower left

in a rhythmic repetition. These curving branches lie at a roughly 90-degree angle to the sun's rays that stream in from the upper left. The artists seem to have set the exposure of the shot perfectly as well, so that details are visible even in intense light and darkness. And one more fact completes this photo's contrivances: To create the effect of sunlight, the artists loosed some mist into the scene before shooting it.

In this chapter we will consider how photography has evolved since the mid-nineteenth century from a tool for capturing people and places into an established artform. We will also consider its use as a means of encouraging social change, and look at the impact of the digital revolution.

The Evolution of Photography

The basic concept of the camera preceded actual photography by more than three hundred years. The desire of Renaissance artists to make accurate depictions of nature was the original impetus behind the eventual invention of photography.

The forerunner of the modern camera was the **camera obscura**, literally "dark room" (**fig. 9.2**). The concept of photography grew out of the fact that reflected sunlight passing through a small hole in the wall of a darkened room projects onto the opposite wall an inverted image of whatever lies outside. In the fifteenth century, Leonardo da Vinci described the device as an aid to observation and picture making.

As a fixed room, or even as a portable chamber, the camera obscura was too large and cumbersome to be widely used. In the seventeenth century, when inventors realized that the person tracing the image did not have to be inside, the camera obscura evolved into a portable dark box. During the course of this pre-camera evolution, a lens was placed in the small hole to improve image clarity. Later an angled mirror was added to right the inverted image, enabling anyone, skilled or unskilled, to trace the projected pictures with pen or pencil.

Photography became possible when scientists discovered that certain chemicals were sensitive to light. Thus, it was not until about 1826 that the first vague photographic image was made by Joseph Nicéphore Niépce. He recorded and fixed on a sheet of pewter an image he made by exposing the sensitized metal plate

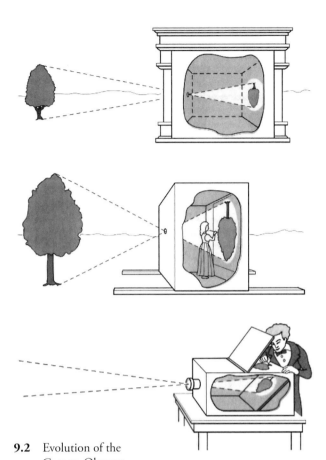

9.2 Evolution of the Camera Obscura.
Top: Sixteenth-century camera obscura.
Middle: Seventeenth-century portable camera obscura.
Bottom: Seventeenth- to nineteenth-century table model camera obscura.

to light for eight hours. During the next decade, the painter Louis-Jacques-Mandé Daguerre further perfected Niépce's process and produced some of the first satisfactory photographs, known as **daguerreotypes**. He made them by exposing iodized silver plates in the presence of mercury vapor; images were fixed on the plate with a mineral salt solution.

At first, because the necessary exposure times were so long, photography could record only stationary objects. In Daguerre's photograph *Le Boulevard du Temple* (**fig. 9.3**), taken in Paris in 1839 (the year his process was made public), the streets appear deserted because moving figures made no lasting light impressions on the plate. The exposure time for this plate was about a half hour. However, one man, having his shoes shined, stayed still long enough to become part of the image. He is visible on the corner in the lower left, the

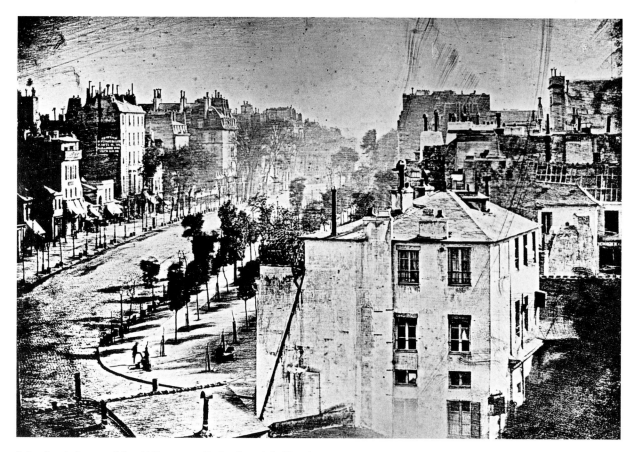

9.3 Louis-Jacques-Mandé Daguerre. *Le Boulevard du Temple.* 1839. Daguerreotype.
Bayerisches National Museum, Munich (R6312).

first person ever to appear in a photograph. It was a significant moment in human history: At last images of people and things could be made without the hand of a trained artist. Although some painters at the time felt the new medium was unfair competition and spelled the end of their art, the invention of photography actually marked the beginning of a period when art would be more accessible to all through photographic reproductions; it also marked not the end but the beginning of new approaches to painting, complemented by the new art of photography.

Before the development of the camera, only the wealthy could afford to have their portraits painted. By the mid-nineteenth century, people of average means were going in great numbers to photography studios to sit, stiff and unblinking, in bright sunlight for five to eight seconds to have their portraits made with the camera.

From the beginning, portrait painting greatly influenced portrait photography. One of the first great portrait photographers was Julia Margaret Cameron. By 1864, she had become an avid photographer,

creating expressive portraits. Cameron pioneered the use of close-ups and carefully controlled lighting to enhance the images of her subjects, who were often family members and famous friends. Her photo titled *Paul and Virginia* (**fig. 9.4**) shows many of her concerns. She finely crafted her exposure to allow enough light to perfectly define the children's round bodies and their disheveled clothing. She posed them off-center, and created a dynamic balance with the umbrella and its diagonal. The two children are known to us from other photos, but Cameron titled the work after a popular novel about a pair of shipwrecked children. She suggests the atmosphere of the novel in both the title and the poses.

Many nineteenth-century photographers were heavily influenced by painters. Many painters, meanwhile—now freed by photography from their ancient role as recorders of events—were greatly influenced by photography. Shorter exposure times, less-toxic technology, and printing on paper all helped to popularize photography as the nineteenth century progressed.

9.4 Julia Margaret Cameron. *Paul and Virginia*. 1864. Albumen print. 10″ × 7⅞″.
J. Paul Getty Museum, Los Angeles. 84.XZ.186.3.

Photography as an Artform

In the beginning, the public was reluctant to accept photography as an art because of its reliance on a mechanical device. Today, however, most people agree that the camera can be a vehicle for personal expression and symbolic communication. An early crusader in the art photography movement was the American Alfred Stieglitz, who opened a photography gallery in New York City in 1905. He also founded an influential magazine, *Camera Work*, which published photography along with essays about modern art and culture.

Stieglitz's own photography was almost always "straight"—that is, produced with no technical manipulation of the negative. His 1901 photograph *Spring Showers, New York* (**fig. 9.5**) is a superb exercise in tonal control because it effortlessly handles subtle gradations of texture and shade. The wet street looks different from the sidewalk, for example, as both differ from the misty sky with its looming buildings in the distance. Stieglitz created and exhibited photos to show that photographers could be as skilled as painters in capturing and interpreting the world around them. In early photographs such as this one, he revealed the poetry he found in everyday urban scenes.

9.5 Alfred Stieglitz. *Spring Showers, New York.* 1901. Photograph. 3¾″ × 1½″.

Courtesy of George Eastman House, International Museum of Photography and Film © 2013 Georgia O'Keeffe Museum/ Artists Rights Society (ARS), New York.

✹ **Explore** the Discovering Art tutorial on photography on myartslab.com

9.6 Henri Cartier-Bresson. *Place de l'Europe Behind the Gare St.-Lazare, Paris.* 1932. Photograph.

© H. Cartier-Bresson/Magnum Photos.

🔍 **View** the Closer Look for the technique of black-and-white photography on myartslab.com

French photographer Henri Cartier-Bresson captured a subtle moment of drama in *Place de l'Europe Behind the Gare St.-Lazare, Paris* (**fig. 9.6**). Here he released the shutter at exactly the right moment to capture a man leaping over a puddle. The man's shape is echoed in both his own reflection and that of the dancer in the poster behind, just as semicircular ripples find a parallel in the round shapes close by in the water. For Cartier-Bresson, good photography is a matter of capturing the decisive moment:

> To me, photography is the simultaneous recognition, in a fraction of a second, of the significance of an event as well as of a precise organization of forms which give that event its proper expression.[1]

If Cartier-Bresson and Stieglitz wake us up to everyday poetry that we might not otherwise notice, Manuel Álvarez Bravo seeks out jarring surprises in the urban environment. His photo *Two Pairs of Legs* (**fig. 9.7**) combines a billboard and a building site. The subjects of this work seem to ascend in pairs, starting with the legs from a shoe advertisement. Above that is a pair of lamps, and further up a pair of (doubled) windows from an office building under construction. Other pleasant revelations await the careful viewer: the parallel between the woman's skirt and the shadow of the awning, which creates a "skirt" on the man; the shadows of the lamps as they collide with the rectilinear pieces of the billboard; the way the bodies seem to disappear into the building above; and how the photographer's angle of vision makes room for the sign at the top.

9.7 Manuel Álvarez Bravo. *Two Pairs of Legs*. 1928–1929. Gelatin silver print. 6½" × 9½".
© Colette Urbajtel/Archivo Manuel Álvarez Bravo SC.

Other photographers went beyond the camera itself to achieve more inventive effects. Man Ray made innovative photographs, which he called "rayographs," by placing objects on light-sensitive paper and exposing them to sunlight. The rayographs are not really photographs, because they are not "pictures" of anything and no cameras or lenses are used. Rather, they are visual inventions recorded on film. Sometimes, as in the work pictured here (**fig. 9.8**), it is not even clear what the original subject was.

9.8 Man Ray. *Rayograph.* 1927.
Gelatin silver print. 11⁷⁄₁₆″ × 9⅛″.
Private Collection/The Stapleton Collection/The Bridgeman
Art Library. © 2013 Man Ray Trust/Artists Rights Society
(ARS), NY/ADAGP, Paris.

Photography and Social Change

Each generation produces its own memorable photographs. Such photographs move us not only because of the way their subjects are presented, but also because we know the photographer was there. We join the photographer as witnesses. The significance of such images lies not only in their ability to inform us, but also in their power to stir our emotions.

Only a few decades after the invention of the medium, photographers began to bring public attention to suffering caused by war, poverty, hunger, and neglect. The new tool made visual statements believable in ways that no other medium could. Of all the arts, photography is uniquely suited not only to documenting events and social problems, but to bringing about empathetic awareness that can lead to reform.

An early leader in the use of photography for social change was the Danish-born American Jacob Riis. In the late nineteenth century, he photographed squalid living and working conditions in poor areas of New York and published them for the world to see. Photographs such as *Five Cents a Spot* (**fig. 9.9**) drew public attention that led to stricter housing codes and improved work safety laws. The vividness of this photo was made possible by the recent invention of flash photography, which took the camera into unforeseen places. His most famous book, *How the Other Half Lives*, was a landmark in the social impact of photography.

For most of the twentieth century, photography enjoyed an unquestioned reputation as a vehicle of truth, giving rise to the saying, "The camera never lies." During the 1930s, Margaret Bourke-White introduced the concept of the photographic essay—an approach that other photographers soon adopted. A photo essay is a collection of photographs on a single subject, arranged to tell a story or convey a mood in a way not possible with a single photograph. She documented construction projects, industrial plants, foreign customs, and Depression-era poverty in many such works. On assignment to document the effects of a flood in 1937, she created *Louisville Flood Victims* (**fig. 9.10**), one of the iconic images of the Depression in the United States.

In addition to focusing on social problems, photography has aided the efforts of environmentalists. Ansel Adams often used his photographs to increase public awareness of the need for conservation of the natural environment. His *Clearing Winter Storm, Yosemite National Park* (**fig. 9.11**) reflects the symphonic grandeur of nature's design. It renders the cathedral-like Yosemite Valley as an orchestration in black and white, where stark rock mingles with soft mist. Adams viewed aspects of nature as symbols of spiritual life, capable of transcending the conflicts of society. In his majestic black-and-white photographs, nature becomes a timeless metaphor for spiritual harmony.

Today's environmental photographers are more likely to focus on climate change or environmental degradation. Gary Braasch, for example, has been photographing the diminishing habitat of polar bears since 2000. His photo *Polar Bear Outside Barrow, Alaska* (**fig. 9.12**) gives vivid evidence of warmer temperatures in the Arctic regions and testifies to the power of a picture to wake us up to a new environmental issue.

9.9 Jacob Riis. *Five Cents a Spot.*
Unauthorized lodging in Bayard
Street Tenement. c.1890.
Gelatin silver print. 6³⁄₁₆″ × 4¾″.
Museum of the City of New York, The Jacob A. Riis
Collection (#155) (90.13.4.158).

9.10 Margaret Bourke-White. *Louisville Flood Victims.* 1937. Photograph.
Time & Life Pictures/Getty Images.

9.11 Ansel Adams. *Clearing Winter Storm, Yosemite National Park, California.* 1944. Photograph.

9.12 Gary Braasch. *Polar Bear Outside Barrow, Alaska.* 2008.

Color Photography

Photography began as a black-and-white (sometimes brown-and-white) process. For the first one hundred years, black and white was the only practical option for photographers. Through much of the twentieth century, technical problems with color persisted: Film and printing papers were expensive, and color prints faded over time. Even when fairly accurate color became practical, many photographers felt that color lacked the abstract power of the black-and-white image.

The development of color photography began in 1907 with the invention of positive color transparencies. In 1932, the Eastman Kodak Company began making color film. The key invention came in 1936 with Kodachrome film, which substantially improved the versatility and accuracy of color photography. Later progress improved the relative permanence of color prints.

Through the 1960s, most art photographers disdained color film, first because the negatives were unstable, later because color was associated with family snapshots and tourist photographs. But when William Eggleston exhibited his color work at the Museum of Modern Art in 1976, the world took notice and a new branch of art photography was born.

Eggleston's pictures from the *Los Alamos Portfolio* are elegant compositions of everyday things. In *Untitled* (*Nehi Bottle on Car Hood*) (**fig. 9.13**), two cars block out an abstract composition of off-balance diagonals against a paved background darkened by wedges of shadow. The soda bottle seems perfectly positioned to both anchor the composition and capture the sunlight. Besides the skillful arrangement, the photo rivets our attention because it immediately evokes a world: a casual social setting in some American rural area on a warm afternoon. To prove the validity of Eggleston's commitment to color photography, all we have to do is imagine this work in black and white.

9.13 William Eggleston. *Untitled (Nehi Bottle on Car Hood).* From *Los Alamos Portfolio.* 1965–1974. Color photograph.

Pushing the Limits

Artists have recently explored a variety of techniques to go beyond photography's assumed limits. British artist Susan Derges lays large sheets of photosensitive paper on the bottom of shallow ponds at night, and captures the look of the night sky through the water. She often shines a flashlight on the paper through surrounding bushes to compose ghostly nocturnes with

their shadows (**fig. 9.14**). She thus creates landscapes of a new kind, as if we were looking up from below the water's surface.

Vietnamese-born artist Binh Danh invented his own method of recording photographs onto plant material. He takes or borrows photographs and then attaches them to leaves from his garden. He then places the leaf and photo between layers of glass, and exposes them outdoors for up to several weeks on the roof of his house. The sunlight transfers the photographic images to the leaves, in a process he calls chlorophyll printing.

Danh most often uses images of the victims of warfare in Southeast Asia to create haunting works that memorialize the dead. In the *Iridescence of Life* series (**fig. 9.15**), he embedded the printed leaves in resin, and paired them with butterfly specimens. The resulting works seem fragile, precious, and beautiful.

Some artists use photographs themselves as artifacts, a new method of "taking" a picture. Zoe Leonard gathered over four thousand postcards that depict Niagara Falls and hung them in a large array in

9.14 Susan Derges. *Gibbous Moon Cloud*. 2009. Unique ilfochrome print. 66½″ × 36″.
Purdy Hicks Gallery, London.

9.15 Binh Danh. *Iridescence of Life #7*. 2008. Chlorophyll print, butterfly specimen, and resin. 14″ × 11″ × 2″.
Courtesy of the artist and Haines Gallery.

Watch a podcast interview with contemporary photography dealer Stephen Wirtz on my artslab.com

FORMING ART

Binh Danh (b. 1977): Reconstructing Memories

9.16 Binh Danh.
Courtesy of the artist.

If a photograph is a repository for memories, then Binh Danh is creating them for both himself and his viewers. At the time of his birth in Vietnam, the Khmer Rouge regime in neighboring Cambodia was eliminating dissidents of all kinds in a genocide that eventually claimed nearly two million victims. Danh migrated to the United States with his refugee parents in 1979. His unique versions of photography poetically reconstruct a difficult past.

"I am half Cambodian," he said. "My father is Cambodian and my mother is Vietnamese. The Khmer Rouge were pretty much exterminating any foreigners in the country, including people who wore glasses, who drank milk, who were artists, or Buddhist monks, Catholic nuns."[2] Because he has no memory of his homeland, he reconstructed it through the landscape.

"You could call me a landscape photographer, because I'm looking at the landscape, but instead of just photographing the landscape, I'm looking into the landscape, into the earth, underneath the soil, into the cells of plants."[3]

The face that emerges from *Iridescence of Life #7* (see fig. 9.15) came from the Genocide Museum in Cambodia, which holds thousands of photos that the Khmer Rouge methodically took of their victims. Danh said, "I have tried to show how like plants humans are; we participate in the kinetics of events and the process of creating memories by absorbing the history around us—and, like leaves, we wither and eventually die. The residue of our existence nourishes the memories of the living like a decaying leaf nourishes the soil."[4]

However, the victims gain a new life through his work: "When I remove a negative off of one of these leaves I have been printing in the sun for several weeks, there is such a wonderful feeling, a magical quality of this picture emerging."[5] The butterfly alongside similarly emerges from the chrysalis to begin a radiant new phase of life.

Danh also took an interest in the daguerreotype process, in which an image is exposed on a treated metal plate, and developed with mercury vapor.

"They called the daguerreotype a mirror with a memory; it is a mirror you hold up to yourself, and it remembers who you are; it has a ghostly quality to it."[6] The daguerreotypes that he made, such as *Angkor Wat* (**fig. 9.17**), also recall old photographs that early European colonizers took of that region. We see not only the subject of the image, but also the passing of the intervening time.

"These specific photographic processes allow me to exhume the landscape and all of its metaphors. I consider this work social documentary. For me, social documentary examines historical events and their relation to our contemporary lives."[7]

9.17 Binh Danh. *Angkor Wat.* 2008. Daguerrotype. Plate 9″ × 12″. Edition Variée of 4.
Courtesy of the artist and Haines Gallery.

9.18 Zoe Leonard. *You See I Am Here After All.* 2008. Approximately 4,000 postcards. Variable dimensions. Installation view, Dia:Beacon, Riggio Galleries, Beacon, New York, 2009.
© the artist, courtesy Galerie Gisela Capitai, Cologne, Germany. Photo Bill Jacobson.

a gallery installation that she called *You See I Am Here After All* (**fig. 9.18**). Niagara Falls is, of course, one of North America's premier tourist destinations, and generally people send postcards to relatives as a way of marking their presence at such famous places. The artist's collection of postcards begins in the early twentieth century, shortly after the postal service first began accepting postcards for mailing. She grouped similar views and spread them out over a 20-foot mural-sized installation. An awe-inspiring natural site thus became a module for seemingly endless repetition.

The Digital Revolution

Near the end of the twentieth century, the chemical photographic negative began to go out of fashion under the impact of the new digital technology. Now most cameras do not use film; rather, the lens focuses information onto an array of sensors that translate the hue and intensity of light into digital files. Using photo-editing computer programs, these files can be manipulated in almost infinite ways, and reproduced endlessly.

The implications of these changes are profound. If a photo can be altered, then its reputation as a vehicle of truth is in danger, and the camera can indeed lie. And the reproducibility of images means that the specialness of a photograph is much reduced. Many contemporary photographers take advantage of these facts.

Jeff Wall, for example, calls himself a "near-documentary" photographer. He creates scenes that seem vividly "real," yet they retain a decidedly stagy quality. *Boy Falls from Tree* (**fig. 9.19**) seems a matter-of-fact photo of an unfortunate (but not entirely uncommon) event. Yet he created it at his computer by combining several related photos. Photographing the falling boy in motion would require a fast exposure that would make it impossible to render the rest of the backyard perfectly in one shot. But today's digital cameras enable such effects. Wall also takes full advantage of the high-resolution technology by blowing up his pictures to maximum size, in this case about 8 by 10 feet. We are left wondering what is real and what is manipulated in this too-perfect picture of a minor calamity.

As we have seen, the invention of photography and the increasing availability of cameras and photographs has had a significant impact on the way we see and interpret our world. As Edwin Land, inventor of the Polaroid instant camera, said, "At its best, photography can be an extra sense, or a reservoir for the senses. Even when you don't press the trigger, the exercise of focusing through a camera can make you better remember thereafter a person or a moment. . . . Photography can teach people to look, to feel, to remember in a way that they didn't know they could."[8]

✓— Study and review on myartslab.com

9.19 Jeff Wall. *Boy Falls from Tree*. 2010.
Color photograph. 92″ × 123″.
Courtesy of the artist and Marian Goodman Gallery, New York.

THINK BACK

1. How and when was photography invented?

2. Who took the lead in making photography an artform?

3. Why is photography a useful medium for influencing social change?

4. What impact has digital technology had on photography in the twenty-first century?

TRY THIS

Try to think of a recent example of citizen-journalists influencing public awareness of events through rapid transmission of photographs.

KEY TERMS

camera obscura – the forerunner of the modern camera, a dark room (or box) with a small hole in one side, through which an inverted image of the view outside is projected onto the opposite wall, screen, or mirror, and then traced

daguerreotype – a photograph taken by an early photographic process developed in the 1830s, in which a treated metal plate was exposed to light, and the chemical reactions on the plate created the first satisfactory photographic images

10

MOVING IMAGES: FILM AND DIGITAL ARTS

THINK AHEAD

10.1 Trace the development of motion pictures from its origins in photography.

10.2 Describe technical innovations and effects used to make motion pictures.

10.3 Discuss how political concerns about film's popular influence has affected motion pictures.

10.4 Identify and describe landmark films by directors in popular and experimental cinema.

10.5 Distinguish the commercial role of television from art using video and other electronic media.

The first experimental color film ever seen in Germany had to be shown under false pretenses. The year was 1933 and the film was *Circles* by Oskar Fischinger (**fig. 10.1**). It was a nonrepresentational film, composed of dancing and interlocking rings and circles that moved and evolved across the screen, accompanied by dramatic orchestral music. Only a few minutes in length, it was screened together with entertaining black-and-white feature films. The public seemed to enjoy Fischinger's experiment in color and form.

However, those were the years in which the Nazi party suppressed all forms of abstract art, which they regarded as "degenerate." In order to avoid such censorship, Fischinger made *Circles* as an advertisement for a public relations company; the last few moments of the film display the name of the company and an advertising slogan. Finding Nazi browbeating intolerable, Fischinger left Germany for Los Angeles in 1936.

This story illustrates two important points: First, the cinema is a mass art closely monitored by those in authority; and second, creative people have been making experimental films for generations. In this chapter we will examine films that have broken new creative ground, some in the mass market and others in smaller, more artistic circles. We will also look at how the digital revolution has led to the creation of new artforms and new ways of presenting artworks.

10.1 Oskar Fischinger. *Circles.* 1933–34. Film still.
© Fischinger Trust, courtesy Center for Visual Music.

((•─ **Listen** to the chapter audio on myartslab.com

Film: The Moving Image

Before the advent of movies in the late nineteenth century, it was discovered that looking at rapidly changing short sequences of still drawings gave the illusion of motion. By spinning drawings depicting various stages of a movement in a magic lantern, or flipping them in a flip book, viewers experienced a flickering appearance of movement. The magic lantern and flip book phenomena led the way to the invention of **cinematography** (the art of photography and camerawork in filmmaking). When camera lenses and film evolved to the point where they could capture clear photographs of each stage of an object in motion, technology made motion pictures possible.

The art of cinema made a major advance when Leland Stanford (the founder of Stanford University) made a bet in 1872 that all four of a horse's hooves came off the ground simultaneously when it ran. To settle the bet, he commissioned photographer Eadweard Muybridge to find a way to capture the horse's motion in pictures. After a few blurry photos settled the bet, Muybridge improved the documentation by commissioning faster exposure mechanisms. He then lined up a series of still cameras close together alongside a California racetrack; each camera shutter was fixed with a string that the horse's front legs tripped as it ran by. The resulting pictures of *The Horse in Motion* (**fig. 10.2**) dramatically proved Stanford correct. After Muybridge later discovered a way to project his still photographs in rapid succession, he made the first primitive cinema. He called his invention a zoöpraxiscope (fortunately for all of us, the name did not survive). Others soon began experimenting with sequences of projected photographs, and cinematography was born, changing forever the way we see movement.

Film and Visual Expression

First and foremost, a movie is a visual experience. The illusion of motion is made possible by the **persistence of vision**, the brief retention of an image on the retina of our eyes after a stimulus is removed. Film's rhythmic, time-based structure makes motion picture photography a very different sort of visual art from painting or from still photography. A painter or photographer designs a single moment, but a filmmaker designs sequences that work together in time.

Each piece of film photographed in a continuous running of the camera is called a **shot**. Film makes possible a dynamic relationship among three kinds of movement: the movement of objects within a shot, the movement of the camera toward and away from the action, and the movement created by the sequence of shots.

Much of the power of film comes from its ability to reconstruct time. Film is not inhibited by the constraints of clock time; it can convincingly present the past, the present, and the future, or it can mix all three in any manner. Film time can affect us more deeply than clock time, because film sequences can be constructed to approximate the way we feel about time. In addition to editing, filmmakers can manipulate time by slowing or accelerating motion. The filmmaker's control over time, sequence, light, camera angle, and distance can create a feeling of total, enveloping experience so believable that it becomes a new kind of reality.

10.2 Eadweard Muybridge. *The Horse in Motion.* 1878. Photographs.
Courtesy of the Library of Congress LC-USZ62-45683 DLC.

10.3 Georges Méliès. *Voyage to the Moon*. 1902. Film still.

Early Techniques

The recognition of film as a significant artform came slowly. At first, film was simply a novelty. In order to gain public acceptance, early filmmakers tried to make their movies look like filmed theatrical performances. Actors made entrances and exits in front of a camera fixed in place, as though it too were a member of the audience at a stage play. These early films were also silent; the technology for recording sound on film was not perfected until more than 30 years after the first films were made.

One of the first important film makers was Georges Méliès, who began his career as a magician. By 1913 he had directed over 500 films, most of them just a few minutes in length and based on narration of a single event. He pioneered certain effects that are now standard in filmmaking, such as dissolves between scenes (fading instead of rapid cutting) and time-lapse photography (photographing slow-moving processes at regular intervals and projecting the resulting pictures rapidly). The fantasy *Voyage to the Moon* (**fig. 10.3**) is among his most highly regarded films. Four astronauts climb into a bullet-shaped projectile and are shot out of a huge cannon. On the lunar surface, they find a culture based on the popular conception of Pacific Islanders. Because silent films did not depend on spoken language, Méliès' films were enjoyed across the Western world.

Between 1907 and 1916, American director D. W. Griffith helped bring the motion picture from its infancy as an amusement to fuller stature as a means of artistic expression. Griffith introduced the moving camera by releasing it from its fixed, stagebound position in order to better express narrative content. The camera was placed where it would best reveal the dramatic meaning of each scene. A scene thus came to be composed of several shots taken from different angles, thereby greatly increasing the viewer's feeling of involvement.

Assembling a scene from several shots involves **film editing**, a process in which the editor selects the best shots from raw footage, then reassembles them into meaningful sequences and finally into a total, unified progression.

Later, Griffith used parallel editing to compare events occurring at the same time in different places (person in danger and the approach of would-be rescuer) or in different times, as in his film *Intolerance* (**fig. 10.4**), in which he cut back and forth among four stories set in four periods of history.

Griffith was the first to use the close-up and the long shot. Today the close-up is one of the most widely

10.4 D. W. Griffith. *Intolerance (The Modern Story).* 1916. Film still (*Belshazzar's Feast*).
The Museum of Modern Art/Film Stills Archive.

used shots; but when Griffith first wanted to try a close shot, his cameraman balked at the idea of a head without a body! In a long shot the camera photographs from a distance to emphasize large groups of people or a panoramic setting.

Directors and Artists: A Parallel Evolution

Following the Russian Revolution in 1917, Sergei Eisenstein emerged as a major film artist, honored as much in the West as in Russia. Eisenstein greatly admired Griffith's film techniques, but he developed them further, becoming one of the first filmmakers to produce epic films of high quality.

One of Eisenstein's major contributions was his skilled use of **montage** to heighten dramatic intensity. Introduced by Griffith in 1916, montage is the editing technique of combining a number of very brief shots, representing distinct but related subject matter, in order to create new relationships, build strong emotion, or indicate the passage of time. With the use of montage, a great deal seems to happen simultaneously, in a short time.

In his film *The Battleship Potemkin* (**fig. 10.5**), Eisenstein created one of the most powerful sequences in film history: the terrible climax of a failed revolt as army troops crush a protest. The montage of brief

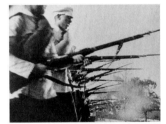

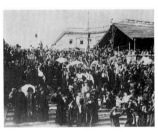

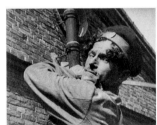

10.5 Sergei Eisenstein. *The Battleship Potemkin.* 1925. Selected frames from Odessa Steps sequence. Film stills.
The Museum of Modern Art/Film Stills Archive.

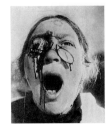
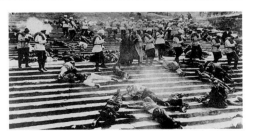

View the Closer Look for *The Battleship Potemkin* on myartslab.com

10.6 Salvador Dalí and Luis Buñuel. *Un Chien Andalou (An Andalusian Dog)*. 1929. Film still.
AF archive/Alamy.

👁 Watch *Un Chien Andalou* with commentary on myartslab.com

introduced two years earlier. Color was introduced in the 1930s; the wide screen and three-dimensional images in the 1950s.

By the 1930s, Hollywood had become the film capital of the world. Most Hollywood films simply repeated plot formulas already proven successful at the box office. Beginning in mid-1934, the major studios all adhered voluntarily to the Motion Picture Production Code Authority, which attempted to regulate the moral content of films. The Code forbade profanity in the script, as well as depictions of nudity, sexual activity, drug use, interracial romance, and ridicule of the clergy. It also prohibited the glamorization of crime, so that all criminals had to be arrested or killed in the end. Studios submitted scripts to the Code authorities prior to shooting, and any film that lacked a Code seal of approval had no chance of wide distribution. At times, Code strictures were relaxed somewhat: Clark Gable's famous farewell to Vivien Leigh in *Gone With the Wind* ("Frankly, my dear, I don't give a damn") remained in

shots, edited into a sequence of no more than a few minutes, effectively portrays the tragedy of the historic event. Rather than shoot the entire scene with a wide-angle lens from a spectator's perspective, Eisenstein intermixed many close-ups to give viewers the sensation of being caught as participants in the middle of the violence. The juxtaposition of close-ups and long shots gives audiences a powerful sense of the people's fear and the tragedy that took place.

A film resembles a collective dream, in which a group of people sitting in the dark experience the same vivid story. In 1929, Surrealist artists Salvador Dalí and Luis Buñuel took advantage of this fact when they made *Un Chien Andalou* (*An Andalusian Dog*) (**fig. 10.6**). Like our dreams, the film is a sequence of seemingly irrational events: Ants crawl out of a man's palm; two dead donkeys lie bleeding in a pair of grand pianos; a woman's eye is sliced open with a razor. The overall theme of the picture seems to be unrealized sexual desire, and at the end the man and woman are frozen in the soil like a pair of half-buried statues. The manifest illogic of *An Andalusian Dog* influenced the hallucinatory content of music videos decades later.

An Andalusian Dog is silent with a musical accompaniment, but in fact synchronized sound had been

10.7 Orson Welles. *Citizen Kane*. 1941. Film still.
The Museum of Modern Art/Film Stills Archive.

10.8 Edgar G. Ulmer. *Detour*. 1945. Film still.

the film, but the producer paid a fine of $5,000 for it. The Code's authority declined in succeeding decades, but remained in effect until 1968, when the Motion Picture Association of America introduced the ratings system that is still in force today.

Many film critics rank the 1941 film *Citizen Kane* (**fig. 10.7**) as a landmark in cinema. Orson Welles coauthored the script, directed, and played the leading role in the thinly disguised biography of the newspaper tycoon William Randolph Hearst. Because of its aesthetic quality and meaningful social message, *Citizen Kane* immediately set new standards for filmmaking. The film employs an unprecedented array of cinematic devices: dramatic lighting that communicates feeling, distorted lenses, dialog that bridges breaks between scenes, and clever editing to show the passage of time. Welles and his cinematographer, Gregg Toland, also pioneered the use of extreme camera angles. The low-angle camera presents Kane (Welles) as a towering

presence; another such angle is the tilt, which emphasizes Kane's crooked politics. The film is also important for the life that it portrays. Hearst was the prototype of the media mogul who achieves fame and wealth by selling sensational news ("If the headline is big enough, it makes the news big enough," he says).

During the 1940s, a new style called **film noir** originated in Hollywood. These dark and brooding black-and-white films usually dealt with murder, sometimes committed by professional criminals, or sometimes by ordinary folks down on their luck who are tempted at the wrong moment. These films depict the dark side of the American Dream, few of them more grimly than *Detour* (**fig. 10.8**), in which the main character tries to illicitly collect a dead man's large inheritance, but ends up as a suspect in two murders. The film noir genre is based primarily on American detective fiction, filmed with expressive lighting and camera-angle techniques borrowed from *Citizen Kane* and the Europeans.

10.9 Federico Fellini. *La Dolce Vita*. 1961. Film still.
© INTERFOTO/Alamy.

Italian director Federico Fellini's 1961 film *La Dolce Vita* (*The Sweet Life*) foreshadows many of today's critiques of the mass media (**fig. 10.9**). Marcello Mastroianni plays the lead character, a tabloid journalist (also named Marcello) who makes his career reporting on sensations, scandals, and celebrities.

The protagonist follows the lifestyles of the rich and famous, dutifully attending spectacles of all kinds, from the exploits of American movie stars to decadent parties to religious visions. He frolics in a fountain at 4 A.M. with a starlet. He joins the media circus as thousands throng to a small town where two children say they saw the Virgin Mary. One of these fellow travelers is a photographer friend nicknamed Paparazzo (after the "pop" of the camera flash) and, ever since this film's release, intrusive photographers throughout the world have been called *paparazzi*. The film's construction facilitates its message: The director criticizes the sweet life by plunging into it, with long and loosely connected scenes.

Only occasionally did the lives of artists intersect successfully with those of Hollywood directors. In the late 1930s, Walt Disney recruited Oskar Fischinger to collaborate on *Fantasia* (see fig. 10.12), but the partnership was not a success because Disney opposed Fischinger's commitment to abstract art. In 1945,

however, Alfred Hitchcock worked more fruitfully with Salvador Dalí to create a dream sequence for *Spellbound*, in which lead character Gregory Peck relates a dream that unlocks his amnesia. By the 1960s, the separation between artists and directors was as complete as it would ever be. Most artists who made films considered their work "underground" and rarely showed it outside galleries and art venues. Sometimes an artist's experimental film influenced the mainstream, as happened with Kenneth Anger's *Scorpio Rising* (**fig. 10.10**).

This 1964 film is in effect a documentary about the rituals of a Brooklyn motorcycle gang. They fix their bikes, go to parties, take drugs, and even suffer deadly crashes. Anger filmed it all in highly saturated color above a soundtrack of pop songs of the day. *Scorpio Rising* memorably creates a world, with intercut footage from other films and music that comments on the main action. The film basically created the "biker movie" genre, and Hollywood directors such as Stephen Spielberg and Martin Scorsese have said that its mood-creating qualities influenced their own films.

The decline of the Production Code in the late 1960s released directors to explore formerly restricted story lines regarding relationships, violence, and sexuality. This led many directors to rethink the old genres, experimenting with characters and plots

10.10 Kenneth Anger.
Scorpio Rising. 1964. Film still.
Photofest.

in Westerns, thrillers, romances, and others. Robert Altman led this reconsideration in *The Long Goodbye* (**fig. 10.11**), a witty and knowing detective story adapted from a famous novel. The main character is Philip Marlowe, a hapless but hardworking private eye, set adrift in sunny and self-centered 1970s Los Angeles. He copes (barely) with several gangsters, a less-than-honest best friend, neighbors who meditate outdoors in the nude, and abusive police who suspect him of murder. Altman inserted many deft touches: every time Marlowe appears in any scene, he lights a cigarette; the musical score consists of one song, played in myriad arrangements; numerous references to previous detective movies ricochet through the script. The film repays study of earlier movies, and awareness of cinematic conventions, because it satirizes or undercuts many of them.

10.11 Robert Altman. *The Long Goodbye.* 1973. Film still.
Photos 12/Alamy.

10.12 Walt Disney. *Fantasia*. 1940. Film still
(*The Sorcerer's Apprentice*).
© Walt Disney Studios/Photofest.

Animation, Special Effects, and Digital Processes

Beginning in the 1930s, animators from the Walt Disney studio have meticulously explored the possibilities of animation. With *Fantasia* (**fig. 10.12**), Disney created a new form of film that integrated classical music, painting, dance, and drama with a mix of human cartoon characters as the stars.

Ideas for such animations were initially portrayed on **storyboards** (a series of drawings or paintings arranged in sequence), which were then used to visualize the major shots in the film. Layout artists made the story come alive as the spatial relationships were worked out, and animators then dramatized individual characters in each action sequence. Disney's goal was always to create characters who gave the illusion—at 24 frames per second—that they were not just moving, but thinking and feeling.

10.13 *Princess Mononoke*. 1997. Film still.
Moviestore collection Ltd/Alamy.

Some of the best animated films in more recent times have been made in Japan, where meaningful characters combine with epic story lines in visually stunning productions. One of the best of these was *Princess Mononoke* (**fig. 10.13**), a saga in which a warrior overcomes a curse as he defeats the evil effects of technology.

Special effects have been made possible in recent years by a merging of old techniques, such as animation, and new technology. Teams of artists and technicians work with producer-directors such as George Lucas, creator of the *Star Wars* series, to provide working sketches, models, animation, and sets that are fantastic yet believable. Industrial Light and Magic (ILM), the special effects division of Lucasfilm Ltd., was the leading special effects studio of the late 1970s and 1980s. Lucas was also responsible for the increased use of computers to edit film.

A new kind of film that shows today's more global society is the international co-production. Companies from several countries may collaborate in financing and distributing these films, so that the risk to any one of them is minimized.

A recent example is *Pan's Labyrinth* (**fig. 10.14**), a joint Spanish-American production by Mexican director Guillermo del Toro. The film shows what happens when imagination and reality intersect in the life of an 11-year-old girl in fascist-dominated Spain of the 1930s. Her difficult life under a cruel stepfather leads her to take refuge in a fantasy world populated by tiny flying fairies and trees that move, led by a faun who represents a kingdom beyond this world. He recognizes her as royalty, but she must first prove her status by performing certain tasks that cross the line between her fantasies and "real" existence. The film's principal theme is how imagination can help us cope with adversity, and its many vivid sets and characters are testimony to the director's visual creativity. *Pan's Labyrinth* has moments of both stunning beauty and aching horror; del Toro refuses to tell us which is real and which imaginary, leaving the final decision to us.

Today, the shift from photochemical film to digital processes is nearly complete, and this has important implications for both the creation and the enjoyment of film. Most major Hollywood studios are owned by large international corporations, and they have discovered that they can draw audience

interest around the world with movies that employ luxurious special effects with a fast-moving story line. Digital production, with its speed of composition and editing, greatly facilitates this type of cinema. To boost international receipts, these "blockbusters" generally do not rely on character development, local cultural traditions, or divisive social comment for their success, and some are promoted together with merchandise based on the film.

Digital projection also facilitates uniform worldwide distribution: Instead of heavy film cans, theaters now receive a DCP (Digital Cinema Package), a hard drive about the size of a paperback book which a worker plugs into a projection device. Soon the DCP will be replaced by satellite transmission for mass-market movies. Theaters that specialize in projecting curated programs of vintage cinema, or any work created on photochemical film, are vanishing.

One of the most recent blockbusters, Ridley Scott's *Prometheus*, exemplifies many of these trends. It was shot using multiple digital cameras to enable 3D projection, and it opened in 49 countries over a

10.14 Guillermo del Toro. *Pan's Labyrinth.* 2006. Film still.
AF archive/Alamy.

ten-day period in mid-2012. It has many scenes that seamlessly blend human actors with digital animation (**fig. 10.15**). The plot is the story of a multinational corporation's effort to find the origins of human life in a distant galaxy. The crew of the spaceship *Prometheus* is multi-ethnic, and it includes a robot who seems as human as some of the other actors.

10.15 Ridley Scott. *Prometheus.* 2012. Film still.
20th Century Fox/Photos 12/Alamy.

FORMING ART

Ridley Scott (b. 1937): Visualizing the Story

10.16 Ridley Scott.
Steve Granitz/Getty.

Film directors create by reading a script, and then envisioning a way to present it. Because Ridley Scott was trained first as a visual artist, drawing and storyboarding play a strong role in his creative process. He said, "The storyboard starts off in my mind as I'm reading the script. And I can literally get flashes of the location, which will very often give me a reason to choose that particular location. And I start to thumbnail, to scribble things down . . . The storyboard is the first look at the film."[1]

He excels in the types of film that demand the most imagination. His early works *Alien* (1979) and *Blade Runner* (1982) heavily influenced the visual style of many later science-fiction films. "What I do is create worlds," he said. "Whether it's historical or futuristic, creating a world is the most attractive thing to me about filmmaking because everything goes—it's a matter of drawing up your rule book and sticking to it."[2] Science

fiction is particularly attractive because it is "a futuristic fiction which could be possible."[3]

Prometheus was Scott's first digital sci-fi film, but it did not go as heavily into special effects as many contemporary blockbusters do. This is because Scott believes that "less is more": "When you see an explosion where no one could have survived that explosion, and the person is still running, then it's bull—. And that's frequently why [special-effects blockbusters] are just not as good, you know. Whereas when you've got to do it physically, you've got to be careful—like really careful. And it's different. With digital, the painting book is unlimited, and there are advantages and disadvantages to that."[4] Thus he does not automatically reach for animation sequences when actual filmed ones will serve as well.

Because of his art training, certain scenes in his films refer to historical art works far more often than with other directors. For example, at one point in *Prometheus* when the crew is exploring the target planet, one of the characters comes upon a three-dimensional planetarium (see fig. 10.15). The director based the digital apparatus on a well-known British painting from the eighteenth century (see *A Philosopher Gives a Lecture on the Orrery*, fig. 17.26).

Another innovative characteristic of Scott's films is the presence of strong

female characters, and this too reflects his background: "All the relationships in my life have been with strong women, and I think I get on better with them. My mother was a big part of bringing up three boys, so I accepted that as the status quo. Oddly enough, I find it quite engaging to be working with a female when I'm directing. There are a lot of men who feel they're being emasculated by having the woman in charge; I've never had that problem. The stronger the woman, the better for me."[5] Thus one of the principal heroes in *Prometheus*

is a woman, as is the lead character in *Alien*. The female leads in his other films *Thelma and Louise* and *G. I. Jane* are similarly strong.

But the visual aspects of his films are what make him one of today's leading directors. A critic wrote of his 1989 film *Black Rain* (**fig. 10.17**), "Light never simply comes through a window as it might in someone else's movie."[6] For Scott, the explanation is simple: "I've never lost the art school background, you see. Always draw the storyboards, and the old paintings."[7]

10.17 Ridley Scott. *Black Rain.* 1989. Film still.
© Paramount. Photograph: AF archive/Alamy.

10.18 Nam June Paik. *Video Flag Z.* 1986.
Multimedia, television sets, videodiscs,
videodisc players, and Plexiglas modular cabinet.
74″ × 138″ × 18½″.

Television and Video

Literally "vision from afar," television is the electronic transmission of still or moving images with sound by means of cable or wireless broadcast. Television is primarily a distribution system for advertising, news, and entertainment. Video is the medium for television; it can also be an artform.

Video Art

The Sony corporation set the stage for the beginning of video art in 1965 when it introduced the first portable video recording camera, the Portapak. Although the camera was cumbersome, some artists were drawn to the new medium because of its unique characteristics: The instant feedback of video did away with development times necessary for film. Video works could be stored on inexpensive cassettes, erased and re-recorded. In addition, because a video signal could be sent to more than one monitor, it allowed flexibility of presentation.

Early videos by artists were relatively simple, consisting mainly of recordings of the artists themselves performing, or of dramatic scenes staged with only a few actors or props. Because no editing was possible, and the black-and-white image was incompatible with the color resolution of television broadcasts of the time,

the medium was most suited to private screenings for small groups. In 1972, the compatibility issue was resolved with the introduction of standardized ¾-inch tape; this allowed artists to work with television production equipment, and even to broadcast the results of their labors. The 1980s brought vast improvements in video technology in the form of lighter cameras, color, and computerized editing.

In the short history of video art, some artists have consistently tried to expand the limits of the medium's technical capacities. The Korean-born Nam June Paik frequently used the video medium in a slyly humorous fashion to comment on the role of television in our lives. His 1986 work *Video Flag Z* (**fig. 10.18**), for example, uses 84 television sets in an array that resembles the American flag. On each monitor, portions of old Hollywood films flicker endlessly across the screens, as if our very national identity is made up of what we see in movies.

Other video artists have used the medium to create and tell stories using themselves as actors. In

10.19 Joan Jonas. *Volcano Saga.* 1987. Performance.
The Performing Garage, NY.

10.20 Matthew Barney. *CREMASTER 3.* 2002. Production still.
© 2002 Matthew Barney. Photo: Chris Winget. Courtesy Gladstone Gallery, New York.

Volcano Saga (**fig. 10.19**), Joan Jonas tells a story of a memorable trip to Iceland. Caught in a fierce windstorm, she is blown off the road and loses consciousness. Awakened by a local woman who offers help, the artist is magically transported back to ancient times in the company of Gudrun, a woman from Icelandic mythology who tells her dreams. The artist sympathizes with Gudrun's struggles in her ancient society, and returns to her New York home feeling kinship with women of the past. In the video, images move back and forth between past and present with the aid of overlays and an evocative musical score.

The cathode-ray television tube has now disappeared in favor of the flat screen monitor, and videotapes have given way to DVDs. Given the ease of shooting and editing digital video today, the line between video art and filmmaking has blurred. The five films of the *CREMASTER Cycle* by Matthew Barney were shot on digital video and are usually projected in art galleries, but part of *CREMASTER 3* (**fig. 10.20**) has been released on DVD as well.

These movies innovate in their elaborately symbolic storylines and expensive production values. Describing the plot of any of the *CREMASTER* movies is difficult, but plot is less important than the symbolic content that each movie has. The portion released on DVD is called "The Order," and it recounts an endurance test that the Apprentice must undergo by passing four ordeals at various levels of the Guggenheim Museum. Allusions to Masonic Orders, Mormon theology, heavy metal music, and famous convicted murderer Gary Gilmore only begin to describe the various layers of this video. The Apprentice passes through each obstacle, and thus gains the right to kill another character called

10.21 Doug Aitken. *Song 1*. 2012. Outdoor digital projections on Hirshhorn Museum building, Washington D.C.
Hirshhorn Museum and Sculpture Garden, Smithsonian Institution, Joseph H. Hirshhorn Bequest Fund and Anonymous Gift, 2012.
Courtesy Doug Aitken Studio and 303 Gallery, New York.

the Architect. The murder takes place at the Chrysler Building, but the building itself takes revenge by killing the Apprentice.

Doug Aitken takes video outdoors with projections that transform public spaces. His 2012 work *Song 1* (**fig. 10.21**) uses 11 high-definition digital projectors to completely wrap the circular Hirshhorn Museum in a 360-degree movie. It ran between sunset and midnight each night for eight weeks, and viewers could remain stationary or move at will, because Aitken composed the imagery in a plotless, non-linear fashion. He designed the rhythm of the projections in *Song 1* according to the 1934 classic pop song "I Only Have Eyes for You." For the soundtrack he recruited a long list of performers, including Beck, Tilda Swinton, Devendra Barnhart, and the punk band X. The work brought an entirely new dimension to the Hirshhorn's location on the highly symbolic space of the National Mall in Washington, D.C.

Digital Artforms

The art-making capacity of computer-linked equipment ranges from producing finished art, such as color prints, film, and videos, to generating ideas for works that are ultimately made in another medium. Computers are also used to solve design problems by facilitating the visualization of alternative solutions. The computer's capacity to store images in progress enables the user to save unfinished images while exploring ways of solving problems in the original.

The multipurpose characteristics of the computer have accelerated the breakdown of boundaries between media specializations. A traditional painter working with a computer can easily employ photo imaging or even add movement and sound to a work. A photographer can edit an image in almost any imaginable way.

Early computer art looks dull by today's standards. The first exhibition of computer-generated digital imagery took place in a private art gallery in 1965. Few claimed it was art. Most of the earliest digital

10.22 Vera Molnar. *Parcours (Maquette pour un Environment Architectural)*. 1976.
Courtesy of the artist. © 2013 Artists Rights Society (ARS), New York/ADAGP, Paris.

artists used computers to make drawings with a plotter: a small ink-bearing, wheeled device that moves over a piece of paper drawing a line in one color according to programmed instructions.

With the help of technicians, Vera Molnar made some of the most visually interesting of these early efforts, such as her digital 1976 work *Parcours* (**fig. 10.22**). The computer was programmed to create variations on a basic set of plotter movements, yielding a work that resembles a drawing quickly done by hand. In many of these early types of computer art, the plotter's motions were not entirely predictable, a fact that added to the attractiveness of the images. The expense and complexity of computer technology in those years, however, kept all but a few pioneer artists away from the medium.

The advent of faster computers, color printers, and interactive graphics radically changed the scenario in the mid-1980s; as the computer's capabilities grew, more artists began to take interest. Today, many photographers, filmmakers, designers, sculptors, and architects now use the computer to aid their projects. They may store and alter images, or they may use a 3D-modeling application to help visualize the shape of a design. For some artists, however, software and digital equipment are an essential part of their creative practice. Here are three recent projects that show some of the pathways artists are taking.

Lynn Hershman Leeson confronted the issue of digital simulation when she created the video cyborg *DiNA* (**fig. 10.23**). (The title comes from the phrase "digital DNA.") *DiNA* appears on a video installation in which viewers walk up to a microphone and interact with the virtual woman on the screen before them. *DiNA* is running for the imaginary office of Telepresident, and in her slightly disembodied cybervoice she invites viewers to use the microphone to raise questions and concerns. *DiNA*'s responses sound surprisingly intelligent for a machine, but she is linked to the Internet and searches in real time for text to use in response to viewer input. After interacting with *DiNA* for a few minutes, viewers learn that she takes

10.23 Lynn Hershman Leeson. *DiNA*. 2004. Artificially intelligent agent, network connection, custom software, video, and microphone. Dimensions variable.
Courtesy of bitforms gallery.

10.24 Nova Jiang. *Ideogenetic Machine.* 2011. Interactive installation. Dimensions variable. Installation shot.
OK Offenes Kulturhaus/Center for Contemporary Art, Linz/Austria. Photograph: Otto Saxinger.

moderately liberal positions on abortion and capital punishment, for example. Most viewers conclude either that *DiNA* could indeed run for office, or that she seems more thoughtful than most politicians. Her campaign slogan is "Artificial intelligence is better than no intelligence." In an age when telling the real from the prepackaged is difficult, *DiNA* complicates the issue in a memorable way. The artist created a campaign Web site in time for the 2004 presidential elections and stocked it with "live footage," just to ensure that *DiNA*'s positions on the issues would be available to voters.

Some digital works take advantage of motion-sensing capabilities to build works in real time. Nova Jiang's work *Ideogenetic Machine* (**fig. 10.24**) takes the motions of spectator-participants, filters them through software, combines them with a database of the artist's drawings, and puts out a comic book based on all of it in real time. Each installation of the work leads to a new comic creation, which the participants can download in PDF format at the end of the evening. The comic book comes with empty speech bubbles so that viewers can invent their own stories to accompany the pictures.

Some artists create work for today's handheld tablet devices. One fairly sophisticated example of this is Tal Halpern's *Endgame: A Cold War Love Story* (**fig. 10.25**). Viewers begin by assembling a simple puzzle; as each piece is inserted, the application loads movies, photos, and transcripts from the Cold War era, which the viewer navigates interactively. Assembling the puzzle thus creates a narrative that includes spies, propaganda, and Congressional hearings. Viewers who lack the appropriate tablet device can view the work online.

As we have seen, film has progressed from a novel entertainment to an important artform capable of accommodating many types of experiments and thematic statements. The advent of digital technology in the 1980s has not only led to a special effects revolution but has also changed the way films are shown and distributed around the world. Digital technology has also led to new artforms as artists use software and digital equipment as part of their creative practice.

✓•—[**Study** and review on myartslab.com

10.25 Tal Halpern. *Endgame: A Cold War Love Story*. 2011.
Digital work for the Internet and Flash-enabled touch-screen devices.
Courtesy of the artist.

THINK BACK

1. What are the major stages in the evolution of film?

2. When was the Motion Picture Production Code in effect?

3. What kind of interactive technologies are artists using today?

TRY THIS

Compare an independent film by an artist, such as Kenneth Anger's *Scorpio Rising*, with a Hollywood production that takes a similar theme, such as *The Wild One*. Consider camera usage, shot lengths, characterization, and overall message.

KEY TERMS

film editing – the process by which an editor compiles shots into scenes and into a film

film noir – a genre of dark and brooding black-and-white films originating in Hollywood in the 1940s

montage – in motion pictures, the combining of shots into a rapid sequence to portray the character of a single event through multiple views

persistence of vision – an optical illusion that makes cinema possible; the eye and mind tend to hold images in the brain for a fraction of a second after they disappear from view

shot – any uninterrupted run of a film camera; shots are compiled into scenes, then into movies

11

DESIGN DISCIPLINES

THINK AHEAD

11.1 Demonstrate the prevalence of design in our everyday lives.

11.2 Analyze graphic design's function in communicating different ideas.

11.3 Describe the emerging disciplines of motion graphics and interactive design.

11.4 Assess everyday products that integrate utility, technology, and cutting-edge design.

11.5 Define terminology used in graphic and product design.

The Saks Fifth Avenue department store had a problem. Its brand name was already iconic, and it had stores in most large cities. Its reputation for quality and elegance was established. Its demographic of upscale shoppers was dependable, as it had been ever since the first store opened in 1924. The problem was

this: How do you renew a brand, keeping the best of the old while you show the public that you can still innovate? How do you attract younger shoppers while keeping the (aging) old ones?

Saks presented the situation to Michael Bierut of the graphic design firm Pentagram, and asked for suggestions on how to renovate the company's logo in a way that was recognizable but new, traditional yet cutting-edge. Bierut created a new logo (**fig. 11.1**) for the firm in 2007 that shattered the previous elements of the design. He took the familiar cursive script of the old logo, sliced it into 64 square pieces, and recombined them randomly. The logo is still recognizable to everyone who has ever taken home a Saks bag, but it also looks so innovative that it is even a little disorienting at first glance.

Bierut did what designers generally are supposed to do: solve problems and present solutions. In addition to graphic design, designers can work in a number of design disciplines, including interactive design, motion graphics, product design, textile design, clothing design, interior design, and environmental design. In this chapter, we will consider several of these disciplines, beginning with graphic design and moving on to motion graphics and interactive design, and concluding with product design.

11.1 Michael Bierut. Saks Fifth Avenue logo. 2007.
Design Firm: Pentagram. Courtesy of Saks Fifth Avenue.

((•—[**Listen** to the chapter audio on myartslab.com

Graphic Design

Of all artforms, we encounter graphic design most frequently in our daily life. We interact with graphic design on an almost constant basis; most designers have chosen it as their profession because they relish that close interaction with people in all situations. Our encounters with graphic design are usually casual and unintended; we do not seek out design the way we might seek other artforms in a gallery or museum. This fact gives graphic designers an unequalled opportunity to attract, inform, persuade, delight, bore, offend, or repel us.

The term "graphic design" refers to the process of working with words and pictures to enhance visual communication. Much of graphic design involves designing materials to be printed, including books, magazines, brochures, packages, posters, and imagery for electronic media. Such design ranges in scale and complexity from postage stamps and trademarks to billboards, film, video, and Web pages.

Graphic design is a creative process employing art and technology to communicate ideas. With control of symbols, type, color, and illustration, the graphic designer produces visual compositions meant to attract, inform, and persuade a given audience. A good graphic designer can memorably arrange text and image for the benefit of both.

Typography

Letterforms are artforms. **Typography** is the art and technique of composing printed material from letterforms (**typefaces** or **fonts**). Designers, hired to meet clients' communication needs, frequently create designs that relate nonverbal images and printed words in complementary ways.

Just a few decades ago, when people committed words to paper, their efforts were handwritten or typewritten—and nearly all typewriters had the same typeface, the name of which was unknown to most users. Now anyone who uses a computer can select fonts and create documents that look professional, producing desktop publications such as newsletters, brochures, and Web pages. But computer programs, like pencils, paintbrushes, and cameras, are simply tools: They can facilitate artistic aims if their operator has artistic sensibilities.

Since the Chinese invention of printing in the eleventh century, thousands of typefaces have been created—helped recently by digital technology. This book uses Adobe Garamond for its elegance and readability.

Many European-style typefaces are based on the capital letters carved in stone by early Romans. Roman letters are made with thick and thin strokes ending in **serifs**—short lines with pointed ends, at an angle to the main strokes. In typesetting, the term "roman" is used to mean "not italic." Sans serif (without serifs) typefaces have a modern look thanks to their association with modernist designs. They are actually ancient in origin. Black letter typefaces are based on Northern medieval manuscripts and are rarely used today.

Today, many type designers are redesigning and updating old fonts, keeping in mind readability and contemporary preferences. We see the typographer's art in action with the Clearview Hwy typeface (**fig. 11.2**). Donald Meeker and his associates designed this font because they thought they could improve the readability of white-on-green Interstate freeway signs. Using the existing font as a starting point, they expanded the hollow spaces in the lowercase letters, such as e's and a's, and they narrowed the size ratio between lower- and upper-case letters. They made many other more subtle changes, such as adding a base to the lower-case l. The Federal Highway Administration tested the new font in all kinds of weather and lighting conditions, with drivers of varying visual acuity, and they found that it was more quickly legible than the old typeface. They approved this new font for Interstate highway signs in 2004, and it will gradually replace the old one across the United States, as new signs are required.

Heidi Cody took a more ironic stance with her 2000 work *American Alphabet* (**fig. 11.3**). She found all 26 letters in the initials of corporate logos. She said, "I try to get viewers to consciously acknowledge how indoctrinated, or 'branded' they are."[1]

Craig Ward takes typography further toward art with his personal projects. He believes that words can function like pictures, full of expressive power. To create *You Blow Me Away* (**fig. 11.4**), he shattered a pane of glass that bears the title in the classic modern font Helvetica. We see the sentence disappearing in an explosion that will indeed blow it away.

Everglades Blvd.

Mariposa Ave.

Bergaults Street

11.2 Donald Meeker.
Clearview Hwy typeface. 2004 to present.
a. Sample road sign using Clearview 5-w.

b. Development of Clearview Hwy font
from previous Federal Highway font.

FHWA Series E Original Sketch Clearview Version 1 Clearview 5-W

FHWA Series E-m ClearviewOne BD-55

11.3 Heidi Cody. *American Alphabet.* 2000.
A set of 26 light boxes which feature
the isolated first letters of American
grocery products. Lambda Duratrans
print in an aluminum light box.
Each box 28″ × 28″ × 7″.
© 2000 Heidi Cody, www.heidicody.com.

Watch a podcast interview with
Heidi Cody about *American
Alphabet* on myartslab.com

11.4 Craig Ward. *You Blow Me Away.* 2007.
Screenprinted glass, photography.
Photographer: Jason Tozer.

11.5 Superflex. Bankrupt Banks series. 2012.
Acrylic on cotton. Each 79″ × 79″.
a. Sovereign Bank acquired by
Banco Santander SA, October 13, 2008.
b. Colonial Bank acquired by BB&T, August 14, 2009.
Courtesy the artist and Peter Blum Gallery, New York.

Logos

In our age, when image seems to be everything, companies spend large sums on graphic design to present the best "identity package." A **logo** is an identifying mark, or trademark, based on letterforms combined with pictorial elements. As we saw with the Saks Fifth Avenue logo at the beginning of this chapter, corporations finely calibrate such designs to present a distinctive and memorable appearance.

Let us examine logos from two banks to see the messages that they carry as simple symbols. The artist group Superflex recently appropriated the logos for artworks, stripping away their associated typography; this creates an opportunity to examine how logos communicate. The Sovereign Bank logo (**fig. 11.5a**) is a lantern that sheds light. It looks radiant, but also prim and traditional, which is what many people imagine banks to be. The logo for Colonial Bank is based on the letter C, which is turned into a lighted orb like the sun (**fig. 11.5b**). The image of the eagle in the C is traditionally American; this eagle seems to stand guard, peering off into the distance, as vigilant as one might hope for in a banker. The color blue is like the sky, reassuring and indicative of fair weather. The messages of these two logos could not, however, prevent

the two banks from failing during the mortgage crisis of 2008; this made possible the action that Superflex took, turning the logos into artworks on banners.

Posters and Other Graphics

A poster is a concise visual announcement that provides information through the integrated design of typographic and pictorial imagery. In a flash, an effective poster attracts attention and conveys its message. The creativity of a poster designer is directed toward a specific purpose, which may be to advertise or to persuade.

The concept of the modern poster is more than a hundred years old. In the nineteenth century, most posters were lithographs, and many artists made extra income by designing them. Henri de Toulouse-Lautrec was the most important of these (see fig. 8.15). Early lithographic posters were all hand-drawn; designers added color to their work by printing the same sheet with multiple stones, one for each color. In the 1920s and 1930s, advances in printing methods

11.6 Chaz Maviyane-Davies. *Article 15: Everyone Has the Right to Nationality and to Change It.* 1996. Poster.
Courtesy of the artist.

made high-quality mass production possible, including the printing of photographs at large scale with text. Since the 1950s, radio, television, and print advertising have overshadowed posters. Although they now play a lesser role than they once did, well-designed posters can still fulfill needs for instant communication.

Many social causes find vivid expression in posters. The Black Panther Party, an African-American activist organization, made many creative (and militant) posters in the 1960s and 1970s. Near the same time, the Chicano movement commissioned many artists to make silkscreens promoting the causes of Mexican Americans. (An example of the latter is the poster by Ester Hernández, see fig. 8.20). Some posters remind us of our rights rather than urge us to change our behavior. Chaz Maviyane-Davies in 1996 based a set of posters on the United Nations Universal Declaration of Human Rights. His poster *Article 15* (**fig. 11.6**) includes text that guarantees the right to a nationality. He used the face of a black man who watches hopefully between the stripes of a flag. He hoped to counteract the common popular image of Africans as victims of war or famine.

One of the cleverest recent uses of silkscreen came in 2011 in Amsterdam, where a non-profit cultural center commissioned a series of posters on the burdens of increasing tourist trade in the city. Many Amsterdam sites had been designated as historical monuments, which increases tourism but also limits the scope for evolution of a neighborhood. The cultural center created the poster campaign to stimulate public debate about the increasing number of heritage sites. Michiel Schuurman created *Matter of Monument*

11.7 Michiel Schuurman. *Matter of Monument.* 2011.
Silkscreen poster. 46½" × 33".
Photo: Bart Dykstra.

(**fig. 11.7**) by overlaying various opinions about civic monuments, in intensely bright colors that seem to drip as if freshly written. He created several versions of this poster, each with a different statement on top.

Humor has great appeal in design. Maira Kalman's cover for *The New Yorker* magazine (**fig. 11.8**) gently mocks the boisterous subcultures of Manhattan and environs with exotic-sounding names. Some of these are Botoxia, Hiphopabad, Trumpistan, and al-Zeimers. Published in December 2001, the design allowed New Yorkers to laugh at themselves again after the tragedy of September 11.

English designer Jonathan Barnbrook mocked the media overload that seems to accompany every

11.8 Maira Kalman and Rick Meyerowitz.
Newyorkistan.
The New Yorker cover. December 10, 2001.
Rick Meyerowitz and Maira Kalman/*The New Yorker*/
© Condé Nast 2001.

11.9 Virus Fonts. *Drowning in Advertising.*
From *Olympukes* set of pictograms. 2009.
iPhone wallpaper, 480 × 320 pixels.
Barnbrook.

11.10 Jamie Reid. *God Save the Queen.* 1977. Album cover.
Michael Ochs Archives/Stringer/Getty Images.

renewal of the Olympic Games. For the 2010 Winter Games, Barnbrook and his firm Virus Fonts created a set of pictograms called *Olympukes*. One of the set was called *Drowning in Advertising* (**fig. 11.9**). In a sea of deep red and wavy lines borrowed from the logo of a famous brand of soft drink, we see the head and arm of a submerged consumer calling for help. Barnbrook and Virus Fonts designed this *Olympuke* as desktop wallpaper for an iPhone and made it available as a free download.

The subculture of punk music in the late 1970s developed its own design style, which does not look designed at all. The Sex Pistols released their first single, *God Save the Queen* (**fig. 11.10**), to coincide with the Silver Jubilee celebrations of the twenty-fifth year of the reign of Queen Elizabeth II. The song was so controversial that it was banned from the airwaves, yet it still became the number-one-selling song. Twenty-five years later, the book *100 Best Record Covers of All Time* judged Jamie Reid's cover the best record cover ever produced.

Motion Graphics

One of the breaking waves in design in 2013 is in the field of motion graphics, in which a designer uses visual effects, live action, and animation to create a two-dimensional project that moves. Designers combine these techniques in various ways for time-based sequences in Web sites, television commercials, public signage, and music videos.

Motion graphics as a discipline began with **title sequences** for Hollywood movies, the roll of credits at the beginning of a film. Most title sequences were merely slow scrolls of names until the arrival of Saul Bass in the early 1960s. Bass said in an interview that an opening title sequence for a film can "create a climate for the story that is to follow," because "the audience involvement with a film should really begin with the first frame."[2]

The arrival of advanced digital editing in the 1990s ensured the takeoff of motion graphics. The new computer applications enable designers to create each frame of a sequence with all the freedom that photo editing allows. Thus, motion graphics designers are increasingly directors of short but intense projects that combine input from many sources.

11.11 Kyle Cooper. Title sequence for *Se7en*. 1995.
Film directed by David Fincher.
A Time Warner Company, Inc.

View the Closer Look for Kyle Cooper's title
sequence for *Se7en* on myartslab.com

The most original use of the new technologies
came with Kyle Cooper's work on the title sequence
for *Se7en* (**fig. 11.11**), a dramatic crime story. The
title sequence has a plot of its own, as a man with ban-
daged fingers assembles and stitches together a book-
let about murder and sexual deviance. Layered images,
film clips, and spoiled type nervously twitch across
the screen along with the hand-lettered credits, over a
soundtrack by Nine Inch Nails. Most important, this
haunting close-up sequence has a
function in the script: It introduces
the audience to the mind of the
killer, who does not appear until 40
minutes into the film. Cooper said
that his aptitude for vivid graphics
came in part from his earlier study
at Yale with Paul Rand, one of
America's legendary designers.

Cooper's tense style was widely imitated in credits
for other thriller and sci-fi films, but the motion graph-
ics medium is capable of almost any mood. In contrast
to the haunted and raw atmosphere of *Se7en*, Karin
Fong more recently created a fast-moving and reveal-
ing sequence for the T.V. series *Rubicon* (**fig. 11.12**).
The main character of the series is an intelligence ana-
lyst who, as he investigates the suspicious death of his
mentor, begins to uncover a wide-ranging conspiracy
among a secret society of war profiteers. The clues and
hunches that he follows in his investigation are fore-
shadowed in the opening title sequence, which com-
bines still images, animations, live action, and sound.
Rubicon lasted for just one season, but Fong's title
sequence was nominated for an Emmy award.

11.12 Karin Fong. Trial frames for title sequence to *Rubicon*. 2010. Film stills.
Courtesy of the artist.

FORMING ART

Karin Fong (b. 1971): Animating New Narratives

11.13 Karin Fong.

Karin Fong began her design career at a very young age. She recalled, "I always was a designer before I knew what to call it. I spent my childhood making my own newspapers, books and comics that my dad would take to work and 'publish' for me on a Xerox machine."[3] This led her to the Yale School of Art, where her senior project was an animated children's book. Animating graphics was a leading-edge idea at the time, as digital animation was still in its infancy. After graduation, she was among the founders of Imaginary Forces, one of the leading motion graphics design firms.

Her specialty is title sequences for movies and television programs. "I always think a great main title is a little bit like the curtain opening," she says. It invites the audience to "leave the real world and go into this other place."[4]

Creating a motion graphics title sequence involves shaping many types of media into a cohesive whole. She describes the birth of a project: "The process usually begins with a conversation with the film's director. From there we bounce around ideas. Sometimes there's a concept outlined in the script, but often there are just some basic themes to explore. That's one of my favorite stages: the research and design phase where we try to learn all we can about the film and its world. From there many ideas can bloom, and we often work on a few storyboards to flush something out. We'll brainstorm different ways to enter into the story."[5]

In the case of *Rubicon*, the plot of the T.V. show involves espionage, conspiracies, coded messages between undercover operatives, and detection of imminent threats. The title sequence that Fong created (see fig. 11.12) follows a hand-drawn yellow chalk line through lists of data, pages of computer printouts, barcodes, maps, censored documents, aerial photographs, and short film clips. It hints at a person searching for connections among clues found in various kinds of evidence, just as the lead character of the series does.

Motion graphics designers today create in a wide variety of media; Fong has also designed a trailer for the video game *God of War: Ascension*, and a television advertisement for Target stores that starred Christina Aguilera as a comic-book superhero. One project for the Lincoln Center for the Performing Arts in New York required the coining of a new name: an *Infopeel* (**fig. 11.14**), which is a template of moving shapes, with spaces for the insertion of dates of upcoming events and photos of the performers. The goal was to create a design that attracted the attention of moving viewers, while directing their eyes to the information. Pedestrians and motorists who cross that busy Broadway intersection can now inform themselves about Lincoln Center programming without stopping.

"I have always been interested in the relationship between image, story, and word," Fong says. Motion graphics today provides "opportunities for new narrative structures and new ways of telling a story," aided by the latest software and technology. "The world of filmmaking is opening up," she says, "because people are accepting—and expecting—the integration of animation and live action and type. So it's becoming a new language, and that's very exciting."[6]

11.14 Karin Fong and Mark Gardner. *Lincoln Center Infopeel.* 2009. Outdoor motion graphics display at 65th St. and Broadway, New York.

Interactive Design

As more and more of our media become interactive, designers work to organize the information presented and keep the layouts attractive. This is a relatively new area of design, but already there have been a few standout projects.

With millions of handheld tablet devices sold every year, this new consumer item is quickly becoming a principal vehicle for interactive design. The Apple iPad, for example, has thousands of "apps" available—small pieces of software that allow users to interact with information, games, books, and music. When the Icelandic singer Björk released her album *Biophilia*

in late 2011, it came as a set of iPad apps (**fig. 11.15**). The title frame, a revolving constellation of imaginary galaxies, takes the viewer to each song on the album, which opens as a separate app. These apps play the song, send the lyrics along a text line, and allow the viewer to contribute to the interactive environment by tipping the screen, rotating it, tapping, or drawing with a fingertip. The designer is Scott Snibbe, who has designed several other games and apps for the iPad. (For an interactive project on the Android platform, see Tal Halpern's *Endgame*, fig. 10.25.)

Across all of our print media, the QR code (or Quick Response code) is increasingly a symbol of

11.15 Scott Snibbe. *Biophilia Apps*. 2011. Title screen from album by Bjork.

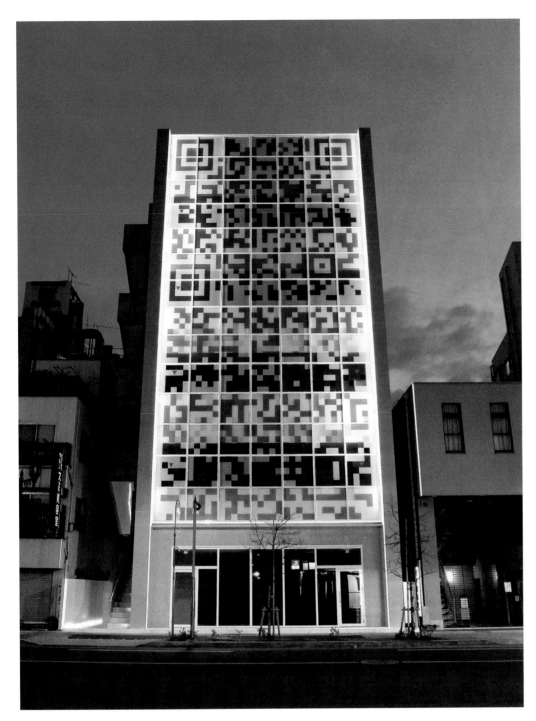

11.16 Terada Design Architects. N Building. 2009. Tachikawa, Japan. Interactive façade by Qosmo, Inc.; lighting by Izumi Okayasu Lighting Design.
Photograph by Yuki Omori.

interactive potential. Scanning a QR code with an enabled device such as a smartphone brings up a Web site, a video, an application, or other information. A 2009 building in Japan broke new ground by building interactivity into its surface (**fig. 11.16**). Scanning the QR codes on the façade will show information about the building's hours of operation, sales that are taking place in the stores inside, and even recent tweets by users who walk its hallways. The designers of the building created an alternative to billboards; instead of pushing content on everyone as most outdoor displays do, the information in the N Building is accessible only if a consumer "asks" by activating its QR codes.

Product Design

We all handle designed products every day, and industrial designers work to make these products more beautiful, useful, and sustainable. We close this chapter by examining some recent objects that are making history by integrating utility, technology, and cutting-edge design.

The One Laptop Per Child project (OLPC) is working to make computers accessible to schoolchildren around the world. The OLPC XO-3 (**fig. 11.17**) is making learning easier through networking and Web access. Besides its eye-catching and break-resistant thin design, it has two other unique features: it uses an intuitive operating system that does not require literacy in any language, and it costs approximately $100 per unit. The low price is facilitating its adoption in developing nations.

11.18 Mission One. Electric-powered motorcycle. 2009. Mission Motors, San Francisco. Designer: Yves Behar. Courtesy Mission Motors.

A quick glance at the Mission One motorcycle (**fig. 11.18**) will show what it is missing, compared to most other bikes: a gas tank and a tailpipe. This is because the Mission One is electric, powered by a lithium-ion battery. The entire design of the Mission One suggests forward-leaning speed, as it is made from lightweight aluminum in an aerodynamic body. Producing zero emissions and running silently, it has a top speed of 150 mph.

Many product designers today are finding ways to make their projects greener; a notable event in this evolution occurred in 2009 when some English designers applied themselves to making a new kind of wind turbine for generating electricity. Most wind turbines resemble huge aircraft propellers: they are large, noisy, and need fairly strong breezes, making them suitable only for rural areas (where they often damage birds). But the QR5 wind turbine (**fig. 11.19**) solved all of those problems with a new design in a graceful-looking frame. This new turbine is almost perfectly silent, runs on lighter breezes, is small enough to place atop a house, and has not injured a single bird. The "qr" of the turbine's name stands for both the company name and its main selling point: quiet revolution.

As we have seen, we encounter graphic design and related design disciplines frequently in our daily lives. Design is a creative process that employs art and technology to produce visual compositions that can attract, inform, and persuade us.

11.17 Fuseproject. *OLPC XO-3*. Ongoing. Tablet computer. Image courtesy of Fuseproject.

✔—**Study** and review on myartslab.com

1. What are the major branches of design?

2. What causes people trained in the arts to go into design?

3. How has the computer influenced design practice?

TRY THIS

Assess the use of design in your everyday life. Over the next week, find one designed object that seems well designed in terms of usefulness, sustainability, and so on, and one that seems poorly designed. Analyze what accounts for the difference between them.

KEY TERMS

font – the name given to a style of type

logo – a sign, name, or trademark of an institution, firm, or publication, consisting of letterforms or pictorial elements

title sequence – the roll of credits at the beginning of a motion picture or television program.

typography – the art and technique of composing printed materials from type

11.19 Quietrevolution Ltd. QR5 wind turbine. 2009.
Carbon fiber and epoxy resin. Height of unit 16′5″.
Quietrevolution, Ltd.

12

SCULPTURE

THINK AHEAD

12.1 Distinguish sculpture as three-dimensional art that viewers examine from multiple perspectives.

12.2 Compare examples of freestanding and relief sculpture.

12.3 Describe additive, subtractive, and constructive techniques used to make sculpture.

12.4 Identify materials used in sculpture including kinetic and mixed media works.

12.5 Discuss the use of installation and site-specific art to transform their surroundings.

Most viewers who approach Martin Puryear's work *C.F.A.O.* (**fig. 12.1**, left) will first see a dizzying welter of wood pieces, stacked in a loose network and glued together, atop an old wheelbarrow. Mostly unpainted, the stack of pieces seems to have a rectilinear organization, but it is too dense to see through. It is also, at 8 feet 5 inches, rather tall. It looks as if someone may have thought of a unique way of bringing home the day's purchases from the lumber yard.

But if we walk around it and look from the other side (**fig. 12.1**, right), we see the reason for the apparent density of the work: a large, curving shape, based on an elongated African mask, that the artist painted white. Clearly, in order to see and grasp this work, we must walk around it and examine it from various angles.

As *C.F.A.O.* illustrates, sculpture is a work in three dimensions: It has height, breadth, and depth. It thus exists in space, as we do. As we look at a sculpture, the total experience of the piece is the sum of its masses, surfaces, and profiles. In this chapter we will consider the two main types of sculpture—freestanding and relief—and explore the various methods and materials used to create them.

((•—**Listen** to the chapter audio on myartslab.com

Freestanding and Relief Sculpture

Sculpture meant to be seen from all sides is called in-the-round, or **freestanding**. As we move around it, our experience of a sculpture is the sum of its various aspects. A single photograph shows only one view of a sculpture under one kind of light; thus, we receive only a limited impression of a sculpture unless we can see many photographs or, better yet, a video; or best of all, view the piece ourselves.

A sculpture that is not freestanding but projects from a background surface is in **relief**. In **low-relief** (sometimes called **bas-relief**) sculpture, the projection from the surrounding surface is slight. As a result, shadows are minimal. Coins, for example, are works of low-relief sculpture stamped from molds. A high point in the art of coin design was reached on the island of Sicily during the classical period of ancient Greece. The Apollo coin (**fig. 12.2**), shown here slightly larger than actual size, has a strong presence in spite of being in low relief and very small.

Some of the world's best and most varied low-relief sculptures are found at the temple of Angkor Wat in Cambodia. This vast temple complex was the center of the Khmer empire in the twelfth century. Here Khmer kings sponsored an extensive program of sculpture and architecture. Within the chambers

12.1 Martin Puryear. *C.F.A.O.* 2006–2007. Painted and unpainted pine and found wheelbarrow. 8′5″ × 6′5½″ × 61″.

The Museum of Modern Art, New York. Courtesy of the McKee Gallery. Photo Richard Goodbody.

12.2 Apollo. c.415 BCE. Greek silver coin. Diameter 1⅛″.

Hirmer Fotoarchiv.

of the complex, carvings are in such delicate low relief that they seem more like paintings than sculpture. One scene, *Army on the March* (**fig. 12.3**), depicts a king's army commanded by a prince. The rhythmic pattern of the spear-carrying soldiers contrasts with the curving patterns of the jungle foliage in the background. The soldiers and background provide a setting for the prince, who stands with bow and arrow poised in his carriage on the elephant's back. Intricate detail covers entire surfaces of the stone walls.

In **high-relief** sculpture, more than half of the natural circumference of the modeled form projects from the surrounding surface, and figures are often substantially undercut.

This is the case with Robert Longo's *Corporate Wars: Wall of Influence* (**fig. 12.4**), where male and

12.3 *Army on the March.*
Relief from Angkor Wat, The Great Temple of the
Khmers, Cambodia. 1100–1150. Sandstone.
Time & Life Pictures/Getty Images.

12.4 Robert Longo. *Corporate Wars: Wall of Influence.* 1982.
Middle portion. Cast aluminum. 7′ × 9′.
Courtesy of the artist and Metro Pictures.

👁 **Watch** a video about the technique of relief
sculpture carving on myartslab.com

female figures convulse in painful conflict. Much of the
composition is high relief; in only a few areas are limbs
and garments barely raised above the background sur-
face. Dynamic gestures and the diagonal placement of
torsos and limbs make the sculpture very active. The
emotional charge of the piece suggests that Longo is
horrified by the intense competition of corporate life.

Methods and Materials

Traditionally, sculpture has been made by modeling,
casting, carving, constructing, and assembling, or a
combination of these processes.

Modeling

Modeling is usually an **additive** process. Pliable mate-
rial such as clay, wax, or plaster is built up, removed,
and pushed into a final form.

Cultures around the world have left us examples of
their arts through modeled ceramics. Tool marks and

12.5 *Ballplayer with Three-Part Yoke and Bird Headdress.*
Maya Classic period. 600–800. Ceramic with traces
of blue pigment. 13¹⁵⁄₃₂″ × 7″.
Princeton University Art Museum. Museum purchase, Fowler McCormick, Class
of 1921, Fund, in honor of Gillett G. Griffin on his 70th birthday. 1998–36.
Photo by Bruce M. White. Photograph: Princeton University Art Museum/Art
Resource NY/Scala, Florence.

12.6 Viola Frey. *Stubborn Woman, Orange Hands.* 2004. Ceramic. 72″ × 80″ × 72″.
Courtesy of Nancy Hoffman Gallery Art © Artists' Legacy Foundation/Licensed by VAGA, New York, NY.

fingerprint impressions are visible on the surface as evidence of the modeling technique employed to make *Ballplayer with Three-Part Yoke and Bird Headdress* (**fig. 12.5**). Body volume, natural gesture, and costume detail are clearly defined. The ancient Maya, who lived in what are now parts of Mexico, Guatemala, and Honduras, used clay to create fine ceramic vessels and lively **naturalistic** sculptures like this one.

The working consistencies of clay, wax, and plaster are soft. To prevent sagging, sculptors usually start all but very small pieces with a rigid inner support called an **armature**. When clay is modeled to form large sculptures, the total piece can be built in relatively small, separately fired, structurally self-sufficient sections, thereby eliminating the need for an armature.

Viola Frey used an armature to create her work *Stubborn Woman, Orange Hands* (**fig. 12.6**). Like most clay works of this size, it is hollow; the artist cut it into pieces for more convenient firing. The armature held it up as she worked on it. Typical of Frey's style, this figure is larger than life-size. It depicts Everywoman, staring resolutely forward. She is unclothed because the artist thought that women were more powerful in their "birthday suits." She left the seams between the parts visible, admitting viewers into the creative process.

12.7 Ken Price. *Vink*. 2009.
Acrylic on fired ceramic. 9″ × 20″ × 11″.
L.A. Louver, Venice, CA.

Artworks made through modeling need not be representational, as Ken Price's *Vink* (**fig. 12.7**) shows. He modeled this work out of clay, fired it, painted it with multiple layers of acrylic paint, and then sanded the surface to expose spots of the paint layers below. Though the title refers to a small European songbird, any resemblance is coincidental. Rather, this piece suggests body parts, undersea organisms yet undiscovered, or some kind of knobby plant life. The iridescent color adds to the mysteriousness of the shape.

Casting

Casting processes make it possible to execute a work in an easily handled medium (such as clay) and then to reproduce the results in a more permanent material (such as bronze). Because most casting involves the substitution of one material for another, casting is also called a **substitution** process. The process of bronze casting was highly developed in ancient China, Greece, Rome, and parts of Africa. It has been used extensively in the West from the **Renaissance** to modern times.

Casting requires several steps. First, a **mold** is taken from the original work. The process of making the mold varies, depending on the material of the original and the material used in the casting. In any case, the mold completely surrounds the original, leaving no gaps. Materials that will harden can be used to make molds: clay diluted with water, molten metal, concrete, or liquid plastic. Second, the original sculpture is removed from the mold; this may require disassembly of either the original or the mold. Next, the casting liquid is poured into the resulting hollow cavity of the mold. Finally, when the casting liquid has hardened, the mold is removed.

Some casting processes use molds or flexible materials that allow many casts to be made from the same mold; with other processes, such as the **lost-wax** process (**fig. 12.8**), the mold is destroyed to remove the hardened cast, thus permitting the creation of only a single cast.

12.8 The Casting Process.

👁 **Watch** a video about the technique of lost-wax bronze casting on myartslab.com

Castings can be solid or hollow, depending on the casting method. The cost and the weight of the material often help determine which casting method will be used for a specific work. The Statue of Liberty in New York harbor, for example, was cast in many pieces and reassembled into a hollow whole on site; an elaborate armature holds it up.

The process of casting a large object like Giacometti's *Man Pointing* (see fig. 3.14) is extremely complicated. Except for small pieces that can be cast solid, most artists turn their originals over to foundry experts, who make the molds and do the casting. Most of our monuments in public parks were cast in bronze from artists' clay or wax models. Robert Longo's *Corporate Wars: Wall of Influence* (see fig. 12.4) is made from cast aluminum.

Many items are cast besides art, such as automobile engine parts, some dishes, and children's toys. Charles Ray made witty reference to the latter in his cast steel work *Father Figure* (**fig. 12.9**). He based it on a green plastic toy tractor, which he enlarged to life-size in a plaster model before casting in solid steel. The work weighs more than 18 tons, and its original toy-like nature has vanished as the "father figure" looms up, faintly menacing, at one with his machinery.

12.10 Kaz Oshiro. *Tailgate (OTA)*. 2006.
Acrylic and Bondo on canvas.
53″ × 17⅞″ × 1¾″. Bottom edge 12″ from wall.
Collection of Barry Sloane, Los Angeles.

Watch a podcast interview with Kaz Oshiro about *Tailgate (OTA)* on myartslab.com

Kaz Oshiro used paint, canvas, and Bondo putty to create the strikingly realistic *Tailgate (OTA)* (**fig. 12.10**). This eye-popping work duplicates the size, shape, and worn look of a real pickup truck tailgate. He completed the illusion with Bondo, a compound used in auto body repair shops. Viewers who peer around behind the work are rewarded with a glimpse of the wooden armature that holds it together. *Tailgate*, like *Father Figure*, uses sculpture's three-dimensional presence to play an elaborate game between image and reality.

12.9 Charles Ray. *Father Figure*. 2007.
Painted steel. 93¾″ × 137″ × 71¾″.
© Charles Ray, Courtesy Matthew Marks Gallery, New York.

Sculptors such as Oshiro who attempt to fool our eyes with works that resemble real things are working in an ancient Western tradition that values realism as evidence of artistic skill. According to myth, the classical Greek artist Zeuxis once painted a man holding a bowl of grapes so realistically that a bird flew down and tried to eat the fruit. Zeuxis was unsatisfied with the work, however, because, he reasoned, if he had painted the man with equal skill, the figure would have frightened the bird away. Unfortunately, none of his works survives. The belief that the greatest artists are the best at capturing a likeness still holds much sway in our society, and artists such as Oshiro make charming allusion to it in their works.

English artist Rachel Whiteread uses new materials such as polyvinyl resin in fascinating cast pieces that turn empty spaces into solid volumes. To create *Untitled (Hive) I* (**fig. 12.11**), she filled a beekeeper's hive with lustrous, brown-orange resin and then took away the hive to leave only the interior, now rendered solid. In casting, artists make use of absence and presence, replacing one substance with another. By casting empty volumes, Whiteread gives absence a new kind of haunting presence.

12.11 Rachel Whiteread. *Untitled (Hive) I*. 2007–2008. Resin (two parts). $32\frac{1}{8}$″ × $20\frac{15}{16}$″ × $25\frac{3}{16}$″.
© Rachel Whiteread. Courtesy Gagosian Gallery.

Carving

Carving away unwanted material to form a sculpture is a **subtractive** process. Michelangelo preferred this method. Close observation of his chisel marks on the surfaces of the unfinished *Awakening Slave* (**fig. 12.12**) reveals the steps he took toward increasingly refined cutting, even before he had roughed out the figure from all sides. Because Michelangelo left this piece in an unfinished state, it seems as though we are looking over his shoulder midway through the carving process. For him, making sculpture was a process of releasing the form from within the block of stone. This is one of four figures, later called *Slaves*, that Michelangelo abandoned in various stages of completion.

Carving is the most challenging of the three basic sculptural methods because it is a one-way technique that provides little or no opportunity to correct errors. Before beginning to cut, the sculptor must visualize the finished form from every angle within the original block of material. (Another example of Michelangelo's carving is his *Pietà*, see fig. 4.20.)

The various types of stone with their different characteristics greatly influence the type of carving that can be done with them. The marble that Michelangelo and many sculptors in the European tradition prefer is typically soft and workable enough that it can be cut with a chisel. Final polishing with a light abrasive yields a smooth and creamy surface not unlike human skin. Marble has been a preferred material in the West for outdoor sculpture for centuries, but modern air pollution and acid rain harm the stone, making it far less desirable today. Granite avoids these pitfalls, and thus is often used for outdoor monuments such as tombstones, but granite is so hard that carving in detail is difficult. Sandstone and limestone are sedimentary materials that have also found wide use in many parts of the world. The Cambodian creators of *Army on the March*, for example (see fig. 12.3), took advantage of the qualities of sandstone. Sedimentary stones are relatively soft, allowing much detail, and can be polished to a high gloss, though weather reduces this over time.

The ancient Egyptians used schist, a dense stone similar to slate. The jade that the Chinese favored is so hard and brittle that it can only be ground down by abrasion or filing; hence it is suitable only for

12.12 Michelangelo Buonarroti. *Awakening Slave.* 1530–1534. Galleria dell'Accademia. Marble. Height 9′.
akg-image/Rabatti - Domingie.

12.13 Disk (*bi*). China, Western Han dynasty, c.100–220 CE. Jade (nephrite). Diameter 7″.
Freer Gallery of Art, Smithsonian Institution, Washngton. D.C.: Gift of Charles Lang Freer, F1916.155.

know each child will face. Both figures have been abstracted in a composition of bold sweeping curves and essential shapes. Solidity of the mass is relieved by the open space between the uplifted chin and raised elbow and by the convex and concave surfaces. An engraved line indicating the mother's right hand accents the surface of the form. The highly polished smooth wood invites the viewer to touch.

Martin Puryear manipulates and shapes wood in several different ways. In *C.F.A.O.* (see fig. 12.1), he combined carving with mere stacking. His pieces also often involve carving, assembling, and then finishing, as in *Hominid* (see fig. 12.16), a finely crafted shape measuring more than 6 feet tall.

12.14 Elizabeth Catlett.
Mother and Child #2. 1971. Walnut. Height 38″.
Photograph by Samella Lewis. © Catlett Mora Family Trust/Licensed by VAGA, New York, NY.

small pieces. The disk, or *bi* (**fig. 12.13**), found in a Chinese royal tomb is an exquisite example of carving using pale green nephrite, a rare type of jade. Chinese workers ground the stone nearly two thousand years ago, using drills and quartz sand in a highly laborious process. The results of their work in this piece show a rare order of quality; the raised circles in the disk (called **bosses**) line up in perfectly even rows, and the feline monster above shows a rounded body and graceful, cat-like movement, amid a pattern that suggests clouds and wind.

In wood carving, many sculptors prefer walnut and cypress because of their strength and ease of working. The gesture of the mother in Elizabeth Catlett's carved *Mother and Child* (**fig. 12.14**) suggests anguish, perhaps over the struggles all mothers

FORMING ART

Martin Puryear (b. 1941): Shaping Possibilities

Why become a sculptor? Martin Puryear said, "The difference is so great when you go into the third dimension. . . . It's not simply a two-dimensional thing expanded. It's like an infinitely multiple view, an infinitely multiplied sense of possibilities, spatial possibilities. That's what interests me."[1]

The abbreviation in the title of his work *C.F.A.O.* (see fig. 12.1) stands for Compagnie Française de l'Afrique Occidentale, a private-sector trading company in the former French colony of Sierra Leone. He began the work with an old wheelbarrow, the sort that laborers the world over might use. It is an obviously handmade implement, and Puryear respects it for that: "I'm really interested in vernacular cultures," he says, "where people have to live closer to the source of material and the making of objects for use. And in trades, in which people make things in ways that are not necessarily artistic."[2]

The C.F.A.O. no longer functioned when Puryear lived in Sierra Leone in the early 1960s as a Peace Corps volunteer. But many Africans remembered it as a tool of oppression, as it bought African products at low prices for sale overseas, and kept Africans from developing their own industries. Perhaps to symbolize this colonial situation, Puryear burdened the wheelbarrow with a bewildering array of wood pieces that weigh it down and block the operator's view.

Then, in the rear of the work, hidden from the first approach of most viewers, Puryear installed a huge mask. If the mask symbolizes traditional African culture, its "hidden" location parallels the disrespect that most French colonizers had for native African ways. It also reflects back the face and perhaps the body of its indigenous driver.

These attempts to find meaning in this work are all tentative, because Puryear would prefer to leave any symbolism in an open-ended state. His work does not generally allow easy equation of imagery and meaning. He said, "I value the referential quality of art, the fact that a work can allude to things or states of being without in any way representing them. The ideas that give rise to a work can be quite diffuse, so I would describe my usual working process as a kind of distillation—trying to make coherence out of things that can seem contradictory."[3] In this case, a wheelbarrow holding a tall stack of wood, and an outsized mask painted white seem to have little to do with each other. He explains, "Coherence is not the same as resolution. The most interesting art for me retains a flickering quality, where opposed ideas can be held in tense coexistence."[4]

In the case of *Hominid* (**fig. 12.15**), the work and its title seem to have just that sort of uneasy relationship. A hominid is a pre-human primate, halfway between chimp and person, while the work is an irregular polygonal block on wooden rollers. We may well imagine hominids pushing this piece along on its rollers, for reasons that remain mysterious. Puryear finished the block using all of the cabinet-maker's traditional skills of sawing, joining, and finishing, but these only add to its enigmatic quality. In titling a work, Puryear tries to "juxtapose things in order to open up various possible meanings to the imagination."[5] In *Hominid* as in many of his other works, his creation shows obvious craftsmanship, but its meaning is only suggested to the viewer.

Puryear's sculptures create an absorbing mix of possibilities in the mind. The time that it takes for viewers to sense, and then weigh, possible meanings is the key moment for appreciating his work. He says, "I think my work speaks to anybody who has the capacity to slow down."[6]

12.15 Martin Puryear. *Hominid.* 2007–2011. Pine. 73" × 77½" × 57". Currently located at Martin Puryear's studio.
Courtesy of the McKee Gallery. Photo: Christian Erroi.

👁 **Watch** the Art21 video of Martin Puryear discussing his work on myartslab.com

Constructing and Assembling

For most of recorded history, the major sculpting techniques in the Western world were modeling, carving, and casting. Early in the twentieth century, assembling methods became popular. Such works are called **assembled sculpture** or constructions.

In the late 1920s, Spaniard Julio González pioneered the use of the welding torch for cutting and welding metal sculpture. The invention of oxyacetylene welding in 1895 had provided the necessary tool for welded metal sculpture, but it took three decades for artists to utilize the new tool's potential.

González had learned welding while working briefly in an automobile factory. After several decades—and limited success—as a painter, González began assisting Picasso with the construction of metal sculpture. Subsequently, González committed himself to sculpture and began to create his strongest, most original work. In 1932 he wrote:

> The Age of Iron began many centuries ago by producing very beautiful objects, unfortunately mostly weapons. Today it makes possible bridges and railroads as well. It is time that this material cease to be a murderer and the simple instrument of an overly mechanical science. The door is wide open, at last! for this material to be forged and hammered by the peaceful hands of artists.[7]

González welded iron rods to construct his linear abstraction *Maternity* (**fig. 12.16**). It is airy and playful as it suggests a feminine anatomy atop a stone base.

12.16 Julio González. *Maternity.* 1934. Steel and stone. Height 49⅞".
© Tate, London 2013 © 2013 Artists Rights Society (ARS), New York.

12.17 Deborah Butterfield. *Conure.* 2007. Found steel, welded. 92½" × 119" × 30".
Courtesy L.A. Louver, Venice, CA. © Deborah Butterfield/ Licensed by VAGA, New York, NY.

Since the 1970s, Deborah Butterfield has created figures of horses from found materials such as sticks and scrap metal. She spends much of her time on ranches in Montana and Hawaii where she trains and rides horses and makes sculpture. Painted, crumpled, rusted pieces of metal certainly seem an unlikely choice for expressing a light-footed animal, yet Butterfield's *Conure* (**fig. 12.17**) has a surprisingly lifelike presence. The artist intends her sculptures to feel like horses rather than simply look like them. The old car bodies she has used for many of her welded and wired metal horses add a note of irony: The scrapped autos take on a new life as a horse.

Some sculptors assemble found objects in ways that radically change the way we see familiar things. Yet we see enough of the objects' original characteristics that we can participate in their transformation. Such work requires metaphorical visual thinking by both artists and viewers. This type of constructed sculpture is called assemblage.

Picasso found a wealth of ready-made ingredients from salvaged fragments of daily life. In his assemblage *Bull's Head* (**fig. 12.18**) he joined two common objects together to create a third. Describing how it happened, he said: "One day I found in a pile of jumble an old bicycle saddle next to some rusted handle bars . . . In a flash they were associated in my mind . . . The idea of this Bull's Head came without my thinking of it . . . I had only to solder them together."[8]

Some assemblages gather meaning from the juxtaposition of real objects. Marc André Robinson shops in thrift stores for pieces of old used furniture and assembles new objects from them. *Throne for the Greatest Rapper of All Time* (**fig. 12.19**) is one such work. We see at the lower center that the piece is based on found chairs, but he added a higher back and wings to the sides. If the purpose of a throne is to dignify whoever sits in it, this assemblage accomplishes that. This throne is a higher form of chair, made mostly from chairs.

12.18 Pablo Picasso. *Bull's Head*. 1943. Bronze. Seat and handles of a bicycle. Height 16⅛".
Paris, musée Picasso. RMN-Grand Palais/Photo by Bernice Hatala
© 2013 Estate of Pablo Picasso/Artists Rights Society (ARS), New York.

12.19 Marc André Robinson. *Throne for the Greatest Rapper of All Time*. 2005. Wood. 76″ × 69″ × 48″.
Private Collection.

12.20 Jesús Rafael Soto. *Escritura Hurtado (Hurtado Writing)*. 1975.
Paint, wire, nylon cord, and wood. 40″ × 68″ × 18″.
Reprinted with permission from the General Secretariat of the OAS AMA. Art Museum of the
Americas Collection. © 2013 Artists Rights Society (ARS), New York/ADAGP, Paris.

12.21 Cai Guo-Qiang. *Inopportune: Stage One*. 2004. Nine cars and sequenced multichannel light tubes. Dimensions variable.
Collection of Seattle Art Museum, Gift of Robert M. Arnold, in honor of the 75th Anniversary of the Seattle Art Museum, 2006.

Kinetic Sculpture

Alexander Calder was among the first to explore the possibilities of kinetic sculpture, or sculpture that moves. Sculptors' traditional focus on mass is replaced in Calder's work by a focus on shape, space, and movement. Works such as his huge *Untitled* (see fig. 3.33) at the National Gallery of Art in Washington, D.C., are often called **mobiles** because the suspended parts move in response to small air currents.

If Calder's mobiles are massive and exuberant, far more delicate are the mobiles of Jesús Rafael Soto, such as *Hurtado Writing* (**fig. 12.20**). Against a background of painted, thin vertical stripes, suspended curves of wire slowly sway in whatever air currents are present. These wire pieces resemble the strokes of handwriting; hence the title. Their motion makes the background seem to vibrate.

Mixed Media

Today's artists frequently use a variety of media in a single work. Such works may be labeled with a long list of materials, or they may be identified only as mixed media. The media may be two-dimensional, three-dimensional, or a mixture of the two. Often, the choice of media expresses some cultural or symbolic meaning.

The contemporary Chinese-born artist Cai Guo-Qiang created a huge and symbolic mixed media piece in 2004 with *Inopportune: Stage One* (**fig. 12.21**), now in the Seattle Art Museum. The work consists of nine automobiles with light tubes perforating them. The cars are arrayed as if we are seeing momentary glimpses of one car flipping through the air as it explodes. Cai intended this work to refer both to contemporary action movies (where cars often explode and fly through the air) and to car bombings by terrorists. The work challenges us to consider if this is a thrilling scene, as in a movie, or a horrendous one, as in real life.

When Lara Schnitger drapes and stretches fabric over wooden armatures, she creates both a sculpture and a hollow interior space. The work of this Los Angeles-based artist straddles the boundary between sculpture and fashion design, just as the figures she creates hover nervously between human and some other living thing. In *Grim Boy* (**fig. 12.22**), for example, she used various dark-colored fabrics together with beads and fur to suggest a mannequin from hell. This tense, lurking figure seems to exude the nervous energy of an adolescent combined with the quick eye of a bird. But it stands almost 6 feet tall, like a gangling teenager, and the work's title may remind us of a brooding, trenchcoat-clad youth. There is an additional feminist message to most of Schnitger's work as well, because she is doing a sort of "dressmaking,"

12.22 Lara Schnitger. *Grim Boy.* 2005. Wood, fabric, and mixed media. 71″ × 59″ × 20″.
Anton Kern Gallery, New York.

a traditional women's artform. Rather than creating beautiful adornments, though, she fashions curious quasi-human beings.

Matthew Monahan cobbles together various media to make works that seem like museum exhibits gone wrong. He carved the two principal figures in *The Seller and the Sold* (**fig. 12.23**) out of floral foam. The upper figure is tensely posed in a manner similar to one of Michelangelo's *Awakening Slaves* (see fig. 12.12). The larger figure in the box is tipped head downward, like a toppled statue of a dictator. The artist painted the face of this figure in deep earth tones and gave it a faraway expression, like some mummified king. Seeing this work in a gallery is like finding the ruins of a dead civilization, encased in a museum exhibit. But its title leads us to think of the business world; perhaps the figure above is the seller and the upended figure is the sold.

12.23 Matthew Monahan. *The Seller and the Sold.* 2006. Drywall, glass, wax, foam, and pigment. 67″ × 25″ × 25″.
Courtesy of Stuart Shave/Modern Art, London and Anton Kern Gallery, New York.

Installations and Site-Specific Art

Many artists now use the three-dimensional medium of **installation** to make their visual statement. An installation artist transforms a space by bringing into it items of symbolic significance. This medium is most similar to constructed sculpture, but the artist treats the entire space as an artwork and transforms it.

A recent installation that is both simple and profound is *Eavesdropping* (**fig. 12.24**) by Amalia Pica. To create this work, she obtained a batch of drinking glasses in various sizes and colors, and then attached them to a gallery wall. They create a mysterious yet somewhat playful atmosphere, as they are completely out of place for normal use. Yet when attached to a wall in this way, drinking glasses amplify sounds on the other side of the wall, making them a simple tool for the eavesdropping of the title. When we consider that the artist grew up in Argentina when it was a repressive military dictatorship, we may sense another, more ominous, level of meaning to this seemingly straightforward installation.

Eavesdropping could theoretically be relocated and installed in another spot, but some installations are intended only for particular locations. Such works are called **site-specific**. Site-specific works that are created for the great outdoors, sometimes in far-off locations, are in turn referred to as **earthworks**, or land art. (One of the earliest and best-known of these is Robert Smithson's *Spiral Jetty*, see fig. 24.33).

The best-known work of site-specific art in the United States became famous because of a lawsuit that tested the limits of the artist's power. In 1981, the government installed Richard Serra's work *Tilted Arc* (**fig. 12.25**) in the plaza adjoining a federal office building; it was a tilting, curving, blade of steel 12 feet high. Soon the office workers began to complain about it: it blocked the view; it forced them to walk a detour around it; it became a homeless shelter; it collected graffiti. When the government announced plans to relocate the work, the artist filed a lawsuit, claiming

12.24 Amalia Pica. *Eavesdropping*. 2011.
Drinking glasses and glue.
78″ × 240″ × 8″.
Courtesy of Mark Foxx Gallery.

that *Tilted Arc* was meant for that spot, and to relocate it would be to destroy it. The artist lost his case, but the matter did not turn on any legal requirement of site-specificity; rather, the court held that the government, as owner of the work, could dispose of it. After years of court cases, *Tilted Arc* was removed in 1989.

When the Tate Modern took over an old power plant in London in 2000, the museum inherited a uniquely large indoor space for site-specific art: a huge atrium nearly 500 feet long that it now uses for large-scale temporary installations. One of the

12.25 Richard Serra. *Tilted Arc*. 1981. Steel. Height 12′, length 120′.
AP Photo/Mario Cabrera.

👁 **Watch** the Art21 video of Richard Serra discussing his work on myartslab.com

12.26 Olafur Eliasson. *The Weather Project* (The Unilever Series). 2003.
Installation in Turbine Hall, Tate Modern, London. Monofrequency lights, projection foil,
haze machines, mirror foil, aluminum, and scaffolding. 87′7³⁄₁₆″ × 73′2″ × 509′10⁷⁄₆₄″.
Photo: Jens Ziehe. Courtesy the artist; Neugerriemschneider, Berlin, and Tanya Bonakdar Gallery, New York © Olafur Eliasson 2003.

most striking of these installations so far has been *The Weather Project* (**fig. 12.26**) by Danish artist Olafur Eliasson. He installed a huge semicircular sun of bright lamps and then covered the ceiling in mirrors, so that the yellow orb seemed whole. The lights that illuminated it were single-frequency bulbs, which created an intense yellow glow throughout the hall. A few strategically placed fans blew mist from evaporating dry ice, creating clouds that lazily gathered and dispersed.

Museum officials estimated that *The Weather Project* drew two million visitors over its five-month run during the bleak London winter of 2003–04.

Viewers basked in the seeming warmth of a huge yellow sun that never set; they watched the passing indoor weather; they lay on the floor and looked at their reflections on the ceiling 115 feet above. The installation generally served as a space of communal meditation.

When an artist creates a work in three dimensions, the result is called sculpture. A sculptor may create an object using diverse materials and processes, or even alter an entire space, converting it into an artwork.

✔•—⌐**Study** and review on myartslab.com

THINK BACK

1. What are the principal techniques of sculpture?

2. How are most public monuments made?

3. What are some recent innovations in how sculptors work in a space?

TRY THIS

Buy some modeling clay and try to make a miniature version of Ken Price's *Vink* (fig. 12.7).

KEY TERMS

additive sculpture – sculptural form produced by adding, combining, or building up material from a core or (in some cases) an armature

assemblage – sculpture made by assembling found or cast-off objects that may or may not contribute their original identities to the total content of the work

casting – a process that involves pouring liquid material such as molten metal, clay, wax, or plaster into a mold; when the liquid hardens, the mold is removed, and a form in the shape of the mold is left

freestanding – describes any piece or type of sculpture that is meant to be seen from all sides

kinetic sculpture – sculpture that incorporates actual movement as part of the design

relief – sculpture in which three-dimensional forms project from the flat background of which they are a part

site-specific – any work made for a certain place, which cannot be separated or exhibited apart from its intended environment

subtractive sculpture – sculpture made by removing material from a larger block or form

13

CRAFT MEDIA: FLIRTING WITH FUNCTION

THINK AHEAD

13.1 Examine the historical distinction of craft and art.

13.2 Identify the visual and physical properties of different craft media (clay, glass, metal, wood, and fiber).

13.3 Contrast the techniques and forms used by artists working with craft media.

13.4 Provide examples of objects made from craft media that serve functional, aesthetic, and expressive purposes.

13.5 Consider the social and cultural meaning of traditional craft artforms.

William Morris' *Windrush* (**fig. 13.1**) is an elegant and well-crafted woodblock print that pushes at the boundary between art and utility. A design in several colors that is repeatable, it can serve as a textile or a wallpaper pattern. Covering your table or your bedroom wall with Windrush can enrich your surroundings, so that it may seem as if you are living with an artwork.

In the Western world, we have often separated art from "craft." Art may be highly crafted, but it is often not "useful," meaning that we cannot employ it to meet our basic needs. At the same time, such items as eating utensils, blankets, or clothing are often thought too close to being "functional" to be artworks. Even if they are beautiful, they are craftworks. Artists and craftworkers, William Morris among them, have tried to break down this barrier at various times.

In 1861 in England, Morris created an interior design company with the goal of helping people improve their lives by making them more artistic. In several books and hundreds of public lectures, he urged the creation of art for everyday use, affordable to

buy and enjoyable to live with. "I do not want art for a few, any more than education for a few, or freedom for a few," he said. Artists, he believed, should devote their skills to creating useful objects for everyone. "Have nothing in your house that you do not know to be useful or believe to be beautiful," was the maxim he tried to live by. Thus in his workshop he made dishes, wallpaper, furniture, and fabrics, all by hand like craftworkers of the Middle Ages.

Many other artists have found stimulation in working along the boundary between art and useful objects. They create works that challenge our notion of function, either by making artworks that resemble useful things, or by creating useful objects of such beauty that to actually use them would seem a crime. In fact, most of the world's cultures have always regarded an excellent piece of pottery as highly as a painting, and a book illustration as equal in merit to a piece of sculpture.

In this chapter, we will consider several media generally associated with crafts: clay, glass, metal, wood, and fiber; most are three dimensional. In a previous era, we might have regarded the works illustrated here as "craftworks." But in this day and age (and here) they are all artforms.

((•—**Listen** to the chapter audio on myartslab.com

13.1 William Morris. *Windrush*. 1892. Textile pattern. Woodblock print on paper. Repeatable.

Victoria and Albert Museum, London © V&A Images.

Clay

Clay comes from soil with a heavily volcanic makeup, mixed with water. Since humans began to live in settled communities, clay has been a valuable art material. It is extremely flexible in the artist's hands, yet it hardens into a permanent shape when exposed to heat.

The art and science of making objects from clay is called **ceramics**. Any person who works with clay is a **ceramist**; a ceramist who specializes in making dishes is a **potter**. A wide range of objects, including tableware, dishes, sculpture, bricks, and many kinds of tiles, are made from clay. Most of the basic ceramic techniques were discovered thousands of years ago. All clays are flexible until baked in a dedicated high-temperature oven called a **kiln**, a process known as **firing**.

Clays are generally categorized in one of three broad types. **Earthenware** is typically fired at a relatively low temperature (approximately 800°C to 1,100°C) and is porous after firing. It may vary in color from red to brown to tan. Earthenware is the most common of the three types, and a great many of the world's pots have been made from it. **Stoneware** is heavier, is fired at a higher temperature (1,200°C to 1,300°C), and is not porous. It is usually grayish or brown. Combining strength with easy workability, stoneware is the preferred medium of most of today's ceramists and potters. **Porcelain** is the rarest and most expensive of the three types. Made from deposits of decomposed granite, it becomes white and nonporous

13.2 Betty Woodman. *Divided Vases: Cubist.* 2004.
Glazed earthenware, epoxy resin, lacquer, and paint. 34½″ × 39″ × 7″.
Salon 94, New York.

✳ **Explore** the Discovering Art tutorial
on crafts on myartslab.com

after firing at a typically high temperature (1,300°C to 1,400°C). It is translucent and rings when struck, both signs of its unique quality. Porcelain was first perfected in China, and even today in Britain and America the finest white dishes are called "china," no matter where they are made.

With any type of clay, the ceramic process is relatively simple. Ceramists create functional objects or purely sculptural forms from soft, damp clay using hand-building methods such as modeling, or by **throwing**—that is, by shaping clay on a rapidly revolving wheel. Invented in Mesopotamia about six thousand years ago, the potter's wheel allows potters to produce circular forms with great speed and uniformity. In the hands of a skilled worker, the process looks effortless, even magical, but it takes time and practice to perfect the technique. After shaping, a piece is air dried before firing in a kiln.

Two kinds of liquids are commonly used to decorate ceramics, though rarely on the same piece. A slip is a mixture of clay and water about the consistency of cream, sometimes colored with earthen powders. With this relatively simple technique, only a limited range of colors is possible, but many ancient cultures made a specialty of this type of pottery decoration (see fig. 2.2).

A **glaze** is a liquid paint with a silica base, specially formulated for clay. During firing, the glaze vitrifies (turns to a glasslike substance) and fuses with the clay body, creating a nonporous surface. Glazes can be colored or clear, translucent or opaque, glossy or dull, depending on their chemical composition. Firing changes the color of most glazes so radically that the liquid that the ceramist applies to the vessel comes out of the kiln an entirely different color.

Recent works by two of today's leading ceramists will help to show the possibilities of this medium; both are vessels with handles, but they show widely divergent styles. Betty Woodman's *Divided Vases: Cubist* (**fig. 13.2**) have an exuberant, free-form look that

preserves the expressiveness of spontaneous glaze application. The handles are actually flat perforated panels that still show traces of the working process. Woodman used earthenware, a relatively coarse clay that is conducive to natural shapes like the bamboo segments that the vase bodies suggest. She threw each in three pieces on the wheel, and then joined them before adding the handles. The *Divided Vases* have a fresh look, as if they just came out of the firing kiln.

Adrian Saxe's *Les Rois du monde futur (Rulers of the Future World)* (**fig. 13.3**) seems precious and exquisite by comparison. He used porcelain for the main body, working it into a gourdlike shape before tipping it slightly off-axis. The overly elegant handles recall

13.4 Peter Voulkos. *Untitled Plate CR952*. 1989. Anagama wood-fired stoneware. 20½″ × 4½″.
Sherry Leedy Contemporary Art. © The Voulkos Family Trust.

13.3 Adrian Saxe.
Les Rois du monde futur (Rulers of the Future World). 2004. Porcelain, stoneware, overglaze enamel, lusters, mixed media. 26¼″ × 13¼″ × 10″.
Frank Lloyd Gallery, Santa Monica. Photo: Anthony Cunha.

👁 **Watch** a podcast interview with Adrian Saxe about *Rulers of the Future World* on myartslab.com

antique picture frames, while the rough base quotes the style of traditional Chinese pottery. The work's title shows the artist's sarcastic mindset: The rulers of the future world are insects, two of which crawl up the cap.

The acceptance of clay as an art medium (rather than something to shape into dishes) owes a great deal to the California sculptor Peter Voulkos. He was trained as a potter and had a studio that sold dishes in upscale stores until the mid-1950s. Then he began to explore abstract art, and he found ways to incorporate some of its techniques into his ceramic work. At first he took a fresh approach to plates: He flexed them out of shape and scratched their surfaces as if they were paintings, thereby rendering them useless in the traditional sense. We see the results of this treatment in his *Untitled Plate CR952* (**fig. 13.4**). His first exhibition of these works in 1959 caused a great deal of controversy because most people did not think of stoneware as an art medium. Yet none could deny the boldness of his inventions.

Both Peter Voulkos and Toshiko Takaezu were influenced by the earthiness and spontaneity of some traditional Japanese ceramics, as well as by Expressionist painting, yet they have taken very different directions. Voulkos's pieces are rough and

13.5 Toshiko Takaezu. *Makaha Blue II*. 2002.
Stoneware. 48″ × 18½″.
Courtesy of Toshiko Takaezu Trust and Charles Cowles Gallery, NY.

Glass

Glass has been used for at least four thousand years as a material for practical containers of all shapes and sizes. Stained glass has been a favorite in churches and cathedrals since the Middle Ages. Elaborate, blown-glass pieces have been made in Venice since the Renaissance. Glass is also a fine medium for decorative inlays in a variety of objects, including jewelry.

Glass is an exotic and enticing art medium. One art critic wrote, "Among sculptural materials, nothing equals the sheer eloquence of glass. It can assume any form, take many textures, dance with color, bask in clear crystallinity, make lyrics of light."[2]

Chemically, glass is closely related to ceramic glaze. As a medium, however, it offers a wide range of unique possibilities. Hot or molten glass is a sensitive, amorphous material that is shaped by blowing, casting, or pressing into molds. As it cools, glass solidifies from its molten state without crystallizing. After it is blown or cast, glass may be cut, etched, fused, laminated, layered, leaded, painted, polished, sandblasted, or slumped (softened for a controlled sag). The fluid nature of glass produces qualities of mass flowing into line, as well as translucent volumes of airy thinness.

aggressively dynamic, but Takaezu's *Makaha Blue II* (**fig. 13.5**) offers subtle, restrained strength. By closing the top of container forms, she turns vessels into sculptures, thus providing surfaces for rich paintings of glaze and oxide. She reflected on her love of the clay medium:

> When working with clay I take pleasure from the process as well as from the finished piece. Every once in a while I am in tune with the clay, and I hear music, and it's like poetry. Those are the moments that make pottery truly beautiful for me.[1]

Ceramic processes evolved very slowly until the mid-twentieth century, when new formulations and even synthetic clays became available. Other changes have included more accurate methods of firing and less-toxic techniques and equipment.

13.6 Dale Chihuly. *Mauve Seaform Set with Black Lip Wraps*. From the *Seaforms* series. 1985. Blown glass.
Courtesy of the artist. Photography by Dick Busher.

The character of any material determines the character of the expression; this statement is particularly true of glass. Molten glass requires considerable speed and skill in handling. The glassblower combines the centering skills of a potter, the agility and stamina of an athlete, and the grace of a dancer to bring qualities of breath and movement into crystalline form.

The fluid and translucent qualities of glass are used to the fullest in Dale Chihuly's *Seaforms* series (**fig. 13.6**). He produces such pieces with a team of glass artists working under his direction. In this series, he arranged groups of pieces and carefully directed the lighting to suggest delicate undersea environments.

Chihuly is one of many artists today who treat glass as a sculptural medium, but Mona Hatoum returns us to the contemplation of usefulness with her provocative work *Nature morte aux grenades* (*Still Life with Hand Grenades*) (**fig. 13.7**). She researched the design of various sorts of small explosive devices that the world's armies use, and recreated them in colorful pieces of solid crystal. She placed these precious-looking objects on a gurney as if they were specimens of some kind, which they are: specimens of humanity's tendency to violence. She used the beauty of glass to represent "useful" objects of a lethal sort.

Metal

Metal's primary characteristics include both strength and formability. The various types of metal most often used for crafts and sculpture can be hammered, cut, drawn out, welded, joined with rivets, or cast. Early metalsmiths created tools, vessels, armor, and weapons.

In Muslim regions of the Middle East in the thirteenth and fourteenth centuries, artists practiced shaping and inlaying with unparalleled sophistication. The d'Arenberg Basin (**fig. 13.8**), named after a French collector who owned it for many years, was made for the last ruler of the Ayyubid dynasty in Syria in the mid-thirteenth century. The body of the basin was first cast in brass; its extremely intricate design included lowered areas into which precisely cut pieces of silver were placed. Although most of the silver pieces are only a fraction of an inch in size, they enliven a carefully patterned design that occupies several finely proportioned horizontal bands. The lowest band is a decorative pattern based on repeated plant shapes. Above is a row of real and imaginary animals that decorates a relatively narrow band. The next band depicts a scene of princely pleasure, as well-attired people play polo. The uppermost band contains more plant shapes between the uprights of highly stylized Arabic script that expresses good wishes to the owner of the piece. A central panel in this upper row depicts a scene from the life of Christ, who is regarded as an important teacher in Islam.

13.7 Mona Hatoum.
Nature morte aux grenades. 2006–2007.
Crystal, mild steel, rubber. 38⅜″ × 81⅛″ × 27½″.
Photograph: Marc Domage. Courtesy of Alexander and Bonin, New York.

13.8 The d'Arenberg Basin.
Probably Damascus, Syria. 1247–1249.
Brass inlaid with silver. 8⅞″ × 19⅝″.
Freer Gallery of Art, Smithsonian Institution, Washington, DC. F1955.10.

13.9 Cal Lane. *Untitled (Map 3)*. 2007.
Plasma-cut steel. 78½″ × 71¾″.
Courtesy Samuel Freeman Gallery.

Wood

The living spirit of wood is given a second life in handmade objects. Growth characteristics of individual trees remain visible in the grain of wood long after trees are cut, giving wood a vitality not found in other materials. Its abundance, versatility, and warm tactile qualities have made wood a favored material for human use and for art pieces. Like many natural products, wood can be harvested in a sustainable manner or a wasteful one. Many woodworkers today have moved toward sustainability by using wood that is already down, or harvested in certified forests.

Henry Gilpin generally makes furniture on commission, but when he heard about a huge elm tree near his studio that had died because of encroaching construction, he secured

Cal Lane combines some of the intricate metalwork of Middle Eastern pieces with ideas ripped from today's headlines, in works such as *Untitled (Map 3)* (**fig. 13.9**). She worked for years as a welder, a woman in a traditionally male occupation, and she used those skills on a 55-gallon oil drum to create this work. First she flattened it, and then she cut it to show a map of the world, with the lid and base of the drum forming the poles. The oil drum has tremendous symbolic significance as a source of much of the world's energy, wealth, conflicts, and pollution. This work, with its sun-shaped form at the upper right, suggests the global dominance of oil in our economy and our energy. It also creatively transforms a useful object into an artwork that comments on its own significance.

13.10 Henry Gilpin. *Curiously Red.* 2006.
Stained elm, pigment, magnets. 36″ × 74″ × 16″.
Courtesy the artist and Gallery NAGA.

13.11 Liv Blåvarp. *Untitled.* Necklace, 2002. Dyed sycamore, painted birch, gold leaf. 11″ × 8″ × 2″.
Museum of Arts and Design, NYC. Gift of Barbara Tober, 2002 Inv 2002.16. Photo John Bigelow Taylor.

a piece of it. He found that the crowded growing conditions had caused the wood grains in the tree to cross and twist, so that when he dried the piece it emerged contorted. He decided to make this casualty of progress into a table by mounting the warped plank atop a frame (**fig. 13.10**). The surface is so uneven that this work titled *Curiously Red* is barely usable. To honor the tree's sacrifice of its life, he poured red stain over it, and left the drips to show at the bottom of the legs to resemble bloodstains. What might at first glance appear

to be a warped side table thus becomes a meditation on life and death.

We get another view of wood's capabilities with the untitled necklace by Liv Blåvarp (**fig. 13.11**). The artist carved the segments into deeply grooved shapes that resemble living things. While her work is based on folk traditions of her native Norway, this piece looks very contemporary. Note also that it is asymmetrical, unlike most necklaces, and that the clasp resembles an animal's tail.

Fiber

Fiber arts include such processes as weaving, stitching, basketmaking, surface design (dyed and printed textiles), wearable art, and papermaking by hand. These fiber processes use natural and synthetic fibers in both traditional and innovative ways. Artists working with fiber (like artists working in any medium) draw on the heritage of traditional practices and also explore new avenues of expression. Fiber arts divide into two general classes: work made with a loom, and work made **off-loom**, or without a loom.

All weaving is based on the interlacing of fibers. Weavers generally begin with long fibers in place, called the **warp** fibers, which determine the length of the piece they will create. Often the warp fibers are installed on a **loom**, a device that holds them in place and may pull them apart for weaving. They cross the warp fibers at right angles with **weft** fibers (related to the word *weave*). Weavers create patterns by changing the numbers and placements of interwoven threads, and they can choose from a variety of looms and techniques. Simple hand looms can produce very sophisticated, complex weaves. A large tapestry loom, capable of weaving hundreds of colors into intricate forms, may require several days of preparation before work begins.

Some of the world's most spectacular carpets came from Islamic Persia during the Safavid dynasty in the sixteenth century. Here, weavers employed by royal workshops knotted carefully dyed wool over a network of silk warps and wefts. The Ardabil Carpet (**fig. 13.12**), long recognized as one of the greatest Persian carpets, contains about three hundred such knots, over fine silk threads, per square inch. Thus this carpet required approximately 25 million knots!

The design of the carpet is centered on a sunburst surrounded by 16 oval shapes. Two mosque lamps of unequal size share space with an intricate pattern of flowers. At the corners of the main field, quarters of the central design are repeated. A small panel at the right gives the date and the name of an artist, who must have been the designer. Another inscription is a couplet by Hafiz, the best-known lyrical poet in Iran: "I have no refuge in this world other than thy threshold. My head has no resting-place other than this doorway." The carpet originally covered the floor of a prayer chapel.

Contemporary artists have not abandoned the loom; rather, they use it in new ways. A few even make **tapestries**, a traditional type of weaving in which carefully trimmed and dyed weft threads are

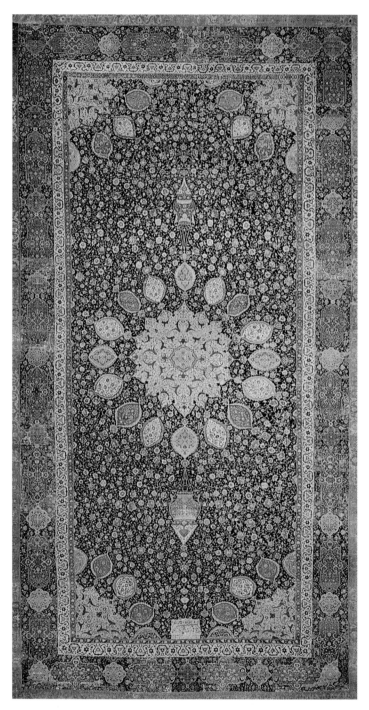

13.12 The Ardabil Carpet. Tabriz. 1540.
Wool pile on silk warps and wefts. 34′ × 17′6″.

pulled through stable warps to create patterns or pictures. Egyptian artist Lara Baladi creates large-scale tapestries that combine hundreds of pictures. *Sandouk el Dounia* (*The World in a Box*) (**fig. 13.13**), for example, was titled after a type of ambulatory street theater practiced in Egypt in the early twentieth century. To form the work, she first created a huge collage of about 900 photographs of costumed and staged scenes that she shot in Cairo, as well as photographs drawn from her personal archive, taken in many parts of the world. She then photographed the collage and used this high-resolution reproduction to program a digitally operated loom at Flanders Tapestries in Belgium. The pixels of the photograph take on new life as vividly dyed strands of fabric. She attempts in this multilayered piece, she says, "to blur the boundary between the mundane and the sacred, the private and the public, the pharaonic and the contemporary."[3]

13.13 Lara Baladi. *Sandouk el Dounia (The World in a Box)*. 2007. Digitally woven tapestry, 10′4″ × 8′2⁹⁄₁₀″ collage of 900 C41 3¹⁵⁄₁₆″ × 5²⁹⁄₃₂″ prints. Installation view at the exhibition "Penelope's Labour; Weaving Words and Images," Cini Foundation, Venice, 2011. Detail: 25′7″ × 21′3⁹⁄₁₀″.
Artwork and photo Lara Baladi.

Quilt making has traditionally been a woman's province, carried on for generations in some communities. In the 1970s, some feminist artists used quilt making as a way of breaking down the barrier between art and craft work, feeling that relegating craft to a lower status demeaned the achievements of women throughout history.

Miriam Schapiro borrowed techniques from quilting for works such as *Personal Appearance #3* (**fig. 13.14**), which is large enough to cover a small bed. Its composition includes a large orange rectangle at its center that describes a bedlike shape, and the black

13.15 Polly Apfelbaum. *Flatterland Funkytown.* 2012. Synthetic crushed velvet pieces. Dimensions variable.
CB8595. Courtesy the artist and Clifton Benevento, New York.

square near the top is placed like a pillow. The work is exuberant and vibrant, and made partly from cloth scraps like a quilt. This was certainly part of the artist's intent: to pay homage to quilt makers past and present, by making a work that resembles a quilt in many ways but is not one. The work thus hovers on the brink of usefulness; it takes on the appearance of a useful object without exactly being one.

Polly Apfelbaum also uses off-loom techniques to create installations that show the influence of both modern abstract art and feminism. She said that she wanted to do a contemporary version of the traditional crazy quilt, in which random fragments of leftover cloth are stitched together in dazzling patterns. In this way she claims descent from the women who have traditionally woven and sewn most textiles. In *Flatterland Funkytown* (**fig. 13.15**), she used bright colors to stain oval-shaped pieces of velvet. She attached them together to heighten the resemblance to quilts, and then installed them on the floor of a gallery. The resulting work resembles a quilt, a carpet, and a luxurious bed of flower petals. *Flatterland Funkytown* looks spontaneous, but the creation involved months of labor. She cut each piece by hand, and applied fabric dye to each part with a squeeze bottle. Her dyeing process resembles painting, but the works she creates are closer to sculpture and textile art. She sometimes calls her works "fallen paintings," because placing the work on the floor allows viewers to interact with the work from more angles.

Faith Ringgold uses quilt making, as well as paintings and soft sculptures, to speak eloquently of her life and ideas. Memories of her childhood in Harlem in the 1930s provide much of her subject matter. *Mrs. Jones and Family* (**fig. 13.16**) represents Ringgold's own family. Commitments to women, the family, and cross-cultural consciousness are at the heart of Ringgold's work. With playful exuberance and insight, she draws on history, recent events, and her own experiences for her depictions and narratives of class, race, and gender.

Fiber can be worked in infinite ways, and Chicago-based Nick Cave has likely used them all at one time or another to create his ongoing series

13.16 Faith Ringgold. *Mrs. Jones and Family.* 1973. Mixed media. 74″ × 69″. Series: *Family of Women Mask 3.*
Collection of the artist. Faith Ringgold ©1997.

FORMING ART

Faith Ringgold (b. 1930): Stitching History

13.17 Faith Ringgold, with detail of *The Purple Quilt.* 1986.
C'Love/Faith Ringgold, Inc.

Most quilt makers have worked to create dazzling designs from fabric, but Faith Ringgold innovated by using her own life and heritage to make quilts that tell stories. In 1972 she left a teaching position and began to devote herself full time to art. She also began a ten-year collaboration with her mother in the creation of works on cloth. Quilt making had been a family tradition as far back as her great-great-grandmother, who had made them as a slave in Florida. The mother–daughter team collaborated on a new type of textile art that included images and stories on the sewn fragments.

Ringgold said of quilt making: "It is an art form that slave women used, to embellish and beautify useful objects such as quilts. Because the African-American experience with quiltmaking was very much like the African who made the tools roughly, and then adorned them and made them skillfully, so that things were useful, but then they

were beautified. So here's something: We're going to sew some cloth together to cover ourselves because we want to keep warm. And now we're going to beautify those pieces so that we sew them together and make them into quilts. So now it's an art piece, and it's useful. I really like that."[4]

Her themes are highly varied. Some are personal and autobiographical, such as *Change: Faith Ringgold's Over 100 Pound Weight Loss Performance Story Quilt.* Others expose injustice, such as the *Slave Rape* series, which dealt with the mistreatment of African women in the slave trade. Some are about important African-American cultural figures, such as *Sonny's Quilt,* which depicts the jazz saxophonist Sonny Rollins (a childhood friend), performing as he soars over the Brooklyn Bridge.

A standout among the artist's "story quilts" is *Tar Beach* (**fig. 13.18**), which tells the story of the fictional Cassie, an eight-year-old character who is based on Ringgold's own childhood memories of growing up in New York City. She would go up to the asphalt roof of her apartment building ("Tar Beach") with her family on hot nights, because there was no air-conditioning in the home. Cassie describes Tar Beach as a magical place, with a 360-degree view of tall buildings and the George Washington Bridge in the distance. She dreams

that she can fly, that she can do anything she imagines, as she lies on a blanket with her little brother. She dreams that she can give her father the union card that he has been denied because of his race. She dreams that she can let her mother sleep late, and eat ice cream every day for dessert. She even dreams that she can buy the building her father works in, and that her mother will not cry when her father can't find work. The quilt depicts the two children on the blanket, and her parents playing cards with the neighbors next to a table set with snacks and drinks. We also see Cassie flying through the sky near the top center. *Tar Beach* was later made into a children's book, one of several that Ringgold has written.

Asked her view of the artist's function in society, Ringgold replied in a way that illuminates *Tar Beach*: "I think the artist's role is to, in some ways, document the times. Because we look at art through history. We can tell a lot about the time the artist lived by just looking at the pictures, or the sculpture that they did. And every group of people does this, every culture of people, every race of people does this. Those who have highly developed, fascinating cultures create artists who have the same, because they work together. So as a black woman, my role is to speak in my voice as to race and gender, about the times that I lived in. And I see that as a responsibility that I take on."[5]

13.18 Faith Ringgold. *Tar Beach*. Part I from *The Women on a Bridge* series. 1988.
Acrylic on canvas, bordered with printed, painted, quilted, and pieced cloth. 74⅝″ × 68½″.
Guggenheim Museum, New York. Gift of Mr. and Mrs. Gus and Judith Lieber © Faith Ringgold 1988.

View the Closer Look for Faith Ringgold's *Tar Beach* on myartslab.com

of Soundsuits (**fig. 13.19**). These extravagant cos-
tumes are all wearable, and over the years they have
included such offbeat materials as human hair, twigs,
toys, garbage, buttons, dryer felt, stuffed animals,
fake fur, feathers, and flowers, besides sequins and
beads of all kinds.

In the Soundsuit shown here, a cloud of ceramic
birds surrounds a body suit of crocheted yarn pieces.
Cave (who is not related to the Australian musician
of the same name) grew up in a large family where
he personalized the hand-me-down clothing he often
wore. However, the Soundsuits do the opposite: most
of them completely hide the wearer, thus conferring an
alternate identity. The roots of these pieces are in New
Orleans Mardi Gras costumes and African ceremonial
garments, but in Cave's hands they become both exu-
berant and mysterious.

Many contemporary artists are using media form-
erly associated with crafts—clay, glass, metal, wood,
and fiber—to create works that challenge the bound-
ary between craft and art. Most of the world's cultures
do not distinguish between craft and art, and Western
culture is gradually moving toward that view.

✔—[**Study** and review on myartslab.com

13.19 Nick Cave. *Soundsuit*. 2009. Mixed media. Height 92″.
Photo: James Prinz. Courtesy of the artist and Jack Shainman Galley, NY.

THINK BACK

1. What are the major types of clay?

2. Who perfected metal inlays in the
 thirteenth century?

3. What are the two major classifications of fiber art?

TRY THIS

Inventory the ceramics in your home, including
the dishes, to find out which of the three principal
classifications predominates.

KEY TERMS

glaze – a silica-based paint for clay that fuses with the clay
body on firing; can be almost any color, or translucent

slip – clay that is thinned to the consistency of cream and
used as paint on earthenware or stoneware ceramics

warp – in weaving, the threads that run length-wise
in a fabric, crossed at right angles by the weft

weft – in weaving, the horizontal threads interlaced
through the warp

14 ARCHITECTURE

THINK AHEAD

14.1 Consider the function of architecture to record and reflect a culture's values.

14.2 Explain the need for architects to combine function, form, and structure.

14.3 Identify traditional materials and methods used in architecture.

14.4 Describe the relationship of technological innovations to changes in architectural forms and structure.

14.5 Recognize the impact of contemporary environmental concerns on architecture.

Among the world's oldest surviving structures is the dolmen in northwestern France pictured here (**fig. 14.1**). This dolmen was constructed from huge boulders, some set upright and another used as a roof to create a space. Its most likely function was to house the dead in an enclosed tomb. This bulky structure resembles others in many parts of the world, including the British Isles, Jordan, India, and Korea. Though other dolmens have various functions, they all share a primitive construction technique and a massive appearance.

For at least five thousand years, people have built impressive structures, like this dolmen, that go beyond providing mere shelter. Architecture is thus the art and science of designing and constructing buildings not only for practical purposes but also for symbolic and aesthetic ones. It has great potential for enhancing many aspects of our daily lives; from the houses we live in to the places where we work, worship, or spend our leisure time.

In this chapter we will examine the art and craft of architecture, from primitive structures to today's high-tech creations. We will see that beyond the necessity for shelter, architecture can make important expressive statements that record and communicate a society's values.

An Art and A Science

No matter what sort of structure they are building, architects address and integrate three key issues: function (how a building is used); form (how it looks); and structure (how it stands up). As an art, architecture both creates interior spaces and wraps them in an expressive shape.

14.1 Dolmen. Crocuno, north of Carnac, France.
James Lynch/The Ancient Art & Architecture Collection Ltd.

((•–**Listen** to the chapter audio on myartslab.com

As a science, architecture is a physics problem: How does a structure hold up its own weight and the loads placed on it? Architecture must be designed to withstand the forces of compression, or pushing (→ ←); tension, or stretching (← →); and bending, or curving (()); and any combination of these physical forces.

Like the human body, architecture has three essential components. These are a supporting skeleton; an outer skin; and operating equipment, similar to the body's vital organs and systems. The equipment includes: plumbing; electrical wiring; appliances; and systems for cooling, heating, and circulating air as needed. In earlier centuries, structures of wood, earth, brick, or stone had no such equipment, and the skeleton and skin were often one.

Traditional Materials and Methods

The evolution of architectural techniques and styles has been determined by the materials available and by the changing needs and values of societies. In ancient times, when nomadic hunter-gatherers became farmers and village dwellers, housing evolved from caves, huts, and tents to more substantial structures.

Because early building designers (as well as those in nonindustrialized countries today) made structures only out of the materials at hand, regional styles developed that blended with their sites and climates. Modern transportation and the spread of advanced technologies now make it possible to build almost anything anywhere.

Wood, Stone, and Brick

Since the beginning of history, most structures have been made of wood, stone, earth, or brick. Each of these natural materials has its own strengths and weaknesses. For example, wood, which is light, can be used for roof beams. Stone, which is heavy, can be used for load-bearing walls but is less effective as a beam. Much of the world's major architecture has been constructed of stone because of its permanence, availability, and beauty. In the past, entire cities were slowly built by cutting and placing stone upon stone.

Dry Masonry

Probably the simplest building technique is to pile stones atop one another, as we saw with the dolmen above. The process has been used to make such rudimentary structures as markers, piles, and cairns throughout the world. When such massing is done with a consistent pattern, the result is called **masonry**. In dry masonry, where no mortar is used, the weight of the stones themselves holds the structure up. If the stones are cut or shaped before use, they are **dressed**.

Great Zimbabwe ("Great Stone House") in East Africa (**fig. 14.2**) is an elliptical structure that gave its name to the country in which it is located. Probably built between 1350 and 1450 CE, it was used for about three hundred years. Great Zimbabwe is nearly round, with several conical structures inside whose original function

14.2 Great Zimbabwe. Zimbabwe. Before 1450. Height of wall 30′.

a. Plan. b. Interior.

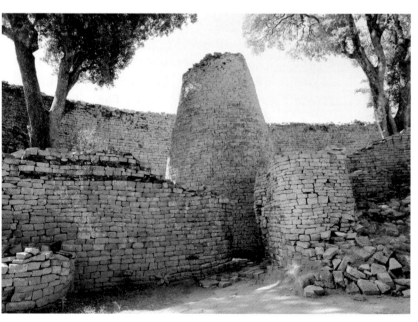

Peter Groenendijk/Robert Harding.

is still unknown. Its walls, made of dressed local stone, are approximately 30 feet high. For added stability, the walls were built up to 15 feet thick at the base, tapering slightly toward the top. Roofing was probably grass or thatch held together with sticks. The structure is the largest of a group of ancient stone dwellings that formed a trading city of perhaps twenty thousand people at its height. Though the outer walls of Great Zimbabwe have openings in selected locations for entry and exit, there are no windows; because these tend to weaken masonry walls, only structures that are considerably smaller can use them without external support.

Great Zimbabwe is the largest ancient stone structure in Africa south of the great pyramids of Egypt, which are also built of dry masonry (see Chapter 15). Other notable examples of such buildings are Machu Picchu in Peru (see Chapter 20) and the ancient pueblos of the American Southwest, such as Mesa Verde.

Post and Beam

Prior to the twentieth century, two dominant structural types were in common use: **post-and-beam** (also called **post-and-lintel**); and **arch** systems, including the **vault**. Most of the world's architecture, including modern steel structures, has been built with post-and-beam construction (**fig. 14.3**). Vertical posts or columns support horizontal beams and carry the weight of the entire structure to the ground.

The form of post-and-beam buildings is determined by the strengths and weaknesses of the materials used. Stone beam lengths must be short, and posts relatively thick to compensate for stone's brittleness. Wood beams may be longer, and posts thinner, because wood is lighter and more flexible. The strength-to-weight ratio of modern steel makes it possible to build with far longer beams and thus to create much larger interior spaces.

Bundled reeds provided the model for the monumental post-and-beam Egyptian temples. A row of columns spanned, or connected, by beams is called a **colonnade**, as seen in the Colonnade and Court of Amenhotep III (**fig. 14.4**). Most ancient Egyptian temples were symmetrical, with aisles for processions that connected adjacent pavilions. Their arrangement was also generally hierarchical, with the more remote precincts accessible only to the higher-ranking priests.

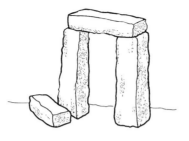

14.3 Post-and-Beam Construction.

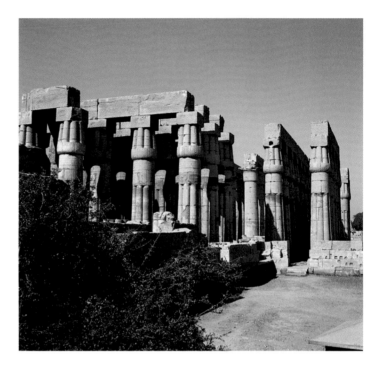

14.4 Colonnade and Court of Amenhotep III. Temple of Amun-Mut-Khonsu. 18th dynasty. Luxor, Thebes, Egypt. c.1390 BCE.
Alistair Duncan © Dorling Kindersley.

Following the lead of the Egyptians, the Greeks further refined stone post-and-beam construction. For more than two thousand years, the magnificence of the Parthenon and other classical Greek architecture (see Chapter 16) has influenced the designers of a great many later buildings.

Round Arch, Vault, and Dome

Both Egyptian and Greek builders had to place their columns relatively close together because stone is weak under the load-bearing stresses inherent in a beam. The invention of the round arch (**fig. 14.5**) allowed builders to transcend this limitation and create new architectural forms. An arch may be supported by either a column or a **pier**, a more massive version of

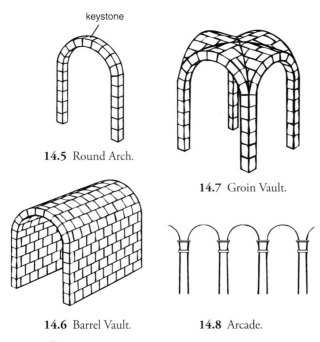

keystone

14.5 Round Arch.

14.7 Groin Vault.

14.6 Barrel Vault.

14.8 Arcade.

Watch **Watch** an architectural simulation of barrel and groin vaults on myartslab.com

a column. When extended in depth, the round arch creates a tunnel-like structure called a **barrel vault** (**fig. 14.6**). Roman builders perfected the round arch and developed the groin vault (**fig. 14.7**), formed by the intersection of two barrel vaults.

A vault is a curving ceiling or roof structure, traditionally made of bricks or blocks of stone tightly fitted to form a unified shell. In recent times, vaults have been constructed of materials such as cast **reinforced concrete**.

Early civilizations of western Asia and the Mediterranean area built arches and vaults of brick, chiefly for underground drains and tomb chambers. But the Romans were the first to use the arch extensively in above-ground structures. They learned the technique of stone arch and vault construction from the Etruscans, who inhabited central Italy between 750 and 200 BCE.

A round stone arch can span a longer distance and support a heavier load than a stone beam because the arch transfers the load more efficiently. The Roman arch is a semicircle made from wedge-shaped stones fitted together with joints at right angles to the curve. During construction, temporary wooden supports carry the weight of the stones. The final stone that is set in place at the top is called the **keystone**. When the keystone is placed, a continuous arch with load-bearing capacity is created and the wood support is removed. A series of such arches supported by columns forms an **arcade** (**fig. 14.8**).

Roman builders used the arch and arcade to create structures of many types throughout their vast empire in most of Europe, the Near East, and North Africa. The aqueduct bridge called the Pont du Gard, near Nîmes, France (**fig. 14.9**), is one of the finest remaining examples of the functional beauty of Roman engineering. The combined height of the three levels of arches is 161 feet. Dry masonry blocks, weighing up to 2 tons each, make up the large arches of the two lower tiers. Water was once carried in a conduit at the top, with the first level serving as a bridge for traffic. The excellence of its design and construction has kept this aqueduct standing for two thousand years.

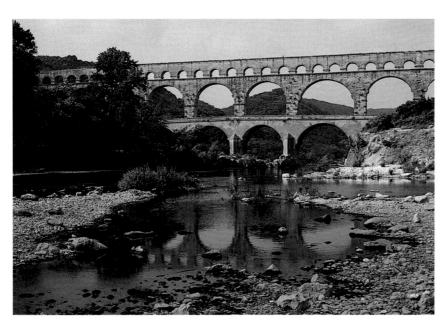

14.9 Pont du Gard. Nîmes, France. 15 CE. Limestone. Height 161′, length 902′.
Photograph: Duane Preble.

Watch **Watch** a video about the Pont du Gard on myartslab.com

Watch **Watch** an architectural simulation of the round arch on myartslab.com

a. Dome (arch rotated 180°).

b. Dome on a cylinder.

c. Dome on pendentives.

14.10 Dome.

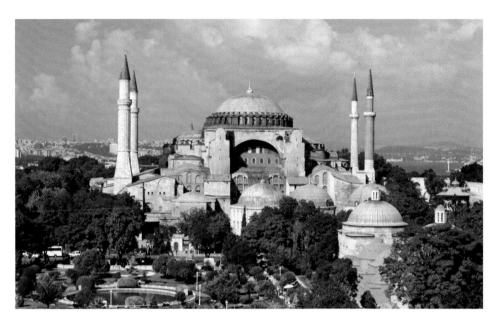

14.11 Hagia Sophia. 532–535. Istanbul, Turkey.
a. Exterior.
Photograph: Ayhan Altun.

Roman architects borrowed Greek column design and combined it with the arch, enabling them to greatly increase the variety and size of their architectural spaces. The Romans also introduced liquid **concrete** as a material for architecture. Concrete is a mixture of water, sand, gravel, and a binder such as lime or gypsum. Cheap, stonelike, versatile, and strong, concrete allowed the Romans to cut costs, speed construction, and build on a massive scale.

An arch rotated 180 degrees on its vertical axis creates a **dome** (**fig. 14.10**). Domes may be hemispherical or pointed. In general usage the word *dome* refers to a hemispherical vault built up from a circular or polygonal base. The weight of a dome pushes downward and outward all around its circumference. Therefore, the simplest support is a cylinder with walls thick enough to resist the downward and outward thrust.

One of the most magnificent domes in the world was designed for the Byzantine cathedral of Hagia Sophia ("Holy Wisdom") in Istanbul (**fig. 14.11**). It was built in the sixth century as the central sanctuary of the Eastern Orthodox Christian Church. After the Islamic conquest of 1453, **minarets** (towers) were added and it was used as a mosque. It is now a museum. The dome of Hagia Sophia rests on curving triangular sections called **pendentives** over a square base.

Hagia Sophia's distinctive dome appears to float on a halo of light—an effect produced by the row of

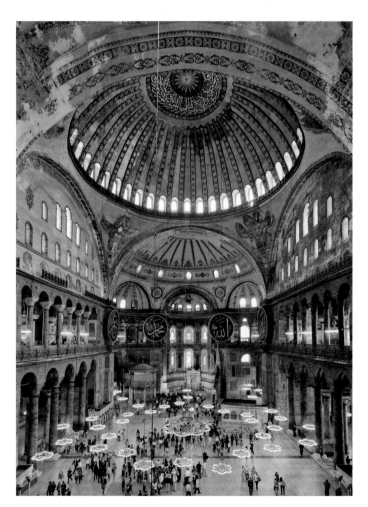

b. Interior.
Photograph: Ayhan Altun.

windows encircling its base. Pendentives carry the enormous weight from the circular base of the upper dome downward to a square formed by supporting walls.

Pointed Arch and Vault

After the round arch, the pointed arch was the next great structural advance in the Western world. This new shape seems a small change, but it had a spectacular effect on the building of cathedrals. Vaults based on the pointed arch made it possible to build wider aisles and higher ceilings. We see the results of this new technology in the awesome height of the central aisle in the cathedral of Notre-Dame de Chartres, France (**fig. 14.12**).

A pointed arch (or Gothic arch, **fig. 14.13**) is steeper than a round arch, and therefore sends its weight more directly downward, but a substantial sideways thrust must still be countered in tall buildings. **Gothic** builders accomplished this by constructing elaborate supports called **buttresses** at right angles to the outer walls. In the most developed Gothic cathedrals, the outward force of the arched vault is carried to large buttresses by stone half-arches called **flying buttresses** (**fig. 14.14**).

By placing part of the structural skeleton on the outside, Gothic builders were able to make their cathedrals higher and lighter in appearance. Because the added external support of the buttresses relieved the

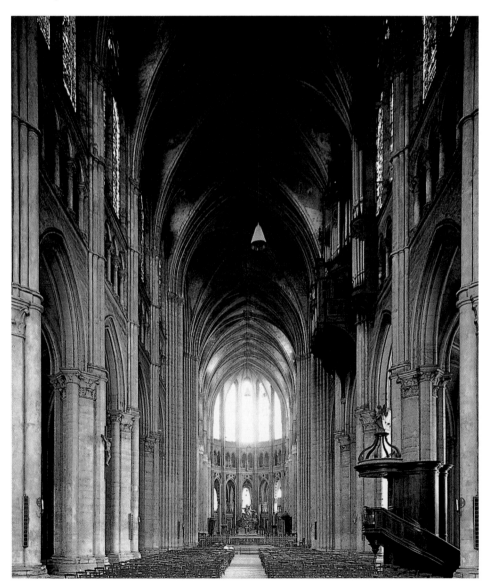

14.13 Gothic Arch.

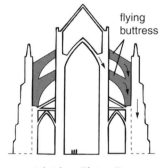

14.12 Notre-Dame de Chartres.
Chartres, France.
1145–1513.
Interior, nave.
Height 122′, width 53′,
length 130′.
© Photo Scala, Florence.

14.14 Flying Buttresses.

cathedral walls of much of their structural function, large parts of the wall could be replaced by enormous stained-glass windows, allowing more light (a symbol of God's presence) to enter the sanctuary. From the floor of the sanctuary to the highest part of the interior above the main altar, the windows increase in size. Stones carved and assembled to form thin ribs and pillars make up the elongated columns along the nave walls, which emphasize verticality and give the cathedral its apparent upward thrust. (We will consider the stylistic features of Gothic architecture in more detail in Chapter 16.)

After the Gothic pointed arch and vault, no basic structural technique was added to the Western architectural vocabulary until the nineteenth century. Instead, architects designed a variety of structures—at times highly innovative—by combining elements from different periods. Forms and ornamentation from the classical and Gothic periods were revived again and again and given new life in different contexts.

Truss and Balloon Frame

Wood has a long history as a building material. Besides the expected post and beam, timbers or logs have been used for centuries in **trusses** (**fig. 14.15**). A truss is a triangular framework used to span or to support. The perfection of mass-produced nails and mechanical saws in the nineteenth century led to advances in wood construction; the most important of these was the **balloon frame** (**fig. 14.16**). In balloon framing, heavy timbers are replaced with thin studs held together only with nails, leading to vastly reduced construction time and wood consumption. (Old-timers who were unwilling to use the new method called it

balloon framing because they thought it was as fragile as a balloon.) The method helped to make possible the rapid settlement of North America's western frontier and is still used in suburban new construction today.

Modern Materials and Methods

Beginning in about 1850, modern materials have revolutionized architecture. The techniques (post and beam, arch, vault) have remained the same, but the arrival of cast iron, steel, and reinforced concrete have provided a wealth of new ways to create and organize spaces. More recently, some even newer materials, such as carbon fiber and cross-laminated timber, are shaping the buildings that we use.

Cast Iron

Iron has much greater strength than stone or wood and can span much larger distances. After the technology for uniform smelting was perfected in the nineteenth century, cast and wrought iron became important building materials. Iron supports made possible lighter exterior walls and more flexible interior spaces because walls no longer had to bear structural weight. Architects first used this new material in factories, bridges, and railway stations.

The Crystal Palace (**fig. 14.17**), designed by Joseph Paxton, was a spectacular demonstration of what cast iron could do. It was built for the Great Exhibition of the Works of Industry of All Nations, the first international exposition, held in London in 1851. Designed to show off the latest mechanical inventions, the Crystal Palace was built in six months and covered 19 acres of park land. This was the first time new industrial methods and materials were used on such a scale.

Paxton used relatively lightweight, factory-made modules (standard-size structural units) of cast iron and glass. By freeing himself from past styles and masonry construction, he created a whole new architectural vocabulary. The light, decorative quality of the glass and cast-iron units was created not by applied ornamentation, but by the structure itself. Paxton, inspired by leaf structures, said, "Nature gave me the idea." The modular units provided enough flexibility for the entire structure to be assembled on the site, right over existing trees, and later disassembled and moved across town.

14.15 Trusses.

14.16 Balloon Frame.

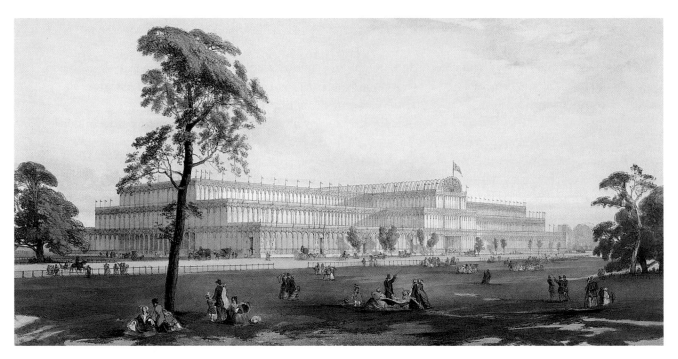

14.17 Joseph Paxton. Crystal Palace. London. 1850–1851. Cast iron and glass.
The Newberry Library. Photograph: Stock Montage, Inc.

Watch an architectural simulation about cast-iron construction on myartslab.com

Unfortunately, the building also showed the great defect of early cast-iron buildings: The unprotected metal struts tend to buckle on exposure to heat, making such buildings very susceptible to destruction by fire. The Crystal Palace indeed burned in 1936 after a fire broke out in its interior.

Steel and Reinforced Concrete

The next breakthrough in construction methods for large structures came between about 1890 and 1910 with the development of high-strength structural steel, used by itself and as the reinforcing material in reinforced concrete. The extensive use of cast-iron skeletons in the mid-nineteenth century had prepared the way for multistory steel-frame construction in the late 1880s.

Steel frames and elevators, together with rising urban land values, impelled a fresh approach to structure and form. The movement began to take shape in commercial architecture, symbolized by early skyscrapers, and found one of its first opportunities in Chicago, where the big fire of 1871 had cleared the way for a building boom.

Leading the Chicago school was Louis Sullivan, regarded as the first great modern architect. Sullivan rejected references to past buildings, and sought to meet the needs of his time by using new methods and materials. He had a major influence on the early development of what became America's and the twentieth century's most original contribution to architecture: the "skyscraper."

Among the first of these skyscrapers was Sullivan's Wainwright Building (**fig. 14.18**) in St. Louis, Missouri, which was made possible by the invention of the elevator and by the development of steel for the structural skeleton. The building boldly breaks with nineteenth-century tradition. Its exterior design reflects the internal steel frame and emphasizes the height of the structure by underplaying horizontal elements in favor of tall vertical shafts. Sullivan demonstrated his sensitivity and adherence to the harmony of traditional architecture by dividing the building's façade into three distinct zones, reminiscent of the base, shaft, and capital of Greek columns (see fig. 16.6). These areas also reveal the various functions of the building, with shops at the base, offices in the central section, and utility rooms at the top. The heavily ornamented band at the top stops the vertical thrust of the piers located between the office windows.

Thus, the exterior form of the building shows its interior functions; this was a novel concept. Sullivan's observation that "form ever follows function"[1]

14.18 Louis Sullivan. Wainwright Building.
St. Louis, Missouri. 1890–1891.
© Art on File/CORBIS. All Rights Reserved.

View the Closer Look for the
Wainwright Building on myartslab.com

14.19 Le Corbusier.
Domino Construction System. Perspective
drawing for Domino Housing Project. 1914.
© 2013 Artists Rights Society (ARS), New York/ADAGP, Paris/F.L.C.

eventually helped architects to break with their reliance on past styles and to rethink architecture from the inside out.

In this spirit, modern architecture arose in Europe between 1910 and 1930. Younger architects rejected decorative ornamentation and references to the past, as well as traditional stone and wood construction, and they began to think of a building as a useful arrangement of spaces rather than as a mass. The resulting **International Style** expressed the function of each building, its underlying structure, and a logical (usually asymmetrical) plan that used only modern materials such as concrete, glass, and steel.

The French architect and planner Le Corbusier showed the basic components of steel columns and reinforced-concrete slabs in a system that he called the Domino Construction System (**fig. 14.19**). The six steel supports are placed in concrete slabs at the same approximate locations as the spots on a domino game piece. Le Corbusier's idea of supporting floors and roof on interior load-bearing columns instead of load-bearing walls made it possible to vary the placement of interior walls according to how the various rooms were used. He called one of his homes a "machine for living in," but in fact its flexible spaces made it very comfortable. And because walls no longer bore any weight, they could become windows and let in a great deal of natural light.

14.20 Walter Gropius. Bauhaus Building. Exterior. 1926–1927.
Vanni Archive/CORBIS. © 2013 Artists Rights Society (ARS),
New York/VG Bild-Kunst, Bonn.

Walter Gropius used the principles of the International Style in his new building for the **Bauhaus** when the design school moved to Dessau, Germany (**fig. 14.20**). The workshop wing, built between 1925 and 1926, follows the basic concept illustrated in Le Corbusier's drawing. Because the reinforced-concrete floors and roof were supported by steel columns set back from the outer edge of the building, exterior walls did not have to carry any weight: they could be **curtain walls** made of glass. Even interior walls were non-load-bearing and could be placed anywhere they were needed.

Generally the public was slow to accept the stripped-down look of the new International Style. In response, architects developed a more decorative and exuberant style in the 1920s and 1930s called Art Deco. This style used some of the structural tenets of the International Style, but retained decoration, often in an abstract style. The Kress Building (**fig. 14.21**) in Hollywood, California, for example, rises up to

14.21 Edward F. Sibbert. Kress Building. Hollywood, California. 1935.
Photograph: Patrick Frank.

14.22 Steel-Frame Construction.

a vaulted ceiling at the top floor, adorned by shapes abstracted from growing fruit trees.

Le Corbusier's idea for alleviating urban crowding by using tall, narrow buildings surrounded by open space, and Sullivan's concept for high-rise buildings that express the grid of their supporting steel-frame construction (**fig. 14.22**), came together in the Seagram Building (**fig. 14.23**). Non-load-bearing glass walls had been a major feature of plans for skyscrapers conceived as early as 1919, but only in the 1950s, with greater public acceptance of modern architecture, could such structures be built. In the Seagram Building, interior floor space gained by the height of the building allowed the architects to leave a large, open public area at the base. The vertical lines emphasize the height and provide a strong pattern that is capped by a top section designed to give a sense of completion. The austere design embodies architect Mies van der Rohe's famous statement "Less is more."

The International Style had an enormous, if sometimes negative, influence on world architecture. It often replaced unique, place-defining regional styles. By mid-century, modern architecture had become synonymous with the style. The uniformity of glass-covered rectilinear grid structures was considered the appropriate formal dressing for the anonymity of the modern corporation.

Recent Innovations

In the late twentieth century, improved construction techniques and materials, new theories regarding structural physics, and computer analyses of the strengths and weaknesses in complex structures led to the further development of fresh architectural forms.

Suspension structures were known for decades through their use in tents and bridges, but the most

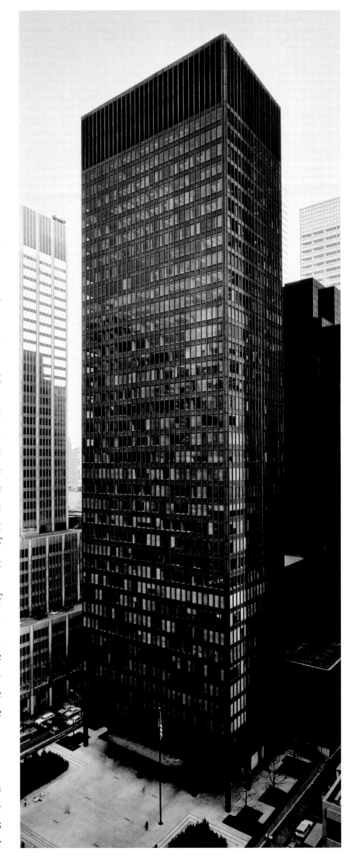

14.23 Ludwig Mies van der Rohe and Philip Johnson. Seagram Building. New York. 1956–1958.
Photograph: Andrew Garn.

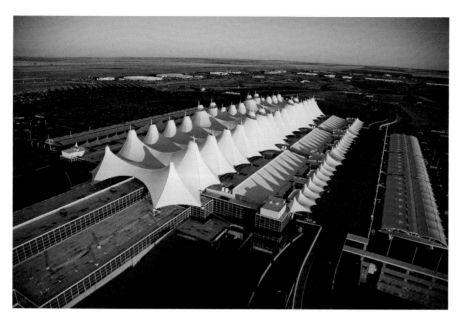

14.24 Fentress-Bradburn Architects. Jeppesen Terminal Building. Denver International Airport. 1994.
Photograph provided courtesy of the Denver International Airport.

director Thomas Krens envisioned a museum that would celebrate the ever-evolving, often large-scale inventions of leading contemporary artists, while also featuring the art of architecture. Two other examples of museum architecture are the Museum of Contemporary Art, Denver (see fig. 14.30), and the Modern Wing of the Art Institute of Chicago (see fig. 25.31).

Architecture's first technical innovation of the twenty-first century is carbon fiber, and it may have an important impact on how we build in the future. Scientists found that heating carbon atoms in an oxygen-free environment fuses them together into some of the lightest and strongest materials yet discovered. Certain aircraft parts, racing car bodies, and bicycle frames already use carbon fiber. Shaping this fiber carefully and coating it with polyester or nylon yields a new material that can literally be woven to create a building.

dramatic recent use of this technique in a major public building was in the Jeppesen Terminal Building at Denver International Airport (**fig. 14.24**). Its roof is a giant tent composed of 15 acres of woven fiberglass, making it one of the largest suspension buildings on Earth. This white roofing material lets in large amounts of natural light without conducting heat, and it is coated with Teflon for water resistance and easy cleaning. Its exterior design was inspired by the snow-capped Rocky Mountains, which are visible from inside.

In recent years, art museums have become showplaces for cutting-edge architecture. Frank Gehry's Guggenheim Museum, Bilbao (**fig. 14.25**), is more like a piece of functional sculpture. The development of computer graphics and modeling applications in the 1980s made possible this design, which the architect called a "metallic flower." It is a dramatic limestone and titanium-clad cluster of soaring, nearly-dancing volumes that climax in a gigantic, glass-enclosed atrium. Museum

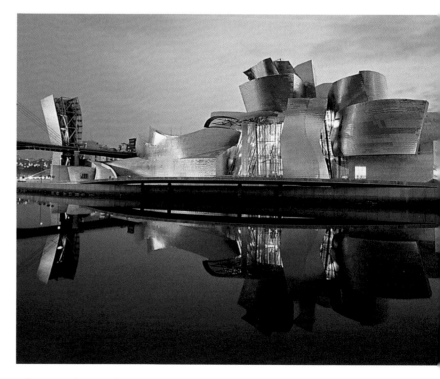

14.25 Frank O. Gehry. Guggenheim Museum Bilbao. Bilbao, Spain. 1997.
Photograph by Erika Barahona Ede © FMGB Guggenheim Bilbao Museo.

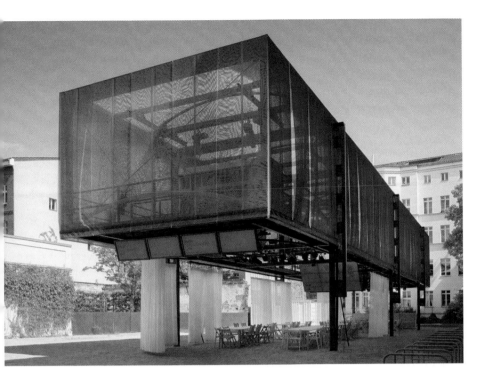

The Tokyo firm Atelier Bow-Wow recently created a public seminar space using carbon fiber (**fig. 14.26**). All of this building's components are light enough to be handled by one person easily. The BMW Guggenheim Lab can shelter talks, exhibitions, discussions, screenings, and workshops; all of the implements for such functions are stored in the upper portion on pulleys, to be raised or lowered as needed. The building's lightness was advantageous, because it eventually housed seminars on three continents.

Some old materials are also getting new treatments in the twenty-first century. Cross-laminated timber (CLT) uses wood in a new way, by laminating slabs of wood with their grains at an angle. This makes wood as strong as concrete, but much lighter. CLT slabs can range up to 11 inches thick and 60 feet long, and their flexibility makes them more earthquake resistant than concrete. Using trees harvested from sustainable forests also makes CLT a carbon-neutral building material.

The Alex Monroe jewelry store in London (**fig. 14.27**) is built of CLT, with the ground floor designed to harmonize with the surrounding shops. This floor is a showroom, while the upper floors house workshops and meeting rooms. Using prefabricated slabs brought to the site, builders erected the studio in only one week.

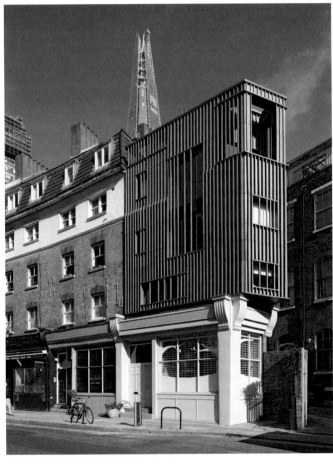

14.27 DSDHA. Alex Monroe jewelry store. 2011. Snowsfields, London.
Photo © Dennis Gilbert/VIEW.

FORMING ART

Xten Architecture: Shaping a Building

Some architectural offices are based more on collaboration between architects than on the insights and vision of a single creator. Xten Architecture is one

such firm, created in 2000 as a partnership with offices in California and Switzerland. Besides collaboration, their practice emphasizes using

sustainable technologies to create buildings that are "strong sculptural forms at the scale of the landscape,"[2] according to their statement.

The State Archive in Lucerne outgrew its quarters in 2011, and decided to move to a new location in a new building that would enable better use of digital technology. Xten Architecture proposed this design as an entry in an international competition. The notes and plans from the project show how it took form.

The Archive site is located on an intersection of two major streets, and it slopes downward away from the corner (**fig. 14.28a**). As the process diagram shows (**fig. 14.28b**), the design evolved from a basic rectangle at one end

of the site. The main floor includes administrative spaces and a library, above two levels of storage underground. This allows the landscape to dominate the exterior views, provides better security, and greatly reduces heating and cooling needs for the stored documents, some of which date from the Middle Ages. The main floor is shaped to provide both views to the outside and a pleasing profile from the exterior. These working spaces occupy the south and east sides of the building, to maximize natural daylight illumination. The diagram also envisions a Phase 2, with expanded underground storage on the north side.

The ground plan (**fig. 14.28c**) shows entry from the east (left), under a large covered porch

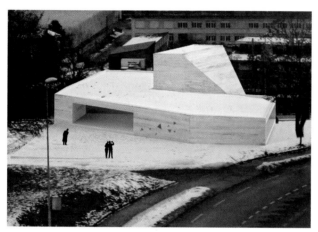

14.28a Xten Architecture. Proposal for State Archive. Lucerne, Switzerland. 2011. Bird's eye view.

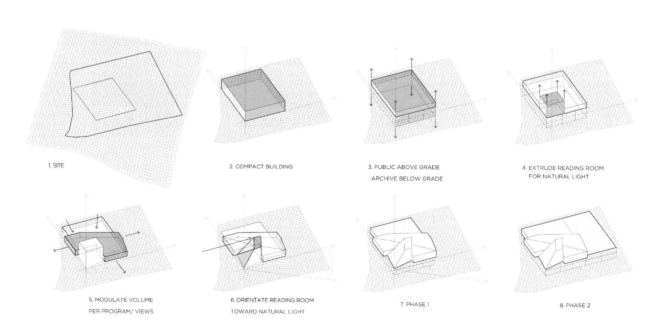

1. SITE

2. COMPACT BUILDING

3. PUBLIC ABOVE GRADE
ARCHIVE BELOW GRADE

4. EXTRUDE READING ROOM
FOR NATURAL LIGHT

5. MODULATE VOLUME
PER PROGRAM/ VIEWS

6. ORIENTATE READING ROOM
TOWARD NATURAL LIGHT

7. PHASE 1

8. PHASE 2

14.28b Process Diagram.

to protect from the elements, which leads directly to a library with two glass walls. The reading room is on the same level, but it sits at the base of a hollow 33-foot tower that rises above. This tower is aligned facing northward, with a large high window to admit light. Northern natural light is more constant than southern, and it is always indirect, an important consideration for document conservation. The back wall of this tower is angled to reflect the light downward. Because the site occupies a slight rise, many exterior windows have a view of the city.

The bird's eye view (see fig. 14.28a) shows the building's striking façade, which is mostly determined by the usage of the spaces that it frames. The architects resisted the idea that a storage facility should resemble a fortress. This view shows the entry with its covered porch. We see the reading room tower with its sloping back wall above.

The design calls for a concrete exterior, poured on-site with controlled and layered irregularities in the mix. This allows the building to show sedimentation that reflects both the local soil and the gently sloping landscape nearby.

We will never know how the building actually looks, because this design did not win the competition (the jury voted for a building with more above-ground storage). But the Xten project was widely commented on in the architecture press and won several awards.

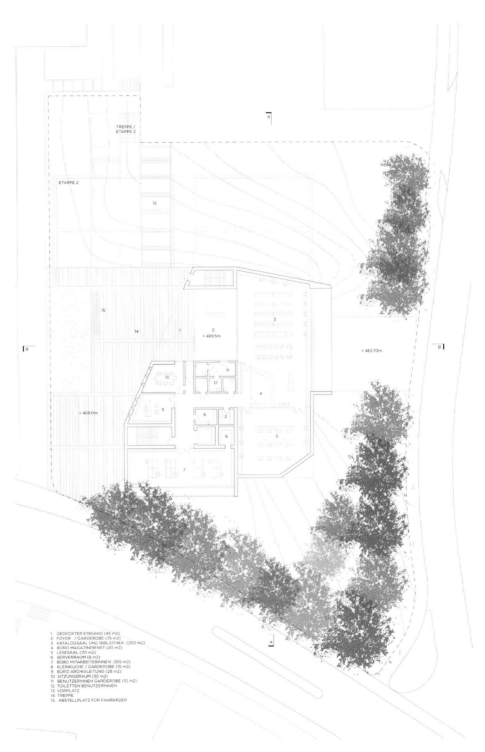

1. GEDECKTER EINGANG (45 m2)
2. FOYER / GARDEROBE (75 m2)
3. KATALOGSAAL UND BIBLIOTHEK (200 m2)
4. BÜRO MAGAZINDIENST (20 m2)
5. LESESAAL (110 m2)
6. SERVERRAUM (8 m2)
7. BÜRO MITARBEITERINNEN (105 m2)
8. KLEINKÜCHE / GARDEROBE (15 m2)
9. BÜRO ARCHIVLEITUNG (28 m2)
10. SITZUNGSRAUM (30 m2)
11. BENUTZERINNEN GARDEROBE (10 m2)
12. TOILETTEN BENUTZERINNEN
13. VORPLATZ
14. TREPPE
15. ABSTELLPLATZ FÜR FAHRRÄDER

14.28c Ground Plan.

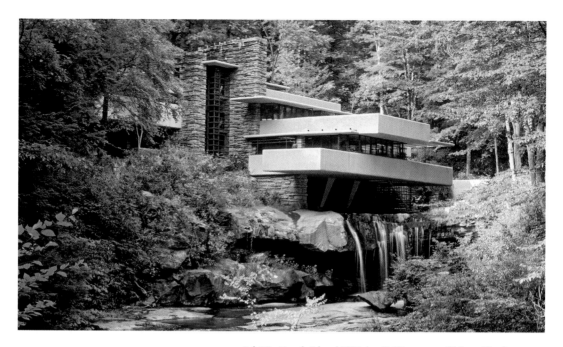

14.29 Frank Lloyd Wright. Fallingwater (Edgar Kaufmann Residence). Bear Run, Pennsylvania. 1936.
Mike Dobel/Alamy © 2013 Frank Lloyd Wright Foundation, Scottsdale, AZ/Artists Rights Society (ARS), NY.

360°—**Explore** the architectural panorama of Fallingwater on myartslab.com

Designing with Nature

Most of the stylistic revolutions of the twentieth century did not consider a building in relation to its environment. An early exception to this trend was the work of American Frank Lloyd Wright, one of the most important (and iconoclastic) architects of the era. Wright was among the first to use open planning in houses, even before the International Style took hold (see his Robie House, fig. 22.26). Wright eliminated walls between rooms, enlarged windows, and discovered that one of the best ways to open a closed-in room was to place windows in corners. With these devices, he created flowing spaces that opened to the outdoors, welcomed natural light, and related houses to their sites and climates. Sliding glass doors were influenced by the sliding paper-covered doors in traditional Japanese architecture.

Wright also made extensive use of the **cantilever** to unite indoor and outdoor spaces. When a beam or slab is extended a substantial distance beyond a supporting column or wall, the overhanging portion is called a cantilever. Before the use of steel and reinforced concrete, cantilevers were not used to a significant degree because the available materials could not extend far enough to make the concept viable.

One of the boldest and most elegant uses of the principle occurs in Wright's Kaufmann Residence (also known as Fallingwater) at Bear Run, Pennsylvania

(**fig. 14.29**). Horizontal masses cantilevered from supporting piers echo the rock ledges on the site and seem almost to float above the waterfall. Vertical accents were influenced by surrounding tall, straight trees. The intrusion of a building on such a beautiful location seems justified by the harmony Wright achieved between the natural site and his equally inspiring architecture.

Building with an awareness of the surroundings is a generally accepted basic practice today. We see a contemporary example of such thinking in the recent project for the State Archives of Lucerne, Switzerland (see fig. 14.29). Xten Architecture took account of the slope, soil, and sunshine at the site, along with the special needs of a document storage facility. Located on a terrace overlooking the city center, the architects shaped the project in accordance with usage and environmental needs.

Contemporary Approaches

Increasing numbers of architects in recent years are thinking of ways to reduce the impact of building on the environment, and to make the interiors more

14.30 David Adjaye. Museum of Contemporary Art, Denver. Denver, Colorado. 2007.

Photo by Dean Kaufman, courtesy Museum of Contemporary Art, Denver.

14.31 Michelle Kaufmann. mkSolaire Home. 2008. Prefabricated house.

As exhibited at Museum of Science and Industry, Chicago. Photo by John Swain Photography, courtesy of Michelle Kaufmann.

healthful. In the United States, the Green Building Council gives annual awards for leadership in environmentally sensitive design. Architects can submit their plans to the Council for rating, and the Council assigns points for such factors as harmony with prevailing wind or sunshine patterns, indoor energy efficiency, use of recycled water, and reduction of transportation costs for materials. The Council then makes annual awards for Leadership in Energy and Environmental Design (LEED), presenting Certified, Silver, Gold, and Platinum awards each year to projects that reach designated point levels.

Some museums have joined the quest to build green. The Museum of Contemporary Art, Denver (**fig. 14.30**), sits atop a cleaned-up hazardous waste site. Heating comes from a radiant floor; cooling is a low-energy evaporative cooler rather than an air conditioner. But the majority of its exterior wall is a double-skin façade, which reduces the need for both heating and cooling. The roof is a green garden planted with local native species. Twenty percent of its building materials come from recycled sources. Using 32 percent less energy than a comparable conventional structure, this museum is the greenest yet built, and it earned a Gold rating.

The mkSolaire Home by Michelle Kaufmann (**fig. 14.31**) represents the leading edge in green single-family home design. This prefabricated house can be placed on a wide variety of sites in an orientation to maximize sunlight. It uses the most efficient insulation available, and window placements maximize cross-ventilation. On-demand water heaters, low-flow fixtures, and a green roof also reduce energy demands. The architect certifies that this home, depending on where it is located, will earn either a Gold or a Platinum certification.

Most skyscrapers, with their heavy structural skeletons, sealed interior environments, and glassy exteriors, are very energy-inefficient. But the Aqua Tower in Chicago (**fig. 14.32**) incorporates several green characteristics that emboldened the owner to seek LEED Certification. The curving balconies that give the residential tower such a striking appearance also have a practical function: They reduce the building's sway in windstorms, so that the structural supports on the upper floors can use less material. Heat-resistant glass reduces the need for air conditioning in summer. The three-story entrance pavilion at the base has an 80,000 square-foot garden on its roof, a literal "patch of green." Inside the building, the apartments have sustainable bamboo floors and energy-efficient appliances. A 24-car electric vehicle-charging system awaits drivers in the basement.

In addition to their high efficiency, all these green buildings look good; but not all green buildings appear innovative from the outside. This is because some designers prefer to take the greenest route: to redesign existing buildings rather than build new ones.

14.32 Jeanne Gang/Studio Gang Architects.
Aqua Tower. Chicago, Illinois. 2010.
Steve Hall © Hedrich Blessing. Courtesy of Studio Gang Architects.

Architecture is a frequently overlooked artform because it is generally considered a necessity rather than an expressive statement. As we have seen in the examples above, however, it is both. As the artform that surrounds us in our daily lives, architecture has long made human survival both possible and enjoyable.

✓—⃞**Study** and review on myartslab.com

THINK BACK

1. What are the traditional methods of construction used in architecture?

2. What impact has the development of high-strength structural steel had on architecture?

3. How are environmental concerns affecting architecture today?

TRY THIS

We come to understand a building through a succession of experiences in time and space. To do this we must explore buildings inside and out. Walk around your house or apartment. How do you respond to the entrance? The height of the ceilings? Wall and floor colors, textures, materials? Window sizes and placements?

KEY TERMS

cantilever – a beam or slab projecting a substantial distance beyond its supporting post or wall

colonnade – a row of columns usually spanned or connected by beams

International Style – an architectural style that emerged in several European countries between 1910 and 1920; characterized by the use of modern materials (concrete, glass, steel), avoidance of applied decoration, and focus on a building's inner uses

masonry – building technique in which stones or bricks are laid atop one another in a pattern

post-and-beam system – structural system in which uprights or posts support a horizontal beam that spans the space between them

truss – a structural framework of wood or metal based on a triangular system, used to span, reinforce, or support walls, ceilings, piers, or beams

vault – a curving masonry roof or ceiling constructed on the principle of the arch

Part Three

ART AS CULTURAL HERITAGE

From the Earliest Art to the Bronze Age

The Classical and Medieval West

Renaissance and Baroque Europe

Traditional Arts of Asia

The Islamic World

Africa, Oceania, and the Americas

15

FROM THE EARLIEST ART TO THE BRONZE AGE

THINK AHEAD

15.1 Trace the origins of early art in the Paleolithic and Neolithic periods.

15.2 Contrast scholarly theories about the cultural function of the earliest artworks.

15.3 State technological and socio-economic changes that gave rise to the first civilizations.

15.4 Compare the stylistic and cultural features of art from Mesopotamia and ancient Egypt.

15.5 Discuss art's memorial function throughout history.

Art history makes history visible and accessible. It is a record of how the people of the past—our ancestors—lived, felt, and acted in widely separated parts of the world at different periods of time.

Art history differs from other kinds of history because works of art from the past are with us in the present. One-to-one communication still occurs, even when artist and viewer are separated by thousands of years. This communicative power of art makes it possible for us to glimpse some of the experiences of those whose lives preceded ours, to better understand societies other than our own, and to see beyond our own cultural boundaries. Although interesting, old science has little practical use; but old art can be as life-enriching as new art.

There is no "better" or "best" when we compare the art of different societies, or even the art of different times within the same society. Rather, differences in art reflect differences in points of view. Pablo Picasso put the subject of art history in perspective in this way:

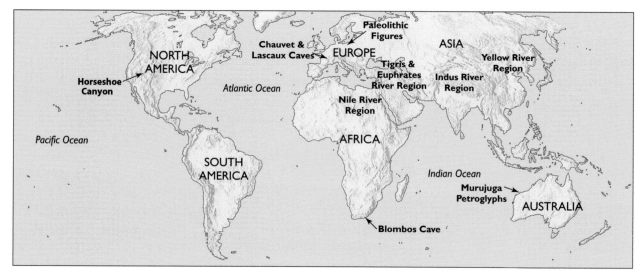

((•—Listen to the chapter audio on myartslab.com

15.1 Prehistoric Sites and Early Centers of Civilization.

15.2 Engraved ochre. From Blombos Cave, South Africa. c.75,000 BCE. Length 4″.
Image courtesy of Christopher Henshilwood.

To me there is no past or future in art. If a work of art cannot live always in the present it must not be considered at all. The art of the Greeks, the Egyptians, the great painters who lived in other times, is not an art of the past; perhaps it is more alive today than it ever was.[1]

The Paleolithic Period

Roughly two million years ago, in east-central Africa, early hominids made crude stonecutting tools. The making of these tools enabled our predecessors to extend their skills and thereby gain a measure of control over their surroundings. From such beginnings, human beings developed the abilities to reason and to visualize: to remember the past, to relate it to the present, and to imagine a possible future. As we became form-creating creatures, our ability to conceive mental images set us apart from other animals. Imagination is our special advantage.

About one million years ago in Africa, and more recently in Asia and Europe, people made more refined tools by chipping flakes from opposite sides of stones to create sharp cutting edges. It took another 250,000 years or so for human beings to develop choppers and hand axes that were symmetrical and refined in shape. An awareness of the relationship of form to function, and of form as enjoyable in itself, was the first step in the history of art.

Sprinkled powders and beads accompany many widely dispersed gravesites from about 100,000 years ago. These finds suggest to archaeologists that humans at that time practiced ritual burial, though the meaning of these decorative additions is unknown.

Recent discoveries have enlivened the debate about when art began. In 2002, archaeologists digging in the Blombos Cave in South Africa unearthed what may qualify as the earliest art that we know of. In a soil layer 77,000 years old, they found some pieces of engraved ochre (**fig. 15.2**) bearing marks that appear to be symbols. The marks form an abstract pattern of parallel diagonal lines between horizontal bars. Any practical use for the markings is highly unlikely; rather, they seem symbolic or at least decorative, making these ochres the oldest embellished objects yet found. In 2010, researchers at a nearby site found ostrich egg shells with similar parallel scratch marks. Many archaeologists concluded that these African sites contain the first known instances of artistic creativity.

More sophisticated examples of **Paleolithic art** have been discovered at many locations around the world. Current scientific dating places the earliest of these findings at about 40,000 years ago, toward the end of the last ice age. As the southern edge of the European ice sheet slowly retreated northward, hunter-gatherers followed the animals that they hunted for food. They carved and painted images of these animals on cave walls deep in the earth.

The oldest surviving carved human figure was found in southwestern Germany in 2008; the Hohle

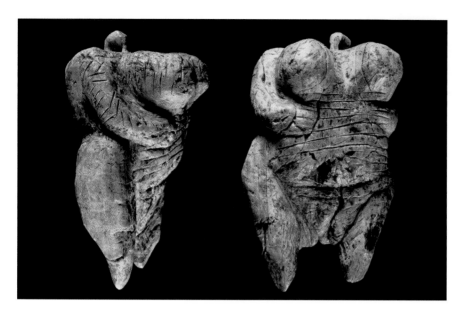

15.3 Hohle Fels figure. c.35,000 BCE. Carved mammoth tusk. Front and side views. Height 2½".
Photograph: H. Jensen. © University of Tübingen.

Fels figure (**fig. 15.3**) is just over 2 inches high and at least 35,000 years old. Her female characteristics are highly exaggerated, and she shows carefully placed grooves at various points on her body. Her arms cling to her abdomen. In place of a head is a ring suitable for stringing the figure around a wearer's neck (the ring shows wearing marks). A similar figure about 10,000 years younger is the Woman of Willendorf (**fig. 15.4**), which was found in northern Austria. In both of these figures, the pointy legs, lack of facial detail, and exaggerated emphasis on hips and breasts implies a specific purpose, which we can only guess at. These figures may be the earliest known works of religious art; some scholars believe that they depict the Paleolithic image of the Creator—the Great Mother Goddess. The predominance of stone pieces among surviving artifacts of the Paleolithic has led us to call this period the Stone Age. But the Hohle Fels figure was found near a three-hole flute carved of bone, indicating that music also existed in that remote era.

European Paleolithic paintings have a different style from the copious bulges of the sculpture. Human beings rarely appear; those that do tend to be more simplified and abstract than the images of animals. Animals portrayed in sculpture and paintings of this period have an expressive naturalism. Findings published in 2012 show fragments of what look like painted animals in a rock shelter that collapsed 37,000 years ago in the Dordogne, in south-central France. The oldest known sets of surviving completed paintings were found in 1994 in the Chauvet Cave in the same general region. The wall painting of animals (**fig. 15.5**) is among dozens of 30,000-year-old images painted with charcoal and earthen pigments on the cave walls. The unknown artists depicted in a lifelike fashion horses, rhinoceroses, tigers, and other large animals, many of them now extinct. Explorers found a bear's skull in the middle of a flat stone slab nearby, which may have been an altar.

Scholars long believed that the purpose of naturalistic Paleolithic art was to bring the spirits of animals into rituals related to the hunt. Many authors accept this theory. However, careful study of footprints and other archaeological remains has recently led some experts to theorize that Chauvet and similar sites were used as sanctuaries where youth were initiated in ceremonies based on symbolic or spiritual associations with the portrayed animals.

Much of the world's Paleolithic art is found in caves, but large parts of this heritage are above ground, painted or carved on stones in many locations around the world where people lived by hunting and gathering.

Some of the oldest Paleolithic rock art in North America is found in Utah, where native peoples painted silhouette forms that resemble humans wrapped in symbolic garments (**fig. 15.6**). The meaning of these ghostly figures eludes us, but they were created

15.4 Woman of Willendorf. c.25,000–20,000 BCE. Limestone. Height 4½".
akg-image/Erich Lessing.

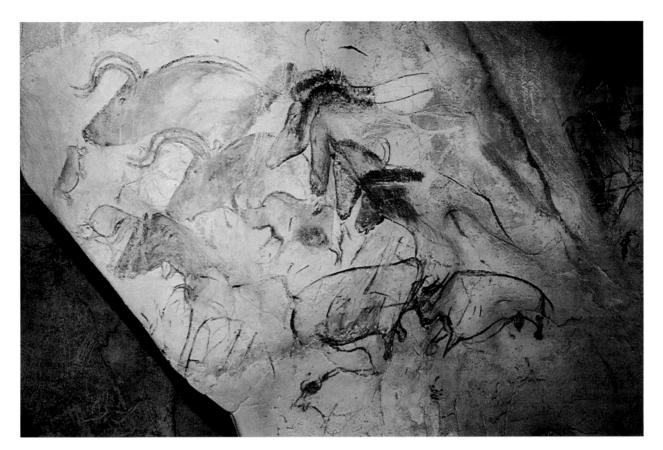

15.5 Wall painting of animals. Chauvet Cave, Pont d'Arc, France. c.28,000 BCE.
French Ministry of Culture and Communication, Regional Direction for Cultural Affairs—Rhône-Alpes region—
Regional department of archaeology. Slide no. 10 Photograph: Jean Clottes.

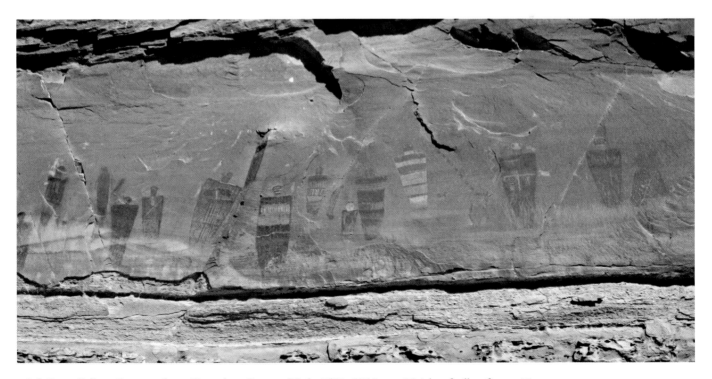

15.6 Great Gallery. Pictographs at Horseshoe Canyon, Utah. 7400–5200 BCE. Height of tallest figures 7′.
Photograph: Patrick Frank.

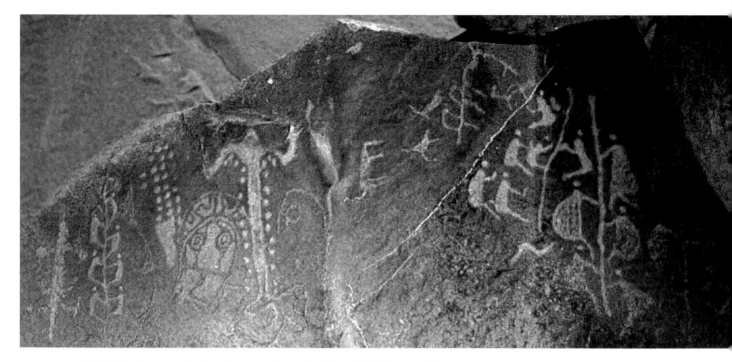

15.7 Murujuga petroglyphs. Northwest Australia. Up to 10,000 years old.
Robert Bednarik.

👁 **Watch** a podcast about rock art on myartslab.com

with a high degree of detail using the same sort of earthen pigments that characterize Paleolithic art the world over. Unlike European Paleolithic paintings, which are much older, the North American artists rarely depicted animals. Many archaeologists speculate that shamanic rituals practiced in the region by successor tribes offer a clue to the meaning and function of these haunting works.

Rock art carvings, also known as **petroglyphs**, are made by scratching or pecking the surface of exposed stone. One of the largest petroglyph complexes is in the Dampier Archipelago off the northwest coast of Australia. There we see the Murujuga petroglyphs (**fig. 15.7**), thousands of carvings that depict humans, animals, and mythic beings. Like the cave paintings, the purpose of the petroglyphs is a matter of conjecture. Their age is also difficult to determine because they are in exposed locations apart from soil sediments. A great deal of the world's rock art is also endangered for this reason; the Murujuga petroglyphs, for example,

have been eroded by acid rain, and economic development in the area threatens their outright destruction.

The Neolithic Period

The transition from Old Stone Age to New Stone Age (Paleolithic to Neolithic) marked a major turning point in human history. The New Stone Age seems to have arisen first in what is now Iraq, between 9000 and 6000 BCE, when people made the gradual transition from the precarious existence of nomadic hunters and gatherers to the relatively stable life of village farmers and herders. The agricultural revolution—this major shift from nomadic groups to small agricultural communities—stabilized human life and produced early architecture and other technological developments. People learned new techniques for working with seasonal rhythms. Because food and seeds required storage, it is not surprising that clay storage pots are among the most significant artifacts of the period.

Neolithic art reflects the great shift in living patterns. The vigorous, naturalistic art of Paleolithic hunters was largely replaced by the geometric abstract art of Neolithic farmers. From about 10,000 to

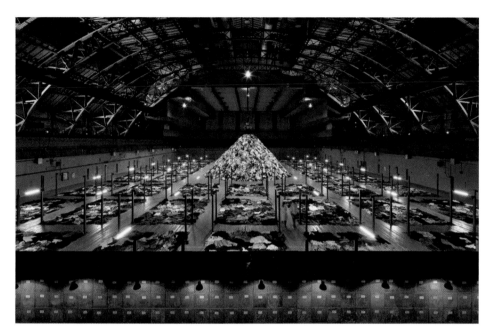

burned candles. The ofrenda celebrates a conception of beauty that diverges from that of the dominant culture. Mesa-Bains said, "In her position as an accepted beauty in both cultures, Dolores gave meaning and power to a generation of Chicanos suffering rejection because of the accepted Anglo standard of beauty. This altar gratefully acknowledges the power of her mythic beauty and her contribution to *Nuestra Cultura* (our culture). The objects on the altar are a gesture symbolizing her glamor, elegance and *corazón* (heart)."[2]

15.17 Christian Boltanski. *No Man's Land*. 2010. Installation in Park Avenue Armory, New York. Clothing, rig, pick, lights, and steel beams.
Courtesy of the artist and Marian Goodman Gallery, New York.
© 2013 Artists Rights Society (ARS), New York ADAGP, Paris.

Commemoration need not always be so solemn, however, as we see in *An Ofrenda for Dolores del Rio* (**fig. 15.18**) by Amalia Mesa-Bains. This installation is an altar, made as an offering (*ofrenda*) to one of Hollywood's first Latin American screen goddesses. Mexican-born Dolores del Rio began her career in silent movies, and reached the heights of stardom in 1933 with the musical *Flying Down to Rio*. In the 1940s and 1950s she was equally famous across the border for her roles in numerous Mexican films. In later years she returned to Hollywood and appeared in several television productions. Her good looks and aristocratic bearing proved irresistible over a period of several decades.

The *ofrenda* takes the form of a traditional home altar, such as many Mexican-Americans erect annually on the Day of the Dead in honor of deceased relatives, a custom dating from indigenous pre-Conquest cultures of Mexico. The artist turned private devotion into a public act, by creating a work about a well-known star and placing it in a gallery. She constructed the altar with film stills and publicity shots, and decorated it with satin curtains and a lacy mantilla, or shawl. On the floor are film cans, dried flowers, and half-

15.18 Amalia Mesa-Bains. *An Ofrenda for Dolores del Rio*. 1984. Mixed media installation. 96″ × 72″ × 48″.
Smithsonian American Art Museum, Washington, D.C. © 2013.
Photograph Smithsonian American Art Museum/Art Resource/Scala, Florence.

beyond the grave. Upon death, bodies of royalty and nobility were embalmed; together with accompanying artifacts, tools, and furniture, they were then buried in pyramids or in hidden underground tombs. Architects put great effort into preventing access to these funerary structures. As a result, most of what we know about ancient Egypt comes from such tombs.

Names of many Egyptian architects are known in association with their buildings. A striking and well-preserved example is the Funerary Temple of Queen Hatshepsut (**fig. 15.19**), designed by Senmut, the queen's chancellor and architect. Complementing the majestic cliffs of the site, the ramps and colonnades provide an elegant setting for ritual pageantry. Wall paintings and reliefs at the site tell of an expedition that Hatshepsut funded to explore the legendary birthplace of the gods, and her own birth from the sun god Amen. This grandiose temple, completed during her reign, aided her effort to be taken seriously as a ruler in her own right, and the narrative art tells the first exploits of a famous woman in the history of art.

Egyptian sculpture is characterized by compact, solidly structured figures that embody qualities of strength and geometric clarity also found in Egyptian architecture. The final form of a piece of sculpture was determined by an underlying geometric plan that was

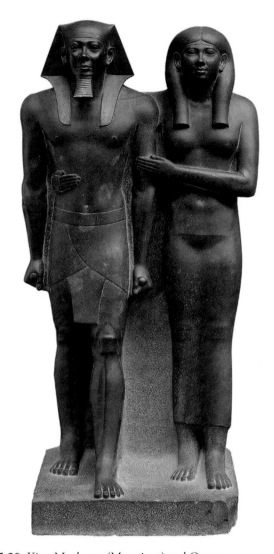

15.20 King Menkaura (Mycerinus) and Queen Khamerernebty. c.2490–2472 BCE. Giza, Egypt. Menkaure Valley Temple. Greywacke stone. 56″ × 22½″ × 21¾″.

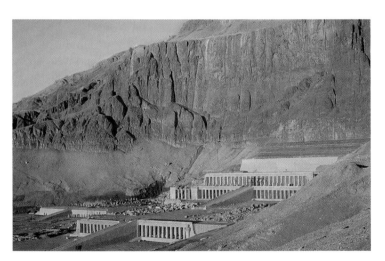

15.19 Funerary Temple of Queen Hatshepsut. Deir el-Bahari, c.1490–1460 BCE.
© Tom Till.

View the Closer Look for the Funerary Temple of Queen Hatshepsut on myartslab.com

first sketched on the surface of the stone block. The sculptor of King Menkaura (Mycerinus) and Queen Khamerernebty (**fig. 15.20**) paid considerable attention to human anatomy yet stayed within the traditionally prescribed geometric scheme. The strength, clarity, and lasting stability expressed by the figures result from this union of naturalism and abstraction. With formal austerity, the couple stands in the frontal pose that had been established for royal portraits. Even so, the figures express warmth and vitality; the queen touches Menkaura in a sympathetic, loving way.

hundreds of extraordinary artifacts from the tomb. Its formal blend of naturalism and abstract idealism is distinctly Egyptian.

Egyptian artists in all media generally depicted the human figure either in a completely frontal position or in profile. Egyptian artists portrayed each object and each part of the human body from what they identified as its most characteristic angle, thus avoiding the ambiguity caused by random or chance angles of view (see also *Pool in the Garden*, fig. 3.18).

In the wall painting from the Tomb of Nebamun (**fig. 15.22**), the painter of the hunting scene presented a wealth of specific information without making the painting confusing. Flat shapes portray basic elements of each subject in the clearest, most identifiable way. The head, hips, legs, and feet of the nobleman who dominates this painting are shown from the side, while his eye and shoulders are shown from the front. Sizes of human figures are determined by social

15.21 Mask from mummy case. Tomb of Tutankhamen. c.1340 BCE. Gold inlaid with enamel and semiprecious stones. Height 21¼″.
Photograph: Jürgen Liepe.

Typical of sculpture of this era are the formal pose with left foot forward, the false ceremonial beard, and figures that remain attached to the block of stone from which they were carved.

Tutankhamen ("King Tut"), who died at age 18, is the best-known Egyptian ruler because his was the only Egyptian royal tomb discovered in modern times with most of its contents intact. The volume and value of the objects in the small tomb make it clear why grave robbers have been active in Egypt since the days of the first pharaohs. Tutankhamen's inlaid gold mask from his mummy case (**fig. 15.21**) is but one of

15.22 Wall painting from the Tomb of Nebamun. Thebes, Egypt. c.1450 BCE. Paint on dry plaster.
The British Museum © The Trustees of the British Museum.

rank, a system known as **hierarchic scale**; the nobleman is the largest figure, his wife is smaller, his daughter smaller still.

The family stands on a boat made of papyrus reeds; plants grow on the left at the shore. The entire painting is teeming with life, and the artist has even taken great care to show life below the water's surface. Attention to accurate detail lets us identify species of insects, birds, and fish. The hieroglyphs—the picture writing of ancient Egyptian priesthood—can be seen behind the figures.

Egyptian art greatly influenced that of early Greece, and the Greeks later developed one of the most important styles in Western art.

✓•—⟮**Study** and review on myartslab.com

THINK BACK

1. How old is the oldest carved human form?

2. Why is the invention of pottery normally associated with Neolithic cultures?

3. What style characteristics are typical of Egyptian painting?

TRY THIS

The proposed memorial to President Dwight Eisenhower is scheduled for dedication in 2016, but the designs by architect Frank Gehry have aroused controversy. See the memorial at its website (http://www.eisenhowermemorial.org) and the protests at the protestors' site (http://www.eisenhowermemorial.net). Form an opinion about which side has better ideas about how to commemorate the President effectively.

KEY TERMS

hierarchic scale – use of unnatural proportions or scale to show the relative importance of figures; most commonly practiced in ancient Near Eastern and Egyptian art

Neolithic art – a period of ancient art after the introduction of agriculture but before the invention of bronze

Paleolithic art – a very ancient period of art coincident with the Old Stone Age, before the discovery of agriculture and animal herding

petroglyph – an image or a symbol carved in shallow relief on a rock surface, usually ancient

ziggurat – a rectangular or square stepped pyramid, often with a temple at its top

16

THE CLASSICAL AND MEDIEVAL WEST

THINK AHEAD

16.1 Explain the artistic and architectural innovations of ancient Greece and Rome.

16.2 Relate the characteristics of classical art to Greek and Roman cultural values.

16.3 Identify architectural elements that characterize classical and medieval structures.

16.4 Discuss the influence of Christianity on art and society in medieval Europe.

16.5 Distinguish visual characteristics of Early Christian, Byzantine, Romanesque and Gothic art.

16.6 Compare different ways artists communicate sacred or religious ideas through art.

If your definition of the word "beautiful" includes something ideal or perfect, then you have been influenced by classical Greece. Greece gave the West several concepts that we still value today. The classical cultures of Greece and Rome dominated Western civilization from the fifth century BCE until the decline of Rome in the late fifth century CE. The later periods of Roman rule of Europe also saw the rise of Christianity, a faith that brought a wealth of new subjects to Western art.

The period between the fall of Rome and the beginning of the Renaissance in the fifteenth century is referred to as the Middle Ages or medieval period, a term that does little justice to the creativity of that era. If you attend a university, then you are at an institution that had its birth during the medieval period. Meanwhile, Eastern Europe was dominated by the Byzantine Empire, headquartered in Constantinople (today's Istanbul). Byzantine Christianity is today known as the Orthodox Church. Hence, Christianity of one form or another was a major force in the art of both Eastern and Western Europe for a thousand years.

((•— **Listen** to the chapter audio on myartslab.com

Greece

The Greeks distinguished themselves from other peoples of Europe and Asia by their attitude toward being human. They came to regard humankind as the highest creation of nature—the closest thing to perfection in physical form, endowed with the power to reason. Greek deities had human weaknesses, and Greek mortals had godlike strengths.

With this attitude came a new concept of the importance of the individual. The Greek focus on human potential and achievement led to the development of democracy and to the perfection of naturalistic images of the human figure in art. The philosopher Plato taught that behind the imperfections of transitory reality was the permanent, ideal form. Thus, to create the ideal individual (the supreme work of nature) became the goal of Greek artists.

Greek civilization passed through three broad stages: the Archaic period, the classical period, and the Hellenistic period. In the art of the Archaic period (from the late seventh to the early fifth centuries BCE), the Greeks assimilated influences from Egypt and the Near East. Greek writers of the time tell us that Greek painters were often better known than Greek sculptors. Yet what we now see of Greek painting appears

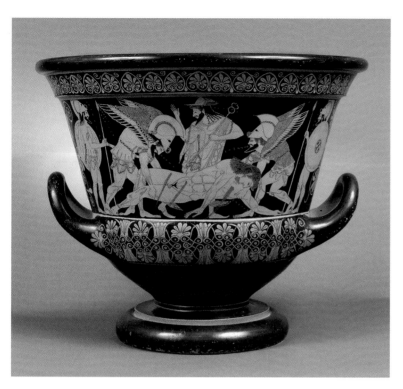

16.1 Euphronios Krater. c.515 BCE.
Terra cotta. Height 18″, diameter 21¾″.
Photograph Scala, Florence. Courtesy of the Ministero Beni e Att. Culturali.

View the Closer Look for the *Euphronios Krater*
on myartslab.com

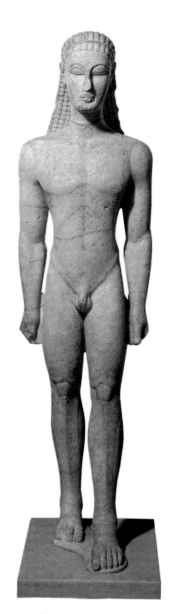

16.2 *Kouros.* Statue of standing youth. c.580 BCE.
Marble. Height 76″.
The Metropolitan Museum of Art, New York. Fletcher Fund, 1932 (32.11.1). ©
2013 Image The Metropolitan Museum of Art/Art Resource/Scala, Florence.

only on pottery because very few wall paintings sur-
vive. The Euphronios Krater (**fig. 16.1**) shows the level
of achievement of Greek potters and painters. It is in
the Archaic "red-figure" style and depicts a scene from
Homer's *Odyssey*: The dead Trojan warrior Sarpedon,
wounds gushing blood, is carried off to eternity by
the gods of Sleep and Death. The painter Euphronios
signed the work; the word **krater** refers to the
vessel's handled shape, traditionally used for mixing
ceremonial beverages.

The Greeks honored individual achievement
by creating numerous life-size, freestanding stat-
ues of nude male and clothed female figures. The
Archaic-style *kouros* (**fig. 16.2**) has a rigid frontal posi-
tion that is an adaptation from Egyptian sculpture.
(**Kouros** is Greek for male youth; **kore** is the word
for female youth.) The Egyptian figure of Menkaura
(see fig. 15.20) and the kouros both stand with arms
held straight at the sides, fingers drawn up, and left

leg forward with the weight evenly distributed on both
feet as they stare off into space.

In spite of the similarity of stance, however, the
character of Greek sculpture is already quite differ-
ent from that of Egyptian. The *kouros* honors an
individual who was not a supernatural ruler. The
kouros thus adapted the Egyptian form to reflect
Greek cultural values.

Within one hundred years of the making of the
kouros figure, Greek civilization entered its classi-
cal phase (480–323 BCE). Greek aesthetic principles

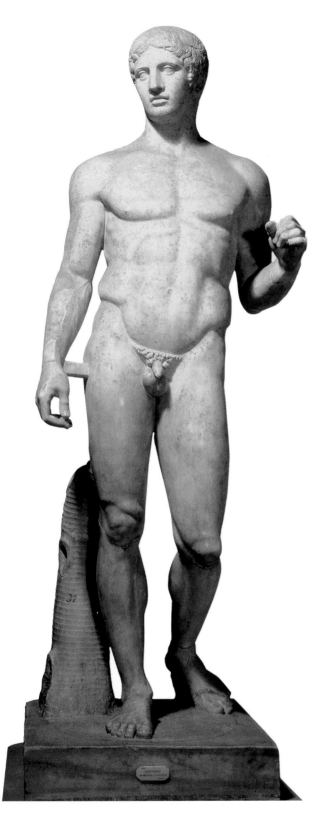

16.3 Polykleitos of Argos. *Spear Bearer (Doryphoros)*. 5th century BCE. Roman copy of Greek original, c.440 BCE. Marble. Height 6′6″.
Museo Acheologico Nazionale, Naples, Italy. akg-images/Nimatallah.

Watch a video about Greek sculpture on myartslab.com

from this period provide the basis for the concept of classicism. **Classical art** emphasizes rational simplicity, order, and restrained emotion. The rigid poses of Egyptian and early Greek figures gave way to a greater interest in anatomy and more relaxed poses. Classical Greek sculpture became increasingly naturalistic and began to show the body as alive and capable of movement, while maintaining an interest in portraying the ideal human anatomy.

The statue known as the *Spear Bearer* (**fig. 16.3**) is an excellent example of Greek classicism. Its sculptor, Polykleitos, wrote a treatise on the perfect proportions of the human form and created this statue as an example. Neither the book nor the original statue survives, but both are known from documents and later copies. Polykleitos envisioned the human body as a harmonious set of divinely inspired ratios. By studying numerous models, he arrived at what he thought were the ideal proportions of the human body. Hence the *Spear Bearer* combines actual observations with mathematical calculation.

The statue depicts an athlete who once held a spear on his left shoulder. Typical of classical art, the figure is in the prime of life, and blemish-free. It is not a portrait of an individual but rather a vision of the ideal. He bears most of his weight on one leg in a pose known as **contrapposto**, meaning counterpoised. The Greeks and then the Romans used this pose to give a lifelike quality to figures at rest. Centuries later, their sculpture would inspire Renaissance artists to use the same technique.

The city-state of Athens was the artistic and philosophical center of classical Greek civilization. Above the city, on a large rock outcropping called the Acropolis, the Athenians constructed the Parthenon (**fig. 16.4**), one of the world's most admired structures. The largest of several sacred buildings on this site, the Parthenon was designed and built as a gift to Athena Parthenos, goddess of wisdom and prudent warfare, and protector of the Athenian navy. Even in its current ruined state, the temple continues to express the ideals of the people who created it.

When Ictinus and Callicrates designed the Parthenon, they were following Egyptian tradition of temple design based on the post-and-beam system of construction (see fig. 14.3). Rites were performed

a. View from the northwest.

16.4 Ictinus and Callicrates. Parthenon. Acropolis, Athens. 448–432 BCE.

Both photographs: Duane Preble.

360° **Explore** the architectural panorama of the Parthenon on myartslab.com

b. View from the southwest.

on altars placed in front of the eastern entrance; the interior space held a 40-foot statue of Athena. The axis of the building was carefully calculated so that on Athena's birthday the rising sun coming through the east doorway would fully illuminate the towering (now lost) gold-covered statue.

The Parthenon exhibits the refined clarity, harmony, and vigor that are the basis of the Greek tradition (**fig. 16.4a**). The proportions of the Parthenon are based on harmonious ratios. The ratio of the height to the widths of the east and west ends is approximately 4 to 9. The ratio of the width to the length of the building is also 4 to 9. The diameter of the columns relates to the space between the columns at a ratio of 4 to 9, and so on.

None of the major lines in the building is perfectly straight. The columns have an almost imperceptible bulge (called **entasis**) above the center, which causes them to appear straighter than if they were in fact straight-sided, and this gives the entire structure a tangible grace. Even the steps and tops of doorways rise slightly in perfect curves. Corner columns, seen against the light, are somewhat larger in diameter to counteract the diminishing effect of strong light in the background. The axis lines of the columns lean inward a little at the top. If extended into space, these lines would converge about a mile above the building. These unexpected variations are not consciously seen, but they are felt, and they help to make the building visually appealing and to correct optical illusions.

16.4c. The Battle of the Lapiths and Centaurs.
 Metope from the Parthenon. c.440 BCE.
 Marble. Height 67¾″.

The sculptural program of the Parthenon shows specific aspects of the culture of that time. Athens had just concluded a successful war to resist a Persian invasion, and the costs of the Parthenon were paid from leftover war contributions collected from other Greek cities.

Surrounding the entire building just above the colonnade, the designers installed evenly spaced square panels called metopes; these, too, promote Greek culture. The theme of the metopes is the Battle of the Lapiths and Centaurs (**fig. 16.4c**): In an ancient myth, the Lapiths were ruled by reason, and the Centaurs were violent and unpredictable; when the Centaurs kidnapped the Queen of the Lapiths, the Lapiths went to war and defeated the Centaurs in battle. Just as order and reason triumphed in that ancient conflict, the democratic Greeks had defeated the despotic Persians. Thus, recent events confirmed the ultimate triumph of the Greek worldview.

During the latter part of the classical period (the late fourth century BCE), Greek sculpture took a turn away from the noble and serious idealism of the *Spear Bearer* toward a more sensuous vision. *Venus de' Medici* (**fig. 16.5**) is a Roman copy of a fourth-century BCE Greek original by Praxiteles, the best-known sculptor

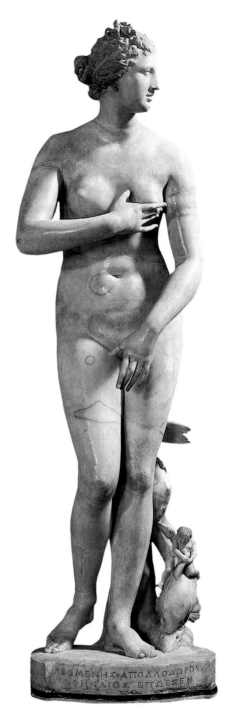

16.5 *Venus de' Medici (Medici Venus)*.
 3rd century BCE. Marble. Height 5′.

of this time. Nude goddesses were unknown in previous periods. Its refined profile and modest pose are features of the Greek idealization of human figures. This figure came to represent a feminine ideal, and has strongly influenced many art works since that time, down to the feminists of the twentieth century who rebelled against it.

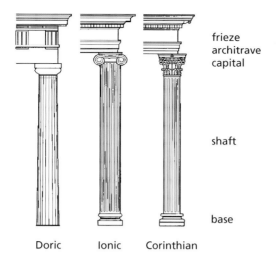

frieze
architrave
capital

shaft

base

Doric Ionic Corinthian

16.6 Architectural Orders.

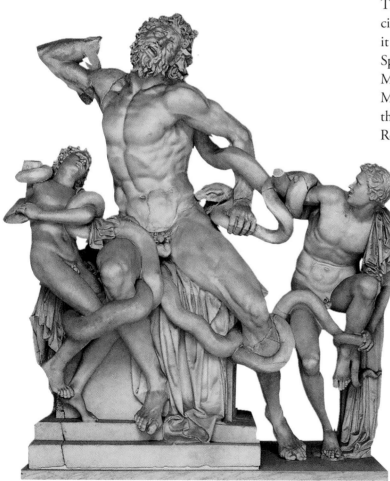

16.7 *The Laocoön Group.* c.1st century CE.
Roman copy of a 1st- or 2nd-century BCE Greek
original. Marble. Height 95¼".
Musei Vaticani, Rome. Photo Scala, Florence.

The Greeks developed three architectural orders: Doric, Ionic, and Corinthian (**fig. 16.6**). Each order comprises a set of architectural elements and proportions. The most telling details for identification of the orders are the three types of **capitals** used at the tops of columns. Doric, which came first, is simple, geometric, and sturdy; Ionic is taller and more decorative than Doric; Corinthian is complex and organic. The Parthenon is in the Doric order, the first of the three to be developed.

After the decline of the Greek city-states at the end of the fourth century BCE, the art of the Mediterranean changed. Though Greek art was still the strongest influence, the art was often produced for non-Greek patrons. Thus, Mediterranean art during this era is called **Hellenistic**, meaning Greek-like. The transition from classical to Hellenistic coincided with the decline of Athens as a city-state after it fought a useless war with the neighboring city of Sparta, and with the rise of an absolute monarchy in Macedonia that soon took over the entire peninsula. Most historians date the period from approximately the death of Alexander the Great (323 BCE) to the Roman conquest of Egypt (30 BCE).

In the Hellenistic period, Greek art became more dynamic and less idealized. Everyday activities, historical subjects, and portraiture became more common subjects for art. Hellenistic Greek art contrasts with classical Greek art in that it is more expressive and frequently shows exaggerated movement.

The Laocoön Group (**fig. 16.7**) is a Roman copy of a Hellenistic work. In Greek mythology, Laocoön was the Trojan priest who warned against bringing the wooden horse into Troy during the Trojan War. Later, he and his sons were attacked by serpents, an act the Trojans interpreted as a sign of the gods' disapproval of Laocoön's prophecy. Laocoön is shown in hierarchic proportion to his sons.

The rationalism, clarity, and restraint of classical sculpture have given way to writhing movement, tortured facial expressions, and strained muscles expressing emotional and physical anguish. When this sculpture was unearthed in Italy in 1506, it had an immediate influence on the young Michelangelo.

Rome

The Hellenistic era saw the rise of Rome, a formidable new force in the Mediterranean. By the second century BCE, Rome had become the major power in the Western world. At its height, the Roman Empire would include Western Europe, North Africa, and the Near East as well as the shores of the Mediterranean. Their governance of a multitude of unique peoples and cultures provides evidence of the Roman genius for order and practical politics. Roman culture has affected our lives in many areas: our systems of law and government, our calendar, festivals, religions, and languages. Roman art reflects this need to administer a huge empire.

The Romans were practical, less idealistic than the Greeks, and their art reflects these characteristics. They admired, collected, and copied Greek works, but their own art was not merely imitative. Roman portraiture of the Republican period, such as the *Portrait Head of an Old Man* (**fig. 16.8**), achieved a high degree of individuality rarely found in Greek sculpture. The warts-and-all style probably grew out of the Roman custom of making wax death masks of ancestors for the family shrine or altar. Later, these images were recreated in marble to make them more durable. Roman sculptors observed and carefully recorded those physical details and imperfections that give character to each person's face. Even Roman civic monuments to its heroes were relatively realistic portraits, as the *Augustus of Prima Porta* shows (see fig. 2.16).

The Romans' greatest artistic achievements were in civil engineering, town planning, and architecture. They created utilitarian and religious structures of impressive beauty and grandeur that had a major influence on later Western architecture. The outstanding feature of Roman architecture was the semicircular arch, which the Romans utilized and refined in the construction of arcades, barrel vaults, and domes (see diagrams in figs. 14.5–14.8).

An excellent example of a Roman public works project is the Colosseum (**fig. 16.9**). Built by the aristocratic Flavian family between 70 and 80 CE, it was originally known as the Flavian Amphitheater. The foundation of the Colosseum is an elliptical ring of concrete over 44 feet high. Brick, stone, and marble blocks complete the structure. The exterior is a three-story round-arch colonnade, with each level a different architectural order; each round arch on the lower floors opens to a concrete barrel vault. The principal use of the building was for amusements such as gladiatorial matches and wild game hunts. Its capacity was between 50,000 and 75,000 spectators, about as many

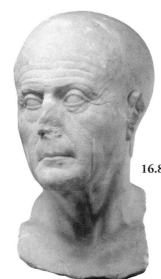

16.8 *Portrait Head of an Old Man.* Italy. 25 BCE–10 CE. Marble. 13¾" × 6¹⁵⁄₁₆" × 9¾".
The J. Paul Getty Museum, Villa Collection, Malibu, California.

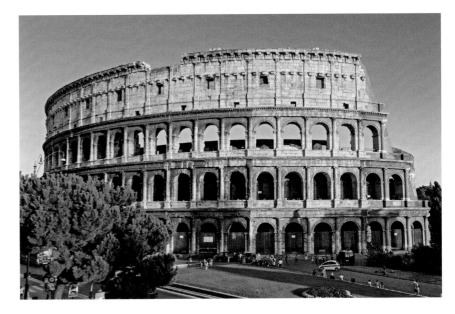

16.9 The Colosseum. Rome. 70–80 CE.
© John McKenna/Alamy.

Watch a video about the Colosseum (Flavian Amphitheater) on myartslab.com

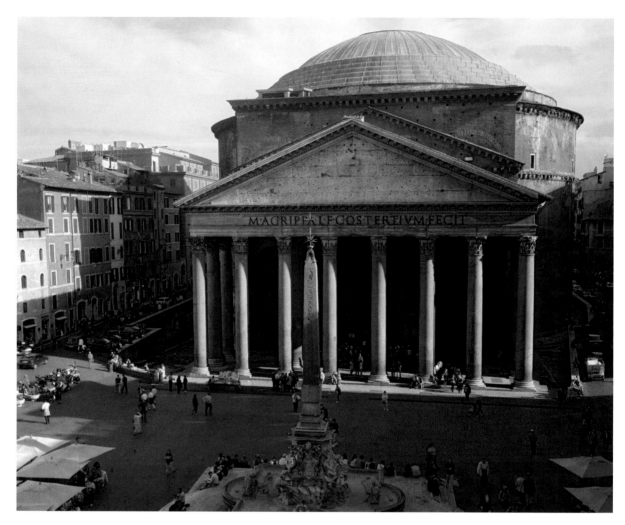

16.10 Pantheon. Rome. 118–125 CE.
a. View of the entrance.
© Vincenzo Pirozzi, Rome.

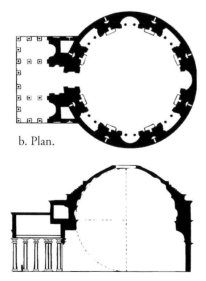

b. Plan.

c. Section.

as today's sports stadiums (a more accurate guess is impossible because much of the exterior marble was carried off during the Middle Ages). The Flavian family likely built the Colosseum to improve its public image and thus its legitimacy as rulers.

By developing the structural use of concrete combined with semicircular arch and vault construction, the Romans were also able to enclose large indoor spaces. In the Pantheon (**fig. 16.10**), a major temple dedicated to all the gods, Roman builders created a domed interior space of immense scale. The building is essentially a cylinder, capped by a hemispherical dome, with a single entrance framed by a columned porch, or **portico**. Because the interior of the Pantheon is dimly lit and difficult to photograph, we see it here in a famous 1734 painting (**fig. 16.11**).

16.11 Giovanni Paolo Panini.
The Interior of the Pantheon,
Rome. c.1734. Oil on canvas.
50½″ × 39″.
National Gallery of Art, Washington, D.C.,
Samuel H. Kress Collection, 1939.1.24

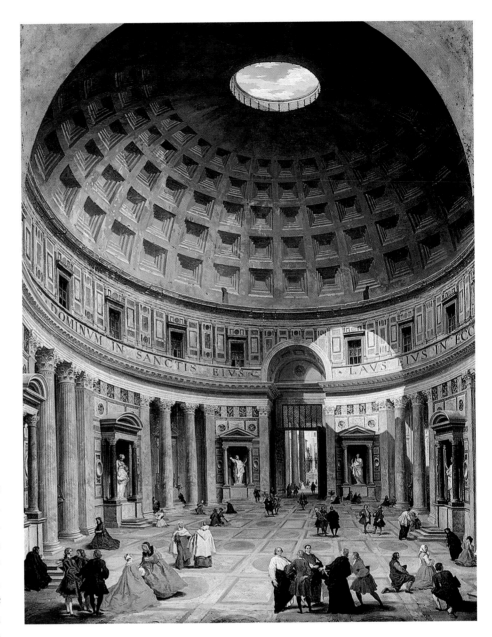

Whereas Greek temples, such as the Parthenon, were designed both as inner sanctuaries for priests and as focal points for outdoor religious ceremonies, the Pantheon was built as a magnificent, awe-inspiring interior space that complemented its once opulent exterior. To meet their need for spacious interiors to accommodate larger numbers of people, the Romans developed many other great domed and vaulted buildings.

The Pantheon's circular walls, which support the huge dome, are stone and concrete masonry, 20 feet thick and faced with brick. The dome diminishes in thickness toward the crown, and it is patterned on the interior surface with recessed squares called **coffers**, which both lighten and strengthen the structure. Originally covered with gold, the coffered ceiling symbolizes the dome of heaven. The distance from the summit to the floor is equal to the 143-foot diameter, making the Pantheon a virtual globe of space. At the dome's crown, an opening called an oculus, or eye, 30 feet in diameter, provides daylight and ventilation to the interior. Neither verbal description nor views of the exterior and interior can evoke the awe many visitors experience on entering the Pantheon.

Wall paintings show the Roman love of luxury. The majority of surviving Roman paintings come from Pompeii, Herculaneum, and other towns buried—and thus preserved—by the eruption of Mt. Vesuvius in 79 CE. In the first century, Roman artists continued the late Greek tradition of portraying depth in paintings of landscapes and urban views.

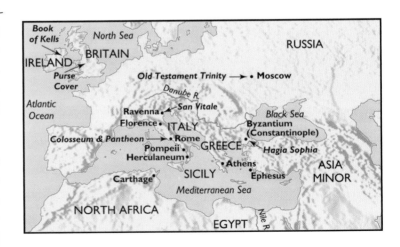

16.12 Europe from 117 to 1400.

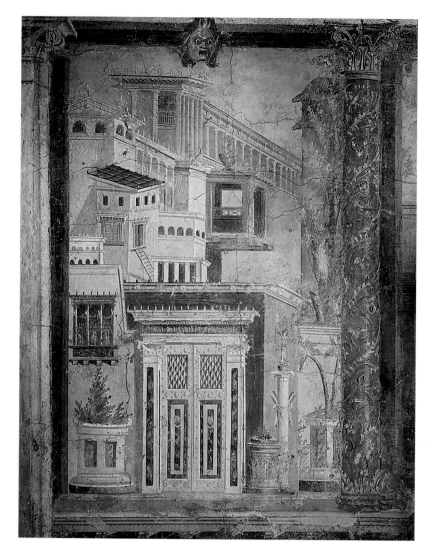

16.13 Roman painting. 1st century BCE. Bedroom from the villa of P. Fannius Synistor at Boscoreale, Pompei. Fresco on lime plaster. Height (average) 8´.
Metropolitan Museum of Art. Rogers Fund, 1903. N. inv.: 03.14.13a-g © 2013 Image copyright The Metropolitan Museum of Art/Art Resource/Scala, Florence.

The Roman painting from a villa near Naples (**fig. 16.13**) presents a complex urban scene painted with a form of perspective inherited from Hellenistic murals. As is typical of Roman painting, the receding lines are not systematically related to one another to create a sense of common space, nor is there controlled use of the effect of diminishing size relative to distance. (In other words, neither one-point perspective nor recession in space was practiced.) Perhaps the artist intended viewers simply to enjoy the pleasing interwoven shapes, patterns, colors, and varied scale. After the collapse of the Roman Empire, representation of the third dimension ceased to be of interest, and the knowledge was forgotten until it was rediscovered and developed as a scientific system during the Renaissance, more than one thousand years later.

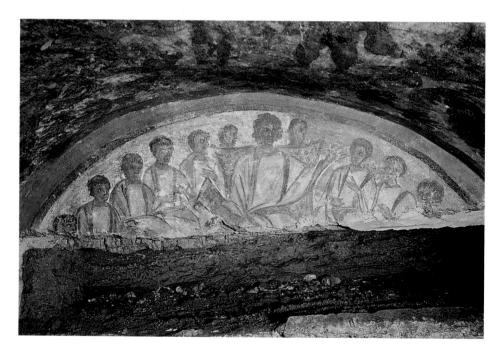

16.14 *Christ and the Apostles.* Early Christian fresco. Catacomb of St. Domitilla, Rome, Italy. Mid-4th century CE.
Photograph Scala, Florence.

Early Christian and Byzantine Art

The Romans first regarded Christianity as a strange cult and attempted to suppress it through law. This forced the followers of Christ to worship and hide their art in private homes and underground burial chambers called **catacombs**. The earliest Christian art was a simplified interpretation of Greco-Roman figure painting, with a new emphasis on storytelling through images of Christ and other biblical figures, as well as through symbols. *Christ and the Apostles* (**fig. 16.14**) shows a beardless Christ, dressed like a Roman senator, only slightly larger than the faithful who surround him.

By the time Emperor Constantine acknowledged Christianity in 313, Roman attitudes had changed considerably. The grandeur of Rome was rapidly declining. As confidence in the stability of the material world fell, more people turned toward the spiritual values that Christianity offered. To reflect this change in orientation, Constantine pioneered a new type of imperial portrait, as we see in the *Head of Constantine* (**fig. 16.15**). Once part of an immense figure, the head is an image of imperial majesty, yet the large eyes and stiff features express an inner spiritual life. The late Roman style of the facial features, particularly the eyes, is very different from the naturalism of earlier Roman portraits, and Constantine's otherworldly gaze contrasts markedly with the realistic squint of the *Portrait Head of an Old Man* (see fig. 16.8).

In 330, Constantine moved the capital of the Roman Empire east from Rome to the city of Byzantium, which he renamed and rebuilt as Constantinople (present-day Istanbul). Although he could not have known it, the move would effectively split the empire in two. In 395, the Roman Empire was officially divided, with one emperor in Rome and another in Constantinople. The latter city became known as Byzantium, capital of the Byzantine, or Eastern, Empire. Over the course of the next century, the Western empire was repeatedly attacked by nomadic Germanic tribes. They placed one of their own on the imperial throne in 476, a convenient marker for the end of the Western Roman Empire. Under attack from the tribes, and weakened from within by military rebellions and civil wars, the political unity of the

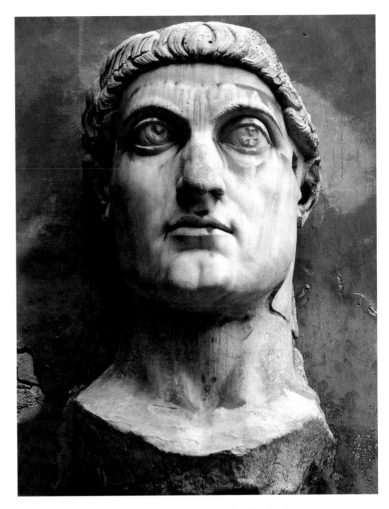

16.15 *Head of Constantine.* c.312 CE. Marble. Height 8′.
Museo dei Conservatori, Rome. Photograph: Duane Preble.

Western Roman Empire decayed, ushering in the era in Europe known as the Middle Ages.

The eastern portion of the empire, however, did not collapse. Indeed, the Byzantine Empire survived well into the fifteenth century. Founded as a Christian continuation of the Roman Empire, Byzantium developed a rich and distinctive artistic style that continues today in the mosaics, paintings, and architecture of the Orthodox churches of Eastern Europe.

Besides granting Christianity official recognition, Constantine also sponsored an extensive building program. Thus, in the late Roman and early Byzantine empires, we find the first flowering of Christian art and architecture. For example, Christians adapted the Roman **basilica**, or assembly hall, for use in public worship. The original Roman basilica was a long hall flanked by columns with a semicircular **apse** at

16.16 Old St. Peter's Basilica. Rome. c.320–335.

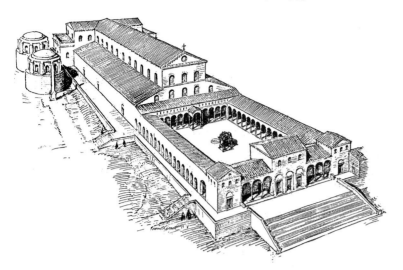

a. Reconstruction drawing.
Kenneth J. Conant, Old St. Peter's Basilica, Rome. Restoration study.
Courtesy of the Frances Loeb Library, Harvard Graduate School of Design.

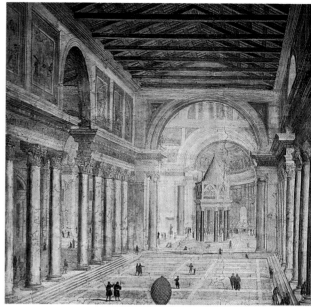

b. Interior view of basilica of Old Saint Peter's.
Fresco. S. Martino ai Monti, Rome, Italy.
Photograph: Scala, Florence/Fondo Edifici di Culto - Min. dell'Interno.

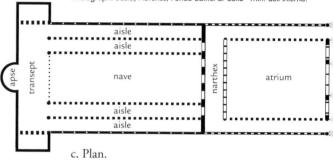

c. Plan.

each end where government bodies and law courts met. One of the earliest Christian churches was Old St. Peter's Basilica in Rome (**fig. 16.16**). Its long central aisle, now called the **nave**, ends in an apse, as in a Roman building. Here, Christians placed an altar.

In contrast to the external grandeur of Greek and Roman temples, early Christian churches were built with an inward focus. Their plain exteriors gave no hint of the light and beauty that lay inside.

The rapid construction of many large churches created a need for large paintings or other decorations to fill their walls. Mosaic technique was perfected and widely used in early Christian churches. Although other cultures knew the art of attaching pieces of colored glass and marble (**tesserae**) to walls and floors, early Christians used smaller tesserae, with a greater proportion of glass, in a wider range of colors. Thus they achieved a new level of brilliance and opulence.

We see the transition from Early Christian to Byzantine styles in the churches of Ravenna, an old Roman city about 80 miles south of Venice. Hoping to avoid the Germanic invasions, the Roman emperor moved his capital there in 404. When the Western empire fell in 476, Ravenna remained an important administrative center. However, Emperor Justinian sent an army from his capital of Constantinople and reconquered it in 540, turning it into a showplace of Byzantine culture on the Italian peninsula.

The most important sixth-century Byzantine church is San Vitale in Ravenna (**fig. 16.17a–b**). The glittering mosaic compositions that cover most of the interior surfaces depict the figures of Emperor Justinian and Empress Theodora (**fig. 16.17c**) in addition to religious figures and events. In a blending of religious and political authority, Justinian and Theodora are shown with halos, analogous to Christ and Mary, yet both are royally attired and bejeweled.

The elongated, abstracted figures provide symbolic rather than naturalistic depictions of the Christian and royal figures. Emphasis on the eyes is a Byzantine refinement of the stylized focus seen in the *Head of Constantine*. Figures are depicted with heavy outline and stylized shading. The only suggestion of space has been made by overlap. Background and figures retain a flat, decorative richness typical of **Byzantine art**.

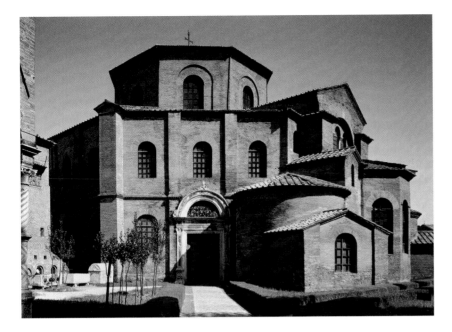

a. Exterior.
Photograph: Scala, Florence.

16.17 San Vitale.
Ravenna, Italy. 526–547.

b. Plan.

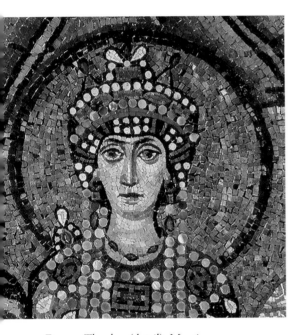

c. *Empress Theodora* (detail). Mosaic.
© Cameraphoto Arte, Venice.

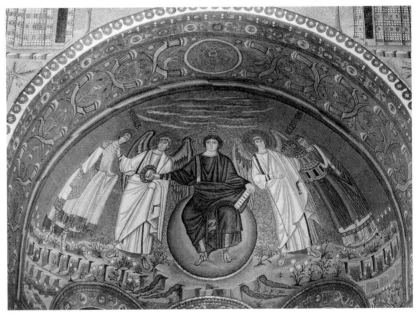

d. Apse mosaic.
akg-images/Cameraphoto.

The arts of the Early Christian period were affected by an ongoing controversy between those who sought to follow the biblical prohibition against the making of images and those who wanted pictures to help tell the sacred stories. The Byzantine style developed as a way of inspiring the illiterate while keeping the biblical commandment that forbids the making of graven images. Byzantine theory held that highly stylized (abstract) and decorative images could never

be confused with a real person, as a naturalistic work might be. As a result, the naturalism and sense of depth found in Roman painting gradually gave way to Byzantine stylization.

The apse mosaic in the interior of San Vitale (**fig. 16.17d**) shows Christ dressed in royal purple and seated on an orb that symbolizes the universe. He is beardless, in the fashion of classical gods. With his right hand, he passes a crown to San Vitale, who

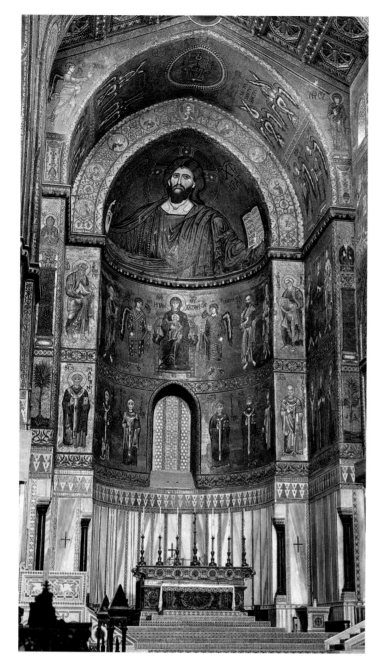

16.18 *Christ as Pantocrator with Mary and Saints.*
Apse mosaic. Cathedral of Monreale, Sicily.
Late 12th century.
Photograph: Scala, Florence.

View the Closer Look for the technique
of mosaic on myartslab.com

stands in a depiction of the biblical paradise along with
other saints and angels. The appearance of all of these
figures owes something to Roman art, but in keeping
with Byzantine style, they stand motionless and stare
straight ahead. In their heavenly majesty, they seem to
soar above human concerns.

In the eighth and ninth centuries, the Byzantine
Empire was wracked by the Iconoclastic Controversy,
a debate over religious images that at times turned vio-
lent. In 726, Byzantine emperor Leo III ordered the
destruction of all images of Christ, Mary, the saints,
and the angels. He and his party believed that such
images encouraged idolatry, or worship of the image
rather than the divine being. They were soon termed
iconoclasts, or image-breakers, and they punished
persons who owned images by flogging or blinding
them. (The iconoclasts did not resist all decoration;
they permitted jeweled crosses and pictures of leafy
paradises, for example.) Those who favored images
(the iconophiles) argued that just as Christ was both
god and human, an image of Christ combines the spir-
itual and the physical.

Although the emperor's decree was not uniformly
enforced, the controversy lasted for more than a hun-
dred years, and it contributed to the split between the
Roman Catholic and the Eastern Orthodox churches.
There was a political struggle as well: The iconoclasts
favored the emperor's power over that of local mon-
asteries, which were wealthy with sumptuous images.
The dispute finally came to an end in 843, when
Empress Theodora officially overturned Leo's decree.

As the controversy subsided, the inside of the
dome of Hagia Sophia was adorned with a new kind of
image, Christ as ruler of the universe, or **Pantocrator**.
This mosaic (now destroyed) became the inspiration
for similar portrayals in smaller Byzantine churches
such as the cathedral of Monreale, Sicily, where the
mosaic of *Christ as Pantocrator with Mary and Saints*
(**fig. 16.18**) shows the typical Byzantine style employ-
ing hierarchic scale to express the greater magnitude
of Christ relative to Mary, the saints, and angels por-
trayed in rows below him.

By the tenth and eleventh centuries, Byzantine art-
ists had created a distinct style that expressed Eastern
Orthodox Christianity and also met the needs of a lav-
ish court. The style had its roots in the Early Christian
art of the late Roman Empire, as we have seen. But
it also absorbed Eastern influences, particularly the
flat patterns and nonrepresentational designs of Islam.
Eastern influence continued with the hierarchical
sizing and placement of subject matter in Byzantine
church decoration.

The Byzantine style is still followed by painters and others working within the tradition of the Eastern Orthodox Church. Clergy closely supervise the iconography and permit little room for individual interpretation. Artists of the Eastern Orthodox faith seek to portray the symbolic or mystical aspects of religious figures rather than their physical qualities. The figures are painted in conformity to a precise formula. Small paintings, referred to as icons (from the Greek *eikon*, meaning image or picture), are holy images that inspire devotion but are not worshipped in themselves. The making of portable icon paintings grew out of mosaic and fresco traditions.

Even within the relatively tight stylistic confines of the Orthodox style, occasionally an artist is able to make icons that not only have the required easy readability but also communicate powerful feeling. Such an artist was Andrei Rublev, one of the most highly regarded painters in Russian history. His *Old Testament Trinity* (**fig. 16.19**) depicts a story in which Jewish patriarch Abraham entertained three strangers who later turned out to be angels: Christians have seen this story as foreshadowing their doctrine of the

16.20 Byzantine School.
Madonna and Child on a Curved Throne.
13th century. Tempera on panel. 32⅛″ × 19⅜″.
National Gallery of Art, Washington, D.C. Andrew W. Mellon Collection, 1937.1.1

16.19 Andrei Rublev. *Old Testament Trinity.* c.1410.
Tempera on panel. 55½″ × 44½″.
Photo Scala, Florence.

Trinity. Rublev gave the scene a sweetness and tenderness through subtle facial expressions and elongation of bodies. The bright colors add intensity to the work, even in its present poor state.

The design of the icon painting *Madonna and Child on a Curved Throne* (**fig. 16.20**) is based on circular shapes and linear patterns. Mary's head repeats the circular shape of her halo; circles of similar size enclose angels, echoing the larger circle of the throne. The lines and shapes used in the draped robes that cover the figures give scarcely a hint of the bodies beneath. Divine light is symbolized by the gold background that surrounds the throne in which the Virgin Mary sits. The large architectural throne symbolizes Mary's position as Queen of the City of Heaven. Christ appears as a wise little man, supported on the lap of a heavenly, supernatural mother.

In order that they be worthy of dedication to God, icons are usually made of precious materials. Gold leaf was used here for the background and costly lapis lazuli for the Virgin's robe.

The Middle Ages in Europe

The one thousand years that followed the fall of the Western Roman Empire have been called the medieval period, or the Middle Ages, because they came between the fall of the Roman Empire and the rebirth, or renaissance, of Greco-Roman ideas in the fifteenth century. The age that gave us transcendent cathedrals also gave birth to memorable art works in many media.

Early Medieval Art

The art of the early Middle Ages took shape as Early Christian art absorbed a new influence: the art of the invaders. Many nomadic peoples traveled across the Eurasian grasslands, which extend from northwest China to central Europe. Their migrations occurred over a long period that began in the second millennium BCE and lasted well into the Middle Ages. The Greeks called these nomads (and other non-Greeks) "barbarians." What little we know about them is derived from artifacts and records of literate cultures of the Mediterranean, the Near East, and China, to whom the nomads were a menace. Both the Great Wall of China and Hadrian's Wall in Britain were built to keep out such invaders.

The lack of a written language has counted somewhat unfairly against these nomads. Recent archaeological research has, however, counteracted some of these ancient prejudices. Far from uncivilized, the nomadic peoples of Central Asia had a unique horse-based culture, living neither by hunting and gathering nor settled in agricultural villages. They had elaborate trading networks and sophisticated religious rituals.

The round tray on conical stand shows a man holding an offering cup, kneeling before a horse (**fig. 16.21**). The two seem perfectly still, and the silent yet intense interaction between them suggests a narrative meaning that remains mysterious. This bronze stand, found in an aristocratic burial in Central Asia, may have held incense or offerings.

Nomadic metalwork often exhibits exceptional skill. Because of frequent migrations and the durability and value of art objects, the style was diffused over large geographic areas. The gold and enamel purse cover (**fig. 16.22**) found in a grave at Sutton Hoo in Suffolk, England, belonged to a seventh-century East Anglian king. The distinct variations of its motifs indicate that they are derived from several sources. The motif of a man standing between confronting animals likely came to East Anglia via nomadic cultures.

The meeting of decorative nomadic styles with Christianity can be seen most clearly in the illustrated holy books created in Ireland.

16.21 Round tray on conical stand.
5th to 3rd century BCE. Bronze. Height 10⅞".
Central State Museum of the Republic of Kazakhstan, Almaty. Inv. KP8591.

16.22 Purse cover.
From the Sutton Hoo Ship Burial, Suffolk, England.
Before 655. Gold and enamel. Length 7½".

View the Closer Look for the technique of enamel on myartslab.com

The Irish had never been part of the Roman Empire, and in the fifth century they were Christianized without first becoming Romanized. During the chaotic centuries that followed the fall of Rome, Irish monasteries became the major centers of learning and the arts in Europe, and they produced numerous hand-lettered copies of religious manuscripts.

The initial letters in these manuscripts were increasingly embellished over time, moving first into the margin and then onto a separate page. This splendid initial page is the opening of St. Matthew's account of the Nativity in the *Book of Kells* (**fig. 16.23**), which contains the Latin Gospels. It is known as the "Chi-Rho monogram" because it is composed of the first two letters of Christ in Greek (*XP*) and is used to represent Christ or Christianity. Except for *XP* and two Latin words beginning the story of Christ's birth, most of the page is filled with a rich complexity of spirals and tiny interlacings. If we look closely at the knots and scrolls we see angels to the left of the X, a man's head in the P, and cats and mice at the base.

16.23 Chi-Rho monogram (XP).
Page from the *Book of Kells*. Late 8th century.
Inks and pigments on vellum. 12¾" × 9½".

Romanesque

The stylistic term **Romanesque** was first used to designate European Christian architecture of the eleventh and twelfth centuries, which revived Roman principles of stone construction, especially the round arch and the barrel vault. This term is now applied to all medieval art of Western Europe during that period.

Romanesque art developed in a Western Europe dominated by feudalism and monasticism. Feudalism involved a complex system of obligations to provide services through personal agreements among local leaders of varying ranks. In addition to accommodating religious practices, monasteries provided shelter from a hostile world and served as the main sources of education.

Religious pilgrimages brought large groups of Christians to remote places, creating the need for larger churches. Romanesque architecture made liberal use of round arches and vaults, creating a feeling of solid stability. Churches continued to have wooden roofs, but stone vaults gradually replaced fire-prone wooden ceilings, giving the new structures a close resemblance to Roman interiors. Consistent throughout the variety of regional styles was a common feeling of security provided by massive, fortress-like walls.

Romanesque churches feature imaginative stone carvings that are an integral part of the architecture. Subjects and models came from miniature paintings in illuminated texts, but sculptors gradually added a degree of naturalism not found in earlier medieval work. In addition to stylized and at times naïve figures from biblical stories, relief carvings include strange beasts and decorative plant forms. The largest and most elaborate figures were placed over the central doorways of churches. Such figures were the first large sculpture since Roman times.

16.24 *Christ of the Pentecost.* Church of Saint Madeleine, Vézelay, France. 1125–1150. Stone. Height of the tympanum 35½′.
Hervé Champollion/akg-images.

Deviation from standard human proportions enabled sculptors to give appropriately symbolic form to figures such as *Christ of the Pentecost* (**fig. 16.24**). The mystical energy and compassion of Christ are expressed in this relief carving above the doorway of the Church of Saint Madeleine at Vézelay, France. As worshippers enter the nave, the image above them depicts Christ at the time he asked the apostles and all Christians to take his message to the world. The image of Christ is larger in scale than the other figures, showing his relative importance. The sculptor achieved a monumental quality by making the head smaller than normal and by elongating the entire figure. Swirling folds of drapery are indicated with precise curves and spirals show an imaginative linear energy. Surrounding Christ and the apostles are depictions of the peoples of the world; in the round medallions we see the signs of the zodiac and the monthly tasks associated with each.

Gothic

The Romanesque style had lasted barely a hundred years when the **Gothic** style began to replace it in about 1145. The shift is seen most clearly in architecture, as the Romanesque round arch was superseded by the Gothic pointed arch. This new advance, coupled with the flying buttress, made possible some of the most spectacular religious buildings ever seen.

Gothic cathedrals were expressions of a new age of faith that grew out of medieval Christian theology and mysticism. The light-filled, upward-reaching structures symbolize the triumph of the spirit over the bonds of earthly life, evoking a sense of joyous spiritual elation. Inside, the faithful must have felt they had actually arrived at the visionary Heavenly City.

Gothic cathedrals such as Notre-Dame de Chartres (Our Lady of Chartres) (**fig. 16.25a**) were the center of community life. In many cases, they

16.25 Notre-Dame de Chartres. Chartres, France. 1145–1513. Cathedral length 427´; south tower height 344´; north tower height 377´. a. View from the southeast.
© John Elk, III.

Watch a video about Chartres Cathedral on myartslab.com

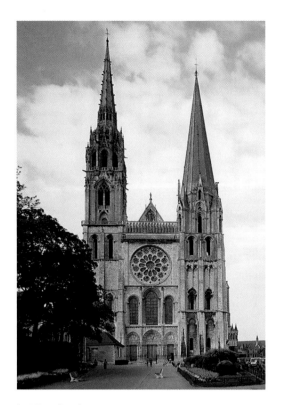

b. West façade.
Photograph: Duane Preble.

The principal goal of the Gothic structural advances was to fill churches with light, a metaphor for the presence of God. Stained-glass windows fulfill this transcendent function in a specifically Christian fashion, in imagery that transforms the nave with showers of color, changing hour by hour. At Chartres, the brilliant north rose window (**fig. 16.25c**), known as the "Rose de France," is dedicated to the Virgin Mary, who sits in majesty, surrounded by doves, angels, and royal figures of the celestial hierarchy. (See also the interior photo, fig. 14.12.)

Like most medieval cathedrals, Notre-Dame de Chartres was also an active pilgrimage site. Pilgrims typically entered through the west doors and proceeded

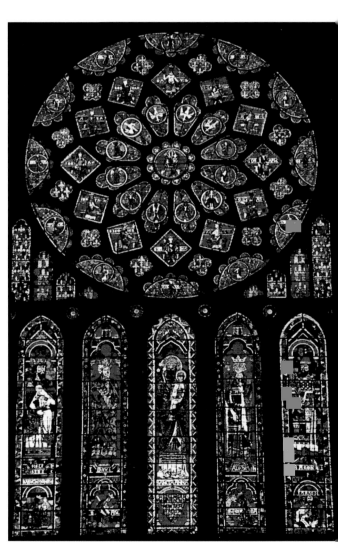

c. "Rose de France" window. c.1233.
Photograph: Duane Preble.

were the only indoor space that could hold all the townspeople at once; thus they were used for meetings, concerts, and religious plays. But, most of all, they were places of worship and pilgrimage. Above the town of Chartres the cathedral rises, its spires visible for miles around.

The entire community cooperated in the building of Notre-Dame de Chartres, although those who began its construction never saw its final form. The cathedral continued to grow and change for more than three hundred years. Although the basic plan is symmetrical and logically organized, the architecture of Chartres has a rich, enigmatic complexity that is quite different from the easily grasped totality of the classical Parthenon.

One of the first cathedrals based on the full Gothic system, it helped set the standard for Gothic architecture in Europe. In its west façade (**fig. 16.25b**), Chartres reveals the transition between the early and late phases of Gothic architecture. The massive lower walls and round arch portals were built in the mid-twelfth century. The north tower (on the left) was rebuilt with the intricate flamelike or **flamboyant** curves of the late Gothic style early in the sixteenth century, after the original tower collapsed in 1506.

along the side aisles (**fig. 16.25d**). They passed along the walls behind the altar, where smaller round chapels held relics of saints. The most notable relic here was a piece of cloth reputed to be the veil that Mary wore the night that she gave birth to Christ.

The statues of the Old Testament prophet, kings, and queen (**fig. 16.25e**) to the right of the central doorway at the west entrance of Chartres are among the most impressive remaining examples of early Gothic sculpture. The kings and queen suggest Christ's royal heritage and also honor French monarchs of the time. The prophet on the left depicts Christ's mission as an apostle of God. In contrast to active, emotional Romanesque sculpture, the figures are passive and serene. Their elongated forms allow them to blend readily with the vertical emphasis of the architecture.

Although they are part of the total scheme, the figures stand out from the columns behind them. Their draped bodies, and especially their heads, reveal a developing interest in portraying human features. Such interest eventually led again to full portraiture and freestanding figures.

The cathedral expresses an idea of Abbot Suger, the man credited with starting the Gothic style. At the abbey church of St. Denis, where Suger began the Gothic style, he had an inscription placed on the entrance door stating his idea of the church's spiritual purpose:

> Whoever you may be, if you are minded to
> praise this door,
> Wonder not at the gold, nor at the cost, but at
> the work.
> The work shines in its nobility; by shining
> nobly,
> May it illumine the spirit, so that, through its
> trusty lights,
> The spirit may reach the true Light in which
> Christ is the Door.
> The golden door proclaims the nature of the
> Inward:
> Through sensible things, the heavy spirit is
> raised to the truth;
> From the depths, it rises to the light.[1]

✓—**Study** and review on myartslab.com

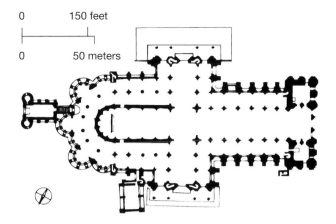

d. Plan based on Latin cross.

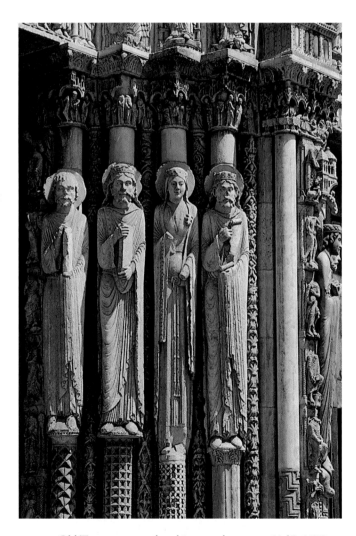

e. Old Testament prophet, kings, and queen. c.1145–1170. Doorjamb statues from west (or royal) portal.
Photograph: Duane Preble.

360°—**Explore** the architectural panorama of Chartres Cathedral on myartslab.com

ART FORMS US: WORSHIP AND RITUAL

Approaching the Sacred

In the Western world, religious architecture is an important aid to worship, be it a Greek temple such as the Parthenon (see fig. 16.4), or a Gothic cathedral (see fig. 16.25).

Other cultures also share the same impulse to lead people to the divine through architecture, and some of the most awe-inspiring buildings of this type are located in the Islamic world. The Sheikh Lutfallah Mosque in Iran (**fig. 16.26**), built in the early seventeenth century, is a particularly stunning example. The relatively dark

16.27 Bill Viola. *Ocean Without a Shore.* 2007. Video/sound installation. Color high-definition video triptych. Installed at Church of San Gallo, Venice.
Photograph: Thierry Bal.

16.26 Sheikh Lutfallah Mosque. Isfahan, Iran. 1603–1619. Interior.
Photograph: Jonathan Bloom and Sheila Blair.

interior is lighted with a circle of grille windows beneath a dome. Eight high pointed arches, framed in twisted turquoise molding, provide the basic visual rhythm to the space. Ceramic tiles cover the wall surfaces, either with written passages from Muslim scripture, or organic forms of twining vegetation with flowers. Tasteful color choices and dazzling patterns, all organized into clear compositional elements, allow the interior of this building to combine piety with opulence, to memorable effect. Passing through the door of this mosque brings worshippers into another world, filled with highly crafted decoration

of rare sumptuousness. The underlying order and rhythm of the arches and decorative elements is intended to lead worshippers to an awareness of God (*Allah* in Arabic), the architect and orderer of the universe.

The contemporary meets the traditional in *Ocean Without a Shore* by Bill Viola, which he installed in a small church building in Venice, Italy, in 2007 (**fig. 16.27**). The building is no longer used for worship but it still has its three large marble altars. The artist installed a plasma screen above each, for presenting three related slow-motion films. Each screen shows a hazy

figure in black and white, walking slowly toward the viewer. At a certain moment, these figures pass through a thin sheet of falling water, drenching themselves as they also come to life in full color. After standing, dripping, for a few moments, the figures slowly pass back through the water to the murkier depths from which they came. Viewers see the three figures enact a symbolic passage between two realms: one vividly colorful and near at hand, the other more gloomy and receding. References to the physical and spiritual worlds come easily to mind, with the watery passageway standing for birth and death. The artist said of this work, "The video sequence documents a succession of individuals slowly approaching out of darkness and moving into the light in order to pass into the physical world. Once incarnate, however, all beings realize that their presence is finite and so they must eventually turn away from material existence to return from where they came. The cycle repeats without end."[2] The symbolic meanings of this work resided well in a church where the resurrection of Christ was celebrated for centuries.

Many artforms in the Caribbean nation of Haiti respond to the needs of the vodou religion, which combines African and Christian elements. No vodou ceremony can begin without an invocation of the Sacred

16.28 *Marassa.* Ceremonial vodou flag. Sequins on fabric. 30″ × 30½″.
© Collection of the Figge Art Museum; gift of the Marcus L. Jarrett Family 1995.1. Image courtesy of the Figge Art Museum, Davenport, Iowa.

Twins, or Marassa, who represent the gateway to the spirit world. They are the subject of the flag (**fig. 16.28**), where two dark vertical lines represent the sacred pair. The cross shape that meets in the center refers to crossroads or thresholds, the boundary between the living world and the spiritual one, which the twins guard. The twins invite worshippers to arrive at the crossroads and enter the spiritual world through music and dance. The unfurling of the flag symbolizes the invitation to worshippers to join the ritual. While the twins must be present at any vodou ceremony, their special day is December 6, the Roman Catholic feast of St. Nicholas, patron of children.

1. What were the principal characteristics of classical Greek sculpture?

2. What structural innovations did Roman buildings exploit?

3. What is the main distinction between Romanesque and Gothic architecture?

Compare the depiction of Christ in *Christ and the Apostles* (fig. 16.14) with *Christ as Pantocrator* (fig. 16.18). What techniques have the artists used to convey such divergent images of the subject?

KEY TERMS

basilica – a Roman town hall, with three aisles and an apse at one or both ends; Christians appropriated this form for their churches

catacomb – underground burial places in ancient Rome

classical art – the art of ancient Greece and Rome, particularly the style of Greek art that flourished during the fifth century BCE; emphasizes rational simplicity, order, and restrained emotion

Gothic – primarily an architectural style that prevailed in Western Europe from the twelfth through the fifteenth centuries; characterized by pointed arches, ribbed vaults, and flying buttresses

iconoclast – in Byzantine art, one who opposes the creation of images of holy persons, believing that they promote idolatry

kouros – an Archaic Greek statue of a standing nude young male

krater – in classical Greek art, a wide-mouthed vessel with handles, used for mixing wine and water for ceremonial drinking

Romanesque – a style of European architecture prevalent from the ninth to the twelfth centuries with round arches and barrel vaults

17

RENAISSANCE AND BAROQUE EUROPE

THINK AHEAD

17.1 Explain the concept of humanism and its impact on Renaissance art and culture.

17.2 Contrast the techniques, media, and themes in Italian and Northern European art of the Renaissance.

17.3 Describe how social and religious events of the seventeenth century shaped Baroque art.

17.4 Compare stylistic characteristics of Renaissance, Baroque, and Rococo art.

17.5 Recognize the relationship of Rococo art to the French aristocracy.

17.6 Discuss examples of art that function to persuade or influence the viewer.

Many works generally regarded as masterpieces were created during the **Renaissance**, when ambitious artists combined technical advances with profound subject matter to create works that still resonate today. Then in the **Baroque** period, an exceptionally dynamic time in Western history, artists expanded the means of producing works of art and their subject matter. The **Rococo** period that followed was a more decorative and playful elaboration of the Baroque style. Many techniques and attitudes developed in the Renaissance and Baroque remained in force until the twentieth century.

The Renaissance

A shift in attitude occurred in Europe as the religious fervor of the Middle Ages was increasingly challenged by logical thought and the new philosophical, literary, and artistic movement called **humanism**. Leading humanist scholars did not discard theological concerns, yet they supported the secular dimensions of life, pursued intellectual and scientific inquiry, and rediscovered the classical culture of Greece and Rome. Humanist thought gives most importance to human rather than to divine or supernatural mat-

ters. Humanists stress the potential value and ability of humans, using their God-given wisdom, to solve problems, and they seek rational solutions rather than divinely inspired ones.

The cultural focus gradually shifted from God and the hereafter to humankind and the here and now. For many Europeans, the Renaissance was a period of achievement and worldwide exploration—a time of discovery and rediscovery of the world and of the seemingly limitless potential of individual human beings. The period was foreshadowed in the fourteenth century, reached its clear beginning in the early fifteenth century, and came to an end in the early seventeenth century. However, Renaissance thinking continues to influence our lives today, not only in Western countries but in all parts of the world where individualism, modern science, and technology influence the way people live. In art, new and more scientific approaches were brought to the quest for representational accuracy. The resulting naturalism defined the Western tradition for more than four hundred years.

The intellectuals of the time were the first in European history to give their own era an identifying name. They named their period the Renaissance—literally, "Rebirth"—an apt description for the period of revived interest in the art and ideas of classical

((• Listen to the chapter audio on myartslab.com

17.1 Giotto di Bondone. *Lamentation.* Scrovegni Chapel, Padua, Italy. c.1305. Fresco. 72″ × 78″.
© Studio Fotografico Quattrone, Florence.

🔍 **View** the Closer Look for the technique of fresco on myartslab.com

Greece and Rome. Fifteenth-century Italians believed they were responsible for the rebirth of "the glory of ancient Greece," which they considered the high point of Western civilization. Yet Greco-Roman culture was not totally reborn, because this "classical" heritage had never truly disappeared from the medieval West. Muslim scholars in Spain, Egypt, and Iraq maintained respect for the Greeks and translated their works into Arabic for their libraries. Muslim and European scholars of the thirteenth and fourteenth centuries then recovered these works and made them available in Latin. In essence, the Renaissance was a period of new and renewed understanding that transformed the medieval European world, and laid the foundation for modern society.

New values combined with technological advances brought forth a new style of art in the fourteenth century. Painting and sculpture were liberated from their medieval roles as supplements to architecture. Artists, who considered themselves anonymous workers in the Middle Ages, came to be seen as individuals of creative genius.

The art of the Renaissance evolved in different ways in northern and southern Europe because the people of the two regions had different backgrounds, attitudes, and experiences. The Gothic style reached its high point in the north while Byzantine and Greco-Roman influences remained strong in the south. Italian Renaissance art grew from classical Mediterranean traditions that were human-centered and often emphasized the ideal. In contrast, the art of the northern Renaissance evolved out of pre-Christian, nature-centered religions that had become God-centered through conversion to Christianity.

We see the beginnings of the new humanistic art in Italian painter Giotto di Bondone, known as Giotto. He departed from the abstract, Byzantine style by portraying the feelings and physical nature of human beings. His innovative depictions of light, space, and mass gave a new sense of **realism** to painting. In *Lamentation* (**fig. 17.1**), Giotto depicted physical as well as spiritual reality. His figures are shown as individuals within a shallow, stagelike space, and their expressions portray personal feelings of grief rarely seen in medieval art.

In retrospect, Giotto is considered not only a precursor of the Renaissance, but also the reinventor of naturalistic painting, which had not been seen in Europe since the decline of Rome a thousand years earlier. This "realism" is still an important current in Western painting.

The ancient Greeks had been concerned with idealized physical form; Roman artists had emphasized physical accuracy; and artists of the Middle Ages had focused on spiritual concerns rather than physical existence. In the Renaissance, as attention shifted from heaven to earth, artists portrayed Christian subjects in human terms. Italian civic leaders expressed a desire to equal or surpass the glory of ancient Greece and Rome and to imbue their achievements with the light of Christian understanding.

Italy was the principal homeland of the Renaissance. In time the movement spread northward, but it did not flourish everywhere in Europe; it came late to Spain and Portugal, and it barely touched Scandinavia.

The Renaissance in Italy

Artistic and intellectual developments in the Italian city-states were aided by a flourishing economy set against a chaotic political background. The wealth of Italian merchants enabled them to compete with one another, and with church officials and nobility, for the recognition and power that came with art patronage.

Italian architects, sculptors, and painters sought to integrate Christian spiritual traditions with the rational ordering of physical life in earthly space. Artists began an intense study of anatomy and light, and they applied geometry to the logical construction of implied space through the use of linear perspective (see Chapter 3). In turn, the careful observation of nature initiated by Renaissance artists aided the growth of science.

About one hundred years after Giotto, Masaccio became the first major painter of the Italian Renaissance. In his fresco *The Holy Trinity* (**fig. 17.2**), the composition is centered on an open chapel in which we see the Trinity: God the father, Christ the son, and between their heads a white dove symbolizing the Holy Spirit. Within the niche, Mary the mother of Jesus stands, gesturing to Christ; opposite her is St. John. Kneeling outside are the donors who paid for the painting, a husband and wife who headed a powerful banking family of that time. He is wearing the red robe that marks him as a member of the Florence city council. Below, a skeleton lies on a sarcophagus beneath the inscription, "I was what you are, and what I am, you shall become." If we view the painting from top to bottom, we move from the spiritual to the physical.

The Holy Trinity was the first painting based on the systematic use of linear perspective. Although perspective was known to the Romans in a limited way, it did not become a consistent science until architect Filippo Brunelleschi rediscovered and developed it in Florence early in the fifteenth century. Masaccio used perspective to construct

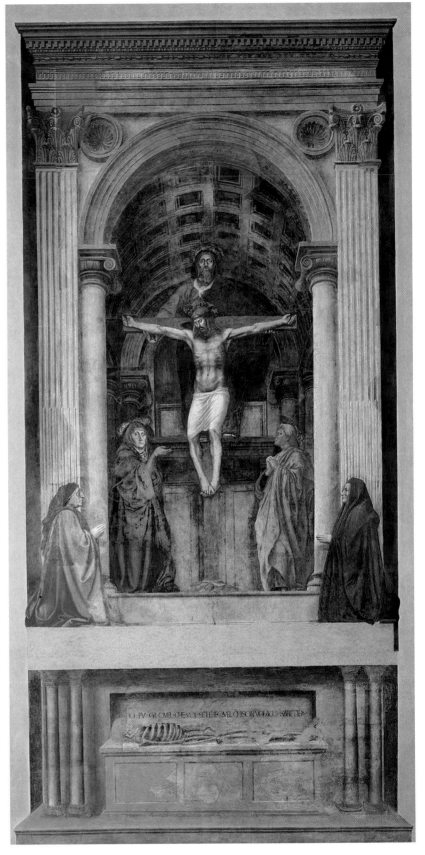

17.2 Masaccio. *The Holy Trinity.* Santa Maria Novella, Florence, Italy. 1425. Fresco. 21′10½″ × 10′5″.
© Studio Fotografico Quattrone, Florence.

an illusion of figures in three-dimensional space. The single vanishing point is below the base of the cross, about 5 feet above ground, at the viewer's eye level. Masaccio's perspective is so precise that we can see the interior of the illusionary chapel as a believable extension of the space we occupy. The setting also reveals Masaccio's knowledge of the new Renaissance architecture developed by Brunelleschi, which he based on Roman prototypes.

The figures in *The Holy Trinity* have a physical presence that shows what Masaccio learned from the work of Giotto. In Giotto's work, however, body and drapery still appear as one; Masaccio's figures are clothed nudes, with garments draped like real fabric.

During the Italian Renaissance, the nude became a major subject for art, as it had been in Greece and Rome. Unclothed subjects are rare in medieval art and appear awkward, their bodies graceless. In contrast, sculpted and painted figures by Italian Renaissance artists appear as strong and natural as the Greek and Roman nudes that inspired them.

As Masaccio innovated in painting, Donatello did in sculpture. Donatello brought the Greek ideal of what it means to be human into the Christian context. As a young adult, he made two trips to Rome, where he studied medieval and Roman art.

Donatello shows himself as an ambitious artist even in his early work. His bronze figure *David* (**fig. 17.3**) was the first life-size, freestanding nude statue since ancient Roman times. To Florence, where the work was located, David was not only a biblical figure; his resistance to foreign domination of the Jews inspired the Florentines, who were surrounded by stronger enemy cities.

Although he was greatly attracted to the classical ideal in art, Donatello's sculpture was less idealized and more naturalistic than that of ancient Greece. He chose to portray the biblical shepherd, David—slayer of the giant Goliath and later king of the Jews—as an adolescent youth rather than as a robust young man. The sculptor celebrated the sensuality of the boy's body by clothing him only in hat and boots. Every shift in the figure's weight and pose is expressive. The youth's position is derived from classical contrapposto. The few nudes that appeared in medieval art showed little sensual appeal and often portrayed shame and lust. Under the influence of humanist scholars who sought to surpass the Greeks and Romans in the nobility of form, the nude became a symbol of human worth and divine perfection, a representation of the "immortal soul."

During the Renaissance, artists received growing support from the new class of wealthy merchants and bankers, such as the Medici family, who, with great political skill and a certain ruthlessness, dominated the life of Florence and Tuscany. It is likely that Donatello created his bronze *David* as a private commission for Cosimo de' Medici, for the courtyard of the Medici palace.

A major influence on Donatello and other Renaissance artists was the renewal of Neoplatonist philosophy, embraced by the Medici family and their circle of humanist philosophers, artists, and historians. These intellectuals believed that all sources of inspiration or revelation, whether from the Bible or classical mythology, are a means of ascending from earthly existence to mystical union with the divine. In this context, Donatello's *David* was intended to be a symbol of divine beauty.

17.3 Donatello. *David.*
c.1425–1430.
Bronze. Height 62¼″.
Museo Nazionale del Bargello, Florence.
© Studio Fotografico Quattrone, Florence.

17.4 Donatello. *Mary Magdalene.*
c.1455. Wood, partially
gilded. Height 74″.
Photo Scala, Florence/Fondo Edifici di
Culto—Min. dell'Interno.

Donatello's work displayed a wide range of expression, from lyric joy to tragedy. In contrast to the youthful and somewhat brash *David*, Donatello's *Mary Magdalene* (**fig. 17.4**) is haggard and withdrawn—a forcefully expressive figure of old age and repentance. For this late work, Donatello chose painted wood, the favorite medium of northern Gothic sculptors.

Another Medici commission is Sandro Botticelli's *Birth of Venus* (**fig. 17.5**), the first large mythological painting since antiquity. Completed about 1480, this work depicts the Roman goddess of love just after she was born from the sea. She is blown to shore by a couple symbolizing the wind. As she arrives, Venus is greeted by a young woman who represents Spring. The lyric grace of Botticelli's lines shows Byzantine influence. The background is decorative and flat, giving almost no illusion of deep space. The figures appear to be in relief, not fully three-dimensional. Botticelli and his Medici patrons believed that an artwork need not be Christian to be uplifing and beautiful.

The posture and gestures of modesty were probably inspired by the classical Venus statue that Botticelli must have seen in the Medici family collection (see fig. 16.5). In her posture of introspection and repose, Botticelli's Venus combines the classical Greek idealized human figure with a Renaissance concern for thought and feeling.

To place a nude "pagan" goddess at the center of a large painting, in a position previously reserved for the Virgin Mary, was novel. Botticelli's focus on classical mythology was, like Donatello's, based on Neoplatonist philosophy, a central preoccupation of the business-oriented, secular art patrons who commissioned most Renaissance art.

17.5 Sandro Botticelli. *Birth of Venus.* c.1480. Tempera on canvas. 5′8⅞″ × 9′1⅞″.
Uffizi Gallery, Florence, Italy. © Studio Fotografico Quattrone, Florence.

17.6 Leonardo da Vinci. *The Fetus in the Womb.* c.1510. Pen and ink. 11⅞″ × 8⅜″.

The Royal Collection © 2013 Her Majesty Queen Elizabeth II/ The Bridgeman Art Library.

his time. His study *The Fetus in the Womb* (**fig. 17.6**) has a few errors, yet much of the drawing is so accurate that it could serve as an example in one of today's medical textbooks.

So frequently has Leonardo's world-famous portrait *Mona Lisa* (**fig. 17.7**) been reproduced that it has become a cliché and the source of innumerable spoofs. Despite this overexposure, it still merits our attention as an expression of Renaissance ideas. We can still be intrigued by the mysterious

The High Renaissance

Between about 1490 and 1530—the period known as the High Renaissance—Italian art reached a peak of accomplishment in the cities of Florence, Rome, and Venice. The three artists who epitomized the period were Leonardo da Vinci, Michelangelo Buonarroti, and Raffaello Sanzio (Raphael). They developed a style of art that was calm, balanced, and idealized, combining Christian theology with Greek philosophy and the science of the day.

Leonardo was motivated by strong curiosity and belief in the human ability to understand the fascinating phenomena of the physical world. He believed that art and science are two means to the same end: knowledge.

Leonardo showed his investigative and creative mind in his journals, where he documented his research in notes and drawings (see also fig. 6.2). His notebooks are filled with studies of anatomy and ideas for mechanical devices, explorations that put him at the forefront of the scientific development of

17.7 Leonardo da Vinci. *Mona Lisa.* c.1503–1506. Oil on wood. 30¼″ × 21″.

Musée du Louvre, Paris, France. RMN/Michel Urtado.

View the Closer Look for the *Mona Lisa* on myartslab.com

mood evoked by the faint smile and the strange, otherworldly landscape. The ambiguity is heightened by the hazy light quality that gives a sense of atmosphere around the figure. This soft blurring of the edges—in Leonardo's words, "without lines or borders in the manner of smoke"[1]—achieved through subtle value gradations, is a special type of chiaroscuro invented by Leonardo. Most important for the history of art, this work is a portrait of an individual, a type of art fairly common in ancient Rome and almost unknown in the medieval period.

Humanism influenced the belief that an individual could be worthy of a portrait.

The impact of Renaissance humanism becomes apparent when we compare *The Last Supper* by Leonardo (**fig. 17.8**) with the Byzantine mosaic *Christ as Pantocrator* (see fig. 16.18). In the Byzantine work, Christ is portrayed as a lofty being of infinite power, the King of Heaven. In Leonardo's painting, Jesus sits across the table from us—an accessible person who reveals his divinity in an earthly setting, among disciples who look like us.

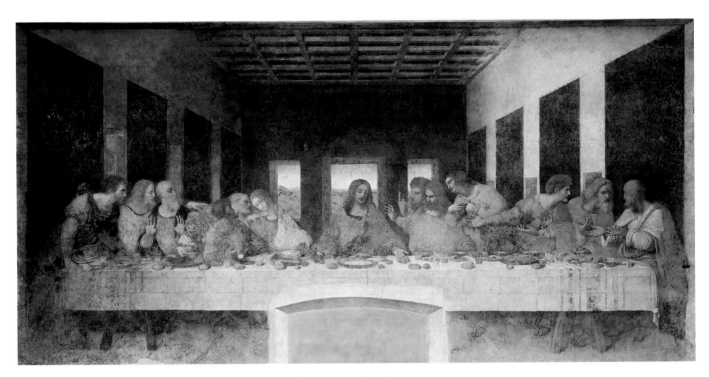

17.8 Leonardo da Vinci. *The Last Supper.* Santa Maria delle Grazie, Milan, Italy. c.1495–1498. Experimental paint on plaster. 14′5″ × 28′¼″.
© Studio Fotografico Quattrone, Florence.

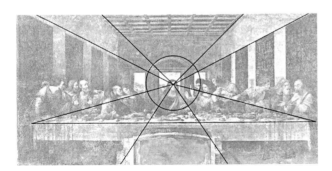

a. Perspective lines as both organizing structure and symbol of content.

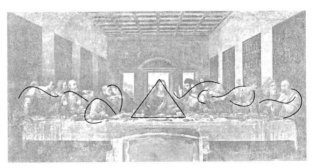

b. Christ's figure as stable triangle, contrasting with active turmoil of the disciples.

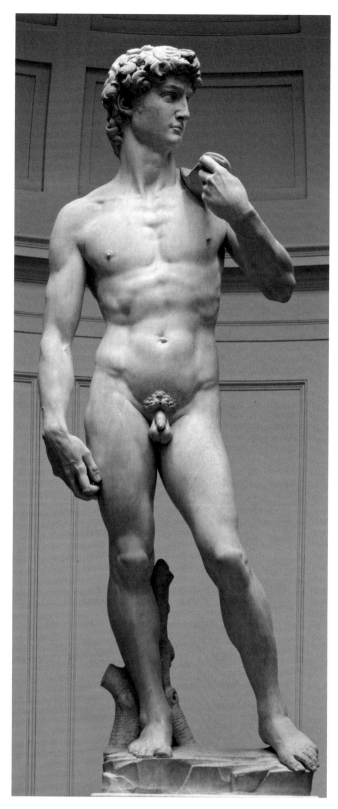

17.9 Michelangelo Buonarroti. *David*. 1501–1504. Marble. Height of figure 14′3″.

Accademia, Florence. Photograph © Studio Fotografico Quattrone, Florence.

Watch a podcast comparing the statues of *David* by Michelangelo and Bernini on myartslab.com

The naturalist style of the work contains a hidden geometry, which structures the design and strengthens the painting's symbolic content. The interior is based on a one-point linear perspective system, with a single vanishing point in the middle of the composition, behind the head of Christ. Leonardo placed Christ in the center, at the point of greatest implied depth, associating him with infinity. Over Christ's head an architectural **pediment** suggests a halo, further setting him off from the irregular shapes and movements of the surprised disciples on either side. In contrast to the anguished figures surrounding him, Christ is shown with his arms outstretched in a gesture of acceptance, his image a stable triangle.

Like *The Last Supper*, Michelangelo's *David* (**fig. 17.9**) is an important work that expresses many Renaissance ideas. The biblical hero David was an important symbol of freedom from tyranny for Florence, which had just become a republic. Other Renaissance artists such as Donatello had already given the city images of the young David, but Michelangelo's figure gave the most powerful expression to the idea of David as hero, the defender of a just cause.

Michelangelo took *David*'s stance, with the weight of the body on one foot, from the contrapposto of Greek sculpture. But the positions of the hands and tense frown indicate anxiety and readiness for conflict. Through changes in proportion and the depiction of inner feeling, Michelangelo humanized, then made monumental, the classical Greek athlete.

Michelangelo worked for three years on this sculpture. When it was finished and placed in the town square, most citizens of Florence greeted it with approval. With this achievement, Michelangelo became known as the greatest sculptor since the Greeks.

When Pope Julius II decided to redecorate the ceiling of his private prayer chapel, he begged, cajoled, and eventually ordered the unwilling sculptor to take on the painting commission. Michelangelo began work on the Sistine Chapel ceiling (**fig. 17.10a**) in 1508 and finished it four years later. The surface is divided into three zones. In the highest are nine panels of scenes of the creation of the world from Genesis, including *The Creation of Adam*. The next level contains prophets and sibyls (female prophets). The lowest level consists of groups of Old Testament figures, some of them Christ's biblical ancestors. *The Last Judgment*, painted later, fills the end wall above the altar.

The most-admired composition on the ceiling is the majestic *Creation of Adam* (**fig. 17.10b**), in which God reaches out to give life to the first man. Eve, not yet mortal, stares at Adam from behind God's left arm.

The work powerfully expresses the Renaissance humanist concept of God: an idealized, rational man who actively tends every aspect of creation, and has a special interest in humans. Michelangelo invented this powerful image, which does not exist in the Bible, to tell the story of the relationship between God and people from a Renaissance point of view.

Raphael was the third major artist of the High Renaissance. His warmth and gentleness were in sharp contrast to Leonardo's solitary, intellectual nature and Michelangelo's formidable moodiness. Of these three major creators, Raphael's work most frequently embodied the clarity and balance that marked the art of the period. His paintings present his awareness of the divine in human beings, the insight that was the driving enthusiasm of the Italian Renaissance.

In *The School of Athens* (see fig. 3.22), we see one of the clearest summations of Renaissance beliefs. Raphael organized the complex composition into symmetrical sub-groups, all revolving around the central figures of Plato and Aristotle under the arch. Perspective lines help to frame our focus on them. Most of the figure poses in this work are based in

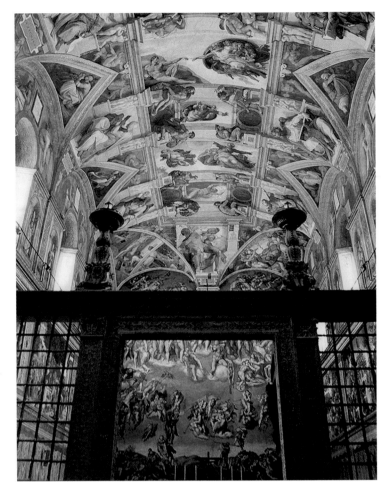

17.10 Michelangelo Buonarroti. Frescoes on the ceiling of the Sistine Chapel. Vatican, Rome. 1508–1512.
a. The Sistine Chapel.
Vatican Museums, Rome, Italy. © Reuters/Corbis.

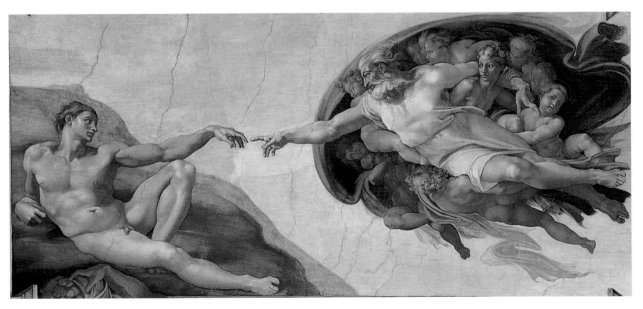

b. *The Creation of Adam.*
Vatican Museums, Rome, Italy.

classical antiquity. More important, *The School of Athens* elevates human reason by presenting a philosophical discussion among learned people as an ideal. The Pope commissioned this work for the wall of a meeting room, so that persons discussing Church business could be inspired by an ideal meeting of great people from the past. Rarely has humanism been so clearly expressed.

For Pope Leo X (a Medici descendant), Raphael made a series of cartoons for tapestries that would decorate the walls of the Sistine Chapel, below Michelangelo's ceiling. The tapestries have faded, but the cartoons retain most of the original vivid colors (**fig. 17.11**). Leo wished to glorify the early Church by commissioning illustrations of important events in the Acts of the Apostles, and Raphael responded by creating memorable and dramatic works. *Paul Preaching at Athens* is a diverse yet well-organized composition, as Paul preaches to the philosophically inclined Athenians. Among the audience is Pope Leo, just to the left of Paul. The message of this work, that reason can transmit religious truth, perfectly expresses Renaissance beliefs.

The Renaissance in Northern Europe

As the Early Renaissance was unfolding in Italy, a parallel new interest in realism arose in northern Europe, where artists were even more concerned than the Italians with depicting life in the real world. Jan van Eyck was a leading painter in Flanders, the region of present-day Belgium and adjacent parts of France and the Netherlands. He was one of the first to use oil as a painting medium (see also fig. 7.11). The fine consistency and flexibility of the new oil medium made possible a brilliance and transparency of color that were previously unattainable. His oil paintings remain in almost perfect condition, attesting to his skill and knowledge of materials. Later Italian artists admired and imitated the innovations of van Eyck and other Flemish artists.

On the same type of small wooden panels previously used for tempera painting, van Eyck painted in minute detail, achieving an illusion of depth, directional light, mass, rich implied textures, and the physical likenesses of particular people. Human figures and their interior settings took on a new, believable presence.

17.11 Raphael.
Paul Preaching at Athens.
1515–1516. Watercolor on paper mounted on canvas.
11′5½″ × 14′6¾″.
Victoria and Albert Museum, London
© V&A Images/The Royal Collection, on loan from HM The Queen.

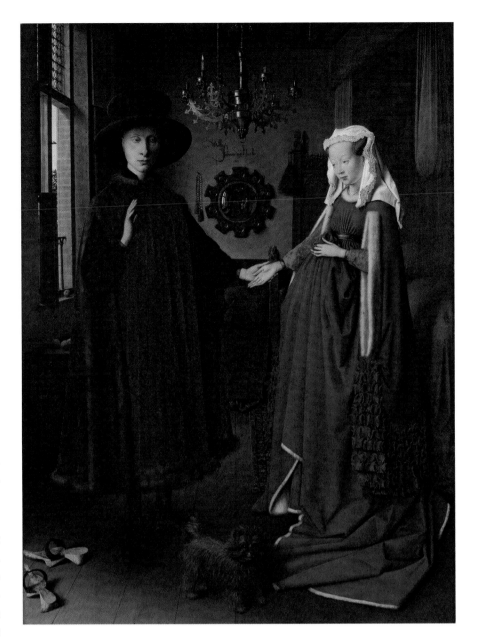

17.12 Jan van Eyck. *The Arnolfini Portrait.* 1434. Oil on panel. 33½" × 23½".
© 2013. Copyright The National Gallery, London/ Scala, Florence.

View the Closer Look for *The Arnolfini Portrait* on myartslab.com

His most famous work, *The Arnolfini Portrait* (**fig. 17.12**), is also among the most puzzling. It likely commemorates a wedding or a betrothal, though because the identity of the people is in question, we may never know. Many of the ordinary objects portrayed with great care have sacred significance. The single lighted candle in the chandelier symbolizes the presence of Christ; the amber beads and the sunlight shining through them are symbols of purity; the dog indicates marital fidelity. The bride's holding up her skirt suggestively in front of her stomach may indicate her willingness to bear children. Green, a symbol of fertility, was often worn at weddings. As witness to the event, Jan van Eyck placed his signature and the date, 1434, directly above the mirror—and he himself appears reflected in the mirror (see fig. 3.54). What makes this a Renaissance work is the fact that it seems to take place in the next room, the figures and the space are so accurately captured. The concept of a painting as a window into a world similar to ours originated with works such as this.

In the early sixteenth century in Germany, Albrecht Dürer further developed the practice of combining instructive symbolism with detailed realism. His engraving *The Knight, Death, and the Devil* (see fig. 8.10) combines Christian symbols with familiar subjects in the Flemish tradition of van Eyck.

A major factor that conditioned art production in northern Europe was the Protestant Reformation, which began in approximately 1521 when Pope Leo X excommunicated the rebellious monk Martin Luther from the Roman Catholic Church. Clergy allied with the burgeoning Protestant movement discouraged elaborate church interiors, and this led to a sharp drop in commissions for altarpieces and religious decorations. Therefore, a great deal of Renaissance art in the North was destined for private possession in homes.

Pieter Bruegel developed a new artistic vision of the northern European landscape. As a young man, he traveled extensively in France and Italy. Under the influence of Italian Renaissance painting, Bruegel developed a broad sense of composition and spatial depth. The focus of Bruegel's paintings was the lives and surroundings of common people. Such works that depict everyday life are still beloved today and are called **genre paintings**.

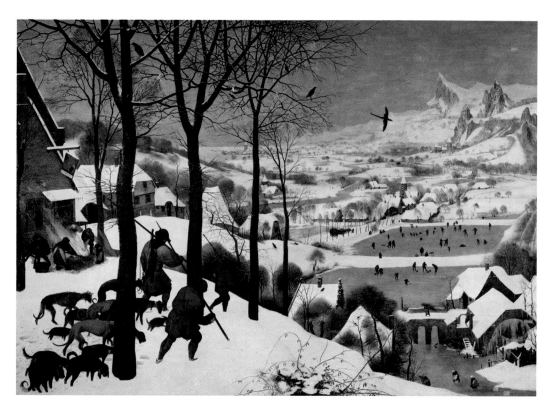

17.13 Pieter Bruegel. *Hunters in the Snow.* 1565. Oil on panel. 46½" × 63¾". Kunsthistorisches Museum, Vienna, Austria. akg images/ Erich Lessing.

Toward the end of his life, Bruegel did a series of paintings representing the activities of the 12 months of the year. The work corresponding to January, *Hunters in the Snow* (**fig. 17.13**), is among the most highly regarded. Following the precedent set by manuscript painters (illuminators) of medieval calendars, who depicted each month according to the agricultural labor appropriate to it, Bruegel shows peasants augmenting their winter diet by hunting. New here is the emphasis on nature's winter mood rather than on human activity. The heavy steps of the hunters are extended in the row of trees and the frozen ponds in the distance. The illusion of deep space, so important to this image, came from the innovations of the Italians and was also inspired by Bruegel's journey over the Alps.

Late Renaissance in Italy

During the later sixteenth century, architects made a deliberate effort to rethink and extend classical rules even as they used classical forms. The most learned and influential architect was the Venetian Andrea Palladio. His famous Villa Rotonda (**fig. 17.14**) is a free reinterpretation of the Roman Pantheon (see fig. 16.10). It has four identical sides, complete with porches resembling ancient temple façades, built around a central domed hall. The villa's design hardly satisfies the architectural goal of livability, but it was not intended for family living; it was designed for a retired nobleman as a kind of open summer house for social occasions. From its hilltop site, visitors standing in the central rotunda could enjoy four different views of the countryside.

Palladio's designs were published in books that were widely circulated throughout the Western world. For the next two centuries, architects and builders from Russia to Pennsylvania often used motifs that he developed, and his designs have even reappeared on **postmodern** buildings in our generation.

Palladio's Venice became the scene of the last great flowering of Renaissance art. Using the newly developed oil paints on canvas supports, Venetian painters experimented with figure poses, compositions, and subjects. Responding to a clientele made wealthy from trading across the Mediterranean world, Venetian painting was rich and lavish, less idealized than the work of central Italian artists such as Raphael and Michelangelo.

We see an example of Venetian opulence in one of its most celebrated paintings, *Feast in the House of Levi* (**fig. 17.15**) by Paolo Veronese. This large work depicts a sumptuous banquet described in the New Testament that Jesus attended (we see him seated at the center).

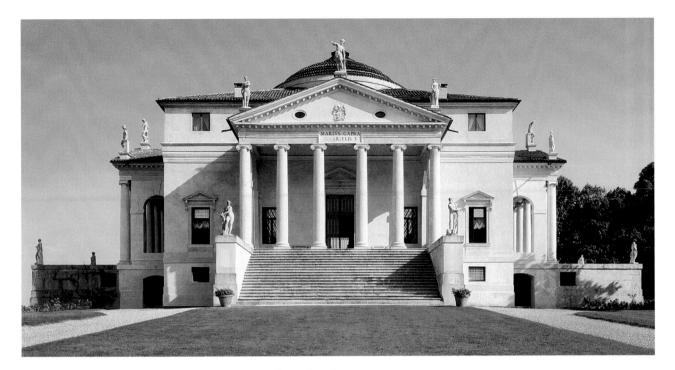

17.14 Andrea Palladio. Villa Rotonda. Vicenza, Italy. 1567–1570.
Cameraphoto/AKG Images.

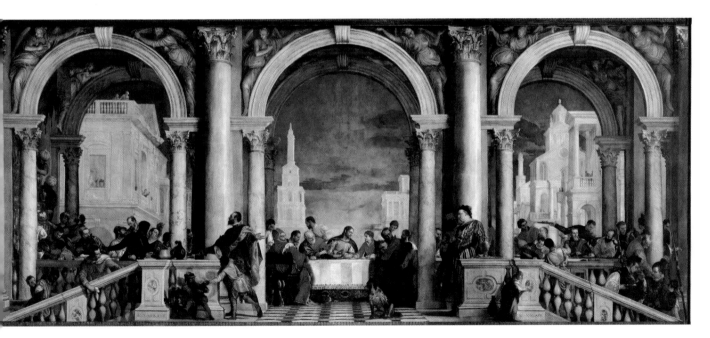

17.15 Paolo Veronese. *Feast in the House of Levi.* 1573. Oil on canvas. 18′4″ × 16′7″.
Accademia Gallery, Venice/© Cameraphoto Arte, Venice.

The artist set the scene under a Venetian arcade, using features borrowed from Palladio's buildings. Servants rush about, waiting on persons of various nationalities (including a German in stripes at the right center). Not everyone in the work is sober. The atmosphere is one of elegant yet boisterous wealth.

Today, the work is called *Feast in the House of Levi*, but it was commissioned by the monks of a monastery for their dining hall as a Last Supper. Veronese took such liberties with the traditional subject of Christ's bidding farewell to his disciples (compare to Leonardo's *Last Supper*), that the religious authorities

suspected the artist of impiety or heresy. They called him before the Inquisition, the tribunal where such cases were heard. This led to one of the first important trials of artistic freedom in the Western world.

Why, they asked Veronese, did he include depictions of "buffoons, drunkards, Germans, dwarfs, and similar vulgarities" when none were present at the actual Last Supper? The artist's defense was one that most Western artists have eagerly embraced ever since: The artist should be free to interpret subjects as he wishes. Or, as Veronese said: "I paint pictures as I see fit and as well as my talent permits."[2] The Inquisitors ordered him to alter the painting and bring it more in line with what viewers of a Last Supper could expect. But instead of changing the work, the artist merely retitled it to reflect the lively party in the house of Levi. The controversy had no discernible impact on Veronese's reputation in otherwise liberal-minded Venice.

Baroque

During the Baroque period, which ran from about 1600 to about 1750, artists used Renaissance techniques to move art in the direction of drama, emotion, and splendor. The Baroque period had more varied styles than the Renaissance, yet much of the art shows great energy and feeling, and a dramatic use of light, scale, and composition. Baroque artists set aside the balanced harmony achieved by Renaissance artists such as Raphael in his *School of Athens* and Michelangelo in his *David*, as they explored more innovative uses of space and more intense ranges of light and shadow. Their art, with its frequent use of curves and counter-curves, often appeals to the emotions first. Also, we can see a new degree of vivid realism in compositions using sharp diagonals and extreme **foreshortening**.

Many of the characteristics of the Baroque style were spawned and promoted by the Counter-Reformation, the Roman Catholic Church's response to the Protestant Reformation. In a series of decrees that emanated from the Council of Trent, the Church reaffirmed the mysteries of the sacraments, glorified the saints, and encouraged the arts as aids to prayer. Much Baroque religious art places a new emphasis on personal and mystical types of faith.

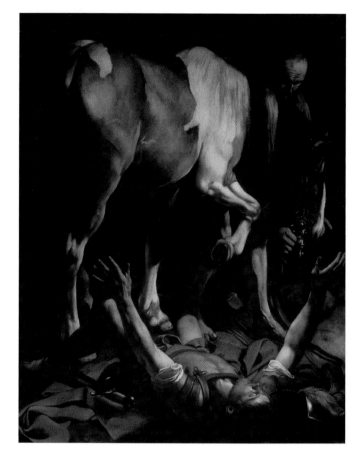

17.16 Michelangelo Merisi da Caravaggio. *The Conversion of Saint Paul.* 1600–1601. Oil on canvas. 100½″ × 69″.
Santa Maria del Popolo, Rome, Italy. © Vincenzo Pirozzi, Rome.

Michelangelo Merisi da Caravaggio's down-to-earth realism and dramatic use of light broke from Renaissance idealism and became the leading influences on other Baroque painters, north and south. Caravaggio created the most vivid and dramatic paintings of his time, using directed light and strong contrasts to guide the attention of the viewer and intensify the subject matter.

In *The Conversion of Saint Paul* (**fig. 17.16**), Caravaggio used light to imply a blinding flash, symbolizing the evangelist's sudden and soul-shattering conversion. The figure of Paul, in Roman dress, is foreshortened and pushed into the foreground, presenting such a close view that we feel we are right there. In keeping with the supernatural character of the spiritual events he portrayed, Caravaggio evoked a feeling for the mystical dimension within the ordinary world. Here we see a Baroque figure far removed from Raphael's logical, reasonable Paul who preached at Athens. Some of the Roman clergy rejected his style; his emotional realism was too strong for people

accustomed to idealized aristocratic images that demonstrated little more than gestures of piety.

Emotional realism and use of extreme chiaroscuro, especially in Caravaggio's night effects, influenced later Baroque painters. Displayed in a dark chapel, Caravaggio's paintings take on a vivid, lifelike quality intended to heighten the religious experience.

We see an example of Caravaggio's influence in the work of Artemisia Gentileschi, who turned the style toward depiction of female religious heroes. *Judith and the Maidservant with the Head of Holofernes* (**fig. 17.17**) is a scene from the Old Testament story of Judith, who helped to liberate the Jews from foreign domination by visiting the Assyrian general Holofernes in his tent, getting him drunk, and then beheading him. This work shows Judith and her servant cleaning up the scene as they wrap their victim's severed head in a towel. According to the story, they then carried the head back to their people and displayed it as a symbol of resistance. The dramatic lighting, off-balance composition, and sweeping curves in

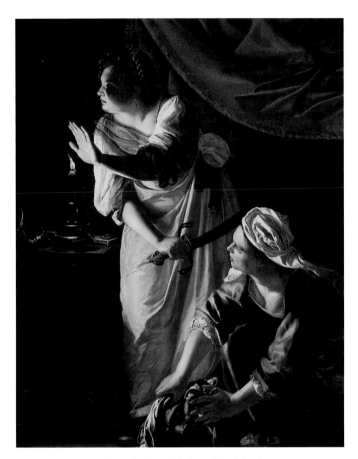

17.17 Artemisia Gentileschi. *Judith and the Maidservant with the Head of Holofernes.* c.1625. Oil on canvas. 6′½″ × 4′7¾″.
Detroit Institute of Art Gift of Mrs. Leslie H. Green.
Photogrpah © The Detroit Institute of Arts/The Bridgeman Art Library.

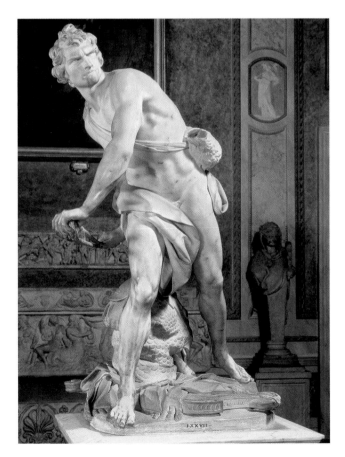

bodies and draperies mark this as a particularly dramatic, even lurid, example of the Baroque style. The artist portrayed Judith with many of her own features, showing that she identified with the heroine.

Gianlorenzo Bernini was as influential in sculpture as Caravaggio was in painting. Because Bernini's *David* (**fig. 17.18**) is life-size rather than monumental, viewers become engaged in the action. Rather than capture an introspective moment, as Michelangelo did, Bernini depicted David in the midst of his backswing, as he prepares to fling the stone at Goliath. *David*'s splayed limbs, twisting torso, and intent face underline the drama of the struggle.

Bernini's elaborate orchestrations of the visual arts are the climax of Italian Baroque expression. The emotional intensity of his art is vividly apparent in his major

17.18 Gianlorenzo Bernini. *David.* 1623. Marble. Life-size.
Galleria Borghese, Rome. Photograph: Scala.

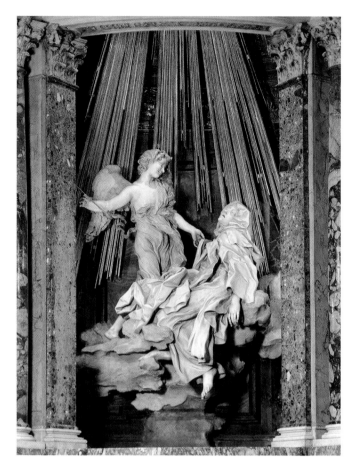

17.19 Gianlorenzo Bernini. *The Ecstasy of Saint Teresa.*
1645–1652. Detail of the altar. Marble. Life-size.
Cornaro Chapel, Santa Maria della Vittoria, Rome, Italy.
Photograph: © Canali Photobank.

work *The Ecstasy of Saint Teresa* (**fig. 17.19**). It features a life-size marble figure of the saint and depicts one of her visions as she recorded it in her diary. In this vision, she saw an angel who seemed to pierce her heart with a flaming arrow of gold, giving her great pain as well as pleasure and leaving her "all on fire with a great love of God,"[3] as she wrote in her autobiography. Bernini made the visionary experience vivid by portraying the moment of greatest feeling, revealing spiritual passion through physical expression. A skylight above provides dramatic lighting for the sculpture, and turbulent drapery heightens the emotional impact. Bernini's departure from the balanced, classical norm soon influenced artists throughout Europe.

Flemish painter Peter Paul Rubens, a renowned diplomat and humanist, was the most influential Baroque artist in northern Europe. He studied painting in Antwerp, then traveled to Italy in 1600. During a stay of several years, he carefully studied the work of Michelangelo and the Venetians. When Rubens returned north, he won increasing acclaim and patronage; being a sophisticated businessman, he enjoyed an aristocratic lifestyle. His work came to be in such demand by the nobility and royalty of Europe that he established a large studio with many assistants. Although Rubens was noted for the exuberant quality of his nudes, there was a tendency for everything in his paintings to take on a similar sensuality. His free brushwork influenced many painters.

In *The Raising of the Cross* (**fig. 17.20**), we see his interpretation of a religious subject, painted for an important Roman Catholic cathedral in his homeland. The composition is arranged along a diagonal anchored at the bottom right by the well-muscled figure. This and other taut bodies in the work show the

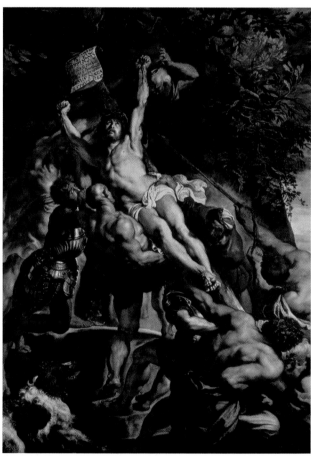

17.20 Peter Paul Rubens. *The Raising of the Cross.*
1610–1611. Oil on panel. One part of a
three-part work. 15′2″ × 11′2″.
Onze Lieve Vrouwkerk, Antwerp Cathedral, Belgium.
Photograph: Peter Willi/Bridgeman Art Library.

results of the artist's recent visit to Italy, where he saw works by Michelangelo and Caravaggio. At the same time, there is a high degree of realistic detail in the foliage and the dog at the bottom left that show Rubens's Flemish heritage from Jan van Eyck and others. The action and drama in the work seem to burst out of the frame, led by the upward glance of Christ. This visual dynamism, extending the action of the work into the viewer's space, marks this work as a Baroque painting.

Many artists worked on behalf of the Church during the Baroque period; some worked in the service of the nobility. The most innovative of these was the Spaniard Diego Velázquez, who spent most of his career in the court of Philip IV, King of Spain. Philip was a broad-minded monarch who took delight in his chief painter's sometimes adventurous works. Such a painting is *The Maids of Honor* (**fig. 17.21**), in which Velázquez plays an elaborate game. At first it is unclear who the subject is, because the artist himself stares out from behind a canvas, brush in hand. The maids of honor surround the king's daughter, who stares coquettishly at us, as if expecting something. She seems to be the center of the composition, as she stands in the brightest light. Another courtier stands in an illuminated doorway in the background. Only when we see the mirror on the far wall, with the faces of the royal couple reflected in it, do we realize that this is a court portrait changed into a visual riddle. Velázquez painted a portrait of himself making a royal portrait! Like other Baroque works, this painting reaches out beyond its frame in a subtle dynamism of glance and image in which light and shadow play a major role.

We have seen that Baroque characteristics are found in art that depicts both religious and secular subjects. This was primarily because artists no longer relied wholly on the Church for their support; many worked for nobles and aristocrats. In the Dutch Republic, however, a new type of art patron emerged in the seventeenth century as a result of recently won independence and booming international trade—wealthy middle-class merchants and bankers, most of them Protestants. These new patrons enjoyed and invested in contemporary art. Favored subjects were the same ones preferred to this day: landscape, still life, genre scenes, and portraits. Through Dutch painters, art became accessible and understandable in everyday terms.

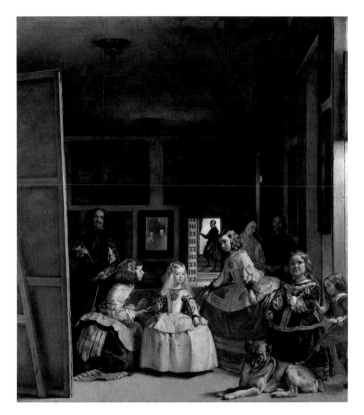

17.21 Diego Velázquez. *Las Meninas (The Maids of Honor)*. 1665. Oil on canvas. 10′5″ × 9′.
Museo del Prado, Madrid, Spain. Photograph: akg-images/Erich Lessing.

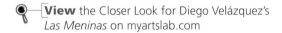

View the Closer Look for Diego Velázquez's *Las Meninas* on myartslab.com

We can see why Rembrandt remains one of the Western world's most revered artists in his large work *Return of the Prodigal Son* (**fig. 17.22**). The story comes from the Bible: A disobedient son cuts himself off from his family, demands his inheritance early, wastes it in disorderly living, and ends up in dire poverty. When he reaches the end of his rope, he returns to his wealthy father and asks for a job feeding the hogs. The father is not scornful or judgmental, rather the opposite. He tenderly welcomes the haggard and forlorn young man. Rembrandt portrays this touching scene with great reserve and economy. We see the prodigal son's ragged clothing, and the father's gentle embrace. We also see standing at the right, hanging back guardedly, the father's other son.

Rembrandt's composition shows the influence of the Italian Baroque painters in its dramatic contrasts of light and dark. The story, however, is not of the miraculous vision of a saint, as in Caravaggio's *Conversion of Saint Paul*, but rather a miraculous restoration of affection between estranged people.

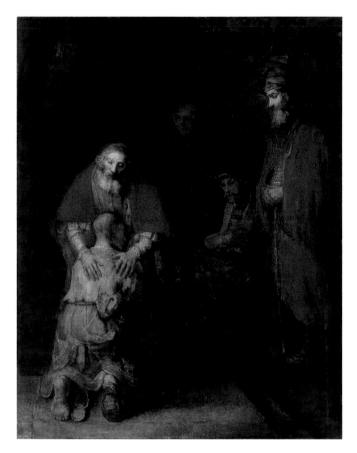

17.22 Rembrandt van Rijn. *Return of the Prodigal Son.*
c.1668–1669. Oil on canvas. 8′8″ × 6′8″.
The State Hermitage Museum, St. Petersburg, Russia.

Rembrandt was also a printmaker of considerable reputation. His many etchings show him putting the Baroque language of light and dark to good use in framing religious subjects, a common theme of his.

Jan Vermeer, another seventeenth-century Dutch painter, created genre paintings that raise daily life to a level of great solemnity. Unlike Caravaggio and Rembrandt, who used light for dramatic emphasis, Vermeer concentrated on the way light reveals each color, texture, and detail of the physical world. He showed immense passion for seeing, and apparent love for the visual qualities of the physical world.

Vermeer's understanding of the way light defines form enabled him to give his images a clear, luminous vitality. Much of the strength of *The Kitchen Maid* (**fig. 17.23**) comes from a limited use of color: yellow and blue accented by red-orange, surrounded by neutral tones. The light has a mystical quality in this work; the act of pouring milk takes on the air of solemn ritual.

Still life painting enjoyed a new vogue during the Baroque period as well. A **still life** is a painting

in which the subject is arranged by the artist on a tabletop, generally beginning with fruits or flowers, and often including other food items and domestic utensils. The term originated in the Netherlands, and Dutch artists were leaders in this field during the sixteenth and seventeenth centuries, as they painted elaborate still lifes celebrating the bounty of nature. Another important center was in Spain, where artists often isolated just a few items in dramatic light.

In the work of Juan van der Hamen we see influences from both schools. In *Still Life with Sweets and Pottery* (**fig. 17.24**), the stark lighting and bare setting are typically Spanish, but the rich bowls of fruit and pastries show northern influence. The artist here captured various textures of baskets, clay pots, and wood boxes along with the edible items. This work is also an interesting exercise in composition, as the artist created a rhythm of circular forms seen from various angles on the plain gray shelves.

During the Baroque period, French artists adopted Italian Renaissance ideas but made them their

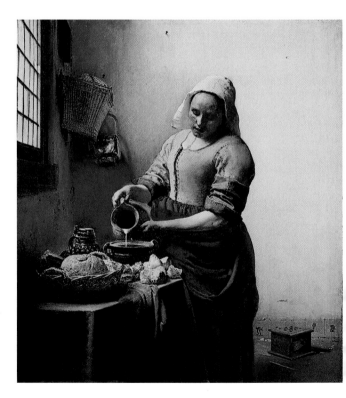

17.23 Jan Vermeer. *The Kitchen Maid.* c.1658.
Oil on canvas. 18″ × 16⅛″.
Rijksmuseum, Amsterdam.

own. We can glimpse a clear view of Baroque aristocratic splendor in the architecture of the French royal palace of Versailles, built for King Louis XIV. The main palace and its gardens exemplify French Baroque architecture and landscape design (see fig. 2.17 for an overview). The Hall of Mirrors (**fig. 17.25**), at the heart of the palace, functioned like a stage set for the king's entrances and exits. The hall appears doubled in width by the nearly solid wall of mirrors opposite the glass windows. Such glassworks were very expensive in that era, making the hall a display of opulence unique in Europe. Almost lost in the reflected splendor is the classical detailing in the pilasters and round arches. The ceiling is covered with paintings that depict the recent exploits of Louis XIV. At Versailles, Louis and his successors created a visual spectacle that supported their belief in the monarchy as the source of all power.

17.24 Juan van der Hamen. *Still Life with Sweets and Pottery.* 1627. Oil on canvas. 33¼" × 44⅜".
National Gallery of Art, Washington D.C. Samuel H. Kress Collection 1961.9.75.

17.25 Jules Hardouin-Mansart. The Hall of Mirrors. Versailles. Begun 1678. Length approx. 240′.
© Corbis.

◉ **Watch** a video about the Palace and Park of Versailles on myartslab.com

Inspiration

Versailles is one of the Western world's clearest examples of persuasive art, in which its patron or creator tries to convince us of something or influence our beliefs (in this case, about absolute monarchy). But while some works of art, like the Hall of Mirrors at Versailles (see fig. 17.25), attempt to persuade us with their splendor and expense, others inspire us through more subtle means. Here we consider three works that attempt, through inspiration, to make the case that progress is a good thing.

Joseph Wright of Derby's *A Philosopher Gives a Lecture on the Orrery* (**fig. 17.26**) is a compelling piece of propaganda for a scientific worldview that was beginning to dawn in the mid-eighteenth century and which would reach greater fruition in the Enlightenment (see Chapter 21). An orrery, named after the English earl that sponsored the first one, is a model of the solar system with the sun at its center amid the orbits of various planets. At the time this work was painted in 1766, scientific lectures and demonstrations were just entering a phase of popularity as public events, and Wright probably attended such lectures. In the painting he used the Baroque conventions of dramatic lighting. A lamp takes the place of the sun, while a red-garbed professor who resembles the English scientist Isaac Newton describes the motion of the planets around it. The reactions of the spectators, which range from contemplative to awestruck, give us a glimpse of this work's intended impact: In the (artificial) glow of the sun/lamp, they experience scientific enlightenment. This work thus inspires us to contemplate the virtues of scientific inquiry and the expansion of knowledge.

The westward expansion of the United States in the nineteenth century is an established part of the national mythology, and the German-born painter Emanuel Leutze helped to put it there, with paintings such as *Westward the Course of Empire Takes Its Way* (**fig. 17.27**). In this work a group of settlers has reached the Continental Divide, and they gaze out at the vast expanse of land with its seemingly endless possibilities before them, as other members of the party hack out the trail immediately ahead. Below is a horizontal panel depicting the Pacific shore, between portraits of explorers Daniel Boone and William Clark.

Leutze wrote of his intent in the work: "To represent as near and truthfully as the artist was able, the grand peaceful conquest of the great west."[4] We know, of course, that the conquest of the west was far from peaceful, and that the family groups seen here generally traveled on paths already established. Still, this work's intent to inspire is clear enough that the United States government commissioned Leutze to paint a larger version in a stairwell of the national Capitol in Washington, D.C. There it exercises its influence, silently but vividly encouraging the belief that the "Manifest Destiny" of the United States is to occupy the land from the Atlantic to the Pacific.

Tall buildings can be inspirational, "proud and soaring things,"[5] as the architect Louis Sullivan wrote. Vladimir Tatlin's *Monument to the Third International* (**fig. 17.28**) is probably the most inspirational building never built. The Third

17.26 Joseph Wright of Derby. *A Philosopher Gives a Lecture on the Orrery.* 1766. Oil on canvas. 58″ × 80″.
Derby Museum and Art Gallery.
akg-images/Erich Lessing.

17.27 Emanuel Leutze.
Westward the Course of Empire Takes its Way.
1860. Mural study. U.S. Capitol. 33¼" × 43⅜".
Smithsonian American Art Museum Washington, D.C. © 2013. Photo Smithsonian American Art Museum/ Art Resource/Scala, Florence.

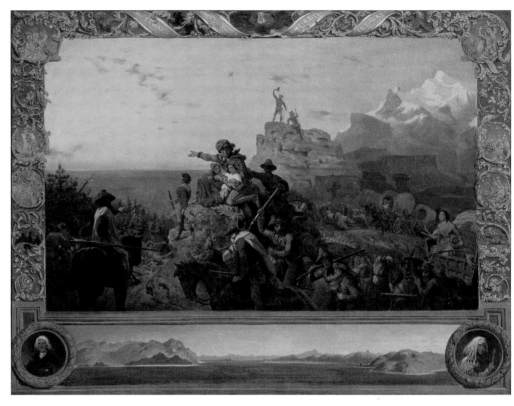

17.28 Vladimir Tatlin.
Model for *Monument to the Third International.*
1919. Photograph.
The Bridgeman Art Library.

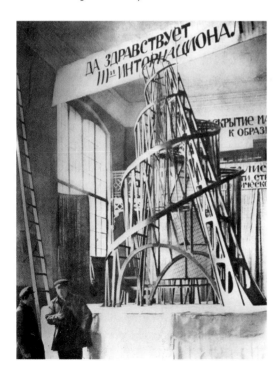

International was a new party founded by revolutionary leader Vladimir Lenin in 1919 to spread Communism around the world. Originally planned for a height of over 1,300 feet, this twisting metal structure was intended to symbolize the technological prowess of the new Communist Russia that was born with the 1917 revolution. The helix-shaped frame houses three glass buildings that were intended for use as a people's assembly hall, offices, and a radio-loudspeaker broadcasting news and inspirational messages. These pavilions were designed to rotate at varying speeds: once a year, once a month, and once a day.

Tatlin conceived the tower to compete with the recently completed Eiffel Tower in Paris, but his tower would be more useful to society, a constant source of encouragement to all who passed by, as well as a functional structure. Its realization at the time, when Russia was still suffering from post-revolutionary shortages and political unrest, was certainly impossible. However, models of the tower were built from time to time for exhibitions and even for carrying in parades. Thus, though the world never saw the full-sized version, models and miniatures inspired the Soviet people at various times.

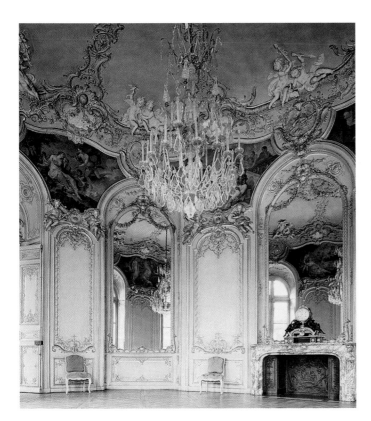

17.29 Germain Boffrand. Salon de la Princesse. Hôtel de Soubise, Paris. Begun 1732.
Hirmer Fotoarchiv, Munich, Germany.

Rococo

In the middle years of the eighteenth century in France, the heavy, theatrical qualities of Italian Baroque art gradually gave way to the decorative Rococo style, a light, playful version of the Baroque. Designers copied the curved shapes of shells for elegantly paneled interiors and furniture, and they influenced the billowing shapes later found in paintings. The arts moved out of the marble halls of palaces such as Versailles and into fashionable town houses (called *hôtels*) such as the Hôtel de Soubise (**fig. 17.29**).

The enthusiastic sensuality of the Rococo style was particularly suited to the extravagant and often frivolous life of the French court and aristocracy. Some of the movement, light, and gesture of the Baroque remained, but now the effect was one of lighthearted abandon rather than dramatic action or quiet repose. Rococo paintings provided romantic visions of life free from hardships, in which courtship, music, and festive picnics filled the days.

We clearly see the aristocratic life of ease and dalliance in Jean-Honoré Fragonard's painting *Happy Accidents of the Swing* (**fig. 17.30**). A well-dressed and idle young woman, attended by a dimly visible bishop, swings in a garden. At the lower left, a youth hides in the bushes and admires her. The story line of the work is provided by her flying shoe, which has come off and will soon land in the young man's lap. Fragonard learned the lessons of the Baroque well, as we can see in the off-balance composition arranged along the diagonal, and the contrasts of light and dark visible in the lush garden. But Baroque drama gives way here to the sensual abandon and light-as-air subject matter of the Rococo at its best.

Or worst. The next generation of French artists and intellectuals would rebel against the social irresponsibility portrayed in this type of art, which they saw as merely fluffy. The Enlightenment was already breaking out across Western Europe, and its new ideas of social equality and scientific inquiry would soon shake European culture to its core.

✓—**Study** and review on myartslab.com

THINK BACK

1. What technical advances in art helped make the Renaissance possible?

2. How do northern Renaissance paintings differ from their Italian counterparts?

3. Who were the three major client groups that commissioned Baroque art?

TRY THIS

Compare the Renaissance *David* by Michelangelo (fig. 17.9) with the Baroque *David* by Bernini (fig. 17.18). In your opinion, which is the better work of art, and why?

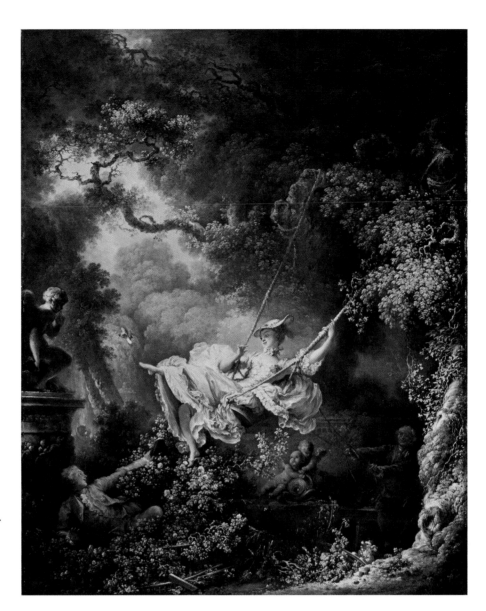

17.30 Jean-Honoré Fragonard. *Happy Accidents of the Swing.* 1767. Oil on canvas. 31⅞″ × 25¼″.
The Wallace Collection, London.
The Bridgeman Art Library.

KEY TERMS

Baroque – the seventeenth-century period in Europe characterized in the visual arts by dramatic light and shade, turbulent composition, and pronounced emotional expression

genre painting – a type of art that takes as its subject everyday life, rather than civic leaders, religious figures, or mythological heroes

humanism – a cultural and intellectual movement during the Renaissance, following the rediscovery of the art and literature of ancient Greece and Rome

Renaissance – the period in Europe from the late fourteenth through the sixteenth centuries, characterized by a renewed interest in human-centered classical art, literature, and learning

Rococo – a style used in interior decoration and painting in France and southern Germany in the eighteenth century, characterized by small-scale and ornate decoration, pastel colors, and asymmetrical arrangement of curves

still life – a painting of inanimate objects, such as flowers, fruit, other food items, and domestic utensils

18 TRADITIONAL ARTS OF ASIA

THINK AHEAD

18.1 Describe the historical origins and philosophical beliefs of Hinduism, Buddhism, Daoism, Confucianism, and Shinto.

18.2 Explain religious iconography common in Asian art.

18.3 Discuss the influence of Buddhism and Hinduism on local traditions of Chinese and Japanese art and architecture.

18.4 Compare techniques, themes, and visual characteristics found in Chinese and Japanese art.

18.5 Recognize how art emphasizes beauty and sensory appeal.

The human presence in Asia dates back to the Paleolithic period. Asia experienced a development of ancient cultures similar to that of Europe and Africa, from hunting and gathering to agricultural village societies, to Bronze Age kingdoms. (For examples of ancient Asian art, see Chapter 15.) Culturally as well as geographically, India is at the core of the continent. Many ideas that later permeated Asian societies originated in India and radiated outward. However, because each region of Asia also had its own local culture, outright borrowing was rare. Rather, we can trace the passage of ideas and art styles across the continent as they were adapted and modified in various locations.

India

Excavations at the sites of the ancient city of Harappa have revealed the remains of a well-organized society with advanced city planning and a high level of artistic production. The city was the focal point for a civilization that extended for a thousand miles along the fertile Indus Valley between three thousand and five thousand years ago. (Most of this valley, where Indian culture

((•— **Listen** to the chapter audio on myartslab.com

began, became part of Pakistan after Indian independence in 1947.)

Ancient Indus Valley sculpture already shows the particularly sensual naturalism that characterizes much of later Indian art. This quality enlivens the small, masterfully carved male torso from Harappa (**fig. 18.1**). Comparing this figure with the classical Greek *Spear Bearer* (see fig. 16.3) is highly instructive. The male torso seems fleshy; the underlying bone structure difficult to see. *Spear Bearer,* in contrast, seems to have flesh integrated with a skeleton.

Very few works of art survive from the period between 1800 BCE, when the Indus Valley Civilization declined, and 300 BCE, when the first Buddhist art appeared. Nevertheless, the years in that interval were important ones for the development of Indian thought and culture.

Starting at around 1500 BCE, the Indian subcontinent was infiltrated by migrating Aryan tribes from the northwest. The Aryans' beliefs, gods, and social structure influenced the subsequent development of Indian civilization. Key Aryan beliefs that influenced later Indian thought include the idea that the universe evolves in repeated cycles of creation and destruction; that individuals are reincarnated after death; and

18.1 Male Torso. Harappa, Indus Valley. c.2400–2000 BCE. Limestone. Height 3½″.
National Museum of India, New Delhi, India/The Bridgeman Art Library.

that there is one supreme form of wisdom. These beliefs were spelled out in the Vedas (hymns) and Upanishads (philosophical works), texts still regarded as sacred by many Indians. What came into being as Indian art is a synthesis of indigenous Indian art forms and the religious ideas of the Aryans.

Hindus accepted the Vedas as scripture. In the sixth century BCE, two influential spiritual leaders preached variations on Hindu beliefs. They were Siddhartha Gautama (563–483 BCE), founder of Buddhism, and Mahavira (599–527 BCE), founder of Jainism. Although most Indians today are Hindus, Buddhism dominated the formative years of the development of Indian art, and it became a major cultural factor elsewhere in Asia.

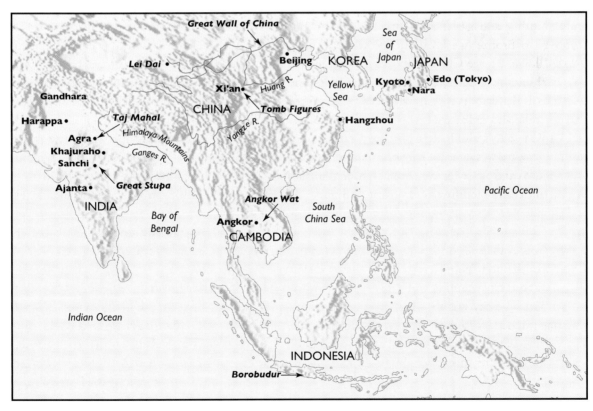

18.2 Historical Map of Asia.

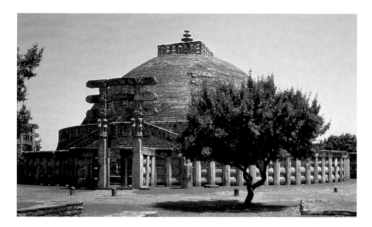

18.3 a. The Great Stupa. Sanchi, India. 10 BCE–15 CE.
Photograph: Prithwish Neogy. Courtesy of Duane Preble.

View the Closer Look for the Great Stupa at Sanchi on myartslab.com

Buddhist Art

The Buddhist religion began when Siddhartha Gautama achieved enlightenment. Seeking an answer to the question of human suffering, he arrived at what Buddhists call the Four Noble Truths: (1) Existence is full of suffering. (2) The cause of suffering is desire. (3) To eliminate suffering, one must eliminate desire. (4) To eliminate desire, one must follow the moral code of the Eightfold Path, which regulates speech, thought, and action. He also taught that if one achieves enlightenment, the endless cycle of death and rebirth will be broken, and the believer will experience a final rebirth (Nirvana) in a pure spiritual realm. Siddhartha began to attract followers in the late sixth century BCE; they called him the "Enlightened One," or the Buddha.

Early Buddhism did not allow the production of images. Eventually, however, religious practice needed visual icons as support for contemplation, and images began to appear. The many styles of Buddhist art and architecture vary according to the cultures that produced them. As Buddhism spread from India to

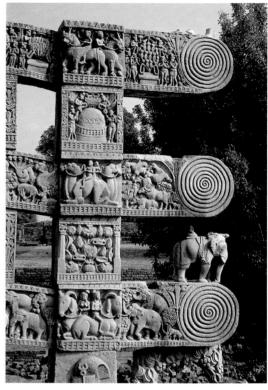

b. Eastern gate of The Great Stupa.
© Adrian Mayer Edifice/CORBIS.

Southeast Asia and across central Asia to China, Korea, and Japan, it interacted fruitfully with native religious and aesthetic traditions.

An excellent example of early Indian Buddhist art is the domelike structure called the **stupa**, which evolved from earlier burial mounds. At the Great Stupa at Sanchi (**fig. 18.3a–b**), four gates are oriented to the four cardinal directions. The devout walk around the stupa in a ritual path, symbolically taking the Path of Life around the World Mountain. Such stupas were erected at sacred locations, and relics (items belonging to a holy person) were usually buried in their core.

d. Japanese pagoda. 7th century CE.

c. Chinese pagoda. 5th to 7th centuries CE.

b. Later Indian stupa. 2nd century CE.

18.4 Evolution of Buddhist Architecture.

a. Early Indian stupa.
 3rd century to early
 1st century BCE.

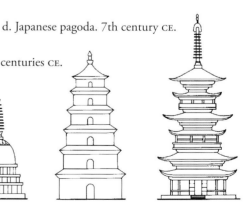

The four gateways to the Great Stupa include layers of sculpture in relief. These tell the story of the Buddha's life, but without depicting him directly. The characteristic sensuousness that we observed in the male torso from Harappa still enlivens these early monuments.

We can trace the evolution of Buddhist architecture (**fig. 18.4**) from its origin in India to its later manifestations in other parts of Asia. Buddhist pagodas developed from a merging of the Indian stupa and the traditional Chinese watchtower. The resulting stepped tower structure was in turn adopted and changed by the Japanese.

Alexander the Great's conquest of large parts of West Asia in the fourth century BCE caused one of the world's great artistic fusions. This region of today's Afghanistan and Pakistan, then called Gandhara, continued its contacts with the West during the peak years of the Roman Empire. Buddhist sculptors in Gandhara developed a distinctive style that owes about equal amounts to East and West; the Bodhisattva from Gandhara (**fig. 18.5**) is an excellent example. Here the sculptor shows a knowledge of the realism of Roman portraiture, as well as the classical Greek method of revealing a subject's body beneath the folds of the drapery in the legs. The subject, however, is Buddhist. A **bodhisattva** is a person who is on the point of achieving enlightenment, but delays it in order to remain on earth and teach others. Bodhisattvas are usually depicted wearing rich garments and jewels.

The Indian Gupta dynasty (c.320–540) is notable for major developments in politics, law, mathematics, and the arts. In the visual arts, the Gupta style combines native Indian ways of seeing with the naturalism of the Gandhara. Although slightly damaged, the carved stone Standing Buddha (**fig. 18.6**) is a fine example of Gupta sculpture. In its cool, idealized perfection, the refined Gupta style marks a period of high achievement in Indian art. The simplified mass of the figure seems to push out from within as though the body were inflated with breath. The rounded form is enhanced by curves repeated rhythmically down the figure. The drapery seems wet as it clings to and accentuates the softness of the body.

The Standing Buddha shows several conventions in representing the Buddha that remained in force for

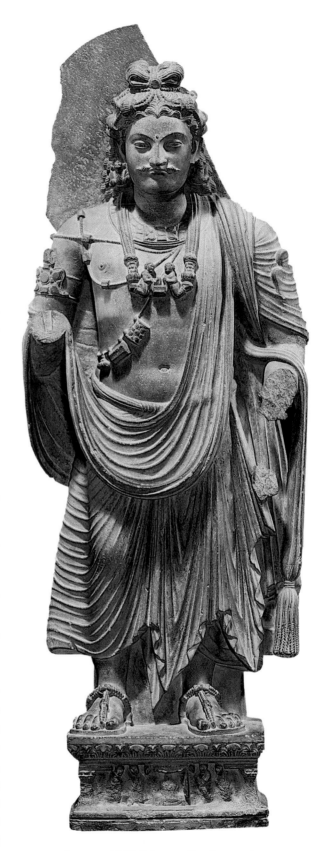

18.5 Bodhisattva. N.W. Pakistan, Gandhara region. Late 2nd century CE. Kushana period. Gray schist. 43⅛″ × 15″ × 9″.
Courtesy of Boston Museum of Fine Arts, Boston. Helen and Alice Colburn Fund.37.99. Photograph © 2013 Museum of Fine Arts, Boston.

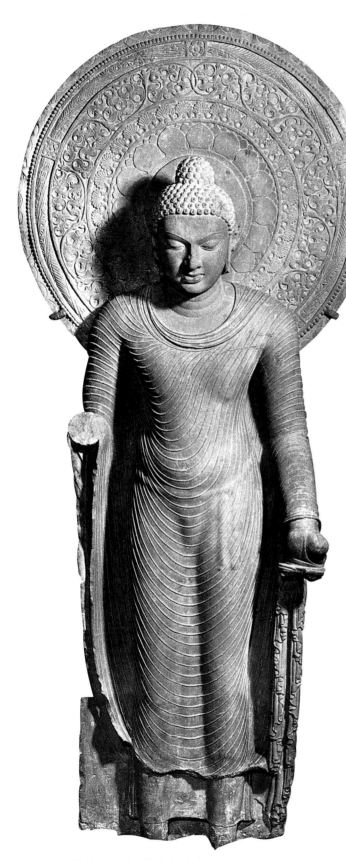

centuries. He wears the simple garment of a monk. His earlobes are long, referring to his earlier life as a wealthy prince who wore expensive earrings. The topknot on his head symbolizes his enlightenment. He is also shown in meditation; this latter characteristic contrasts vividly with Western depictions of God and Christ as active beings.

We can see similar elegance and linear refinement in the noble figure known as the "Beautiful Bodhisattva" Padmapani (**fig. 18.7**), part of a series of elaborate paintings in the Ajanta Caves in central India. The fine linear definition of the figure accents full, rounded shapes, exemplifying the relaxed opulence of the Gupta style. When Buddhism began to spread to China and Southeast Asia, this was the style that came with it.

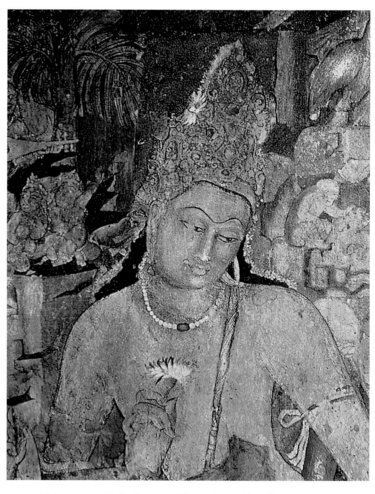

18.6 Standing Buddha. 5th century.
Red sandstone. Height 5′3″.
Indian Museum, Calcutta.

18.7 "Beautiful Bodhisattva" Padmapani (detail).
Fresco from Cave 1. Ajanta, India. c.600–650.
Photograph: Duane Preble.

Hindu Art

Hinduism recognizes three principal gods: Brahma, the creator of all things; Vishnu, the sustainer; and Shiva, the destroyer. These three gods intervene in human affairs at appropriate moments either to guarantee the continuing evolution of the cosmos, or to restore the proper balance of good and evil forces in the world. Most Hindu devotional practices are done individually (rather than in a group as is common in Christian worship), and Shiva is the god most often venerated in architecture and sculpture.

The Hindu temple is a major architectural form of India, and one of the world's most distinctive. It typically includes two parts: a porch, for the preparation and purification of the worshipper, and the Womb Chamber, called in Sanskrit the **garba griha**, the sacred room where an image of the god is kept.

The Kandarya Mahadeva Temple at Khajuraho in north-central India (**fig. 18.8a**) is one of the most spectacular and best preserved. A stairway leads to not one, but several porches, which allow access to the *garba griha*. The sacred chamber is marked on the outside by a tall tower that has replicas of itself on its sides. The rounded projecting forms, symbolizing both male and female sexuality, seem to celebrate the procreative energy existing in nature and within ourselves.

Shown in **fig. 18.8b** is one of hundreds of erotic scenes from the abundant sculpture on the outside of Kandarya Mahadeva Temple. To the Hindu worshipper, union with God is filled with a joy analogous to the sensual pleasure of erotic love. The natural beauty and fullness of the human figures emphasize maleness and femaleness. Fullness seems to come from within the rounded forms, as we saw in the more ancient male torso from Harappa (see fig. 18.1). The intertwining figures symbolize divine love in human form, an allegory of ultimate spiritual unity.

In Hindu belief, Shiva encompasses in cyclic time the creation, preservation, dissolution, and re-creation of the universe. Shiva shows these roles in sculptures that are as rich in iconography as any in the world. An eleventh-century image

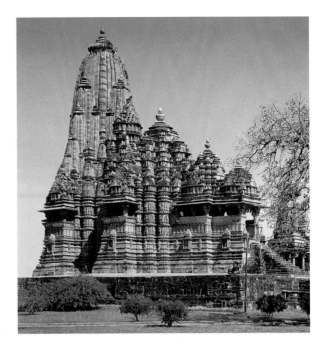

18.8 Kandarya Mahadeva Temple. Khajuraho, India. 10th–11th centuries.
a. Exterior
Photograph: Borromeo. Art Resource, NY.

Watch an architectural simulation about stupas and temples on myartslab.com

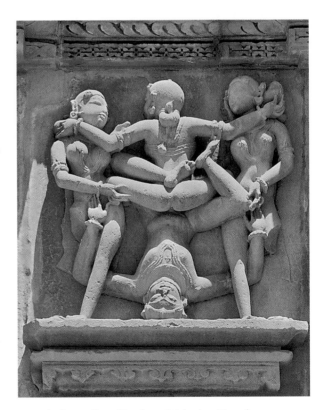

b. Scene from Kandarya Mahadeva Temple. Erotic reliefs. Chandella dynasty. 1025–1050.
Kandariya Mahadeva Temple, Khajuraho, Madhya Pradesh, India.
Photograph: Copyright Borromeo/Art Resource, NY.

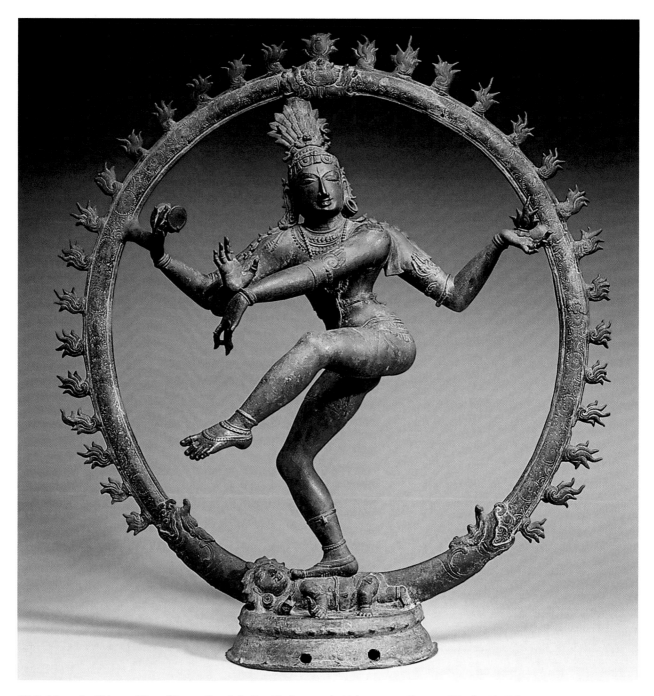

18.9 *Nataraja, Shiva as King of Dance.* South India. Chola period, 11th century. Bronze. Height 3′ 7⅛″.
© 2001 The Cleveland Museum of Art. Purchase from the J. H. Wade Fund. 1930.331.

from South India, *Nataraja, Shiva as King of Dance* (**fig. 18.9**), shows Shiva performing the cosmic dance within the orb of the sun. He tramples on the monster of ignorance as he holds sacred symbols in his hands. The encircling flame is the purifying fire of destruction and creation. He taps on a small drum to mark the cosmic rhythm of death and rebirth. As he moves, the universe is reflected as light from his limbs.

The sculpture implies movement so thoroughly that motion seems contained in every aspect of the piece. Each part is alive with the rhythms of an ancient ritual dance. Multiple arms increase the sense of movement, while his face is composed and impassive, indicating that there is nothing to fear.

Most of India was conquered by Islamic Mughal rulers in the early sixteenth century. Several local

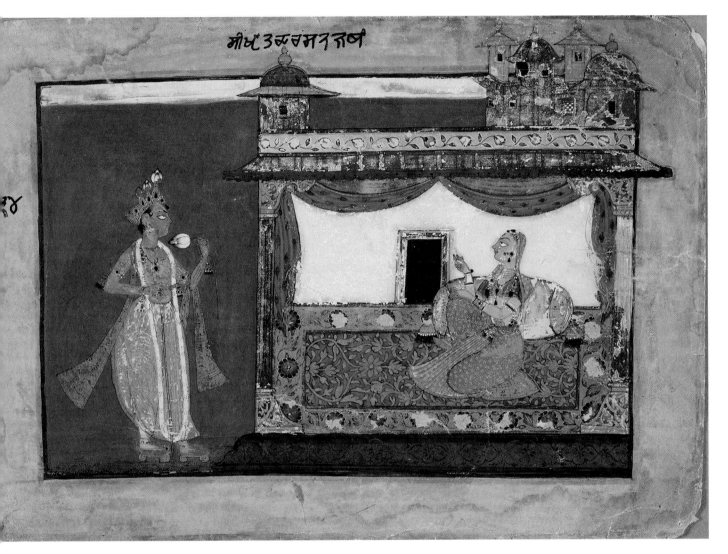

मीर उ…म…ण

18.10 *The Approach of Krishna.* c.1660–1670.
Pahari region, India. Basohli style.
Color, silver, and beetle wings on paper. 6⅞″ × 10¼″.
© The Cleveland Museum of Art. Edward L. Whittemore Fund. 1965.249.

Indian art styles soon arose in the foothills of the Himalayas, as artists influenced by Muslim techniques began to render Hindu subjects. We see the Basohli style to good advantage in *The Approach of Krishna* (**fig. 18.10**). A woman waits breathlessly for her lover, the blue-skinned god Krishna. Like many other Indian works, this painting uses erotic desire as a symbol for the spiritual longing for union with the divine. The inscription reads, "Friend, give up your waywardness of mind." The bright red and blue colors symbolize the emotional states of expectancy and desire for the crowned and bejeweled Krishna, who brings a fragrant flower. The use of color to depict emotional states is a technique that modern artists in the West would take up in the late nineteenth and early twentieth centuries, though without knowing of these early examples.

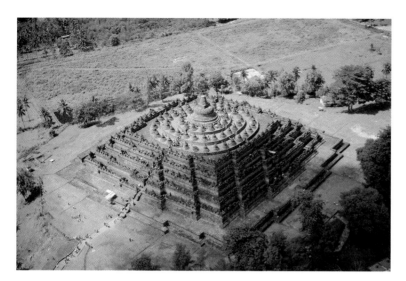

18.11 Borobudur. c.800. Java, Indonesia.
a. Aerial view.
Photograph: Luca Tettoni/Robert Harding.

Watch a video about the Borobudur temple compounds on myartslab.com

b. Corridor at Borobudur. First Gallery.
Photograph: Werner Forman Archive, Ltd.

Southeast Asia

The Bronze Age in Southeast Asia began when that metal was first imported into the region in about 800 BCE Soon thereafter, the major cultural division of the region appeared: The eastern coast, encompassing most of what is now Vietnam, fell under Chinese influence; most of the remainder willingly adopted and transformed cultural influences from India.

Buddhism and Hinduism both spread southward and eastward from India with traders and merchants. Early Southeast Asian art is primarily Buddhist; later monuments combine motifs, gods, and figures from both religions, as each region of Southeast Asia developed its own interpretation of the major Indian styles.

By any standard, Borobudur (**fig. 18.11**) must rank among the major works of world art. Built about 800 CE on the island of Java (now part of Indonesia), it is an extremely elaborate version of an Indian stupa, or sacred mountain. Rising from a relatively flat plain, it stands above the local surroundings, measuring 105 feet high and 408 feet on a side. It is oriented to the four cardinal directions, with stairways at the four midpoints.

Pilgrims who come for spiritual refreshment may enter at any opening and then walk around and climb the various terraces in a clockwise direction, as at the Great Stupa at Sanchi. More than 10 miles of relief sculpture adorn the various corridors (**fig. 18.11b**), telling stories that duplicate the journey to enlightenment. On the lower levels, the reliefs deal with the struggle of existence and the cycle of death and rebirth. Then come reliefs depicting the life of the Buddha. As pilgrims walk in these corridors, the high walls prevent them from seeing out, and the curves in the path limit the view ahead. Upper terrace reliefs depict the ideal world of paradise. However, there is still more to come.

The final four circular levels permit the pilgrim to look out over the landscape and take in the broad view, suggesting enlightenment.

18.12 Angkor Wat. c.1120–1150.
a. West entrance.
© John Elk III/Photoshot.

b. Plan.

Each of the 72 small hollow stupas contains a statue of a seated Buddha that is only dimly visible from the outside. At the very top is a sealed stupa whose contents the pilgrim can only guess at. Thus, Borobudur presents the Buddhist conception of the pathway through the cycles of birth and death, which culminates in enlightenment.

The sacred mountain of Borobudur was a principal influence on the Cambodian temple of Angkor Wat (**fig. 18.12**), which was erected in the twelfth century near the capital of the Khmer empire. This was the most prosperous period in Cambodia's history, as the rulers mastered the science of irrigation and were able to make the jungles produce abundant crops. The people at that time seemed to accord their rulers near-divine status because the many stone carvings of Buddhas, bodhisattvas, and Hindu gods appear also to be portraits of real rulers. The two religions were apparently considered compatible.

Angkor Wat, which faces due west, was originally surrounded by moats, as if to remind everyone that management of water was the source of wealth. The many corridors are decorated with low-relief sculpture depicting primarily Hindu myths about the god Vishnu. One of the best of these was *Army on the*

March (see fig. 12.3). The ruler of Cambodia thought of himself as a descendant of Vishnu, guarding the fertility of his domain. This emphasis on fertility in the design of Angkor Wat extends to the tops of the towers, which resemble sprouting buds.

China and Korea

Chinese civilization up to the modern period was characterized by the interaction of three traditions: Confucianism, Daoism, and Buddhism. The first two are Chinese creations, while Buddhism came from India. All three have interacted with and influenced each other, imparting richness and variety to Chinese culture. Before these traditions developed, however, distinctive Chinese arts were already flourishing.

Some of the world's finest cast-bronze objects were produced in China during the Shang dynasty (sixteenth to eleventh centuries BCE). The ritual vessel (**fig. 18.13**) is covered with an intricate composite of animal forms: The handles are animals with pig-like faces and winged backs, pointing downward. The entire side of the vessel is a face, its large round eyes and symmetrical brows prominent. This central face is a **taotie mask**, a composite monster with wings, claws, and horns whose meaning is unfortunately lost to us, but which appears on a great many Chinese bronze vessels. The lowest ring likewise has a procession of stylized monsters.

Most bronze vessels were used in rituals in honor of ancestors. The Chinese believed that one's ancestors lived eternally in the spiritual realm, and that they could influence worldly affairs for better or worse. These beliefs evolved into Confucianism, a moral and ethical system developed by Confucius (Kong Fuzi, 551–479 BCE). Confucius was no mystic; asked once about the proper way to honor the spirits, he replied, "You do not even honor man; how can you honor the spirits!" Cautious innovation and respect for tradition characterize much Chinese art because of his influence.

In the hope of improving their afterlife, many persons were buried with most of their possessions. No one, however, was more vain in collecting objects for their burial than the emperor Qin Shihuangdi, who at the time of his death in 210 BCE had unified China in something like its present form. (His dynastic name, Qin—pronounced chin—is the root of the word *China*.) So intent was he on guarding his afterlife that he ordered a massive army of life-size clay soldiers made for his protection. The Terra Cotta Warriors (**fig. 18.14**) number about six thousand in

18.13 Ritual Vessel. China. 12th century BCE. Cast bronze. Height 7⅛".
Freer Gallery of Art, Smithsonian Institution, Washington, D.C.: Gift of Eugene and Agnes E. Meyer, F1968.29.

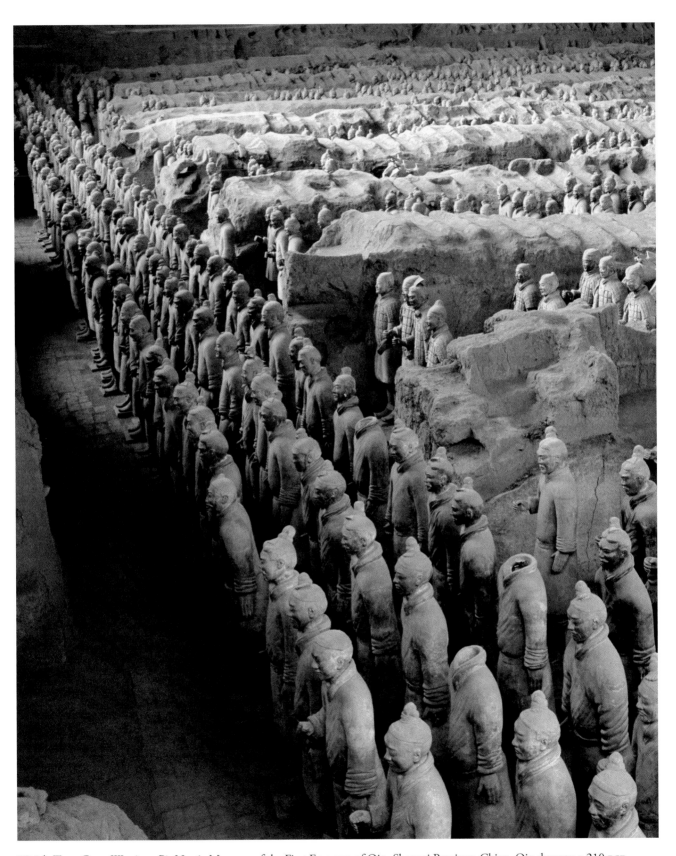

18.14 Terra Cotta Warriors. Pit No. 1, Museum of the First Emperor of Qin. Shaanxi Province, China. Qin dynasty. c.210 BCE.
National Geographic Image Collection.

all, among them cavalrymen, archers, and foot soldiers. These lifelike figures in their huge tomb were discovered in 1974, an extraordinary archaeological find.

The Chinese empire during the Han dynasty (206 BCE–221 CE) was contemporary with the Roman Empire, but much larger. Grave goods have yielded most of the surviving artwork from that period, and from these remains we can learn a great deal about life in China.

The Wu Family Shrine in northeast China shows elaborate relief sculpture; some of this is captured in the stone tomb relief (**fig. 18.15**). (This illustration was made by laying paper over the relief and rubbing with graphite to show the imagery more clearly.) In the lowest register at the right, diggers open a mound and find ancient bronze objects. One of these is a disk that a nobleman presents as an offering to a ruler immediately above. In the top register at the left, we see a horse and chariot, among other scenes of vivid interaction.

18.15 Stone Tomb Relief. Rubbing. Wu Family Shrine, Shandong Province, China. 2nd century CE.
© 2013 The Field Museum, A114787d_003. Photo John Weinstein.

View the Closer Look for the rubbing of a stone relief on myartslab.com

None of the scenes in the Wu Family Shrine has much detail, but all are full of energy. Capturing this inner life force, or **qi** in Chinese, animates a great deal of art production through the centuries in that culture.

The concept of *qi* derives from Daoist beliefs. For Daoists, the best life is one of harmony with the force that animates all created beings. According to traditional Daoism, achieving this harmony will make one immortal; the mirror with Xiwangmu (**fig. 18.16**) honors such a person. Also known as the Queen Mother of the West, she understood the harmony of the Dao and dispensed immortality from her home on faraway Jade Mountain. The mirror (which is shiny on the other side) depicts Xiwangmu seated at the left of the mirror's central bulb. Opposite her is the Lord Duke of the East; according to Daoist mythology, the two meet each year on the seventh day of the seventh month, a lucky day on the calendar. Just outside their circle, an inscription

18.16 Mirror with Xiwangmu. China. Six Dynasties period, 317–581. Bronze. Diameter 7¼".
© Cleveland Museum of Art. The Severance and Greta Millikin Purchase Fund, 1983.213.

wishes good fortune to the mirror's owner. In the outer bands are other heavenly beings and circles of clouds, which symbolize the endless cycle of time.

Traditional Chinese painting revolves around two focal points: calligraphy and landscape. Chinese leaders of all kinds were expected to express the strength of their character through elegant writing. By introducing calligraphic brush techniques for expressive purposes, painters sought to elevate painting to the levels that calligraphy and poetry had already attained. In China, painting and writing are closely related, and Chinese artists often include poems within their paintings. The same brushes and ink are used for both, and in both each brush stroke is important in the total design. Artists "paint" their poems as much as they "write" their paintings.

Contemporaries of the court painter Fan Kuan regarded him as the greatest landscape painter of the Song dynasty (960–1279). In his large hanging scroll *Travelers Among Mountains and Streams* (**fig. 18.17**), intricate brushwork captures the spirit of trees and rocks. Like most Chinese landscape paintings, this work renders no specific place; rather, it is an imaginative creation intended to capture some aspect of the energy of nature. Artists used many kinds of brush strokes, each identified by descriptive names such as "raveled rope," "raindrops," "ax cuts," "nailhead," and "wrinkles on a devil's face." Here "raindrop" and other types of brush strokes suggest the textures of the vertical face of the cliff. Men and donkeys, shown in minute scale in the road at the lower right, travel a horizontal path dwarfed by high cliffs rising sharply behind them. To highlight the stylized waterfall as the major accent in the design, Fan Kuan painted the crevice behind the waterfall in a dark wash, and left the off-white silk unpainted to suggest the falling water. The vertical emphasis of the composition is offset by the almost horizontal shape of the light area behind the rocks in the lower foreground. The massive centrality of the composition is typical of the efforts of Northern Song artists to capture the more powerful aspects of nature.

18.17 Fan Kuan. *Travelers Among Mountains and Streams.* Song dynasty. Early 11th century. Hanging scroll. Ink on silk. Height 81¼".
National Palace Museum, Taipei, Taiwan, Republic of China. © Corbis.

18.18 Ma Yuan. *Watching the Deer by a Pine-Shaded Stream.*
Southern Song dynasty. Album leaf. Ink on silk.
9½″ × 10″.
© Cleveland Museum of Art. Gift of Mrs. A. Dean Perry, 1997.88.

18.19 Huang Gongwang.
Dwelling in the Fuchun Mountains (detail). 1350.
Handscroll. Ink on paper. 13″ × 252″.
The Art Archive/Superstock.

When a vertical line intersects a horizontal line, the opposing forces generate a strong center of interest. Fan Kuan took advantage of this phenomenon by extending the implied vertical line of the falls to direct the viewer's attention to the travelers. Figures

give human significance to the painting and, by their small scale, indicate the vastness of nature. Fan Kuan achieved his monumental landscape in part by grouping the fine details into a balanced design of light and dark areas.

A Mongol invasion from the north dislocated China's Song dynasty rulers in 1125. (These were the same Mongols who under Genghis Khan eventually occupied an empire stretching from Korea to eastern Poland and Baghdad to Siberia.) The Song court and art academy moved south to Hangzhou, where a new painting style arose.

If the earlier Northern Song style was monumental and philosophical, the later Southern Song was intimate and personal, emphasizing poetic views of relatively smaller landscapes. One of the leaders in the new style was Ma Yuan, a fifth-generation descendant of academy teachers who was a favorite of the emperor. Ma's painting *Watching the Deer by a Pine-Shaded Stream* (**fig. 18.18**) captures a contemplative moment in which a scholar or official enjoys a respite on a wooded path. Ma's way of depicting pine branches gives the work an ethereal calm. The brushwork is as meticulous as in the preceding Northern Song, but the composition is relatively adventurous as it fades away into mist at the upper left. This composition is so off-balance that the artist's contemporaries referred to him as "one-corner Ma" because of his tendency to leave large areas of his works unpainted. Such boldness responds to Daoist beliefs, however, because without the voids we would not appreciate the fullness.

Most of the important painters of the Song dynasty were associated with official art academies or government service. During the following Yuan dynasty (1279–1368), the final conquest of China by Mongols radically altered this scenario. The most creative artists refused to paint or teach for the foreign government; rather, they lived outside official sponsorship. Devoting themselves to a life of art and poetry, they flaunted their amateur status and created a new style called **literati painting**. An excellent picture of literati life is *Poet on a Mountaintop* (see fig. 3.25).

The Yuan dynasty literati painters made many innovations in brushwork and subject matter. One of the most important was to give paintings a more spontaneous look. A leader in this trend was Huang

Gongwang, who worked briefly in the Yuan administration before suffering false imprisonment in a corruption scandal. On his release he gave up government service and devoted himself to the literati life of painting and literature.

His large work *Dwelling in the Fuchun Mountains* (**fig. 18.19**) is one of the most revered literati paintings. It is a **handscroll**, meaning that it is a long painting on paper, meant to be viewed by slowly scrolling from the right hand to the left. The section of the work illustrated here shows Huang's varied and expressive brushwork techniques. Though he worked on this painting for over three years, it has the look of a spontaneous creation.

Traditional Chinese painters often copied (with personal variations) the works of earlier artists. Even fully mature painters often produced a work in the style of an older master they particularly admired. This tendency reveals one of the basic precepts of Confucianism: respect for the past. The idea that a painter must fully comprehend tradition before expressing individuality was a hallmark of the artists who worked for the imperial court in the sixteenth and seventeenth centuries, and they produced many works in which this homage is clear.

For example, in Qiu Ying's work *Fisherman's Flute Heard Over the Lake* (**fig. 18.20**), a looming cliff at the upper right echoes the massive but meticulous landforms in Fan Kuan's *Travelers Among Mountains and Streams*, painted over three centuries earlier (see fig. 18.17). The human presence in both works is quite small, but Qiu included a scholar standing in his pavilion at the lower center. This motif of the scholar finding refreshment in nature is also common in Chinese landscape paintings (see fig. 18.18). The scholar in Qiu's work has taken a break from his studies, because he hears the fisherman at the left edge playing a haunting tune on his flute. This music was most likely "The Fisherman's Song," a famous Daoist hymn about the harmony of land and water. After Qiu's death, later artists made so many copies of his paintings, out of a similar respect for the past, that determining the authenticity of his works is often difficult.

The Chinese have traditionally held ceramic arts in high regard, and the history of pottery in China is primarily the story of imperial sponsorship and nearly

18.20 Qiu Ying. *Fisherman's Flute Heard Over the Lake.* c.1547. Hanging scroll. Ink and color on paper. 5′2⅞″ × 33⅛″.
The Nelson-Atkins Museum of Art, Kansas City, Missouri. Gift of John M. Crawford Jr., in honor of the Fiftieth Anniversary of the Nelson-Atkins Museum of Art, F82-34.

continuous technical advances. Probably the best-known type of Chinese ceramic is porcelain, made from a rare type of clay that when fired becomes pure white (see Chapter 13 for a more technical discussion of porcelain). Early porcelains, such as the porcelain

plate pictured (**fig. 18.21**), were decorated with blue because that was the only color that could withstand the high temperatures necessary to fire porcelain correctly. The Chinese were the first to develop this type of pottery. Porcelain emerges translucent from the oven, and it rings when struck; from this the Chinese concluded that their best dishes contained music. After it was first imported into the Western world, European workshops tried for generations to duplicate its translucency and deep blue colors. In the Ming dynasty, potters discovered how to glaze porcelain in almost any color through multiple firings.

Throughout Asia, potters in different provinces and countries produced their own variations on Chinese ceramic styles. The wine pitcher (**fig. 18.22**) is an exquisite example of a Korean adaptation of the Chinese blue-green celadon glaze, with the addition of a new style of decoration. The potter etched out the background behind the flower decorations in the lower part of the vessel, and also etched the shapes of the flying cranes above. The potter then filled these

18.22 Wine Pitcher.
Koryo dynasty. Korea, Mid-12th century. Gourd-shaped bottle inlaid with peony design. Stoneware with celadon glaze and inlaid white and black slip. Height 13½″.
National Museum of Korea, Seoul. National Treasure No. 116.

lowered areas with white and black slip (liquid clay) before firing the vessel for the final time. This slip-inlay technique is a Korean invention, and here the smooth surface complements the graceful curves of the double-gourd shape and elegant handle of the pitcher. The shapes and decorations of this piece work so well together that the Korean government designated this wine pitcher a national treasure.

Korea developed some of its own art forms despite the influential presence of nearby China and Japan. We see one of these in the *Avatamaska Sutra* (**fig. 18.23**), a book page produced in the mid-fourteenth century. A sutra is a book of Buddhist teachings, and this one includes the important teaching that all beings have the Buddha nature. The Korean artists who illustrated it used fine strands of gold and silver to depict a gallery of immortals and other divine beings.

Chinese painting in the Ming and later dynasties evolved down two parallel paths. Within the academies, artists copied old masters and innovated cautiously, outside academies, the literati took a bolder and freer approach. One of the boldest of the latter

18.21 Porcelain Plate.
Mid-14th century. China, Late Yuan dynasty. Painted in underglaze blue. Diameter 18″.
Metropolitan Museum of Art. Purchase, Mrs. Richard E. Linburn Gift, 1987. Acc.n.: 1987.10. © 2012 Image copyright The Metropolitan Museum of Art/Art Resource/Scala, Florence.

18.23 *Avatamaska Sutra (Hwaomgyong)*.
Vol. 12. 13th–14th century. Korea. Goryeo period.
Folded book with illustrated frontispiece.
Gold and silver text on paper. 8" × 17¼".
© The Cleveland Museum of Art. The Severance
and Greta Millikin Purchase Fund, 1994.25.

was Bada Shanren, a descendant of Ming dynasty roy-
alty who lived in the early part of the succeeding Qing
dynasty (1644–1912). The Qing, like the Yuan, were
foreign. Because the Qing persecuted descendants
of the Ming, Bada lived the life of a recluse, taking
refuge in a monastery and later faking madness. On
the door of the abandoned building where he lived,
he scrawled the word "dumb" (mute), and when visi-
tors came he would laugh and drink with them but
would not talk. This behavior lasted about five years.
In 1684, he gave up his faked insanity and lived in
his provincial capital, trading paintings for food. His
works, such as *Cicada on a Banana Leaf* (**fig. 18.24**),
combine free execution with subtle political com-
ments. The cicada is a symbol of rebirth in Chinese
mythology, and in Bada's painting it signifies a hope
for the resurrection of the failed Ming.

Bada's art remained almost unknown until the
twentieth century. Then, as artists began to radi-
cally question their tradition, Bada's wildness was an
important precursor to more modern experiments in
Chinese painting.

18.24 Bada Shanren. *Cicada on a Banana Leaf.*
Qing dynasty. 1688–1689. Leaf "f" from
an album *Flowers and Birds*. Ink on paper.
Courtesy of the Freer Gallery of Art, Smithsonian Institution,
Washington, D.C. Purchase, F1955.21e.

View the Closer Look for the technique
of ink painting on myartslab.com

Japan

Throughout its history, Japanese culture has been marked by periods of nationalism, in which typically Japanese forms have prospered, alternating with periods of eager borrowing of foreign influences.

The indigenous religion of Japan is an ancient form of nature and ancestor worship called Shinto. In this religion, forests, fields, waterfalls, and huge stones are considered holy places where gods dwell. The Shinto shrines at Ise occupy a sacred site within a forest. With only a few lapses, the present Main Shrine at Ise (**fig. 18.25**) has been completely and exactly rebuilt every 20 years since the late seventh century. Builders take wood for the shrine from the forest with gratitude and ceremonial care. As a tree is cut into boards, the boards are numbered so that the wood that was joined in the tree is reunited in the shrine. No nails are used; the wood is fitted and pegged. In keeping with the Shinto concept of purity, surfaces are left unpainted and the roof is natural thatch. The shrines at Ise combine simplicity with subtlety. Refined craftsmanship, sculptural proportions, and spatial harmonies express the ancient religious and aesthetic values of Shinto.

The first major wave of cultural borrowing took place in the seventh century, when Japanese emperor Shotoku sent emissaries to China to study that civilization. They returned very impressed with many aspects of Chinese culture. For example, the emperor enthusiastically adopted Buddhism, making it the official religion. (Many Shinto gods became sacred beings in Japanese Buddhism.) Japanese Buddhist sculpture from this period was heavily influenced by Chinese sculpture, which the Japanese reinterpreted with subtle changes. Shotoku also encouraged the Japanese aristocracy to learn Chinese and use Chinese script. Confucian teachings about social order and respect for tradition were also adopted, along with many aspects of Chinese art and architecture. In fact, because much of Chinese ancient architecture has not survived, the best place to study it is in Japan on the Yamato plain near Kyoto, where Shotoku set up his capital and the emperors lived for centuries after.

The temple complex of Horyuji (**fig. 18.26**) exemplifies the Buddhist monastery as it existed in both China and Japan. In the center of the courtyard, we can see the many-storied pagoda, which has a symbolic function relating to its descent from Chinese watchtowers and Indian stupas (see fig. 18.4). Next to it is the *kondo,* or Golden Hall, a meditation hall where Buddha statues are kept. In the center of one wall is a gatehouse; opposite it along the back wall is a larger lecture hall, where monks hear religious teaching. The oldest parts of Horyuji date from the late seventh century, and are among the world's oldest surviving wooden buildings.

To hold up a two-story structure with a heavy tile roof, Japanese architects (influenced by Chinese predecessors) developed an elaborate bracketing system (**fig. 18.26b**) for the *kondo* at Horyuji. The empty second story is merely an accent to show the importance of the building, but it also demonstrates the skill of the architect.

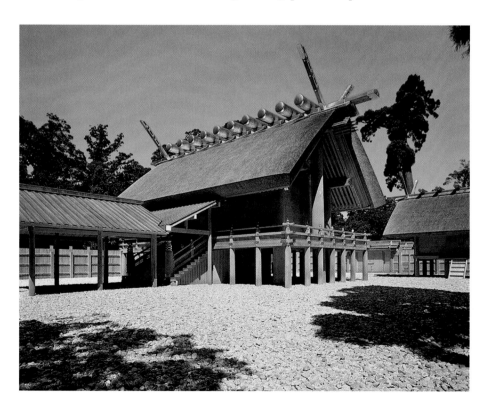

18.25 Main Shrine. Ise, Japan. c.685
Rebuilt every twenty years.
Photograph: Kyoto News.

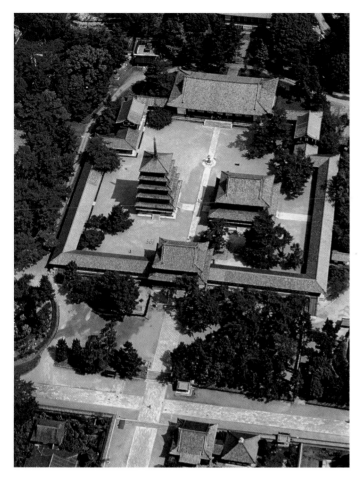

18.26 Horyuji Temple.
Nara, Japan. c.690.
a. Aerial view.
Photograph: Kazuyoshi Miyoshi. Pacific Press Service.

b. *Kondo.* Structural diagram.
From *The Art and Architecture of Japan,*
Robert Treat Paine and Alexander Coburn Soper.
By permission of Yale University Press.

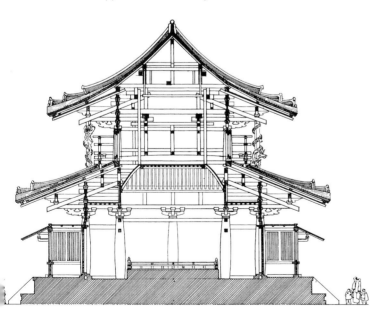

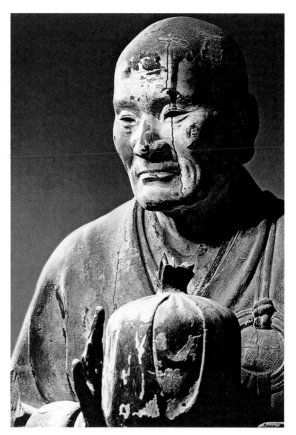

18.27 Unkei. *Muchaku* (detail). c.1212.
Wood. Height 75".
Kofuku-ji Temple, Nara, Japan. 1212 National Treasure.
Photograph courtesy of Duane Preble.

Japan has the oldest surviving royal family of any society. This longevity has been made possible by frequent military interventions in which the generals ruled on behalf of the emperors, as in the Kamakura period (1185–1333). The dominant taste of the leaders at that time favored a vigorous realism in art, and we see this in the wood portrait statue of the detail of *Muchaku* (**fig. 18.27**). Unkei, one of the greatest sculptors of Japan, created this life-size work depicting a legendary Buddhist priest from India holding a cloth-covered, round offering box. The vividness of the facial expression and the delicacy of the hand gesture belie the wooden material from which he carved it.

Japanese painters of this period found the handscroll particularly effective for long narrative compositions that depict the passage

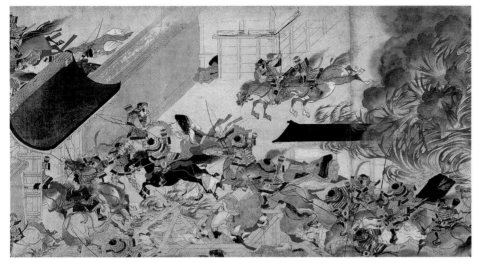

18.28 *Night Attack on the Sanjo Palace.* From the *Heiji Monogatari Emaki* (illustrated Scrolls of the Events of the Heiji Era). Japan. Second half of the 13th century. Kamakura period. Handscroll, ink and colors on paper. 16¼″ × 275½″.
Museum of Fine Arts, Boston, Fenollosa-Weld Collection, 11.4000. Photograph © 2013 Museum of Fine Arts, Boston.

of time. *Night Attack on the Sanjo Palace* (**fig. 18.28**) is from the *Heiji Monogatari Emaki*, a scroll that describes an insurrection of 1160. As the scroll is unrolled from right to left, the viewer follows a succession of events expertly designed to tell the story. Through effective visual transitions, the horror and excitement of the action are connected. The story builds from simple to complex events, reaching a dramatic climax in the scene of the burning palace, a highly effective depiction of fire. The color of the flames emphasizes the excitement of the historic struggle. Parallel diagonal lines and shapes, used to indicate the palace walls, add to the sense of motion and provide a clear geometric structure in the otherwise frantic activity of this portion of the scroll. Today, such dramatic events are presented through film or television.

Zen Buddhism, which came to Japan from China in the thirteenth century, strongly influenced many Japanese artists. Zen teaches that enlightenment can be attained through meditation, and that enlightenment can come at any time. The influence of Zen on Japanese aesthetics can be seen in spontaneous and intuitive approaches to poetry, calligraphy, painting, gardens, and flower arrangements.

Zen Buddhist priest Sesshu is considered the foremost Japanese master of ink painting. In 1467, he traveled to China, where he studied the works of Southern Song masters and saw the countryside that inspired them. Sesshu adapted the Chinese style and set the standard in ink painting for later Japanese artists. He was most influential when he painted in a simplified, somewhat explosive style, later called *haboku*, meaning "flung ink." *Haboku, Splashed Ink Landscape* (**fig. 18.29**) is abstract in its simplification of forms and freedom of brushwork.

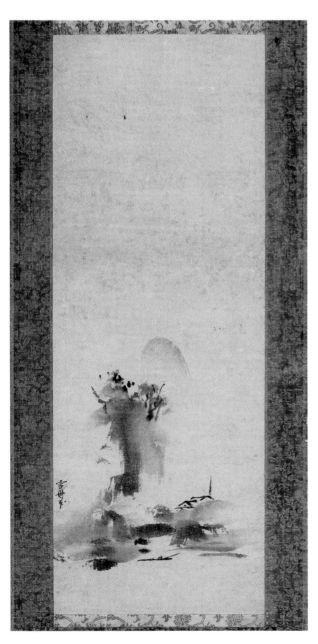

18.29 Sesshu Toyo. *Haboku, Splashed Ink Landscape.* 1400s–early 1500s. Hanging scroll. Ink on paper. 28¼″ × 10½″.
© The Cleveland Museum of Art. Gift of The Norweb Collection, 1955.43.

Sesshu suggested mountains and trees with single, soft brush strokes. The sharp lines in the center foreground indicating a fisherman, and the vertical line above the rooftops representing the staff of a wine shop, contrast with the thin washes and darker accents of the suggested landscape.

In traditional Japan, folding screens provided privacy by separating areas within rooms. Artists have used the unique spatial properties of the screen format in highly original ways. In contrast to the European easel paintings that function like a window in the wall, a painted screen within the living space of a home becomes a major element in the interior.

Tawaraya Sotatsu's large screen *Waves at Matsushima* (**fig. 18.30**) is one of a pair of six-panel folding screens. The screens are designed so that together or separately they form complete compositions. The subject is a pair of islands where there were ancient Shinto shrines. The degree of abstraction present in the ocean waves and the gold background landscape are typically Japanese.

In keeping with well-established Japanese artistic practices, Sotatsu created a composition charged with the churning action of waves, yet as solid and permanent in its design as the rocky crags. He translated his awareness of natural phenomena into a decorative, abstract design. Spatial ambiguity in the sky and water areas suggests an interaction that the viewer should feel, rather than read as a literal transcription of nature. In addition to rhythmic patterns that fill much of the surface, boldly simplified shapes and lines are contrasted with highly refined details and eye-catching surprises. The strongly asymmetrical design, emphasis on repeated patterns, and relatively flat spatial quality are all often used in Japanese painting from the sixteenth to the nineteenth centuries.

By the mid-seventeenth century, the art of woodcut printing had developed to meet the demand for pictures by the newly prosperous middle class. Japanese artists took the Chinese woodcut technique and turned it into a popular art form. For the next two hundred years, hundreds of thousands of these prints were produced. The prints are called **ukiyo-e**, meaning "pictures of the floating world," because they depict scenes of daily life, including landscapes, popular entertainments, and portraits of theater actors—the impermanent, pleasurable aspects of life known as the "floating world."

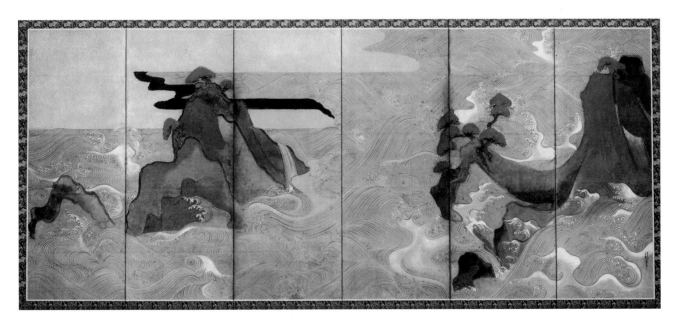

18.30 Tawaraya Sotatsu. *Waves at Matsushima*. 17th century. Japan. Edo period.
Folding screen. Ink, color, gold, and silver on paper. 59⅞″ × 145½″.
Courtesy of the Freer Gallery of Art, Smithsonian Institution, Washington, D.C. Gift of Charles Lang Freer, F1906.231.

View the Closer Look for the *Waves at Matsushima* on myartslab.com

Beauty

Visual delight in a work of art can take many forms, including an appreciation of beauty. Contemplation of beauty takes us away from the complexities and routines of life, allowing us to forget where we are for a moment.

Much Asian art throughout history was created primarily to delight the senses with beauty, sometimes through pleasant subject matter, and sometimes through the use of rich colors or materials. When Tawaraya Sotatsu worked with calligrapher Honami Koetsu to create *Anthology with Cranes* (**fig. 18.31**), they produced a long handscroll that did both. Sotatsu used paint tinted with gold and silver to depict flocks of cranes in the air. He created these birds with just a few strokes each, and they establish a graceful rhythm with their wings and extended legs. His effortless brushwork gave them highly lifelike shapes. Koetsu added calligraphy by transcribing lines of ancient poetry that praised the beauty of nature. His alternating thick and thin strokes mimic a traditional style of writing from an earlier aristocratic period. The free yet confident strokes establish a vertical rhythm that contrasts with the diagonals of the cranes. We need not understand the text in order to appreciate the beauty and spontaneity of this scroll, which is more than 44 feet long.

In Western art, landscape painting has traditionally been a means of providing delight. In contemplating the landscape, viewers can forget the burdens of work and society as they focus on nature. One of the founders of Western landscape painting was Claude Lorrain, who worked mostly in Italy during the Baroque period. His landscapes do not generally depict specific locations; rather, he composed and arranged material from his observations into idealized, nearly perfect scenes.

In *The Judgment of Paris*, for example (**fig. 18.32**), we see a cave at the far left near a waterfall. Trees at the center and far right filter sunlight, which comes from a low spot above the horizon out of view. Sheep and goats in the foreground help establish a tranquil mood. The figural group at the left enacts the mythological story of Paris, a Trojan shepherd who was charged by the gods with choosing the most beautiful among three goddesses. Many European artists have used this subject matter, but Claude's painting is unique in the prominence that it gives to the landscape. Paris's choice of Aphrodite later precipitated the Trojan War, but Claude here ignores all of the tragedy of that fateful decision, placing the contest in an ideal world. His canvases were eagerly sought by the aristocrats of Europe at the time, and they helped to establish a new concept of beauty. The term **picturesque** soon came into use to describe desirable locations, or gently poetic natural landscapes.

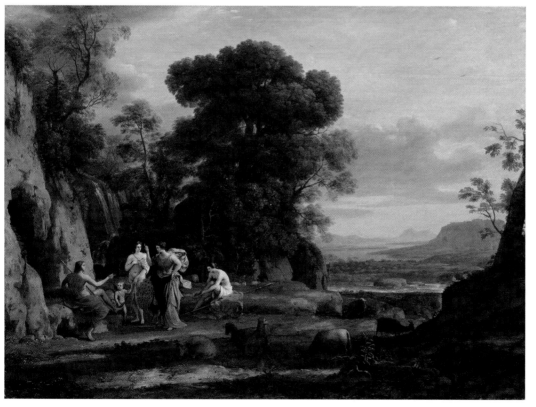

18.32 Claude Lorrain. *The Judgment of Paris*. 1645–1646. Oil on canvas. 44¼″ × 58⅞″.
National Gallery of Art, Washington D.C. Ailsa Mellon Bruce Fund 1969.1.1.

18.31 Tawaraya Sotatsu and Honami Koetsu. *Anthology with Cranes* (detail). Edo period. Early 17th century. Silver and gold paint on paper. 13⅜" × 44½'.
Kyoto National Musuem.

While we experience delight by contemplating beautiful things, we may also do so by "looking good" ourselves: attractive clothing can provide enjoyment for both wearer and viewer. The modern artist Sonia Delaunay-Terk aimed for this in the 1920s when she created brightly colored clothing for fashionable women of the day. In this photograph (**fig. 18.33**), we see her work in dress design, which she extended to the side of the automobile. Her designs were influenced by the modern paintings that she also created (see fig. 5.4). Just as she titled her painting *Simultaneous Contrasts*, so she called her clothing designs "Simultaneous Dresses." She intended them to evoke the fast-paced lifestyle of the modern independent woman. In a wider sense, she was an early leader in the effort to use modern art styles for the beautification of useful things.

18.33 Sonia Delaunay-Terk. Clothing and Customized Citroen B-12. 1925. Photograph.
© Pracusa 2013021.

姿見七人化粧

18.34 Kitagawa Utamaro. *Reflected Beauty, Seven Beauties Applying Make-Up: Okita.* c.1790.
Woodblock print. 14¼″ × 9½″.
Honolulu Museum of Art. Gift of James A. Michener, 1969. (15,490).

curve representing the mirror's edge. In contrast to Western composition with its typically centered balance and subjects well within the frame, here the figure is thrust in from the right and cut off abruptly by the edge of the picture plane, rather than presented completely within the frame. This type of radically cropped composition was one of the elements of Japanese art that influenced European artists in the nineteenth century.

Japanese architects show a similar interest in asymmetry, casualness, and surprise. Katsura Detached Palace (**fig. 18.35**), a Japanese imperial villa, was built in Kyoto beside the Katsura River, whose waters were diverted into the garden to form ponds. All elements—land, water, rocks, and plants—were integrated in a garden design that blends human-made and natural elements. Because many of the palace walls are sliding screens, they provide flexible interconnections between interior and exterior spaces.

In contrast to a European royal palace, Katsura seems humble. The complex was planned with no grand entrance either to the grounds or to the buildings. Instead, one approaches the palace along garden paths, watching unexpected views open up. Earth contours, stones, and waterways are combined to symbolize—on a small scale—mountains, rivers, fields, inlets, and beaches. The tea house (**fig. 18.35a**), which borrows from modest country dwellings, is constructed of common natural materials. It provides the appropriate setting for the tea ceremony, which embodies the attitudes of simplicity, naturalness, and humility that permeate the entire palace grounds.

Traditional Japanese houses, such as those at Katsura, are built of wood using post-and-beam construction. The result is essentially a roof on posts, allowing walls to be sliding screens rather than supports. The Japanese use of unpainted wood and the concept of spatial flow between indoors and outdoors have been major influences on modern architects in the West.

Kitagawa Utamaro's woodcut print *Reflected Beauty* (**fig. 18.34**) transforms the ordinary subject into a memorable image consisting of bold, curving outlines and clear, unmodeled shapes. As with many Japanese paintings and prints, flat shapes are emphasized by the absence of shading. The center of interest is the reflected face of the woman, set off by the strong

18.35 Katsura Detached Palace. Kyoto, Japan. 17th century.
a. Gardens and tea house.
Photograph: Alex Ramsay/Alamy.

b. Imperial villa and gardens.
Photograph: © Robert Holmes/Corbis.

In the nineteenth century, European commerce and missionary work began to have a decisive impact across Asia. Various parts of Asia reacted differently to this new influence. India submitted, not always willingly, to colonial status under Britain. The Chinese tried to severely limit foreign influence on their culture, leading to conflicts that lasted into the twentieth century. Commodore Perry's 1854 mission to Japan caused debate and turmoil among the aristocracy. A revolt in 1868 restored the emperor to power, and he began a vigorous program of cultural importation from the West.

Prints created by Tsukioka Yoshitoshi illustrate some of the turbulence of the period. *The Battle of Sanno Shrine* (**fig. 18.36**) depicts a turning point in the conflict that restored the emperor's power. We see soldiers fighting at the far left; in the corner a dead body lies, foreshortened in a way that shows the influence of Western art. At the right, a general and a soldier converse about how to resist the attack of the emperor's forces. The rightmost figure is the general who will soon lose this battle, which Yoshitoshi witnessed firsthand. The degree of journalistic accuracy and Western influence in this work is unprecedented, but it merely foreshadows the degree of cultural interchange between East and West that continues into the present.

✔— **Study** and review on myartslab.com

18.36 Tsukioka Yoshitoshi. *The Battle of Sanno Shrine.* 1874. Triptych of woodblock prints. 14⅟₁₆″ × 28⅜₁₆″.
Los Angeles County Museum of Art (LACMA) Herbert R. Cole Collection (M.84.31.142a-c) Digital Image Museum Associates/LACMA/Art Resource NY/Scala, Florence.

THINK BACK

1. How does the style of rendering the human form in India differ from that of the classical West?

2. Which religious currents that influenced Chinese art are of local origin, and which imported?

3. Is Japanese art primarily nationalistic or does it admit foreign influences?

TRY THIS

Scroll electronically through the handscroll *Dwelling in the Fuchun Mountains* by Huang Gongwang (fig. 18.19). Go to the Web site of the National Palace Museum, Taiwan (http://www.npm.gov.tw/en/collection/). The work is in the Selections from the Painting collection; clicking "enlarge" will lead to a screen that allows scrolling through the entire work.

KEY TERMS

bodhisattva – a Buddhist holy person who is about to achieve enlightenment but postpones it to remain on earth to teach others

garba griha – the sacred room of a Hindu temple, where rituals are performed and the image of the god is kept

literati painting – most commonly used to describe the work of painters not attached to the royal courts of the Yuan, Ming, and Qing dynasties in China

stupa – a domelike structure probably derived from Indian funeral mounds

taotie mask – a mask of abstracted shapes commonly found on ancient Chinese bronze vessels

ukiyo-e – Japanese prints that depict scenes of the "floating world," including landscapes, popular entertainments, and theater scenes or actors

19

THE ISLAMIC WORLD

THINK AHEAD

19.1 Summarize the historical development of Islam as a world religion.

19.2 Discuss art and architectural forms most common to Islamic cultures.

19.3 Use terms that are particular to Islamic art and architecture.

19.4 Compare characteristics of Islamic art to Christian artistic traditions in Europe.

19.5 Recognize the importance of visual pattern and aesthetic pleasure in Islamic art.

Islam is one of the three major world religions built on the teachings of the religious seers of the Middle East. Although based on the revelations to the prophet Muhammad, Islam shares some fundamental beliefs and religious history with its predecessors Judaism and Christianity. An adherent of Islam is called a Muslim—Arabic for "one who submits to God." Art produced in Muslim cultures is among the world's most beautiful and finely crafted.

The Islamic calendar begins in 622 CE with the Hegira, Muhammad's emigration to the city of Medina on the Arabian peninsula. The new religion spread quickly into much of what was once the Eastern Roman or Byzantine Empire, then fanned out to include North Africa, Spain, and parts of Europe. Within one hundred years of the Prophet's death, Christian armies were repelling Muslim troops from Tours in central France. Islam is now the principal religion in the Middle East, North Africa, and some parts of Asia.

The Muslims facilitated their rule by allowing the peoples of conquered lands to retain their own religions and cultures, as the Romans had done. This strategy enabled the Muslims, who had little art of their own in their early history, to adapt earlier artistic

traditions. At its height, from the ninth through the fourteenth centuries, Islamic culture synthesized the artistic and literary traditions and scientific knowledge of the entire ancient world.

Unlike the medieval Christians, who mostly rejected pre-Christian civilization and scholarship, Muslims adapted and built on the achievements of their predecessors. Muslim scholars translated the legacy of Greek, Syrian, and Hindu knowledge into Arabic, and Arabic became the language of scholarship from the eighth through the eleventh centuries for Muslims as well as many Christians and Jews. During the European Middle Ages, Islamic civilization flourished, producing outstanding achievements in the arts, sciences, administration, and commerce that were not attained in Europe until the height of the Renaissance, in the late fifteenth century.

Traditional Muslims frown upon the representation of human figures in art that will be used in a religious context. Many Muslims believe that if an artist were to try to recreate the living forms of humans, he or she would be competing with Allah (God), who created everything. Muhammad also prohibited any pictures of himself while he was alive, claiming that he was not in any way exceptional—he was only a messenger. Thus the human form is rare in Islamic religious art, where more attention is given to geometry, to forms of vegetation, and to writing.

((•─[**Listen** to the chapter audio on myartslab.com

Arab Lands

When Islam first began to spread, local rulers took responsibility for building houses of worship in their territories. Early rulers often adapted abandoned buildings, converting them into mosques. (The word is based on the Arabic *masjid*, which means "place of prostration.") The typical mosque must be big enough to accommodate all male worshippers for Friday prayers, during which they hear a sermon and bow down in the direction of Mecca, Islam's most holy city. The basic plan of a mosque is based on the design of the Prophet's house, which had an open courtyard bordered by colonnades. Often, mosques include one or more **minarets** (towers), which mark the building's location and are used by chanters who ascend and call the faithful to prayer.

An early mosque that still stands in something resembling its original condition is the Great Mosque in Kairouan, Tunisia (**fig. 19.1**). The open courtyard is

19.2 Pitcher (Spouted Ewer).
Kashan. Early 13th century.
Luster over tin glaze. Height 6⅘".
Reproduced by permission of the Syndics of the Fitzwilliam Museum, Cambridge, from the Ades Loan Collection. The Bridgeman Art Library.

◉ ▭ **Watch** a podcast interview with Jonathan Bloom about Islamic art on myartslab.com

surrounded by porches, with a minaret over the main entrance in the center of one short side. The deeper covered area opposite the minaret shelters the **mihrab**, the niche in the end wall that points the way to Mecca.

The ceramic arts are highly valued in Islam, and Arab potters in Iraq made a major advance when they perfected the luster technique, probably in the ninth century. This glaze effect imparts a metallic sheen to the surface of a vessel; it is one of the most difficult to control in ceramics. Ancient potters equated the luster technique with alchemy, the effort to convert simple materials into gold. Most luster pottery was for the exclusive use of nobles and rulers. The pitcher shown here (**fig. 19.2**) has a very thin body, indicating that it was probably intended for decorative purposes rather than practical use. The script on this piece expresses praise and good wishes to the owner.

19.1 Great Mosque. Kairouan, Tunisia. 836–875.
Photograph: © Roger Wood/Corbis.

Spain

Muslims first conquered Spain for Islam in the eighth century, but soon the region (together with bordering North Africa) became a distinct Muslim culture with important scientists, poets, philosophers, architects, and artists. Some of Europe's best libraries were in the Spanish Muslim cities of Córdoba and Granada, and respect for books and learning was higher here than in most other areas of the continent.

Calligraphy is an important Islamic art because it is used to enhance the beauty of the word of God. The most respected practice for a calligrapher is the art of writing the words of the Qur'an, the sacred text of Islam, which Muslims believe was revealed in Arabic by God to Muhammad. In the Islamic world, the written text of the Qur'an (**fig. 19.3**) is the divine word in visible form. According to Islamic tradition, God's first creation was a reed pen for writing his words.

The decorative qualities of Arabic scripts combine well with both geometric and floral design motifs. We saw them combined in the pitcher, but they work together with unforgettable effect in the Court of the Lions at the Alhambra palace (**fig. 19.4**), which contains elaborate stucco arches resting on 124 white marble columns. Many of the walls seem to consist entirely of translucent webs of intricate decoration in marble, alabaster, glazed tile, and cast plaster. Light coming through the small openings in the decoration gives many of the rooms and courtyards a luminous splendor. Just above the columns is a horizontal band of calligraphy that says, "There is no victor except God."

The Court of the Lions is part of the much larger Alhambra, the royal palace and fort of the Muslim rulers in Granada. Occupying a commanding hill, the Alhambra was a self-contained city, with meeting rooms, royal residences, gardens, and housing for workers of various kinds. This was one of the last strongholds of Muslim rule in Spain, and when the last ruler abandoned it in 1492, the Spanish rulers kept it intact.

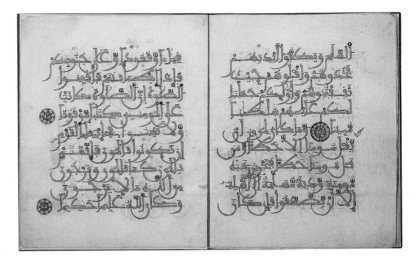

19.3 Text of the Qur'an. North Africa or Spain. 11th century. Colors on paper.
MS no. 1544. Reproduced by kind permission of the Trustees of the Chester Beatty Library, Dublin.

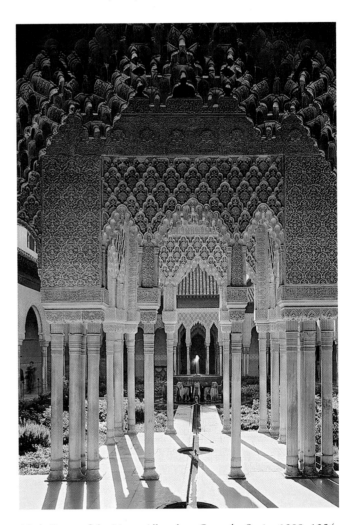

19.4 Court of the Lions, Alhambra. Granada, Spain. 1309–1354.
Photograph: SuperStock, Inc.

360°— **Explore** the architectural panoramas of the Alhambra on myartslab.com

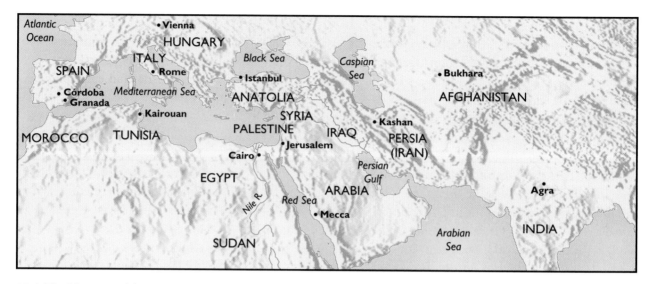

19.5 The Islamic World.

Persia

Probably the best-known item of Persian art in the West is the carpet (see fig. 13.12 for the Ardabil Carpet, one of the most impressive). Carpets were not only prized possessions; they were important to the history of Islamic arts as a means of spreading design ideas. Relatively portable, a carpet is a repository of motifs and compositions. Many decorative schemes on buildings or pottery were influenced by carpet design from distant regions.

Decorating architecture with tiles is an important offshoot of the ceramic arts, and this technique reached a peak of achievement in Persia. The mihrab shown here (**fig. 19.6**) was taken from a mosque, where it pointed the way to Mecca for worshippers. The disavowal of images in the religious context means that the art cannot tell a story with human figures, as is common in the West. Instead, Islamic art uses extremely intricate designs that satisfy the sensuous urge for beauty while also engaging the mind's desire for order and pattern. The writing on this mihrab contains well-known verses from the Qur'an about the value of building mosques. In this way, a work such as this one can be absorbing to look at, spiritually uplifting, and aesthetically pleasing.

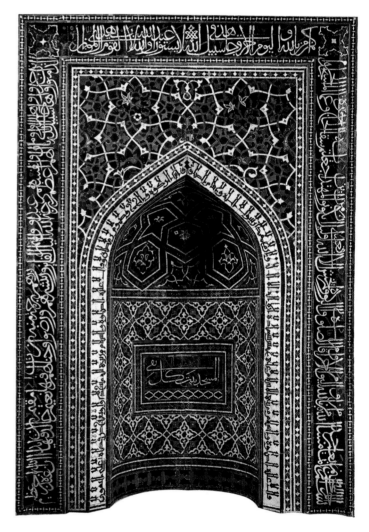

19.6 Mihrab. Iran. c.1354. Composite body, glazed, sawed to shape and assembled in mosaic. Height 11′3″.
The Metropolitan Museum of Art. Harris Brisbane Dick Fund, 1939 (39.20).
Image copyright The Metropolitan Museum of Art/Art Resource/Scala, Florence.

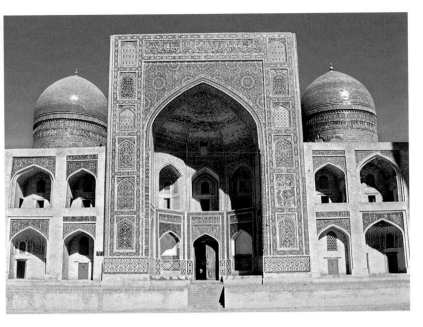

two domes, one marking the lecture hall, and the other the founder's tomb. Most surfaces are dazzling with tiles in floral, geometric, and epigraphic patterns, showing how color is often integral to Islamic architecture.

Persian painters rank among the world's great illustrators, as they made pictures to accompany handwritten copies of their major literary works. Such illustrated books were prized possessions of the aristocracy. One of the finest illustrations is *Sultan Sanjar and the Old Woman* (**fig. 19.8**), from the *Khamseh*, or "Five Poems," by Nizami. The story is an allegory on vanity: The

19.7 Mir-i-Arab Madrasa. Bukhara, Uzbekistan. 1535–1536. Façade.
Photograph: David Flack.

The mihrab has been separated from its original site, but it provides an example of the richness of Persian decorative arts (see fig. 16.26). Such techniques were often applied to entire buildings, as we see at the Mir-i-Arab Madrasa in Uzbekistan (**fig. 19.7**). A **madrasa** is a Muslim theological school where the history of Islam and the interpretation of the Qur'an are taught. This one was named for its founder, a member of the philosophical Muslim sect known as Sufism.

The well-proportioned array of openings in two stories provides a counterpoint to the **iwan**, the large covered porch at the center. Behind are

19.8 Attributed to Sultan-Muhammad. *Sultan Sanjar and the Old Woman*. From the *Khamseh (Five Poems)* of Nizami, folio 181. 1539–1543. Gouache on paper. 14½" × 10".
The British Library London © British Library Board/Robana.

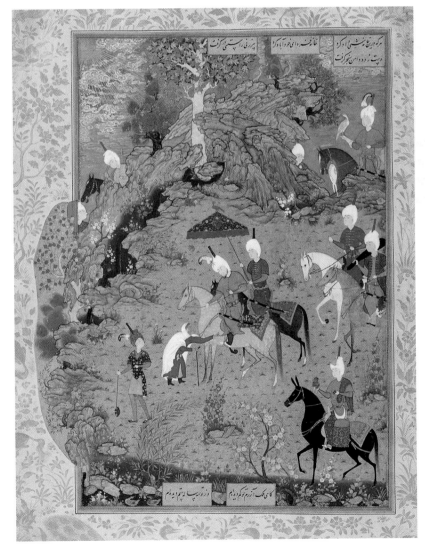

ART FORMS US: WORSHIP AND RITUAL

Contemplating Pattern

19.9 Usama Alshaibi. *Allahu Akbar*. 2003.
Still from digital video.
PAL, black/white, sound.

Art that is visually attractive and well crafted can lift us out of our daily routine and take us to a higher realm. In much of the art and architecture of Islam, intricate decorative schemes are used not only to satisfy the urge for beauty, but also to provide such spiritual uplift. The surfaces of mosques and madrasas (see figs. 19.6 and 19.7) are often decorated with glazed tiles that include floral and geometric patterns, as well as calligraphy. These richly colored and elaborate designs are intended to lead worshippers to an awareness of God (*Allah* in Arabic), the ordered patterns reflecting the divine patterning in God's original creativity.

Many modern Muslim artists use these traditional patterns in new ways. Usama Alshaibi, an Iraqi-American film director, based his short 2003 film on decorative motifs of the sort found in mosques or on carpets. He scanned several of these patterns, and animated them with motion graphics software (**fig. 19.9**). His idea, he said, was "taking hand-drawn patterns and moving them in ways that they have not been moved before."[1] In the five-minute film, the patterns slowly spin, come apart, and overlay one another, to a background score of Iraqi music. Though he does not profess to be an observant Muslim, he titled the work *Allahu Akbar* (God is Great), a reflection of the traditional connection between visual delight and religious piety. He said of this work: "New images emerged, and created an entirely different way of viewing these traditionally static designs. *Allahu Akbar* attempts to come closer to that ultimate beauty and mystery."[2]

The other main type of abstract pattern used in Islamic art is calligraphy, which is held sacred because it beautifies the word of God. Iranian artist Charles Hossein Zenderoudi made calligraphy the basis of his art for many years. In the 1970s he began a series of large works that consist mostly of Persian syllables, repeated hundreds of times like a meditation exercise. He explained the origin of his style: "It was around 1955 or 1956 while I was still studying at the Fine Art College [in Teheran], when I came across a shirt in the National Museum, covered with prayers and numbers . . . I was shocked in a strange way. I realized that I can use these religious elements."[3] The title of his 1972 work, *VAV + HWE* (**fig. 19.10**), is based on two Persian words that mean "by" and "he," the latter referring to God. The concentric circles of brushwork syllables may refer to the passage of stars around the Pole Star, or the circular path of pilgrims around Islam's holiest shrine in Mecca. Zenderoudi said of his work: "Like the architect who uses stones or bricks to construct a building, I use calligraphy to construct my painting."[4] His calligraphic strokes take the eye on a pilgrimage, lifting us from the complexities and routines of daily life.

19.10 Charles Hossein Zenderoudi. *VAV + HWE*.
1972. Acrylic on canvas. 78¾" × 78¾".
Private Collection. Photo © Christie's Images/The Bridgeman Art Library
© 2013 Artists Rights Society (ARS), New York/ADAGP, Paris.

sultan was out riding with his courtiers one day when an old woman approached him, complaining that one of his soldiers had robbed her. Sanjar dismissed her, saying that her troubles were nothing compared to his with his military campaigns. The woman then confronted him, saying, "What good is conquering foreign armies when you can't make your own behave?"

The work is a careful composition with luxurious details in the fabrics, vegetation, and clouds. Subtle gestures help to tell the story, which takes place in the center. The method of rendering rocks in Persian painting owes a great deal to Chinese art, which the Persians knew, but the Persian artist made some of these resemble faces. These paintings were most often produced in workshops, so that we do not generally know the artists' names, but in this case it seems fairly certain that the work is by Sultan-Muhammad, one of the two or three most highly regarded painters of Safavid Persia.

India: The Mughal Empire

Heirs to both Persian and Mongol traditions, the Mughal rulers of the Indian subcontinent governed a wide mix of cultures in the sixteenth and seventeenth centuries. Their subjects were Hindu, Jain, Zoroastrian, and even Christian. Only a minority (the upper classes) were Muslim. This meant that in the Mughal Empire, Islam evolved further from its Arab roots than anywhere up to that time.

Governing such a diverse people led the Mughal rulers to a level of tolerance unknown elsewhere in the world. Akbar, for example, who ruled from 1556 to 1605, ordered his ministers to learn about the various religions practiced in his realm, and he hired tutors to teach them. He also established a new religion that combined elements of all, and made himself the head of it, the better to resolve disputes. When Jesuit missionaries from Baroque Rome visited him, he entertained them lavishly and bought Western religious prints from them for his art collection. He encouraged figural representation in art, saying that trying to copy God's handiwork by making pictures would lead artists to a deeper respect for divine creativity.

19.11 Divan-i-Khas. Interior. 1570–1580. Fatehpur Sikri, Uttar Pradesh, India.
Photo Jonathan M. Bloom and Sheila S. Blair.

View the Closer Look for the private audience hall, Fatehpur Sikri, on myartslab.com

Akbar embodied his novel precepts in architecture, as we see in his throne room, the Divan-i-Khass (**fig. 19.11**). The room is dominated by an ornate pillar with four passageways that lead to it. The stone used for building was soft, making possible the carving of the numerous openwork grilles. Akbar sat at the center, atop the pillar, at the intersection of the religious systems in his realm. The English word *mogul*, with its connotations of wealth and power, derives from Mughal rulers such as Akbar.

The last Mughal ruler to hold the realm together was Shah Jahan, who also created the most memorable piece of Mughal art, the Taj Mahal (see fig. 2.13). Alongside a river, Jahan erected this unforgettable building as a memorial to his favorite wife after she died in childbirth. There is no similar architectural testament to romantic love in all the world. Its white marble surfaces show different colors throughout the day, as the building catches sunlight from various angles. The bulb-shaped dome seems light in weight. The walls seem paper-thin, with arch openings in a graceful rhythm. The building appears to hover above a garden whose design is based on the description of Paradise in the Qur'an.

The central iwan is fronted with a pointed arch; just above the opening is a decoration of twining vegetation

(**fig. 19.12**). The beauty of this building comes not from decorations, but rather from expensive materials and poetic arrangement of masses. The paradise motif of the garden is continued in the long inscription surrounding the doorway arch, which contains the most important chapter from the Qur'an describing the afterlife. Tombs for both Shah Jahan and his wife are at the center on a lower floor. He expressed his vision for the building in a written note: "Like the garden of heaven a brilliant spot, full of fragrance like paradise fraught with perfume."[5] The Taj Mahal's central dome and high iwan show influence from earlier Mughal tombs, but here the rich marble and perfectly balanced masses create an otherworldly building.

Study and review on myartslab.com

19.12 Taj Mahal. Central iwan, upper portion. Agra, India. 1632–1648.
Gavin Hellier/Robert Harding.

Watch an architectural simulation about the Taj Mahal on myartslab.com

View the Closer Look for the Taj Mahal on myartslab.com

THINK BACK

1. Why is the human figure rare in Islamic art?

2. What are the key features of a typical mosque?

3. Why are carpets extremely important to the history of Islamic art?

TRY THIS

The figural arts are not banned in Islam (see fig. 19.8). How might an artist commissioned to create a work determine if it could or could not include figures?

KEY TERMS

iwan – a high vaulted porch to mark an important building or entrance

madrasa – a building that combines a school, prayer hall, and lodging for students

mihrab – a niche in the end wall of a mosque that points the way to Mecca

minaret – a tower outside a mosque where chanters stand to call the faithful to prayer

20 AFRICA, OCEANIA, AND THE AMERICAS

THINK AHEAD

20.1 Describe art's integral role in the daily activities of native cultures in Africa, Oceania, and the Americas.

20.2 Recognize the variety of materials, styles, and cultural purposes that characterize traditional African art.

20.3 Compare ways that art serves a commemorative function in society.

20.4 Analyze the range of visual characteristics and meaning found in Oceanic art.

20.5 Examine the continuation of artistic traditions in native North American cultures.

20.6 Discuss art tracing historical developments in Central and South America.

Most of us in the West tend to think of art as something to go and see in a museum; this is where most art is kept, after all. Or perhaps we believe that art is something that decorates our homes. Most of us arrange paintings or sculptures (or reproductions of them) as embellishments of our personal spaces.

In this chapter we will consider traditional arts from regions where art is not created solely for visual pleasure or embellishment. These cultures did not set aside places for the care and enjoyment of art. Rather, the cultures we consider here found uses for art in religious ritual, civic life, and community functions.

Africa

The arts of the African continent are extremely varied, and the diversity of style reflects the variety of cultures on the continent (**fig. 20.1**). Africa is larger than China, the United States, and Europe combined. North of the Sahara, the art forms of Africa generally fall under the influence of Egyptian (see Chapter 15), Roman (see Chapter 16), or Islamic traditions (see Chapter 19). Here we will focus on sub-Saharan Africa.

Humanity originated in Africa. But because most ancient African art was made from perishable materials, little remains from before the thirteenth century. Tin miners digging in central Nigeria accidentally unearthed the oldest surviving examples of sub-Saharan art, such as the head from the Nok

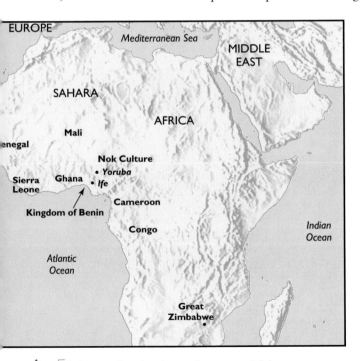

20.1 Africa.

((•— **Listen** to the chapter audio on myartslab.com

culture shown here (**fig. 20.2**). Archaeological evidence indicates that these works, of which hundreds have been found, date from the time of the Greeks and the Romans. Modeled in **terra cotta** (unglazed reddish earthenware), they are nearly life-size. The heads were probably once attached to torsos. Their finely carved hair ornaments and facial features show that there had been sophisticated wood carving in that region. The vivid facial expression of the head makes it seem like a portrait of an individual, but at the same time there is a degree of abstraction in the treatment of the eyes and nose. Little else has survived from the Nok culture. Although we know little about it, its art seems to have heavily influenced other cultures of West Africa.

Concurrent with the Gothic era in twelfth-century Europe, a naturalistic style of court portraiture was developed for the royal court of Ife, a sacred Yoruba city in southwestern Nigeria. The male portrait head (**fig. 20.3**) demonstrates the Ife skill in bronze casting. Such thin-walled, hollow metal casting probably represents the culmination of generations of technical progress. Grooved lines emphasize facial contours; rows of small holes probably held a beaded veil.

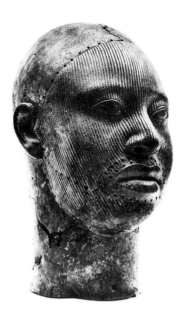

20.3 Male Portrait Head.
 Ife, Nigeria. 13th century. Bronze. Height 11⁷⁄₁₆″.
 University of Glasgow Archive Services, Frank Willett collection.

Ife influenced the sculptural arts of neighboring Benin. The Benin head (**fig. 20.4**) exemplifies another court style, developed in Benin, which was somewhat abstract in comparison to the naturalism of Ife portrait sculpture.

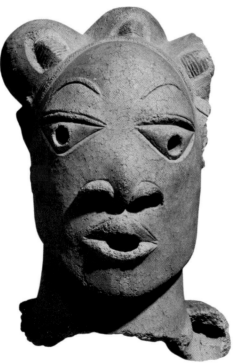

20.2 Head. Nok culture. Nigeria.
 500 BCE–200 CE. Terra cotta. Height 14½″.
 National Museum, Lagos, Nigeria. Photograph: Werner Forman Archive.

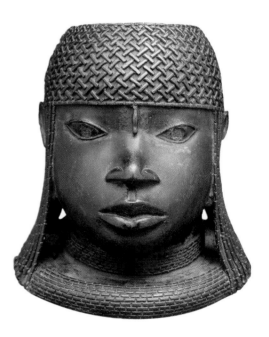

20.4 Benin Head. c.1550. Nigeria.
 Metalwork-bronze, 9¼″ × 8⅝″ × 9″.
 The Metropolitan Museum of Art, New York. The Michael C. Rockefeller Memorial Collection. Bequest of Nelson A. Rockefeller, 1979. Acc.n.: 1979.206.86. Photograph: Schecter Lee. Image © The Metropolitan Museum of Art/Art Resource/Scala, Florence.

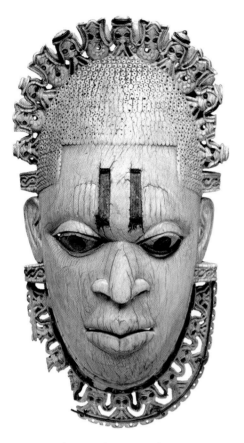

20.5 Pendant Mask. Court of Benin, Nigeria. Early 16th century. Ivory, iron, copper. Height 9⅜″.

Metropolitan Museum of Art, New York. The Michael C. Rockefeller Memorial Collection, Gift of Nelson A. Rockefeller, (1978.412.323). Image © The Metropolitan Museum of Art/Art Resource/Scala, Florence.

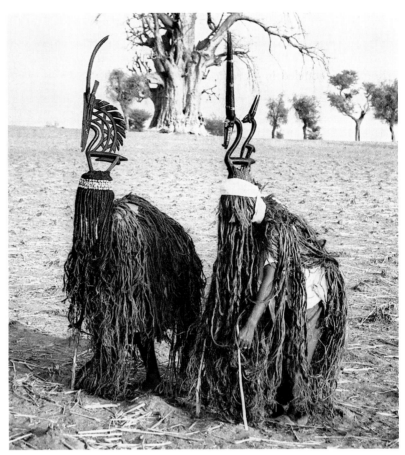

20.6 Tyi Wara Dancers. Mali.

Photograph: Dr. Pascal James Imperato.

Bronze casting in Benin was an art form devoted exclusively to glorifying the king (or *oba*). The technology was a closely guarded secret, which only licensed royal artisans could practice. Most of the Benin heads are portraits of royalty or other distinguished ancestors. The heads were generally placed in altars that successive generations tended.

When sixteenth-century Europeans first arrived in the kingdom of Benin, they were impressed by cast-bronze sculptures, palaces, and a city that compared favorably to their own capital cities. The ivory pendant mask from Benin (**fig. 20.5**) was carved in the sixteenth century, and modern versions are still worn on the oba's chest, or at his waist, during ceremonies. This pendant mask portrays a queen mother who gazes out with a serene expression. She wears a crown that depicts alternating human heads and mudfish. The human heads are meant to represent Portuguese traders and sailors who regularly visited Benin and,

at times, helped the king resolve diplomatic disputes with neighboring peoples. A close examination of the figures reveals that they wear round caps and have long mustaches. The mudfish symbolize immortality because they seem to rise up alive from the mud each year. The two vertical marks in the queen mother's brow are shallow slots that held consecrated ointments during ceremonies.

The Bamana people of Mali are renowned for their carved wooden antelope figure headdresses, which young men attach to basketry caps and wear atop their heads during agricultural ceremonies. When a new field is cleared, the most diligent male workers are selected to perform a dance of leaps in imitation of the mythical *tyi wara* (**fig. 20.6**), who taught human beings how to cultivate crops. The dance always represents both male and female *tyi wara* figures: The female is identified by a baby on her back, the male by a stylized mane. Abstracted antelope bodies become energized, almost

linear forms. Rhythmic curves are accented by a few straight lines in designs that emphasize an interplay of solid mass and penetrating space.

The bold, uninhibited style of art of the grasslands region of Cameroon looks far removed from the aristocratic styles of Ife and Benin, even though it also was developed for royal courts. The separate areas of the large dance headdress (**fig. 20.7**) are clearly defined by different patterns and textures. This heavy sculpture, worn by court officials, does not copy the human head but reinterprets it.

The Yoruba peoples of Nigeria have a tradition of figural woodcarving that makes use of diminutive proportions and almond-shaped parts. The house post (**fig. 20.8**) by Olembe Alaye is not only a literal support for a roof; it is also a meditation on the idea of support. Stacked in this composition are (from the top) an elder of the tribe seated in a folding chair, a

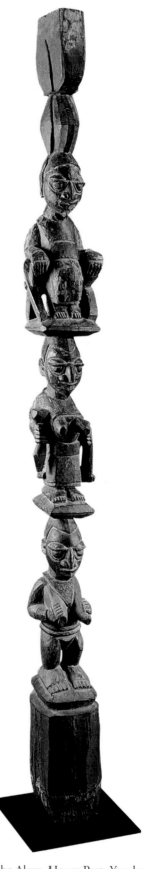

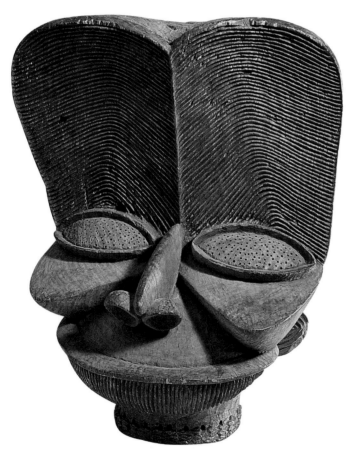

20.7 Large Dance Headdress. Bamenda area, Cameroon, Africa. 19th century. Wood. Height 26½″.

Museum Rietberg, Zurich. Edward von der Heydt Collection. Photograph: Wettsin & Kauf.

20.8 Olembe Alaye. House Post. Yoruba, Nigeria. Mid-20th century. Wood and paint. Height 83″.

Fowler Museum at UCLA. Photograph by Don Cole.

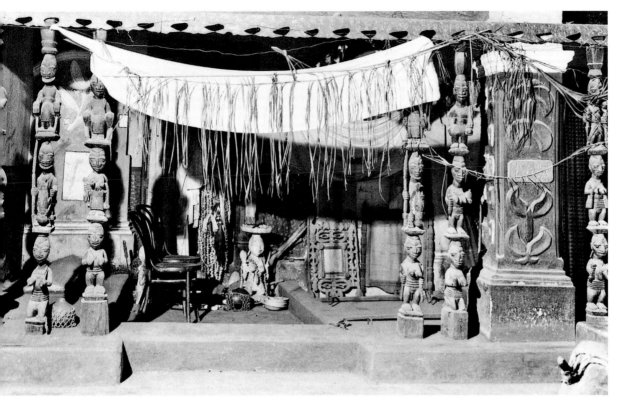

20.9 Tomb of Former Chief Lisa. Ondo, Nigeria.
Our featured House Post is third from left.
Photograph: W. Fagg, 1959. William B. Fagg Archive. Fowler Museum at UCLA.

woman holding a baby on her back, and a second woman holding her breasts in a traditional gesture of respectful welcoming. All three of these people are important to the maintenance of the society, as they represent wisdom, nurturing, and hospitality. All three personify characteristics that support the community.

The house post takes on added meaning when we see it on location in a 1959 photograph, Tomb of Former Chief Lisa (**fig. 20.9**). The chief was the "pillar of the community;" placing these posts at the front of his tomb added significance and honor to his memory. He is buried among other emblems of support that, all together, symbolize important aspects of tribal life.

Not all African art has been made for royal or honorific uses. As with the *tyi wara* antelope figures discussed earlier (see fig. 20.6), much art is intended to influence future events for the better, or to secure the social order. An example is the Mangaaka power figure (**fig. 20.10**) from Congo. This figure was created to personify the force of justice (or Mangaaka). The carver endowed it with an honorary headdress

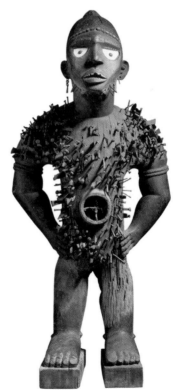

20.10 Mangaaka Power Figure. 19th century.
Yombe people, Republic of the Congo.
Wooden figure with iron nails. Height 34⅝".
Photograph: Claudia Obrocki. Ethnologisches Museum, Staatliche Museen, Berlin, Germany. Bildarchiv Preussischer Kulturbesitz/Art Resource, NY.

Veneration

Commemoration may be personal, as we each hold memories of people important in our lives. But commemoration can also be a more public act, one of remembrance or one that honors the life and actions of a significant person. A hero is someone who is widely admired for his or her achievements or noble qualities, and art has been used throughout history and across the world to commemorate such people. The traits that make someone a hero vary from culture to culture, as do the forms of veneration.

In many traditional societies of Africa, much art has a commemorative aspect. This carving (**fig. 20.11**) represents Shyaam the Great, the founder and most important king of the Kuba peoples of the Congo. He holds a ceremonial weapon in his left hand as he sits, cross-legged and aloof, the picture of quiet detachment. His headdress is traditional royal regalia, a hoe-shaped cap that alludes to his introduction of iron smelting and his encouragement of agriculture as the basic economic activity of the region. His eyes are shaped like cowrie shells, a symbol of wealth. The oval-shaped box at his feet represents the strategic board game known as *mankala* that he invented in order to improve the intellectual abilities of his subjects. While Shyaam was alive, this statue was kept in the quarters of his wives, to increase their fertility. On his death, his successor slept with the statue in order to facilitate the transmission of wisdom between generations. Thereafter, the statue was stored as part of a commemorative altar, and regularly rubbed with oil, which gives this work its rich glow. If a royal portrait statue is ever damaged, artists create a replica to prolong the memory; this work is an eighteenth-century copy of a seventeenth-century original.

One of the most poignant examples of commemoration in Western art is *The Death of Marat* (**fig. 20.12**), a painting that honors an activist during the time of the French Revolution at the end of the eighteenth century. Jean-Paul Marat was a scientist and physician who published a newspaper called *The People's Friend*, which he used as a forum for attacking entrenched aristocrats who guarded their privileges. With the fall of the French monarchy in 1792, Marat was elected to the National Convention, a governing and law-making body. However, he suffered from a rare skin disease, and his worsening condition in the next year forced him to retire to his home, where he wrote copiously and took medicinal baths.

In July 1793, a member of a competing faction entered his house and stabbed him fatally. The artist Jacques-Louis David, a friend of Marat and sympathetic to the revolutionary cause, created the commemorative painting soon after. David depicted Marat without the scabs and discolorations that blotched his diseased skin, and minimized the bloodshed. The work shows Marat dying a quiet and serene death, as if he were a martyr bathed in divine light. Rather than dying for his religion, however, Marat died for a political cause that he believed in. The wooden packing crate that Marat used

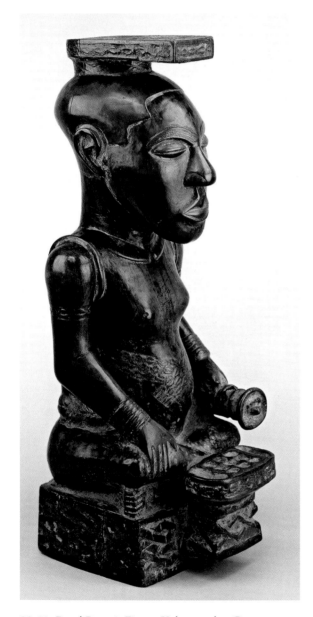

20.11 Royal Portrait Figure. Kuba peoples. Congo, 18th century. Wood. Height 22″.
The British Museum © The Trustees of the British Museum.

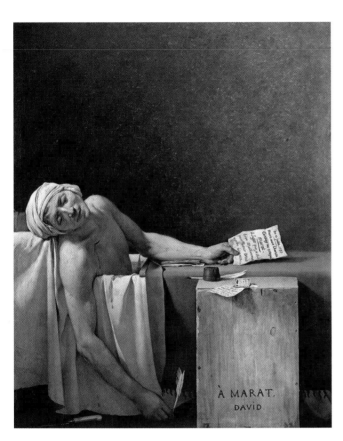

20.12 Jacques-Louis David. *The Death of Marat*. 1793. Oil on canvas. 5′5″ × 4′2½″.
Musées Royaux des Beaux-Arts de Belgique, Brussels/The Bridgeman Art Library.

unreal movie world that he inhabits suggested by the flat silver background.

Warhol first exhibited this work in a gallery along with 27 other identical, life-size images of Elvis; most singles, some doubles, and at least one *Triple Elvis*. He was fascinated by the repetitions that the silkscreen medium can yield. The multiplicity of copies undercuts the uniqueness of celebrity status, highlighting instead the reproducible quality of both the silkscreen medium and the cinema. So, Warhol seems to be saying, we should commemorate our celebrities in the same way that they come to us: as clever combinations of real and copy, in an infinitely reproducible format.

for furniture carries the artist's signature and a dedication. Rarely has a violent death been commemorated so peacefully.

To the French Revolution's supporters, Marat was a hero. But who are our heroes now? How should we commemorate them? Andy Warhol offered ironic answers to both questions in his silkscreen work *Double Elvis* (**fig. 20.13**). In place of heroes, this work seems to say, we now have celebrities. Unlike a hero, a celebrity excites more fascination or curiosity than admiration, and his or her fame depends on the mass media. In this work, Warhol borrowed a publicity photo of Elvis Presley from the 1960 Western film *Flaming Star*, and scaled it close to life-size. By draining out the color Warhol presented the image people might have seen on their black-and-white television screens, which were still common in those days. The "hero" here is devoid of context, more an icon than a human being, the

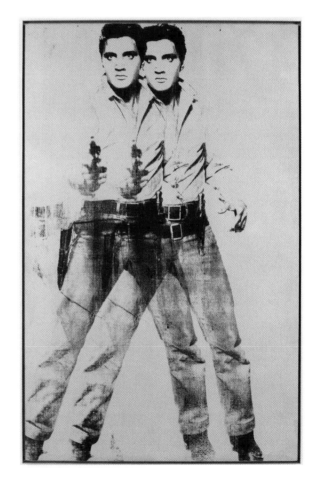

20.13 Andy Warhol. *Double Elvis*. 1963. Silkscreen and acrylic on canvas. 83″ × 53″.
Museum of Modern Art (MoMA) Gift of the Jerry and Emily Spiegel Family Foundation in honor of Kirk Varnedoe. Acc. n.: 2480.2001. © 2013. Digital image The Museum of Modern Art, New York/Scala, Florence. © 2013 The Andy Warhol Foundation for the Visual Arts, Inc./ Artists Rights Society (ARS), New York.

and posed it leaning forward in an assertive manner to suggest decisiveness. In the abdominal cavity, tribal authorities placed medicinal matter (now lost) intended to strengthen the statue's function. Then, whenever a civil case was concluded, a treaty ratified, or a law enacted in the presence of the statue, tribal members affected by the decision symbolized their agreement by driving a metal piece into the statue's surface. More than 400 such pieces adorn this work, testifying to its use over many decades.

The textile arts are highly developed in Africa, and many cloth styles have specific uses. The Ashanti peoples of Ghana use looms to weave narrow cloth strips,

20.15 Adire Cloth. "Women's Wrapper with Human Hands and Proverbs" (detail). Yoruba, Lagos, Nigeria. 1984. Dark and light blue cotton cloth, paste-resist and stencils, natural indigo dye. 76″ × 62″.
Collection of Flora *Edouwaye* S. Kaplan, NY. Photograph: Sheldan Collins.

20.14 Kente Cloth. "Mmeeda" ("Something that has not happened before"). Ghana. 20th century. Cloth (strip weave). 59¹⁄₁₆″.
Seattle Art Museum, Gift of Katherine White and the Boeing Company. Photograph: Paul Macapia.

which they then sew together into patterns that symbolize important proverbs or ideas. For example, the Kente cloth pattern called "Mmeeda" (**fig. 20.14**) is worn when something unprecedented happens. The most famous instance of the use of this pattern came when Ghana was still a colony and the political party of jailed independence leader Kwame Nkrumah won national elections. He wore this pattern when the British released him from prison three days after the balloting. Later, when announcing Ghana's independence on March 6, 1957, Nkrumah (by then Ghana's first president) wore a cloth with the pattern that said, "I have done my best."

Making adire cloth such as the piece pictured here (**fig. 20.15**) requires a stencil made from a sheet of tin. Women lay the stencils over the cloth, and then press flour-and-water paste into the openings. When the stencil is lifted off, the patches of paste remain on the cloth and resist the action of the blue indigo dye. The rest of the fabric takes on the typical deep blue color after repeated soakings, leaving the words and designs a lighter shade. This adire cloth contains repeated handprints, together with traditional Nigerian proverbs and sayings about the hand, such as "My hand is my closest friend."

Oceania and Australia

Oceania is the collective name for the thousands of Pacific islands that comprise Melanesia, Micronesia, and Polynesia (including New Zealand). These islands were settled by migrants from Southeast Asia over a very long period, lasting from about 26,000 BCE, when New Guinea and Irian Jaya were populated, until about 800 CE, when migrants reached New Zealand. Although it is difficult to generalize about Oceanic art, because the cultures, physical environments, and raw materials vary greatly over an enormous area, a few traditional beliefs seem to have been held in common across the Pacific, and these have influenced the creation of art.

First is the belief that the world as we know it was created by the union of the Earth Mother and the Sky Father. Their contact created life forms on the planet's surface. The Oceanic traditions view ancestors as intermediaries between people and the gods. Because ancestors who now live in the spirit world can intercede and influence future events, Oceanic artists have created many objects to honor or placate them.

Another widely shared concept is **mana**, or spiritual power. Mana may reside in persons, places, or things. Many art forms of Oceania were intended to possess this power, which can keep adversity at bay, promote community well-being, and enhance personal power and wisdom.

Oceanic peoples developed very little pottery because of a shortage of clay, and they were not acquainted with metal until traders introduced it in the eighteenth century. For tools, they used stone, bone, or shell; they made houses, canoes, mats, and cloth with wood, bark, and small plants. Feathers, bone, and shells were employed not only for utensils and sculpture, but also for personal adornment.

In the Solomon Islands and New Ireland (part of Melanesia), woodcarvings and masks are designed to serve ritual purposes. In the art of many Melanesian societies, birds appear with human figures to act as guides or messengers between the physical world of the living and the spiritual world of deceased ancestors. The bird held by the protective prow figure from a war canoe (**fig. 20.17**) from the Solomon Islands guides voyagers by acting as a protective spirit that watches out for shoals and reefs. Although the carving is only the size of a hand, it looks much larger because of the boldness of its form. The exaggerated nose and jaw help give the head its forward thrust. Against the blackened wood, inlaid mother-of-pearl provides strongly contrasting white eyes and rhythmically curving linear ZZZ bands.

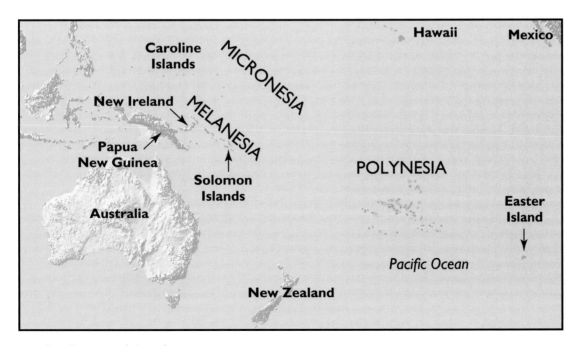

20.16 Oceania and Australia.

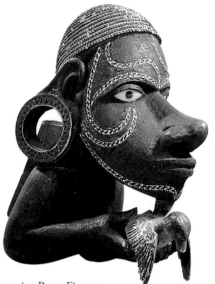

20.17 Protective Prow Figure
from a War Canoe.
New Georgia Island, Solomon Islands. 19th century.
Wood, inlaid with mother-of-pearl. Height 6½″.
Werner Forman Archive/Museum fur Volkerkunde, Basle,
Switzerland. Location: 03.

A bird also plays a prominent role in the New Ireland mask (**fig. 20.18**). The elaborately carved openwork panels are painted in strong patterns that accent and at times oppose the dynamic forms of the carving. Snail-shell eyes give the mask an intense expression. In the wings of this mask, chickens hold snakes in their mouths, a reference to the opposition of sky and earth. Anthropologists believe that this piece was used to remove bad influences from a new ceremonial house. Once it had fulfilled its function, it was regarded as "used up" and discarded.

Carvings made in Micronesia and in much of Polynesia are streamlined and highly finished. The female figure from Nukuoro Atoll (**fig. 20.19**) has a distinctive spare quality. This figure is one of about 30 similar sculptures that were collected in the nineteenth century. All show similar bodily proportions, which suggests that the carvers followed a set of traditional customs. The degree of abstraction in these pieces is unusual. Most anthropologists believe that the figures

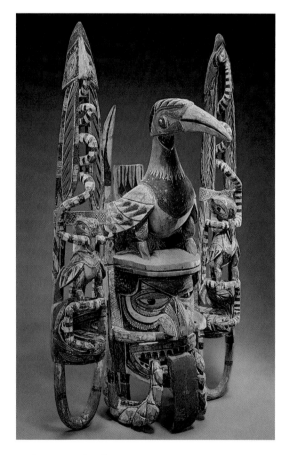

20.18 Mask. New Ireland. c.1920.
Painted wood, vegetable fiber, shell. 37½″ × 21⅓″.
Fowler Museum at UCLA. Photograph by Don Cole.

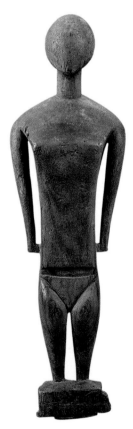

20.19 Female Figure. Nukuoro Atoll, Central Carolines.
19th century. Wood. Height 15⁹⁄₁₆″.
Honolulu Museum of Art, by exchange, 1943 (4752).

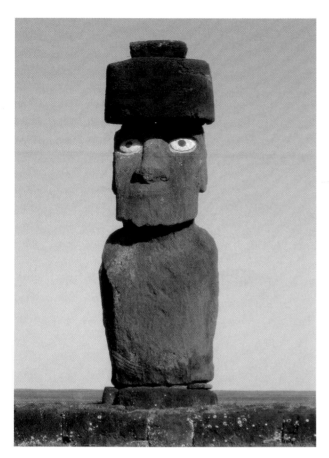

20.20 Moai. Easter Island. c.1000–1500.
Volcanic rock. Height 12′.
Photograph: Patrick Frank.

settlements along the coastline, as if protecting and overseeing the activities below. Many Polynesian cultures accord similar homage to ancestors, but none on the scale we see here.

An outstanding example of semi-abstract Hawaiian sculpture is the forceful aumakua (**fig. 20.21**) (ancestral deity) found in the burial cave of a chief or high priest. By eliminating extraneous details and carefully articulating the parts of the body, the sculptor increased the impact of the female figure's bold stance. Its power is enhanced by the attached reddish human hair, shell eyes, and open mouth with bone teeth.

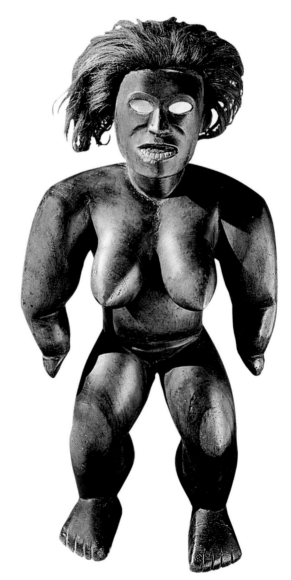

20.21 Aumakua. Forbes Cave, Hawaii.
Koa wood. Height 29″.
Photograph: Seth Joel, Bishop Museum.

represent gods, but the local religion died out under the impact of missionaries and population shifts. Although Nukuoro is located in the southern part of Micronesia, the culture is Polynesian.

Polynesia covers a large, triangular section of the Pacific, from New Zealand to Hawaii to Easter Island. Widely separated Polynesian islands and island groups developed greatly varied arts that include both delicate and boldly patterned bark cloth, featherwork, shellwork, woodcarvings, and huge rock carvings.

The original inhabitants of Easter Island left more than 600 carved moai (**fig. 20.20**) before European explorers first visited the island in the 1770s. These stone figures, which are up to 32 feet tall, are statues of torsos and heads; some have a topknot made from stone of a different color, as we see here. These figures represent ancestors who have taken on spiritual power; they were placed on raised platforms overlooking small

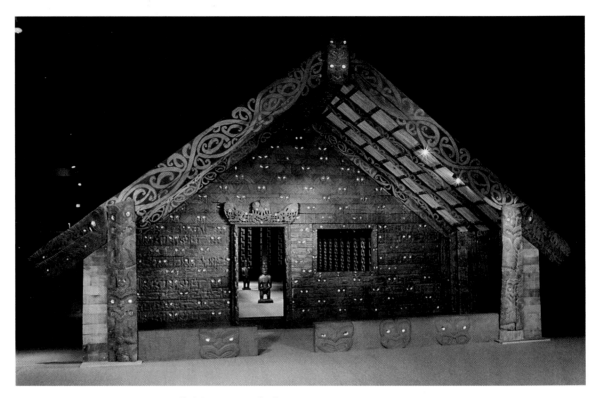

20.22 Maori Meeting House. Called "Ruatepupuke."
New Zealand. 1881. Length 56′. Height 13′10″.
The Field Museum, Chicago.
Photograph: Diane Alexander White, Linda Dorman.

a. Front view.
Neg. #A112508c.

b. Ridge pole.
Neg. #A112508_c.

The arms-out, knees-bent, feet-apart position gives the figure a strong presence. Full upper arms taper to small forearms and even smaller hands. There is consistent use of full, rounded, almost inflated mass. The well-polished dark wood and inset material show a high degree of craftsmanship.

Many art forms come together in the Maori meeting house (**fig. 20.22a**), which is a typical structure of traditional New Zealand. Such houses are used for extended family gatherings and rituals in honor of ancestors. The house pictured is named Ruatepupuke in honor of the ancient ancestor of a clan that lives in the eastern corner of the north island.

Not only is the house named for the ancestor, it symbolizes his presence. His face is at the top of the gable; the ridge represents his back; the rafters are his ribs; the outer upright posts symbolize his arms, as if he is on all fours, looking straight ahead. The front gable boards are painted in patterns that derive from

20.23 Bunia. *Funerary Rites and the Spirit's Pathway After Death.* Mid-20th century. Australia. Natural colors on bark.
Groote Eylandt, Arnhem Land, Northern Australia.
© The Art Gallery Collection/Alamy.

growing ferns. The faces of numerous other ancestors are carved in relief across the front of the house; most noticeable are the eyes of each, which are made from inlaid abalone shell. Through the doorway can be seen two center posts that hold up the ridge pole; these also represent ancestors. On the inner walls, relief carvings alternate with abstract patterns in matted flax.

The ridge pole above the porch (**fig. 20.22b**) is a relief carving of the Earth Mother and the Sky Father, the ancestors of all life forms. The degree of abstraction in these figures is typical of Maori carving, with swirling bands and spirals used in body decoration and derived from plant forms. This single board was carved in 1881; it cracked after drying unevenly. The slightly ferocious aspect of these figures indicates that they inhabit the spirit world, and this carving attempts to communicate some of their mana.

The human presence in Australia dates back forty thousand years. For tens of thousands of years before the invention of writing, Native Australians maintained an intimate bond with nature, as demonstrated by their art. While most other human groups gradually changed from wandering food foragers to settled farmers, manufacturers, and merchants, Native Australians continued to live as semi-nomadic hunter-gatherers without clothing or permanent shelters and with only a few simple but highly effective tools.

The recognition of their dependence on nature is evident in nearly all art done by Native Australians and other tribal peoples. Native Australians see the bond between themselves and nature as a close relationship established by creative beings in the mythical or Eternal Dreamtime. The many disciplines and practices related to spiritual life vary from tribe to tribe, but Dreamtime spirits are prominent in nearly all Native Australian groups.

In the bark painting entitled *Funerary Rites and the Spirit's Pathway After Death* (**fig. 20.23**), animal and human symbols tell a story, with time segments shown in four sections. In the upper left section, a dying man lies on a funeral platform; in the lower left, a didjeridu player and two dancers perform for him until he dies. In the upper right, the spirit of the dying man and his two wives also dance until he dies. After his death, the man's spirit leaves the platform and begins the journey to the spirit world; along the way he crosses over the great snake. In the lower right, he uses a stone to kill a large fish as food for the journey. Some Native Australian artists began using paint and canvas in the 1970s, but their imagery has remained relatively constant for hundreds of years.

Native North America

Native peoples lived in North America for thousands of years before Europeans arrived on the continent. The oldest human-made artifacts—stone hearths and simple tools—may be 20,000 to 30,000 years old. Some carved bone tools and spear points are about 10,000 years old.

The Hopewell culture flourished in what is now Ohio from the second century BCE to the sixth century CE. Large Hopewell burial mounds contained rich offerings placed in elaborate log tombs. The later Adena culture built the Great Serpent Mound (**fig. 20.25**) in about 1070 CE near some of these early burials. The mound-builders first outlined the writhing design with rows of stones and then piled dirt between them. The serpent has a spiral tail, and its curving body ends with open jaws holding a large oval object. If it were extended, it would stretch more than 1,300 feet in length. Its meaning is a matter of debate, but the serpent's head and mouth point to the sunset at every summer solstice.

Native Americans today produce an astonishing variety of artworks, depending on their cultural tradition and the materials available in their region. In most cases, native art forms that are now practiced vigorously went through a period of disuse in the late nineteenth century when Indian reservations were first established. Today many Native American artists are making traditional works, and many more are working in contemporary and even "cutting-edge" styles.

The Navajo of Arizona have been resourceful weavers for more than two centuries. While many men weave blankets today, the art form was traditionally a woman's province. The Second

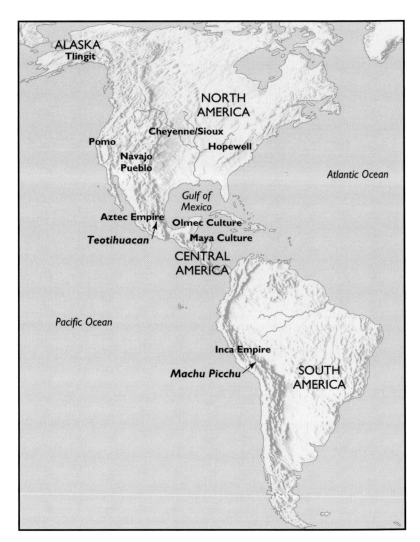

20.24 Americas.

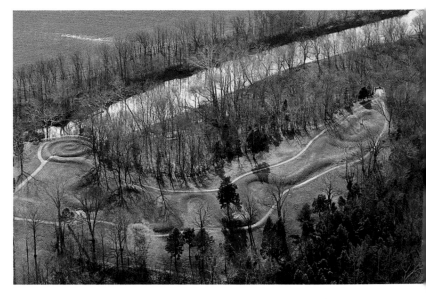

20.25 Great Serpent Mound. Ohio. Adena culture. c.1070 CE. Uncoiled length 1,370′.
Photograph: Mark Burnett/Photo Researchers, Inc.

20.26 Second Phase Chief Blanket. Navajo. c.1830–1850. Handspun wool with natural dyes. 74″ × 60″.
Private Collection. Photograph: Tony Berlant.

Phase Chief Blanket (**fig. 20.26**) comes from an early period, before the Navajo were exiled to eastern New Mexico in 1863–68. Like most Navajo weavings, it was created on a loom with warps spaced close together, yielding a dense fabric that is nearly waterproof. The design of this blanket has an austere, symmetrical geometric pattern that includes some subtle touches, such as the thin blue lines, and the continous red border around the four central bars. This style is called a Chief Blanket not because it was reserved for high officials, but because its quality made it so expensive that few could afford to own one.

The Pueblo peoples of the Southwest are best known for pottery, which is traditionally done by women. Each Pueblo has its own style; the jar (**fig. 20.27**) that we see here is from Ácoma. These pots are made from local earthenware and shaped without a wheel. The artists fire them in open fires and decorate them with pigments made from earthen powders. The abstract symbols in Pueblo pots generally do

20.27 Jar. Ácoma Pueblo. c.1850–1900. Height 12½″.
Museum of Indian Arts & Culture/Laboratory of Anthropology Collections, Museum of New Mexico. Photographer Blair Clark. 7912/12.

delighted children, provide humor, and occasionally give public scoldings. The carved and painted kachinas, such as the Hopi kachina shown here (**fig. 20.28**), are made by Hopi and Zuni fathers and uncles as a means of teaching children their sacred traditions.

Native Americans of the Pacific Coast region produce fine baskets. In northern California, Pomo artists made baskets of such incredible tightness that they can hold water. They vary greatly in size, shape, and decoration, from large containers up to 4 feet in diameter to tiny gift baskets less than a quarter of an inch across. Pomos wove strong geometric designs into many of their baskets and used ornaments such as feathers and shells to embellish others. The highest artistic achievements in Pomo culture are brightly colored feather baskets (**fig. 20.29**). As with Pueblo pottery, the art of basketmaking was traditionally passed down in families from mother to daughter and aunt to niece. The instruction was frequently accompanied by training in other tribal traditions. Treasured pieces were made as gifts, designed solely to delight the eye.

20.28 Marshall Lomakema. Hopi Kachina. 1971.
Shungopovi, Arizona. Painted wood.
Height: 34″.
Courtesy of National Museum of the American Indian/Smithsonian Institution (24/7572). Photograph: Carmelo Guadagno.

not have a fixed meaning, but refer to the forces of nature or to community life.

Most Pueblo peoples recognize the spirits of invisible life forces. These spirits, known in Zuni Pueblo and neighboring Hopi areas as **kachinas**, are impersonated by masked and costumed male members of the tribes, who visit the villages in a variety of forms, including birds, animals, clowns, and demons. During ceremonies they dance, present kachina figures to

20.29 Pomo Feather Basket. California. Before 1920.
Feathers, beads, and shells. 4″ × 13″ × 13″.
Southwest Museum of the American Indian Collection, Autry National Center of American West, Los Angeles; 811.G.1683/CT.294. Photograph by Larry Reynolds.

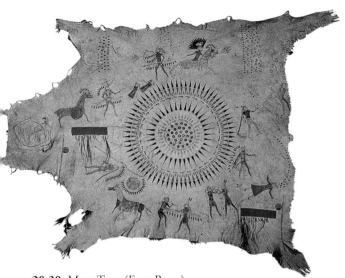

20.30 Mato Tope (Four Bears).
Robe with Mato Tope's Exploits. c.1835.
Buffalo hide, red wool cloth, sinew, dyed porcupine
quills, horsehair and human hair; brown, yellow,
and black pigment. 63″ × 83¾″.
Ethnographic Collection at the Bernisches Historisches Museum.
Photograph: S. Rebsamen.

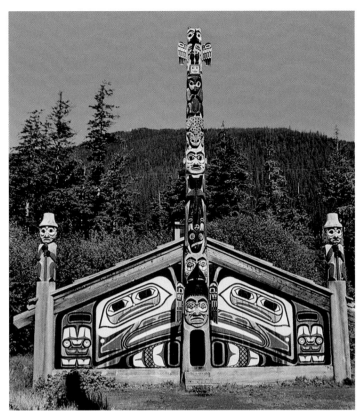

20.31 Tlingit Community House. Ketchikan, Alaska.
Photograph: Steve McCutcheon.

Plains Indians practiced the traditional art of painting on buffalo hides. Men traditionally made representational paintings of their deeds in battle, as we see in the hide robe showing Mato Tope's exploits (**fig. 20.30**). Mato Tope stretched this hide in the sun to dry and then painted it with organic pigments in a water-based solution. Exploit paintings are typically full of action, with the moving figures seen in profile views with no horizon line. The best examples date from before European contact, but they are very rare. Our example was collected by a fur trader and sent to Switzerland. Later hides depict battles with U.S. Army troops.

Northwest Coast tribes developed highly imaginative arts to depict their mythology. Elegant abstractions of animal subjects typify the painting and sculpture of the Tlingit and other tribes that inhabit the coastline from Seattle to Alaska. On house walls, boxes, blankets, and even dishes, major features of a symbolic animal form are laid out in two-dimensional abstract patterns. With its wide, gently sloping roof, elaborately painted façade, and totem poles, the Tlingit Community House (**fig. 20.31**) is characteristic of the art and architecture of the region. A **totem** is an object such as an animal or plant that serves as an emblem of a family or clan; it often symbolizes original, prehuman ancestors. The word itself, from a Native American language of the Upper Midwest, means "he is related to me."

The flat surfaces of the Tlingit Community House show abstract shapes of beavers, bears, whales, and ravens. The totem pole at the center consists of such stacked symbols, which help a family clan to remember its history back to mythological times, much like a family crest.

Pre-Conquest Central and South America

A variety of agricultural civilizations flourished in Mexico from about the time of Christ until the Spanish conquest of the 1520s. These cultures influenced one another through trade and conquest, and as a result they share many cultural forms, among them pyramids, calendars, and some important gods and myths. The earliest was the Olmec, who inhabited the Gulf Coast near what is now Veracruz. Probably more influential were the people who built the city of Teotihuacan, located in the central valley about 40 miles north of where Mexico City is today.

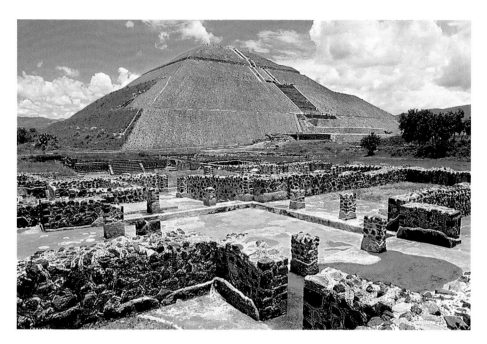

20.32 Pyramid of the Sun. Teotihuacan.
1st–7th century CE. 700′ wide, 200′ high.
© John Flannery/Photoshot.

👁 **Watch** a video about Teotihuacan
on myartslab.com

The Pyramid of the Sun (**fig. 20.32**)
in Teotihuacan is among the largest in the
world, covering slightly more ground than
the largest of the pyramids of Egypt. It rises
only about half as high, and it imitates the
shape of the surrounding mountains. Many
ancient Mexican cultures believed that
humanity first emerged from a hole in the
ground, and this pyramid may mark the
spot: It sits over a deep cave. The pyramid is
aligned to face the sunset on August 12, the
date corresponding to the beginning of time
in the Maya calendar. As we can see in the
photograph, the Pyramid of the Sun was at
the center of a large city, which archaeologists
calculate was the world's sixth largest at its
peak in 600 CE.

At one end of the central avenue of
Teotihuacan lies the Temple of the Feathered
Serpent (**fig. 20.33**), which has sculptural
decorations that influenced several other cul-
tures. Alternating on the layers of the temple

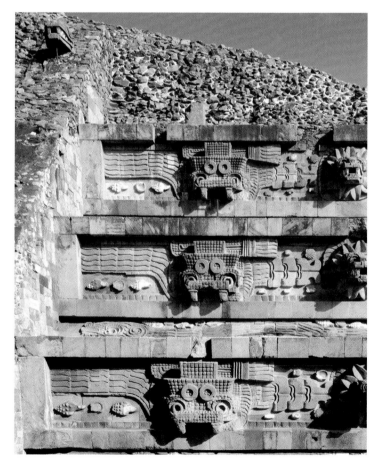

20.33 Temple of the Feathered Serpent (detail).
Teotihuacan. 150–200 CE.
Photograph: v0v/Fotolia.

priests used on ceremonial occasions; they emerged onto the high platform to perform dances as worshippers watched below.

Walls and roofs of Maya stone temples were richly carved and painted. An excellent example of Maya sculpture from one such temple is Lintel 24 (**fig. 20.35**) from Yaxchilan, a site on the border between Mexico and Guatemala. This stone relief is best understood with the help of the written symbols along its edges, which have recently been decoded. Standing is the king, Lord Shield Jaguar, holding a flaming torch. The sculptor seems to have rendered effortlessly the casual

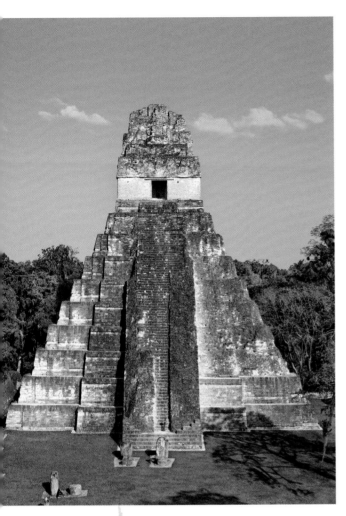

20.34 Temple I. Tikal, Guatemala. Maya. c.300–900 CE.
Photograph: Danny Lehman/Corbis.

👁— **Watch** a video about the rise and fall of the Maya on myartslab.com

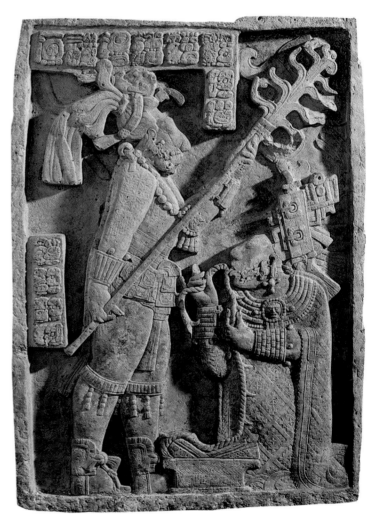

20.35 Lintel 24. Yaxchilan. Maya. 709 CE.
Limestone. Height 43″.
British Museum, London. © Justin Kerr, K2887.

🔍— **View** the Closer Look for Lintel 24, Yaxchilan, on myartslab.com

are relief heads of the storm god, with its goggle eyes and scaly face, and the feathered serpent, its fanged head emerging from a plumed wreath. Teotihuacan itself was abandoned after burning in a mysterious fire in about the year 750 CE. However, both of these gods were widely adopted by later cultures in ancient Mexico.

The Maya, whose descendants still live in what are now parts of Mexico, Guatemala, and Honduras, developed a written language, an elaborate calendar, advanced mathematics, and large temple complexes of stone.

The hundreds of stone temples at Tikal suggest that Maya priests had great power. Temple I (**fig. 20.34**), built during the classical Maya period (300–900 CE), rises over a great plaza in a Guatemalan rainforest. The 200-foot-high pyramid has a temple at the top, which

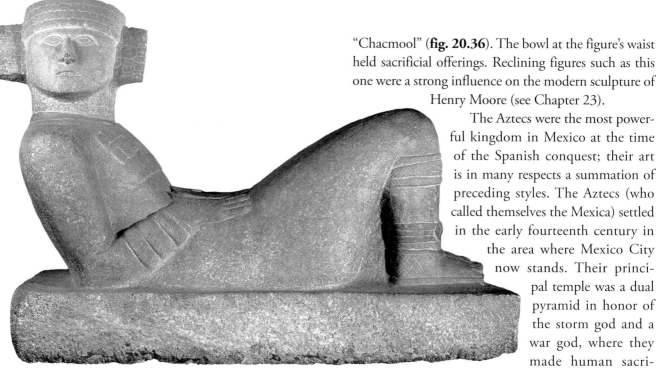

20.36 Chacmool. 10th–12th century.
Toltec. Stone. Length 42″.
akg-images/François Guénet.

"Chacmool" (**fig. 20.36**). The bowl at the figure's waist held sacrificial offerings. Reclining figures such as this one were a strong influence on the modern sculpture of Henry Moore (see Chapter 23).

The Aztecs were the most powerful kingdom in Mexico at the time of the Spanish conquest; their art is in many respects a summation of preceding styles. The Aztecs (who called themselves the Mexica) settled in the early fourteenth century in the area where Mexico City now stands. Their principal temple was a dual pyramid in honor of the storm god and a war god, where they made human sacrifices of the prisoners they had taken in warfare with neighboring peoples. The Aztecs believed that such sacrifices were necessary in order to honor and recreate the self-sacrifice that the feathered serpent had performed in ancient times in order to ensure the continuation of the world. They believed that this original sacrifice had occurred at Teotihuacan, which they regarded as a holy place.

The feathered serpent is frequently depicted in Aztec sculpture, but rarely with more horrific effect than in the Vessel of the Feathered Serpent Quetzalcoatl (**fig. 20.37**), a vessel for sacrificial

fall of the feathers in his headdress. His wife Lady Xoc kneels before him performing a ritual. She draws blood from her pierced tongue, which she will blot with the pieces of paper in the basket in front of her. She wears richly patterned clothing that hints at highly developed textile arts of that time (none of which, unfortunately, survive). Her elaborate headdress is crowned with the goggle-eyed storm god, who looks almost directly upward from the back of Lady Xoc's head. Especially noteworthy are the sculptor's evocation of the fleshiness of the figures, their subtle interaction, and the rich textures of their clothing. The writing on the work describes the action and even gives its date: October 28, 709.

The Toltec civilization that developed in central Mexico between the ninth and thirteenth centuries forms a bridge between the decline of the Maya and the rise of the Aztecs. During a time of conflict and change, the Toltecs initiated a major new era in the highlands of central Mexico, distinguished by architectural innovations and massive carved figures. A Toltec form that also occurs in Aztec and Maya art is the recumbent figure from Chichen Itza known by the Maya name

20.37 Vessel of the Feathered Serpent Quetzalcoatl.
Aztec. 1450–1521. Stone. Height 19″.
Museo Nacional de Antropologia, Mexico City.

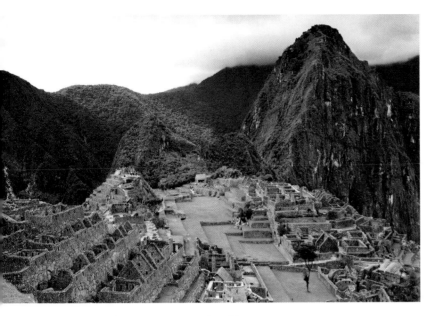

20.38 Machu Picchu. Inca. Peru. Early 16th century.
© Kent Kobersteen/National Geographic Society/Corbis.

👁 **Watch** a video about the historic sanctuary of Machu Picchu on myartslab.com

offerings. Two snakes face each other, their fangs and split tongues forming a symmetrical design. The rather menacing aspect of this piece is typical of much Aztec stone sculpture, which reflects the militaristic and regimented nature of Aztec society. When the Spanish first visited the Aztec capital, they found the city cleaner and better governed than most European cities. The Aztec also had highly developed arts of poetry and literature.

In the Andes of South America, Inca culture flourished for several centuries prior to the Spanish conquest of 1532. Spanish reports from the time tell of the magnificence of Inca art, but most of the culture's exquisite gold objects were melted down soon after the conquest, and all but a few of the refined fabrics have perished with age and neglect.

The Inca are perhaps best known for their skillful shaping and fitting of stones. Their masonry is characterized by mortarless joints and the "soft" rounded faces of granite blocks. The royal retreat center of Machu Picchu (**fig. 20.38**) was built on a ridge in the eastern Andes, in what is now Peru, at an elevation of 8,000 feet. The city, which escaped Spanish detection, was planned and constructed in such a way that it seems to be part of the mountain. Respect for stones was an integral part of Inca culture. According to the Inca creation myth, two of their early ancestors who emerged from the earth immediately turned themselves into stones. Some stone shrines were regarded as living things requiring offerings and care.

On a desert plateau overlooking Nazca Valley, ancient Nazca peoples created a crisscrossing of geometric lines and patterns in the dry sand. There are perfectly straight lines, some almost 5 miles long, and geometric patterns such as spirals, trapezoids, and triangles, as well as abstracted images of various known and unknown birds and other animals, including the hummingbird (**fig. 20.39**) shown here. This gigantic sketchpad dwarfs the seemingly insignificant Pan American Highway that crosses at the upper left.

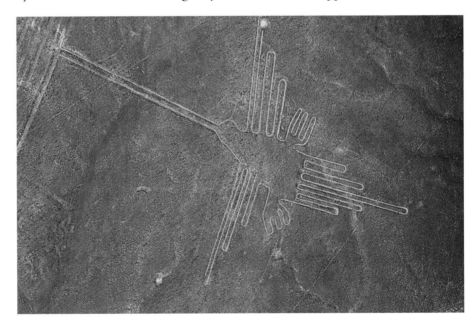

20.39 Hummingbird. Nazca Valley, Peru.
Photograph: Georg Gerster/Photo Researchers, Inc.

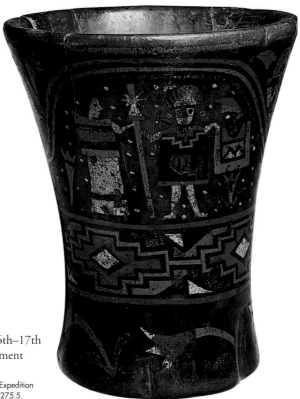

20.40 Kero Cup. Peru. Late 16th–17th century. Wood with pigment inlay. 7⅜″ × 6¹⁵⁄₁₆″.
Brooklyn Museum of Art, Museum Expedition 1941, Frank L. Babbott Fund. 41.1275.5.

One of the few Inca art forms to survive the Spanish conquest intact was the carving and painting of kero cups such as the one seen here (**fig. 20.40**). Kero cups held beverages for ancient rituals that the Inca performed in secret for many generations. The flat patterns in the decoration are stylistic descendants of both pottery and textile design.

✓•—Study and review on myartslab.com

THINK BACK

1. What are some community functions for art in Africa?

2. What basic belief about human origins is widely shared across Polynesia?

3. Which Native American art forms are traditionally reserved for women?

4. What cultural forms did the civilizations of pre-conquest Mexico share?

TRY THIS

Compare the three methods of textile creation pictured in this chapter.

Does any Western concept parallel the Polynesian idea of mana?

KEY TERMS

kachina – one of many deified ancestral spirits honored by the Hopi and other Pueblo Indian peoples; usually depicted in doll-like form

mana – in Oceania, spiritual power that may reside in persons, places, or things

terra cotta – a type of earthenware that contains enough iron oxide to impart a reddish tone when fired

totem – an object such as an animal or plant that serves as an emblem of a family or clan

Part Four

THE MODERN WORLD
Late Eighteenth and Nineteenth Centuries
Early Twentieth Century
Between World Wars
Postwar Modern Movements

À MARAT.

DAVID.

21

LATE EIGHTEENTH AND NINETEENTH CENTURIES

THINK AHEAD

21.1 Explain the social and political ideas that gave rise to Neoclassical art and architecture.

21.2 Recognize the visual characteristics and themes in Romanticism.

21.3 Discuss the origins of photography and its relationship to painting in the nineteenth century.

21.4 Describe the stylistic features and artistic concerns characterizing Realism, Impressionism and Post-Impressionism.

21.5 Identify representative artists and artworks of the late eighteenth and nineteenth centuries.

21.6 Assess the use of current events by artists to call attention to social concerns.

The period of great social and technological change we call the modern age was launched by three revolutions: the Industrial Revolution, which began in Britain about 1760; the American Revolution of 1776; and the French Revolution of 1789. The Industrial Revolution caused the most significant shift in the way people lived since the Neolithic agricultural revolution ten thousand years earlier. The American and French revolutions implanted the ideas of the Enlightenment in government and public affairs.

The Enlightenment, or Age of Reason, as the late eighteenth century has been called, was characterized by a shift to a more rational and scientific approach to religious, political, social, and economic issues. Belief in the importance of liberty, self-determination, and progress caused renewed interest in democracy and secular concerns. Consistent belief systems that tended to unify earlier societies became increasingly fragmented. Traditional values were challenged by the new atmosphere of independent investigation, by technological changes, and by increased contact between peoples and cultures. Artists both expressed and abetted these changes.

((•—Listen to the chapter audio on myartslab.com

A new stylistic pluralism began to grow. In earlier periods, artists generally adhered to a dominant style. Following the French Revolution and the subsequent break with traditional art patronage in France, a variety of styles developed simultaneously. The traditional sources of art patronage (royalty, aristocracy, the Church) gradually withered away, leaving artists to hope for commercial galleries and business-class collectors to fill the gap.

Neoclassicism

With the beginning of the French Revolution in 1789, the luxurious life that centered on the French court ended abruptly, and French society was disrupted and transformed. As the social structure and values changed, so tastes also changed.

One of the artists who led the way to revolutions in both art and politics was painter Jacques-Louis David. Believing that the arts should serve a beneficial social purpose in a time of social and governmental reform, he rejected what he saw as the frivolous immorality of the aristocratic Rococo style. When he painted *The Oath of the Horatii* (**fig. 21.1**), David pioneered an austere style called **Neoclassicism**. The term refers to the emulation of classical Greek and Roman art;

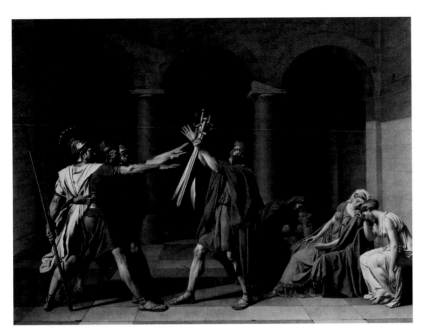

21.1 Jacques-Louis David. *The Oath of the Horatii.* 1784.
Oil on canvas. 10′10″ × 14′.
Musée du Louvre, Paris, France. RMN-Grand Palais/Gérard Blot/Christian Jean.

The women at the right of *The Oath of the Horatii* seem overcome by emotion, unable to participate in the serious decisions required of men who would defend their homeland. This painting reflects the common belief at that time that women were unfit for public life. Their exclusion from most professions was also true of the art world, where women were banned from academy classes in which unclothed models were used. If a woman did succeed as an artist, it was because she either could afford private study or came from an artistic family.

In the works of the Neoclassicist Angelica Kauffmann, who overcame such obstacles, we see a different vision of woman's abilities. Born in Switzerland and trained by her father, Kauffmann spent six years in Italy before settling in London in 1768. She was elected a full member of the British Royal Academy two years later, the last woman to be so honored until the 1920s. She created *Cornelia, Pointing to Her Children As Her Treasures* (**fig. 21.2**)

much of the subject matter in Neoclassical art was Roman because Rome represented a republican, or non-hereditary, government.

The subject of *The Oath of the Horatii* is a story of virtue and readiness to die for liberty: The three brothers pledge to take the swords their father offers in order to defend Rome. With such paintings, David gave revolutionary leaders an inspiring image of themselves rooted in history. "Take courage," was the painting's message, "your cause is a noble one, and it has inspired heroes of the past."

David's Neoclassicism, seen in the rational, geometric structure of his composition, provides strong contrast to the lyrical softness of Rococo designs (see *Happy Accidents of the Swing*, fig. 17.30). *The Oath of the Horatii* has the quality of classical (Greco-Roman) relief sculpture, with strong side light emphasizing the figures in the foreground. Even the folds in the garments are more like carved marble than soft cloth. The background arcade gives strength to the design and provides a historically appropriate setting for the Roman figures. The two center columns separate the three major parts of the subject. Vertical and horizontal lines parallel the edges of the picture plane, forming a stable composition that resembles a stage set.

21.2 Angelica Kauffmann. *Cornelia, Mother of the Gracchi, Pointing to Her Children As Her Treasures.* c.1785.
Oil on canvas. 40″ × 50″.
Virginia Museum of Fine Arts, Richmond. The Adolph D. and Wilkins C. Williams Fund. Photo: Katherine Wetzel. © Virginia Museum of Fine Arts. 75.22/50669.2.

21.3 Thomas Jefferson. Monticello.
Charlottesville, Virginia. 1793–1806.
Monticello/Thomas Jefferson Foundation, Inc.

a year after David's *Oath of the Horatii*. Cornelia is at the center of the work, talking with a friend seated at the right. The friend shows a string of jewels as if boasting about them, to which Cornelia replies that her children are her jewels. Indeed, to a student of Roman history, this was true: Cornelia's children adopted her well-known democratic beliefs and went on to become important figures in the development of the Roman republic.

The new classical (that is, Neoclassical) spirit also infected architecture. After the American statesman-architect Thomas Jefferson spent five years in Europe as minister to France (1784–1789), he redesigned his home, Monticello (**fig. 21.3**), in accordance with classical ideals. Monticello is based on Andrea Palladio's Renaissance reinterpretation of Roman country-style houses (see fig. 17.14). The Greco-Roman portico, topped by a dome, makes the entire design reminiscent of the Pantheon (see fig. 16.10) by way of contemporary French Neoclassical architecture.

Both Monticello and Jefferson's designs for the University of Virginia show the Roman phase of Neoclassical American architecture, often called the Federal Style. Jefferson advocated this Neoclassical style as an embodiment of the values of the new American republic where Roman civic virtues of courage and patriotism would be reborn. Jefferson's Neoclassical style is reflected in much of American architecture before the Civil War. Neoclassical architecture can be found in practically every city in the United States, and it dominated government buildings in Washington, D.C., into the twentieth century.

Romanticism

The Enlightenment celebrated the power of reason; however, an opposite reaction, **Romanticism**, soon followed. This new wave of emotional expression motivated the most creative artists in Europe from about 1820 to 1850. The word Romanticism comes from *romances*, popular medieval tales of adventure written in romance languages.

Neoclassicism and Romanticism agree on the importance of individual liberty, but little else. Romantic artists, musicians, and writers believed that imagination and emotion are more valuable than reason, that nature is less corrupt than civilization, and that human beings are essentially good. Romantics celebrated nature, rural life, common people, and exotic subjects in art and literature. They asserted the validity of subjective experience and sought to escape Neoclassicism's fixation on classical forms.

Spanish artist Francisco Goya was a groundbreaking Romantic painter and printmaker. A contemporary of David, he was aware of the French Revolution, and he personally experienced some of the worst aspects of the ensuing Napoleonic era, when French armies invaded Spain and much of the rest of Europe. Goya at first welcomed Napoleon's invading army because

his sympathies lay with the French Revolution and its democratic values. But he soon discovered that the occupying army was destroying rather than defending the Revolution's best ideals. Napoleon's troops occupied Madrid in 1808; on May 2, a riot broke out against the French in the central square. Officers fired from a nearby hill, and the cavalry was ordered to cut down the crowds. The following night, firing squads were set up to shoot anyone suspected of causing the disturbance. Later, Goya vividly and bitterly depicted these brutalities in his powerful indictment of organized murder, *The Third of May, 1808* (**fig. 21.4**).

The Third of May is enormous, yet so well conceived in every detail that it delivers its message instantly. A structured pattern of light and dark areas organizes the scene, giving it impact and underscoring its meaning. Mechanical uniformity marks the faceless firing squad, in contrast to the ragged group that is the target. From the soldiers' dark shapes, we are led by the light and the lines of the rifles to the central figure in white. The focal point is this man, raising his arms in a gesture of helpless defiance. This work is more than a mere reconstruction of history; it is a universal protest against the brutality of tyrannical governments.

Goya's painting deals with events that took place only six years before the artist took up the brush; a preoccupation with current events (rather than a mythological past) is an important characteristic of

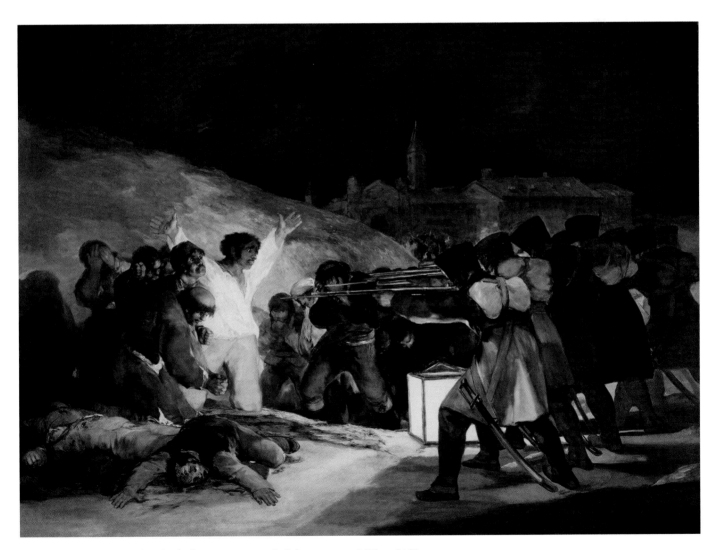

21.4 Francisco Goya. *The Third of May, 1808.* 1814. Oil on canvas. 8′9″ × 3′4″.
Museo Nacional del Prado, Madrid. © Museo Nacional del Prado/Oronoz.

21.5 Joseph Mallord William Turner. *The Burning of the Houses of Lords and Commons.* 1834. Oil on canvas. 36¼″ × 48½″.
© Cleveland Museum of Art, Bequest of John L. Severance.

the Romantic movement. When the British Houses of Parliament burned in a disastrous fire one night in 1834, Joseph Mallord William Turner witnessed the event and made several sketches that soon became paintings. His work *The Burning of the Houses of Lords and Commons* (**fig. 21.5**) typifies the Romantic movement in several ways.

The brushwork is loose and expressive, as if he created the painting in a storm of passion. The colors are bright and vivid. Although the work depicts an event that happened only a few months before, the artist introduced distortions and exaggerations. According to contemporary reports, the flames did not leap up into the night as the artist shows them. Moreover, the Thames River has a curve that would partially block the view; Turner "straightened" the river to afford a wide horizon. Turner made these departures from factual accuracy in order to convey the feeling of the event, as a British national symbol burned. This emphasis on feeling over fact is Romantic. Turner's loose painting style influenced the later Impressionist movement, but there are important differences between them, as we shall see.

Many Romantic artists also painted the landscape, finding there a reflection of their own emotional state. Romantic landscape painting flourished especially in the United States, where Thomas Cole founded the Hudson River School in the 1830s. Like Turner, Cole began with on-site oil and pencil sketches, then made his large paintings in his studio. The broad, panoramic view, carefully rendered details, and light-filled atmosphere of paintings such as *The Oxbow* (**fig. 21.6**) became the inspiration for American landscape painting for several generations. (See also Asher Durand's *Kindred Spirits*, fig. 3.24).

21.6 Thomas Cole. *The Oxbow.* 1836.
Oil on canvas. 51½″ × 76″.

The Metropolitan Museum of Art, New York. Gift of Mrs.
Russell Sage, 1908 (08.228) © 2103. Photograph © The
Metropolitan Museum of Art/Art Resource/Scala, Florence.

In nineteenth-century America it was difficult to obtain the education necessary to become a professional artist; for an African American it was almost impossible. Nevertheless, with the help of antislavery sponsors, a few succeeded.

Robert S. Duncanson was one of the first African-American artists to earn an international reputation. As the son of a Scots-Canadian father and an African-American mother, he may have had an easier time gaining recognition as an artist than those who did not straddle the color line. Prior to settling in Cincinnati, he studied in Italy, France, and England, and he was heavily influenced by European Romanticism. With *Blue Hole, Little Miami River* (**fig. 21.7**), Duncanson reached artistic maturity. He modified the precise realism of the Hudson River School with an original, poetic softening. He orchestrated light, color, and detail to create an intimate and engaging reverie of a person in nature.

In France, the leading Romantic painter was Eugène Delacroix. Delacroix's painting *The Death of Sardanapalus* (**fig. 21.8**) is based on the life of a literary character, an ancient Assyrian king who may or may not have existed. In the play *Sardanapalus* by Lord Byron, Sardanapalus leads a decadent and wasteful life, and ends it in a hopeless military situation, surrounded by enemies. Rather than surrender, he takes poison and orders all of his favorite possessions brought before him and destroyed in an orgy of violence. Delacroix composed this writhing work along a diagonal and lit it using strong chiaroscuro in a way that recalls certain Baroque paintings (see fig. 17.20). His brushwork is loose and open, or **painterly**, not at all like the cool precision of Neoclassicism. Delacroix used all of these devices in order to enhance the viewer's emotional response to a horrifying, if imagined, event. The Romantic painters in general stressed strong viewer involvement, use of color in painterly strokes, and dramatic movement, in contrast to the detached rationality and clear idealism of the Neoclassicists.

21.7 Robert S. Duncanson. *Blue Hole, Little Miami River.* 1851. Oil on canvas. 29¼″ × 42¼″.
Cincinnati Art Museum. Gift of Norbert Heermann and Arthur Helbig. 1926.18. Photograph: The Bridgeman Art Library.

21.8 Eugène Delacroix. *The Death of Sardanapalus.* 1827. Oil on canvas. 12′1½″ × 16′2⅞″.
Musée de Louvre, Paris. Photograph: Copyright Kevaler/Art Resource, NY.

Photography

Landscape and portrait painters initially saw photography as a threat to their livelihood. In fact, the camera freed painters from the roles of narrator and illustrator, allowing them to explore dimensions of visual experience that were largely out of reach in Western art since the Renaissance. At the same time, photography offered new opportunities to infuse images of objective reality with personal visions.

In its first two generations, the new medium was put to many uses. (See fig. 9.3 for an early example of a daguerreotype.) The perfection of glass-plate negatives in the 1850s made printed reproductions of photographs possible, though the technology was still quite cumbersome to use. Photographers had to smear a glass plate with just the right amount of toxic chemicals, insert it into a camera, expose the plate for the correct number of seconds, and develop the image almost immediately by applying more toxic chemicals in complete darkness.

If we transfer those operations to a small covered wagon in the trackless Western wilderness, we get a sense of the practical challenges of early landscape photography, as executed by Timothy O'Sullivan and others. Between 1867 and 1874, O'Sullivan traveled with several mapping expeditions that explored the more barren regions of the West. His stark and austere photographs show careful compositional balance, high resolution for that time, and well-crafted contrasts of light and dark. The "sitter" in this photo (**fig. 21.9**) is unknown—O'Sullivan himself was behind the camera—but he is perfectly positioned in

21.9 Timothy O'Sullivan. *Iceberg Canyon, Colorado River, Looking Above.* 1871. Albumen print. 8″ × 11″.
National Gallery of Art, Washington D.C. Diana and Mallory Walker Fund and Horace W. Goldsmith Foundation through Robert and Joyce Menschel 2005.10.1.

21.10 Nadar (Félix Tournachon).
Sarah Bernhardt. 1855.
Courtesy of George Eastman House,
International Museum of Photography and Film.

Félix Tournachon, known as Nadar, first gained fame as a balloonist, and from a hot air balloon he made the first aerial photographs. He even took the first underground photographs in the sewers and catacombs of Paris, using artificial lighting techniques and long exposures.

Nadar recognized that photography was primarily a mechanical process, and that the photographer had to be intelligent and creative in order to make significant works of art with a camera. The most notable artists, writers, and intellectuals of Paris went to him to have their portraits made. His photograph of French actress Sarah Bernhardt (**fig. 21.10**) is an evolutionary link between Romantic painted portraits and the glamour photography of today. Another pioneer portrait photographer was Julia Margaret Cameron, who began photographing at age 48 and created an impassioned body of work (see fig. 9.4).

As both a tool and a way of seeing, photography influenced the next major stylistic development.

Realism

Both Neoclassicism and Romanticism had their beginnings in rebellion. But by mid-century each had become institutionalized, functioning as a conservative force in French artistic life. At the state-sponsored Ecole des Beaux Arts, or School of Fine Arts, students were taught by members of the Academy of Fine Arts (an organization of government-approved artists) that "great painting" demanded "classical" technique and the "elevated" subject matter found in history, mythology, literature, or exotic locations.

Delacroix accused Academy members of teaching beauty as though it were algebra. Today, the term **academic art** describes generally tradition-minded works that follow overused formulas laid down by an academy or school, especially the French Academy of the nineteenth century.

this lunar-looking, rocky region. The publication in books of photos such as this helped Americans to learn about their new territories, and exposed alert viewers to the eye of an artist.

Delacroix was one of the first to recognize the difference between camera vision and human vision. He believed that photography was potentially of great benefit to art and artists. In an essay for students, Delacroix wrote:

> A daguerreotype is a mirror of the object; certain details almost always overlooked in drawing from nature take on in it characteristic importance, and thus introduce the artist to complete knowledge of construction as light and shade are found in their true character.[1]

French Academy members played a major role in selecting artists for a huge annual exhibition known as the **Salon**. Participating in the Salon was virtually the only way an artist might become known to the public in those days. The art history of the rest of the nineteenth century is largely one of rebellion against such institutions and authority figures. Vast changes in art and the artist's role in society were about to topple the dominance of the French Academy.

Realism describes a style of art and literature that depicts ordinary existence without idealism, exoticism, or nostalgia. We have seen it before the nineteenth century, notably in Roman portrait sculpture (see Chapter 16) and Flemish and Dutch painting (see Chapter 17). By mid-century, a growing number of artists were dissatisfied with both the Neoclassicists' and the Romantics' attachment to mythical, exotic, extraordinary, and historical subjects. They believed that art should deal with human experience and observation.

They knew that people in the nineteenth century were living a new kind of life, and wanted art to show it.

In the 1850s, French painter Gustave Courbet revived Realism with new vigor by employing a direct, painterly technique for the portrayal of the dignity of ordinary things and common life. In doing so, he laid the foundation for a rediscovery of the extraordinary visual qualities of everyday experience.

The Stone Breakers (**fig. 21.11**) shows Courbet's rejection of Romantic and Neoclassical formulas. His subject is neither historical nor allegorical, neither religious nor heroic. The men breaking stones are ordinary road workers, presented almost life-size. Courbet did not idealize the work of breaking stones or dramatize the struggle for existence; he simply said, "Look at this."

Courbet's detractors were sure that he was causing artistic and moral decline by painting what they considered unpleasant and trivial subjects on a grand

21.11 Gustave Courbet. *The Stone Breakers.* 1849 (destroyed in 1945). Oil on canvas. 5′5″ × 7′10″.
Galerie Neue Meister, Dresden, Germany. Photograph: © Staatliche Kunstsammlungen Dresden/The Bridgeman Art Library.

21.12 Rosa Bonheur. *The Horse Fair*. 1853–1855. Oil on canvas. 96¼″ × 199½″.
The Metropolitan Museum of Art, New York. Inscribed: Signed and dated (lower right): Rosa Bonheur 1853.5. Gift of Cornelius Vanderbilt, 1887. Acc.n.: 87.25. Image copyright The Metropolitan Museum of Art/Art Resource,NY/Scala, Florence.

scale. They accused him of raising "a cult of ugliness" against cherished academic concepts of Beauty and the Ideal. Conservative critics and most of the public saw Realism as nothing less than the enemy of art, and many believed that photography was the source and the sponsor of this disaster. When *The Stone Breakers* was exhibited in Paris at the Salon of 1850, it was attacked as inartistic, crude, and socialistic. The latter charge actually had some validity: Courbet was in fact a lifelong radical who espoused anarchist philosophies. He believed that most governments were oppressive institutions that served only the wealthy, and that average people could better meet their needs by banding together in voluntary associations for such functions as public works, banking, and policing. Beginning in 1855, Courbet practiced what he preached and set up his own exhibitions.

Courbet was one of the first to finish his paintings outdoors, working directly from nature. Previously, most landscape painting had been done in the artist's studio from memory, sketches, and reference materials such as rocks and plants brought in from outside. When portable tubes of oil paint became available

in 1841, oil painting outdoors became practical. By working directly from subjects outdoors, painters were able to capture first impressions. This shift in practice opened up whole new ways of seeing and painting.

Of his own work, Courbet said: "To be able to represent the customs, the ideas, the appearance of my own era . . . to create living art; that is my aim."[2]

Realism of a more popular sort was practiced by Rosa Bonheur, who specialized in painting rural scenes with animals. In *The Horse Fair* (**fig. 21.12**), she captured the surging energy of a group of horses offered for sale, some of them untamed. Many scholars believe that the riding figure in the blue-green coat near the center of the picture is a portrait of the artist wearing men's clothing.

The Realist paintings of American artist Thomas Eakins are remarkable for their humanity and insight into the everyday world. A comparison of the paintings of Eakins and those of his teacher, Jean-Léon Gérôme, shows the contrast between Realism and officially sanctioned academic art. Both *Pygmalion and Galatea* (**fig. 21.13**) by Gérôme and *William Rush Carving His Allegorical Figure* (**fig. 21.14**) take up the

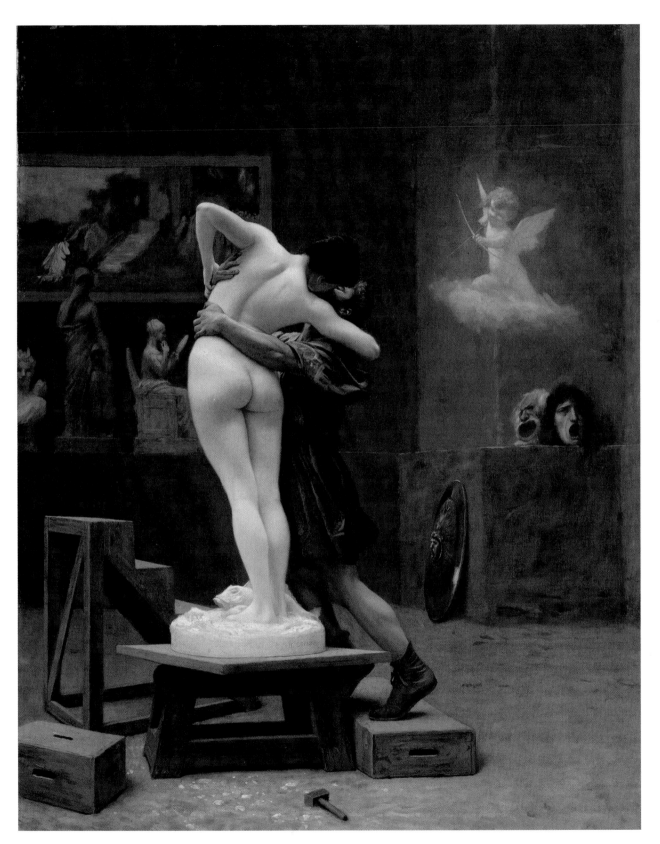

21.13 Jean-Léon Gérôme. *Pygmalion and Galatea.* c.1860. Oil on canvas. 5″ × 27″.
The Metropolitan Museum of Art, New York. Gift of Louis C. Raegner, 1927. Acc.n.: 27.200. © 2013.
Image copyright The Metropolitan Museum of Art/Art Resource/Scala, Florence.

theme of the sculptor and his model; Gérôme created his painting based on classical and academic teachings, choosing a story from mythology, idealizing the figures, and painting it in a controlled fashion. Gérôme placed the woman, Galatea, on a pedestal, both literally and figuratively. The Greek myth of Pygmalion tells of a sculptor who carved a statue of a woman so beautiful that he fell in love with it. Pygmalion prayed to Aphrodite, goddess of love, who responded by making the figure come to life. The sentimental approach (note the cupid at right), smooth finish, and mild eroticism are typical of academic art.

In contrast, Eakins presented a Realist view of the sculptor's trade, as he showed respect for the beauty of the ordinary human being. The somewhat lumpy model stands holding a dictionary as the carver works at the left, and the chaperone tends to her knitting. The painting style is also far looser, especially in the background. Eakins's insistence on painting people the way they actually look led him to escape the bondage of stylization imposed by the rules of the Academy; it also led to shock and rejection by the public and much of the art world. Eakins selected this subject because William Rush was the first American artist to use nude models, bringing controversy on himself in the 1820s, much as Eakins did 50 years later.

We can see Eakins's influence in the work of his student and friend Henry Ossawa Tanner, who was

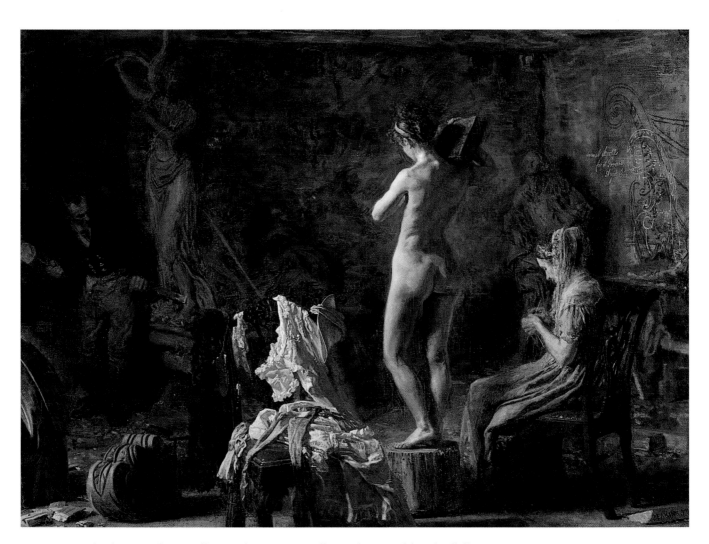

21.14 Thomas Eakins. *William Rush Carving His Allegorical Figure of the Schuylkill River.* 1876–1877. Oil on canvas on masonite. 20⅛" × 26⅛".
Philadelphia Museum of Art. Gift of Mrs. Thomas Eakins and Miss Mary Adeline Williams, 1929.
Acc.n.: 1929-184-27. Photograph: The Philadelphia Museum of Art/Art Resource/Scala, Florence.

the best-known African-American painter before the twentieth century. At the age of 13, Tanner watched a landscape painter at work and decided to become an artist. While studying with Eakins at the Academy of Fine Arts in Philadelphia, Tanner changed his subject matter from landscapes to scenes of daily life. In 1891, after an exhibition of his work was largely ignored, Tanner moved to France, where he remained for most of the rest of his life. He found less racial prejudice in Paris than in the United States. His paper "The American Negro in Art," presented at the 1893 World's Congress on Africa in Chicago, voiced the need

for dignified portrayals of blacks, and he offered his painting *The Banjo Lesson* as a model (**fig. 21.15**).

The lively realism of *The Banjo Lesson* reveals Tanner's considerable insight into the feelings of his subjects, yet he avoids the sentimentality that was common in many late nineteenth-century American paintings. This painting shows the influence of Eakins in its detail and its humanistic content.

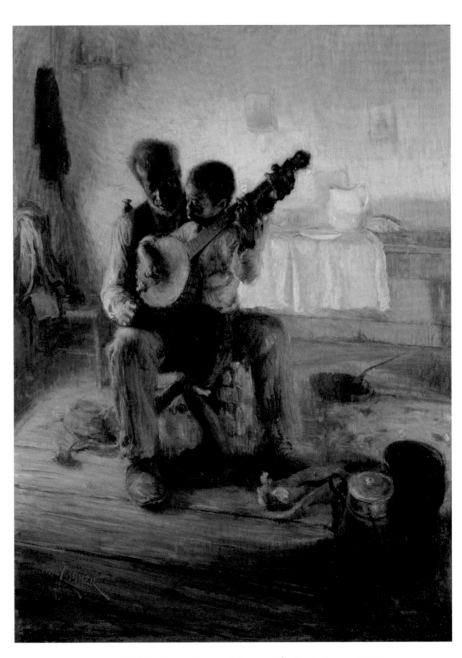

21.15 Henry Ossawa Tanner. *The Banjo Lesson*. 1893. Oil on canvas. 49″ × 35½″. Hampton University Museum, Virginia.

Current Events in Art

Much Romantic and Realist art is based on the presentation of a creator's vision, or on his or her interpretation of a certain corner of the world. Some artists, past and present, have used their works to comment on current events, providing a visual account that can shape people's understanding not only of what has happened but of the wider world in which they live. In Goya's *Third of May, 1808* (see fig. 21.4), for example, the artist acted as a witness to a shocking recent incident, bringing the brutality of an invading army to the public's attention.

Another Romantic who commented on a divisive current event was Théodore Géricault in his painting *The Raft of the "Medusa"* (**fig. 21.16**). This work tells of a scandalous 1816 shipwreck off the coast of Africa, in which 137 passengers on the *Medusa* perished owing to the incompetence of the ship's captain. He had reserved all of the lifeboats for himself, the crew, and a few dignitaries, leaving the 152 passengers to fend for themselves on a makeshift raft. They drifted for 13 days, wasting away, before their rescue; only 15 survived.

The case was a scandal because the captain was a government appointee unfit for the job. The artist was not present, but he read all available news accounts and

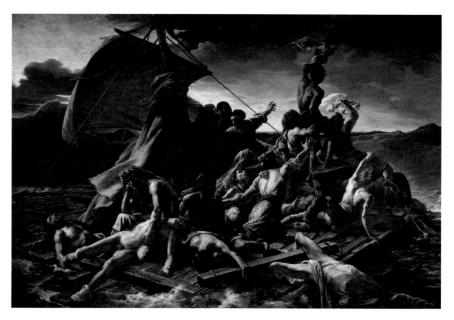

21.16 Théodore Géricault. *Raft of the "Medusa."* 1818–1819. Oil on canvas. 16′ × 23′6″.
Musée du Louvre, Paris. Photograph: akg-images/Erich Lessing.

View the Closer Look for Théodore Géricault's *Raft of the Medusa* on myartslab.com

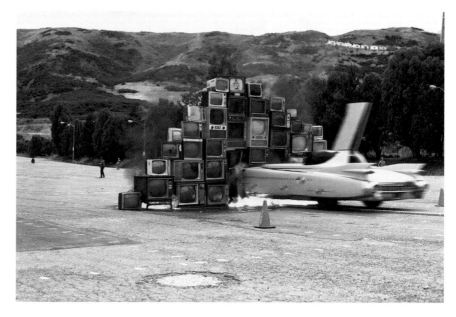

21.17 Ant Farm. *Media Burn.* Outdoor performance event, July 4, 1975. The Cow Palace, San Francisco.
University of California, Berkeley Art Museum. Photograph: John Turner.

interviewed several survivors. Like a true Romantic, he depicted one of the most dramatic moments in the story: when the survivors first sight their rescue ship. The painting is not journalistically accurate; the raft was much larger and the survivors were emaciated, weak, and sunburned. But he captured the emotional climate of the moment, intense with fear and hope. The "heroes" are all common people, including the black African at the top, who was standing lookout at the time. The work is a commentary on human endurance in a dreadful situation.

Contemporary artists also comment on the news, sometimes in ironic or sarcastic ways. One of the most pointed commentaries of the 1970s was a staged public event that took place on Independence Day 1975 (**fig. 21.17**). The event began with T-shirt sales and a July 4 speech by a comedian who both looked and sounded like former president John F. Kennedy. Then the artists' collective Ant Farm rolled out a customized, futuristic-looking car, staffed with two "pilots" wearing astronaut suits, and smashed it through a pile of burning television sets erected in a rented parking lot. *Media Burn* was both a protest against homogeneous television programming (then mostly controlled by three networks)

and a comment on sensational news broadcasts. This event both made news and satirized it, and the media did their part by eagerly covering *Media Burn*.

More recently, the artist duo Allora and Calzadilla created a work that comments on current economic news (**fig. 21.18**). *Algorithm* is a custom-built, 20-foot-tall pipe organ, but in place of a keyboard the artists installed a functioning automatic teller machine. They placed this work in the United States Pavilion of the Venice Biennale, one of the world's foremost contemporary art exhibitions. Users who inserted bank cards could make deposits and withdrawals but, as they did so, their keystrokes created input that the organ pipes interpreted by playing programmed snippets of music. The more money each person withdrew or deposited, the longer the song. The obvious comment that this work made is that money may have replaced religion as our focus of worship. In a more subtle fashion, it commented on the economic downturn of 2008, which many economists believe was partly caused by lack of transparency in the banking sector. *Algorithm* created "instant transparency" by making everyone's transactions immediately audible in a crowded public place.

21.18 Allora and Calzadilla. *Algorithm*. 2011. Custom-built pipe organ, automatic teller machine. Height 20′.
U.S. Pavilion, 54th International Art Exhibition. Presented by the Indianapolis Museum of Art. Photograph: Andrew Bordwin.

21.19 Edouard Manet. *Le Déjeuner sur l'herbe (Luncheon on the Grass).* 1863. Oil on canvas. 7′ × 8′10″.
Musée d'Orsay, Paris. RMN/Hervé Lewandowski.

View the Closer Look for Edouard Manet's
Le Déjeuner sur l'herbe (Luncheon on the Grass)
on myartslab.com

The most important predecessor of Impressionism in French art is without a doubt Edouard Manet, who was the most controversial artist in Paris in the 1860s. He studied with an academic master, but soon broke away from traditional teaching in an effort to update the art of the Old Masters (Veronese, Velázquez, and Rembrandt, for example) by infusing painting with a dose of realism inherited from Gustave Courbet. In addition, Manet often flattened out the figures in his paintings under the influence of the Japanese prints that he knew and admired. His loose, open brushwork and sometimes commonplace subjects were an inspiration to younger painters who led the Impressionist movement.

Manet's painting *Luncheon on the Grass* (**fig. 21.19**) scandalized French critics and the public—because of the way it was painted as well as the subject

matter. Manet painted the female figure without shading, employed flat patches of color throughout the painting, and left bare canvas in some places. He concentrated on the interplay among the elements of form that make up the composition: light shapes against dark, cool colors accented by warm colors, directional forces, and active balance. Manet's concern with visual issues over content or storytelling was revolutionary.

The juxtaposition of a female nude with males dressed in clothing of the time shocked viewers, but such a combination was not new. Nude and clothed figures were combined in landscape paintings going back to the Renaissance and even Roman compositions that depicted ancient myths or stories from the Bible. However, in Manet's painting, there is no allegory, no history, no mythology, and not even a significant title to suggest morally redeeming values. Manet based his composition (but not his meaning) on the figures in an engraving of a Renaissance drawing by Raphael, who in turn had been influenced by Roman relief sculpture.

It is ironic that Manet, who had such reverence for the art of the past, would be attacked by the public and the critics for his radical innovations. Simultaneously, he was championed by other artists as a leader of the avant-garde. Manet became the reluctant leader of an enthusiastic group of young painters who later formed the group known as the Impressionists.

Impressionism

In 1874, a group of painters who had been denied the right to show at the Salon of 1873 organized an independent exhibition of their work. These artists, opposing academic doctrines and Romantic ideals, turned instead to the portrayal of contemporary life. They took their canvases outdoors and sought to paint "impressions" of what the eye actually sees, rather than what the mind knows or interprets from a scene. This is no simple goal; we usually generalize what we think we see from the most obvious fragments. A river may become a uniform blue-green in our mind, whereas direct, unconditioned seeing shows a rich diversity of colors.

Landscape and ordinary scenes painted outdoors in varied atmospheric conditions, seasons, and times of day were among the main subjects of these artists. For example, in 1877 Claude Monet took his easel to the St.-Lazare railroad station in Paris and painted a series of works in the train shed, among them *Arrival of the Normandy Train, Gare St.-Lazare* (**fig. 21.20**). Rather than focus on the human drama of arrival and

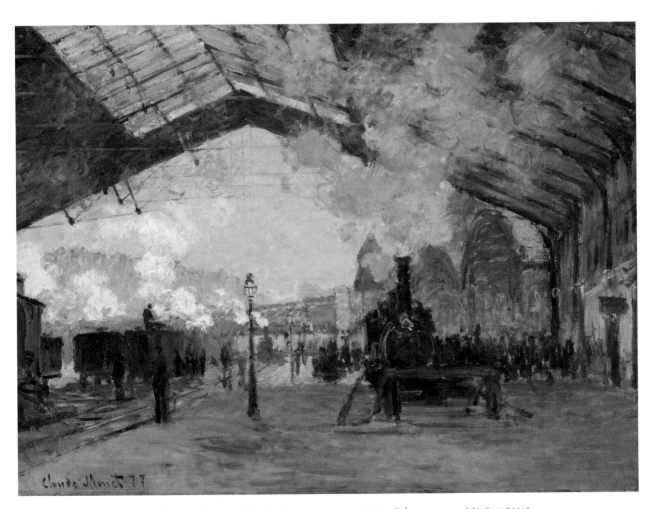

21.20 Claude Monet. *Arrival of the Normandy Train, Gare St.-Lazare.* 1877. Oil on canvas. 23½" × 31½".
The Art Institute of Chicago, Mr. and Mrs. Martin A. Ryerson Collection, 1933.1158. Photography: © The Art Institute of Chicago.

Watch the podcast Slamming the Impressionists on myartslab.com

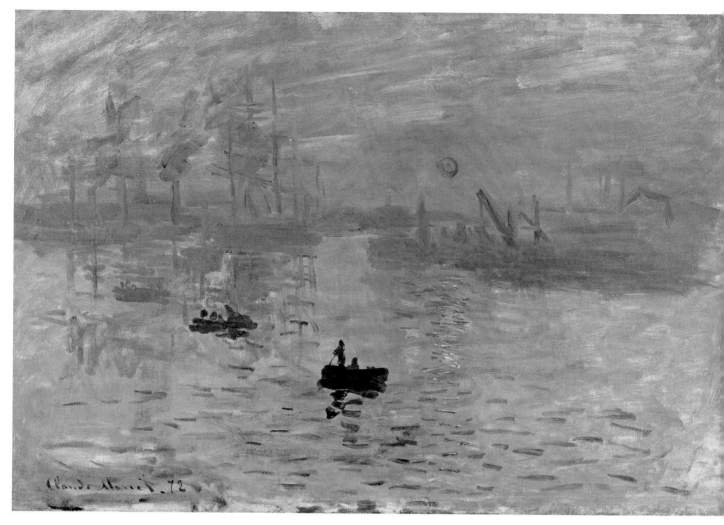

21.21 Claude Monet. *Impression: Sunrise.* 1872. Oil on canvas. 19½″ × 25½″.
Musée Marmottan Monet, Paris. Photograph: Giraudon/The Bridgeman Art Library.

departure, he was fascinated by the play of light amid the steam of the locomotives and the clouds glimpsed through the glass roof. He made his paintings quickly under the constantly shifting conditions, painting as traditional artists might make sketches.

Monet and his colleagues were dubbed **Impressionists** by a critic who objected to the sketchy quality of their paintings. The term arose from one of Monet's versions of *Impression: Sunrise* (**fig. 21.21**). Although the critic's label was intended to be derogatory, the artists adopted the term as a fitting description of their work. Monet had seen the extremely fluid paintings of Turner (see fig. 21.5), but he used Turner's techniques in a more objective and less emotional manner.

From direct observation and from studies in physics, the Impressionists learned that we see light

as a complex of reflections received by the eye and reassembled by the mind during the process of perception. Therefore, they used small dabs of color that appear merely as separate strokes of paint when seen close up, yet become lively depictions of subjects when seen at a distance. Monet often applied strokes of pure color placed next to each other, rather than colors premixed or blended on the palette. The viewer perceives a vibrancy that cannot be achieved with mixed color alone. The effect was startling to eyes accustomed to the muted, continuous tones of academic painting.

The Impressionists enthusiastically affirmed modern life, as Monet's paintings in the railroad station show. They saw the beauty of the world as a gift and the forces of nature as aids to human progress. Although misunderstood by their public, the Impressionists

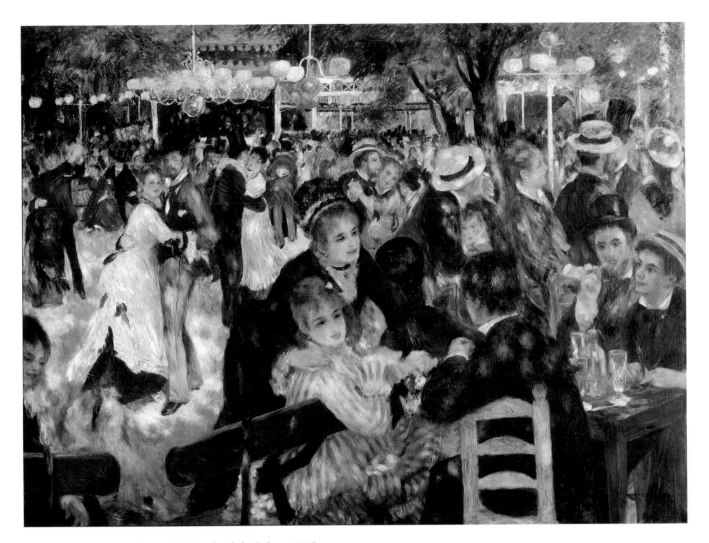

21.22 Pierre-Auguste Renoir. *Le Moulin de la Galette.* 1876.
Oil on canvas. 51½″ × 68⅞″.
Musée d'Orsay, Paris. Photograph: RMN Reunion des Musées Nationaux.

made visible a widely held optimism about the promise of the new technology. Impressionism was at its most creative between about 1870 and 1880. After 1880, Claude Monet continued for more than 40 years to advance Impressionism's original premise.

Pierre-Auguste Renoir's *Le Moulin de la Galette (The Pancake Mill)* (**fig. 21.22**) depicts a popular Impressionist theme: contemporary middle-class people enjoying outdoor leisure activities. The young men and women depicted are conversing, sipping wine, and generally enjoying the moment at the popular outdoor café that served up pancakes and dance music with equal liberality. The Industrial Revolution had created an urban middle class with leisure, respect for the new technology, and a taste for fashion, and the Impressionists chronicled their lives. Renoir was more interested in

the human drama than Monet—we sense the mood of some of the people in this work—but he was also very interested in how the light, filtered by leaves of the trees, hits the bodies and clothing in the crowd.

Edgar Degas exhibited with the Impressionists, although his approach differed somewhat from theirs. He shared with the Impressionists a directness of expression and an interest in portraying contemporary life, but he combined the immediacy of Impressionism with a highly inventive approach to pictorial composition. Degas, along with the Impressionists, was influenced by the new ways of seeing and composing that he saw in Japanese prints and in unposed, street-scene photography.

Conventional European compositions placed subjects within a central zone. Degas, however, used surprising, lifelike compositions and effects that often cut figures at the edge. The tipped-up ground planes and bold asymmetry found in Japanese prints inspired

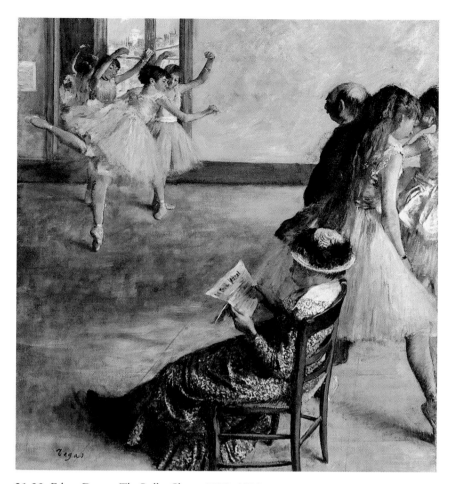

21.23 Edgar Degas. *The Ballet Class.* c.1879–1880.
Oil on canvas. 32⅜″ × 30¼″.
Philadelphia Museum of Art. Purchased with the W. P. Wilstach Fund.
W1937-2-1. Photograph: The Philadelphia Museum of Art/
Art Resource/Scala, Florence.

Degas to create paintings filled with intriguing visual tensions, such as those in *The Ballet Class* (**fig. 21.23**), in which two diagonal groups of figures appear on opposite sides of an empty center.

Degas depicted ballet classes in ways that showed their unglamorous character. Often, as here, he was able to turn his ability to the task of defining human character and mood. The painting builds from the quiet, uninterested woman in the foreground, up to the right, then across to the cluster of dancing girls, following the implied sightline of the ballet master.

American painter Mary Cassatt was born into Philadelphia high society, and when she went to Paris in the late 1860s to further her artistic development she did not seek out Academy teachers. Rather, she was independent-minded enough to befriend Manet and Degas, and soon she joined and exhibited with the Impressionists. She was among the many European and American artists who were influenced by Japanese prints and by casual compositions of late nineteenth-century do-it-yourself photography. (See also her print *The Letter*, fig. 8.12.) A resemblance to Japanese prints is readily apparent in the simplicity and bold design of *The Boating Party* (**fig. 21.24**). Cassatt defined her subject in sweeping curves and almost flat shapes.

There is, in addition, subtle feminist content in this work. The difference in clothing styles between the woman and the man shows that she has hired him to take her and the child out for a boat ride. This was an unusually assertive thing for a woman to do for herself in those days, and the glances between all three persons in the painting show some of the social tension that would have accompanied this event. The work is typical of Cassatt in its focus on the world of women and their concerns.

The Impressionist group disbanded after its eighth exhibition in 1886, but its influence was immeasurable—in spite of the fact that Impressionist paintings were looked upon with indifference or hostility by most of the public until the turn of the twentieth century.

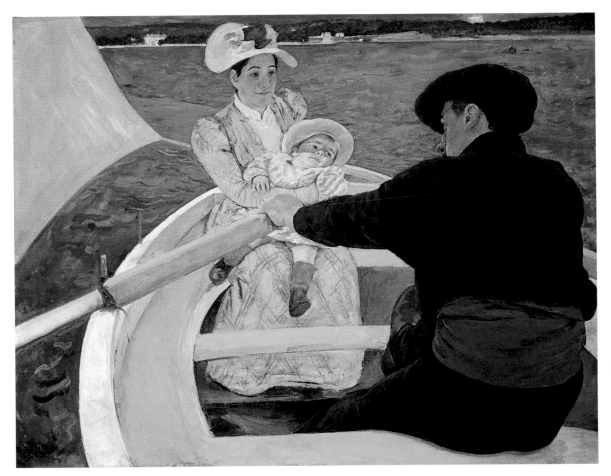

21.24 Mary Cassatt. *The Boating Party.* 1893–1894.
Oil on canvas. 35⁷⁄₁₆″ × 46³⁄₁₆″.
National Gallery of Art, Washington, D.C. 1963.10.94
Chester Dale Collection.

Auguste Rodin was at least as innovative in sculpture as his contemporaries were in painting; he instituted a level of innovation not seen since Bernini (see fig. 17.19).

In 1875, after training as a sculptor's helper, Rodin traveled to Italy where he carefully studied the work of the Renaissance masters Donatello and Michelangelo. Rodin was the first to use Michelangelo's unfinished pieces (see fig. 12.12) as an inspiration for making rough finish an expressive quality. In contrast to Michelangelo, however, Rodin was primarily a modeler in plaster and clay, rather than a carver in stone.

His best-known work, *The Thinker* (**fig. 21.25**), shows his expressive style to good advantage. He wrote that at first he was inspired by a figure of the medieval poet Dante, but he rejected the idea of a thin, ascetic figure:

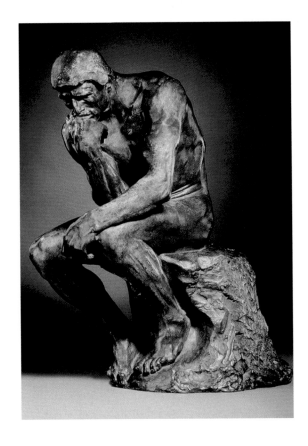

21.25 Auguste Rodin. *The Thinker.* c.1910. Bronze. Life-size.
Photograph: Christie's Images Ltd./SuperStock.

Guided by my first inspiration I conceived another thinker, a naked man, seated upon a rock, his feet drawn under him, his fist against his teeth, he dreams. The fertile thought slowly elaborates itself within his brain. He is no longer dreamer, he is creator.[3]

In *The Thinker*, Rodin projected the universal artist/poet as creator, judge, and witness, brooding over the human condition. Rodin combined a superb knowledge of anatomy with modeling skill to create the fluid, tactile quality of hand-shaped clay. He restored sculpture as a vehicle for personal expression after it had lapsed into mere decoration and heroic monuments.

The Post-Impressionist Period

Post-Impressionism refers to trends in painting starting in about 1885 that followed Impressionism. The

Post-Impressionist painters did not share a single style; rather, they built on or reacted to Impressionism in different ways. Some felt that the Impressionists' focus on sketchy immediacy had sacrificed solidity of form and composition. Others felt that Impressionism's emphasis on objective observation did not leave enough room for personal expression or spiritual content. Thus, Post-Impressionist artists went in two different directions: some toward clearer formal organization, and some toward greater personal expression.

Georges Seurat and Paul Cézanne were interested in developing formal structure in their paintings. Each in his own way organized visual form to achieve structured clarity of design, and their paintings influenced twentieth-century formalist styles.

Seurat's large painting *A Sunday on La Grande Jatte* (**fig. 21.26**) has the subject matter, light, and color qualities of Impressionism, but this is not a painting

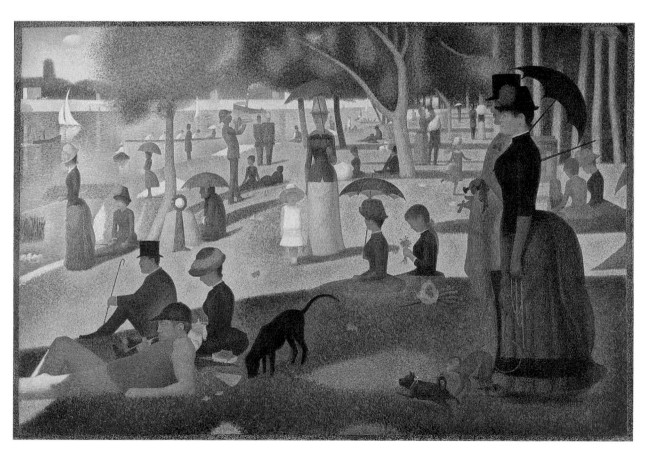

21.26 Georges Seurat. *A Sunday on La Grande Jatte*. 1884–1886. Oil on canvas. 81¾″ × 121¼″.
Art Institute of Chicago. Helen Birch Bartlett Memorial Collection 1926.22. Photograph © The Art Institute of Chicago.

View the Closer Look for *A Sunday on La Grande Jatte* on myartslab.com

of a fleeting moment; it is a carefully constructed composition of lasting impact. Seurat set out to systematize the optical color mixing of Impressionism and to create a more solid, formal organization with simplified shapes. He called his method **divisionism**, but it is more popularly known as **pointillism**. With it, Seurat tried to develop and apply a "scientific" technique. He arrived at his method by studying the principles of color optics that were being formulated at the time. Through the application of tiny dots of color, Seurat achieved a vibrant surface based on **optical color mixture**.

Seurat preceded *A Sunday on La Grande Jatte* with more than 50 drawn and painted preliminary studies in which he explored the horizontal and vertical relationships, the character of each shape, and the patterns of light, shade, and color. The final painting shows the total control that Seurat sought through the application of his method. The frozen formality of the

figures seems surprising, considering the casual nature of the subject matter; yet it is precisely this calm, formal grandeur that gives the painting its strength and enduring appeal.

Like Seurat, Cézanne sought to achieve strength in the formal structure of his paintings. "My aim," he said, "was to make Impressionism into something solid and enduring like the art of the museums."[4]

Cézanne saw the planar surfaces of his subjects in terms of color modulation. Instead of using light and shadow in a conventional way, he relied on carefully developed relationships between adjoining strokes of color to show solidity of form and receding space. He questioned, then abandoned, linear and atmospheric perspective and went beyond the appearance of nature, to reconstruct it according to his own interpretation.

Landscape was one of Cézanne's main interests. In *Mont Sainte-Victoire* (**fig. 21.27**), we can see how he

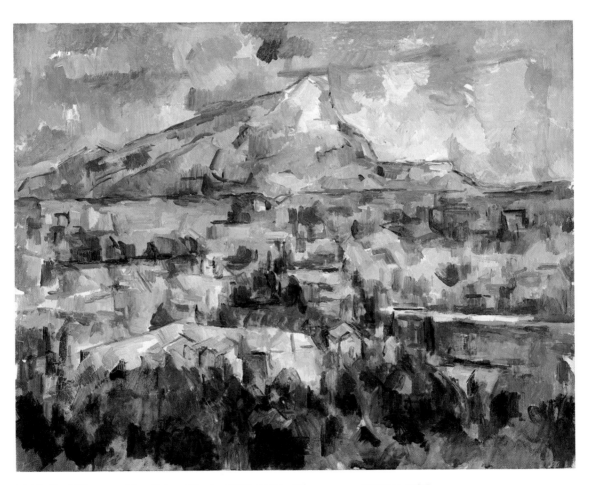

21.27 Paul Cézanne. *Mont Sainte-Victoire.* 1902–1904. Oil on canvas. 27½″ × 35¼″.
Philadelphia Museum of Art. The George W. Elkins Collection, 1936. Photograph: The Philadelphia Museum of Art/Art Resource/Scala, Florence.

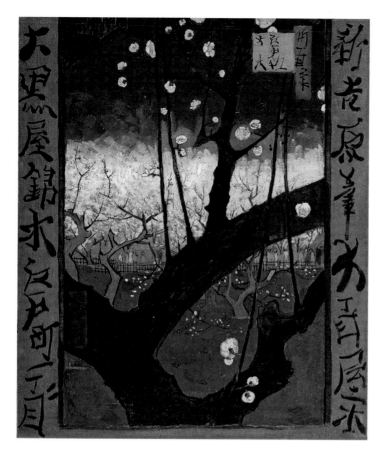

21.28 Vincent van Gogh. *Japonaiserie: Flowering Plum Tree.* 1887. After Hiroshige. Oil on canvas. 21½″ × 18″.
Van Gogh Museum, Amsterdam (Vincent van Gogh Foundation).

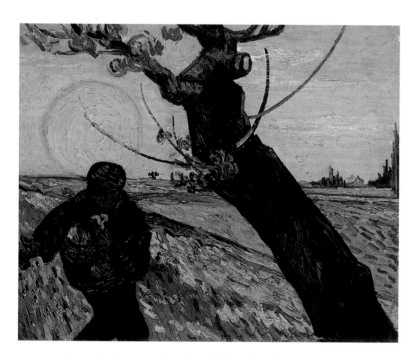

21.29 Vincent van Gogh. *The Sower.* 1888.
Oil on canvas. 12⅖″ × 15¾″.
Van Gogh Museum, Amsterdam (Vincent van Gogh Foundation).

flattened space, yet gave an impression of air and depth with some atmospheric perspective and the use of warm (advancing) and cool (receding) colors. The dark edge lines around the distant mountain help counter the illusion of depth. Cézanne simplified the houses and trees into patches of color that suggest almost geometric planes and masses. This entire composition uses color and brush stroke to orchestrate nature to a degree then unprecedented in Western art. His rhythm of parallel brush strokes and his concept of a geometric substructure in nature offered a new range of possibilities to later artists.

Among Post-Impressionists of an expressive bent, Vincent van Gogh and Paul Gauguin brought to their work emotional intensity and a desire to make their thoughts and feelings visible. They often used strong color contrasts, shapes with clear contours, bold brushwork, and, in van Gogh's case, vigorous paint textures. Their art greatly influenced twentieth-century **Expressionist** styles.

With Vincent van Gogh, late nineteenth-century painting moved from an outer impression of what the eye sees to an inner expression of what the heart feels.

From Impressionism, van Gogh learned the expressive potential of open brushwork and relatively pure color, but the style did not provide him enough freedom of expression. Van Gogh intensified the surfaces of his paintings with textural brushwork that recorded each gesture of his hand and gave an overall rhythmic movement to his paintings. He also began to use strong color in an effort to express his emotions more clearly. In letters to his brother Theo, he wrote: ". . . instead of trying to reproduce exactly what I have before my eyes, I use color more arbitrarily so as to express myself forcibly. . . ."[5]

As did other artists of the period, van Gogh developed a new sense of design from studying Japanese prints, as we see in *Japonaiserie: Flowering Plum Tree* (**fig. 21.28**). In *The Sower* (**fig. 21.29**), the Japanese influence led van Gogh to adopt bold, simplified shapes and flat color areas. The wide band of a tree trunk

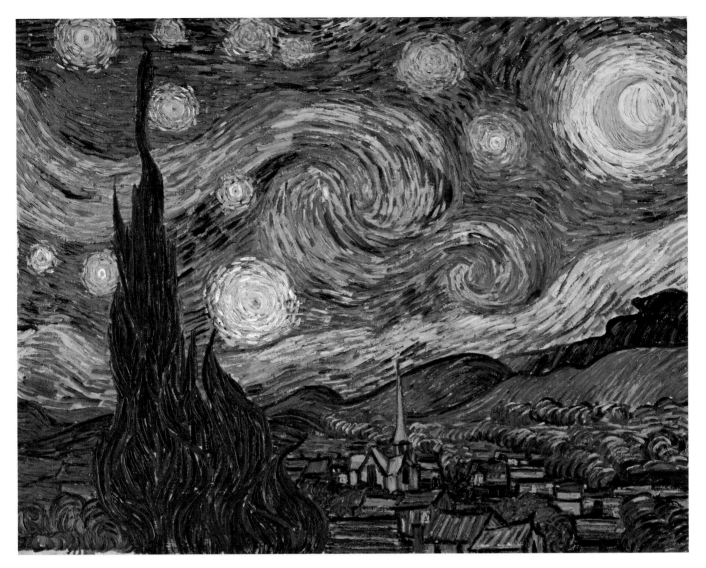

21.30 Vincent van Gogh. *The Starry Night.* 1889. Oil on canvas. 29″ × 36¼″.

The Museum of Modern Art, New York. Acquired through the Lillie P. Bliss Bequest. (472.1941).
Digital image, The Museum of Modern Art, New York/Scala, Florence.

View the Closer Look for Vincent van Gogh's *The Starry Night* on myartslab.com

cuts diagonally across the composition; its strength balances the sun and its energy coming toward us with the movement of the sower.

Van Gogh had a strong desire to share personal feelings and insights. In *The Starry Night* (**fig. 21.30**), a view of a town at night became the point of departure for a powerful symbolic image. Hills seem to undulate, echoing tremendous cosmic forces in the sky. The small town nestled into the dark forms of the ground plane suggests the small scale of human life. The church's spire reaches toward the heavens, echoed by the larger, more dynamic upward thrust of the cypress trees in the left foreground. (The evergreen cypress is traditionally planted beside graveyards in Europe as a symbol of eternal life.) All these elements are united by the surging rhythm of lines that express van Gogh's passionate spirit and mystical vision. Many know of van Gogh's bouts of mental illness, but few realize that he did his paintings between seizures, in moments of great clarity.

French artist Paul Gauguin was highly critical of the materialism of industrial society. He experienced that business world firsthand during the several years that he worked as a stockbroker to support his family, painting on the weekends. He exhibited occasionally with the Impressionists, but he longed to escape what he called "the European struggle for money." This attitude led Gauguin to admire

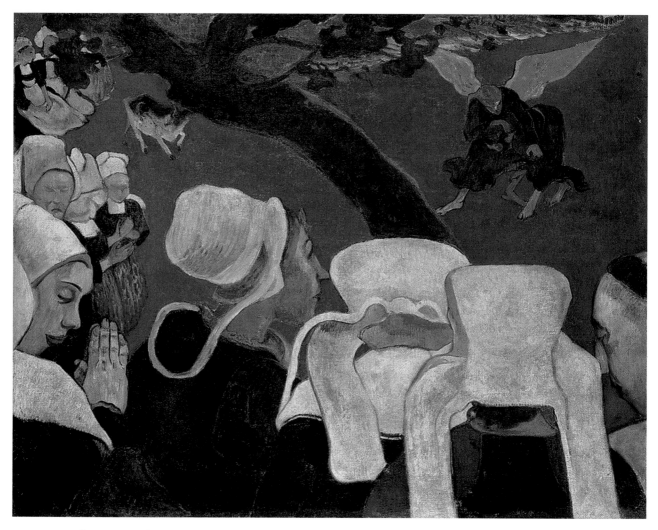

21.31 Paul Gauguin. *The Vision After the Sermon (Jacob Wrestling with the Angel).* 1888. Oil on canvas. 28¾″ × 36½″.
National Galleries of Scotland.

the honest life of the Brittany peasants of western France. In 1888, he completed *The Vision After the Sermon* (**fig. 21.31**), the first major work in his new, expressive version of Post-Impressionism. The large, carefully designed painting shows Jacob and the angel as they appear to a group of Brittany peasants in a vision inspired by the sermon in their village church.

The symbolic representation of unquestioning faith is an image that originated in Gauguin's mind rather than in his eye. With it, Gauguin took a major step toward personal expression. In order to avoid what he considered the distraction of implied deep space, he tipped up the simplified background plane and painted it an intense vermilion. The entire composition is divided diagonally by the trunk of the apple tree, in the manner of Japanese prints. Shapes have

been reduced to flat curvilinear areas outlined in black, with shadows minimized or eliminated.

Both van Gogh's and Gauguin's uses of color were important influences on twentieth-century painting. Their views on color were prophetic. The subject of a painting, Gauguin wrote, was only a pretext for symphonies of line and color.

> In painting, one must search rather for suggestion than for description, as is done in music. . . . Think of the highly important musical role which color will play henceforth in modern painting.[6]

Gauguin retained memories of his childhood in Peru that persuaded him that the art of ancient and non-

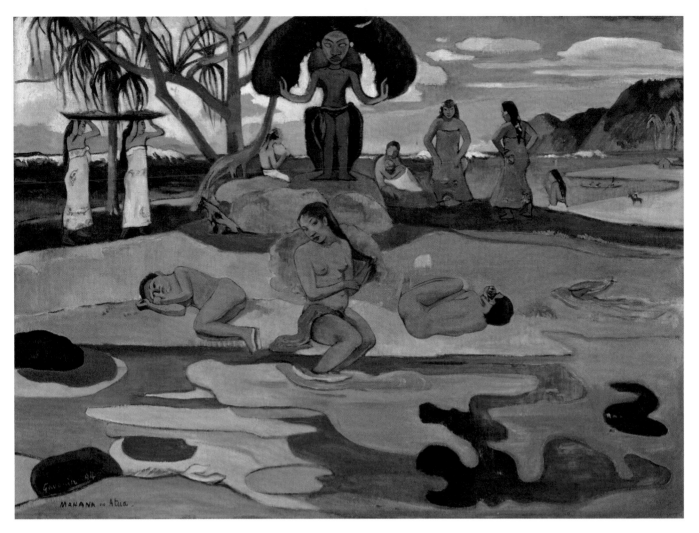

21.32 Paul Gauguin. *Mahana no Atua (Day of the God).* 1894. Oil on canvas. 26⅞″ × 36″.
The Art Institute of Chicago. Helen Birch Bartlett Memorial Collection,
1926.198. Photography © The Art Institute of Chicago.

Western cultures had a spiritual strength that was lacking in the European art of his time. He wrote:

> Keep the Persians, the Cambodians, and a bit
> of the Egyptians always in mind. The great
> error is the Greek, however beautiful it may be.
> A great thought system is written in gold
> in Far Eastern art.[7]

Gauguin's desire to rejuvenate European art and civilization with insights from non-Western traditions would be continued in the early twentieth century by Matisse, Picasso, and the German Expressionists. They adopted Gauguin's vision of the artist as a spiritual leader who could select from the past, and from various world cultures, anything capable of releasing the power of self-knowledge and inner life.

At the age of 43, Gauguin tried to break completely with European civilization by going to Tahiti, leaving behind his wife and their five children. In *Day of the God* (**fig. 21.32**), he summarized the results of several years of painting. At the top center of this beach scene is a god figure from a book about Southeast Asia (not Tahiti). The women at the left bring offerings as the two on the right dance. In the foreground, three other women sit or lie on the edge of the sea, but the colors of this body of water are nothing like reality; rather, Gauguin here used colors as "the language of dreams,"[8] as he put it. Where we might expect to see the statue reflected, we get a mysterious ooze of organic shapes in acidic hues. The seated figure just above stares back at us with a mysterious look.

For Gauguin, art had become above all a means of communicating through symbols, a synthesis of visual form carrying memory, feelings, and ideas. These beliefs link him to **Symbolism**, a movement in literature and the visual arts that developed around 1885.

Reacting against both Realism and Impressionism, Symbolist poets and painters sought to lift the mind from the mundane and the practical. They employed decorative forms and symbols that were intentionally vague or open-ended in order to create imaginative suggestions. The poets held that the sounds and rhythms of words were part of their poems' deeper meaning; the painters recognized that line, color, and other visual elements were expressive in themselves. Symbolism, a trend rather than a specific style, provided the ideological background for twentieth-century abstraction; it has been seen as an outgrowth of Romanticism and a forerunner of Surrealism.

Henri de Toulouse-Lautrec painted the gaslit interiors of Parisian nightclubs and brothels. His quick, long strokes of color define a world of sordid gaiety. Toulouse-Lautrec was influenced by Degas, but Toulouse-Lautrec plunged more deeply into nightlife. In *At The Moulin Rouge* (**fig. 21.33**), Toulouse-Lautrec used unusual angles, cropped images (such as the face on the right), and expressive, unnatural color to heighten feelings about the people and the world he painted. His paintings, drawings, and prints of Parisian nightlife influenced twentieth-century Expressionist painters, just as his posters influenced graphic designers (see fig. 8.15).

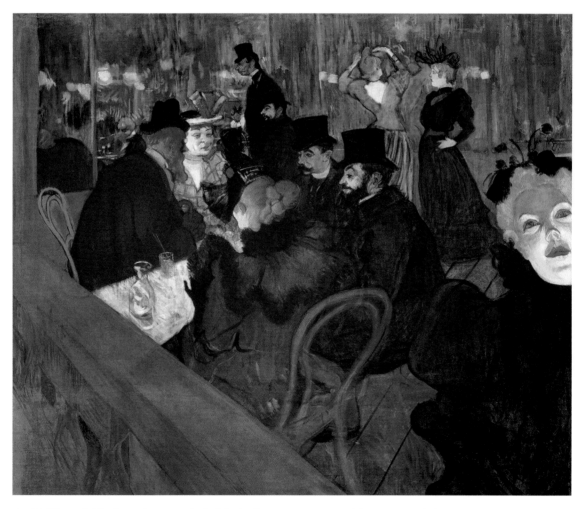

21.33 Henri de Toulouse-Lautrec. *At the Moulin Rouge.* 1893–1895. Oil on canvas. 48⅜″ × 55¼″.
The Art Institute of Chicago, Helen Birch Bartlett Memorial Collection, 1928.610. Photography © The Art Institute of Chicago.

21.34 Victor Horta. Stairway. Tassel House, Brussels. 1892–1893.
© 2013—Victor Horta, Bastin & Evrard /SOFAM—Belgium.

In the last decade of the nineteenth century, some artists' explorations of line and color were transplanted into architecture and interior design. This yielded an abstract style called **Art Nouveau**, "new art." Using ideas gleaned from Paul Gauguin, Japanese prints, and the decorative schemes of William Morris (see fig. 13.1), architects and designers created projects that brought nature into art in new ways.

An early leader in this trend was the Belgian architect Victor Horta. Not content to design only the structure of a building, he also created its wallpaper and furnishings. The curving shapes that he used throughout the Tassel House (**fig. 21.34**) were derived from

21.35 Edvard Munch. *The Scream.* 1893. Tempera and crayon on cardboard. 36″ × 28⅞″.
National Gallery, Oslo Foto: Jacques Lathion/Nasjonalmuseet © 2013 The Munch Museum/The Munch-Ellingsen Group/
Artists Rights Society (ARS), NY.

nature, but abstracted into controlled, graceful shapes. The Art Nouveau style soon spread across Europe and the United States, where it also influenced graphic design and product design.

As the century closed, Norwegian artist Edvard Munch articulated some of its darkest nightmares. He had traveled to Paris to study the works of his contemporaries, especially Gauguin, van Gogh, and Toulouse-Lautrec. What he learned from them, particularly from Gauguin's works, enabled him to carry Symbolism to a new level of expressive intensity. Munch's powerful paintings and prints explore depths of emotion: grief, loneliness, fear, love, sexual passion, jealousy, and death.

In *The Scream* (**fig. 21.35**), Munch takes the viewer far from the pleasures of Impressionism and extends considerably van Gogh's expressive vision. In this powerful image of anxiety, the dominant figure is caught in isolation, fear, and loneliness. Despair reverberates in continuous linear rhythms. Munch's image has been called the soul-cry of the age.

The Impressionists had staged their own exhibitions that competed with the official Salons; the following generation of Post-Impressionists and

Symbolists gave up on even that level of recognition. The most creative artists worked outside the normal channels of advancement in the art world, giving rise to the term **avant-garde** to describe their social group. The term comes from military theory: It describes the foremost soldiers who attack in advance of the main body of troops—literally, the "advance guard." The analogy held that the most creative artists similarly work well ahead of the general public's ability to comprehend, pioneering new ideas in taste and thought that will eventually take hold in society at large. This model aptly symbolized the social structure of artistic innovation far into the twentieth century.

✔●—Study and review on myartslab.com

THINK BACK

1. How did Neoclassicists rebel against the preceding Rococo?

2. How is Impressionism an outgrowth of Realism?

3. What two stylistic directions did the Post-Impressionist artists take?

TRY THIS

Vincent van Gogh greatly admired the work of the painter Adolphe Monticelli, who is not well known today. Examine some Monticelli works online at the National Gallery, London (http://www.nationalgallery.org.uk/artists/adolphe-monticelli), and look for commonalities in style between the two artists, especially in landscape painting.

KEY TERMS

academic art – art governed by rules, especially works sanctioned by an official institution, academy, or school

Art Nouveau – a style of decorative art and architecture characterized by curving shapes abstracted from nature

avant-garde – artists who work in an experimental or innovative way, often opposing mainstream standards

Impressionism – a style of painting executed outdoors aiming to capture the light and mood of a particular moment and the transitory effects of light and color

Neoclassicism – a revival of classical Greek and Roman forms in art, music, and literature

optical color mixture – apparent rather than actual color mixture, produced by interspersing brushstrokes or dots of color instead of physically mixing them

painterly – painting characterized by openness of form, in which shapes are defined by loose brushwork in light and dark color areas rather than by outline or contour

Realism – the mid-nineteenth-century style of Courbet and others, based on the idea that ordinary people and everyday activities are worthy subjects of art

Romanticism – a literary and artistic movement aimed at asserting the validity of subjective experience; characterized by intense emotional excitement, and depictions of powerful forces in nature, exotic lifestyles, danger, suffering and nostalgia

Salon – an official art exhibition in France, juried by members of the official French Academy

22

EARLY TWENTIETH CENTURY

During the first decade of the last century, Western views of the nature of reality changed radically. In 1900, Sigmund Freud published *The Interpretation of Dreams*, a vast work that explored the power and influence of the subconscious mind on all of us. In 1903, the Wright brothers flew the first power-driven aircraft, and Marie and Pierre Curie isolated the radioactive element radium for the first time. In 1905, Albert Einstein changed our conception of time, space, and substance with his theory of relativity. Matter could no longer be considered solid; rather, it was a form of energy.

The Industrial Revolution had changed life in myriad ways. Thousands of new jobs opened in city-based factories, drawing rural people into a new, crowded, and impersonal urban environment. Business-oriented capitalism moved the workplace farther from family life than it had ever been before, and most wage work became much more unpleasant. The most violent revolutions of the century—in Russia, Mexico, and China—sprang from class tensions. At the same time, the industrial system created vast amounts of wealth that engendered a middle class and gave millions a financial floor. Better

vaccines and public health led to longer life expectancies and a lower birth rate. A steady stream of inventions made business more productive and made scientists into heroes. Government functions expanded into new areas such as factory inspection, education, regulation of currency, and product safety.

Simultaneously, great changes occurred in art, and some of them were inspired by scientific discoveries. In 1913, Russian artist Wasily Kandinsky described how deeply he was affected by the discovery of subatomic particles:

> A scientific event cleared my way of one of the greatest impediments. This was the further division of the atom. The crumbling of the atom was to my soul like the crumbling of the whole world.[1]

The art of the twentieth century came from a series of revolutions in thinking and seeing. Its characteristics are those of the century itself: rapid change, diversity, individualism, and exploration—accompanied by abundant discoveries. Twentieth-century artists, as well as scientists, have helped us see the world in new ways and revealed new levels of consciousness.

((•─ **Listen** to the chapter audio on myartslab.com

The explosion of new styles of art at the beginning of this century grew from Impressionist and Post-Impressionist innovations. Yet in their search for forms to express the new age, European artists often looked to ancient and non-Western cultures for inspiration and renewal. In so doing, they overturned the authority of the Renaissance, which had dominated Western artistic thought for five hundred years.

The merest glance at *Harmony in Red* (**fig. 22.1**) by Henri Matisse reveals that a new world is dawning in art. The rich maroon of the tablecloth shows a deep-blue vine pattern that also claws its way up the wall. The colors of the fruit are bold and flat. The window with its bright golden edge looks out to a radically simplified, yet intensely colored scene. Matisse was a leader in the early-twentieth-century movement known as **Fauvism**, which expanded on the innovations of the Post-Impressionists.

The Fauves and Expressionism

At the turn of the century, the most creative young painters in France carefully studied Post-Impressionist works. Some drew inspiration from the rationalizing tendencies of Cézanne; others wanted to move farther down the expressive path that Vincent van Gogh and Paul Gauguin had charted.

Matisse was in the latter camp. He saw a large collection of Gauguin's Tahitian works in 1905 and soon he extended the older artist's innovations. He also led a faction of painters who experimented with vigorous brushwork and large flat areas of highly expressive color. Their first group exhibition shocked the public. A critic of that show derisively called them *"les fauves"* (the wild beasts).

However, Matisse was not as rebellious as his detractors claimed; rather, he was a thoughtful person who simply tried to express his enthusiasm for life. Every part of a painting by Matisse is expressive: the lines, the colors, the subject, and the composition itself. He frequently reduced his subjects to a few outlines, rather than fill in all of their details. He did this to better preserve the original impulse of feeling.

22.1 Henri Matisse. *Harmony in Red (The Red Room).* 1948. Oil on canvas. 70⅞″ × 86⅝″.
The State Hermitage Museum, St. Petersburg. © 2013 Succession H. Matisse/Artists Rights Society (ARS), New York.

More detail in a work would merely overburden the viewer and distract attention from the immediate burst of emotion.

Matisse's painting *The Joy of Life* (**fig. 22.2**) is another early Fauvist work that shows the artist's degree of enthusiasm. Pure hues vibrate across the surface; lines, largely freed from descriptive roles, align with simplified shapes to provide a lively rhythm in the composition. The seemingly careless depiction of the figures is based on Matisse's knowledge of human anatomy and drawing. The intentionally direct, child-like quality of the form serves to heighten the joyful content. Matisse defined his aim: "What I am after, above all, is expression."[2]

Matisse had befriended fellow Fauve member André Derain while the two were still in art school. In Derain's *London Bridge* (**fig. 22.3**), brilliant, invented color is balanced by some use of traditional composition and perspective. Derain spoke of intentionally using discordant color. It is an indication of today's acceptance of strong color that Derain's painting does not appear disharmonious today. Note also the pure touches of yellow, blue, and green in the lower left; these are expanded versions of the pointillist dots of Georges Seurat.

22.2 Henri Matisse. *Le Bonheur de vivre (The Joy of Life).* 1905–1906. Oil on canvas. 69⅛″ × 94⅞″.
The Barnes Foundation/The Bridgeman Art Library. © 2013 Succession H. Matisse/Artists Rights Society (ARS), New York.

22.3 André Derain. *London Bridge.* 1906. Oil on canvas. 26″ × 39″.
The Museum of Modern Art (MoMA) Gift of Mr. and Mrs. Charles Zadok. 195.1952
Digital image: The Museum of Modern Art, New York/Scala, Florence. © 2013 Artists Rights Society (ARS), New York/ADAGP, Paris.

The Fauve movement lasted little more than two years, from 1905 to 1907, yet it was one of the most influential developments in early-twentieth-century painting. The Fauves took color farther from its traditional role of describing the natural appearance of an object. In this way, their work led to an increasing use of color as an independent expressive element.

We can categorize Fauvism as an expressive style. **Expressionism** is a general term for art that emphasizes inner feelings and emotions over objective depiction. (Expressionism has also enlivened works of music and literature.) In Europe, romantic or expressive tendencies can be traced from seventeenth-century Baroque art to the early-nineteenth-century painting of Eugène Delacroix, who in turn influenced the expressive side of Post-Impressionism (particularly van Gogh).

A few German artists at the beginning of the century shared the expressionist goals of the Fauves. Their desire to express attitudes and emotions was so pronounced and sustained that we call their art German Expressionism. They developed imagery characterized by vivid, often angular simplifications of their subjects and dramatic color contrasts, with bold, at times crude finish. These techniques added emotional intensity to their works. Like their Fauve counterparts, the German Expressionists built on the achievements of Gauguin and van Gogh and the soul-searching paintings of Munch. They felt compelled to use the power of Expressionism to address the human condition, often exploring such themes as natural life, sorrow, passion, spirituality, and mysticism. As their art developed, it absorbed formal influences from medieval German art and some non-Western art from Africa and Oceania.

Two groups typified the German Expressionist movement of the early twentieth century: The Bridge (Die Brücke) and The Blue Rider (Der Blaue Reiter). Ernst Ludwig Kirchner, architecture student turned painter, was one of the founders of The Bridge. They appealed to artists to revolt against academic painting and establish a new, vigorous aesthetic that would form a bridge between the Germanic past and modern experience. They first exhibited as a group in 1905, the year of the first Fauve exhibition.

Kirchner's concern for expressing raw emotion gave his work an intensity similar to that of Munch (see fig. 21.35). Kirchner's early paintings employed

22.4 Ernst Ludwig Kirchner. *Street, Berlin.* 1913.
Oil on canvas. 47½" × 35⅞".
Museum of Modern Art (MoMA) Purchase. 274.1939.
Digital image: The Museum of Modern Art, New York/Scala, Florence.

View the Closer Look for Ernst Ludwig Kirchner's *Street, Berlin* on myartslab.com

the flat color areas of Fauvism; by 1913, he had developed a style that incorporated the angularities of Cubism (discussed presently), African sculpture, and German Gothic art. In *Street, Berlin* (**fig. 22.4**), elongated figures are crowded together. Repeated diagonal lines create an urban atmosphere charged with energy. Dissonant colors, chopped-out shapes, and rough, almost crude, brushwork heighten the emotional impact.

Paula Modersohn-Becker developed an Expressionist language apart from the organized groups. Trips to Paris in 1903 and 1905 exposed her

22.5 Paula Modersohn-Becker. *Self-Portrait with an Amber Necklace.* 1906. Oil on canvas. 24″ × 19¾″.
Kunstmuseum Basel. Photograph: akg-images.

Kandinsky's paintings evolved toward an absence of representational subject matter. In *Blue Mountain*, subject matter had already become secondary to the powerful effect of the visual elements released from merely descriptive roles.

By 1910, Kandinsky overturned one of the most important rules of Western art. He made the shift to totally nonrepresentational imagery in order to concentrate on the expressive potential of pure form, freed from the need to depict anything. After Kandinsky, art need not be a "picture" of some subject. A person of mystical inclinations, Kandinsky hoped to create art only in response to what he called "inner necessity," or the emotional stirrings of the soul, rather than in response to what he saw in the world. He said that art should transcend physical reality and speak directly to the emotions of viewers without intervening subject matter. He sought a language of visual form comparable to the sound language we experience in music. The rhythms, melodies, and harmonies of music please or displease us because of the way they affect us. To exploit this relationship between painting and music, Kandinsky often gave his paintings musical titles, such as *Composition IV* (**fig. 22.7**). Here we see colors and shapes that only vaguely correspond to things in the world. Rather, the artist painted out of inner necessity to make visible his personal mood at that time. Just as a composer uses harmony and melody, Kandinsky used color and form to (as he put it) "set the soul vibrating."

Kandinsky said that the content of his paintings was "what the spectator *lives* or *feels* while under the effect of the *form and color combinations* of the picture."[3] He was an important innovator in the history of art, and his revolutionary nonfigurative works played a key role in the development of later nonrepresentational styles. His purpose was not simply aesthetic: He saw his paintings as leading a way through an impending period of catastrophe to a great new era of spirituality. Kandinsky hoped that abstract art could provide spiritual nourishment for the modern world.

to the art of Cézanne and Gauguin, and she combined their influences in self-revealing paintings such as *Self-Portrait with an Amber Necklace* (**fig. 22.5**). She reduced the curves of her head to flat regions, and used color for expressive rather than representational purposes. The oversized eyes seem to tell us something, but they remain mysterious.

The Blue Rider group was led by Russian painter Wasily Kandinsky, who lived in Munich between 1908 and 1914. He shared with his German associates a concern for developing art that would turn people away from false values, toward spiritual rejuvenation. He believed that a painting should be "an exact replica of some inner emotion": In *Blue Mountain* (**fig. 22.6**), he created a "choir of colors" influenced by the vivid, freely expressive color of the Fauves.

22.6 Wassily Kandinsky. *Der blaue Berg (Blue Mountain).* 1908–1909. Oil on canvas. 41¾″ × 38″.

Solomon R. Guggenheim Museum, New York. Solomon R. Guggenheim Founding Collection, By gift 41.505. © 2013 Artists Rights Society (ARS), New York/ADAGP, Paris.

22.7 Wassily Kandinsky. *Composition IV.* 1911. Oil on canvas. 62¹³⁄₁₆″ × 98⅝″.

Kunstsammlung Nordrhein-Westfalen, Düsseldorf. Photograph: Walter Klein, Düsseldorf. Peter Willi/ The Bridgeman Art Library. © 2013 Artists Rights Society (ARS), New York/ADAGP, Paris.

View the Closer Look for Wassily Kandinsky's *Composition IV* on myartslab.com

Nature

22.8 Vincent van Gogh. *Wheatfield with Crows*. 1890. Oil on canvas. 20″ × 40″.
Van Gogh Museum, Amsterdam (Vincent van Gogh Foundation).

When an artist conveys information about his or her personality or feelings, art fulfills an expressive function. Such works allow viewers to understand something of the creator's personality and state of mind. Many artists who express themselves take nature as their subject. Some find their moods or mental states mirrored in natural scenery or atmospheric conditions; others project themselves onto the landscape, turning nature into a vehicle for expressing feeling.

An immediate predecessor to the Fauves and German Expressionists was Vincent van Gogh, who used nature as a pretext for personal expression through color, brushwork, and composition. In *Wheatfield with Crows* (**fig. 22.8**), he appears to have stabbed the

22.9 Emil Nolde. *Restless Sea*. Not dated. Watercolor on paper. 13¼″ × 18″.
Stadtgalerie Kiel © Nolde Stiftung Seebuel.

canvas with sharp, gashing strokes of pure and intense color. The field is a turbulent sea of yellow and green paint, an effect heightened by the work's texture. The crows are mere flecks of black. The sky is ominously dark, with the blackest tones at the top, weighing the composition down. The angular roads in the field lead nowhere. Van Gogh wrote to his brother, "I've painted another three large canvases . . . They're immense stretches of wheatfields under turbulent skies, and I made a point of trying to express sadness, extreme loneliness."[4] This painting is a polar opposite to the optimism of Matisse's *The Joy of Life* (see fig. 22.2), but both clearly express the mood of each artist. Other works by van Gogh are more hopeful, but this one powerfully communicates his darker thoughts.

The German Expressionist painter Emil Nolde used different techniques to express his inner self through nature. In the 1930s he began using watercolor to create dramatic landscapes in which he avoided most traces of brushstrokes. He laid wet colors down next to each other and allowed them to stain the paper and flow into each other, as we see in *Restless Sea* (**fig. 22.9**). The horizon line seems to coincide with the lower edge of the red zone, but the lighter region below it contradicts this, making the scene appear unstable. The irregular shapes of intense reds, yellows, and purples evoke dramatic encounters.

"Each color has a soul of its own," Nolde often said; here the intensity of the reds and yellows stands out against the cooler purple-blues. This work evokes powerful and mysterious forces in nature, which the artist found analogous to his own surging feelings. He wrote, "Sometimes it seems to me that I am capable of absolutely nothing, but that nature through me can accomplish a great deal."[5] Through painting the moods of nature, Nolde hoped to arouse a "restless sea" of feelings in viewers, similar to what he himself felt.

The influence of the Fauves and Expressionists persisted in the twentieth century. The German-American painter Hans Hofmann knew many of those artists personally, and when he came to the United States in the early 1930s, he set up a highly influential art school. His own painting was often joyous and spontaneous, sometimes veering into natural subjects. In creating *The Wind* (**fig. 22.10**), Hofmann laid the canvas flat and dripped paint as he moved his arm above it, its twisting motions capturing the swirling winds of a stormy day. His vision is not threatening, however, but rather intense and lyrical. He experiences wind as vibrant and bracing; its invisibility frees him to interpret its breezes freely. Hofmann's knowledge of modern art, and his charismatic teaching, influenced several artists of the New York School of the 1940s (see Chapter 24).

22.10 Hans Hofmann. *The Wind*. 1942. Oil, duco, gouache, and India ink on poster board. 43⅞″ × 28″.
University of California, Berkeley Art Museum. Photograph: Benjamin Blackwell.

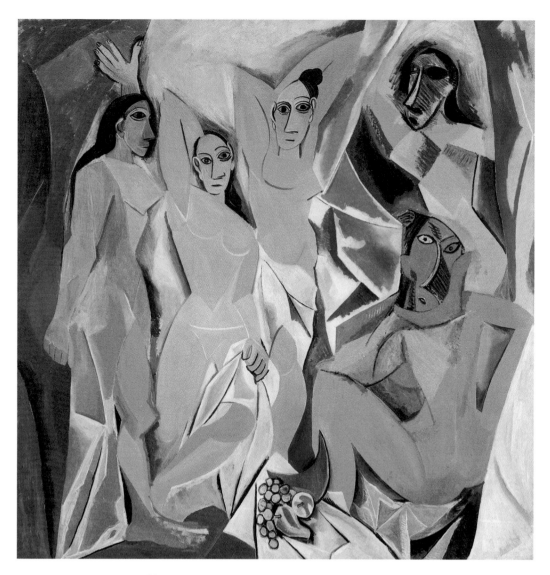

22.11 Pablo Picasso. *Les Demoiselles d'Avignon (Young Ladies of Avignon)*. Paris. 1907. Oil on canvas. 8′ × 7′8″.

The Museum of Modern Art, New York. Acquired through the Lillie P. Bliss Bequest (333.1939) Digital image,The Museum of Modern Art, New York/Scala, Florence. © 2013 Estate of Pablo Picasso/Artists Rights Society (ARS), New York.

View the Closer Look for Picasso's *Les Demoiselles d'Avignon* on myartslab.com

22.12 Kota Reliquary Figure. French Equatorial Africa. Probably 20th century. Brass sheeting over wood. Length 27½″.

Department of Anthropology, Smithsonian Institution. Cat. No. 323686, Neg. No 36712A.

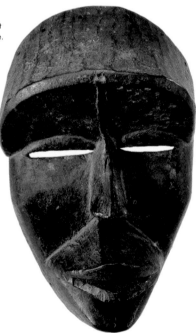

22.13 Mask. Ivory Coast. Wood. 9¾″ × 6½″.

Collection Musée de l'Homme, Paris. Photograph: D. Ponsard.

Cubism

While living in Paris, Spanish artist Pablo Picasso shared ideas and influences with French artist Georges Braque. Together they pursued investigations that led to **Cubism**, another principal innovation in painting before World War I. Generally speaking, Cubist painters emphasized pictorial composition over personal expression. Cubism heavily influenced the basic visual structure of many of the notable paintings and sculptures of the century. Through its indirect influence on architecture and the arts, Cubism has become part of our daily lives.

Picasso absorbed influences quickly, keeping only what he needed to achieve his objectives. His breakthrough painting, *Les Demoiselles d'Avignon (Young Ladies of Avignon)* (**fig. 22.11**), shows a radical departure from traditional composition. Picasso created a new vocabulary of form influenced by Cézanne's faceted reconstructions of nature, and by the inventive abstraction and power he admired in African sculpture such as the Kota reliquary figure (**fig. 22.12**) and the mask from Ivory Coast (**fig. 22.13**). While the meanings and uses of African sculpture held little interest for him, their form revitalized his art.

In *Les Demoiselles d'Avignon*, the fractured, angular figures intermingle with the sharp triangular shapes of the background, activating the entire picture surface. This reconstruction of image and ground, with its fractured triangulation of forms and its merging of figure and ground, was the turning point. With this painting, Picasso shattered the measured regularity of Renaissance perspective. Doing away with vanishing points, uniform lighting, and academic figure drawing, he overturned some important traditions of Western art. *Les Demoiselles* thus set the stage and provided the impetus for the development of Cubism. Though some art historians decry this work's negative depiction of women, viewers are challenged by the painting's hacked-out shapes and overall intensity.

A comparison of two paintings—Cézanne's *Gardanne*, completed in 1886 (**fig. 22.14**), and Braque's *Houses at l'Estaque* (**fig. 22.15**), completed

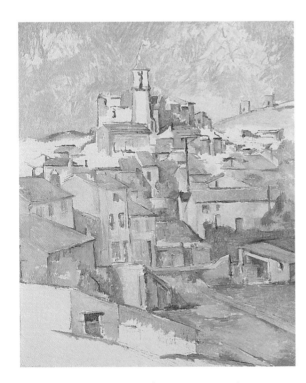

22.14 Paul Cézanne. *Gardanne*. 1885–1886. Oil on canvas. 31½″ × 25¼″.

The Metropolitan Museum of Art. Gift of Dr. and Mrs. Franz H. Hirschland, 1957. (57.181). Image copyright The Metropolitan Museum of Art/Art Resource/Scala, Florence.

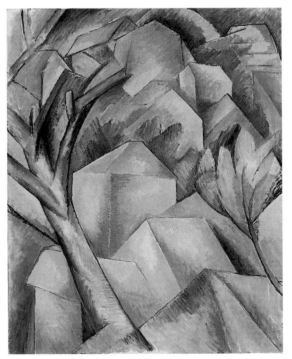

22.15 Georges Braque. *Houses at l'Estaque*. 1908. Oil on canvas. 28½″ × 23″.

Rupf Foundation, Bern, Switzerland. Photograph: Giraudon/ The Bridgeman Art Library. © 2013 Artists Rights Society (ARS), New York/ADAGP, Paris.

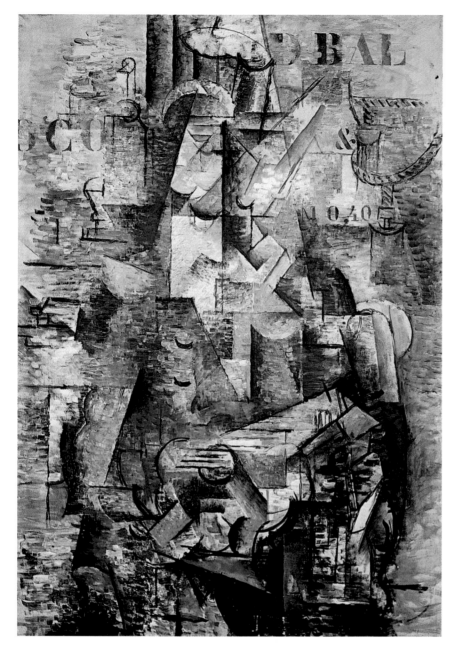

22.16 Georges Braque. *The Portuguese.* 1911.
Oil on canvas. 46″ × 32″.
Offentliche Kunstsammlung, Basel, Switzerland/The Bridgeman Art Library.
© 2013 Artists Rights Society (ARS), New York/ADAGP, Paris.

Instead of the regular perspective that had been common in European painting since the Renaissance, Braque's shapes define a rush of forms that pile up rhythmically in shallow, ambiguous space. Buildings and trees seem interlocked in an active space that pushes and pulls across the picture surface.

Houses at l'Estaque provided the occasion for the movement's name: When Matisse saw this painting, he declared it to be nothing but a bunch of little cubes. (His somewhat dismissive attitude indicates the widely varying goals of the Cubists and the Expressionistic Fauves.) From 1908 to 1914, Braque and Picasso were jointly responsible for inventing and developing Cubism. Braque later described their working relationship as resembling mountain climbers roped together. They worked for a time in relatively neutral tones, to explore formal structure without the emotional distractions of color.

By 1910, Cubism had become a fully developed style. During the Analytical phase of Cubism (1910 to 1911), Picasso, Braque, and others analyzed their subjects from various angles, then painted abstract, geometric references to these views. This is how we see, after all: by building up a mental image through brief, focused glances at a subject rather than a long, centered look. Because mental concepts of familiar objects are based on experiences of seeing many sides, the artists aimed to show objects as the mind, rather than the eye, perceives them. Braque's *The Portuguese* (**fig. 22.16**) is a portrait of a man sitting at a café table strumming a guitar. The subject is broken down into facets and recombined with the background. Figure and ground thus collapse into a shallow and jagged pictorial space.

Cubism was a rational, formalist counterpart to the personal emphasis of the Fauves and other Expressionists. Above all, it was a reinvention of pictorial space. The Cubists realized that the two-dimensional space of the picture plane was quite

in 1908—shows the beginning of the progression from Cézanne's Post-Impressionist style to the Cubist approach that Braque and Picasso developed.

Picasso made the first breakthrough with *Les Demoiselles d'Avignon*, but Braque did more to develop the vocabulary of Cubism. In a series of landscapes painted in the South of France (where Cézanne had worked), Braque took Cézanne's faceted planar constructions a step further.

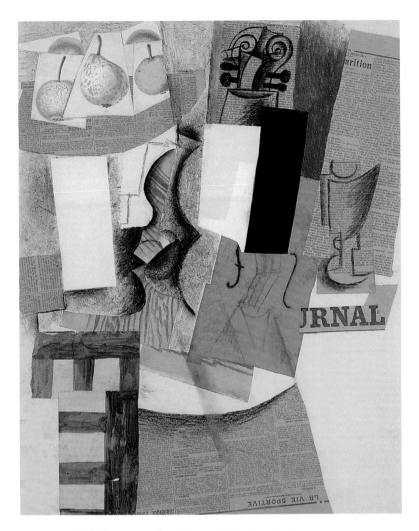

22.17 Pablo Picasso. *Violin, Fruit and Wineglass.* 1913. Charcoal colored papers, gouache, and painted paper collage. 25¼″ × 19½″.
Philadelphia Museum of Art; A.E. Gallatin Collection, 1952-61-106. ©2013 Photo The Philadelphia Museum of Art/Art Resource/Scala, Florence. RMN-Grand Palais/Béatrice Hatala.

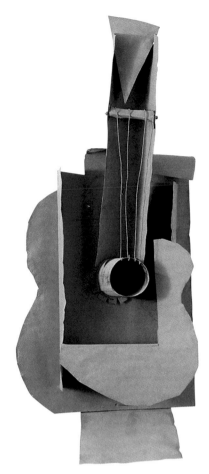

22.18 Pablo Picasso. *Guitar.* 1914. Construction of sheet metal and wire. 30½″ × 13¾″ × 7⅝″.
The Museum of Modern Art. Gift of the artist. 94.1971 Digital image: The Museum of Modern Art, New York/ Scala, Florence. © 2013 Estate of Pablo Picasso/ Artists Rights Society (ARS), New York.

different from the three-dimensional space we occupy. Natural objects were points of departure for abstract images, demonstrating the essential unity of forms within the spaces that surround and penetrate them. Cubism is thus a reconstruction of objects based on geometric abstraction. By looking first at Cézanne's *Gardanne*, then at Braque's *Houses at l'Estaque*, and finally at *The Portuguese*, we see a progression in which forms seem to build, then spread, across the surface in overlapping planes.

In 1912, Picasso and Braque modified Analytical Cubism with color, textured and patterned surfaces, and the use of cutout shapes. The resulting style came to be called **Synthetic Cubism**. Artists used pieces of newspaper, sheet music, wallpaper, and similar items,

not represented but actually *presented* in a new way. The newspaper in *Violin, Fruit and Wineglass* (**fig. 22.17**) is part of a real Paris newspaper. The shapes that in earlier naturalistic, representational paintings would have been "background" have been made equal in importance to foreground shapes. Picasso chose traditional still-life objects; but rather than paint the fruit, he cut out and pasted printed images of fruit. Such compositions, called *papier collé* in French, or pasted paper, became known as **collage** in English. Analytical Cubism involved taking apart, or breaking down, the subject into its various aspects; Synthetic Cubism was a process of building up or combining bits and pieces of material.

Picasso extended the Cubist revolution to sculpture when he assembled his *Guitar* (**fig. 22.18**) from pieces of sheet metal; the flat pieces in this work

overlap in a way similar to a Cubist painting. This work began a dominant trend toward sculptural construction: Before *Guitar*, most sculpture was carved or modeled. Since *Guitar*, a great deal of contemporary sculpture has been constructed.

Toward Abstract Sculpture

At the beginning of the twentieth century, the most influential sculptor was Auguste Rodin (see fig. 21.25), who had brought a new expressiveness to the medium. The Romanian Constantin Brancusi

22.19 Constantin Brancusi. *Sleep.* 1908. White marble. 44 × 13¾″ × 47¼″.

National Art Museum of Bucharest. Photograph: Adam Woolfitt/ Corbis/© 2013 Artists Rights Society (ARS), New York/ADAGP, Paris.

22.20 Constantin Brancusi. *Sleeping Muse I.* 1909–1911. Marble. 6¾″ × 10⅝″ × 8⅜″.

Hirschhorn Museum and Sculpture Garden, Smithsonian Institution. Gift of Joseph H. Hirschhorn (1966). © 2013 Artists Rights Society (ARS), New York/ADAGP, Paris.

22.21 Constantin Brancusi. *Newborn [I].* 1915. White marble. 5¾″ × 8¼″ × 5⅞″.

Philadelphia Museum of Art. Louise and Walter Arensberg Collection, 1950.134.10. © 2013 Photo The Philadelphia Museum of Art/Art Resource/ Scala, Florence. © 2013 Artists Rights Society (ARS), New York/ADAGP, Paris.

22.22 *Cycladic II.* Naxos, Greece. 2700–2300 BCE. Marble. Height 10½″.

Louvre Museum, Paris, France. RMN/ Hervé Lewandowski.

started sculpting under Rodin's influence but later his work moved toward abstraction.

A sequence of Brancusi's early work shows his radical, yet gradual, break with the past. *Sleep* (**fig. 22.19**) of 1908 appears similar to Rodin's romantic naturalism. With *Sleeping Muse I* (**fig. 22.20**) in 1911, Brancusi simplified the subject as he moved from naturalism to abstraction. *Newborn [I]* (**fig. 22.21**) of 1915 is stripped to essentials. Brancusi said, "Simplicity is not an end in art, but one arrives at simplicity in spite of oneself, in approaching the real sense of things."[6]

Brancusi's journey toward abstraction was also a journey back to a pre-classical style of carving. Ancient sculpture from the Cyclades (islands of the Aegean Sea) has a distinctive, highly abstract elegance similar to Brancusi's, as the *Cycladic II* head (**fig. 22.22**) shows. Just as the Cubists studied African sculpture, Brancusi spent time in the Louvre sketching works in the Ancient Art section.

Brancusi gradually eliminated the surface embellishments that had dominated European sculpture since the Gothic period, instead creating shapes that were recognizable but simplified. He achieved expressive strength by carefully reducing forms to their essence. As a result, his sculpture invites contemplation.

With *Bird in Space* (**fig. 22.23**), Brancusi transformed inert mass into an elegant, uplifting form. The implied soaring motion of the "bird" embodies the idea of flight. The highly reflective polish Brancusi applied to the bronze surface contributes to the form's weightless quality. Brancusi started working on this visual concept about a decade after the Wright brothers initiated the age of human flight, but long before the world was filled with streamlined consumer goods. Brancusi said, "All my life I have sought the essence of flight."[7]

22.23 Constantin Brancusi. *Bird in Space.* 1928. Bronze (unique cast). 54" × 8½" × 6½".
The Museum of Modern Art (MoMA) Given anonymously. 153.1934.
© 2013 Artists Rights Society (ARS), New York /ADAGP, Paris.

The Modern Spirit in America

As Picasso and Braque took the steps that led to Cubism, American photographer Alfred Stieglitz was turning photography into an art form. When Picasso saw Stieglitz's photograph *The Steerage* (**fig. 22.24**), he said, "This photographer is working in the same spirit as I am."[8] By that he meant that Stieglitz had a similar eye for abstract composition.

The Steerage looked overly fragmented to many people; some of the artist's friends felt that it should have been two photographs rather than one. Stieglitz, however, saw the complex scene as a pattern of interacting forces of light, shade, shape, and direction. Aboard a ship headed for Europe, he saw the composition of this photograph as "a round straw hat, the funnel leaning left, the stairway leaning right, the white drawbridge with its railings made of circular chains, white suspenders crossing on the back of a man on the steerage below, round shapes of iron machinery, a mast cutting into the sky, making a triangular shape. . . . I saw a picture of shapes and underlying that, the feeling I had about life."[9] He rushed to his cabin to get his camera, and he made the photograph he considered his best.

Stieglitz also played a key role in introducing the new European painting and sculpture to Americans. In 1905, he opened a gallery in New York and began showing the work of the most progressive European artists, including photographers. The gallery was known as 291 after its address on Fifth Avenue. Though it had few visitors except those "in the know," its influence was immense. The gallery was the first in America to show works by Cézanne, Matisse, Brancusi, Picasso, and Braque. Stieglitz also published a highly influential magazine, *Camera Work*, that featured essays on photography and modern aesthetics. 291 also exhibited children's art and African art.

Following the exhibition of art by the European pioneers, Stieglitz began to show work by the first American modernists, including Georgia O'Keeffe. Her work from the time of World War I was innovative, consisting mostly of abstractions based on nature. In 1917, while teaching in the Texas Panhandle, she took frequent walks in the lonely, windswept prairie. Finding its emptiness immensely stimulating, she made a series of pioneering abstract watercolors entitled *Evening Star* (**fig. 22.25**), based on her sightings of the planet Venus in the darkening sky. Venus is the small unpainted circle that the yellow orb encloses, and this empty spot seems to radiate ever wider sweeps of rich, saturated color. The grandiosity of the Texas landscape inspired her; she wrote to a friend, "It is absurd how much I love this country."[10]

Between 1905 and 1910, architects began to challenge traditional concepts of form in space just as painters and sculptors had done. While Cubism was developing in painting, leading American architect Frank Lloyd Wright was designing "prairie houses," in which he often omitted or minimized walls between living and dining rooms, and between interior and exterior spaces. Wright's concept of open

22.24 Alfred Stieglitz. *The Steerage*. 1907.
From *Camera Work*, No. 34, published October 1911.
Photogravure. 12⅝" × 10³⁄₁₆".
Digital image, The Museum of Modern Art, New York/Scala, Florence.
© 2013 Georgia O'Keeffe Museum/Artists Rights Society (ARS), New York.

22.25 Georgia O'Keeffe. *Evening Star No. VI.* 1917. Watercolor on paper. 8⅞″ × 12″.

The Georgia O'Keeffe Museum. Gift of the Burnett Foundation 1997.18.03. Photo: Malcolm Varon 2001. Georgia O'Keeffe Museum, Santa Fe/Art Resource/Scala, Florence. © 2013 Georgia O'Keeffe Museum/Artists Rights Society (ARS), New York.

plans changed the way people design living spaces. In many present-day homes, kitchen, dining room, and living room now join in one continuous space, and indoors often intermingles with outdoors.

In the Robie House (**fig. 22.26**) of 1909, a striking cantilevered roof reaches out and unifies a fluid design of asymmetrically interconnected spaces. Through Wright's influence, the open flow of spaces became a major feature of contemporary architecture. To get a feeling of how far ahead of his time Wright was, imagine the incongruity of a new 1909 automobile that could have been parked in front of the Robie House the year it was completed. (See also fig. 14.28.) Wright's designs were published in Europe, and influenced the course of modern architecture there.

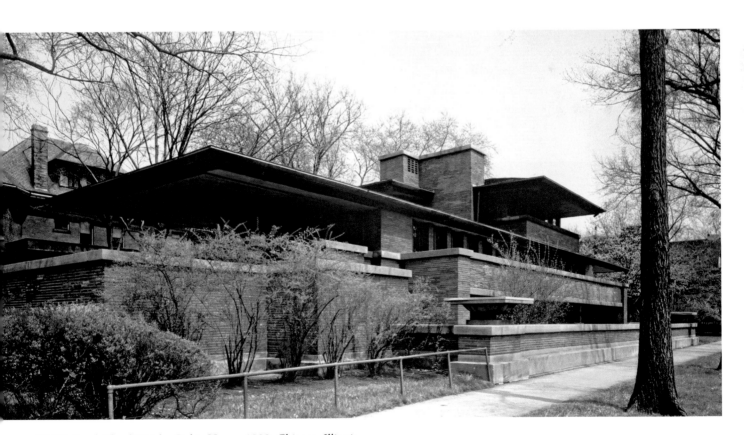

22.26 Frank Lloyd Wright. Robie House. 1909. Chicago, Illinois.

Chicago History Museum HB-19312A2. © 2013 Frank Lloyd Wright Foundation, Scottsdale, AZ/Artists Rights Society (ARS), NY.

The American public had its first extensive look at leading developments in European art during the Armory Show, which opened in New York in 1913 before traveling to Boston and Chicago. In this show of over thirteen hundred works, the organizers attempted to demonstrate that modern art was not revolutionary, but rather had evolved from movements in the mid-nineteenth century. Most of the public missed this lesson, however, in the shock of seeing Cubism and Expressionism for the first time. Though the show was controversial, it was also extremely popular, drawing over three hundred thousand visitors. American artists were able to see key works by Impressionists, Post-Impressionists, and Fauves—particularly Matisse, who was much maligned by critics. Also shown were paintings by Picasso and Braque, and sculpture by Brancusi. As a result, Cubism and other forms of abstract art spread to America.

Futurism and the Celebration of Motion

The Italian **Futurists** were among the many artists who gained their initial inspiration from Cubism, but they used it to different ends. To the shifting planes and multiple vantage points of Cubism, Futurists such as Giacomo Balla and Umberto Boccioni added a sense of speed and motion and a celebration of the machine.

By multiplying the image of a moving object, Futurists expanded the Cubist concepts of simultaneity

22.28 Umberto Boccioni.
Unique Forms of Continuity in Space. 1913.
Bronze (cast in 1931). 43⅞″ × 34⅞″ × 15¾″.
Museum of Modern Art (MoMA). Acquired through the Lillie P. Bliss Bequest. 231.1948. Digital image: The Museum of Modern Art, New York/Scala, Florence.

22.27 Giacomo Balla. *Abstract Speed—The Car Has Passed.*
1913. Oil on canvas. 19¾″ × 25¾″.
© Tate Gallery, London/Art Resource, NY © 2013
Artists Rights Society (ARS), New York/SIAE, Rome.

of vision and metamorphosis. In 1909, the poet Filippo Tommaso Marinetti proclaimed in the *Initial Manifesto of Futurism*: ". . . the world's splendor has been enriched by a new beauty; the beauty of speed . . . a roaring motorcar . . . is more beautiful than the [classical] Victory of Samothrace."[11]

The Futurists translated the speed of modern life into works that captured the dynamic energy of the new century. Giacomo Balla intended his work *Abstract Speed—The Car Has Passed* (**fig. 22.27**) to depict the rushing air and dynamic feeling of a vehicle passing. This "roaring motorcar" is passing at about 35 miles an hour, but at that time this was the pinnacle of speed.

An abstract sculpture of a striding figure climaxed a series of Umberto Boccioni's drawings, paintings, and sculpture. Boccioni insisted that sculpture should be released from its usual confining outer surfaces in order

to open up and fuse the work with the space surrounding it. In *Unique Forms of Continuity in Space* (**fig. 22.28**), muscular forms seem to leap outward in flamelike bursts of energy. During this period, the human experience of motion, time, and space was transformed by the development of the automobile, the airplane, and the movies. Futurist imagery reflects this exciting period of change.

French artist Marcel Duchamp, working independently of the Futurists, brought the dimension of motion to Cubism. His *Nude Descending a Staircase, No. 2* (**fig. 22.29**) was influenced by stroboscopic photography, in which sequential camera images show movement by freezing successive instants (see fig. 10.2 for an example). Through sequential, diagonally placed, abstract references to the figure, the painting presents the movement of a body through space, seen all at once, in a single rhythmic progression. Our sense of gravity intensifies the overall feeling of motion. When the painting was displayed at the Armory Show in New York in 1913, it caused cries of dismay and was seen as an exercise in madness. The painting, once described as "an explosion in a shingle factory,"[12] has remained an inspiration to artists who use repetition and rhythm to express motion.

Sonia Delaunay-Terk expressed motion in her paintings through color contrasts. Her large work *Le Bal Bullier* (**fig. 22.30**) is an interpretation of couples moving about on the floor of one of Paris's leading nightclubs of the time. We see Cubist influence in the work, as it is composed of flat shapes that overlap in shallow space. But the added push and pull of contrasting color contributes both depth and motion to the composition. Stretching a canvas 12 feet across proved difficult, so the artist used mattress ticking. (See also her painting *Simultaneous Contrasts*, fig. 5.4). Delaunay-Terk was an early crusader for the integration of modern art into everyday things. Even as she painted, she made book bindings, embroideries, textiles, and fashions that included ideas from the latest modern art movements. She started her own clothing design studio in 1922, where she specialized in what she called "Simultaneous Dresses" (see fig. 18.33). Not for many years would such ideas take hold in the mass market.

22.29 Marcel Duchamp.
Nude Descending a Staircase, No. 2. 1912.
Oil on canvas. 58″ × 35″.
Philadelphia Museum of Art. The Louise and Walter Arensberg Collection, 1950. Photo The Philadelphia Museum of Art/Art Resource/Scala, Florence. © Succession Marcel Duchamp/ADAGP, Paris/Artists Rights Society (ARS), New York 2013.

View the Closer Look for Marcel Duchamp's *Nude Descending a Staircase, No. 2* on myartslab.com

Study and review on myartslab.com

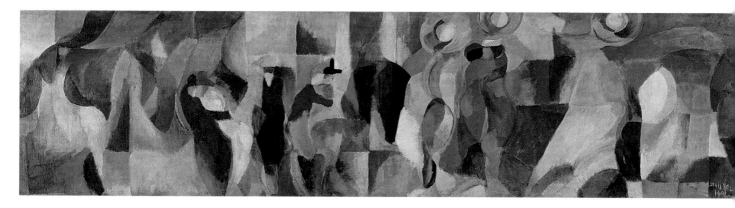

22.30 Sonia Delaunay-Terk. *Le Bal Bullier.* 1913. Oil on mattress ticking. 3′2³⁄₁₆″ × 12′9½″.
Musée National d'Art Moderne, Centre Pompidou. White Images/Scala, Florence. © Pracusa 2013020.

THINK BACK

1. Was Expressionism a revolutionary movement? Or was it evolutionary?

2. How does Analytical Cubism reflect the way we actually see?

3. What were the two initial ways in which modern art arrived in the United States?

4. Why was the idea of motion so important to the Futurists?

TRY THIS

Find out what Expressionistic music sounds like. Listen to recordings of the music of Arnold Schoenberg or Alban Berg, two leading composers in that style.

KEY TERMS

collage – a work made by gluing various materials, such as paper scraps, photographs, and cloth, on a flat surface

Cubism – an art style developed in Paris by Picasso and Braque, beginning in 1907, based on the simultaneous presentation of multiple views, disintegration, and geometric reconstructions of subjects in flattened, ambiguous pictorial space

Expressionism – refers to individual and group styles originating in Europe in the late nineteenth and early

twentieth centuries, characterized by bold execution and free use of distortion and symbolic or invented color

Fauvism – a style of painting introduced in Paris in the early twentieth century, characterized by areas of bright, contrasting color and simplified shapes

Futurism – a group movement originating in Italy in 1909 that celebrated both natural and mechanical motion and speed

23

BETWEEN WORLD WARS

THINK AHEAD

23.1 Describe the effect of World War I on art of the 1920s.

23.2 Explain Dada's use of the readymade and photomontage as forms for social critique.

23.3 Identify the interests, visual characteristics, and techniques associated with Surrealism.

23.4 Recognize how artists after World War I took Cubism in new directions.

23.5 Compare the artistic and social interests of Constructivism, De Stijl, Bauhaus and the International Style in architecture.

23.6 Contrast artistic styles used to communicate political ideas.

23.7 Distinguish the interests and influences of artists in Latin America and the United States in the years between the wars.

In 1914, enthusiasm for grand, patriotic solutions to international tensions led citizens of many countries into World War I, an intense and protracted conflict that involved most European countries and eventually the United States. But the war turned out to be far more devastating than the people of the time expected: More than ten million were killed and twice that number wounded. The promise of a whole new generation was lost in the world's first experience of mechanized mass killing.

As a result of the war, the political and cultural landscape changed forever. The war set the stage for the Russian Revolution and sowed grievances that the Nazis of Germany and the Fascists of Italy later exploited. Governments assumed new powers to mobilize people and material, to dictate economic life, to censor public expression, and, by controlling information, to manipulate the way people thought. Dissent was denounced as unpatriotic.

Many artists in the interwar period consciously linked their creations to their hopes for a better world. Some expressed those hopes by angrily denouncing present conditions; others offered utopian visions. This tendency to use art as a tool for social betterment is a prominent marker for this period. Another marker is the spread of modernist innovations to non-European populations, as variations on modern styles arose in many places.

Dada

Dada began in protest against the horrors of World War I. The artists and writers who began the movement in Zurich chose the ambiguous word **Dada** as their rallying cry. According to some accounts, they arrived at the name by randomly sticking a knife into a dictionary. The two-syllable word was well suited for expressing the essence of what was more a rebellious attitude than a cohesive style. In the eyes of the Dadaists, the destructive absurdity of war was caused by traditional values, which they set out to overturn. According to artist Marcel Janco:

((•—[**Listen** to the chapter audio on myartslab.com

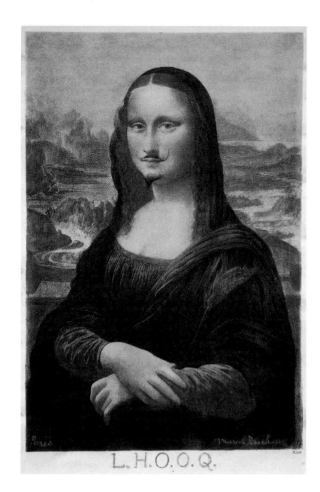

23.1 Marcel Duchamp. *L.H.O.O.Q.* 1919. Pencil on reproduction of Leonardo's *Mona Lisa*. 7¾″ × 4¾″.
Philadelphia Museum of Art, Pennsylvania. Louise and Walter Arensberg Collection, 1950. © Succession Marcel Duchamp/ADAGP, Paris/Artists Rights Society (ARS), New York 2013.

Dada was not a school of artists, but an alarm signal against declining values, routine, and speculation, a desperate appeal on behalf of all forms of art, for a creative basis on which to build a new and universal consciousness of art.[1]

French artist and poet Jean Arp said:

While the thunder of guns rolled in the distance, we sang, painted, glued, and composed for all our worth. We were seeking an art that would heal mankind from the madness of the age.[2]

The insanity of the war proved to Dadaists that European culture had lost its way. To make a new beginning, the Dadaists rejected most moral, social, political, and aesthetic values. They thought it pointless to try to find order and meaning in a world in which so-called rational behavior had produced only chaos and destruction. They aimed to shock viewers into seeing the absurdity of the Western world's social and political situation.

The Dadaists often protested through play and spontaneity. Chance rather than premeditation often guided their literature, art, and staged events. Poets shouted words at random; artists joined diverse elements into startling and irrational combinations.

Marcel Duchamp was the most radical of the Dadaists, and perhaps the most radical artist of the twentieth century. He had the audacity to offer mass-produced objects as art works, calling them **readymades**. For example, he once signed a snow shovel and titled it *In Advance of the Broken Arm*. In 1917, he signed a urinal with someone else's name and called it *Fountain*.

In a purposeful slap at traditional standards of beauty, Duchamp bought a picture postcard reproduction of Leonardo da Vinci's *Mona Lisa*, and drew a mustache and beard on her face. He signed the work with his own name and titled it *L.H.O.O.Q* (**fig. 23.1**). The title is a vulgar pun, comprehensible to those who can read the letters aloud quickly in French. Roughly translated into English it means, "She's hot in the tail." By showing outrageous irreverence toward a deeply treasured painting, Duchamp tried to shake people out of their unthinking acceptance of dominant values.

The American artist Man Ray, a friend of Duchamp, was a leader of Dada in the United States. His Dada works include paintings, photographs, and assembled objects. In 1921, he visited a housewares shop and purchased a clothes iron, a box of tacks, and a tube of glue. After gluing a row of tacks to the smooth surface of the iron, he titled his assemblage *Gift* (**fig. 23.2**), thus creating a useless and dangerous object.

Dadaists expanded on the Cubist idea of collage with **photomontage**, in which parts of photographs are combined in thought-provoking ways. In *The Multi-Millionaire* (**fig. 23.3**), by Dadaist Hannah Höch, industrial-age man stands as a fractured giant among the things he has produced. At the time she created this work, the artist was attacked for lacking originality, because she merely combined already existing things. But now we see how original she was.

23.2 Man Ray. *Cadeau (Gift).* c.1958.
Replica of 1921 original. Painted
flatiron, with row of thirteen tacks,
heads glued to the bottom.
6⅛″ × 3⅝″ × 4½″.

indebted to the irrationality of Dadaism,
and they also drew heavily on the new psy-
chology of Sigmund Freud.

The new movement, **Surrealism**, was
officially launched in Paris in 1924 with the
publication of its first manifesto, written by
poet-painter André Breton. He defined the
movement's purpose as:

> the future resolution of these two states,
> dream and reality, which are seemingly so
> contradictory, into a kind of absolute reality, a
> surreality, if one may so speak.[3]

One of the first converts to the movement was the for-
mer Dadaist Max Ernst, who had fought in the war and
was still haunted by its nightmares. To allow freer play
to fantasy, he laid his canvases over textured surfaces
such as asphalt pavement, and rubbed the canvas with
pencils and crayons. In this way he could be surprised by
the patterns that emerged for fertilization in his paint-
ings. This technique is called **frottage**, the French word
for "rubbing." In the 1927 work *The Horde* (**fig. 23.4**),
we see a gaggle of silhouetted monsters tumbling over
one another in a violent scene. The artist's combat expe-
rience in World War I most likely influenced the chaotic
nature of this work.

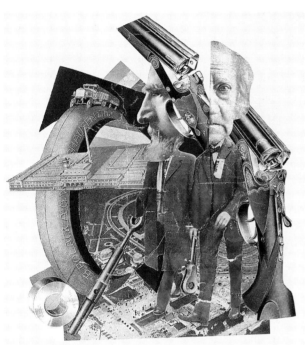

23.3 Hannah Höch. *The Multi-Millionaire.* 1923.
Photomontage. 14″ × 12″.

Some Dadaists maintained that art was dead. By
this they meant that it was useless to try to create beauty
in a world that could destroy itself. They often intended
to be anti-aesthetic but, ironically, they created a new
aesthetic of lasting influence.

Surrealism

In the mid 1920s, a group of writers and painters
gathered to protest the direction of European culture.
They thought that the modern emphasis on science,
rationality, and progress was throwing the conscious-
ness of Europeans out of balance. In response, they
proclaimed the importance of the unconscious mind,
of dreams, fantasies, and hallucinations. They were

23.4 Max Ernst. *The Horde.* 1927.
Oil on canvas. 44⅞″ × 57½″.

23.5 Salvador Dalí. *The Persistence of Memory.* 1931. Oil on canvas. 9½" × 13".

Museum of Modern Art (MoMA) Given anonymously. Acc. n.: 162.1934. Digital image, The Museum of Modern Art, New York/Scala, Florence. © Salvador Dalí, Fundació Gala-Salvador Dalí, Artists Rights Society (ARS), New York 2013.

View the Closer Look for Salvador Dalí's *The Persistence of Memory* on myartslab.com

The Spanish artist Salvador Dalí dealt more directly with his nightmares. He teamed with filmmaker Luis Buñuel on the highly illogical film *Un Chien Andalou (An Andalusian Dog)* (see fig. 10.6). In painting, he recreated his nightmares in a highly illusionistic

fashion based on academic techniques. *The Persistence of Memory* (**fig. 23.5**) evokes the eerie quality of some dreams. Mechanical time wilts in a deserted landscape of infinite space. The warped, headlike image in the foreground may be the last remnant of a vanished humanity. The artist called it a self-portrait.

Dalí's illusionary deep space and representational techniques create near-photographic dream images that make the impossible seem believable. The startling juxtaposition of unrelated objects creates a hallucinatory sense of a superreality beyond the everyday world. This approach has been called Representational Surrealism. In contrast, Joan Miró's **Abstract Surrealism** provides suggestive elements that give wide play to the viewer's imagination, and emphasize color and design rather than storytelling content.

To probe the unconscious, Miró and others used automatic processes, sometimes called **automatism**, in which chance was a key factor. They scribbled, doodled, and poured paint in order to cultivate the chance accident that might prove revealing. With the adoption of such spontaneous and "automatic" methods, the Surrealists sought to expand consciousness by throwing

23.6 Joan Miró. *Woman Haunted by the Passage of the Bird-Dragonfly Omen of Bad News.* 1938. Oil on canvas. 31½" × 124".

Toledo Museum of Art. Purchased with funds from the Libbey Endowment. Gift of Edward Drummond Libbey. 1986.25. © Successió Miró/Artists Rights Society (ARS), New York/ADAGP, Paris 2013.

out the sort of rational planning that frequently accompanies art creation.

Miró's evocative paintings often depict imaginary creatures. He made them by scribbling or doodling on the canvas and then examining the results to see what the shapes suggested. The bold, organic shapes in *Woman Haunted by the Passage of the Bird-Dragonfly Omen of Bad News* (**fig. 23.6**) are typical of his mature work. The wild, tormented quality, however, is unusual for Miró and reflects his reaction to the times. Miró pointed out that this painting was done at the time of the Munich crisis that helped precipitate World War II. Even though

there is a sense of terror here, Miró's underlying playful optimism is apparent. He loved the art of children so much that he tried to paint like a child.

Belgian Surrealist René Magritte used an illogical form of realism, similar to Dalí's in surface appearance but different in content. Magritte's paintings engage the viewer in mind-teasing mystery and playful humor. *The Lovers* (**fig. 23.7**) depicts a couple in an impossible kiss. If we imagine ourselves in that scene, we get the jolt that the Surrealists wanted to induce. (Perhaps his best-known work is *The Treachery of Images,* pictured in fig. 1.11.)

23.7 René Magritte. *The Lovers.* 1928. Oil on canvas. 21⅜″ × 28⅞″.

Expanding on Cubism

Cubism makes possible many ambiguities between presence and absence, representation and abstraction, figure and ground. Far from presenting the world as stable and predictable, Cubism suggests constant change and evolution. An art historian wrote, "By devaluing subject matter, or by monumentalizing simple, personal themes, and by allowing mass and void to elide, the Cubists gave effect to the flux and paradox of modern life and the relativity of its values."[4] Thus,

23.8 Kazimir Malevich.
Suprematist Composition: Airplane Flying. 1915.
Oil on canvas. 22⅞" × 19".

The Museum of Modern Art (MoMA) Purchase. Acquisition confirmed in 1999 by agreement with the Estate of Kazimir Malevich and made possible with funds from the Mrs. John Hay Whitney Bequest (by exchange). 248.1935. Digital image, The Museum of Modern Art, New York/Scala, Florence.

23.9 Fernand Léger. *The City.* 1919. Oil on canvas. 91" × 177½".

Philadelphia Museum of Art. Gallatin Collection, 1952-61-58. Photo The Philadelphia Museum of Art/Art Resource/Scala, Florence. © 2013 Artists Rights Society (ARS), New York/ADAGP, Paris.

Cubism makes visible some important characteristics of modern life.

Russian artists took Cubism toward complete abstraction. A leader there was Kazimir Malevich, who branded his style Suprematism. His painting *Suprematist Composition: Airplane Flying* (**fig. 23.8**) shows in its title that the artist was familiar with Futurism: Its subject is a speeding modern airplane. Yet Malevich so simplified the Cubist pictorial language that we are left with a succession of flat irregular rectangles against a pure background.

Malevich believed that shapes and colors in a painting always communicate, no matter what the subject of the work. Ideally, he thought, art should not need subject matter. This is why he named his movement Suprematism, because he wanted to focus on the supremacy of shape and color in art over representation or narrative. He shared some points of view with his fellow Russian Wassily Kandinsky, whom he knew. But while Kandinsky (who worked in Germany) painted brash, expressive works (see fig. 22.7), Malevich's constant urge to simplify makes him the more radical painter.

In his large painting *The City* (**fig. 23.9**), Fernand Léger crushed jagged shapes together, collapsing space in a composition reminiscent of a Cubist portrait or still life. The forms in his paintings look machine-made, rounded and tubular; this is in keeping with the urban bustle that is the work's subject.

Léger soon took Cubist composition into film when he made *Ballet Mécanique* (**fig. 23.10**), a 17-minute cinematic collage in which churning machines alternate with a swinging pendulum, a smiling woman, and

23.10 Fernand Léger. *Ballet Mécanique.* 1924. Film.
© 2013 Artists Rights Society (ARS), New York/ADAGP, Paris.

shifting geometric shapes. Sometimes these forms are distorted with a kaleidoscopic mirror, which mashes them up and flattens them in the manner of a Cubist still life. Léger intended the film to have a score by the American George Antheil, but practicalities prevented this. Antheil composed an unforgettably riotous work for 17 player pianos, percussion, and a siren, but because it ran twice as long as the film, the two could not be synchronized. Léger's film follows no obvious logic, but it seems to argue that machines and humans are about equally rhythmic if not equally graceful.

Building a New Society

Several art movements that emerged between the wars had the goal of improving the world somehow. Surrealists, for example, hoped to liberate human consciousness. Pioneer abstractionists felt that the nonrepresentational language they were creating would provide an ideal basis for the utopian society they sought. Constructivism, in Russia, focused on developing a new visual language for a new industrial age. De Stijl, in Holland, advocated the use of basic forms, particularly rectangles, horizontals, and verticals. Both movements spread throughout Europe and strongly influenced many art forms.

Constructivism

Constructivism was a revolutionary movement that began in Russia, inspired in part by the Suprematism of Malevich and others. Seeking to create art that was relevant to modern life in form, materials, and content, Constructivists made the first nonrepresentational constructions out of such modern materials as plastic and electroplated metal.

23.11 Lyubov Popova. *Painterly Architectonic*. 1917. Oil on burlap. 27¾" × 27¾".
Museo Thyssen-Bornemisza, Madrid. Inv. 716 (1977.52). Photo Museo Thyssen-Bornemisza/Scala, Florence.

23.12 Aleksandr Rodchenko.
View of The Workers' Club.
Reconstruction exhibited at
the International Exposition of
Modern Decorative and Industrial
Arts, Paris. 1925.
© Estate of Alexander Rodchenko/RAO,
Moscow/VAGA, New York.

The Constructivists agreed with the Cubists in rejecting the traditional view of space as regular and static. The name of the movement came from their preference for constructing planar and linear forms that suggested a dynamic quality and, whenever possible, contained moving elements.

The painter Lyubov Popova pioneered many of these effects in nonrepresentational works that she called *Painterly Architectonic* (**fig. 23.11**). Planes intersect in a shallow space that derives from Cubism (see her earlier Cubist work *The Pianist*, fig. 4.15). Though the work seems to resemble a mechanical contrivance of unknowable function, nothing is pictured here except forms and colors. Popova combined her painting with teaching in workers' schools, and she helped to found the First Working Group of Constructivists in 1921.

One of her Constructivist colleagues was Aleksandr Rodchenko, one of the century's most innovative multimedia artists. He began as a painter, working with compass and ruler in true Constructivist fashion. Soon he renounced painting in favor of more useful arts: He designed posters for public display, as he also worked on furniture, photography, and stage sets. He created The Workers' Club (**fig. 23.12**) as a training ground for the new Soviet mind. Rodchenko envisioned every aspect of this installation to educate workers in the new historical dynamic that would lead to a future classless society. The chairs, shelves, and desks are all made of simple, mass-produced parts, and designed to facilitate sitting upright.

De Stijl

A group of Dutch artists took Cubism toward utopian speculation when they formed the movement called **De Stijl** (The Style). Led by painter Piet Mondrian, this group began to employ nonrepresentational geometric elements in a group style that involved both two- and three-dimensional art forms. Their goal was the creation of a world of universal harmony. Using the new vocabulary of abstract art, they created an inventive body of work in painting, architecture, furniture, and graphic design.

Mondrian's evolution as an artist represents the origin and essence of De Stijl. Working to free painting

23.13 Piet Mondrian.
Tableau 2 with Yellow, Black, Blue, Red, and Gray.
1922. Oil on canvas. 21⅞" × 21⅛".
Solomon R. Guggenheim Museum, New York 51.1309.
© 2013 Mondrian/Holtzman Trust c/o HCR International USA.

Watch a video about Piet Mondrian's place in art history on myartslab.com

completely from both the depiction of real objects and the expression of personal feelings, he developed an austere style based on the expressive potential of simple visual elements and their relationships. He created a new aesthetic that would provide a poetic vitality capable of setting standards of harmony for the new technological age.

From 1917 until his death in 1944, Mondrian was the leading spokesperson for an art reflecting universal order. In his mind, these universal elements were straight lines, the three primary colors, and rectangular shapes. He reduced painting to four elements: line, shape, color, and space. His painting *Tableau 2* (**fig. 23.13**) exemplifies his nonrepresentational work. Mondrian hoped that the rhythms and forms of his works paralleled those of nature itself, which he viewed as rational and orderly.

International Style Architecture

The search for a new visual language engaged architects as well as painters. Ideas about form developed by the Constructivists, the De Stijl artists, and previously by American architect Frank Lloyd Wright, were carried further by architects stimulated by the structural possibilities of modern materials including steel, plate glass, and reinforced concrete.

About 1918, a new style of architecture emerged simultaneously in Germany, France, and the Netherlands and came to be called the International Style. Steel-frame, curtain-wall construction methods made it possible to build structures with undecorated rectilinear planes. The steel frame freed the exterior walls from bearing weight, which brought abundant light and flexible space to interiors. In many International Style buildings, asymmetrical designs created dynamic balances of voids and solids. Unlike Frank Lloyd Wright, who blended houses with their natural surroundings, architects working in the International Style deliberately created a visual contrast between the manufactured-looking house and its natural environment.

Dutch architect Gerrit Rietveld took De Stijl into three dimensions. His Schröder House in Utrecht (**fig. 23.14**) was an early classic of the International Style. Its design of interacting planes, spaces, and primary colors are closely related to Mondrian's paintings.

The International Style buildings designed by Walter Gropius for the Bauhaus (see fig. 14.20) clearly reflect the concepts of both De Stijl and Constructivism. Today, the spare style that Mondrian and the Bauhaus helped to initiate can be seen in the design not only of buildings, but of books, interiors, clothing, furnishings, and many other articles of daily life.

23.14 Gerrit Rietveld. Schröder House. 1924.
Image © Collection Centraal Museum, Utrecht. © 2013
Artists Rights Society (ARS), New York/ c/o Pictoright Amsterdam.

Architect and designer Ludwig Mies van der Rohe was one of the most influential figures associated with the Bauhaus and the International Style. For the Barcelona World's Fair in 1929, he designed the German Pavilion in marble, glass, and steel (**fig. 23.15**). Like the Schröder House, the German Pavilion is an abstract composition similar to a De Stijl painting. Mies designed the pavilion with flowing spaces so that the visitor never feels "boxed in." An attached rectangular pool on the left reflects the elegant design on the water's surface. In 1938, Mies emigrated to the United States. There, his ideas and works potently influenced the post-World War II development of the skyscraper.

23.15 Ludwig Mies van der Rohe. German Pavilion. 1929.
International Exposition, Barcelona. Guggenheim. © 2013 Artists Rights Society (ARS), New York/ VG Bild-Kunst, Bonn.

Political Expressions

Many artists in the interwar period focused their art on political life. Protesting against fascism and dictatorship was a dominant theme.

Throughout the 1920s and into the 1930s, Spanish-born Pablo Picasso continued to produce innovative drawings, paintings, prints, posters, and sculptures. In 1937, while the Spanish Civil War was in progress, Picasso was commissioned by the doomed Spanish democratic government to paint a mural for the Paris International Exposition. On April 26 of that year he was shocked into action by the "experimental" mass bombing of the defenseless Basque town of Guernica. To aid his bid for power, General Franco had allowed Hitler to use his bombers on the town as a demonstration of military power. The bombardment, which leveled the 15 blocks of the city center, was the first incidence of saturation bombing in the history of warfare. Hundreds died, and more were strafed with machine-gun fire from German aircraft as they fled the city into neighboring fields.

Appalled by this brutality against the people of his native country, Picasso responded by creating the mural-size painting *Guernica* (**fig. 23.16**). Although this work stems from a specific incident, it is a statement of protest against the brutality of all war.

Guernica covers a huge canvas more than 25 feet long. It is painted mostly in the somber blacks, whites, and grays of newspapers before the days of color printing. A large triangle embedded under the smaller shapes holds the whole scene of chaotic destruction together as a unified composition. *Guernica* combines Cubism's intellectual restructuring of form with the emotional intensity of earlier forms of Expressionism and Abstract Surrealism. In dream symbolism, a horse often represents a dreamer's creativity. Here the horse is speared and is dying in anguish. Beneath the horse's feet a soldier lies in pieces; near his broken sword a faint flower suggests hope. Above, a woman reaches out from an open window, an oil lamp in hand. Near the old-fashioned lamp and above the horse's head is an eyelike shape with an electric light bulb at the center: Jagged rays of light radiate out from the bottom edge. Sometimes an eye representing the eye of God was painted on the ceiling of medieval churches. The juxtaposition between old and new sources of illumination could be a metaphor relating to enlightenment.

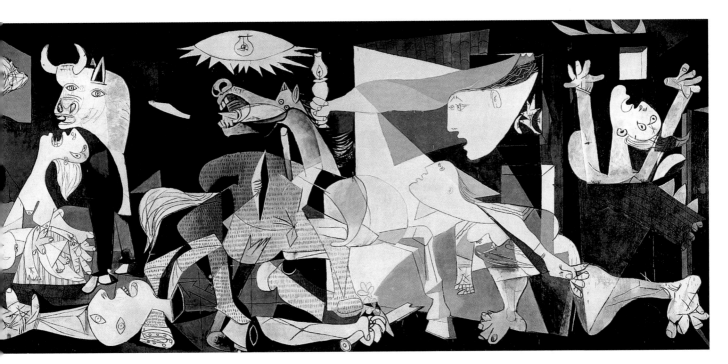

23.16 Pablo Picasso. *Guernica.* 1937. Oil on canvas. 11′5½″ × 25′5¼″.
Museo Nacional Centro de Arte Reina Sofía. Photograph: The Bridgeman Art Library. © 2013 Estate of Pablo Picasso/Artists Rights Society (ARS), New York.

Interviewed during the war, Picasso remarked that "painting is not done to decorate apartments. It is an instrument of war for attack and defense against the enemy."[5] Unfortunately, the type of aerial bombardment that he decried in *Guernica* soon became a common strategy that all sides adopted.

Between the world wars, a socially and politically committed form of art called **social realism** became common in many countries. This style took many forms, but they all include a retreat from the radical innovations of modern art and a desire to communicate more readily with the public about social causes and issues. In Nazi Germany and in Communist Russia this style became an officially sponsored "norm"

for art, which artists could ignore only if they did not care to have a successful career. A good example of Russian social realism is Vera Mukhina's *Monument to the Proletariat and Agriculture* (**fig. 23.17**). Her huge statue, which depicts a male factory worker and a female farm worker in stainless steel 78 feet high, was first exhibited at the Paris International Exposition of 1937. The work expresses the Communist vision of the Soviet state, where rural and urban workers would happily unite in a choreographed dance of praise to the regime. It still stands in Moscow, celebrating the system that came crashing down in 1991 with the fall of the Communist regime.

Mexican social realism took the form of mural paintings that embodied the ideals of the revolution of 1910–17, when a popular uprising overthrew a long-entrenched dictatorship. The Mexican government in 1921 embarked on a program to pay artists an hourly wage to decorate public buildings with murals that spoke to the people about their long history and recent revolution. Inspired by the murals of the Italian Renaissance and by pre-Columbian wall paintings of ancient Mexican cultures, the muralists envisioned a national art that would glorify the traditional Mexican heritage and promote the new post-revolutionary government. Diego Rivera's fresco *The Liberation of the Peon* (**fig. 23.18**) is a good example that deals with a common event of the revolution: The landlord's house burns in the background, while revolutionary soldiers untie the peon from a stake and cover his naked body, which is scarred by repeated lashings. This work is a variation of a large painting on a wall of the Ministry of Education in Mexico City. Both Diego Rivera and fellow muralist José Clemente Orozco visited the United States, where they influenced American art.

During the Depression years of the 1930s, the United States government maintained an active program of subsidy for the arts. The Works Progress Administration (WPA) commissioned painters to paint murals in public buildings, and the Farm Security Administration (FSA) hired photographers and filmmakers to record the eroding Dust Bowl and its workworn inhabitants. With government support, the art of documentary filmmaking reached a peak of achievement.

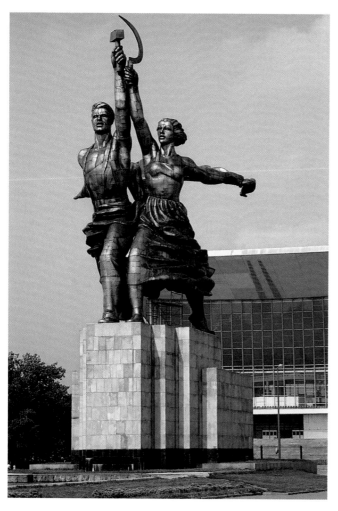

23.17 Vera Mukhina. *Monument to the Proletariat and Agriculture.* 1937. Stainless steel. Height 78′.
© Estate of Vera Mukhina/RAO, Moscow/VAGA, New York.
Photograph: Sovfoto.

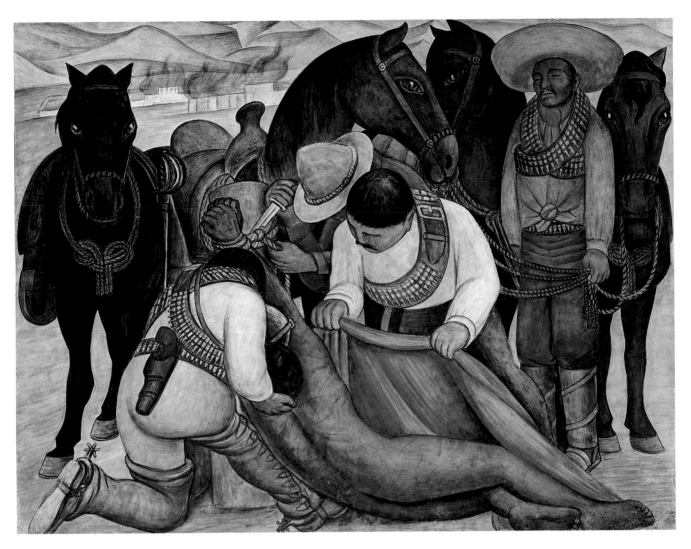

23.18 Diego Rivera.
The Liberation of the Peon. 1931.
Fresco. 73″ × 94¼″.
Philadelphia Museum of Art. Gift of Mr. and Mrs. Herbert Cameron
Morris. 1943–46–1. Photograph: The Philadelphia Museum of Art/
Art Resource/Scala, Florence. © 2013 Banco de México Diego
Rivera Frida Kahlo Museums Trust, Mexico, D.F./Artists Rights Society
(ARS), New York.

Photographer Dorothea Lange documented the
helplessness and hopelessness of the urban unem-
ployed. Her sensitive study, *White Angel Bread Line, San
Francisco* (**fig. 23.19**), is a powerful image of a difficult
period. Photos such as this both made people more
aware of current needs and built sympathy for those
most affected by the Depression.

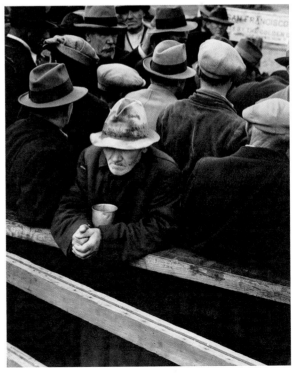

23.19 Dorothea Lange.
White Angel Bread Line, San Francisco. 1933.
Photograph. 4¼″ × 3¼″.
The Oakland Museum of California, City of Oakland.
© The Dorothea Lange Collection. Gift of Paul S. Taylor. A67.137.33001.1.

Projecting Power

23.20 Linguist Staff. Finial. Ashanti, Ghana. 19th–20th century. Gold foil, wood, nails. Overall height 61⅛″.

The Metropolitan Museum of Art. Gift of the Richard J. Faletti Family, 1986. Inv.1986.475a-c. © 2013. Image copyright The Metropolitan Museum of Art/Art Resource/Scala, Florence.

encouraged allegiance to the dominant power. Corporations and organizations today also use art not only to persuade us to do or buy things but to show their power.

In the West African Ashanti culture of Ghana, some kinds of persuasive art are rooted in folklore. The Ashanti king has a group of advisors called linguists, who interpret the king's decrees to the people, and who channel the people's communication to him. When speaking for the king, they clothe his words in proverbs, so that he seems to speak from the depths of the traditional culture. Linguists also engage in diplomatic missions, representing the king in sometimes delicate negotiations where their skill at speaking is needed.

The linguists carry staffs that mark their office. The decoration at the top of each staff, called a **finial**, carries a persuasive message by illustrating an important saying. The finial pictured here (**fig. 23.20**) illustrates the proverb, "No one goes to the spider's house to teach him wisdom." In Ashanti mythology, a spider named Ananse brought wisdom to the Ashanti, along with proverbs and folk tales. He thus occupies a legendary place similar to that of the linguist, a wise speaker. Just as the spider's wisdom is not challenged, so the linguist's statements should be respected. Here we see a spider in his web, with two attendants who seem to wait on him. The gold covering this wood finial gives a radiant

Rulers and governments are among the most common sponsors of persuasive art. Splendid government buildings, public monuments, and impressive artifacts are often used to influence and control the actions and opinions of the populace. In the first part of the twentieth century, for example, regimes in Russia, Mexico, and Germany sponsored artists to create works of art that

23.21 *Bayeux Tapestry* (detail: Harold swearing the oath). Normandy, c.1066–1082. Height 20″.

Musée de la Tapisserie, Bayeux, France/With special authorisation of the city of Bayeux/The Bridgeman Art Library.

View the Closer Look for the Bayeux Tapestry on myartslab.com

appearance that adds to its persuasive impact.

One of the most noted pieces of fiber art from the Middle Ages also has a marked persuasive function. The Bayeux Tapestry recounts in words and pictures the events of the Norman conquest of England in 1066 from the point of view of the invaders. The tapestry (which is not a true tapestry but rather a strip of linen embroidered with colored wools) is 230 feet long, and tells the story through a sequence of separate scenes. One of the crucial moments of the conquest is illustrated here (**fig. 23.21**): Harold, a powerful English noble, swears an oath of allegiance to William of Normandy at the latter's palace in France. We see Harold touching two cabinets that contain relics; William looks on from the left.

Other parts of the Bayeux Tapestry show Harold returning to England, and accepting the English throne upon the death of King Edward. This act incensed William of Normandy, who thought that because Harold had sworn allegiance to him, William himself should assume the crown. The apparent breaking of the oath was the basis for William's invasion in 1066, and led to Harold's death at the Battle of Hastings, events that the work also illustrates. The tapestry was hung in one of the cathedrals of Normandy as public justification for the invasion. Centuries later, Napoleon Bonaparte

23.22 Anish Kapoor and Cecil Balmond.
ArcelorMittal Orbit. 2012. Steel and glass. Height 375´.
Photo ArcelorMittal.

remembered the persuasive intent of the tapestry, and had it displayed in Paris in 1803 as he considered an invasion of Great Britain.

Some works that were created for other purposes also have a persuasive intent, among them the Sistine Chapel ceiling painted by Michelangelo. Acorns and oak leaves are seen in many places on the ceiling fresco, including just below the hip of Adam in *The Creation of Adam* (see fig. 17.10b), the work's most famous scene. The pope who commissioned the work, Julius II, was a member of the della Rovere family (the name means "from the oak"), and his family crest symbol is the oak tree. By painting oak branches in many of the ceiling's biblical scenes, Michelangelo promoted the power of his patron's family.

In our own time, corporations often promote their interests through the acquisition and display of artworks, and through sponsorship of public events. Such sponsorship helps to persuade the public that the corporation is a benevolent social force. For the grounds of the 2012 London Olympics, the ArcelorMittal steel company sponsored the *ArcelorMittal Orbit* (**fig. 23.22**), a looping red and gray tower 375 feet in height. Among the world's tallest pieces of sculpture, it rises higher than the Statue of Liberty. The steel company donated most of the building materials, and visitors will fund the maintenance through their purchase of entrance tickets. ArcelorMittal CEO Lakshmi Mittal said that the tower is intended as a "showcase for the versatility of steel," but it also promotes the company whenever the work's full title is used.

Latin American Modernism

Modern art showed distinctive characteristics when it bloomed across Latin America in the 1920s. Art movements were often interdisciplinary, allying painters with poets or composers. A case in point was Modern Art Week in São Paulo, Brazil, in 1922: Artists showed works influenced by Cubism and abstraction, poets read lyrics denouncing their elders, and musicians played new work that reflected Afro-Brazilian traditions. The crucial question that they all faced was how to relate to European culture, and Brazilian modernists came up with a perfectly logical but also rebellious answer: cannibalism. Brazilians would "ingest" European culture and let it nourish their own self-expression.

Tarsila do Amaral embodied this cannibalism in her painting *Abaporu* (**fig. 23.23**). The style shows her study of Fernand Léger's Cubism and the abstract sculpture of Brancusi (see fig. 22.23). But the composition has "tropical" clichés like the lemon-slice sun and the cactus. Thus she slyly affirmed Brazilian culture. The solitary figure is the cannibal, or, translating the title

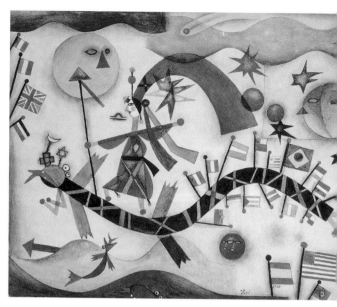

23.24 Xul Solar. *Dragon.* 1927.
Watercolor on paper. 10″ × 12⅝″.
Fundación Pan Klub, Museo Xul Solar, Buenos Aires.
© Pan Klub Foundation–Xul Solar Museum.

from the native Brazilian language, "the one who eats." One of the poets of that period wrote in a *Cannibalistic Manifesto* that Brazilians have a dual heritage: the jungle and the school. Tarsila's art shows both of these.

In Argentina, painters and poets banded together in order to combat the public's ignorance about modern art. Their journal, *Martín Fierro*, extolled the most creative artists, among them Xul Solar. His first name—pronounced "shool"—is the Latin word for "light" spelled backward. Here is an artist who named himself after sunlight! He spent many years in Europe, and when he returned in 1924 he began exhibiting fantasy-based watercolors such as *Dragon* (**fig. 23.24**). Here a figure in an elaborate headdress (a priest?) rides a giant serpent pierced with 15 protruding flagpoles. The head of this dragon is adorned with a cross, a star, and a moon, symbols of Christianity, Judaism, and Islam respectively. The work embodies Xul's hopes for a universal spiritualism, a union of religions and nations. Author Jorge Luis Borges wrote that being Argentine gives artists a uniquely detached perspective on the rest of the Western world; Xul seems to want to embrace all of it.

Uruguayan artist Joaquín Torres-García developed a uniquely American version of Constructivism (and here we refer to all of the Americas, as the artist did). The rectangular blocks in his work *Universal*

23.23 Tarsila do Amaral. *Abaporu.* 1928.
Oil on canvas. 34″ × 29″.
Museo de Arte Latinoamericano, Buenos Aires (Malba).
Courtesy of Guilherme Augusto do Amaral.

Constructivism (**fig. 23.25**) refer both to Mondrian's paintings and to the stone architecture of pre-conquest indigenous Peru. Over that framework, he drew symbols that refer both to modern life and to the pottery designs of ancient Americans. Thus he aimed at a cross-cultural synthesis of modern and ancient that he hoped would have universal appeal. A few words in Spanish (year, light, world) also mark this as a specifically Latin American work.

The Surrealists adopted Mexican painter Frida Kahlo, even though her sources were closer to the

23.26 Frida Kahlo. *The Two Fridas.* 1939.
Oil on canvas. 5′8½″ × 5′8½″.
Museo de Arte Moderno, Instituto Nacional de Bellas Artes, Mexico City. Photo Art Resource/Bob Schalkwijk/Scala, Florence© 2013 Banco de México Diego Rivera Frida Kahlo Museums Trust, Mexico, D.F./Artists Rights Society (ARS), New York.

folk arts of her native country. Her painting *The Two Fridas* (**fig. 23.26**) shows herself as a split personality, divided between her European and Mexican heritage. As each stares back at us, we see their hearts plainly visible, joined by blood vessels. This is an allusion both to ancient Aztec human sacrifice and to the artist's own surgical traumas. Her many self-portraits provide insight into an exceptional person who lived life with passionate intensity.

American Regionalism

In the 1930s, the spread of the Depression, along with political upheaval, helped motivate artists in America (and here we mean the United States) to search for both national and personal identity. American artists were caught between a public largely indifferent to art and a feeling, both at home and abroad, that American art was merely provincial. In this atmosphere of relative cultural isolation, an American regionalism developed, based on the idea that artists in the United States could find their identity by focusing attention on the subject matter that was local and American.

23.25 Joaquín Torres-García.
Universal Constructivism. 1930.
Oil on wood. 23¼″ × 11⅜″.
Museo Nacional Centro de Arte Reina Sofía, Madrid.

23.27 Edward Hopper. *Nighthawks.* 1942.
Oil on canvas. 33⅛″ × 60″.
The Art Institute of Chicago, Friends of American Art Collection. 1942.51.
Photograph © The Art Institute of Chicago.

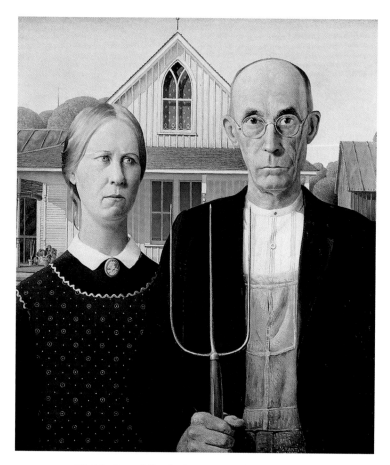

23.28 Grant Wood. *American Gothic.* 1930.
Oil on beaverboard. 29¼″ × 24½″.
Friends of American Art Collection. 1930.934. Photograph © The Art Institute
of Chicago © Figge Art Museum, successors to the Estate of Nan Wood
Graham/Licensed by VAGA, New York, NY.

Edward Hopper made several trips to Europe between 1906 and 1910, but he mostly ignored European avant-garde movements as he portrayed the loneliness of much of American life. *Nighthawks* (**fig. 23.27**) shows Hopper's fascination with the mood of people in a particular place and time. The haunting effect of his paintings comes largely from his carefully organized compositions and his emphasis on controlled use of light and shadow. Both Hopper and the Impressionists were interested in light, but for different purposes: Hopper employed it to clarify and organize the structure of a composition, whereas the Impressionists used light in ways that seemed to dissolve structure.

Regional painter Grant Wood studied art in Paris in the early 1920s. Although he never worked with Cubist or Expressionist ideas, he did identify with modern trends and began making freely brushed paintings derived from Impressionism. After years of little success, Wood returned to his birthplace in rural Midwestern America and dedicated himself to memorializing the unique character of the land, the people, and their way of life.

Wood's personal style of crisp realism was inspired by the paintings of the northern Renaissance masters such as van Eyck and Dürer. He also drew on American folk painting and the characteristically stiff, long-exposure portraits taken by late-nineteenth-century photographers. Wood, like van Eyck, calculated every aspect of design and all details of the subject matter to enhance the content of his paintings.

The idea for the famous painting *American Gothic* (**fig. 23.28**) came to Wood when he saw a modest farmhouse built in a local carpenter's version of the Gothic style. The restrained color, simplification of round masses such as trees and people, and the high detail are typical of Wood's paintings. The two figures (the artist's sister and his dentist) are echoed in the pointed-arch window shapes. Vertical lines and paired elements dominate. For example, the lines of the pitchfork are repeated in the man's overalls and shirt front. The upright tines

23.29 Thomas Hart Benton. *Palisades.* From the series *American Historical Epic.* c.1919–1924. Oil on cotton duck on aluminum honeycomb panel. 66⅛″ × 72″.
The Nelson-Atkins Museum of Art, Kansas City, Missouri. Bequest of the artist, F75-21/2. Photograph: Jamison Miller © T.H. Benton and R.P. Benton Testamentary Trusts/UMB Bank Trustee/Licensed by VAGA, New York, NY.

of the fork seem to symbolize the pair's firm, traditional stance and hard-won virtue. Wood's *American Gothic* has become a national icon that speaks clearly to many; it continues to spark a wealth of responses.

The most forceful spokesperson for American regional art was Thomas Hart Benton, son of a Missouri United States senator. Benton worked to create a style that was American in both form and content—a realistic style that would be easily understood by all, based on the depiction of American themes. Some of the strength in his figures came from the influence of Michelangelo's muscular bodies. But Benton transformed Renaissance and modern influences into a highly personal style in which all forms are conditioned by strong curvilinear rhythms. The push and pull of shapes in shallow space, emphasized by contrasting light and dark edges, shows what Benton learned from Cubism.

Palisades (**fig. 23.29**) was part of a series of paintings titled *American Historical Epic.* In contrast to conventional histories that feature great men, Benton wanted to create a people's history, one that depicted the actions of ordinary people on the land. Here, the European colonizers are staking out and dividing up the land, while the Indians, in contrast, are sharing their knowledge of growing corn, which the newcomers will need for survival.

African-American Modernists

Philosopher Alain Locke wrote in the 1925 book *The New Negro* that African-American artists should reconnect with their roots in the "ancestral arts of Africa." They should not seek to paint or sculpt in highly polished academic styles; neither should they explore Parisian modern movements. Rather, they should attune themselves to their own cultural heritage and express themselves through recognizably African-based styles.

This book was a major force behind the cultural flowering known as the Harlem Renaissance, which

23.30 Sargent Johnson. *Forever Free.* 1933.
Wood with lacquer on cloth. 36″ × 11½″ × 9½″.
San Francisco Museum of Modern Art. Gift of Mrs. E. D. Lederman. 52.4695. Photograph: Phillip Galgiani.

included poets, musicians, and novelists along with visual artists. Some important figures associated with the Renaissance include Langston Hughes, Paul Robeson, Zora Neale Hurston, and many others both in Harlem and elsewhere in the United States. Visual artists were an integral part of the movement; they illustrated books, designed interior spaces, and photographed the teeming life around them.

The principal vehicle for displaying the painting and sculpture of African Americans at that time was the annual traveling exhibition sponsored by the Harmon Foundation; one artist who often won prizes in that show was Sargent Johnson. A resident of California, he produced painted wood sculptures such as *Forever Free* (**fig. 23.30**) that expressed his view of the black

identity. A motherly woman shelters two smaller figures, all of whom show pronounced African characteristics. The title of the work comes from the Emancipation Proclamation of 1863, which ended slavery in the Confederate states. Johnson wrote of this expression of cultural roots: "I am producing strictly a Negro Art, studying not the culturally mixed Negro of the cities, but the more primitive slave type as existed in this country during the period of slave importation."[6]

During the Depression of the 1930s, the Works Progress Administration (WPA) set up community art centers in one hundred cities. Jacob Lawrence was a product of one of these centers in Harlem, where he met most of the leaders of the Renaissance. In 1938, he made a series of 41 paintings on the life of Toussaint l'Ouverture, the black leader of the revolt that made Haiti the first independent nation in Latin America in 1804. *General Toussaint l'Ouverture Defeats the English at Saline* (**fig. 23.31**) shows his style, which he called "dynamic Cubism." Lawrence was not practicing the French Cubism of Braque and Picasso, however; he made his own investigation of African art and reinterpreted it in his own way.

Archibald Motley of Chicago took a realist view of African-American culture. His painting *Barbeque* of 1934 (**fig. 23.32**) is ebullient and full of motion, and

23.31 Jacob Lawrence. *General Toussaint l'Ouverture Defeats the English at Saline.* 1937–1938. Gouache on paper. 19″ × 11″.

Aaron Douglas Collection, The Amistad Research Center, Tulane University. © 2013 The Jacob and Gwendolyn Lawrence Foundation, Seattle/Artists Rights Society (ARS), New York.

● Watch a podcast about Jacob Lawrence's *Toussaint l'Ouverture* series on myartslab.com

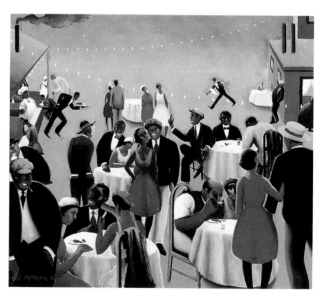

23.32 Archibald Motley Jr. *Barbeque.* 1934. Oil on canvas. 36¼″ × 40⅛″.

Chicago History Museum and Valerie Gerrard Browne.

also shows an interest in how figures look under artificial light. Motley specialized in depicting all aspects of the urban black experience, including on occasion gamblers and drinkers during Prohibition. Such subject matter did not endear him to pretentious art patrons, but Motley replied, "I have tried to paint the Negro as I have seen him and as I feel him, in my self without adding or detracting, just being frankly honest."[7]

Organic Abstraction

The Fascist and Communist regimes in Germany and Russia suppressed most modern art, especially abstract art; European artists in opposition to this stance reaffirmed abstract art by forming the group Abstraction-Creation in 1931. Their second manifesto proclaimed "total opposition to all oppression, of whatever kind it may be." Abstract art thus became a statement on behalf of personal and political freedom. Moreover, because it was not obviously tied to any one nationality, abstract art also stood apart from the intent nationalist focus of Fascist regimes. Many 1930s abstract artists adopted organic shapes that resembled life forms.

An early member of Abstraction-Creation was the English sculptor Barbara Hepworth. Her *Forms in Echelon* (**fig. 23.33**) consists of two pieces of mahogany, carved into shapes that suggest growing plant forms. She was the first to put holes in her sculpted works, opening the shape to light and air. Viewers who

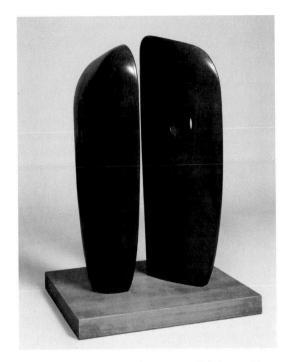

23.33 Barbara Hepworth. *Forms in Echelon*. 1938. Wood. Height 42½".
© Tate, London 2013. Presented by the artist 1964.
© Bowness, Hepworth Estate.

apply a little imagination to the arrangement of *Forms in Echelon* can visualize a conversation, or perhaps mutual nurturing, between the two forms.

Hepworth's colleague and friend Henry Moore took her invention in a more figural direction. After serving in World War I, Moore used a veteran's grant to study art in London. While there, he spent long hours studying the collections of non-Western arts in the British Museum and the Victoria and Albert Museum. His *Recumbent Figure* from 1938 (**fig. 23.34**) is an elaboration of the reclining Toltec Chacmool (see fig. 20.36).

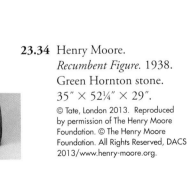

23.34 Henry Moore. *Recumbent Figure*. 1938. Green Hornton stone. 35″ × 52¼″ × 29″.
© Tate, London 2013. Reproduced by permission of The Henry Moore Foundation. © The Henry Moore Foundation. All Rights Reserved, DACS 2013/www.henry-moore.org.

Moore smoothed the stone into an organic abstract shape that suggests the human form without exactly depicting it. Moore's carving of the stone also preserves its origins in sedimentary geological deposits, and the label (Green Hornton stone), specified at Moore's insistence, identifies its source where he quarried it.

The outbreak of World War II in Europe in 1939 took humanity to the brink of destruction yet again.

Besides the suffering that it created, the war also redrew the world map of artistic innovation. Many European artists migrated to the Americas and fertilized modern movements there.

✓—[Study] and review on myartslab.com

THINK BACK

1. How did the Dada movement express opposition to World War I?

2. How did the Surrealists believe that they were working for humanity's benefit?

3. What was a distinctive feature of modern art when it arose in Brazil and Argentina?

4. How can organic abstract sculpture imply a protest against fascism?

TRY THIS

Learn about Soviet Socialist Realism in painting. The Chazen Museum of Art at the University of Wisconsin has a large collection, a gift of former ambassador Joseph E. Davies. Most works are viewable online (http://www.chazen.wisc.edu) in high resolution. Explore the political and national themes of this art movement.

KEY TERMS

automatism – action without conscious control, as employed by Surrealist writers and artists to allow unconscious ideas and feelings to be expressed

Constructivism – art movement that originated in Russia at the time of the Soviet Revolution of 1917, which emphasized abstract art, modern materials, and useful arts such as set design, furniture, and graphics

Dada – a movement in art and literature, founded in Switzerland in the early twentieth century, which ridiculed contemporary culture and conventional art

frottage – a technique in which a canvas is laid over a textured surface and rubbed with crayons and pencils

photomontage – the process of combining parts of various photographs in one photograph

readymade – a concept pioneered by Dadaist Marcel Duchamp in which a common manufactured object is signed by an artist and thereby turned into an artwork

social realism – a socially and politically committed form of art that became common in many countries between the two world wars and which included a retreat from the radical innovations of modern art, and the desire to communicate more readily with the public about social causes and issues

Surrealism – a movement in literature and the visual arts that developed in the mid-1920s, based on revealing the unconscious mind in dream images and the fantastic

24 POSTWAR MODERN MOVEMENTS

THINK AHEAD

24.1 Identify the historical conditions that affected art in the United States after World War II.

24.2 Discuss Abstract Expressionism and distinguish examples of action and color field painting.

24.3 Recognize Assemblage, Happenings and Events as artforms that blurred the line between art and life.

24.4 Describe common techniques and themes characteristic of Pop Art.

24.5 Explain the interests and stylistic features of Minimalism.

24.6 Express the importance of the artist's idea in Conceptual art.

24.7 Survey artistic formats, such as Earthworks, Installation, and Performance art, which remove art from its traditional context.

24.8 Demonstrate the influence of feminist thought on postwar art.

In the years following World War II, modern artists made a frontal assault on the rules of art. The conventions and customs that had governed artistic creation since the Renaissance were gradually overturned, rejected, or ignored. In 1945, even the most innovative artists still worked in traditional media; but 30 years later they were also erecting poles in the desert, copying news photographs, gluing themselves to trees, and selling kisses for money. Whatever an artist did, or whatever a gallery exhibited, became art. It was a restless and wildly creative period.

At the end of World War II, Europe lay in ruins—financially, emotionally, and physically. The war took the lives of a quarter million British people, six hundred thousand French, five million Germans, and twenty million Russians. The Nazi Holocaust accounted for six million of these deaths. Refugees and displaced persons numbered forty million. Britain's wartime prime minister, Winston Churchill, in 1947 described Europe as "a rubble heap, a charnel house, a breeding ground for pestilence and hate."[1] Many prominent European artists had fled from Nazi oppression to the United States, which emerged from the war economically strong and optimistic.

Among the artists who settled in New York were Mondrian, Léger, Duchamp, Dalí, André Breton, and Hans Hofmann. They worked, taught, exhibited, and brought new ideas, opening new possibilities for American artists. This immigration made modernism no longer a distant, European phenomenon; many of its leading practitioners came to the United States. Mexican muralists Diego Rivera and David Siqueiros also exhibited and taught in New York during the 1930s, encouraging artists away from traditional easel painting.

War had altered the consciousness of the developed world in subtle but profound ways. The Nazi genocide machine had taken human cruelty to a new low, and the atomic bomb gave humankind terrifying new powers: People were now living in a world they had the power to destroy in minutes. These conditions formed the background for art and life in Europe and the United States at the close of the war.

((•• **Listen** to the chapter audio on myartslab.com

The New York School

In the first ten years after the end of the war, much innovation centered in New York, giving rise to the term New York School; it consisted of two movements, Abstract Expressionism and color field.

Abstract Expressionism

The horrors of World War II impelled artists to rethink the relationship between art and life. The dislocations caused by war led them to explore visual realms other than the representational and narrative. One result was **Abstract Expressionism**, a culmination of the expressive tendencies in painting from Fauvism and German Expressionism (see Chapter 22), and the automatic methods of Surrealism (see Chapter 23).

The new émigrés influenced many American painters, leading them to move away from the realist styles dominant in the 1930s, and to experiment with more expressive and inventive ways of creating. The unparalleled crisis of the world war also led them to move away from public issues of history and social comment that Depression-era painting emphasized. As a result, they began to paint in styles that were both stylistically innovative and personal.

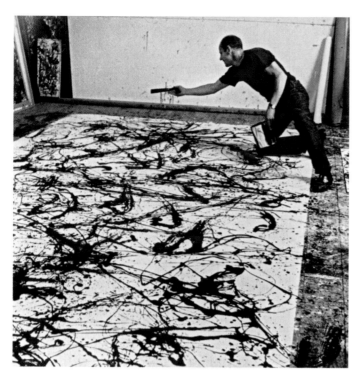

24.1 Rudolph Burckhardt. *Jackson Pollock Painting in East Hampton, Long Island.* 1950. Gelatin silver print.
Photograph © Rudolph Burckhardt/Sygma/Corbis.

⊙ **Watch** a video of Jackson Pollock at work on myartslab.com

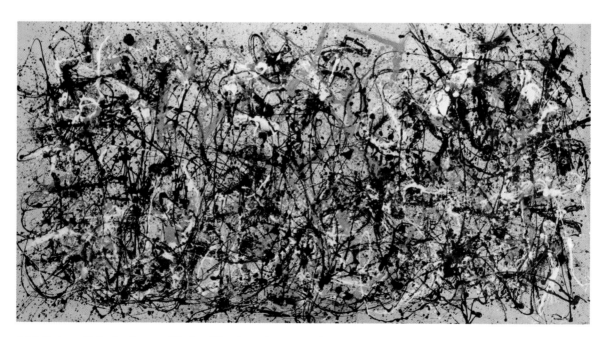

24.2 Jackson Pollock. *Autumn Rhythm (Number 30).* 1950. Oil on canvas. 105″ × 207″.
The Metropolitan Museum of Art George A. Hearn Fund, 1957. Acc.n.: 57.92. Image copyright The Metropolitan Museum of Art/Art Resource/Scala, Florence. © 2013 The Jacob and Gwendolyn Lawrence Foundation, Seattle/Artists Rights Society (ARS), New York.

⚲ **View** the Closer Look for Jackson Pollock's *Autumn Rhythm (Number 30)* on myartslab.com

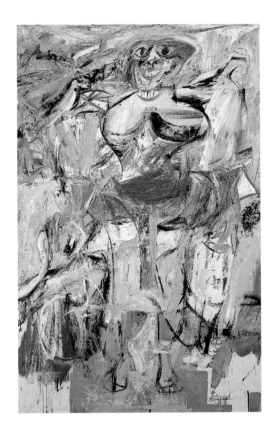

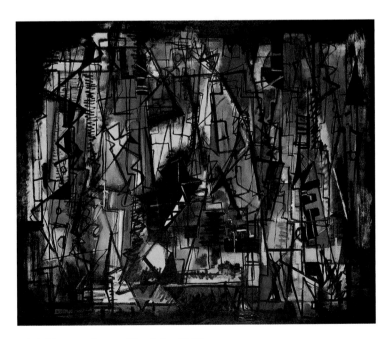

24.3 Willem de Kooning. *Woman and Bicycle.* 1952–1953.
Oil on canvas. 78¼" × 50⅝" × 2".
Whitney Museum of American Art, New York; Purchase 55.35.
© 2013 The Willem de Kooning Foundation/Artists Rights Society (ARS), New York.

provocative use of shapes. Throughout his career, de Kooning emphasized abstract imagery, yet the human figure underlies many of his paintings. After several years of working without subjects, he began a series of large paintings in which ferocious female figures appear. These canvases, painted with slashing attacks of the brush, have an overwhelming presence. In *Woman and Bicycle* (**fig. 24.3**), the toothy smile is repeated in a savage necklace that caps tremendous breasts. While it explodes with the energies of Abstract Expressionism, this work is controversial for the monstrous image of women that it presents.

Norman Lewis was an African-American artist who participated in Abstract Expressionism from its inception. Like most of the Abstract Expressionists, during the 1930s Lewis painted in a social realist style, depicting the urban poverty that he observed in his Harlem neighborhood. During and after World War II, he was increasingly influenced by modern art. His *Untitled* work from 1947 (**fig. 24.4**) documents his shift

Jackson Pollock, the leading innovator of Abstract Expressionism, studied in the 1930s with both Thomas Hart Benton and the Mexican muralist David Siqueiros. The rhythmic structure of Benton's style and the mural-scale art of the Mexicans influenced Pollock's poured paintings of the late 1940s and early 1950s. Searching for ways to express primal human nature, Pollock also studied Navajo sand painting and psychologist Carl Jung's theories of the unconscious. He also benefited from contact with Hans Hofmann (see fig. 22.11). His belief that he was painting for the age of the "atom bomb and the radio" led Pollock to innovative techniques (**fig. 24.1**). He created *Autumn Rhythm (Number 30)* (**fig. 24.2**) by dripping thin paint onto the canvas rather than brushing it on. Working on huge canvases placed on the floor, Pollock was able to enter the space of the painting physically and psychologically. The huge format allowed ample room for his sweeping gestural lines. Pollock dripped, poured, and flung paint, yet he exercised control and selection by the rhythmical, dancing movements of his body. A similar approach in the work of many of his colleagues led some to call this movement **action painting**.

The influence of Expressionist and Surrealist attitudes on Willem de Kooning's work is evident in his spontaneous, emotionally charged brushwork and

24.4 Norman Lewis. *Untitled.* c.1947.
Oil on canvas. 30" × 35½", signed.
Private collection. Courtesy of Michael Rosenfeld Gallery
LLC, New York, and Landor Fine Arts, N.J.

toward a more spontaneous and improvisational style. Lewis's art differs from other Abstract Expressionists in that it seems more poetic and reserved. In addition, his painting at times shows traces of nature or, as we see in this work, city life.

Color Field Painting

A related painting style that evolved at about the same time was **color field**, a term for painting that consists of large areas of color, with no obvious structure, central focus, or dynamic balance. The canvases of color field painters are dominated by unified images, images so huge that they engulf the viewer.

Mark Rothko is now best known as a pioneer of color field painting, although his early works of the 1930s were urban scenes. By the 1940s, influenced by Surrealism, he began producing paintings inspired by myths and rituals. In the late 1940s, he gave up the figure and began to focus primarily on color. In works such as *Blue, Orange, Red* (**fig. 24.5**), Rothko used

24.6 Helen Frankenthaler. *Mountains and Sea.* 1952. Oil and charcoal on canvas. 86⅝″ × 117¼″.
Collection: Helen Frankenthaler Foundation, Inc. (on extended loan to the National Gallery of Art, Washington, D.C.). © 2013 Helen Frankenthaler/Artists Rights Society (ARS), New York.

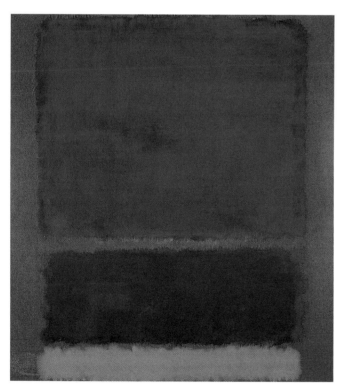

24.5 Mark Rothko. *Blue, Orange, Red.* 1961. Oil on canvas. 90¼″ × 81¼″.
Hirshhorn Museum and Sculpture Garden, Smithsonian Institution, Gift of the Joseph H. Hirshhorn Foundation, 1966. HMSG 66.4420. Photograph: Lee Stalsworth © 1998 Kate Rothko Prizel & Christopher Rothko/Artists Rights Society (ARS), New York.

color to evoke moods ranging from joy and serenity to melancholy and despair. By superimposing thin layers of paint, he achieved a variety of qualities from dense to atmospheric to luminous. Rothko's paintings have sensuous appeal and monumental presence.

Helen Frankenthaler's work also evolved during the height of Abstract Expressionism. In 1952, she pioneered staining techniques as an extension of Jackson Pollock's poured paint and Mark Rothko's fields of color. Brushstrokes and paint texture were eliminated as she spread liquid colors across a horizontal, unprimed canvas. As the thin pigment soaked into the raw fabric, she coaxed it into fluid, organic shapes. Pale, subtle, and spontaneous, *Mountains and Sea* (**fig. 24.6**) marked the beginning of a series of paintings that emphasize softness and openness and the expressive power of color. The 24-year-old Frankenthaler painted it in one day, after a trip to Nova Scotia.

Robert Motherwell's series of paintings titled *Elegy to the Spanish Republic* is permeated with a tragic sense of history. His elegies brood over the destruction of the fragile Spanish democracy by General Franco in the bloody Spanish Civil War of the 1930s. Heavy black shapes crush and obliterate the lighter passages behind them (**fig. 24.7**). Motherwell began with a specific subject as his starting point and expressed its inner mood through abstract means.

24.7 Robert Motherwell. *Elegy to the Spanish Republic No. 34.* 1953–1954. Oil on canvas. 80″ × 100″.
Albright Knox Art Gallery/Art Resource, NY/Scala, Florence. Art © Dedalus Foundation, Inc./Licensed by VAGA, New York, NY.

David Smith, for many critics the most important American sculptor of the postwar period, was strongly influenced by painters. His assembled metal sculpture began with a Cubist framework of overlapping jagged shapes, and added the elemental energy of Abstract Expressionism. His use of factory methods and materials provided new options for the next generation of sculptors. Smith's late work included the stainless steel *Cubi* series (**fig. 24.8**), based on cubic masses and planes balanced dynamically above the viewer's eye level. He scoured the steel surfaces with energetic curving motions as an Abstract Expressionist might, creating reflective exteriors that seem to dissolve their solidity. Smith intended the sculpture to be viewed outdoors in strong light, set off by green landscape.

24.8 David Smith. *Cubi XVII.* 1963.
Polished stainless steel. 107¾″ × 64⅜″ × 38⅛″.
The Dallas Museum of Art. The Eugene and Margaret McDermott Fund.
© Estate of David Smith/Licensed by VAGA, New York, NY.

Architecture at Mid-Century

In the immediate post-war years, the International Style (see fig. 14.20) represented the leading edge of architecture. Its clean masses and sleek exteriors spoke across the Western world of efficiency, cosmopolitanism, and future-oriented thinking.

Most American architects at mid-century also used the International Style, but in simpler, more box-like shapes. Lever House in New York City (**fig. 24.9**) heralded the future of office buildings for the next 25 years: It is a steel-and-glass box that looks slick, convenient, and modern. Most American cities have

24.9 Skidmore, Owings, and Merrill. Lever House. 1952. New York City.
Photograph: Howard Architectural Models Inc.

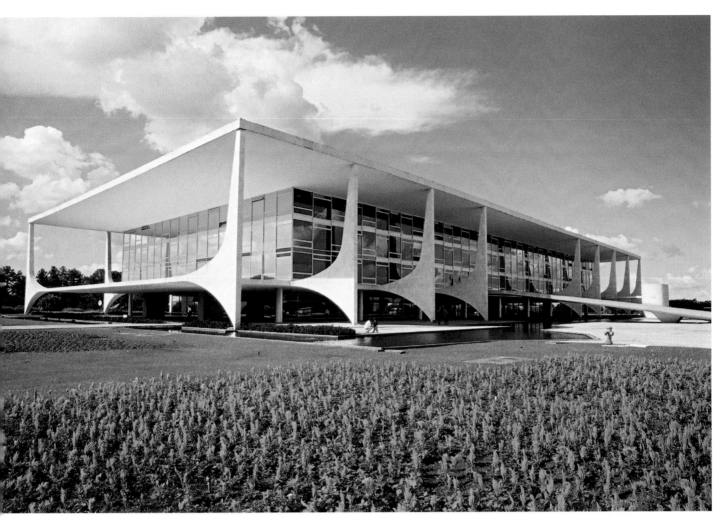

24.10 Oscar Niemeyer. Planalto Palace. Presidential Residence, Brasília, Brazil. 1960.
Photograph: Lamberto Scipione/Dinodia.

such buildings. Later architects would revolt against it, but for a generation this ultra-clean look represented the image of the American corporation. Following the words of American architect Louis Sullivan ("Form ever follows function"), International Style architects built practical buildings that clearly showed structural supports and banished all ornament. While many such buildings (such as Lever House) looked elegant and distinguished, the glass-box regularity of the style began to seem limiting. For example, Brazilian architect Oscar Niemeyer seized the opportunity that his country presented when it commissioned a new capital city to open in 1960.

His Planalto Palace (**fig. 24.10**) participates in the glass-box style yet departs from it in important ways. The entrance ramp hardly looks practical, and the sweeping, curved struts of the external skeleton take on a decorative life of their own. Such imaginative building soon became a hallmark of the postmodern movement (see Chapter 25).

Assemblage

Most leading artists of the 1940s and early 1950s chose not to deal with recognizable subject matter. They mostly avoided referring to the world in which they lived. In the mid-1950s, a few young artists began to acknowledge, confront, and even celebrate the visual diversity of the urban scene; they wanted to move beyond the exclusive, personal nature of Abstract Expressionism. In their effort to re-engage art with ordinary life, these artists created **assemblages**, loose conglomerations of seemingly random objects. The art

of assemblage took the Dada collage of Hannah Höch (see fig. 23.3) into three dimensions.

Under the influence of avant-garde composer John Cage, who urged artists to make art from the lives they were living, Robert Rauschenberg began combining ordinary objects and collage materials with Abstract Expressionistic brushwork in what he called "combine-paintings." If creative thinking involves combining elements of the world in order to make an unexpected, previously unthinkable new thing, this is what Rauschenberg achieved with *Monogram* (**fig. 24.11**). What is a stuffed, long-haired Angora goat with a tire around its middle doing, standing in the middle of a collage-painting?

24.11 Robert Rauschenberg. *Monogram.* 1955–1959. Freestanding combine. 42″ × 64″ × 64½″.
Moderna Museet, Stockholm. © Robert Rauschenberg Foundation/ Licensed by VAGA, New York, NY.

This strange assemblage offers glimpses of seemingly unrelated objects and events, and acts as a symbol for the jarring juxtapositions of modern life. Instead of blocking out the chaotic messages of city streets, T.V., and magazines, Rauschenberg incorporated the disorder of urban civilization in his art.

In the early 1960s, with the aid of the new technique of photographic screenprinting, Rauschenberg brought together images from art history and documentary photographs. In *Tracer* (**fig. 24.12**) he combined Expressionist paint strokes with modified parts of art reproductions and news photographs so that art history, the Vietnam War, and street life interact with one another. Just as we can move from sports to dinner to televised wars and sitcoms, Rauschenberg's work assembles the unrelated bits and pieces of everyday experience.

Assemblage artists on the West Coast made more direct social comments. For example, *John Doe* by Edward Kienholz (**fig. 24.13**) makes the average American into an outrageous caricature. Half of a store mannequin rides on a baby stroller with his chest blown out (revealing a cross). Paint drips add to the ridiculous effect. An inscription below adapts a sarcastic riddle: "How is John Doe like a piano? Because he is square, upright, and grand." Kienholz was friendly with many

24.12 Robert Rauschenberg. *Tracer.* 1963. Oil and silkscreen on canvas. 84⅛″ × 60″.
The Nelson-Atkins Museum of Art, Kansas City, Missouri. Purchase: Nelson Gallery Foundation, F84-70. Photo: Jamison Miller © Robert Rauschenberg Foundation/Licensed by VAGA, New York, NY.

everyday life. In his *Target with Four Faces* (**fig. 24.14**), a target becomes a painting, while the sculpted faces are perceived as a sign.

As with Man Ray's *Gift* (see fig. 23.2), Johns's common subjects are now objects of contemplation. His irony relates back to Dada (see Chapter 23) and forward to **Pop Art** (discussed later in this chapter). The Neo-Dada works of Johns and Rauschenberg provided a bridge between Abstract Expressionism and later Pop Art. Johns and Rauschenberg are champions of art in an environment saturated with media-promoted icons of popular culture.

24.13 Edward Kienholz. *John Doe.* 1959.
Free-standing assemblage: oil and paint on mannequin parts; perambulator, toy, wood, metal, plaster, plastic, and rubber. 39½″ × 19″ × 31¼″.
The Menil Collection, Houston. Acc. #86-27 DJ. Photographer: George Hixson, Houston.

writers of the Beat movement, who similarly despaired over the blandness of middle-class life.

Rauschenberg often discussed art making with Jasper Johns during their formative years in the 1950s. Whereas Rauschenberg's work is filled with visual complexity, Johns's work is deceptively simple. His large early paintings were based on common graphic forms such as targets, maps, flags, and numbers. He was interested in the difference between signs (emblems that carry meaning) and art. In Johns's work, common signs play a dual role: They have the power of Abstract Expressionist forms in their size, bold design, and painterly surface qualities, yet they represent familiar objects and thus bring art back to

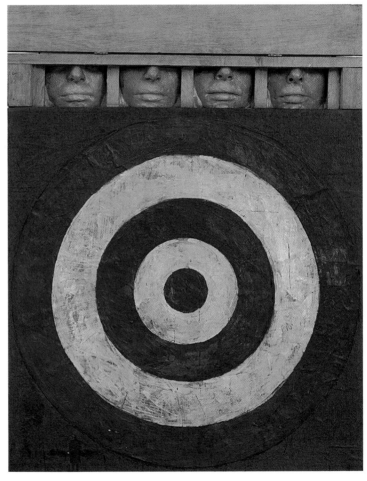

24.14 Jasper Johns. *Target with Four Faces.* 1955.
Assemblage: encaustic on newspaper and collage on canvas with objects, surmounted by four tinted plaster faces in wood box with hinged front. Overall dimensions with box open 33⅝″ × 26″ × 3″.
Museum of Modern Art (MoMA). Gift of Mr. and Mrs. Robert C. Scull. Digital image: The Museum of Modern Art, New York/Scala, Florence. © Jasper Johns/Licensed by VAGA, New York, NY.

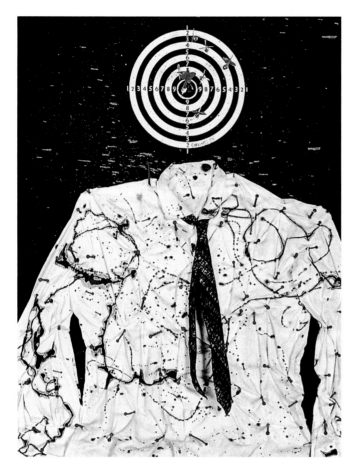

24.15 Niki de Saint Phalle.
Saint Sebastian, or the Portrait of My Love.
1960. Oil, fabric, darts, and nails on wood
and dartboard. 28½″ × 21¾″ × 2¾″.

The Neo-Dada spirit also broke out in
Europe, where in 1958 Yves Klein greeted
visitors at an empty gallery, in a show he called
"The Void." Italian artist Piero Manzoni turned
people into "works of art" by signing their bodies
and clothing. Niki de Saint Phalle made paint-
ings and collages and then symbolically killed
them by piercing them with nails, darts, or even
gunshots. In *Saint Sebastian, or the Portrait of My
Love* (**fig. 24.15**), we see one of her husband's
shirts and neckties below a dartboard. The
artist drove dozens of nails into the shirt, and
then threw darts at the board. These works by
Saint Phalle and others continue the irreverent
aspects of the spirit of Dada. Saint Phalle's target
carries a far more direct meaning than that of
Jasper Johns in his *Target with Four Faces.*

Events and Happenings

Artists have continued to extend the boundaries of the
visual arts until they can no longer simply be defined
as stable aesthetic objects. Some artists in the late
1950s and early 1960s began to create living, moving
art events.

Japanese artists were important in developing the
idea that a work of art could be an event, rather than
an object. The most radical Japanese artists joined a
group called Gutai (Embodiment), which functioned
from 1954 to 1972. One artist made paintings with his
feet; another shot pigment-filled bullets at his canvases.
The Gutai manifesto proclaimed the end of traditional
art making, and the members "decided to pursue the
possibilities of pure and creative activity with great
energy." Saburo Murakami mounted blank sheets of
paper in frames and destroyed them in performances
that he called *Passing Through* (**fig. 24.16**). Because

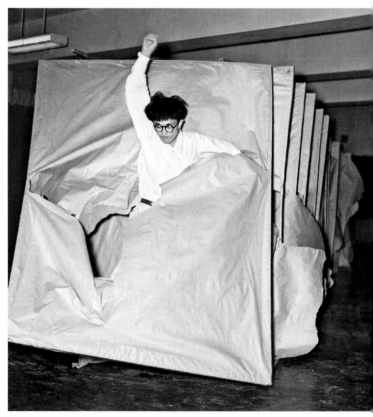

24.16 Saburo Murakami. *Passing Through.* 1956. Performance.

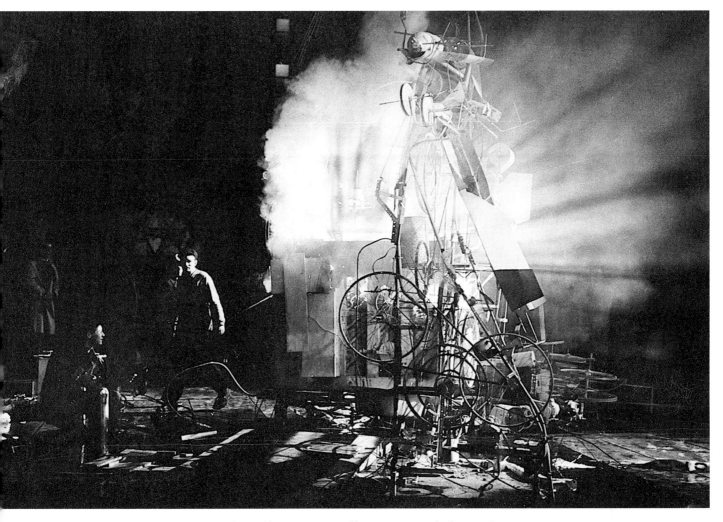

24.17 Jean Tinguely. *Homage to New York: A Self-Constructing, Self-Destructing Work of Art.* 1960.
© 2013 Artists Rights Society (ARS), New York/ADAGP, Paris.

paper is a treasured material in Japan, traditionally thought to manifest a sacred spirit, Murakami's performance symbolized the rebellious, questioning attitude of the postwar period. Performances like his by other members of the Gutai group also anticipated several aspects of **happenings** and **performance art** that emerged later in the West.

For Swiss sculptor Jean Tinguely, life was play, movement, and perpetual change. Tinguely made machines that do just about everything except work in the manner we expect. Although much kinetic art has celebrated science and technology, Tinguely enjoyed a mocking yet sympathetic relationship to machines and machine fallibility. He said, "I try to distill the frenzy I see in the world, the mechanical frenzy of our joyful, industrial confusion."[2]

In 1960, Tinguely built a large piece of mechanized sculpture that he put together from materials gathered from junkyards and stores in and around New York City (**fig. 24.17**). The result was a giant assemblage designed to destroy itself at the turn of a switch—which it did in the courtyard of the Museum of Modern Art in New York City on March 17, 1960. The environmental sculpture was titled *Homage to New York: A Self-Constructing, Self-Destructing Work of Art.* Tinguely's *Homage to New York* was an event, similar in its effect to a happening.

Happenings are cooperative events in which viewers become active participants in partly planned, partly spontaneous performances that combine scripted scenarios with considerable improvisation. One critic defined happenings as drama with "structure but no

plot, words but no dialogue, actors but no characters, and above all, nothing logical or continuous."[3]

The term "happening" was first used by Allan Kaprow in the late 1950s. There were no spectators at Kaprow's happening, *Household* (**fig. 24.18**). At a preliminary meeting, participants were given parts. The action took place at an isolated rural dump, amid smoldering piles of refuse. The men built a wooden tower on a trash pile while the women constructed a nest on another mound. During the course of a series of interrelated events, the men destroyed the nest and the women retaliated by pulling down the men's tower. In the process, participants gained a new perspective on the theater of life in our time.

Pop Art

Pop artists use real objects or mass-production techniques in their art. Like the Dadaists before them, Pop artists wanted to challenge cultural assumptions about the definition of art; they also made ironic comments on contemporary life.

Design and commercial art, long denigrated by painters and sculptors, became a source of inspiration. Pop painters used photographic screenprinting and airbrush techniques to achieve the surface characteristics of such anonymous mass-produced imagery as advertising, food labels, and comic books. The resulting slick look and ironic attitude separates Pop Art works from assemblages.

Pop Art flowered most brilliantly in the United States, but it first appeared in London, where a group of young artists made collages with images cut from popular magazines. In 1957, English artist Richard Hamilton published a list of characteristics

24.18 Allan Kaprow. *Household.*
Happening commissioned by Cornell University. Performed May 1964.
The Getty Research Institute, Los Angeles (980063).
Photograph Solomon A. Goldberg.

of Pop Art for the London artists who were beginning to work in this vein. The list includes qualities of contemporary mass culture these artists addressed. Hamilton wrote that Pop Art should be:

Popular (designed for a mass audience)
Transient (short-term solution)
Expendable (easily forgotten)
Low-cost
Mass-produced
Young (aimed at youth)
Witty
Sexy
Gimmicky
Glamorous
Big business[4]

Pop Art's media sources include the comic strip, the advertising layout, the famous-name-brand package, and the visual clichés of billboard, newspaper, movie theater, and television. Elements from all these mass media are included in Hamilton's collage *Just What Is It That Makes Today's Homes So Different, So Appealing?* (**fig. 24.19**) Hamilton's work is a hilarious parody of the superficiality and materialism of modern popular culture. The word "pop" on the giant sucker gave the movement its name.

American artist James Rosenquist worked as a billboard painter after attending art school. Later, he incorporated his billboard experiences in a mature style that presents impersonally rendered **montages** of contemporary American popular culture. He drew on the techniques and imagery of sign painting, rendering outsized close-up details of faces, natural forms, and industrial objects with a mechanical airbrush.

24.19 Richard Hamilton.
Just What Is It That Makes Today's Homes So Different, So Appealing? 1956. Collage. 10¼″ × 9¾″.
Kunsthalle, Tubingen, Germany/The Bridgeman Art Library
© R. Hamilton. All Rights Reserved, DACS 2013.

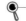 **View** the Closer Look for Hamilton's *Just What Is It That Makes Today's Homes So Different, So Appealing?* on myartslab.com

Rosenquist's huge mural *F-111* (**fig. 24.20**) filled all four walls of the Leo Castelli Gallery in New York City when it was first presented in 1965. The image of an F-111 fighter jet sweeps across his wall-to-wall environment of 1960s Americana. Rosenquist mixed symbols of affluence and destruction in his billboard-sized

24.20 James Rosenquist. *F-111.* 1965. Oil on canvas with aluminum. Four parts. 10′ × 86′.
Private collection. © James Rosenquist/Licensed by VAGA, New York.

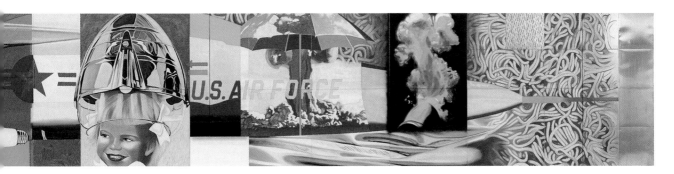

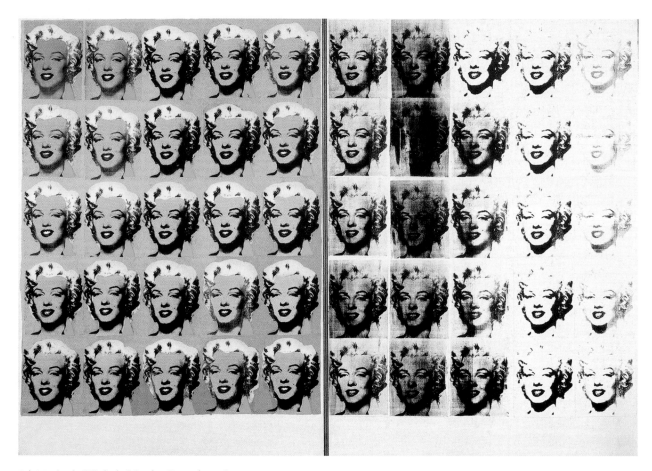

24.21 Andy Warhol. *Marilyn Diptych.* 1962.
Synthetic polymer paint and silkscreen
ink on canvas. 6′10″ × 57″.
© Tate, London 2013 Marilyn Monroe LLC under license authorized by CMG
Worldwide Inc., Indianapolis, In © 2013 The Andy Warhol Foundation for the
Visual Arts, Inc./Artists Rights Society (ARS), New York.

View the Closer Look for Andy Warhol's
Marilyn Diptych on myartslab.com

painting, which includes—in addition to a jet fighter
plane—a chain-link fence, a child under a hair dryer,
a tire, light bulbs, a beach umbrella, and a mushroom
cloud from a nuclear bomb.

No American artist in the 1960s sparked more
public indignation than Andy Warhol. He did not
invent Pop Art, but he was its most visible and contro-
versial exponent. Like Rosenquist, Warhol began his
career as a commercial artist. Warhol's art shows us, in
new ways, the effect of mass media and mass market-
ing on all of us.

Among his most common subjects were consumer
products such as Coca-Cola and Campbell's soup. He
blew up images of these products, silkscreened them
onto canvas, and presented them as art. He made these

works at a time when nationally standardized brands
were just becoming the norm, as Americans began
to prefer them to locally produced goods. If multiple
rows of identical cans in a store make us happy, then
why not make them into art?

Celebrities are also consumer products, and
Warhol's *Marilyn Diptych* (**fig. 24.21**) is his meditation
on celebrity status. The work gives us the actress's face
50 times over, in smudged black-and-white and garish
color. The work seems to be telling us that a celebrity
is a packaged commodity. This was news in the 1960s;
today most people seem to realize it. Warhol's work
called attention to the pervasive and insistent charac-
ter of our commercial environment. The repetition of
mass imagery has become our cultural landscape and
our mythology.

For his treatment of mass media, Warhol borrowed
headline-generating images from news photographs
and recreated them, singly or in identical rows. *Race
Riot* (**fig. 24.22**) shows police dogs attacking non-
violent civil rights protesters in the South. His works
take no position on the event pictured; rather, they
repackage for us their sensational aspect. He discovered

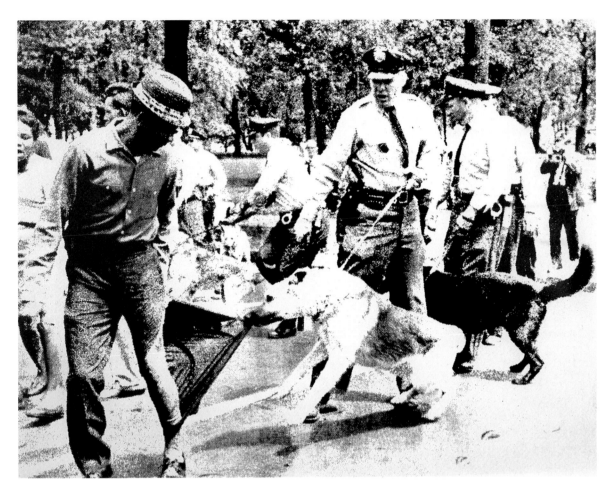

24.22 Andy Warhol. *Race Riot.* 1964. Screenprint on Strathmore drawing paper. 30⅛" × 40".

The Eli and Edythe Broad Collection, Los Angeles. © 2013 The Andy Warhol Foundation for the Visual Arts, Inc./
Artists Rights Society (ARS), New York.

that repeated exposure to events in the media desensitizes us to them, and his works re-enact the boredom. Indeed, boredom was one of his major themes, because it seems to characterize so much of modern life.

In *Drowning Girl* (**fig. 24.23**) and other paintings, Roy Lichtenstein used comic-book images with their bright primary colors, impersonal surfaces, and characteristic printing dots. His work is a commentary on a world obsessed with consumer goods and spectacles. He saw Pop Art as "involvement with what I think to be the most brazen and threatening characteristics of our culture, things we hate, but which are also powerful in their impingement on us."[5]

24.23 Roy Lichtenstein. *Drowning Girl.* 1963.
Oil and magna on canvas. 67⅝" × 66¾".

Museum of Modern Art (MoMA) Philip Johnson Fund and gift of Mr. and Mrs.
Bagley Wright. Acc. n.: 685.1971.© 2013. Digital image, The Museum of
Modern Art, New York/Scala, Florence. © The Estate of Roy Lichtenstein.

Consumerism

Many artists look at what is happening in their society, and use their art to capture that particular time, to examine it, or to express an opinion about it.

We can see one example from the 1960s, when unprecedented prosperity had begun to take hold on both sides of the Atlantic.

Consumers had a much wider choice of goods, and the character of business itself also began to change, as many firms evolved from personally owned companies to conglomerates supervised by professional managers. Such changes made products both more widely available and more impersonal, as standardization, advertising campaigns, and national distribution homogenized the shopping experience, especially in the United States.

Pop artists took a fresh look at these consumer goods, finding newly perfected items whose value stemmed not only from simple usefulness but also from "sign value," or what the product said about the person who purchased it. Their comments on this consumer society often express ironic reverence.

In the early 1960s, a group of French and Swiss artists who sought a deeper involvement with the texture and material of everyday life formed the New Realists. According to their manifesto, their principal goal was to expose "the thrilling adventure of the real, perceived in itself."[6] One member of this group, who shortened his name to Arman (from Armand) because of a printing error, created a series of works called *Accumulations* in which he celebrated the multiplicity of mass-produced products. To create *Accumulation of Teapots* (**fig. 24.24**), he bought a dozen factory-made examples and sliced them lengthwise before installing them in a plastic box. If modern consumer society promises abundance, Arman showed himself willing to adopt and adapt industrial products, taking the abundance into art.

From the middle 1960s, Arman began spending increasing amounts of time in the United States, where he found a vigorous group of Pop artists. Tom Wesselmann, for example, created a series of still lifes which updated that traditional subject using modern consumer products. The fake corncob in *Still Life #24* (**fig. 24.25**) protrudes toward the viewer, making this work as much an assemblage as a painting. Wesselmann clipped photos

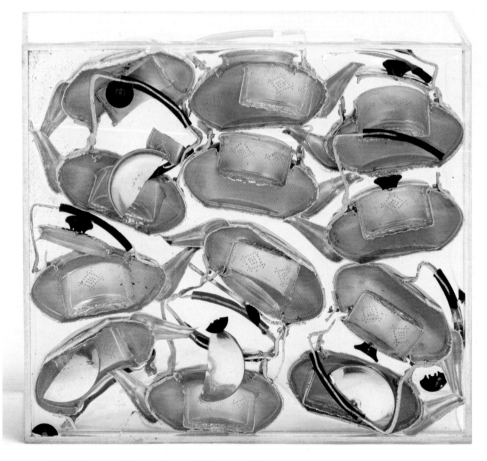

24.24 Arman. *Accumulation of Teapots*. 1964.
Sliced teapots in plastic case. 16" × 18" × 16".
Collection Walker Art Center, Minneapolis. Gift of the T.B. Walker Foundation, 1964. © 2013 Artists Rights Society (ARS), New York/ADAGP, Paris.

24.25 Tom Wesselmann. *Still Life #24*. 1962.
Acrylic polymer, collage and assemblage on board. 48″ × 59⅞″.
The Nelson-Atkins Museum of Art, Kansas City, Missouri. Gift of the Guild of the Friends of Art, F66-54.
Photograph: Jamison Miller. © Estate of Tom Wesselmann/Licensed by VAGA, New York.

"Fast food" became a more common dining option, as more Americans patronized drive-in restaurants where the food was prepared before you ordered it. A leader in this trend was the McDonald's chain, which began in 1954 and soon spread its uniform burgers and basic menus across the country. Oldenburg's piece grossly overstates even the most extravagant claim for cheeseburgers. He wrote in an essay of his intent to embrace common culture: "I am for Kool-Art, 7-UP art, Pepsi-art, Sunshine art, 39 cents art . . . Menthol art, . . . Rx art, . . . Now art."[7] His embrace, as we see in *Two Cheeseburgers*, had a heavy dose of irony.

By expressing such doubt, or heavily qualified enthusiasm, about the new consumer products, these artists attempted to convince the public to take a deeper look at just what they were buying.

of the packaged products from magazine advertisements. Canned asparagus and bottled salad dressing are "convenience" foods, available at all times of the year and all across the country; consumption of such items increased quickly in the postwar years. Through the window we see a view of Diamond Head at Waikiki Beach, a rising destination spot at that time for American vacations. *Still Life #24* is a picture of casual middle-class contemporary abundance, portrayed through the traditional language of the still life. Traditional still lifes (see fig. 17.24) celebrated

the bounty of nature, but Wesselmann's version depicts the bounty of modern consumerism.

Claes Oldenburg's *Two Cheeseburgers, with Everything* (**fig. 24.26**) transforms common food items into stacked, gloppy masses. Though at first they look completely unappetizing, the artist appears to have created these burgers by taking seriously advertisers' claims about softer buns, thicker patties, and extra toppings. Such marketing efforts increased the popularity of hamburgers in the diet of Americans:

24.26 Claes Oldenburg. *Two Cheeseburgers with Everything (Dual Hamburgers)*. 1962. Burlap soaked in plaster, painted with enamel. 7″ × 14¾″ × 8⅝″.
The Museum of Modern Art (MoMA) Philip Johnson Fund. 233.1962.
Digital image, The Museum of Modern Art, New York/Scala, Florence.
© Claes Oldenburg.

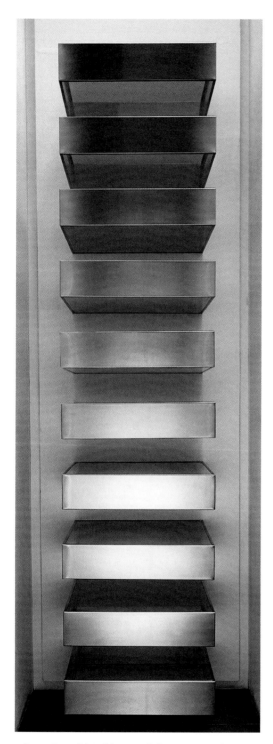

24.27 Donald Judd. *Untitled.* 1967. Stainless steel and plexiglass, ten units. 191⅝" × 40" × 31".
Collection of the Modern Art Museum of Fort Worth,
Museum Purchase, The Benjamin J. Tillar Memorial Trust.
Art © Judd Foundation. Licensed by VAGA, New York, NY.

Minimal Art

In the late 1950s and early 1960s, a number of artists aimed to create art that would exclude subject matter, symbolic meanings, personal content, and hidden messages of any kind. Was it possible to have art that referred to nothing outside itself, told no story except for its own shapes and colors? The artists who went on this quest were called **Minimalists**.

Among the leaders of this movement was Donald Judd. He worked with industrial materials such as sheet metal, aluminum, and molded plastics, which had not previously been used for art. Judd was the major spokesman for the Minimalist movement. In his essay "Specific Objects," he wrote about the aims of his art:

> It isn't necessary for a work to have a lot of things to look at, to compare, to analyze one by one, to contemplate. The thing as a whole, its quality as a whole, is what is interesting. . . . In the new work the shape, image, color, and surface are single, and not partial and scattered.[8]

Judd never titled his works, because he did not want viewers to infer any meaning beyond the colors and shapes that he used. His 1967 *Untitled* work (**fig. 24.27**) tells no story, has no personal expression, no symbolic content; he wants it to be seen as only color and form.

Some painters shared an interest in what they saw as the essence of painting: a flat surface covered with colors. Quick-drying acrylic paints, which were developed at this time, lend themselves to uniform application and to the use of tape to obtain shapes with precise edges. Brush strokes were suppressed, because they told a story of the work's creation. Minimalist painters urged viewers to see their paintings as objects, not as pictures.

24.28 Ellsworth Kelly. *Blue, Green, Yellow, Orange, Red.* 1966. Oil on canvas, 5 panels. Overall 60″ × 240″.
Solomon R. Guggenheim Museum, New York 67.1833.

Ellsworth Kelly's bold paintings are richly hued studies in color and form. *Blue, Green, Yellow, Orange, Red* (**fig. 24.28**) is self-explanatory in at least a superficial sense. At a deeper level, Minimalism is a quest to see if art can still be art without representation, storytelling, or personal feeling. If the work had curved lines, modeled color, or paint strokes, it would not be as pure. Rather, the subject seems to be color itself: how we respond to it, and how different colors interact with each other in our field of view. It is an optical experiment that throws away a great many of the traditional rules. Such quests for the essence of art motivated many in these years.

Frank Stella's paintings of the 1960s emphasize the flatness of the picture plane and its boundaries. He used shaped canvases because a rectangular work might still be seen as a picture. In *Agbatana III* (**fig. 24.29**), Stella used a distinctive outer profile to further extend the concept of the surface as an object in its own right rather than as a field for pictorial allusions. External boundaries of the overall shape are arrived at from the internal shapes. There is no figure–ground relationship; within the painting, everything is figure. Interwoven bands of both muted and intense colors pull together in a tight spatial weave. He summarized the Minimal movement with this statement: "What you see is what you see."[9]

24.29 Frank Stella. *Agbatana III.* 1968.
Fluorescent acrylic on canvas. 120″ × 180″.
Allen Memorial Art Museum, Oberlin College, Ohio. Ruth C. Roush Fund for Contemporary Art and National Foundation for the Arts and Humanities Grant, 1968.37. © 2013 Frank Stella/Artists Rights Society (ARS), New York.

Conceptual Art

During the 1960s and 1970s, artists reacted ever more quickly to each successive aesthetic movement. Pushing back the limits, the next step after Minimalism became art about only an idea. **Conceptual art**, in which an idea takes the place of the art object, was an outgrowth of Minimalism. The Conceptual movement was heavily indebted to Marcel Duchamp, the first champion of an art of ideas.

Joseph Kosuth, the most rigorous early Conceptualist, was perplexed by the materialism of the art market and Pop Art's embrace of commercialism. In 1965, he produced *One and Three Chairs* (**fig. 24.30**), which consisted of a wooden chair, a photograph of the same chair, and a photographic enlargement of a dictionary definition of the word "chair." The work is about how we apprehend things, images, and words; it shows that we process each version of the chair differently.

Conceptual art is based on the fact that a work of art usually begins as an idea in the artist's mind. A great work of art is a great idea first, and its creator merely carries out the idea. If this is true, then art can still be art without a unique, artist-made object. If we "get the idea," then we have understood the piece. Creativity is, after all, a mental process.

Rather than making things, Conceptual artists present us with enough information so that we grasp the concept they have in mind. Another early leader in the movement was Yoko Ono, whose pieces are generally instructions to viewers. One example: Take 15 minutes to pronounce the word *south*. The best way to illustrate this work is to try it yourself and see what happens.

Site-Specific Works and Earthworks

Minimal and Conceptual works are radical, but they are still seen in art galleries. Several artists in the late 1960s and 1970s began creating works for display elsewhere, in specific sites other than the normal art venues. In such site-specific works, the artist's response to the location determines the composition, the scale, the medium, and even the content of each piece. (See fig. 12.25 for a site-specific work by Richard Serra.)

Bulgarian-born artist Christo, a leader in the site-specific movement, first made his living as a portrait painter. Later, he exhibited with the New Realists in Paris, such as Arman (see fig. 24.24), who were presenting common objects as art, rather than making painted or sculpted representations of objects. He often used fabric in his early works at this time and, in 1961, he and his wife and artistic collaborator Jeanne-Claude began creating temporary works of art, often using fabric as well. They began wrapping objects ranging in size from a motorcycle to a mile of Australian sea cliffs.

One of Christo and Jeanne-Claude's most ambitious projects was *Running Fence* (**fig. 24.31**), a temporary environmental artwork that was as much a process and an event as it was sculpture. The 18-foot-high white nylon fence ran from the ocean at Bodega Bay in Sonoma County, California, through 24½ miles

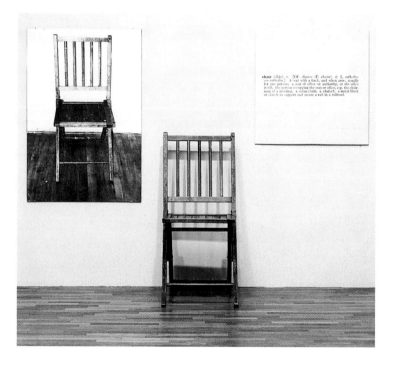

24.30 Joseph Kosuth. *One and Three Chairs*. 1965. Wooden folding chair, photographic copy of a chair, and photographic enlargement of dictionary definition of a chair. Chair 32⅜″ × 14⅞″ × 20⅞″. Photo panel 36″ × 24⅛″. Text panel 24″ × 24⅛″.
The Museum of Modern Art (MoMA) Larry Aldrich Foundation Fund. 393.1970.a-c. Digital image The Museum of Modern Art/Scala, Florence. © 2013 Joseph Kosuth/Artists Rights Society (ARS), New York.

of agricultural and dairy land. *Running Fence* stood for two weeks and ultimately involved thousands of people. The project required 18 public hearings, the agreement of landowners, and the help of hundreds of workers. They paid the workers and raised the funds for this project by selling early works, preparatory drawings and collages.

The seemingly endless ribbon of white cloth made the wind visible and caught the changing light as it stretched across the gently rolling hills, appearing and disappearing on the horizon. The simplicity of *Running Fence* relates it to Minimalist art, but the fence itself was not presented as an art object. Rather, it was the focal point for a work that involved people, process, object, and place.

Walter De Maria's *The Lightning Field* (**fig. 24.32**) consists of four hundred stainless-steel poles arranged in a rectangular grid over an area measuring 1 mile by 1 kilometer (⅝ mile) in west-central New Mexico. The sharpened tips of the poles form a level plane, a kind of monumental bed of nails. Each of the poles can act as

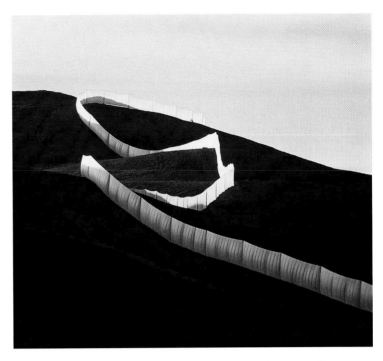

24.31 Christo and Jeanne-Claude. *Running Fence.* Sonoma and Marin Counties, California. 1972–1976. Nylon fabric and steel poles. 18′ × 24½ miles.
© Volz/laif/Camera Press.

24.32 Walter De Maria. *The Lightning Field.* 1977. Quemado, New Mexico. 400 stainless-steel poles, average height 20′7″; land area 1 mile × 1 kilometer.
Photograph: John Cliett. © Dia Art Foundation, New York.

24.33 Robert Smithson. *Spiral Jetty.* 1970. Great Salt Lake, Utah. Earthwork. Length 1,500′, width 15′.
Photograph: Gianfranco Gorgoni. © Estate of Robert Smithson/Licensed by VAGA, New York, NY.

a lightning conductor during the electrical storms that occur occasionally over the desert. Early and late in the day, the poles reflect the sun, creating accents of technological precision in sharp contrast to the otherwise natural landscape. Deliberately isolated from the art-viewing public, *The Lightning Field* combines aspects of both Conceptual and Minimalist art. Viewers must arrange their visits through the Dia Foundation, which commissioned the piece. Once there, they are left to study the work and make their own interpretations.

Site-specific works are environmental constructions, frequently made of sculptural materials, designed to interact with, but not permanently alter, the environment. **Earthworks** are sculptural forms made of materials such as earth, rocks, and sometimes plants. They are often very large, and they may be executed in remote locations. Earthworks are usually designed to merge with or complement the landscape. Many site-specific works and earthworks show their creators' interest in ecology and in the earthworks of ancient America.

Robert Smithson was one of the founders of the earthworks movement. His *Spiral Jetty* (**fig. 24.33**),

completed at Great Salt Lake, Utah, has since gone in and out of view several times with changes in the water level. Its natural surroundings contrast with its form as a willful human design. Although our society has little agreed-upon symbolism or iconography, we instinctively respond to universal signs like the spiral, which are found in nature and in ancient art.

Although site-specific works can be commissioned, they are almost never resold unless someone buys the land they occupy. Artists who create Conceptual art, earthworks, site-specific works, and performance art share a common desire to subvert the gallery-museum-collector syndrome, to present art as an experience rather than as a commodity.

Installations and Environments

While some artists were creating outdoor earthworks and site-specific works, others were moving beyond the traditional concepts of indoor painting and sculpture. Since the mid-1960s, artists from diverse backgrounds and points of view have fabricated interior installations and environments rather than portable works of art. Some installations alter the entire spaces they occupy;

others are experienced as large sculpture; most of them assume the viewer to be a part of the piece.

An early leader in installations was the Japanese artist Yayoi Kusama, who settled in New York in 1958. She made a lot of dot-covered drawings in the early 1950s, but she mainly painted net-paintings in the early 1960s as nets take the form of the negative of dots. She soon painted dots beyond the frame and onto the walls. She loved the effect of the luxurious multiplicity of dots because, she said, it resembled the cosmos: "The entire universe is an accumulation of stars."[10] With the *Infinity Mirror Room: Phalli's Field* (**fig. 24.34**), she reached an endpoint, installing mirrors on the walls of a room filled with hundreds of stuffed phallic shapes, all dotted in bright red. The mirrors gave visitors a vision of infinity, which usually included the artist herself. The installation did not survive, but her reputation as a radical creator did.

24.34 Yayoi Kusama. *Infinity Mirror Room: Phalli's Field.* 1965. Installation. 98½" × 197" × 197".
© Yayoi Kusama

24.35 Alice Aycock. *The Beginnings of a Complex...* 1977. Wood and concrete. Wall Facade: length 40′ × heights 8′, 12′, 16′, 20′, 24′ respectively. Square Tower: 24′ × 8′ × 8′. Tall Tower Group: height 32′. Executed for Documenta 6, Kassel, Germany.
Photograph courtesy of the artist.

The walls of a gallery need not limit an artist's installations. Outside the principal hall of the 1977 Documenta art exhibition in Kassel, Germany, Alice Aycock installed *The Beginnings of a Complex...* (**fig. 24.35**). Viewers who approached the work first saw a group of irregular wooden structures, some with porches or ladders. These five buildings concealed a narrow underground passageway, which viewers could access one at a time by climbing a ladder, then descending a shaft. Once a viewer had entered the passageway there was just one route through the tunnel. Towers were accessible only from underground, and the artist provided no maps.

She wrote of the work, "The complex is designed so that as one emerges from the underground labyrinth, one is contained within a well/shaft or tower. When access to the outside or open air is finally gained, one is so high up that the ground level is inaccessible. One is therefore lost when underground, and imprisoned in towers or stranded on platforms/ledges when above ground."[11] She intended the work to instill fear, claustrophobia, or disorientation in the viewer, upsetting or transforming the normal states of mind. This set of feelings diverges quite radically from what we might normally hope for in a work of art.

Early Feminism

In the late 1960s, many women artists began to speak out against the discrimination they faced in their careers. It was rare for women to be taken seriously in artists' groups; galleries were more willing to exhibit the work of men than of women; and museums collected the work of men far more often than that of women. Moreover, it seemed to the early **feminists** that making art about their experience as women might doom them to obscurity in a male-dominated art world. In the early 1970s in New York and California, they began to take action.

Lucy Lippard, an art critic and feminist, wrote, "The overwhelming fact remains that a woman's experience in this society—social and biological—is simply not like that of a man. If art comes from the inside, as it must, then the art of men and women must be different, too."[12] The work of some women artists definitely is influenced by their gender and their interest in feminist issues.

California feminists tended to work collaboratively, and to make use of media that have been traditionally associated with "craft work" and with women: ceramics and textiles. *The Dinner Party* (**fig. 24.36**) was a collaboration of many women (and a few men), organized and directed by Judy Chicago over a period of five years. This cooperative venture was in itself a political statement about the supportive nature of female experience, as opposed to the frequently competitive nature of the male.

A large triangular table contains place settings for 39 women who made important contributions to world history. These run a wide gamut, from Egyptian queen Hatshepsut to Georgia O'Keeffe. The names of 999 additional women of achievement are inscribed on ceramic tiles below the table. Each place setting includes a hand-embroidered fabric runner and a porcelain plate designed in honor of that woman. Some of the plates are painted with flat designs; others have modeled and painted relief motifs; many are explicitly sexual, embellished with flower-like female genitalia.

East Coast feminists were more pointed in their protests. Some of them formed the group Women Artists in Revolution (WAR), which picketed museums. In response to private dealers who were reluctant to show work by women, they formed their own collaborative gallery, Artists in Residence (AIR). Nancy Spero, a leader in East Coast feminist circles, participated in both groups. Her work from the late 1960s and early 1970s used unusual media such as paper scrolls, stencils, and printing to document subjects such as the torture and abuse of women. Her later scrolls, such as *Rebirth of Venus* (**fig. 24.37**), attempt to present images of women different from those commonly seen in art. In the segment illustrated here, an ancient statue of the love goddess Venus is split open to reveal a woman sprinter who runs directly toward the viewer. The contrast between the two images is difficult to miss. Woman as love object gives way to woman as achiever. (Compare this work to Botticelli's Renaissance *Birth of Venus*, fig. 17.5)

One of the most radical feminists in Europe was Orlan, who, like Judy Chicago, rejected her birth name. Her persistent theme has been the woman's body as the site of cultural debate and struggle. In 1974, she donned a nun's costume based on Bernini's *Ecstasy of Saint Teresa* (see fig. 17.19) and performed a striptease that she documented in a series of photographs. Thus, she passed between the two poles of identity (virgin and whore) that she saw the culture allotting to women.

24.36 Judy Chicago. *The Dinner Party.* 1979. Mixed media. 48′ × 42′ × 3′. Triangular table on white tile floor.
Collection of the Brooklyn Museum of Art, Gift of the Elizabeth A. Sackler Foundation. Photograph © Donald Woodman/Through the Flower. © 2013 Judy Chicago/Artists Rights Society (ARS), New York.

24.37 Nancy Spero. *Rebirth of Venus* (detail). 1984. Handprinting on paper. 12″ × 62′.
Courtesy of the artist. Photograph: David Reynolds. © Estate of Nancy Spero/ Licensed by VAGA, New York, NY.

24.38 Orlan. *Le Baiser de l'artiste (The Artist's Kiss).* 1976–1977. Mixed media with paint, metal chain, photographs, wood, blinking diode, artificial candles, artificial flowers, and CD.
86½" × 67" × 23½".
In the collection of the Fonds Regional d'art Contemporain, Pays de la Loire, France. © 2013 Artists Rights Society (ARS), New York/ADAGP, Paris.

Her most controversial work came in 1977 when she crashed a contemporary art exhibition in Paris with *Le Baiser de l'artiste (The Artist's Kiss)* (**fig. 24.38**). She was not invited to this show, but rather she set up her exhibit at the staircase leading to it. On a large black pedestal, viewers approached either Orlan the Saint (a photo from the earlier strip-tease act) or Orlan the Body (the artist herself sitting behind an invented vending machine). A soundtrack invited viewers to either bring a candle to the virgin, or insert a coin in the slot below the artist's chin. As the coin ran down to its receptacle, the artist dispensed kisses. This rather scandalous performance forcefully raised the issue of woman as virginal ideal or as marketable commodity; it also cost the artist her teaching position.

Performance Art

In performance art, artists do not create anything durable. Rather, they perform actions before an audience or in nature. Thus, this art form contains both visual art and drama, and has historical antecedents in Dada performances of the early twentieth century as well as in Expressionist painting. An Abstract Expressionist painting is the frozen record of an event (the act of making a painting). The next step was logical: Eliminate the record and concentrate on the event itself. The record was in the remembered experience of the participants and in a few photographs. The happenings movement is another important antecedent. Forms of art such as Conceptual art, which emphasize idea and process, are related to performance art.

One of the most influential performance artists of the 1960s and 1970s was German-born Joseph Beuys. He carried out actions that resonated with deep symbolic significance, as if he were a healer or shaman. For one 1965 piece, he swathed his head in honey and gold leaf, and carried a dead rabbit around an art gallery explaining to it the paintings on view, touching the rabbit's lifeless paw to each. Some people, he later said, were as insensitive in their daily lives as the rabbit was in the art gallery.

24.39 Joseph Beuys. *I Like America and America Likes Me.* 1974. Performance at René Block Gallery.
Courtesy Ronald Feldman Fine Arts, New York/www.feldmangallery.com. Photograph: Caroline Tisdall. © 2013 Artists Rights Society (ARS), New York/ VG Bild-Kunst, Bonn.

Arriving in New York for the first time in 1974, he immediately plunged into a work called *I Like America and America Likes Me* (**fig. 24.39**). Met at the airport by an ambulance, he was wrapped in felt and taken to a gallery, where he lived for a week with a coyote. The animal symbolized the Wild West; copies of *The Wall Street Journal* were delivered daily to represent contemporary, business-oriented culture. He meant to heal the breach between the two.

Cuban émigré Ana Mendieta used her own body in several works as a symbol of the Earth and natural cycles. In the *Tree of Life* series (**fig. 24.40**), she coated her body with mud and grasses and stood against ancient tree trunks. She intended to show the essential equivalence between femaleness and natural processes such as birth and growth. For her, as for many early feminists, biology accounted for most of the differences between women and men. Through the natural cycles of their bodies, she seems to be saying, women are closer to the rhythms of the Earth.

Some performance artists engaged the most urgent contemporary issues. The art collective Asco in 1975 laid one of their members down in the street and set out cautionary flares, titling the event *Decoy Gang War Victim* (**fig. 24.41**). The event took place in a strife-torn zone of east Los Angeles where gangs had indeed recently been in conflict. The collective photographed the event and presented it to the media as the last victim of a gang war. Not realizing that it was a hoax, television news channels broadcast the image as another example of gang violence. The work drew attention to an urban social problem as it pushed out the boundaries of art.

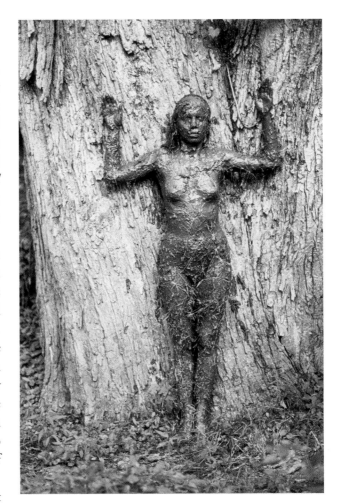

24.40 Ana Mendieta. *Tree of Life*. 1976. Lifetime color photograph. 20″ × 13¼″.
Collection of Raquelin Mendieta, Family Trust [GL2225-B] © The Estate of Ana Mendieta Collection. Courtesy Galerie Lelong, New York.

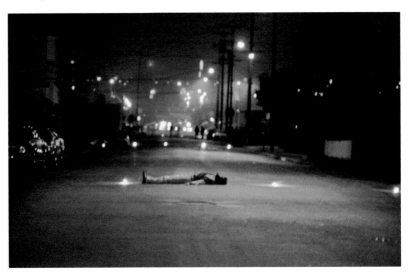

24.41 Asco (Willie Herrón III, Humberto Sandoval, Gronk, Patssi Valdez, Harry Gamboa Jr.). *Decoy Gang War Victim*. 1975.
Photograph: © Harry Gamboa Jr.

✔●—[Study and review on myartslab.com

1. What were the two branches of New York School painting?

2. What are some ways that artists integrated art with everyday life?

3. If an artist only tells you about an idea that she or he had, is that idea art?

4. How did the feminists revolt against their predecessors?

Is there another realm of human endeavor (such as law, religion, science, politics, or some other) in which questioning traditions and breaking rules is as celebrated as it has been in the art world?

KEY TERMS

Abstract Expressionism – an art movement, primarily in painting, that originated in the United States in the 1940s in which artists worked in many different styles that emphasized spontaneous personal expression

action painting – a style of nonrepresentational painting that relies on the physical movement of the artist by using such gestural techniques as vigorous brushwork, dripping, and pouring

assemblage – sculpture made by assembling found or cast-off objects that may or may not contribute their original identities to the total content of the work

color field painting – a movement that grew out of Abstract Expressionism, in which large stained or painted areas, or "fields," of color evoke aesthetic and emotional responses

Conceptual art – a trend developed in the late 1960s; an art form in which the originating idea and the process by which it is presented take precedence over a tangible product

earthwork – a sculptural form made from earth, rocks, or sometimes plants, often on a vast scale and in a remote location

happening – a usually unrehearsed event conceived by artists and performed by artists and others, who may include viewers

Minimalism – a nonrepresentational style of sculpture and painting that came to prominence in the middle and late 1960s; usually severely restricted in the use of visual elements and often consisting of simple geometric shapes or masses

performance art – dramatic presentation by visual artists (as distinguished from theater artists) in front of an audience, usually not in a formal theatrical setting

Pop Art – a style of painting and sculpture that developed in the late 1950s and early 1960s in Britain and the United States, using mass-production techniques (such as silkscreen) or real objects in works that are generally more polished and ironic than assemblages

Part Five

THE POSTMODERN WORLD

Postmodernity and Global Art

25 POSTMODERNITY AND GLOBAL ART

In the late 1970s or early 1980s, the impulses and drives that caused modern art seemed spent. Modern art was based on rejecting tradition and breaking rules. Each new movement found some rule to break: regular perspective, recognizable subject matter, location in a gallery, and creation by hand are only a few of the rules that modern artists cast aside.

The urge to rebel against the norm lost its impact when such rebellion *became* the norm in most Western cultures. We now look intently forward: to the next medical advance, to the next presidential term, or to the next electronic innovation; not backward to the wisdom of our elders, ancient rituals, or eternal principles. Departing from the norm is widely seen as healthy. In fact, this was the slogan of a chain of fast food restaurants in the early 1990s: "Sometimes you just gotta break the rules."

Artists today are left with few rules to break. While it is still possible to create art that offends people, it is difficult to make a new style such as Cubism, Expressionism, Constructivism, or Minimalism. Most artists today are not striving for this.

((•—**Listen** to the chapter audio on myartslab.com

In general, most artists of the present generation prefer to comment on life, rather than perfect their form, create beauty, or fine-tune their sense of sight. They want to create work that illuminates the relationships between what we see and how we think. Rather than objects of timeless beauty or shocking novelty, most artists since the 1980s create objects laden with information about the period in which we live. This chapter will present some movements of the present generation; many of the artists discussed in this chapter could be placed in more than one category, but most would prefer not to be categorized at all.

Postmodern Architecture

Modern architecture rejected tradition, ornament, and references to the past, and embraced modern materials and a utilitarian look. The modern movement culminated in the International Style, a glass-box look that swept most Western cities in the years after World War II. However, a growing discontent with the sterile anonymity of the International Style (see the Lever House, fig. 24.9) led many architects to look once again at meaning, history, and context. Their departure from architectural modernism was dubbed **postmodern** in the late 1970s.

Postmodernists thought that the unadorned functional purity of the International Style made all buildings look the same, offering no identity relative to purpose, no symbolism, no sense of local meaning, no excitement. Postmodern architects celebrate the very qualities of modern life that modern architects rejected: complexity, ambiguity, contradiction, nostalgia, and popular taste.

Among the first architects to rebel against the International Style were Robert Venturi and his partner Denise Scott-Brown, and they did it by writing a book in 1976: *Learning from Las Vegas*. They urged architects to study what is local, vernacular, and even tacky. They realized that even if Las Vegas was tasteless, people loved it, and architects who refuse to recognize that fact turn the public off. The book brought the entire profession to attention.

The postmodern style of Michael Graves uses classical architecture in knowing and even humorous ways. His Public Services Building (**fig. 25.1**) is both

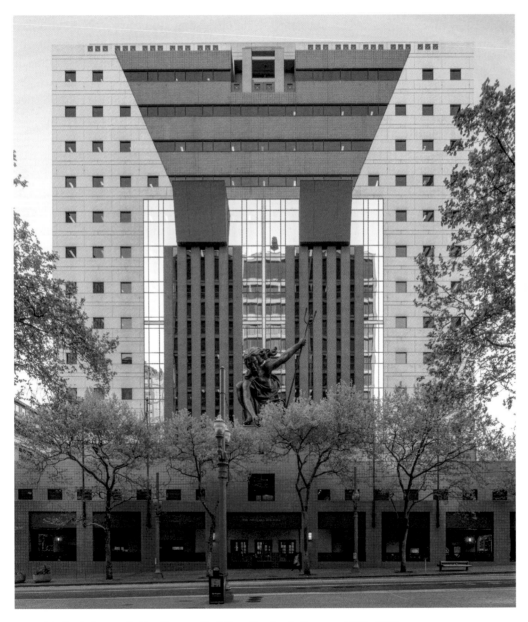

25.1 Michael Graves. Public Services Building. Portland, Oregon. 1980–1982.
Photograph: Nikreates/Alamy.

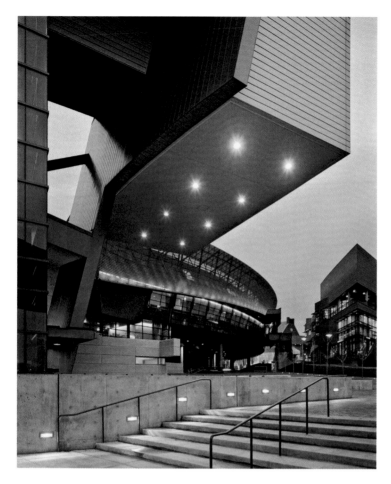

25.2 Thom Mayne and Morphosis.
Campus Recreation Center.
University of Cincinnati. 2006.
Photograph: Roland Halbe.

tradition whimsically like postmodernists. Rather, they try to make visually stunning buildings that fulfill their functions with ease. Californian Thom Mayne is a leader in this new trend in combining aesthetics and utility. His Campus Recreation Center at the University of Cincinnati (**fig. 25.2**) answers a list of tasks: A full gymnasium, classrooms, a food court, and student housing occupy an irregularly shaped building that responds to the surrounding topography and channels foot traffic over the shortest paths to and from surrounding buildings. "I wanted to make a village,"[1] he said of this building, and it fits seamlessly into the fabric of existing structures with an attractive, high-tech look. His firm is called Morphosis, an invented word that roughly means "taking shape," and his buildings take shape in highly creative ways.

Among the most influential younger architects today is Teddy Cruz, who takes inspiration not from gaudy Las Vegas but from improvisational Tijuana. Just south of the border, builders use cast-off materials, and homeowners scavenge dumpyards in search of walls, fences, structures, and roofs. Cruz's buildings, which he calls Manufactured Sites (**fig. 25.3**), pay homage to the ingenuity of people on the lower end of the economic scale. If a dominant trend today is to think green, Cruz shows us that recycling building materials is the essence of greenness.

formal and playful. The exterior is dominated by a pair of fluted classical columns. They are red-brown, a color that the Greeks would never have used. They also share a single huge capital. These off-color vertical elements have no structural function, and Graves underlined this by setting them in a reflecting pool of mirrored glass. The remainder of the façade consists of featureless rows of square openings, an ironic reference to the bureaucrats inside.

If postmodernism freed architects from the rigid ideas of modernism, three-dimensional computer modeling made new shapes possible. Frank Gehry has mastered these techniques more than most architects, as his Guggenheim Museum Bilbao shows (see fig. 14.25).

The most creative architects today neither rebel against modernism nor quote

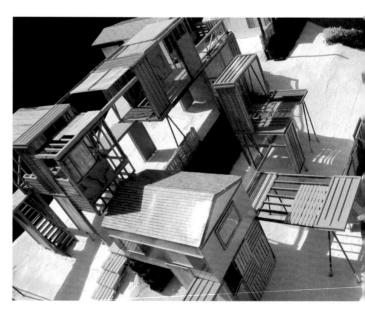

25.3 Teddy Cruz. Manufactured Sites. Project Schematic. 2008.
ETC Estudio Teddy Cruz.

Painting

As modernism came to an end, many painters in America and Europe began to revive expressive, personal styles in a movement known as Neo-Expressionism. This was partly in response to the impersonality of movements such as Conceptual art and Minimalism, and to the ironic, tongue-in-cheek quality of Pop Art and related trends.

One of the first Neo-Expressionists was Susan Rothenberg, who in the 1970s began making symbolic, heavily brushed works in which subject matter teeters on the brink of being recognizable. After the cleansing blankness of Minimalism, Rothenberg could return to figurative images with original vision; what emerges is almost ethereal.

She works in a narrow range of tones, using a muted palette of white, beige, silvery or dark gray, with a bit of color. Her painting *Blue Head* (**fig. 25.4**), which outlines a horse's head in front of a human hand, is a haunting image that resists easy explanation. It is a primal sign operating between the material world and the mystery beyond.

25.4 Susan Rothenberg. *Blue Head.* 1980–1981. Acrylic on canvas. 114″ × 114″.

Virginia Museum of Fine Arts, Richmond. Gift of The Sydney and Frances Lewis Foundation. © Virginia Museum of Fine Arts. © 2013 Susan Rothenberg/ Artists Rights Society (ARS), New York.

The German painter Anselm Kiefer combines the aggressive paint application of Abstract Expressionism with nineteenth-century feelings for history and mythology. Kiefer gives equal attention to moral and aesthetic issues. His paintings, loaded with symbolism, mythology, and religion, speak to the rest of us through powerful stories in dramatic compositions.

Osiris and Isis (**fig. 25.5**) retells the ancient Egyptian myth of the cycle of death and rebirth. Osiris symbolized the indestructible creative forces of nature; according to legend, the god was slain and cut into pieces by his evil brother. Isis, sister (and wife) of Osiris, collected the pieces and brought Osiris back to life. In Kiefer's huge painting, a network of wires attached to fragments of the dismembered Osiris connects to the goddess Isis in the form of a T.V. circuit board atop a pyramid. The heavily textured surface of paint, mud, rock, tar, ceramic, and metal intensifies the image's epic treatment of the afterlife theme.

The Neo-Expressionists tended to favor painting because a seemingly infinite variety of surface textures and colors is possible. Every creative decision can leave a trace on the finished work, registering every twitch in sensibility. Other artists use the painting media because they facilitate storytelling, allowing the artist to create a two-dimensional world with the utmost freedom. This interest in narration is a dominant tendency in contemporary painting.

Elizabeth Murray combines personal meanings with explosive form in works such as *More Than You Know* (**fig. 25.6**). The painting dates from the time between the births of her two children; however, beyond the general outlines of a room with two red chairs, there is little here to suggest the experience of motherhood. Her personal information is only the launching pad for a fascinatingly jagged array of canvas fragments that do not fit together but still seem to cohere. Murray's vibrant and exuberant paintings leave a great deal of the story for the viewer to make up from the suggestive shapes.

25.5 Anselm Kiefer. *Osiris and Isis.* 1985–1987. Oil, acrylic, emulsion, clay, porcelain, lead, copper wire, and circuit board on canvas. 150″ × 229½″ × 6½″.

San Francisco Museum of Modern Art. Purchased through a gift of Jean Stein, by exchange, the Mrs. Paul L. Wattis Fund, and the Doris and Donald Fisher Fund. Photograph by Ben Blackwell. © Anselm Kiefer.

25.6 Elizabeth Murray.
More Than You Know. 1983.
Oil on nine canvases. 108″ × 111″ × 8″.

© 2013 The Murray-Holman Family Trust/Artists Rights Society (ARS), New York.

25.7 Kerry James Marshall. *Better Homes Better Gardens.* 1994. Acrylic and collage on canvas. 8′4″ × 12′.

Denver Art Museum Collection: Funds from Polly and Mark Addison, the Alliance for Contemporary Art, Caroline Morgan, and Colorado Contemporary Collectors: Suzanne Farver, Linda and Ken Heller, Jan and Frederick Mayer, Beverly and Bernard Rosen, Annalee and Wagner Schorr, and anonymous donors, 1995.77. Photograph © Denver Art Museum 2009. All Rights Reserved.

👁 **Watch** the Art21 video of Kerry James Marshall talking about being an artist on myartslab.com

25.8 Gajin Fujita. *Street Fight*. 2005. 24-karat gold leaf, spray paint, Mean Streak marker, and paint marker on wood-panel triptych. 24″ × 48″.
Courtesy L.A. Louver Gallery, Venice, CA.

◉ **Watch** a podcast interview with Gajin Fujita about *Street Fight* on myartslab.com

Kerry James Marshall investigates African-American life in richly textured paintings. His 1994 work *Better Homes Better Gardens* (**fig. 25.7**) is part of a series of paintings that he made about Chicago housing projects that contain the word "garden" in their names. This one is obviously set in Wentworth Gardens, and it depicts a couple walking down a flowered pathway in a low-rise setting. At the left is a fenced area enclosing a communal flower garden. Three bluebirds fly across the upper portion of the scene, and all seems peaceful. Whatever else happens in housing projects, they are places of community and neighborhood feeling, he seems to be telling us.

Yet for all its optimism, there are ironic touches in this work. The perfectly spiraled garden hose, the white blotches over the heads of the couple, and the flowered entry with the "Welcome" sign add a note of complexity to the mood, casting a flickering shadow over its sweetness. The inscription "IL 2-8" in the upper right reminds us that this is both an illustration and a painting that is in fact rigorously composed. It is based on a solid grid of horizontals, verticals, and a few diagonals. Although the work is optimistic, Marshall is not merely painting an idealistic scene.

Los Angeles painter Gajin Fujita began his art career as a graffiti tagger in a crew known as K2S (Kill to Succeed). His recent works draw on both his past as a tagger and the high culture of Asia, in a mix that is thoroughly up-to-date in its wide cross-cultural sampling. His 2005 painting *Street Fight* (**fig. 25.8**) begins with a layer of spray-painted graffiti, some of it by the members of his former tagging crew. A layer of gold leaf provides a sense of the sacred, alluding to both ancient Buddhist and medieval Christian art; the buildings in silhouette quote urban landscape photography and crossword puzzles in newspapers. The sky has abstract patterns based on traditional Japanese screens by Sotatsu and others (see fig. 18.30). The two foreground figures come from Japanese woodblock prints, and the lettering style of the title resembles urban graffiti that decorates most cities worldwide. The theme of the work is both ancient and modern, as the title alludes to contemporary gang life. If this painting borrows from many sources, it also inspired others: the L.A. Latino hip-hop group Ozomatli wrote the songs for its 2007 album *Don't Mess with the Dragon* while working in a gallery where *Street Fight* and other works by Fujita hung.

25.9 Cindy Sherman. *Untitled Film Still #48*. 1979. Black-and-white photograph.
Courtesy of the artist and Metro Pictures.

👁 **Watch** the Art21 video of Cindy Sherman discussing her work on myartslab.com

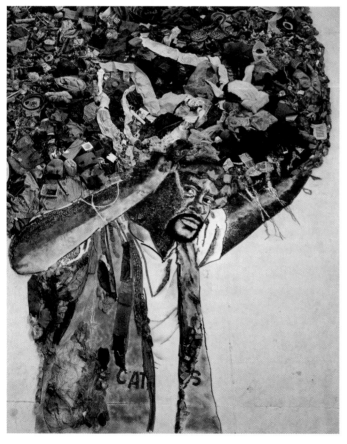

25.10 Vik Muniz. *Atlas (Carlao)*. 2008. Photograph from the series *Pictures of Garbage*.
Photograph: Vik Muniz Studio. © Vik Muniz/Licensed by VAGA, New York, NY.

Photography

The postmodern movement has been a primary influence on recent photography. Postmodern photographers show through their pictures that they know their medium is not an objective one, and that today's cameras can easily lie. Even the most straightforward scenes can have hidden meanings. Postmodernists want to show us that the camera can influence us in ways we may not suspect, and the camera itself has a certain way of seeing.

Cindy Sherman's photographs of the late 1970s were among the first to be called postmodern. She took black-and-white photos of herself, posing with props in scenes that corresponded to stereotyped female characters from popular culture. In *Untitled Film Still #48* (**fig. 25.9**), for example, she stands on a deserted road at dusk, her back to us, hastily packed suitcase at her side. As in many "teen movies" of the 1950s and 1960s, she is the misunderstood daughter running away from home. Other photos from the series depict the girl next door, daddy's little girl, the anxious young career woman, the oppressed housewife. Without referring to specific movies, Sherman's photos are imagined stills from popular film types that have helped to form stereotypical images of women. She knowingly imitates these stereotypes as if to satirize them; this strategy of ironic recycling is some of the purest postmodernism.

Many photographers today do not "find" their subjects; they set them up, as Sherman does. Brazilian-born Vik Muniz works hardest at this task, as we see in his work *Atlas (Carlao)* from the series *Pictures of Garbage* (**fig. 25.10**). The artist arranged huge amounts of trash on his studio floor, thereby "painting" a picture, which he then photographed. He used garbage to create a noble image of a garbage collector, and he used that person's materials to make it.

The photos of Lebanese artist Walid Raad and the Atlas Group are even more complicated in their relationship to reality. Raad witnessed firsthand as a teenager the Lebanese civil war of the 1980s; he took many photos of Beirut, blackened by the smoke of aerial bombardments or artillery fire. When he developed and printed these negatives years later, he found them discolored and pockmarked, aged and damaged like the buildings of his native city.

25.11 Walid Raad/
The Atlas Group.
We decided to let them say,
"we are convinced," twice
(City VI). 2002/2007.
1 of 15 archival
digital prints.
Each 44″ × 67″.
Courtesy Paula Cooper Gallery,
New York.

We decided to let them say, "we are convinced," twice
(City VI) (**fig. 25.11**) is a blurry and smudged photo of
a bomb landing behind a hospital. The degraded qual-
ity gives the image a haunted, distant appearance that
contradicts the violence that it originally recorded.
His photographs thus resemble faded memories: They
record not only the events, but also the tide of history
since they happened.

Sculpture

The range of options available to sculptors has rarely
been wider. Partly in reaction to the simplicity of
Minimal and Conceptual art, sculptors today draw
on a range of techniques and materials. Many con-
temporary sculptors are exploring the symbolic value
of shapes. How can a shape "mean something"? What
range of memories and feelings are viewers likely to
attach to a given figure? At what point does a form
"take shape" so that a viewer can recognize it? Are
viewers likely to see what the creator had in mind?
These are some of the questions that sculptors have
posed in recent years.

Indian-born British sculptor Anish Kapoor takes
such explorations in a ritualistic direction in his work
To Reflect an Intimate Part of the Red (**fig. 25.12**).
He deployed across a gallery floor several shapes that
allude to ancient religious structures such as Maya
pyramids, Indian stupas, and onion-shaped domes.
Kapoor sprinkled his sculpture with powder, an action
that also seems ritualistic. The translation of these
shapes into an art gallery makes us wonder how their
spiritual meanings come about, and how much of that
meaning persists in the new context.

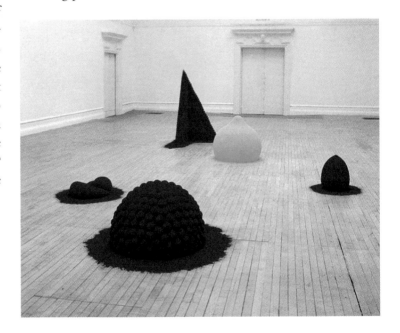

25.12 Anish Kapoor. *To Reflect an Intimate Part of the Red.*
1981. Pigment and mixed media.
Installation 78″ × 314″ × 314″.
Photograph: Andrew Penketh, London. Courtesy Barbara Gladstone.

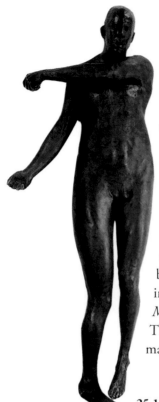

Probably the most potent symbol in sculpture is the human body, and many artists today continue to find new meaning in the figure as a subject. These sculptors see it not as a vehicle for idealism or beauty, but rather for commenting on the ways in which culture shapes our bodies and how we think about them.

Like many artists today, Kiki Smith is influenced by current events. In 1995, when the frozen body of a Stone Age man was found intact in the Alps, she fashioned *Ice Man* (**fig. 25.13**) as a commentary. The piece, showing the unclothed man in the frozen position in which

25.13 Kiki Smith. *Ice Man.* 1995.
Silicon bronze. 80″ × 29¼″ × 12″.
Edition of 2 + 1 AP © Kiki Smith. Photograph by Ellen Page Wilson, courtesy Pace Gallery.

he was found, is modeled life-size and cast in silicon bronze. The material gives the surface a dark color similar to that of the dead man's skin. Smith simplified the facial features, leaving the work's title the only sure clue to the source of the work. She hung the work on the wall slightly above eye level, attached by its back. Thus it became for viewers an object of curiosity, a specimen, just as the frozen Stone Age man was for the anthropologists who studied him.

As some sculptors investigate the meaning of shapes, so others question the meanings of materials. They use almost any substance or object as an experiment, to see what might be said with it. One of these is Rachel Harrison, who brought together an amazing array of things and titled it *This Is Not an Artwork* (**fig. 25.14**). Fake vegetables, a wig model, and a cheap table only begin to list this work's components. It also includes an action figure of the famous classic rock drummer Peter Criss and a surveillance camera. The piece as a whole seems to be a meditation on what is real and what is a representation, a crucial question in today's culture.

25.14 Rachel Harrison. *This Is Not an Artwork.* 2006.
Wood, polystyrene, cement, acrylic, table, fake vegetables, plastic surveillance camera, mannequin, wig, cowboy hat, stickers, and plastic KISS figure with drum. 59″ × 22″ × 22″.
Courtesy the artist and Greene Naftali, New York. Photograph: Jean Vong.

Public Art

Public art is art that you might encounter without intending to; it exists in a public place, accessible to everyone. The idea of public art originated in ancient times, as government and religious leaders commissioned artists to create works for public spaces. In our time, artists still make public art that responds to the needs and hopes of broad masses of people.

The Vietnam Veterans Memorial, located on the Mall in Washington, D.C., is probably America's best-known public art piece (see fig. 2.15). The almost 250-foot-long, V-shaped black granite wall bears the names of the nearly 60,000 American servicemen and women who died or are missing in Southeast Asia. The nonprofit Vietnam Veterans Memorial Fund, Inc., was formed in 1979 by a group of Vietnam veterans who believed that a public monument to the war would help speed the process of national reconciliation and healing after the conflict.

After examining 1,421 entries, the jury selected the design of 21-year-old Maya Lin, then a student at Yale University. Lin had visited the site and created a design that would work with the land rather than dominate it. "I had an impulse to cut open the earth . . . an initial violence that in time would heal. The grass would grow back, but the cut would remain, a pure, flat surface, like a geode when you cut it open and polish the edge. . . . I chose black granite to make the surface reflective and peaceful."[2]

Lin's bold, eloquently simple design creates a memorial park within a larger park. It shows the influence of Minimalism and site-specific works of the 1960s and 1970s. The polished black surface reflects the surrounding trees and lawn, and the tapering segments point to the Washington Monument in one direction and the Lincoln Memorial in the other. Names are inscribed in chronological order by date of death, each name

Watch the Art21 video of Maya Lin discussing her work on myartslab.com

25.15 Ken Smith. *MoMA Roof Garden.* 2005. Outdoor garden at the Museum of Modern Art, New York.
© 2013 Alex S. MacLean/Landslides.

given a place in history. As visitors walk toward the center, the wall becomes higher and the names pile up inexorably. The monument's thousands of visitors seem to testify to the monument's power to console and heal.

When the Museum of Modern Art in New York expanded in 2004, the neighbors in high-rise buildings complained about having to look down onto new ugly roof structures. The museum responded by turning to landscape architect Ken Smith, who said, "Let's camouflage it!" He made the humorous *MoMA Roof Garden* (**fig. 25.15**) out of colored gravel, asphalt, and plastic bushes. The composition is a camouflage

pattern, the better to "hide" the building. This piece of public art is not visible from inside the museum and, more important, requires no maintenance. When the neighbors complained yet again that the garden was completely fake, Smith responded that it was about as fake as nearby Central Park, which had been carefully planted on a stripped and leveled field. The tongue-in-cheek humor of this piece and its witty quotation of camouflage patterns make this work a rare example of postmodern landscape architecture.

A great deal of public art in the United States is created under a mandate that one-half of one percent of the cost of public buildings be spent on art to embellish them. When a community-minded artist works with the local people, the results can be quite successful, as in the following case.

Seattle-based Buster Simpson specializes in public art, and one of his recent commissions embodies the environmental concerns of an eastern Washington agricultural community. *Instrument Implement: Walla Walla Campanile* (**fig. 25.16**) begins with a core of metal farmers' disks arranged in a repeating bell-shape pattern. Sensors track environmental conditions in nearby Mill Creek: water temperature, flow level, and amount of dissolved gases. All three of these measures are critical for the annual salmon migration, which has been diminishing in recent years. The data are processed by a computer that encodes them into musical notes. Hammers on the piece then strike the relevant disks to ring a chime, which becomes an hourly auditory update on the condition of the river. The health of the local salmon is a "canary in the coal mine," an early warning of other environmental problems. Simpson included a yellow effigy of a salmon as an indicator of this. The entire piece is powered by an attached solar collector. *Instrument Implement* is located at Walla Walla Community College, within sight and earshot of hundreds of people each day.

25.16 Buster Simpson. *Instrument Implement: Walla Walla Campanile.* 2008. William A. Grant Water & Environmental Center, Walla Walla Community College, Walla Walla, WA. Height 25′6″.
Courtesy of the artist.

A new type of public art involves the placement of artists' digital artworks on electronic billboards, interspersed with commercial or public service announcements. The Massachusetts Convention Center Authority unveiled a series of such works, commissioned for the 75-foot-tall multi-screen LED marquee located outside the Boston Convention & Exhibition Center. Artist and series participant Kawandeep Virdee, for example, created *Urban Bloom* (**fig. 25.17**), a two-part work in which slowy shifting, highly saturated colors fade past, above an abstract display of moving lights suggesting urban nighttime traffic. This digital embellishment of the streetscape reappears periodically among other artworks as part of the Art on the Marquee program, commissioned by the Massachusetts Convention Center Authority and Boston Cyberarts, a non-profit promoter of new media in that region. *The Boston Globe* editorialized about the series: "Far from being urban blight, each of these billboards enhances its environment because its content balances commercial opportunity with art and public service."[3]

25.17 Kawandeep Virdee. *Urban Bloom*. 2012. Light installation at Boston Convention & Exhibition Center.

Transcendence

Even in our highly secular and fast-moving postmodern world, some artists seek to put viewers in touch with larger forces or encourage them to enter a state of spiritual contemplation. Often they use or depict light to aid this quest for transcendence.

James Lee Byars studied Buddhism in Japan for ten years; this influenced his art toward the use of opulent materials in the pursuit of richly textured beauty. His 1994 installation *The Death of James Lee Byars* (**fig. 25.18**) created an otherworldly glow through the liberal use of gold leaf. The work is a garage-sized empty room with a low platform at the center; gold leaf covers every surface, in many places layered over itself. Each time the work

25.19 Ernesto Pujol. *Awaiting*. 2008. Utah State Capitol Hill steps, Salt Lake City.
Photo: Ed Bateman.

25.18 James Lee Byars.
The Death of James Lee Byars. 1994.
Installation. Gold leaf, 5 crystals, and Plexiglass. 18′ × 18′.
Private Collection. Copyright The Estate of James Lee Byars.

was installed, Byars entered wearing a gold suit and lay down on the platform for varying lengths of time, "practicing my own death" as he put it, usually with a wink and a wry smile. On departure he left five small crystals, a personal ritual barely visible to spectators. Since the artist's death in 1997, the work has been recreated several times. It reminds viewers of mortality by transporting them to a stunningly rich chamber lit with the deep amber glow that only gold can give.

Byars's installation includes an element of performance, but some contemporary artists use performance as a principal medium to recapture a sense

of the spiritual. Ernesto Pujol created *Awaiting* (**fig. 25.19**) as an outdoor event for about 100 volunteer performers in Salt Lake City, Utah, where, he said, he "meant to slow things down and send a subtle reminder of the human need for silence and solitude in order to reflect." The performers, all dressed in white, converged silently at the base of the state capitol building in late afternoon. On a signal from the artist, they began silently walking, slowly ascending and descending the capitol steps for the next 12 hours. The piece ended at sunrise as the performers dispersed, maintaining silence. *Awaiting* had the feeling of a ritual, or a sacred interruption of the city's daily routine. One urban commuter, interviewed in a local newspaper, reported the work's impact on him: "It's definitely not normal for this to be happening, so yeah, it made me stop and think."

Such an effect closely parallels the artist's stated intention: "It's a very gentle invitation to something deeper that is getting lost now that we have cell phones and hand-held devices."[4]

The meditative exercise of slow walking resembles the rhythmic, small, methodical paint strokes that make up *Ancient Light* by Shirazeh Houshiary (**fig. 25.20**). Asked about her artistic goals, she said, "This work is about presence. Presence is like light—how can you describe light? Light can be only experienced, it has a presence. This work also has a presence and has only to be experienced."[5] At approximately 6 by 9 feet, the work fills our visual field with a white glow of light that the artist has called an "energy field." She begins with small adjacent calligraphic pencil strokes, repeated hundreds of times like a meditation exercise (see detail). These combine into softly rippling lines that she compares to breaths or musical vibrations. She created the deep radiance with numerous layers of water-based paint, which gives the sensation of looking into a bottomless yet textured space. She said, "White is an experience of boundlessness, it opens in front of you," helping viewers to experience infinity. We could be staring into a microcosm of atoms, or a boundless expanse of space. But the artist does not mind the contradiction, because she hopes to reach the widest possible audience. She said, "I would like my work to be open and generous, different for every person who sees it."[6]

Detail of fig. 25.20.

25.20 Shirazeh Houshiary. *Ancient Light.* 2009. Pencil, aquacryl, and pigment on canvas, 74¾" × 106¼".

Issue-Oriented Art

Many artists of the most recent generation have sought to link their art to current social questions. Issue-oriented artists believe that if they limit their art to aesthetic matters, then their work will be only a distraction from pressing problems. Furthermore, they recognize that what we see influences how we think, and they do not want to miss an opportunity to influence both. Some public art is issue-oriented, as we saw with Simpson's *Instrument Implement*.

Barbara Kruger was trained as a magazine designer, and this profession shows in her piece *Untitled (I Shop Therefore I Am)* (**fig. 25.21**). She invented the slogan, which sounds as though it came from advertising. The position of the hand, too, seems to come from an ad for aspirin or sleeping medication. Do our products define us? Are we indeed what we shop for? Often we buy a product because of what it will say about us, and not for the thing itself. These are some of the messages present in this simple yet fascinating work. Perhaps its ultimate irony is that the artist later silkscreened it onto a shopping bag.

Artists who create works about racism and class bias show how common practices of museum display contribute to such problems. In 1992, the Maryland Historical Society invited African-American artist Fred Wilson to rearrange the exhibits on one floor to create an installation that he called *Mining the Museum* (**fig. 25.22**). He spent a year preparing for the show,

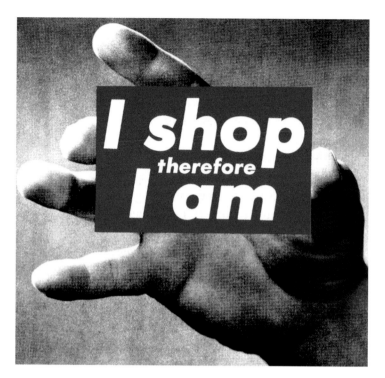

25.21 Barbara Kruger. *Untitled (I Shop Therefore I Am).* 1987. Photographic silkscreen/vinyl. 111″ × 113″.
Courtesy: Mary Boone Gallery, New York. © Barbara Kruger.

25.22 Fred Wilson. *Mining the Museum.* 1992–1993. Installation. Cigar-store Indians facing photographs of Native American Marylanders.
Courtesy of the Maryland Historical Society, Item ID #MTM004. Photograph: Jeff D. Goldman.

Watch the Art21 video of Fred Wilson discussing his work on myartslab.com

rummaging through the Society's holdings and documentary records; the results were surprising. He found very little that related to Maryland's Native American population, but he did find a large collection of wooden statues of Indians that were commonly placed outside cigar stores. He dusted them off and stood them, backs to viewers, facing photographs he took of real Native Americans who lived in Maryland. In an accompanying exhibition brochure, he wrote that a museum should be a place that can make you think. When *Mining the Museum* went on display, attendance records soared.

Egyptian artist Khaled Hafez created a video work in 2006 in which he impersonated various types of Egyptian male identity. *Revolution* (**fig. 25.23**) shows the artist enacting the roles of military officer, businessman, and Muslim fundamentalist. Though he had no way of knowing this, these three types eventually represented the three sorts of political parties that dominated the country after the real "Arab Spring" revolution broke out in 2011. Rather than responding to conditions, this work foreshadowed them.

Street Art

Today's street art has many antecedents, from paintings on cave walls to gang-related graffiti, but it first came to the art world's attention in the late 1970s, when illegal decoration of subway cars began to take on a new sophistication in several cities. Aided by a new proliferation of colors available in spray cans, renegade artists raided the railyards, working at night to embellish—some would say vandalize—public transport vehicles. Most graffiti consisted of random tagging with names or initials until artists such as Lee Quiñones began to think of the entire car as his canvas. In the vehicle pictured here (**fig. 25.24**), the artist wrote his first name in large letters that spread across the available space, in blocky masses that themselves suggest jostling subway cars on a rough track. A later tagger added the purple stains and the ironic "Sorry!" at the lower left, demonstrating an occupational hazard in this type of work. Another occupational hazard is arrest by the police, which forces graffiti artists to work quickly. Quiñones recognized this by calling the movement "rapid enamelism." The New York City Transport Authority "exhibited" this subway car on the tracks for several weeks before repainting it. Like several other graffiti artists, Quiñones later moved on to producing paintings for exhibition in galleries. Other notable street artists who made the same transition in the early 1980s were Jean-Michel Basquiat (see fig. 5.5) and Keith Haring (see fig. 3.50).

25.23 Khaled Hafez. *Revolution (Liberty, Social Equity, Unity)*. 2006. Single-channel split-screen HD video, 4 minutes.

25.24 "LEE" 1976, aka Lee Quiñones. *Top to bottom on IRT 5 Lexington Avenue Express*. 1976. Subway Car 7735. Length 40′.
Photograph: Henry Chalfant.

By the turn of the twenty-first century, street art was a recognized movement, and most of its main practitioners now work both indoors and out, many still under pseudonyms. While sometimes illegal, the boldness and personal risk-taking that street artists display can be inspiring where public display is regulated by corporate or government power.

25.25 Banksy.
Stone Age Waiter. 2006. Spray paint and stencils.
Height 5′6″. Outdoor location, Los Angeles.
Photograph: Patrick Frank.

Probably the most famous street creator today is the English artist Banksy. His street art is generally witty, as we see in *Stone Age Waiter* (**fig. 25.25**). This piece adorns an outdoor location in a Los Angeles neighborhood with many restaurants; a cave man has apparently joined the ranks of the pleasure-seekers. Well-heeled Angelenos who walk the (always short) distance from their cars to their favorite restaurants will pass this stencil-and-spray-paint creation. Banksy is currently one of the most popular artists in his homeland, and many of his outdoor works have been preserved.

A Southern California case recently highlighted some of the legal issues that surround the street art movement. In late 2011, a developer bought a dilapidated three-story house that had sat empty for two years because of the mortgage crisis. While he secured financing to reconstruct it, he engaged two street artists—Retna and Risk—to decorate the scaffolds across its face. Together they created a huge billboard, *Oceans at Risk* (**fig. 25.26**), to promote the local charitable organization Heal the Bay, which campaigns against beach and ocean pollution.

Risk created the colors, which transition from aqua-turquoise to sunset-yellow. Retna painted the white letters, in his typically illegible style of calligraphy. A sign on the fence showed a large Q.R. code which viewers could scan for more information about the contamination of nearby Santa Monica Bay.

Neighborhood reaction was immediate, and deeply divided. Some decried the garish intrusion, while others praised the cause, and the covering of what had been an unsightly ruin. City authorities had the last word, as they declared the structure unlawful and ordered its removal after ten days of legal wrangling. During that time, however, more than 1,500 people visited the site; many of them scanned the code and learned about the largely invisible problem of environmental pollution in local coastal waters. The project's boldness and scale also generated intense media coverage. So while *Oceans at Risk* was illegal and therefore short-lived, it also potently raised an important issue.

25.26 Retna and Risk. *Oceans at Risk.* 2011.
Sprayed and brushed acrylic. 40′ ×100′.
Temporary installation, Santa Monica, CA.
Photograph: Patrick Frank.

The Global Present

Communication and travel technologies are making the world ever smaller. The Internet, air travel, mobile phones, cable television, and international migration are bringing us all into ever closer proximity. After the fall of Soviet Communism, the world is not as divided as it was for the preceding half-century, thus contributing to a more fluid world culture. Many businesses, for example, are not confined by national boundaries any more; they may raise money in one country, buy raw materials in another, set up manufacturing facilities in a third, and sell the final product around the world.

The globalization of culture has had a profound impact on art. Contemporary art forms such as conceptual, installation, and performance art have spread around the world. Innovative work is emerging in formerly unexpected places, as artists in many countries use increasingly international modes of expression to interpret the contemporary world in the light of their own traditions. This union of the cosmopolitan and the local is a major source of the new creative effort that has always fertilized art. A few examples from disparate continents will have to suffice to indicate the directions that art is taking. All these works comment on our global condition today.

The issue of personal and ethnic identity provokes increasing soul-searching in this shrinking world. Do artists from one part of the world need to practice the traditional styles still associated with their origins? Is it appropriate for a Pakistani-American artist to paint in a traditional Pakistani style or vice versa?

Shahzia Sikander answers many of these questions by taking a middle ground, drawing on her roots while giving her work a contemporary look. Born in Pakistan, she was trained first as a traditional illustrator in the ancient gouache medium. After moving to the West in the mid-1990s, she studied at the Rhode Island School of Design. On a trip to Laos in 2008, she read a translation of the Laotian epic poem *Sang Sinxay* and created several works in response. *Sinxay: Narrative as Dissolution #1* (**fig. 25.27**) uses Lao writing as a backdrop for her own calligraphic loops and swirls that are based on her

25.27 Shahzia Sikander.
Sinxay: Narrative as Dissolution #1. 2008.
Ink and gouache on paper. 82″ × 51¼″.
Courtesy of the artist and Sikkema Jenkins & Co., NYC.

Watch the Art21 video of Shahzia Sikander discussing her work on myartslab.com

25.28 El Anatsui. *Sasa.* 2004.
Aluminum and copper wire. 20′11³¹⁄₃₂ × 27′6⁴⁵⁄₆₄″.
Musée National d'Art Moderne, Centre Georges Pompidou
RMN-Grand Palais/Georges Meguerditchian.

earlier training. Which culture this work came from ought not be a consideration, she says: "These days the world is small and one should really consider work in terms of some sort of global context of ideas. Work I believe should stand on its own, irrespective of geography."[7] In this work, an exotic text has become a beautiful garland of careful, flower-like paint strokes.

Because human creativity is spread about equally around the globe, a good idea can emerge from almost anywhere. The African artist El Anatsui uses cast-off liquor bottle tops to weave spectacular tapestries of shimmering color. His 2004 piece *Sasa* (**fig. 25.28**) shows his roots in the tradition of African textiles, in which artists have used materials at hand with great resourcefulness (see Chapter 20). The bottle tops refer to the colonial-era triangular trade that sent slaves from Africa to the New World in exchange for rum. The artist has symbolically transformed that lamentable heritage into a stunning object. The title of the work means "patchwork," which the artist says has a double significance: It refers to both the quilt-like nature of the work and to the way in which European powers carved up Africa into a patchwork of colonies.

25.29 Doris Salcedo. *Plegaria Muda (Silent Prayer)*. 2008–2010. Wood, mineral compound, metal and grass. 166 units as installed at CAM, Fundação Calouste Gulbenkian, Lisbon, November 12, 2011–January 22, 2012.
Photograph: Patrizia Tocci. Image courtesy Alexander and Bonin, New York.

Colombian artist Doris Salcedo creates poignant monuments that channel mourning and hope. Her recent installation *Plegaria Muda* (**fig. 25.29**) begins with a multitude of empty tables, stacked in pairs with one table upended atop another. These give the appearance of an abandoned space, of a once-busy, occupied zone now gone silent. She created this work as a memorial to the innocent victims of civil strife in her country; each table is approximately the size and shape of a coffin, and their upturned legs seem at first to suggest a forest of futility. But between the top and bottom of each pair of tables she embeds masses of soil, so that during exhibitions, thin shoots of grass spring up between the wooden boards of each upended table. The work is thus a "silent prayer" (the meaning of the title) of mourning for the dead, as well as an expression of hope in the fertility of the soil.

Though she created the installation in response to the story of Colombia, the work's evocation of bereavement and tender hope could also speak about many of the world's wounded places.

Like *Plegaria Muda*, much of the best contemporary art is multi-leveled: not necessarily difficult to understand, in media that we can all respond to. Chinese creator Ai Weiwei recently unveiled a similarly layered series of bronze sculptures titled *Circle of Animals/Zodiac Heads* (**fig. 25.30**). He modeled the heads after the 12 imaginary creatures that populate the Chinese zodiac. The slightly monstrous aspect of the work appeals to children, yet the piece has deeper, subtle meanings that address some tense moments in East–West relations. The heads are based on the remnants of an eighteenth-century fountain in a former imperial retreat outside Beijing, where each

25.30 Ai Weiwei. *Circle of Animals/Zodiac Heads.* 2010.
Bronze. 12 units, average height 10′. Grand Army Plaza, New York City.
Private Collection. Images courtesy of the artist and AW Asia.
Photograph: Adam Reich.

spouted water at two-hour intervals. This build-
ing was at first a sign of international cooperation,
as it was designed by European Jesuit architects for
the emperor. When this splendid palace was sacked
and destroyed by French and British troops in 1860,
the majority of the heads vanished, and the Chinese
government soon declared the remainder national
treasures. Ai Weiwei alluded to the ancient fountain
by placing each head atop a column that resembles
a spout of gushing water. He created the piece, in
part, in response to a 2000 art auction at which three
of the formerly lost heads appeared for sale, causing
protests from many Chinese cultural officials. Soon
after its creation, *Circle of Animals/Zodiac Heads* went
on a tour of several world cities, where it was dis-
played over fountains or pools.

Conclusion

We will close with Renzo Piano's new Modern Wing
of the Chicago Art Institute (**fig. 25.31**) because it
embodies ideas that motivate many museums today.
The Modern Wing is an addition to the earlier tradi-
tional building, which was built in 1893 from brick
and stone in a classical style. The original building
expressed the ideals of dignity, trust, and safeguarding
the past. In contrast, the new wing is almost completely
glass-wrapped and open to the light. The architect said
of this wing:

> Today we have a different story to tell. I
> think the story we are telling with the new
> building is about accessibility . . . It's about
> openness. It's about a building that should

25.31 Renzo Piano. Modern Wing. 2009.
Art Institute of Chicago. Photograph: Nic Lehoux, courtesy Renzo Piano Building Workshop.

not be intimidating, but the opposite. It should be inviting.[8]

The examples in this chapter show that art comes from basic feelings that all of us share. Through their work, artists interact with life, to find purpose and meaning in it. Human life varies considerably across time and space, but the art endures. Creative expression is a response to being alive, and artists' creativity can activate the artist within us.

Art offers us a way to go beyond mere physical existence. The ideas and values that constitute the basis of the visual arts can continue to enrich our lives and surroundings. We form art. Art forms us.

Study and review on myartslab.com

TRY THIS

Visit a gallery that specializes in contemporary art, and assess the work on view. Does it take up any issues similar to those discussed in this chapter? For added information about the exhibition, ask a staff member or request a copy of the press release for the show.

THINK BACK

1. What are postmodern architects doing that modernists did not?

2. What kinds of issues do postmodern artists take up in their work?

3. What global issues are contemporary artists addressing?

KEY TERMS

postmodern – an attitude or trend of the late 1970s, 1980s, and 1990s; characterized in architecture by a move away from the International Style in favor of an imaginative, eclectic approach, and in the other visual arts by influence from all periods and styles and a willingness to combine elements of all.

30,000 20,000 10,000 5,000 3,000 2,000 1,000 500 250 BCE 0 CE 200 400 600 800

ericas

OLMECS

NAZCA

MAYA
Temple I

TOLTECS

Rock Art, Utah

Pyramid of
the Sun

sia

VIKINGS

Book of
Kells

Woman of
Willendorf

Bison

Stonehenge

Purse Cover

thern
pe

Chauvet Cave Paintings

CHRISTIAN ERA
BEGINS

■ POMPEII
BURIED

ROMAN EMPIRE

Euphronios
Krater

CLASSICAL
Parthenon
Spear Bearer

Pantheon

Division of
Empire

Fall of Western
Empire

ARCHAIC
Kouros

Head of Constantine

HELLENISTIC
Laocoön

BYZANTIUM
San Vitale

thern
pe

SUMERIAN CITIES
Bull-headed Lyre
Ziggurats

Earthenware
Beaker

■ **BIRTH OF**
CHRIST 4 BCE

■ **BIRTH OF**
MUHAMMAD 570

BRONZE ■
AGE BEGINS

AKKADIANS
Head of Ruler

dle
t

NEOLITHIC
REVOLUTION
BEGINS

OLD KINGDOM
Mycerinus
Pyramids

NEW KINGDOM
Tomb Paintings

Great Mosque,
Kairouan

Mummy Portraits

ca

Blombos Cave

Engraved Ochre

NOK CULTURE
Head

INDUS VALLEY
CIVILIZATION
Harappa Torso

■ **BIRTH OF**
BUDDHA 563 BCE

Great
Stupa

GUPTA
DYNASTY Standing Buddha

ia

BUDDHISM SPREAD TO CHINA

Great Wall

CHAN (LATER ZEN)
BUDDHISM

na

Burial
Urn

SHANG DYNASTY

Ritual
Vessel

■ Terra cotta
Warriors

■ PAPER INVENTED

■ PRINTING
DEVELOPED

an

BUDDHISM
SPREAD
TO JAPAN

Ise Shrine

Horyuji
Temple

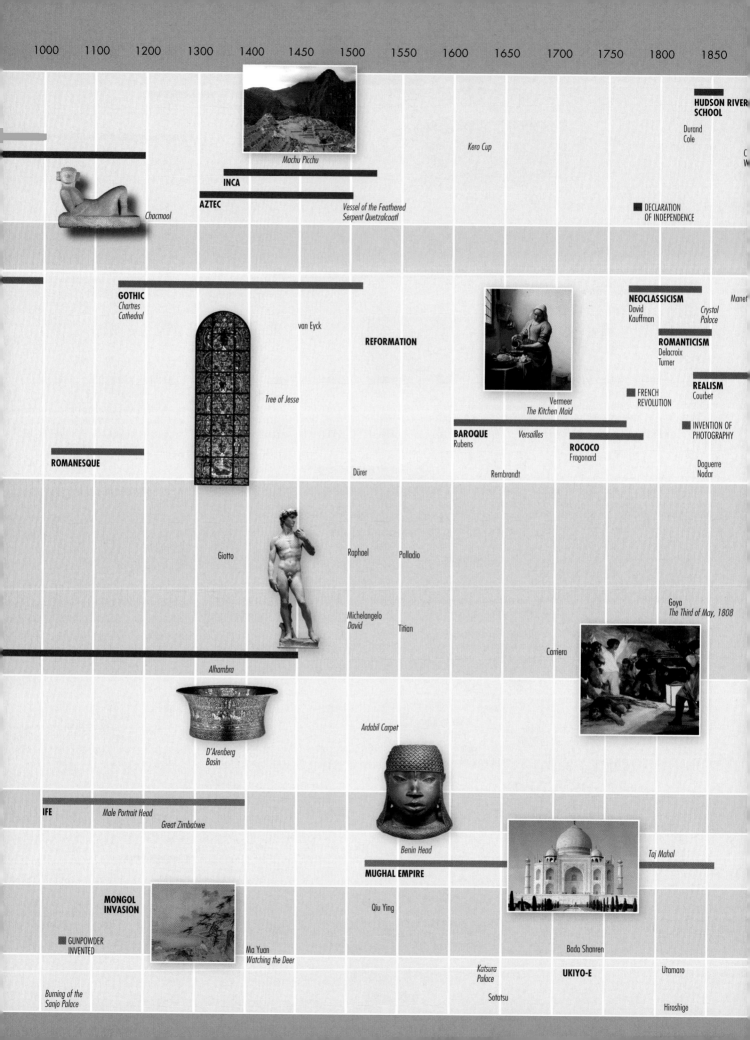

1000 1100 1200 1300 1400 1450 1500 1550 1600 1650 1700 1750 1800 1850

HUDSON RIVER SCHOOL
Durand
Cole

Kero Cup

Machu Picchu

INCA

AZTEC

Vessel of the Feathered Serpent Quetzalcoatl

DECLARATION OF INDEPENDENCE

Chacmool

GOTHIC
Chartres
Cathedral

NEOCLASSICISM
David *Crystal* Manet
Kauffman *Palace*

van Eyck

REFORMATION

ROMANTICISM
Delacroix
Turner

Tree of Jesse

FRENCH **REALISM**
REVOLUTION Courbet

Vermeer
The Kitchen Maid

INVENTION OF PHOTOGRAPHY

BAROQUE Versailles
Rubens

ROCOCO
Fragonard

Daguerre
Nadar

ROMANESQUE

Dürer Rembrandt

Giotto

Raphael Palladio

Michelangelo
David Titian

Goya
The Third of May, 1808

Carriera

Alhambra

D'Arenberg Basin

Ardabil Carpet

IFE *Male Portrait Head*

Great Zimbabwe

Benin Head

Taj Mahal

MUGHAL EMPIRE

MONGOL INVASION

Qiu Ying

GUNPOWDER INVENTED

Ma Yuan
Watching the Deer

Bada Shanren

Katsura
Palace

UKIYO-E Utamaro

Burning of the Sanjo Palace

Sotatsu

Hiroshige

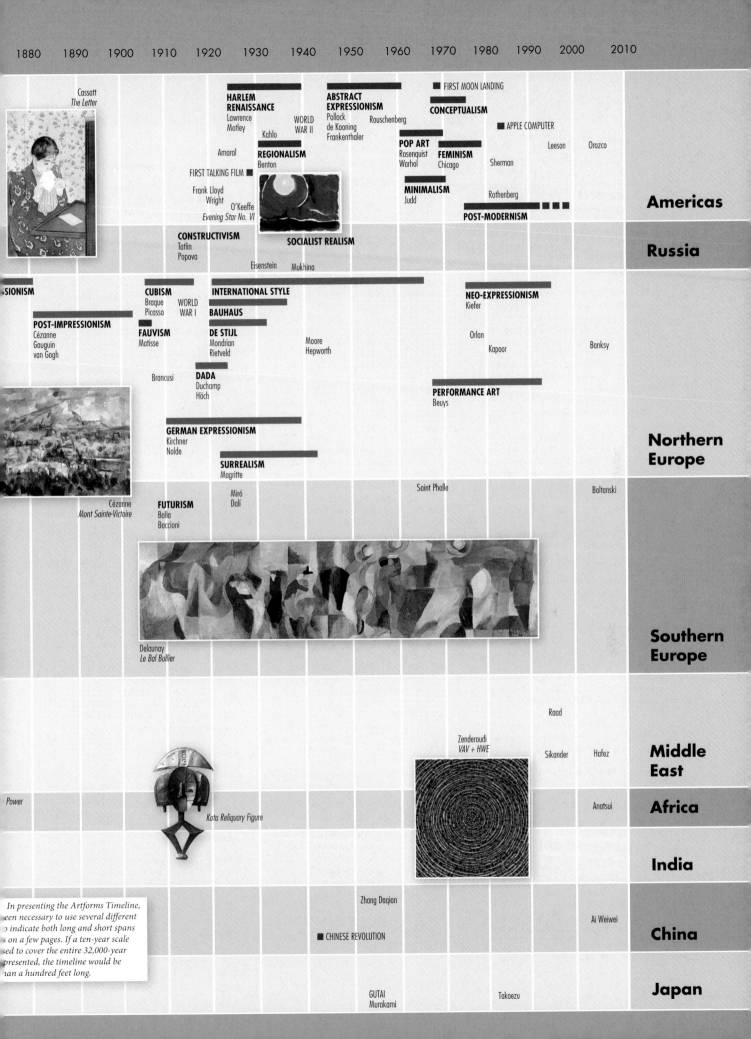

1880 1890 1900 1910 1920 1930 1940 1950 1960 1970 1980 1990 2000 2010

Cassatt
The Letter

**HARLEM
RENAISSANCE**
Lawrence
Motley WORLD
 Kahlo WAR II

Amaral **REGIONALISM**
 Benton

FIRST TALKING FILM ■

Frank Lloyd
Wright
 O'Keeffe
Evening Star No. VI

■ FIRST MOON LANDING

**ABSTRACT
EXPRESSIONISM**
Pollock Rauschenberg
de Kooning
Frankenthaler

CONCEPTUALISM

■ APPLE COMPUTER

POP ART
Rosenquist **FEMINISM** Leeson Orozco
Warhol Chicago

 Sherman

MINIMALISM Rothenberg
Judd

POST-MODERNISM

Americas

CONSTRUCTIVISM
Tatlin
Popova

 Eisenstein Mukhina

SOCIALIST REALISM

Russia

SIONISM

POST-IMPRESSIONISM
Cézanne
Gauguin
van Gogh

CUBISM
Braque WORLD
Picasso WAR I

FAUVISM
Matisse

Brancusi

INTERNATIONAL STYLE

BAUHAUS

DE STIJL
Mondrian Moore
Rietveld Hepworth

DADA
Duchamp
Höch

NEO-EXPRESSIONISM
Kiefer

Orlan

 Kapoor Banksy

PERFORMANCE ART
Beuys

GERMAN EXPRESSIONISM
Kirchner
Nolde

SURREALISM
Magritte

Cézanne
Mont Sainte-Victoire

FUTURISM Miró Saint Phalle Boltanski
Balla Dalí
Baccioni

**Northern
Europe**

Delaunay
Le Bal Bullier

**Southern
Europe**

 Raad

 Zenderoudi
 VAV + HWE
 Sikander Hafez

**Middle
East**

Power

Kota Reliquary Figure

 Anatsui

Africa

India

Zhang Daqian

 Ai Weiwei

■ CHINESE REVOLUTION

China

In presenting the Artforms Timeline,
een necessary to use several different
o indicate both long and short spans
s on a few pages. If a ten-year scale
ed to cover the entire 32,000-year
presented, the timeline would be
an a hundred feet long.

GUTAI Takaezu
Murakami

Japan

GLOSSARY

The following terms are defined according to their use in the visual arts. Words in *italics* are also defined in the glossary.

abstract art Art that is based on natural appearances but departs significantly from them. Forms are modified or changed to varying degrees.

Abstract Expressionism An art movement, primarily in painting, that originated in the United States in the 1940s and remained strong through the 1950s. Artists working in many different styles emphasized spontaneous personal expression in large paintings that are *abstract* or *nonrepresentational*. One type of Abstract Expressionism is called *action painting*. See also *Expressionism*.

Abstract Surrealism See *Surrealism*.

academic art Art governed by rules, especially works sanctioned by an official institution, academy, or school. Originally applied to art that conformed to standards established by the French Academy regarding composition, drawing, and color usage. The term has come to mean conservative and traditional art.

achromatic Having no color (or *hue*); without identifiable hue. Most blacks, whites, grays, and browns are achromatic.

acrylic (acrylic resin) A clear synthetic resin used as a *binder* in acrylic paint and as a casting material in sculpture.

action painting A style of *nonrepresentational* painting that relies on the physical movement of the artist by using such gestural techniques as vigorous brushwork, dripping, and pouring. Dynamism is often created through the interlaced directions of the paint's impact. A subcategory of *Abstract Expressionism*.

additive color mixture The mixture of colored light. When light colors are combined (as with overlapping spotlights), the mixture becomes successively lighter. Light primaries, when combined, create white light. See also *subtractive color mixture*.

additive sculpture Sculptural form produced by adding, combining, or building up material from a core or (in some cases) an *armature*. Modeling in clay and welding steel are additive processes.

aerial perspective See *perspective*.

aesthetics The study and philosophy of the quality and nature of sensory responses related to, but not limited by, the concept of beauty.

Within the art context: the philosophy of art focusing on questions regarding what art is, how it is evaluated, the concept of beauty, and the relationship between the idea of beauty and the concept of art.

airbrush A small-scale paint sprayer that allows the artist to control a fine mist of paint.

analogous colors or **analogous hues** Closely related *hues*, especially those in which a common hue can be seen; hues that are neighbors on the color wheel, such as blue, blue-green, and green.

Analytical Cubism See *Cubism*.

apse A semicircular end to an aisle in a *basilica* or a Christian church. In Christian churches an apse is usually placed at the eastern end of the central aisle.

aquatint An *intaglio* printmaking process in which *value* areas rather than *lines* are etched on the printing plate. Powdered resin is sprinkled on the plate, which is then immersed in an acid bath. The acid bites around the resin particles, creating a rough surface that holds ink. Also, a *print* made using this process.

arcade A series of *arches* supported by columns or piers. Also, a covered passageway between two series of arches, or between a series of arches and a wall.

arch A curved structure designed to span an opening, usually made of stone or other masonry. Roman arches are semicircular; Islamic and *Gothic* arches come to a point at the top.

armature A rigid framework serving as a supporting inner core for clay or other soft sculpting material.

art criticism The process of using formal analysis, description, and interpretation to evaluate or explain the quality and meanings of art.

artist's proof A trial print, usually made as an artist works on a plate or block, to check the progress of a work.

Art Nouveau An art movement of the late nineteenth and early twentieth centuries in Europe and the United States. Flourishing especially in the decorative arts and architecture, the Art Nouveau style emphasized curving, expressive lines based on organic shapes of flowers or vegetation.

assemblage Sculpture made by assembling found or cast-off objects that may or may not

contribute their original identities to the total content of the work.

assembled sculpture Creating a work of sculpture by putting together pieces that are already formed by the artist.

asymmetrical Without *symmetry*.

asymmetrical balance The various elements of a work are balanced but not symmetrical.

atmospheric perspective See *perspective*.

automatism Action without conscious control, such as pouring, scribbling, or doodling. Employed by *Surrealist* writers and artists to allow unconscious ideas and feelings to be expressed.

avant-garde A term from military theory that was applied to modern art, meaning the advance guard of troops that moves ahead of the main army. Avant-garde artists work ahead of the general public's ability to understand.

balance An arrangement of parts achieving a state of equilibrium between opposing forces or influences. Major types are symmetrical and *asymmetrical*. See *symmetry*.

balloon frame A wooden structural support system developed in the United States in the middle nineteenth century in which standardized, thin studs are held together with nails.

Baroque The seventeenth-century period in Europe characterized in the visual arts by dramatic light and shade, turbulent *composition*, and pronounced emotional expression.

barrel vault See *vault*.

basilica A Roman town hall, with three aisles and an *apse* at one or both ends. Christians appropriated this form for their churches.

bas-relief See *low relief*.

Bauhaus German art school in existence from 1919 to 1933, best known for its influence on design, leadership in art education, and its radically innovative philosophy of applying design principles to machine technology and mass production.

beam The horizontal stone or timber placed across an architectural space to take the weight of the roof or wall above; also called a lintel.

binder The material used in paint that causes *pigment* particles to adhere to one another

and to the *support*; for example, linseed oil or acrylic polymer.

biomorphic shape A shape in a work of art that resembles a living organism or an *organic shape*.

bodhisattva A Buddhist holy person who is about to achieve enlightenment but postpones it to remain on earth to teach others. Frequently depicted in the arts of China and Japan, usually bejeweled.

boss a circular, often dome-shaped, decoration that protrudes from a flat surface.

buon fresco See *fresco*.

burin A tool used in *engraving*.

burr The ridge left by scratching a *drypoint* line in a copper plate. The burr holds ink for printing.

buttress A *support*, usually exterior, for a wall, *arch*, or *vault* that opposes the lateral forces of these structures. A flying buttress consists of a strut or segment of an arch carrying the thrust of a vault to a vertical pier positioned away from the main portion of the building. An important element in *Gothic* cathedrals.

Byzantine art Styles of painting, design, and architecture developed from the fifth century CE in the Byzantine Empire of ancient Eastern Europe. Characterized in architecture by round *arches*, large *domes*, and extensive use of *mosaic*; characterized in painting by formal design, frontal and stylized figures, and rich use of color, especially gold, in generally religious subject matter.

calligraphy The art of beautiful writing. Broadly, a flowing use of *line*, often varying from thick to thin.

camera obscura A dark room (or box) with a small hole in one side, through which an inverted image of the view outside is projected onto the opposite wall, screen, or mirror. The image is then traced. This forerunner of the modern camera was a tool for recording an optically accurate image.

cantilever A beam or slab projecting a substantial distance beyond its supporting post or wall; a projection supported only at one end.

capital In architecture, the top part or head of a column or pillar.

cartoon 1. A humorous or satirical drawing. 2. A drawing created as a full-scale working drawing, used as a model for a *fresco* painting, mural, or *tapestry*.

carving A *subtractive* process in which a sculpture is formed by removing material from a block or mass of wood, stone, or other material, with the use of sharpened tools.

casein Milk protein used as a binder in opaque water-based paint.

casting A substitution process that involves pouring liquid material such as molten metal, clay, wax, or plaster into a mold. When the liquid hardens, the mold is removed, and a form in the shape of the mold is left.

catacombs Underground burial places in ancient Rome. Christians and Jews often decorated the walls and ceilings with paintings.

ceramics; ceramist Clay hardened into a relatively permanent material by firing, and the art form that includes this procedure. A practitioner of the ceramic arts is a ceramist.

charcoal A dry drawing *medium* made from charred twigs, usually vine or willow.

chiaroscuro Italian word meaning "light dark." The gradations of light and dark *values* in *two-dimensional* imagery. Especially the illusion of rounded, *three-dimensional* form created through gradations of light and shade rather than line. Highly developed by *Renaissance* painters.

cinematography The art of making motion pictures, referring especially to camera work and photography.

classical art 1. The art of ancient Greece and Rome. In particular, the style of Greek art that flourished during the fifth century BCE. 2. Any art based on a clear, rational, and regular structure, emphasizing horizontal and vertical directions, and organizing its parts with special emphasis on balance and proportion. (The term classic is also used to indicate recognized excellence.)

closed form A self-contained or explicitly limited form; having a resolved balance of tensions, a sense of calm completeness implying a totality within itself. A sculptural shape that seems to look inward rather than outward.

coffer In architecture, a decorative sunken panel on the underside of a ceiling.

collage From the French *coller*, to glue. A work made by gluing various materials, such as paper scraps, photographs, and cloth, on a flat surface.

colonnade A row of columns usually spanned or connected by *beams* (lintels).

color field painting A movement that grew out of *Abstract Expressionism*, in which large stained or painted areas or "fields" of color evoke aesthetic and emotional responses.

color scheme A set of colors chosen for a work of art in order to produce a specific mood or effect.

complementary colors Two *hues* directly opposite one another on a color wheel that, when mixed together in proper proportions, produce a neutral gray.

composition The combining of parts or elements to form a whole; the structure, organization, or total form of a work of art.

Conceptual art An art form in which the originating idea and the process by which it is presented take precedence over a tangible product. Conceptual works are sometimes produced in visible form, but they often exist only as descriptions of mental concepts or ideas. This trend developed in the late 1960s, partly as a way to avoid the commercialization of art.

concrete A liquid building material invented by the Romans. Made of water, sand, gravel, and a binder of gypsum, lime, or volcanic ash.

Constructivism Art movement that originated in Russia at the time of the Soviet Revolution of 1917. Constructivists emphasized *abstract art*, modern materials (glass, metal, plastic), and useful arts such as set design, furniture, and graphics.

Conté crayon A drawing medium developed in the late eighteenth century. Similar to pencil in its graphite content, Conté crayon includes clay and small amounts of wax.

content Meaning or message communicated by a work of art, including its emotional, intellectual, symbolic, thematic, and narrative connotations.

contextual theory A method of art criticism that focuses on the cultural systems behind works of art. These may be economic, racial, political, or social.

contour hatching See *hatching*.

contrapposto Italian for "counterpose." The counterpositioning of parts of the human figure about a central vertical axis, as when the weight is placed on one foot causing the hip and shoulder lines to counterbalance each other—often in a graceful S-curve.

cool colors Colors whose relative visual temperatures make them seem cool. Cool colors generally include green, blue-green, blue, blue-violet, and violet. Warmness or coolness is relative to adjacent *hues*. See also *warm colors*.

cross-hatching See *hatching*.

Cubism Art style developed in Paris by Picasso and Braque, beginning in 1907. The early phase of the style, called Analytical Cubism, lasted from 1909 through 1911. Cubism is based on the simultaneous presentation of multiple views, disintegration, and geometric reconstruction of subjects in flattened, ambiguous pictorial space; figure and ground merge into one interwoven surface of shifting planes. Color is limited to *neutrals*. By 1912, the more decorative phase called Synthetic or *collage* Cubism began to appear; it was characterized by fewer, more solid forms, conceptual rather than observed subject matter, and richer color and *texture*.

curtain wall A non-load-bearing wall, typical of the *International Style*. Generally well-endowed with windows.

Dada A movement in art and literature, founded in Switzerland in the early twentieth century, which ridiculed contemporary culture and conventional art. The Dadaists shared an antimilitaristic and anti-aesthetic attitude, generated in part by the horrors of World War I and in part by a rejection of accepted canons of morality and taste. The anarchic spirit of Dada can be seen in the works of Duchamp, Man Ray, Hoch, Hausmann, and others. Many Dadaists later explored *Surrealism*.

daguerreotype An early photographic process developed by Louis Daguerre in the 1830s, which required a treated metal plate. This plate was exposed to light, and the chemical reactions on the plate created the first satisfactory photographs.

design In *three-dimensional* arts (such as sculpture or architecture), the process of arranging visual elements into a finished work. Also means the product of the process, as in, "The design of that chair is excellent."

De Stijl A Dutch purist art movement begun during World War I by Mondrian and others. It involved painters, sculptors, designers, and architects whose works and ideas were expressed in *De Stijl* magazine. *De Stijl*, Dutch for "the style," was aimed at creating a universal language of *form* that would be independent of individual emotion. Visual form was pared down to *primary hues* plus black and white, and rectangular shapes.

directional forces Pathways that the artist embeds in a work for the viewer's eye to follow. May be done with actual or *implied lines*, or lines of sight among the figures depicted in a work.

direct painting Executing a painting in one sitting, applying wet over wet colors.

divisionism See *pointillism*.

dome A generally hemispherical roof or *vault*. Theoretically, an *arch* rotated 180° on its vertical axis.

dressed stone Stone used for building that is cut, trimmed, or ground down to fit into a *masonry* wall.

drypoint An *intaglio* printmaking process in which lines are scratched directly into a metal plate with a steel needle. The scratch raises a ridge that takes the ink. Also, the resulting *print*.

earthenware A type of clay used for ceramics. It fires at 1100°C–1150°C, and is porous after *firing*.

earthworks Sculptural forms made from earth, rocks, or sometimes plants, often on a vast scale and in remote locations. Some are deliberately impermanent.

edition In printmaking, the total number of *prints* made and approved by the artist, usually numbered consecutively. Also, a limited number of multiple originals of a single design in any medium.

emphasis A method an artist uses to draw attention to an area. May be done with central placement, large size, bright color, or high contrast.

encaustic A type of painting in which *pigment* is suspended in a *binder* of hot wax.

engraving An *intaglio* printmaking process in which grooves are cut into a metal or wood surface with a sharp cutting tool called a *burin* or graver. Also, the resulting *print*.

entasis In *classical* architecture, the slight swelling or bulge in the center of a column, which corrects the illusion of concave tapering produced by parallel straight lines.

etching An *intaglio* printmaking process in which a metal plate is first coated with acid-resistant wax or varnish, then scratched to expose the metal to the bite of nitric acid where lines are desired. Also, the resulting *print*.

expressionism The broad term that describes emotional art, most often boldly executed and making free use of distortion and symbolic or invented color. More specifically, **Expressionism** refers to individual and group styles originating in Europe in the late nineteenth and early twentieth centuries. See also *Abstract Expressionism*.

expressive theory A method of art criticism that attempts to discern personal elements in works of art, as opposed to formal strategies or cultural influences.

eye level In linear *perspective*, the presumed height of the artist's eyes; this becomes the presumed height of the viewer standing in front of the finished work.

Fauvism A style of painting introduced in Paris in the early twentieth century, characterized by areas of bright, contrasting color and simplified shapes. The name *les fauves* is French for "the wild beasts."

feminism In art, a movement among artists, critics, and art historians that began in an organized fashion in the 1970s. Feminists seek to validate and promote art forms that express the unique experience of women, and to redress oppression by men.

figurative art Representational art in which the human form (rather than the natural world) plays a principal role.

figure Separate shape(s) that seem to lie above a background or *ground*.

figure–ground reversal A visual effect in which what was seen as a positive shape becomes a negative shape, and vice versa.

film editing The process by which an editor compiles *shots* into scenes and scenes into a film.

film noir In Hollywood films c.1944–55, a type of black-and-white cinema focused generally on murder as a plot element, filmed with expressive camera angles and often dark lighting, using wry and cynical dialog.

finial An ornament at the end of a staff or of a protruding architectural element.

firing Baking clay in a special high-temperature oven to solidify it. Secondary firings may also be done to fix finishing coats on fired pieces.

frottage Laying paper or canvas over a surface and rubbing with a pencil or chalk to reveal its texture.

fixative A light, liquid varnish sprayed over finished charcoal or pastel drawings to prevent smudging.

flamboyant Literally, "flame-like." A style of late *Gothic* architecture characterized by intricate decorations and sinuous curves.

flying buttress See *buttress*.

focal point The principal area of emphasis in a work of art. The place to which the artist directs the most attention through composition. May or may not be the same as the *vanishing point* in a work.

folk art Art of people who have had no formal, academic training, but whose works are part of an established tradition of style and craftsmanship. Examples include religious carvers, quilt makers, and shop-sign painters.

font The name given to a style of type. The text of *Artforms* is printed in the Adobe Garamond font.

foreshortening The representation of *forms* on a *two-dimensional* surface by shortening the length in such a way that the long axis appears to project toward or recede away from the viewer.

form In the broadest sense, the total physical characteristics of an object or event. Usually describes the visual elements of a work of art that create meaning, for example: A huge, looming shape in a painting is a form that may create haunting or foreboding meaning.

formal theory A method of art criticism that values stylistic innovation over personal expression or cultural communication.

format The shape or proportions of a *picture plane*. Format may be large or small, rectangular or oblong.

freestanding Any piece or type of sculpture that is meant to be seen from all sides.

fresco A painting technique in which *pigments* suspended in water are applied to a damp lime-plaster surface. The pigments dry to become part of the plaster wall or surface. Sometimes called true fresco or *buon fresco* to distinguish it from painting over dry plaster, or "fresco secco."

frottage A technique in which a canvas is laid over a textured surface and rubbed with crayons and pencils.

Futurism, Futurists A group movement that originated in Italy in 1909. One of several movements to grow out of *Cubism*. Futurists added implied motion to the shifting planes and multiple observation points of the Cubists; they celebrated natural as well as mechanical motion and speed. Their glorification of danger, war, and the machine age was in keeping with the martial spirit developing in Italy at the time.

garba griha Literally, "womb chamber." The sacred room of a Hindu temple, where rituals are performed and the image of the god is kept.

genre painting A type of artwork that takes as its subject everyday life, rather than civic leaders, religious figures, or mythological heroes. Flourished in Flanders and Holland between the sixteenth and eighteenth centuries.

geometric shape Any *shape* enclosed by square or straight or perfectly circular lines. Usually contrasted with *organic shapes*.

gesso A mixture of glue and chalk, thinned with water and applied as a *ground* before painting with oil or egg *tempera*. Most gessoes are bright white in color.

glaze 1. In oil painting, a thin transparent or translucent layer brushed over another layer of paint, allowing the first layer to show through but enriching its color slightly. In *ceramics*, a vitreous or glassy coating applied to seal and decorate surfaces. Glaze may be colored, transparent, or opaque. 2. A silica-based paint for clay that fuses with the clay body on *firing*. Can be almost any color, or translucent. The silica base makes a glasslike surface on the clay piece.

Gothic Primarily an architectural style that prevailed in Western Europe from the twelfth through the fifteenth centuries, characterized by pointed *arches*, ribbed *vaults*, and flying *buttresses*, which made it possible to create stone buildings that reached great heights.

gouache An opaque, water-soluble paint. *Watercolor* to which opaque white has been added.

ground The background in *two-dimensional* works—the area around and between *figure(s)*. Also, the surface onto which paint is applied, consisting of *sizing* plus *primer*.

handscroll A long painting in ink on paper, which viewers contemplate by scrolling from hand to hand. Known chiefly in China and Japan.

happening An event conceived by artists and performed by artists and others, who may include viewers. Usually unrehearsed, with scripted roles but including improvisation.

hatching A technique used in drawing and linear forms of printmaking, in which lines are placed in parallel series to darken the value of an area. Cross-hatching is drawing one set of hatchings over another in a different direction so that the lines cross, suggesting shadows or darker areas. Contour hatching is a set of parallel curved lines that suggest a volume in space.

Hellenistic Style of the later phase of ancient Greek art (300–100 BCE), characterized by emotion, drama, and interaction of sculptural forms with the surrounding space.

hierarchic scale Use of unnatural *proportions* or *scale* to show the relative importance of figures. (Larger relative size = greater importance.) Most commonly practiced in ancient Near Eastern and Egyptian art.

high relief Sculpture in relief in which more than half of a significant portion of the subject emerges from the background. High-relief sculpture thus requires undercutting, in contrast to *low relief*.

horizon line In linear *perspective*, the implied or actual line or edge placed on a *two-dimensional* surface to represent the place in nature where the sky meets the horizontal land or water plane.

hue That property of a color identifying a specific, named wavelength of light such as green, red, violet, and so on. Often used synonymously with color.

humanism A cultural and intellectual movement during the *Renaissance*, following the rediscovery of the art and literature of ancient Greece and Rome. A philosophy or attitude concerned with the interests, achievements, and capabilities of human beings rather than with the abstract concepts and problems of theology or science.

icon An image or symbolic representation, often with sacred significance.

iconoclast Literally, "image-breaker." In *Byzantine art*, one who opposes the creation of pictures of holy persons, believing that they promote idolatry.

iconography The symbolic meanings of subjects and signs used to convey ideas important to particular cultures or religions, and the conventions governing the use of such forms. For example, in traditional Christian art, a key symbolizes Saint Peter, to whom Christ gave the keys to the kingdom of heaven. An hourglass symbolizes the passage of time, etc.

idealism The representation of subjects in an ideal or perfect state or form.

impasto In painting, thick paint applied to a surface in a heavy manner, having the appearance and consistency of buttery paste or of cake frosting.

implied line A line in a composition that is not actually drawn. It may be a sight line of a figure in a composition, or a line along which two *shapes* align with each other.

Impressionism A style of painting that originated in France about 1870. (The first Impressionist exhibit was held in 1874.) Paintings of casual contemporary subjects were executed outdoors using divided brushstrokes to capture the light and mood of a particular moment and the transitory effects of natural light and color.

installation An art medium in which the artist arranges objects or artworks in a room, thinking of the entire space as the *medium* to be manipulated. Some installations are site-specific.

intaglio Any printmaking technique in which lines and areas to be inked are recessed below the surface of the printing plate. *Etching, engraving, drypoint,* and *aquatint* are all intaglio processes. See also *print*.

intensity The relative purity or saturation of a *hue* (color), on a scale from bright (pure) to dull. Varying intensities are achieved by mixing a hue with a *neutral* or with another hue.

intermediate hues A *hue* between a primary and a secondary on the color wheel, such as yellow-green, a mixture of yellow and green.

International Style An architectural style that emerged in several European countries between 1910 and 1920. International Style architects avoided applied decoration, used only modern materials (concrete, glass, steel), and arranged the masses of a building according to its inner uses.

iwan A high, vaulted porch frequently used in Islamic architecture to mark an important building or entrance.

kachina One of many deified ancestral spirits honored by Hopi and other Pueblo peoples. These spiritual beings are usually depicted in doll-like forms.

keystone The stone at the central, highest point of a round arch, which holds the rest of the arch in place.

kiln A high-temperature oven in which pottery or *ceramic* ware is *fired*.

kinetic art Art that incorporates actual movement as part of the design.

kore Greek for "maiden." An Archaic Greek statue of a standing clothed young woman.

kouros Greek for "youth." An Archaic Greek statue of a standing nude young male.

krater In *classical* Greek art, a wide-mouthed vessel with handles, used for mixing wine and water for ceremonial drinking.

line A long, narrow mark. Usually made by drawing with a tool or a brush, but may be created by placing two forms next to each other (see *implied line*).

linear perspective See *perspective*.

linocut, linoleum cut A *relief* printmaking process, in which an artist cuts away *negative* spaces from a block of linoleum, leaving raised areas to take ink for printing.

lintel See *beam*.

literati painting In Asian art, paintings produced by cultivated amateurs who are generally wealthy and devoted to the arts, including *calligraphy*, painting, and poetry. Most commonly used to describe work of painters not attached to the royal courts of the Yuan, Ming, and Qing dynasties (fourteenth to eighteenth centuries) in China.

lithography A planographic printmaking technique based on the antipathy of oil and water. The image is drawn with a grease crayon or painted with *tusche* on a stone or grained aluminum plate. The surface is then chemically treated and dampened so that it will accept ink only where the crayon or tusche has been used.

local color The color of an object as we experience it, without shadows or reflections. (Most leaves show a green local color.)

logo Short for "logotype." Sign, name, or trademark of an institution, a firm, or a publication, consisting of letterforms or pictorial elements.

loom A device for producing cloth or fiber art by interweaving fibers at right angles.

lost wax A *casting* method. First, a model is made from wax and encased in clay or casting plaster. When the clay is fired to make a *mold*, the wax melts away, leaving a void that can be filled with molten metal or other self-hardening liquid to produce a *cast*.

low relief Sculpture in relief in which the subjects emerge only slightly from the surface. Also called bas-relief. No undercutting is present.

madrasa In Islamic tradition, a building that combines a school, prayer hall, and lodging for students.

mana In Pacific Island traditional cultures, spiritual power. *Mana* may reside in persons, places, or things, and is often embodied in artworks.

masonry Building technique in which stones or bricks are laid atop one another in a pattern. May be done with mortar or without.

mass *Three-dimensional* form having physical bulk. Usually a characteristic of a sculpture or a building. Also, the illusion of such a form on a *two-dimensional* surface. See also *volume*.

matrix The block of metal, wood, stone, or other material that an artist works to create a *print*.

matte A dull finish or surface, especially in painting, photography, and *ceramics*.

medium (pl. media or mediums) 1. A particular material along with its accompanying technique; a specific type of artistic technique or means of expression determined by the use of particular materials. Examples include oil paint, marble, and video.

metope A square panel, often decorated with *relief sculpture*, placed at regular intervals above the *colonnade* of a *classical* Greek building.

mihrab A niche in the end wall of a mosque that points the way to the Muslim holy city of Mecca.

minaret A tower outside a mosque where chanters stand to call the faithful to prayer.

Minimalism A *nonrepresentational* style of sculpture and painting, usually severely restricted in the use of visual elements and often consisting of simple geometric shapes or masses. The style came to prominence in the middle and late 1960s.

mixed media Works of art made with more than one *medium*.

mobile A type of sculpture in which parts move, usually suspended parts activated by air currents. See also *kinetic art*.

modeling 1. Working pliable material such as clay or wax into *three-dimensional* forms.

mold A cavity created out of plaster, clay, metal, or plastic for use in *casting*.

monochromatic A color scheme limited to variations of one *hue*; a hue with its *tints* and/or *shades*.

montage 1. A composition made up of pictures or parts of pictures previously drawn, painted, or photographed. 2. In motion pictures, the combining of shots into a rapid sequence to portray the character of a single event through multiple views.

mosaic An art *medium* in which small pieces of colored glass, stone, or *ceramic* tile called *tesserae* are embedded in a background material such as plaster or mortar. Also, works made using this technique.

naturalism An art style in which the curves and contours of a subject are accurately portrayed.

nave The tall central space of a church or cathedral, usually flanked by side aisles.

negative shape A background or *ground* shape seen in relation to foreground or *figure* shape(s).

Neoclassicism New classicism. A revival of *classical* Greek and Roman forms in art, music, and literature, particularly during the late eighteenth and early nineteenth centuries in Europe and America. It was part of a reaction against the excesses of *Baroque* and *Rococo* art.

Neolithic art A period of ancient art after the introduction of agriculture but before the invention of bronze. Neolithic means "New Stone Age" to distinguish it from *Paleolithic*, or "Old Stone Age."

neutrals Not associated with any single *hue*. Blacks, whites, grays, and dull gray-browns. A neutral can be made by mixing complementary hues.

nonobjective See *nonrepresentational art*.

nonrepresentational Art without reference to anything outside itself—without representation. Also called "nonobjective"—without recognizable objects.

off-loom A piece of fiber art made without a loom. One of the two major divisions of fiber arts.

offset lithography *Lithographic* printing by indirect image transfer from photomechanical plates. The plate transfers ink to a rubber-covered cylinder, which "offsets" the ink to the paper. Also called photo-offset lithography.

one-point perspective A *perspective* system in which all parallel lines converge at a single *vanishing point*.

opaque Impenetrable by light; not transparent or translucent.

open form A form whose exterior is irregular or broken, having a sense of growth, change, or unresolved tension; form in a state of becoming or reaching out.

optical color mixture Apparent rather than actual color mixture, produced by interspersing brushstrokes or dots of color instead of physically mixing them. The implied mixing occurs in the eye of the viewer and produces a lively color sensation.

organic shape An irregular, non-geometric shape. A shape that resembles any living matter.

Most organic shapes are not drawn with a ruler or a compass. See also *biomorphic shape*.

outsider art Art produced by those with no formal training, outside the established channels of art exhibition. Examples include art by self-directed individuals, prison inmates, and insane persons.

painterly Painting characterized by openness of *form*, in which *shapes* are defined by loose brushwork in light and dark color areas rather than by outline or contour.

Paleolithic art A very ancient period of art coincident with the Old Stone Age, before the discovery of agriculture and animal herding.

Pantocrator Literally, "ruler of everything." A title for Christ, especially as he is depicted in *Byzantine* art.

pastels 1. Sticks of powdered pigment held together with a gum binding agent.

pattern Repetitive ordering of design elements.

pediment A shelf above the *colonnade* on the short ends of a *classical* Greek temple. A triangular space below the gable roof.

pendentive A curving triangle that points downward; a common support for *domes* in Byzantine architecture.

performance art Dramatic presentation by visual artists (as distinguished from theater artists such as actors and dancers) in front of an audience, usually not in a formal theatrical setting.

persistence of vision An optical illusion that makes cinema possible. The eye and mind tend to hold images in the brain for a fraction of a second after they disappear from view. Quick projection of slightly differing images creates the illusion of movement.

perspective A system for creating an illusion of depth or *three-dimensional* space on a *two-dimensional* surface. Usually used to refer to linear perspective, which is based on the fact that parallel lines or edges appear to converge and objects appear smaller as the distance between them and the viewer increases. Atmospheric perspective (aerial perspective) creates the illusion of distance by reducing color saturation (*intensity*), *value* contrast, and detail in order to imply the hazy effect of atmosphere between the viewer and distant objects. Parallel lines remain parallel; there is no convergence. A work executed in *one-point perspective* has a single *vanishing point*. A work in two-point perspective has two of them.

petroglyph An image or a symbol carved in shallow relief on a rock surface. Usually ancient.

photomontage The process of combining parts of various photographs in one photograph.

photo screen A variation of *silkscreen* in which the stencil is prepared by transferring a photograph to the *stencil*.

picture plane The *two-dimensional* picture surface.

picturesque Used to describe natural landscapes that are attractively poetic, rather than dramatic. Original meaning is traced to the paintings of Claude Lorrain and other landscape painters.

pier An upright support for an arch or arcade. Piers fulfill the same function as columns, but piers are more massive and usually not tapered toward the top.

pigment Any coloring agent, made from natural or synthetic substances, used in paints or drawing materials. Usually in powdered form.

pilaster A rectangular column that projects slightly from a wall, usually without a structural function.

plate mark An impression made on a piece of paper by pressing a printing plate onto it. A plate mark is usually a sign of an original *print*.

pointillism A system of painting using tiny dots or "points" of color, developed by French artist Georges Seurat in the 1880s. Seurat systematized the divided brushwork and *optical color mixture* of the *Impressionists* and called his technique "divisionism."

Pop Art A style of painting and sculpture that developed in the late 1950s and early 1960s, in Britain and the United States, and uses mass production techniques (such as silkscreen) or real objects in works that are generally more polished and ironic than *assemblages*.

porcelain A type of clay for *ceramics*. It is white or grayish and fires at 1350°C–1500°C. After *firing*, it is translucent and rings when struck.

portico A porch attached to a building, supported with columns. Usually surmounted by a triangular *pediment* under a gable roof.

positive shape A *figure* or foreground shape, as opposed to a *negative* ground or background shape.

post-and-beam system (post and lintel) In architecture, a structural system that uses two or more uprights or posts to support a horizontal *beam* (or lintel) that spans the space between them.

Post-Impressionism A general term applied to various personal styles of painting by French artists (or artists living in France) that developed from about 1885 to 1900 in reaction to what these artists saw as the somewhat formless and aloof quality of *Impressionist* painting. Post-

Impressionist painters were concerned with the significance of form, symbols, expressiveness, and psychological intensity. They can be broadly separated into two groups—expressionists, such as Gauguin and van Gogh, and formalists, such as Cézanne and Seurat.

postmodern An attitude or trend of the late 1970s, 1980s, and 1990s. In architecture, the movement away from what had become boring adaptations of the *International Style*, in favor of an imaginative, eclectic approach. In the other visual arts, postmodern art is characterized by influence from all periods and styles, including modernism, and a willingness to combine elements of all. Although modernism makes distinctions between high art and popular taste, postmodernism makes no such value judgments. Postmodern works are not only influenced by the past, they make knowing reference to some past style(s).

potter A *ceramist* who specializes in making dishes.

primary hues Those *hues* that cannot be produced by mixing other hues. *Pigment* primaries are red, yellow, and blue; light primaries are red, green, and blue. Theoretically, pigment primaries can be mixed together to form all the other hues in the spectrum.

primer In painting, a primary layer of paint applied to a surface that is to be painted. Primer is used to create a uniform surface.

print A multiple original impression made from a plate, stone, *woodblock*, or *screen* by an artist or made under the artist's supervision. Prints are usually made in *editions*, with each print numbered and signed by the artist.

proportion The size relationship of parts to a whole and to one another.

qi In Chinese, "life force." The vibrant spirit that animates all things.

readymade A common manufactured object that the artist signs and turns into an artwork. Concept pioneered by *Dadaist* Marcel Duchamp.

realism 1. A type of *representational art* in which the artist depicts as closely as possible what the eye sees. 2. **Realism** The mid-nineteenth-century style of Courbet and others, based on the idea that ordinary people and everyday activities are worthy subjects for art.

registration In color printmaking or machine printing, the process of aligning the impressions of blocks or plates on the same sheet of paper.

reinforced concrete Concrete with steel mesh or bars embedded in it to increase its tensile strength.

relief printmaking A printing technique in which the parts of the printing surface that carry

ink are left raised, while the remaining areas (*negative* spaces) are cut away. *Woodcuts* and linoleum prints (*linocuts*) are relief prints.

relief sculpture Sculpture in which *three-dimensional* forms project from the flat background of which they are a part. The degree of projection can vary and is described by the terms *high relief* and *low relief*.

Renaissance Period in Europe from the late fourteenth through the sixteenth centuries, which was characterized by a renewed interest in human-centered *classical* art, literature, and learning. See also *humanism*.

representational art Art in which it is the artist's intention to present again or represent a particular subject, especially pertaining to realistic portrayal of subject matter.

rhythm The regular or ordered repetition of dominant and subordinate elements or units within a design.

Rococo From the French "rocaille" meaning "rock work." This late *Baroque* (c.1715–1775) style used in interior decoration and painting was characteristically playful, pretty, *romantic*, and visually loose or soft; it used small *scale* and ornate decoration, pastel colors, and *asymmetrical* arrangement of curves. Rococo was popular in France and southern Germany in the eighteenth century.

Romanesque A style of European architecture prevalent from the ninth to the twelfth centuries with round *arches* and barrel *vaults* influenced by Roman architecture and characterized by heavy stone construction.

Romanticism 1. A literary and artistic movement of late-eighteenth- and nineteenth-century Europe, aimed at asserting the validity of subjective experience as a countermovement to the often cold formulas of *Neoclassicism*, characterized by intense emotional excitement, and depictions of powerful forces in nature, exotic lifestyles, danger, suffering, and nostalgia. 2. **romantic** Art of any period based on spontaneity, intuition, and emotion rather than carefully organized rational approaches to *form*.

Salon An official art exhibition in France, juried by members of the official French academy. See *academic art*.

saturation See *intensity*.

scale The size or apparent size of an object seen in relation to other objects, people, or its environment. Also used to refer to the quality or monumentality found in some objects regardless of their size. In architectural drawings, the ratio of the measurements in the drawing to the measurements in the building. A building may be drawn in a scale of 1:300, for example.

screenprinting (serigraphy) A printmaking technique in which *stencils* are applied to fabric stretched across a frame. Paint

or ink is forced with a squeegee through the unblocked portions of the screen onto paper or other surface beneath.

secondary hues *Pigment* secondaries are the *hues* orange, violet, and green, which may be produced in slightly dulled form by mixing two *primaries*.

serif Short lines that end the upper and lower strokes of a letter in some *fonts*. The capital *I* has two serifs in Adobe Garamond; the small *m* has one.

serigraphy Or silkscreen. See *screenprinting*.

shade A *hue* with black added.

shape A *two-dimensional* or implied two-dimensional area defined by *line* or changes in color.

shot Any uninterrupted run of a film camera. Shots are compiled into scenes, then into movies.

silkscreen Or serigraphy. See *screenprinting*.

site-specific art Any work made for a certain place, which cannot be separated or exhibited apart from its intended environment.

size Any of several substances made from glue, wax, or clay, used as a filler for porous material such as paper, canvas, or other cloth, or wall surfaces. Used to protect the surface from the deteriorating effects of paint, particularly oil paint.

slip Clay that is thinned to the consistency of cream and used as paint on *earthenware* or *stoneware* ceramics.

social realism *Representational* art that expresses protest at some social condition.

Socialist Realism An officially-approved art style practiced in Communist countries in Europe and Asia from about 1924 until the decline of the Communist system in the late 1980s. Subject matter included contented workers engaged in their tasks, and flattering portraits of political leaders, or other patriotic subjects.

stencil A sheet of paper, cardboard, or metal with a design cut out. Painting or stamping over the sheet prints the design on a surface. See also *screenprinting*.

still life A type of painting in which an artist arranges items on a tabletop for subject matter: generally flowers or fruits, often with food, dishes, or other domestic implements.

stoneware A type of clay for *ceramics*. Stoneware is *fired* at 1200°C–1300°C and is nonporous when fired.

storyboard A sequence of drawings prepared to guide camera shots in motion picture or television production.

stupa The earliest form of Buddhist architecture, a domelike structure probably derived from Indian funeral mounds.

subject In *representational* art, what the artist chooses to depict. It may be a landscape or a mythological scene, or even an invented subject.

subordination Technique by which an artist ranks certain areas of a work as of lesser importance. Areas are generally subordinated through placement, color, or size. See *emphasis*.

substitution The process of making a work of art by *casting*, as opposed to *additive* or *subtractive* processes.

subtractive color mixture Mixture of colored *pigments* in the form of paints, inks, *pastels*, and so on. Called subtractive because reflected light is reduced as pigment colors are combined, generally leading to darker *shades*. See *additive color mixture*.

subtractive sculpture Sculpture made by removing material from a larger block or form.

support The physical material that provides the base for and sustains a *two-dimensional* work of art. Paper is the usual support for drawings and prints; canvas or panels are common supports in painting.

Surrealism A movement in literature and visual arts that developed in the mid-1920s and remained strong until the mid-1940s; grew out of *Dada* and *automatism*. Based upon revealing the unconscious mind in dream images, the irrational, and the fantastic, Surrealism took two directions: *representational* and *abstract*. Dalí's and Magritte's paintings, with their uses of impossible combinations of objects depicted in realistic detail, typify representational Surrealism. Miró's paintings, with his use of abstract and fantastic shapes and vaguely defined creatures, are typical of abstract Surrealism.

Symbolism A movement in late nineteenth-century Europe (c.1885–1900) concerned with communication of inner emotional states through forms and colors that may not copy nature directly.

symmetrical balance The near or exact matching of left and right sides of a *three-dimensional* form or a *two-dimensional* composition

symmetry A design (or *composition*) with identical or nearly identical *form* on opposite sides of a dividing line or central axis.

Synthetic Cubism See *Cubism*.

taotie mask A mask of abstracted shapes commonly found on ancient Chinese bronze vessels. Represents a composite animal whose symbolism is unknown.

tapestry A loom weaving method in which *weft* fibers of irregular length are pulled through stable *warps* to create *patterns* or pictures.

tempera A water-based paint that uses egg yolk as a *binder*. Many commercially made paints identified as tempera are actually *gouache*.

terra cotta A type of *earthenware* that contains enough iron oxide to impart a reddish tone when fired. Frequently used in ancient *ceramics* and modern building decoration.

tessera Bit of colored glass, *ceramic* tile, or stone used in a *mosaic*. Plural: tesserae.

texture The tactile qualities of surfaces, or the visual representation of those qualities.

three-dimensional Having height, width, and depth.

throwing The process of forming clay objects on a potter's wheel.

tint A *hue* with white added.

title sequence The animated list of the names of the principal collaborators, shown at the beginning of a film or television production.

tooth Degree of roughness present in drawing papers; the presence of tooth gives texture to a drawing.

totem In native North American cultures, a mythological animal that symbolizes a clan group. From a native American word meaning "he is related to me."

trompe l'oeil French for "fool the eye." A *two-dimensional* representation that is so naturalistic that it looks actual or real (or *three-dimensional*).

true fresco See *fresco*.

truss In architecture, a structural framework of wood or metal based on a triangular system, used to span, reinforce, or support walls, ceilings, *piers*, or beams.

tusche In *lithography*, a waxy liquid used to draw or paint images on a lithographic stone or plate.

two-dimensional Having the dimensions of height and width only.

typeface See *font*.

typography The art and technique of composing printed materials from type.

ukiyo-e Literally, "pictures of the floating world;" Japanese prints of the Edo period that depict landscapes and popular entertainments.

unity The appearance of similarity, consistency, or oneness. Interrelational factors that cause various elements to appear as part of a single complete form. See also *variety*.

value The lightness or darkness of tones or colors. White is the lightest value; black is the darkest. The value halfway between these extremes is called middle gray. Sometimes called "tone."

vanishing point In linear *perspective*, the point on the *horizon line* at which lines or edges that are parallel appear to converge.

vantage point The position from which the viewer looks at an object or visual field; also called "observation point" or "viewpoint." Artists who make paintings that use *perspective* create a presumed vantage point for the viewer.

variety The opposite of *unity*. Diverse elements in the composition of a work of art. Most works strive a balance between unity and variety.

vault A curving masonry roof or ceiling constructed on the principle of the *arch*. A tunnel or barrel vault is a semicircular arch extended in depth; a continuous series of arches, one behind the other. A groin vault is formed when two barrel vaults intersect. A ribbed vault is a vault reinforced by masonry ribs.

vehicle Liquid emulsion used as a carrier or spreading agent in paints.

vertical placement A method for suggesting the third dimension of depth in a *two-dimensional* work by placing an object above another in the *composition*. The object above seems farther away than the one below.

volume 1. Space enclosed or filled by a *three-dimensional* object or figure. 2. The *implied space* filled by a painted or drawn object or figure. Synonym: *mass*.

warm colors Colors whose relative visual temperature makes them seem warm. Warm colors or *hues* include red-violet, red, red-orange, orange, yellow-orange, and yellow. See also *cool colors*.

warp In weaving, the threads that run lengthwise in a fabric, crossed at right angles by the *weft*. Also, the process of arranging yarn or thread on a *loom* so as to form a warp.

wash A thin, transparent layer of paint or ink.

watercolor Paint that uses water-soluble gum as the *binder* and water as the *vehicle*. Characterized by transparency. Also, the resulting painting.

weft In weaving, the horizontal threads interlaced through the *warp*. Also called woof.

woodcut, woodblock A type of *relief print* made from a plank of relatively soft wood. The artist carves away the *negative* spaces, leaving the image in relief to take ink for printing.

wood engraving A method of *relief printing* in wood. In comparison to *woodcut*, a wood engraving is made with denser wood, cutting into the end of the grain rather than the side. The density of the wood demands the use of *engraving* tools, rather than woodcarving tools.

work of art What the artist makes or puts in front of us for viewing. The visual object that embodies the idea the artist wanted to communicate.

ziggurat A rectangular or square stepped pyramid, often with a temple at its top.

Ácoma (*ah*-co-mah)
Ai Weiwei (eye way-way)
Alhambra (al-*am*-bra)
Usama Alshaibi (oo-*sah*-ma all-shah-*ee*-be)
Tarsila do Amaral (tar-*see*-lah doo ah-mah-*rahl*)
El Anatsui (ell ah-naht-sway)
Angkor Wat (*ang*-kohr waht)
Ardabil (ar-*dah*-bil)
Aumakua (ow-mah-*koo*-ah)
avant-garde (ah-vahn *gard*)
Giacomo Balla (*jah*-koh-moh *bahl*-la)
Jean-Michel Basquait (jawn mee-*shell* boss-kee-*ah*)
Bauhaus (*bow*-house)
Bayeux (buy-yuh)
Benin (ben-*een*)
Gianlorenzo Bernini (jahn-low-*ren*-tsoh ber-*nee*-nee)
Joseph Beuys (*yo*-sef boyce)
Umberto Boccioni (oom-*bair*-toh boh-*choh*-nee)
Bodhisattva (boh-dee-*saht*-vah)
Germain Boffrand (zher-*main* bof-*frohn*)
Rosa Bonheur (buhn-*er*)
Borobudur (boh-roh-boo-*duhr*)
Sandro Botticelli (bought-tee-*chel*-lee)
Constantin Brancusi (*kahn*-stuhn-teen brahn-*koo*-see)
Georges Braque (zhorzh brahk)
Pieter Bruegel (*pee*-ter *broy*-guhl)
Michelangelo Buonarroti see *Michelangelo*
Cai Guo-Qiang (tseye gwoh *chyang*)
Callicrates (kah-*lik*-rah-teez)
Michelangelo da Caravaggio (mee-kel-*an*-jeh-loe da car-ah-*vah*-jyoh)
Rosalba Carriera (roh-*sal*-bah car-*yair*-ah)
Henri Cartier-Bresson (on-*ree* car-tee-*ay* bruh-*sohn*)
casein (cass-*seen*)
Mary Cassatt (cah-*sat*)
Paul Cézanne (say-*zahn*)
chacmool (chalk-mole)
Marc Chagall (shah-*gahl*)
Chartres (*shahr*-truh)
Chauvet (show-*vay*)
Dale Chihuly (chi-*hoo*-lee)

chola (*choh*-lah)
Christo (*kree*-stoh)
Constantine (*kahn*-stuhn-teen)
Conté (kahn-tay)
contrapposto (kohn-trah-*poh*-stoh)
Gustave Courbet (*goos*-tahv koor-*bay*)
Cycladic (sik-*lad*-ik)
Louis-Jacques-Mandé Daguerre (loo-*ee* zhahk mahn-*day* dah-*gair*)
Honoré Daumier (awn-ohr-*ay* doh-mee-ay)
Jacques-Louis David (zhahk loo-*ee* dah-*veed*)
Edgar Degas (ed-gahr deh-*gah*)
Willem de Kooning (*vill*-em duh *koe*-ning)
Eugène Delacroix (oo-*zhen* duh-lah-*kwah*)
André Derain (on-*dray* duh-*ran*)
de Stijl (duh steel)
Donatello (dohn-ah-*tell*-loh)
Marcel Duchamp (mahr-*sell* doo-*shahm*)
Albrecht Dürer (*ahl*-brekht *duh*-ruhr)
Thomas Eakins (*ay*-kins)
Sergei Eisenstein (sair-gay *eye*-zen-schtine)
Olafur Eliasson (o-la-fur ee-*lie*-ah-sun)
M. C. Escher (*esh*-uhr)
Fan Kuan (fahn kwahn)
Jean-Honoré Fragonard (zhon oh-no-*ray* fra-go-*nahr*)
Helen Frankenthaler (*frank*-en-thahl-er)
fresco (*fres*-coh)
Ganges (*gan*-jeez)
Paul Gauguin (go-*gan*)
Frank Gehry (*ger*-ree)
genre (*zhan*-ruh)
Artemisia Gentileschi (ahr-tuh-*mee*-zhyuh jen-till-*ess*-kee)
Théodore Géricault (*zhair*-ee-koh)
Jean-Léon Gérôme (zhon *lay*-on zhay-*roam*)
Alberto Giacometti (ahl-*bair*-toh jah-ko-*met*-tee)
Giotto di Bondone (*joht*-toe dee bone-*doe*-nay)
Francisco Goya (fran-*sis*-coe go-yah)
Walter Gropius (*val*-tuhr *grow*-pee-us)
Guo Xi (gwo shr)
Guernica (*ger*-nih-kah)

Zaha Hadid (*zah*-hah hah-*deed*)
Khaled Hafez (ha-led ha-fez)
Hagia Sophia (hah-zhah so-*fee*-ah)
Hangzhou (hung-joe)
Hatshepsut (hah-*shep*-soot)
Heiji Monogatari (hay-jee mo-no-gah-*tah*-ree)
Ando Hiroshige (*ahn*-doh he-*roh*-shee-gay)
Hannah Höch (*hahn*-nuh *hohk*)
Hokusai (hohk-*sy*)
Pieter de Hooch (*pee*-tuhr duh *hohk*)
Horyuji (hohr-*yoo*-jee)
Shirazeh Houshiary (*sheer*-ah-zey hoosh-*yahr*-ee)
Ictinus (ick-*tee*-nuhs)
Inca (*eenk*-ah)
Ise (*ee*-say)
kachina (kah-*chee*-nah)
Frida Kahlo (*free*-dah *kah*-loh)
Kandarya Mahadeva (Kan-*dahr*-ya mah-hah-*day*-vuh)
Vasily Kandinsky (vass-see-lee can-*din*-skee)
Anish Kapoor (ah-*neesh* kah-*puhr*)
Katsura (kah-*tsoo*-rah)
Khamerernebty (kahm-er-er-*neb*-tee)
Anselm Kiefer (*ahn*-sehlm kee-fuhr)
Ernst Ludwig Kirchner (airnst *loot*-vik *keerkh*-ner)
Krishna (*krish*-nuh)
Laocoön (lay-*oh*-koh-on)
Le Corbusier (luh core-boo-zee-ay)
Fernand Léger (fair-*non* lay-*zhay*)
Emanuel Leutze (*loyts*-uh)
Roy Lichtenstein (*lick*-ten-stine)
Maya Lin (*my*-uh lin)
Machu Picchu (*mah*-choo *peek*-choo)
René Magritte (reh-*nay* mah-*greet*)
Edouard Manet (ed-*wahr* mah-*nay*)
Maori (*mow*-ree)
Masaccio (mah-*sach*-chyo)
Henri Matisse (on-ree mah-*tees*)
Mato Tope (*mah*-toh *toh*-pay)
Chaz Maviyane-Davies (mah-vee-*yah*-neh)
Maya (*my*-uh)
de Medici (deh *meh*-dee-chee)
Cildo Meireles (*seal*-doh may-*rell*-ess)
Mende (men-day)
Ana Mendieta (*ah*-nah men-*dyet*-ah)

metope (*meh*-toe-pee)
Michelangelo Buonarroti (mee-kel-*an*-jeh-loe bwoh-nah-*roe*-tee)
Ludwig Mies van der Rohe (*loot*-vig *mees* vahn dair *roh*-eh)
mihrab (*mee*-rahb)
Mimbres (*mim*-brace)
Moai (*mo*-eye)
Piet Mondrian (*peet mohn*-dree-ahn)
Claude Monet (*klohd* moh-*nay*)
Berthe Morisot (*bairt* moh-ree-*zoh*)
mosque (mahsk)
Vera Mukhina (*vir*-ah moo-*kee*-nah)
Edvard Munch (*ed*-vard *moonk*)
Murujuga (mu-ru-*ju*-ga)
Eadweard Muybridge (*ed*-wurd *moy*-brij)
Mycerinus (miss-uh-*ree*-nuhs)
Nadar (Félix Tournachon) (nah-*dar fay*-leeks toor-nah-*shohn*)
Emil Nolde (*ay*-meal *nohl*-duh)
Notre-Dame de Chartres (*noh*-truh dahm duh *shahr*-truh)
Claes Oldenburg (klahs *ol*-den-burg)
Olmec (*ohl*-mek)
José Clemente Orozco (ho-*say* cleh-*men*-tay oh-*rohs*-coh)
Nam June Paik (nahm joon pike)
Andrea Palladio (ahn-*dray*-uh pahl-*lah*-dyo)
Giovanni Paolo Panini (jyo-*vahn*-nee *pow*-lo pah-*nee*-nee)
Amalia Pica (ah-*mahl*-ya *pee*-kah)
Pablo Picasso (pab-lo pee-*cah*-so)
pietá (pee-ay-*tah*)
Jackson Pollock (*pah*-lock)

Pompeii (pahm-*pay*)
Pont du Gard (pohn duh *gahr*)
Nicholas Poussin (nee-coh-*law* poo-*san*)
Praxiteles (prak-*sit*-el-eez)
qi (chee)
Qiu Ying (choo ying)
Quetzalcoatl (kets-ahl-*kwah*-til)
Lee Quiñones (keen-*yoh*-ness)
Robert Rauschenberg (*row*-shen-buhrg)
Gerrit Rietveld (*gair*-it *reet*-velt)
Rembrandt van Rijn (*rem*-brant van *ryne*)
Pierre-August Renoir (pee-*err* oh-*goost* ren-*wahr*)
Gerhard Richter (*gair*-hart *rick*-ter)
Diego Rivera (dee-*ay*-goh ri-*ver*-ah)
Sabatino Rodia (roh-*dee*-uh)
François August Rodin (frahn-*swah* oh-*goost* roh-*dan*)
Andrei Rublev (*ahn*-dray *ru*-blof)
Niki de Saint Phalle (*nee*-kee duh san *fall*)
Sanchi (*sahn*-chee)
Sassetta (suh-*set*-tuh)
Scythian (*sith*-ee-ahn)
Sesshu (seh-shoo)
Georges Seurat (zhorzh sur-*ah*)
Bada Shanren (*bah*-dah *shan*-ren)
Shiva Nataraja (*shih*-vuh nah-tah-*rah*-jah)
Tawaraya Sotatsu (tah-wa-*rah*-ya *soh*-taht-soo)
Alfred Stieglitz (*steeg*-lits)
stupa (*stoo*-pah)
Toshiko Takaezu (tosh-ko tah-kah-*ay*-zoo)
taotie (taow tyeh)

Teotihuacan (tay-oh-tee-wah-*cahn*)
Jean Tinguely (zhon tan-*glee*)
Tlingit (*kling*-git)
Henri de Toulouse-Lautrec (on-*ree* duh too-*looz* low-*trek*)
tusche (too-*shay*)
Tutankhamen (too-tahn-*kahm*-uhn)
Unkei (*un*-kay)
Ur (er)
Kitagawa Utamaro (kit-ah-*gah*-wah ut-ah-*mah*-roh)
Theo van Doesburg (*tay*-oh van dohz-*buhrg*)
Jan van Eyck (*yahn* van *ike*)
Vincent van Gogh (*vin*-sent van goe; also, van *gawk*)
Diego Velázquez (dee-*ay*-goh behl-*ahth*-kehth; also, veh-*las*-kes)
Robert Venturi (ven-*tuhr*-ee)
Jan Vermeer (*yahn* ver-*mir*)
Versailles (vair-*sigh*)
Elisabeth Vigée-LeBrun (vee-*zhay* leh-*broon*)
Leonardo da Vinci (lay-oh-*nahr*-doh dah *veen*-chi)
Peter Voulkos (*vahl*-kohs)
Andy Warhol (*wohr*-hohl)
Willendorf (*vill*-en-dohrf)
Xiwangmu (shee-wang-moo)
Xul Solar (shool so-*lar*)
Yaxchilan (yash-chee-*lahn*)
Zhang Daqian (zhang dah-*chyen*)
ziggurat (*zig*-uh-raht)

NOTES

Chapter 1: The Nature of Art and Creativity

1. Janet Echelman quoted in "Dust Swirls and Cloud Shadows," http://www.landscapeonline.com/research/article/12361, accessed Nov. 27, 2012.

2. "Park's details, sculpture a nod to city's future," *Arizona Republic*, April 20, 2009, B-6.

3. Georgia O'Keeffe, *Georgia O'Keeffe* (New York: Viking, 1976), opposite plate 13.

4. Jeff Dyer et al, *Innovator's DNA: Mastering the Five Skills of Disruptive Innovators* (Cambridge, MA: Harvard Business Review Press, 2011).

5. Quoted in Grace Glueck, "A Brueghel from Harlem," *New York Times*, Feb. 22, 1975, D29.

6. Ralph Ellison, "The Art of Romare Bearden," *The Massachusetts Review* 18 (Winter 1977): 678.

7, 8, and 10. Romare Bearden interviewed by Charlayne Hunter-Gault, *MacNeil-Lehrer Report*, PBS Television, June 26, 1987.

9, 11, and 12. San Francisco Museum of Modern Art Interactive Feature: The Art of Romare Bearden: http://www.sfmoma.org/explore/multimedia/interactive_features/23, accessed Nov. 17, 2012.

13. History of the Watts Towers, http://www.wattstowers.us/history.htm, accessed Nov. 17, 2102.

14. Henri Matisse, "The Nature of Creative Activity," *Education and Art*, edited by Edwin Ziegfeld (New York: UNESCO, 1953), 21.

15. Edward Weston, *The Daybooks of Edward Weston*, edited by Nancy Newhall (Millerton, NY: Aperture, 1973), vol. 2, 181.

16. Georgia O'Keeffe, *Georgia O'Keeffe* (New York: Viking, 1976), opposite plate 23.

Chapter 2: The Purposes and Functions of Art

1. Clive Bell, "The Aesthetic Hypothesis," *Art* (New York: Frederick A. Stokes, 1913), p. 30.

2. James McNeill Whistler, "Ten O'Clock Lecture," Prince's Hall, Piccadilly, Feb. 20, 1855. Archived at University of Glasgow: http://www.whistler.arts.gla.ac.uk/miscellany/tenoclock/

3. Interview with Gabriel Orozco, Public Broadcasting System, *Art 21*: http://www.pbs.org/art21/artists/gabriel-orozco

4. Gustave Courbet, "Statement on Realism," 1855. Anthologized in Charles Harrison et al, eds., *Art in Theory 1815-1900: An Anthology of Changing Ideas* (Oxford: Blackwell, 1998), p. 372.

5. Thomas Aquinas, *Summa Theologica*, Article 9, "Whether Holy Scripture Should Use Metaphors" archived at Christian Classics Ethereal Library, http://www.ccel.org/ccel/aquinas/summa.FP_Q1_A9.html

6. Benjamin West, quoted in John Galt, *The Life and Works of Benjamin West Esq.* (London: Caddell and Davies, 1820), p. 48.

7. Louis XIV quoted in Gill Perry and Colin Cunningham, eds., *Academies, Museums, and Canons of Art* (New Haven: Yale University Press, 1999), p. 48.

8. Wasily Kandinsky, *Concerning the Spiritual in Art*, Chapter 5.

Chapter 3: The Visual Elements

1. Maurice Denis, *Theories 1870–1910* (Paris: Hermann, 1964), 13.

2. Quoted in "National Airport: A New Terminal Takes Flight," *Washington Post* (July 16, 1997): http://www.washingtonpost.com/wp-srv/local/longterm/library/airport/architect. (htm accessed May 14, 2000.)

3. Keith Sonnier, Interview with the author, New York, April 16, 2008.

4. Faber Birren, *Color Psychology and Color Theory* (New Hyde Park, NY: University Books, 1961), 20.

Chapter 4: The Principles of Design

1. R. G. Swenson, "What is Pop Art?" *Art News* (November 1963), 62.

2. Elizabeth McCausland, "Jacob Lawrence," *Magazine of Art* (November 1945), 254.

3 and 4. Jack D. Flam, *Matisse on Art* (New York: Dutton, 1978), 36; originally in "Notes d'un peintre," *La Grande Revue* (Paris, 1908).

Chapter 6: Drawing

1. Richard Serra quoted in Ellen Gamerman, "Sculpting on Paper," *Wall Street Journal*, Apr. 15, 2011, p. d4.

2. Keith Haring, *Journals* (New York: Viking, 1996), entry for March 18, 1982.

3 and 4. Vincent to Theo van Gogh, April 1882, Letter 214, *Vincent van Gogh: The Complete Letters*: http://vangoghletters.org/vg/letters/let214/letter.html (accessed September 7, 2012).

5. ibid., June 2, 1885.

6. ibid., May 22, 1885.

7 and 8. ibid., Sept. 24, 1888.

9. ibid., May 26, 1888.

10. Josef Pilhofer, "Searching for the Synthesis," http://www.lifeart.net/articles/pillhofer/ripillhofer.htm, accessed Nov. 19, 2012.

11. Anthony Blunt, *Picasso's Guernica* (New York: Oxford University Press, 1969), 28.

12. Marjane Satrapi, "On Writing *Persepolis*," http://www.randomhouse.com/pantheon/graphicnovels/satrapi2.html (accessed July 26, 2007).

13. David Hockney, "The hand, the eye, and the heart," Channel 4 news, Jan. 17, 2012: http://www.channel4.com/news/david-hockney-the-hand-theeye-the-heart, accessed Nov.17, 2012.

Chapter 7: Painting

1. Diego Rivera, "The Radio City Mural," *Workers' Age*, June 15, 1933, 1. Nelson Rockefeller quoted in "Rockefellers Ban Lenin in RCA Mural and Dismiss Rivera," *New York Times*, April 10, 1933, p. 1.

2. Jem Cohen, *Ann Truitt Working*, 2009. Video interview.

3. Keltie Ferris, "Jason Stopa Interviews Keltie Ferris," *NYArts Magazine*, http://www.nyartsmagazine.com/conversations/in-conversation-jason-stopa-interviews-keltie-ferris, accessed Nov. 20, 2012.

4. Jeremy Blake, Interview by Jonathan P. Binstock in *Wild Choir: Cinematic Portraits by Jeremy Blake* (Washington, D.C., Corcoran Gallery of Art, 2007), p. 22.

Chapter 8: Printmaking

1. Quoted in Barbara Isenberg, "Prices of Prints," *Los Angeles Times*, May 14, 2006, E27.

2. Kiki Smith quoted in Crown Point Press, Biographical Summary, http://www.crownpoint.com/artists/211/biographical-summary, accessed Jan. 15, 2013.

3. Mary Weaver Chapin, "The Chat Noir & The Cabarets," *Toulouse-Lautrec and Montmartre* (Washington D.C.: National Gallery of Art, 2005), p. 91.

4. Elizabeth Murray, Gemini G.E.L. Online Catalog, http://www.nga.gov/fcgi-bin/gemini.pl?catnum=35.2.11&command=record, accessed Nov. 20, 2012.

5. Ellen Gallagher, Interview with Cheryl Kaplan, *DB Artmag*, http://db-artmag.de/archiv/2006/e/1/1/408-3.html, accessed Nov. 20, 2012.

Chapter 9: Photography

1. Henri Cartier-Bresson, *The Decisive Moment* (New York: Simon & Schuster, 1952), 14.

2. and 6. Bob Keefer, "Images Make Faces of War Victims Grow," *Register-Guard* (Eugene, OR), June 4, 2009, p. D1.

3. Binh Danh: Life, Times and Matters of the Swamp: http://www.youtube.com/watch?v=3wKPYiVdAy4, accessed Nov. 21, 2012.

4. Robert Schultz, "Faces Fleshed in Green," *Virginia Quarterly Review Online*, Winter 2009: http://www.vqronline.org/articles/2009/winter/schultz-danh-green/, accessed Nov. 21, 2012.

5. "Spark: Binh Danh," http://www.kqed.org/arts/programs/spark/profile.jsp?essid=7660, accessed Nov. 21, 2012.

6. Binh Danh quoted in Anthonly W. Lee, *World Documents* (South Hadley, MA: Hadley House Press, 2011), n.p.

8. "Edwin Land," *Time* (June 26, 1972), 84.

Chapter 10:
Moving Images: Film and Digital Arts

1. "Ridley Scott Demystifies the Art of Storyboarding," *Openculture*: http://www.openculture.com/2012/05/ridley_scott_demystifies_the_art_of_storyboarding.html, accessed Nov. 21, 2012.

2. Christopher Noxon, "The Roman Empire Rises Again," *Los Angeles Times,* http://articles.latimes.com/2000/apr/23/entertainment/ca-22410, accessed Nov. 21, 2012.

3. Ridley Scott, director's commentary on *Blade Runner Final Cut.*

4. "Ridley Scott: Magic Comes Over the Horizon Every Day," http://herocomplex.latimes.com/2012/04/26/ridley-scott-magic-comes-over-the-horizon-every-day/, video interview accessed Nov. 21, 2012.

5. Ridley Scott interviewed by Paul F. Sammon in Lawrence F. Knapp, ed., *Ridley Scott Interviews* (Jackson: University Press of Mississippi, 2005), p. 114.

6. Vincent Canby, "Movie Review: *Black Rain*," *New York Times*, Sept. 22, 1989.

7. Ted Greenwald, interview with Ridley Scott, *Wired Magazine*, vol. 15, no. 19, September 2007.

Chapter 11: Design Disciplines

1. "Do You Know Your ABCs?", *Advertising Age*, June 19, 2000.

2. Saul Bass, interviewed for film *Bass on Titles* (Pyramid Films, 1977).

3. Quoted in Holly Wills, "Biography," http://www.aiga.org/design-journeys-karin-fong/, accessed Nov. 23, 2012.

4. Quoted in Mark Blankenship, "You Are Now Exiting the Real World," *Yale Alumni Magazine*, Nov. 2011. http://www.yalealumnimagazine.com/issues/2011_11/arts_karinfong.html, accessed Nov. 23, 2012.

5. Quoted in interview with Remco Vlaanderen, *Submarine Channel*, http://mmbase.submarinechannel.com/interviews/index.jsp?id=24451, accessed Nov. 23, 2012.

6. Karin Fong, telephone interview with the author, April 30, 2012.

Chapter 12: Sculpture

1. Quoted in Michael Brenson, "Maverick Sculptor Makes Good;" *New York Times,* Nov. 1, 1987.

2. Martin Puryear interviewed for Public Broadcasting System, *Art 21* http://www.pbs.org/art21/artists/martin-puryear, accessed Nov. 23, 2012.

3 and 4. Quoted in Museum of Modern Art Interactive, 2007, http://www.moma.org/interactives/exhibitions/2007/martinpuryear/flash.html, accessed Nov. 23, 2012.

5. Martin Puryear interviewed by David Levi Strauss, *Brooklyn Rail*, Nov. 2007, http://www.brooklynrail.org/2007/11/art/martin-puryear-with-david-levi-strauss, accessed Nov. 23, 2012.

6. Quoted in Michael Kimmelman, "Art View," *New York Times*, March 1, 1992.

7. Ruth Butler, *Western Sculpture: Definitions of Man* (New York: HarperCollins, 1975), 249; from an unpublished manuscript in the possession of Roberta Gonzáles, translated and included in the appendices of a Ph.D. dissertation by Josephine Whithers, "The Sculpture of Julio González: 1926–1942" (New York: Columbia University, 1971).

8. George Brassaï, *Conversations with Picasso* (Paris: Gallimard, 1964), 67.

Chapter 13: Craft Media: Flirting with Function

1. John Coyne, "Handcrafts," *Today's Education* (November–December 1976), 75.

2. Grace Glueck, "In Glass, and Kissed by Light," *New York Times*, August 29, 1997, Bl.

3. Lara Baladi quoted in Roderick Morris, "Show Highlights Return of the Loom," *International Herald Tribune*, June 13, 2011.

4. *Faith Ringgold: Quilting as an Art Form*, http://www.youtube.com/watch?v=lia6SFTOeu8, accessed Nov. 24, 2012.

5. Faith Ringgold interviewed by Ben Portis, New York, NY, March 18, 2008, http://faithrinngggold.blogspot.com/2007/11/welcome.html, accessed Nov. 24, 2012.

Chapter 14: Architecture

1. Louis Sullivan, "The Tall Office Building Artistically Considered," *Lippincott Monthly Magazine*, March 1986, 408.

2. Xten Architecture, "Office Profile," http://xtenarchitecture.com/profile-approach.php, accessed Nov. 24, 2012.

Chapter 15:
From the Earliest Art to the Bronze Age

1. "Picasso Speaks," *The Arts* (May 1923), 319.

2. Amalia Mesa-Bains quoted in Galería Posada, *Ofrendas* exhibition catalog (Sacramento, CA: La Raza Bookstore, 1984), n.p.

Chapter 16:
The Classical and Medieval West

1. Titus Burckhardt, *Chartres and the Birth of the Cathedral* (Bloomington, IN: World Wisdom Books, 1996), 47.

2. Bill Viola quoted in *Ocean Without a Shore*, http://www.pafa.org/billviola/Bill-Viola-Ocean-Without-a-Shore/1184/, accessed Nov. 26, 2012.

Chapter 17:
Renaissance and Baroque Europe

1. Leonardo da Vinci, *Treatise on Painting*, quoted in Irene Earls, *Renaissance Art: A Topical Dictionary* (Boulder, CO: Greenwood, 1987), 263.

2. For a transcript of the entire hearing before the Inquisition, see Philipp Fehl, "Veronese and the Inquisition: A Study of the So-called *Feast in the House of Levi*," *Gazette des Beaux-Arts*, series 6, vol. 43 (1961), 325–54.

3. Saint Teresa of Jesus, *The Life of Saint Teresa of Jesus*, translated by David Lewis, edited by Benedict Zimmerman (Westminster, MD: Newman, 1947), 266.

4. Emanuel Leutze quoted in Gregory Paynter Shyne, "The War and Westward Expansion," National Park Service, http://www.nps.gov/resources/story.htm?id=203, accessed Nov. 27, 2012.

5. Louis Sullivan, "The Tall Office Building Artistically Considered," *Lippincott's Magazine*, March 1896, p. 68.

Chapter 19: The Islamic World

1 and 2. Usama Alshaibi, "Allahu Akbar," http://artvamp.com/usama/allahu-akbar/, accessed Nov. 27, 2012.

3 and 4. Charles Hossein Zenderoudi quoted in *Payvand Iran News*, Feb. 28, 2011, http://www.payvand.com/news/11/feb/1272.html, accessed Nov. 27, 2012.

5. Shah Jahan quoted in John Hoag, *Islamic Architecture* (New York: Abrams, 1975), 383.

Chapter 21: Late Eighteenth and Nineteenth Centuries

1. Beaumont Newhall, "Delacroix and Photography," *Magazine of Art* (November 1952), 300.

2. Margaretta Salinger, *Gustave Courbet, 1819–1877, Miniature Album XH* (New York: Metropolitan Museum of Art, 1955), 24.

3. Albert E. Elsen, *Rodin* (New York: Museum of Modern Art, 1963), 53; from a letter to critic Marcel Adam, published in an article in *Gil Blas* (Paris: July 7, 1904).

4. John Rewald, *Cézanne: A Biography* (New York: Abrams, 1986), 208.

5. Vincent van Gogh, *Further Letters of Vincent van Gogh to His Brother*, 1886–1889 (London: Constable, 1929), 139.

6. Ronald Alley, *Gauguin* (Middlesex, England: Hamlyn, 1968), 8.

7. Paul Gauguin, *Lettres de Paul Gauguin à Georges-Daniel de Monfried* (Paris: Georges Cres, 1918), 89.

8. John Russell, *The Meanings of Modern Art* (New York: HarperCollins, 1974), 35.

Chapter 22: Early Twentieth Century

1. Wassily Kandinsky, "Reminiscences," in Robert L. Herbert, ed., *Modern Artists on Art* (Englewood Cliffs, NJ: Prentice Hall, 1964), 27.

2. Henri Matisse, "Notes of a Painter," as translated by Jack Flam, *Matisse on Art* (New York: Dutton, 1978), 36.

3. William Fleming, *Art, Music and Ideas* (New York: Holt, 1970), 342.

4. Vincent van Gogh to Theo van Gogh, July 10, 1890. *Vincent van Gogh: The Letters*, no. 898, http://vangoghletters.org/vg/letters/let898/letter.html, accessed Nov. 30, 2012.

5. Emil Nolde quoted in Martin Urban, *Emil Nolde Landscapes* (New York: Praeger, 1970), 36.

6. Alfred H. Barr, Jr., ed., *Masters of Modern Art* (New York: Museum of Modern Art, 1955), 124.

7. H. H. Arnason, *History of Modern Art*, rev. ed. (New York: Abrams, 1977), 146.

8. Nathan Lyons, ed., *Photographers on Photography* (Englewood Cliffs, NJ: Prentice Hall, 1966), 133.

9. Beaumont Newhall, *The History of Photography* (New York: Museum of Modern Art, 1964), 111.

10. Georgia O'Keeffe quoted in Dan Flores, *Caprock Canyonlands* (Austin: University of Texas Press, 1990), 129.

11. Joshua C. Taylor, *Futurism* (New York: Museum of Modern Art, 1961), 124.

12. Julian Street, *New York Times* art critic, quoted in Calvin Tomkins, *Duchamp: A Biography* (New York: Henry Holt, 1996), 78.

Chapter 23: Between World Wars

1. Hans Richter, *Dada 1916–1966* (Munich: Goethe Institut, 1966), 22.

2. Paride Accetti, Raffaele De Grada, and Arturo Schwarz, *Cinquant'annia Dada—Dada in Italia 1916–1966* (Milan: Galleria Schwarz, 1966), 39.

3. André Breton, *Manifestos of Surrealism*, translated by Richard Seaver and Helen R. Lane (Ann Arbor: University of Michigan Press, 1972), 14.

4. Sam Hunter and John Jacobus, *Modern Art* (New York: Harry N. Abrams, 1985), 148.

5. Herbert Read, *A Concise History of Modern Painting* (New York: Praeger, 1959), 160.

6. *San Francisco Chronicle*, October 6, 1935, quoted in Evangeline Montgomery, "Sargent Claude Johnson," *Ijele: Art Journal of the African World* (2002), 1–2.

7. Romare Bearden and Harry Henderson, *A History of African American Artists from 1792 to the Present* (New York, 1993), 152.

Chapter 24: Postwar Modern Movements

1. Winston Churchill, "United Europe," lecture delivered at Royal Albert Hall, London, May 14, 1947, *Never Give In! The Best of Winston Churchill's Speeches* (London: Pimlico, 2003), 437.

2. Edward Lucie-Smith, *Sculpture Since 1945* (London: Phaidon, 1987), 77.

3. Calvin Tomkins, *The World of Marcel Duchamp* (New York: Time-Life Books, 1966), 162.

4. Richard Hamilton, *Catalogue of an Exhibition at the Tate Gallery*, March 12–April 19, 1970 (London: Tate Gallery, 1970), 31.

5. R. G. Swenson, "What Is Pop Art?" *Art News* (November 1963), 25.

6. Pierre Restany, "The New Realists," in Charles Harrison and Paul Wood, eds., *Art in Theory 1900–2000: An Anthology of Changing Ideas* (Malden, MA: Blackwell, 1992), 724.

7. Claes Oldenburg, "I am for art …" from *Store Days*, Documents from the Store (1961) and Ray Gun Theater (1962), selected by Claes Oldenburg and Emmett Williams (New York: Something Else Press, 1967).

8. Donald Judd, "Specific Objects," *Arts Yearbook* 8 (1965), 78.

9. Frank Stella quoted in Museum of Modern Art, *MoMA Highlights* (New York: Museum of Modern Art, 2004), 233.

10. Yayoi Kusama, video interview, Tate Modern, London, http://www.tate.org.uk/context-comment/video/yayoi-kusama-9-february-5-june-2012, accessed Nov. 30, 2012.

11. Alice Aycock, *A Project Entitled "The Beginnings of a Complex:" Notes, Drawings, Photographs.* (New York: Lapp Princess Press, 1977), n.p.

12. Lucy R. Lippard, *From the Center: Feminist Essays on Women's Art* (New York: Dutton, 1976), 48.

Chapter 25: Postmodernity and Global Art

1. Thom Mayne, interview with the author, Santa Monica, CA, March 15, 2007.

2. Joel L. Swerdlow, "To Heal a Nation," *National Geographic* (May 1985), 557.

3. "Boston Should Embrace Electronic Billboards," Editorial, *Boston Globe,* July 1, 2012.

4. Quoted in Wendy Leonard, "Art Inspires Reflection on Utah's Capitol Hill," *Deseret News*, April 9, 2010.

5 and 6. Anne Morgan, "From Form to Formlessness: A Conversation with Shirazeh Houshiary," *Sculpture* v. 19 (July 2000): 25.

7. Shahzia Sikander quoted in Sikkema Jenkins, http://sikkemajenkinsco.com/shahziasikander_press.html, accessed Dec. 1, 2012.

8. Renzo Piano interviewed by Jeffrey Brown, *PBS Newshour*, June 11, 2009, http://www.pbs.org/newshour/bb/entertainment/jan-june09/artinstitute_06-11.html, accessed Dec. 1, 2012.

372, *372*
earthenware 207, *208*, 208–9, 245, *245*
earthworks 202, 454, *454*, 460
Easter Island: moai 347, *347*
Eastman Kodak Company 153
Eavesdropping (Pica) 202, *203*
Echelman, Janet: *Her Secret Is Patience* 2, *3*, 3–4
Echo, L' (Seurat) 104, 105, *105*
Ecole des Beaux Arts, Paris 368
Ecstasy of Saint Teresa, The (Bernini) 293–4, *294*, 457
editions, print 128, 129
Effects of Good Government (Lorenzetti) 31, *31*
egg tempera 121
Eggleston, William 153
 Los Alamos Portfolio 153, *153*
Egypt 247, 249, 260
 architecture *see* pyramids *and* temples (*below*)
 Fayum encaustic painting 121
 hierarchic scale 253–4
 hieroglyphs 254
 map *249*
 modern artists 215, 477
 pyramids 223, 249, 250, 252
 sculpture 195, 252–3, 256
 temples 223, 252
 tomb/wall paintings 44, 46, 253–4
Eisenstein, Sergei 161
 The Battleship Potemkin 161, 161–2
electroetching 136
electronic drawing media 112–13
Elegy to the Spanish Republic (Motherwell) 436, *437*
Eliasson, Olafur: *The Weather Project 204*, 205
Ellison, Ralph 6
Emerson, Ralph Waldo 2
emphasis, use of 77
encaustic painting 121, *121*, 127, *441*
Endgame: A Cold War Love Story (Halpern) 173, *174*, 184
engraving(s) 133, *134*, 135, *135*
 wood 131
Enlightenment, the 298, 300, 360, 362
entasis 258
environments 454
Epic of Gilgamesh 248
Ernst, Max 413
 The Horde 413, *413*
Escher, M. C.: *Sky and Water I* 41, *41*
Eskimo societies: shamans 26
etching(s) *23*, 23–4, 39, *39*, 77, 77–8, 133, *135*, 135–6, 296
Etruscan architecture 224
Euphrates River 247

Euphronios Krater 256, *256*
evaluation of art 86–8, 91–2; *see also* art criticism
events 442–3, *see also* happenings
Exile (Murray) 141, *141*
Expressionism/Expressionists 384, 388, 402, 408, 410, 421
 see also Abstract Expressionism; German Expressionism
expressive theories 88, 91, 95
Eyck, Hubert van 122
Eyck, Jan van 122, 295
 The Arnolfini Portrait 65, 66, 289, *289*
 Madonna and Child with the Chancellor Rolin 122, *123*, 124
eye level 46

F-111 (Rosenquist) *445*, 445–6
Facebook 94
Facial Proportions of a Man in Profile (Leonardo) 97, *97*
Fairey, Shepard: *Hope* (poster) 143
Fallingwater, Bear Run, Penn. (Wright) 236, *236*
Fan Kuan 315
 Travelers Among Mountains and Streams 315, 315–16, 317
Fantasia (Disney) 164, 166, *166*
Farm Security Administration (FSA) 422
Fatehpur Sikri, Uttar Pradesh, India: Divan-i-Khass 335, *335*
Father Figure (C. Ray) 193, *193*
Fauves/Fauvism 393, 395, 399, 402, 408, 410, 434
Fayum encaustic portraits 121, *121*
Fear of Comics (G. Hernandez) 109, *109*
Feast in the House of Levi (Veronese) 290–92, *291*
feather baskets, Pomo 352, *352*
Federal Style 362
feminism/feminists 216, 217, 259, 456–8, 459
Fentress-Bradburn Architects: Jeppesen Terminal Building, Denver International Airport 232, *232*
Ferris, Keltie 126
 *++++****))))* 126, *126*
Fetus in the Womb, The (Leonardo) 284, *284*
feudalism 272
fiber arts 2–3, 214–15, 217
 see also quilt making
figurative art 9
figure–ground relationship 40, 451

figure–ground reversal 41, 66
film noir 163, 174
films/movies 48, 51, 97–8
 animated/cartoons 164, 166
 digital processes 166–7
 early techniques 160–63
 editing 160, 161, 166
 first close-ups 160–61
 first color films 158, *158*, 162
 and international co-production 166
 montage 161–2, 174
 sound 162
 title sequences/credits 181–2, *182*, 187
 see also Dalí, Salvador; DVDs; videos
Fincher, David: *Se7en* 182, *182*
firing 207, 210
First Light, (Chan) 57, *57*
Fischinger, Oskar 164
 Circles 158, *158*
Fisherman's Flute Heard Over the Lake (Qiu Ying) 317, *317*
Five Cents a Spot (Riis) 150, *151*
fixatives 104
flamboyant style 274
Flask (Tang dynasty) 64, *65*
Flatterland Funkytown (Apfelbaum) *216*, 217
Flemish painting *65*, 66, 122, 288–90, *289*, *290*, 294–5, *295*, 369
Florence, Italy 282, 284, 286
 Santa Maria Novella fresco (Masaccio) *281*, 281–2
flying buttresses 226, *226*, 273
focal points 77, 85
folding screens, Japanese 323, *323*
folk art/artists 7, 8
Fong, Karin 183, *183*
 Lincoln Center Infopeel (with Gardner) 183, *183*
 Rubicon trial frames for title sequence 182, *182*, 183
Fontana, Lavinia: *Noli Me Tangere* 73, *73*
fonts 176, 187
foreshortening 104, 292
Forever Free (Johnson) *429*, 430
form 14–15, 19, 40, 42
 closed 42
 open 42
formal theories 88, 89–90, 95
formats 82, 85
Forms in Echelon (Hepworth) 431, *431*
Fountain (Duchamp) 412
Fragonard, Jean-Honoré: *Happy Accidents of the Swing* 300, *301*, 361
France
 architecture 30, 224, 272, 229, 297,

University of Cincinnati (with Morphosis) 464, *464*
Media Burn (Ant Farm) *374*, 375
Medici family 282, 283, 288
medieval period *see* Middle Ages
medium/media 3–4, 19
 for crafts 206, 207, 212, 214
 dry 104–6
 liquid 107–8
Meeker, Donald: *Clearview Hwy* typeface 176, *177*
meeting houses, Maori *348*, 348–9
Meeting of Saint Anthony and Saint Paul, The (Sassetta) 49–50, *50*
Mehretu, Julie 103
 Back to Gondwanaland 111, *111*
Meireles, Cildo: *Cruzeiro do Sul* (*Southern Cross*) *81*, 81–2
Melanesia 345–6
Méliès, Georges 160
 Voyage to the Moon 160, *160*
memorials 29, *29*, 250–51, 471
Mende peoples: masks 31–2, *32*
Mendieta, Ana 459
 Tree of Life 459, *459*
Meninas, Las (Velázquez) 295, *295*
Menkaura (Myrcerinus), King, and Khamerernbty, Queen *252*, 252–3, 256
Mesa-Bains, Amalia: *An Ofrenda for Dolores del Rio* 251, *251*
Mesa Verde, USA 223
Mesopotamian civilizations 247–8
metalwork
 Muslim 211
 nomadic (early medieval) 270
metopes 250, 259
Mexican-Americans 251
 artists 98, 109
 see also Chicanos
Mexico 392, 422, 424
 Olmec culture 353
 public monument (bronze) 42
 relief prints 132
 retablo painting 8
 Teotihuacan 353–5, 356
 Toltec civilization 356
 20th-century art 22, 422, 427, 433, 435, *see also* Rivera, Diego
 21st-century art 21, 23
 see also Aztec *and* Maya civilizations
Meyerowitz, Rick *see* Kalman, Maira
Michelangelo Buonarroti 89, 260, 284, 287, 290, 295, 381
 Awakening Slave 195, *195*
 The Creation of Adam 286–7, *287*, 425
 David 286, *286*, 292, 293

The Last Judgment 93, 286
Pietà 82, 82–3
Study of a Reclining Male Nude 101, *101*
Micronesia 345, 346, 347
Middle Ages/medieval period 255, 265, 270–71
 see also Romanesque art and architecture
Mies van der Rohe, Ludwig 231, 420
 German Pavilion, Barcelona World's Fair (1929) 420, *420*
 Seagram Building, New York (with Johnson) 231, *231*
mihrabs 330, *332*, 332–3, 336
Milan, Italy: Santa Maria delle Grazie (*The Last Supper*) 285, 285–6, 291
Miller v. California (court case) 93
Mimbres culture: bowl 21, *21*
Min, Yong Soon 34
 Dwelling 34, *34*
minarets 330, 336
Ming Dynasty (China): porcelain 318
Minimal Art/Minimalists 450–51, 452, 454, 460, 465
Mining the Museum (Wilson) *476*, 476–7
Miró, Joan 414, 415
 Woman Haunted by the Passage of the Bird-Dragonfly Omen of Bad News 414, 415
mirror with Xiwangmu (Chinese) *314*, 314–15
Mission One motorcycle (Behar) 186, *186*
Mitchell, Joan: *Untitled* 124, *125*
mixed media 4, 142–3
 assemblage 34
 costumes 217, 220
 installation 251
 sculpture 7, 201–2
mkSolaire Home (Kaufmann) 237, *237*
moai, Easter Island 347, *347*
mobiles 52–3, *53*
Model for Monument to the Third International (Tatlin) 298–9, *299*
modeling 190–92
 of clay 208
Modernism/Modernists 406
 African-American 429–31
 Latin American 426–7
Modersohn-Becker, Paula 395–6
 Self-Portrait with an Amber Necklace 396, *396*
molds 192
Molnar, Vera: *Parcours* 172, *172*
Mona Lisa (Leonardo) 284, 284–5
Monahan, Matthew 202

The Seller and the Sold 202, *202*
monasticism 272
Mondrian, Piet 419, 420, 427, 433
 Tableau 2 with Yellow, Black, Blue, Red, and Gray 419, *419*
Monet, Claude 378, 379
 Arrival of the Normandy Train, Gare St.-Lazare 377, 377–8
 Impression: Sunrise 378, *378*
Mongols 316
Monkey Puzzle (Haring) 63, *63*
monochromatic color schemes 21, 62
Monogram (Rauschenberg) 440, *440*
Monreale, Sicily: Cathedral apse mosaic 268, *268*
Monroe (Alex) jewelry studio, London (DSDHA) 233, *233*
Monroe, Marilyn: *Marilyn Diptych* (Warhol) 446, *446*
Mont SainteVictoire (Cézanne) *383*, 383–4
montages 445
 film 161–2, 174
Monticelli, Adolphe 391
Monticello, Charlottesville, Virginia (Jefferson) 362, *362*
Monument to the Proletariat and Agriculture (Mukhina) 422, *422*
Moore, Henry 356, 431
 Recumbent Figure 431, 431–2
 Tube Shelter Perspective 96, *96*, 98, 101
More Than You Know (Murray) 465, *466*
Morisot, Berthe 24
 In a Villa at the Seaside 24, *24*
Morphosis: Campus Recreation Center, University of Cincinnati 464, *464*
Morris, William 206, 389
 Windrush (textile pattern) 206, *207*
mosaics
 Byzantine 265, 266, 267–8, 285
 early Christian 266
 Islamic 332–3
mosques 276, 330, *330*, 334
Mother and Child (Catlett) 196, *196*
Motherwell, Robert: *Elegy to the Spanish Republic* 436, *437*
motion 36, 37, 48
 actual *see* kinetic sculpture
 illusion of (in films) 159
 implied 51–2
motion graphics 181–2, 183
Motion Picture Production Code Authority 162–3, 164
Motley, Archibald 430
 Barbeque 430, 430–31
motorcycle, electric-powered 186, *186*